Studies in the History of Art
Published by the National Gallery of Art,
Washington

This series includes: Studies in the History of
Art, collected papers on objects in the Gallery's
collections and other art-historical studies
(formerly *Report and Studies in the History of
Art*); Monograph Series I, a catalogue of stained
glass in the United States; Monograph Series II,
on conservation topics; and Symposium Papers
(formerly Symposium Series), the proceedings of
symposia sponsored by the Center for Advanced
Study in the Visual Arts at the National Gallery
of Art.

[1] *Report and Studies in the History of Art*, 1967
[2] *Report and Studies in the History of Art*, 1968
[3] *Report and Studies in the History of Art*, 1969
 [In 1970 the National Gallery of Art's annual
 report became a separate publication.]
[4] *Studies in the History of Art*, 1972
[5] *Studies in the History of Art*, 1973
 [The first five volumes are unnumbered.]
6 *Studies in the History of Art*, 1974
7 *Studies in the History of Art*, 1975
8 *Studies in the History of Art*, 1978
9 *Studies in the History of Art*, 1980
10 *Macedonia and Greece in Late Classical and
 Early Hellenistic Times*, edited by Beryl Barr-
 Sharrar and Eugene N. Borza. Symposium Series
 I, 1982
11 *Figures of Thought: El Greco as Interpreter of
 History, Tradition, and Ideas*, edited by
 Jonathan Brown, 1982
12 *Studies in the History of Art*, 1982
13 *El Greco: Italy and Spain*, edited by Jonathan
 Brown and José Manuel Pita Andrade.
 Symposium Series II, 1984.
14 *Claude Lorrain, 1600–1682: A Symposium*,
 edited by Pamela Askew. Symposium Series III,
 1984
15 *Stained Glass before 1700 in American
 Collections: New England and New York
 (Corpus Vitrearum Checklist I)*, compiled by
 Madeline H. Caviness et al. Monograph Series I,
 1985
16 *Pictorial Narrative in Antiquity and the Middle
 Ages*, edited by Herbert L. Kessler and Marianna
 Shreve Simpson. Symposium Series IV, 1985
17 *Raphael before Rome*, edited by James Beck.
 Symposium Series V, 1986
18 *Studies in the History of Art*, 1985
19 *James McNeill Whistler: A Reexamination*,
 edited by Ruth E. Fine. Symposium Papers VI,
 1987
20 *Retaining the Original: Multiple Originals,
 Copies, and Reproductions*. Symposium Papers
 VII, 1989
21 *Italian Medals*, edited by J. Graham Pollard.
 Symposium Papers VIII, 1987
22 *Italian Plaquettes*, edited by Alison Luchs.
 Symposium Papers IX, 1989
23 *Stained Glass before 1700 in American
 Collections: Mid-Atlantic and Southeastern
 Seaboard States (Corpus Vitrearum Checklist II)*,
 compiled by Madeline H. Caviness et al.
 Monograph Series I, 1987
24 *Studies in the History of Art*, 1990

25 *The Fashioning and Functioning of the British
 Country House*, edited by Gervase Jackson-
 Stops et al. Symposium Papers X, 1989
26 *Winslow Homer*, edited by Nicolai Cikovsky, Jr.
 Symposium Papers XI, 1990
27 *Cultural Differentiation and Cultural Identity
 in the Visual Arts*, edited by Susan J. Barnes and
 Walter S. Melion. Symposium Papers XII, 1989
28 *Stained Glass before 1700 in American
 Collections: Midwestern and Western States
 (Corpus Vitrearum Checklist III)*, compiled by
 Madeline H. Caviness et al. Monograph Series I,
 1989
29 *Nationalism in the Visual Arts*, edited by
 Richard A. Etlin. Symposium Papers XIII, 1991
30 *The Mall in Washington, 1791–1991*, edited by
 Richard Longstreth. Symposium Papers XIV, 1991
31 *Urban Form and Meaning in South Asia:
 The Shaping of Cities from Prehistoric to
 Precolonial Times*, edited by Howard Spodek
 and Doris Srinivasan. Symposium Papers XV,
 1993
32 *New Perspectives in Early Greek Art*, edited by
 Diana Buitron-Oliver. Symposium Papers XVI,
 1991
33 *Michelangelo Drawings*, edited by Craig Hugh
 Smyth. Symposium Papers XVII, 1992
34 *Art and Power in Seventeenth-Century Sweden*,
 edited by Michael Conforti and Michael
 Metcalf. Symposium Papers XVIII (withdrawn)
35 *The Architectural Historian in America*, edited
 by Elisabeth Blair MacDougall. Symposium
 Papers XIX, 1990
36 *The Pastoral Landscape*, edited by John Dixon
 Hunt. Symposium Papers XX, 1992
37 *American Art around 1900*, edited by Doreen
 Bolger and Nicolai Cikovsky, Jr. Symposium
 Papers XXI, 1990
38 *The Artist's Workshop*, edited by Peter
 Lukehart. Symposium Papers XXII, 1993
39 *Stained Glass before 1700 in American
 Collections: Silver-Stained Roundels and
 Unipartite Panels (Corpus Vitrearum Checklist IV)*,
 by Timothy Husband. Monograph Series I, 1991
40 The Feast of the Gods: Conservation,
 Examination, and Interpretation, by David Bull
 and Joyce Plesters. Monograph Series II, 1990
41 *Conservation Research*. Monograph Series II, 1993
42 *Conservation Research: Studies of Fifteenth- to
 Nineteenth-Century Tapestry*, edited by Lotus
 Stack. Monograph Series II, 1993
43 *Eius Virtutis Studiosi: Classical and Postclassical
 Studies in Memory of Frank Edward Brown*,
 edited by Russell T. Scott and Ann Reynolds
 Scott. Symposium Papers XXIII, 1993
44 *Intellectual Life at the Court of Frederick II
 Hohenstaufen*, edited by William Tronzo,
 Symposium Papers XXIV*

* Forthcoming

Eius Virtutis Studiosi

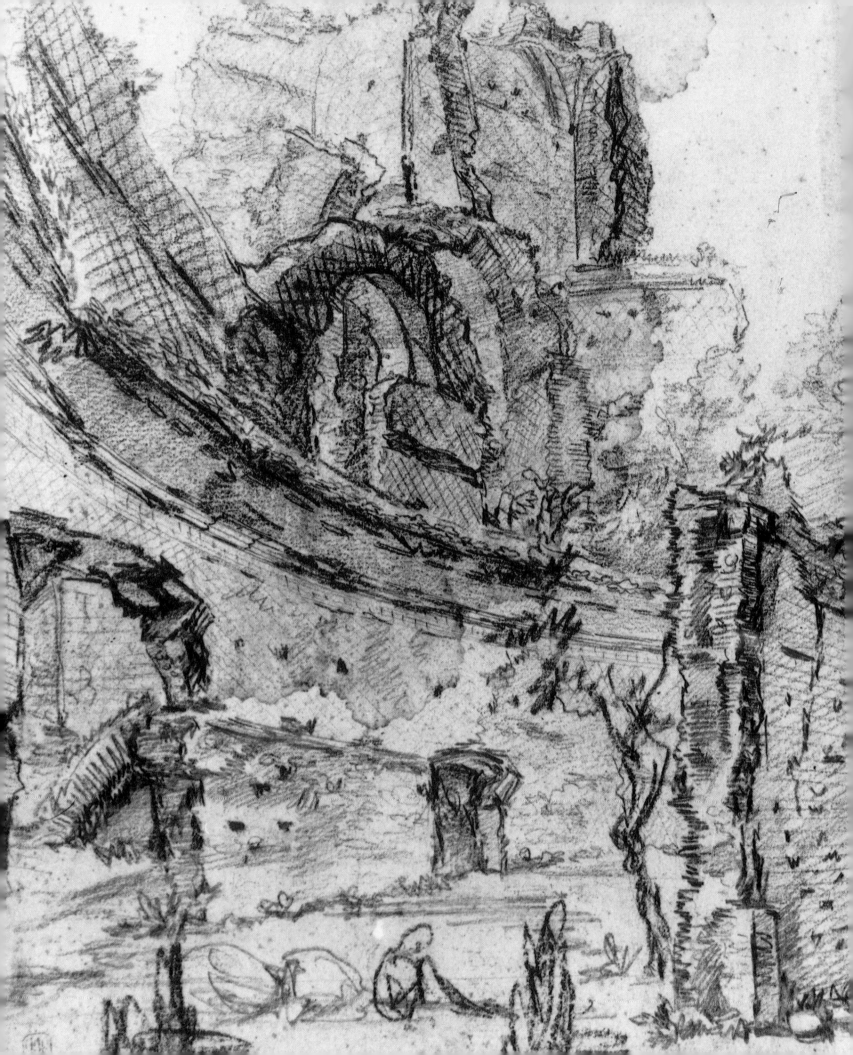

STUDIES IN THE HISTORY OF ART · 43 ·

Center for Advanced Study in the Visual Arts

Symposium Papers XXIII

Eius Virtutis Studiosi:

Classical and Postclassical Studies in Memory of Frank Edward Brown (1908–1988)

Edited by Russell T. Scott and Ann Reynolds Scott

National Gallery of Art, Washington

Distributed by the University Press of New England

Hanover and London 1993

Editorial Board
FRANKLIN KELLY, *Chairman*
SUSAN ARENSBERG
EDGAR PETERS BOWRON
SARAH FISHER
THERESE O'MALLEY
ELIZABETH P. STREICHER

Managing Editor
CAROL ERON

Manuscript Editors
LYS ANN SHORE
SUSAN SCOTT CESARITTI
FRANCES KIANKA

Production Editor
ULRIKE MILLS

Designer
CYNTHIA HOTVEDT

Distributed by the University Press of
New England, 23 South Main Street,
Hanover, New Hampshire 03755

Abstracted by RILA (International Repertory of
the Literature of Art), Williamstown,
Massachusetts 01267

Proceedings of the Symposium, *"Eius Virtutis
Studiosi:* Classical and Postclassical Studies in
Memory of Frank Edward Brown (1908–1988),"
sponsored by the Center for Advanced Study in
the Visual Arts and the American Academy in
Rome, with sessions in Rome on 6 June 1989
and in Washington on 17–18 November 1989.

ISSN 0091–7338
ISBN 0–89468–195–8

This publication was produced by the Editors
Office, National Gallery of Art, Washington
Editor-in-Chief, Frances P. Smyth

Printed by Schneidereith & Sons,
Baltimore, Maryland
The text paper is 80 pound LOE Dull
The type is Trump Medieval, set by
Artech Graphics II, Inc., Baltimore, Maryland

Frontispiece: Giovanni Battista Piranesi, *View
of the Island Enclosure at Hadrian's Villa,*
drawing. Ashmolean Museum, Oxford

Contents

HENRY A. MILLON, *Dean*
Center for Advanced Study in the Visual Arts

Preface

In June and November 1989 the American Academy in Rome and the Center for Advanced Study in the Visual Arts sponsored in Rome and Washington a two-part symposium in memory of Frank Edward Brown. The two institutions wished to commemorate the contributions of Frank Brown to Roman archaeology in West Asia, North Africa, and Italy, as well as to his students and colleagues both within and beyond the field of classical studies in Italy and elsewhere. The papers gathered in this volume signal the esteem accorded the accomplishments of Frank Brown as archaeologist, classicist, and historian. They are testimony to the depth of Frank Brown's erudition and the extent of his regard, which became apparent to those who knew him at the American Academy in Rome as fellow, director of excavations, professor-in-charge of the School of Classical Studies, director, and trustee over forty-five years from 1931 to 1976, and during his tenure in the fall of 1981 as Samuel H. Kress Professor at the Center for Advanced Study.

For more than half a century Frank Brown pursued his scholarly studies of the classical world in Italy and in the United States at Yale University. The capitals of these two nations were natural sites to honor and recognize Frank Brown's enlightened intellectual engagement, sophisticated understanding, and affection for colleagues and students. The twenty-six papers in the present volume include all but the contributions of Andrea Carandini, Carmine Ampolo, Friedrich Rakob, L. Richardson, Jr., and David F. Grose, who did not prepare their papers for publication.

The cosponsoring institutions are particularly grateful to Ann Reynolds Scott and Russell T. Scott for editing the papers for publication and for preparing the introduction to the volume. In addition, the American Academy in Rome and the Center for Advanced Study wish to acknowledge the generous support of the Samuel H. Kress Foundation, which made possible more than a decade of excavation campaigns under the direction of Frank Brown and his successors at Cosa, as well as the symposium on which the present volume is based. Additional support for the symposium was provided by Banca Commerciale Italiana and Alitalia.

The Center for Advanced Study in the Visual Arts was founded in 1979, as part of the National Gallery of Art, to foster study of the history, theory, and criticism of art, architecture, and urbanism through programs of meetings, research, publication, and fellowships. The symposium series of Studies in the History of Art, of which this is the twenty-third volume, is designed to document scholarly meetings, sponsored singly or jointly, under the auspices of the Center for Advanced Study in the Visual Arts. The series is also intended to stimu-

late further research and foster scholarly debate. A summary of published and forthcoming titles may be found on the opening leaf of this volume. Many of the publications result from collaboration between the Center for Advanced Study and sister institutions, including universities, museums, and research institutions. *Eius Virtutis Studiosi* is the first such collaborative endeavor undertaken with the American Academy in Rome.

ANN REYNOLDS SCOTT
University of Delaware

RUSSELL T. SCOTT
Bryn Mawr College

Introduction

These papers, dedicated to the memory of Frank Brown, illustrate the links that have always connected the scholarly pilgrims of all nations who come to Rome to study and reflect upon its powerful and ancient traditions. They also demonstrate the engaging intellectual atmosphere of the hostelry that the American Academy in Rome has represented for its fellows, residents, and visiting scholars for almost a century, and at no time perhaps more vigorously than when Frank Brown was there.

The breadth of his learning and his interests was such that no one who sought his opinion or advice came away empty-handed. It was the most challenging research problem, the most daring hypothesis that especially attracted his imagination and critical attention, the benefits of which the contributors to this volume of essays have acknowledged.

The range and geographical distribution of the subjects treated here by Frank Brown's colleagues and friends also reflect his own cursus from New Haven to Rome, the Middle East, and finally back to Rome again at the center of things: years of physical and intellectual journeying reminiscent of the travels made by one of his favorite imperial architects, the emperor Hadrian, who receives appropriate attention here, along with Piranesi at Tivoli, from William MacDonald and John Pinto, respectively. MacDonald adduces the possibility of a genuine foreign influence for the "marine theater" complex in Hadrian's villa, while Pinto has discovered an important source for understanding just how Piranesi went about his great and still unrivaled enterprise of mapping the villa. The essays of Susan Downey and Susan Matheson take us back to Syria and the years at Dura, the problems of the late architectural complex known as the Palace of the Dux, and those of the management of such a far-flung enterprise as was the Dura excavation from the port of New Haven, and Brown's part therein. Maria Teresa Marabini Moevs, known for her publications of pottery from Cosa, moves from Etruria to address the archaeological puzzle of Ptolemaic court life and festivals in Alexandria, while Lucy Shoe Meritt, whose own career has embraced the architecture of both Greece and Rome, has contributed a versatile study of the Athenian Ionic capital.

The Roman impact on the Italian peninsula, which Brown's years of work at the mid-republican colonial site of Cosa did so much to reveal, is evoked anew in Stefania Quilici Gigli's analysis of the changing shape of Faliscan territory in the republican period, and by that of Lorenzo Quilici on the port of Trajan at Civitavecchia. Both studies exemplify what topographical reconnaissance can still accomplish despite the ravages worked on the Italian archaeological landscape by

modern urban development and bureaucratic obstructionism. The prior impact of Greek colonization on southern Italy is likewise strikingly documented by Joseph Carter's account of the organization of the territory of Metapontum. A significant encounter of Greek and Roman architectural design in the Hellenistic period is illustrated by Malcolm Bell III in his discussion of the development of the Agora of Morgantina in the time of Hieron II and the place of the stoa as precursor of the porticus.

Major influences on the cults and ideologies of early Rome, in which Brown's work at the Regia in the Roman Forum in the 1960s served to rekindle interest, are discussed by Russell Scott and Mario Torelli. The latter's provocative analysis of terracotta decorations from the early to late sixth century B.C. carries us from the self-images promoted by the later Roman kings and their Etruscan peers to those of the emergent Roman aristocracy of the end of the century. The former, in his account of current excavations in the *area sacra* of Vesta, traces the rise and enduring significance of the cults which, from the regal period onward, focused on the survival and well-being of the Roman community, albeit housed in modest structures whose importance to the city over time was inversely proportional to their size. Fausto Zevi offers a new key to reading the series of altars from the federal sanctuary of the Latins at Lavinium, while the topography of the Roman Forum, the Capitoline, and the Roman triumph are the focus of important contributions by Eva Margareta Steinby, Eugenio La Rocca, and Emilio Rodríguez-Almeida. Henry Millon takes us to the Palatine and the ambitious study of its ancient remains that was undertaken by Bianchini in the 1720s. His was a remarkable instance of an early "scientific approach" to the interpretation of antiquity, but one which also, it is argued, could not but respond to the allure of contemporary fashion in architecture and specifically to the appeal of Bernini.

The papers of Alfred Frazer and James Packer on the imperial fora of Rome in general and the Forum of Trajan in particular, and those by Fikret Yegül and Anne Laidlaw on the palaestra at Herculaneum and the House of Sallust in Pompeii remind us how much profit is still to be had from returning to buildings that were to a considerable extent hastily unearthed for selfish and propagandistic ends in the later days of the Kingdom of Naples and under Italian fascism. The artistic traditions that Rome made its own in stone carving, bronze working, and painting from republic to empire are the subjects treated by Jacquelyn Collins-Clinton, who presents a rare Asclepius of Greek origin from Cosa; Emeline Richardson, who offers an extensive inventory of the varieties of small votive bronzes produced in central Italy in the Hellenistic period; Richard Brilliant, who evaluates the potential of hirsute Roman portraits for more than physical manipulation by carvers; and Vincent Bruno, whose study of Roman wall painting carries us in time far beyond the limits of the so-called Second Style. Herbert Bloch's study of the bronze doors of Monte Cassino stands as a forceful postantique complement to these papers, which also insists on the importance of autopsy and a knowledge of the classics as indispensable to the understanding of the legacy of classical antiquity in the West.

Eius Virtutis Studiosi

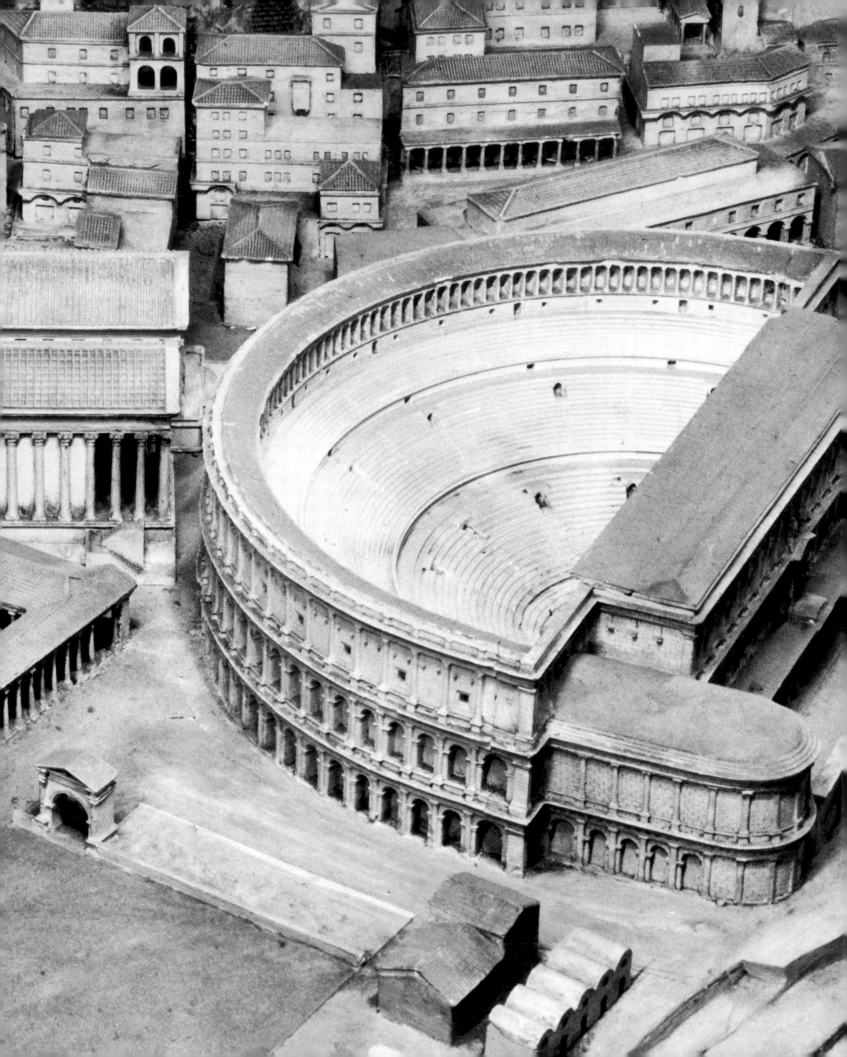

EUGENIO LA ROCCA
Università degli Studi di Pisa

Due monumenti a pianta circolare in circo Flaminio: *il* perirrhanterion *e la* columna Bellica

Oltrepassato l'arco che segna il limite orientale del portico di Ottavia (nel quale si potrebbe riconoscere il *ianus* dedicato a Germanico nel 19 d.C.[1]), si entra in un settore disputato, almeno topograficamente, tra il Circo Flaminio (e quindi il Campo Marzio) ed il Foro Olitorio. Il percorso trionfale che si è soliti inserire tra il teatro di Marcello ed i templi di Apollo Medico e di Bellona presenta obiettive difficoltà di passaggio. Basta osservare qualunque carta archeologica dell'area (fig. 2) e lo stesso settore nel plastico di Roma nel Museo della Civiltà Romana (fig. 1), che tuttavia andrà visto nelle sue linee generali e non certo nei dettagli ricostruttivi molto spesso non documentati archeologicamente, per rendersi conto della inevitabile strettoia tra i complessi monumentali, specialmente tra l'angolo sud-orientale del portico di Ottavia e l'anello esterno del teatro di Marcello, ora parzialmente crollato. Tra le due strutture lo spazio disponibile era di poco più di tre metri: il passaggio della processione trionfale per questa via era abbastanza improbabile.

Ricordiamo che il trionfatore era su un carro tirato da quattro cavalli, che vuol dire, tenendo conto dello spazio necessario tra un cavallo e l'altro, qualcosa più di quattro metri circa. L'immagine offerta da una processione passante per uno spazio così angusto non rispecchia adeguatamente il fasto che le fonti letterarie collegano alla pompa trionfale. È possibile che nelle narrazioni ci sia qualche esagerazione; o meglio, che l'immaginario collettivo contemporaneo, sensibilizzato dalla ben differente struttura urbanistica delle città moderne, dalle parate militari, dalle grandiose sfilate olimpiche, ed anche da 'colossals' cinematografici con trama desunta dalla storia romana, che offrono allo spettatore un'abbondante miscela di scenografica fantasia, abbia in certo qual modo indotto ad un travisamento involontario della realtà del mondo antico. Mi pare probabile, comunque, che la misura massima di larghezza consentita alla processione sia desumibile dalla larghezza del fornice centrale degli archi trionfali ed onorari ancora esistenti (l'arco di Settimio Severo ha il fornice largo 6.80 m circa[2] ed alto 12 m circa; l'arco di Costantino ha il fornice centrale largo 6.50 m ed alto 11.50 m; il supposto arco di Tito al centro del lato curvo del circo Massimo aveva il fornice centrale di 5.20 m circa;[3] l'arco di Tito sulla via Sacra ha una larghezza del suo fornice di 5.28 m circa ed un'altezza di 8.20 m[4]). Si potrà supporre, inoltre, che la massima espansione spettacolare avvenisse nel Circo Massimo dove probabilmente la pompa avrà assunto con una certa rapidità di movimenti una disposizione più allargata e scenografica. In base a questi dati, e tenendo conto che un arco avrà piuttosto ridotto la misura della

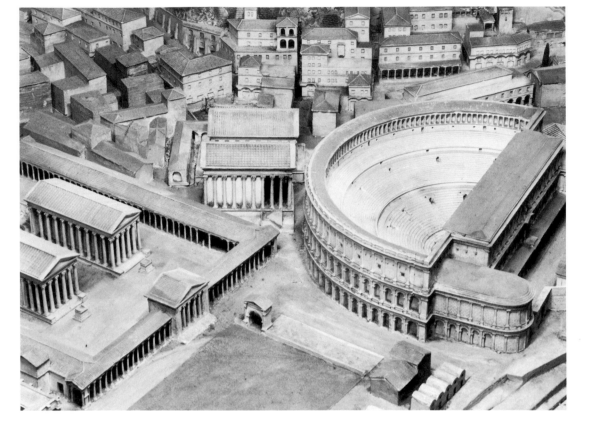

1. Area tra il Circo Flaminio ed il teatro di Marcello, Roma

Plastico del Museo della Civiltà Romana

carreggiata, penso che la pompa trionfale non potesse percorrere una via larga meno di 4.50/5 m circa. Già da questo punto di vista il passaggio della processione dinanzi ai templi di Apollo Medico e di Bellona mi sembra improbabile.

Ma non è tutto. L'ipotesi era finora basata sull'assunto che l'area tra il teatro di Marcello ed i templi di Apollo e di Bellona fosse sgombra da edifici pubblici. In realtà le cose non stanno esattamente in questi termini.

Sotto il profilo archeologico il settore in questione non è stato ancora indagato quanto meriterebbe. Così manca ancora un rilievo preciso della pavimentazione a grandi lastre di travertino che recinge esternamente l'anello circolare della cavea del teatro di Marcello. Qualche saggio stratigrafico fu eseguito nel 1940 da Colini proprio dinanzi al tempio di Apollo Medico; ma i risultati non sono mai stati pubblicati in dettaglio, ad esclusione di una breve informazione.[5] Eppure l'interesse per un'analisi accurata della pavimentazione è rilevante; eseguita forse in età augustea in lastre regolari di travertino

di forma rettangolare, subì in seguito alcuni interventi di restauro, come mostra l'inserzione in alcuni punti di lastre assai meno regolari in marmo ed in pietra lavica. L'effetto originario d'insieme è, in un certo senso, deducibile dall'accurata pavimentazione in travertino, piuttosto ben conservata, tra i templi di Apollo e di Bellona, di età giulio-claudia, di cui esiste invece un accurato rilievo (fig. 2).[6]

Lungo il perimetro esterno del teatro di Marcello, in due settori meno alterati della pavimentazione, sono visibili i segni residui di due fondazioni circolari in travertino. Una di esse è proprio in asse con la cella del tempio di Apollo Medico (fig. 3), dove Colini aveva individuato, nel suo saggio stratigrafico, le sostruzioni di una struttura circolare, del diametro di 5.20 m, considerate come le probabili fondazioni dell'altare: ma questa ipotesi non è facilmente dimostrabile, per almeno due motivi. In primo luogo alla fondazione circolare sembra accostarsi sul lato orientale una lastra in travertino dal bordo incurvato, che sembra essere la soglia di una porta.[7] In secondo luogo a mia conoscenza

2. Templi di Apollo Medico e di Bellona, Roma, pianta: l'area occupata dal *perirrhanterion* è indicata con il n. 1; la presumible area della *columna Bellica* è indicata con il n. 2
Rilievo di R Falconi

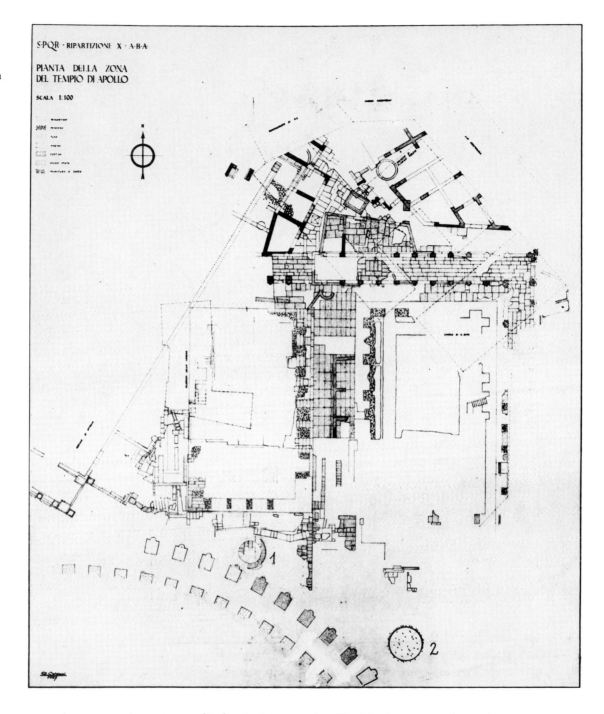

S·P·Q·R · RIPARTIZIONE X · A·B·A·

PIANTA DELLA ZONA DEL TEMPIO DI APOLLO

SCALA 1:100

non ci sono testimonianze di altari circolari di tale misura.[8] Prevalentemente funerari, la forma degli altari a pianta circolare è desunta da modelli greci di età ellenistica,[9] ed ha una discreta diffusione nel periodo tardo-repubblicano fino alla metà del I secolo d.C. circa.[10] Solo l'altare rotondo del tempio del divo Giulio ha una base del diametro di 3.10 m; ma, pur tralasciando la differenza di misura rispetto alla struttura dinanzi al tempio di

Apollo Medico, superiore ai 2 m, questo altare aveva una funzione specifica connessa con la *asylia*.[11]

Gli altari dinanzi ai templi, quelli almeno sicuramente documentati dalla *Forma Urbis*, sono a pianta quadrangolare. Ci sono naturalmente casi dubbi, ma in genere il simbolo del cerchietto sui pannelli della *Forma* si riferisce a basi, fontane o piccoli edifici rotondi non meglio identificati. In un'area non lontana

3. *Perirrhanterion* dinanzi al tempio di Apollo Medico, Roma, tracce tuttora visibili delle fondazioni
Fotografia: Barbara Malter

dal tempio di Apollo, la nuova *forma* di via Anicia testimonia l'esistenza di una struttura circolare davanti al tempio dei Castori nel Circo Flaminio, nella quale si è voluto riconoscere un altare rotondo.[12] Anche in questo caso mancano prove inconfutabili; potrebbe altrettanto bene trattarsi della base di una statua colossale, o di una fontana, visto il rapporto che lega anche i Dioscuri con le acque, come nel Foro Romano.[13]

Laddove si sono rinvenute fondazioni o strutture circolari di misura consistente, è stato possibile stabilirne la funzione di *loci parvi deo sacrati*,[14] nella maggioranza dei casi *saepti*,[15] talora originario luogo di sepoltura ritenuto di eroe, talaltra terreno colpito da un fulmine oppure semplice cavità naturale da dove scaturisce in qualche caso una fonte o un corso d'acqua sotterraneo dagli effetti miracolosi e purificatori. Sembra che la forma circolare intenda proprio un rapporto con le entità ctonie; il che spiega, naturalmente, l'uso di altari a sezione circolare in funzione funeraria.

Cicerone, a proposito del pozzo delle *sortes* nel santuario di Fortuna Primigenia a Praeneste, lo descriveva come un *locus saeptus religiose*. Ed infatti il pozzo è stato plausibilmente riconosciuto sulla 'Terrazza degli Emicicli,' inserito entro un *sacellum* caratterizzato come un *monopteros* su podio.[16]

Non mancano esempi di luoghi di raccolta d'acqua, siano essi fonti sorgive sotterranee o semplicemente pozzi, delimitati da *monopteroi*. Ad Ilio il pozzo con relativo *monopteros* è situato in asse con il tempio di Athena di età ellenistica (restaurato in età augustea) e con il suo altare.[17] Sebbene non in asse con il tempio, una simile strutturazione si incontra nell'area del Foro Triangolare a Pompei; il *monopteros* è ancora di età sannitica, come risulta dalla dedica del *meddix tuticus* Numerius Trebius.[18] Anche se sul bordo del *puteal* non vi sono segni di corda, la funzione del monumento come contenitore di acqua (per lustrazioni?) sembra plausibile.[19]

Altri esempi di particolare rilievo sono identificabili tra i monumenti del Foro Romano.

L'esempio forse piu' significativo in rapporto con la situazione riscontrata dinanzi al tempio di Apollo Medico, è dato dal

4. Sacello di Venere Cloacina nel Foro Romano, Roma, pianta
Da Christian Hülsen, "Die Ausgrabungen auf dem Forum Romanum," *RM* 20, 1905

5. *Perirrhanterion* dinanzi al tempio di Apollo Medico, Roma, capitello corinzio
Fotografia: Barbara Malter

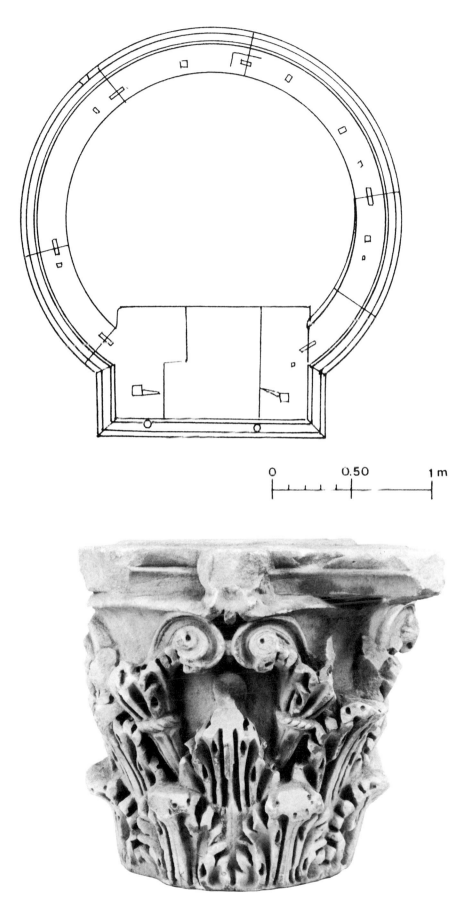

0 0.50 1 m

sacello di Venere Cloacina, situato presso la Basilica Emilia, lungo il corso della cloaca Massima (fig. 4). Il *sacrum* di Cloacina è il luogo dove "*Romanos Sabinosque, cum propter raptas virgines dimicare voluissent, depositis armis purgatos in eo loco qui nunc signa Veneris Cloacinae habet. . . .*"[20] Secondo la testimonianza di Plinio la purificazione avveniva con l'uso di rami di mirto, connessi con Venere e con il matrimonio; va tenuto presente, tuttavia, che nelle cerimonie di *ovatio*, forse l'originaria forma latina del trionfo prima dell'accoglimento del rito trionfale secondo la tradizione etrusca,[21] i vincitori erano incoronati con mirto e non con alloro. La testimonianza di monete e il rinvenimento della struttura superstite permettono di ricostruire idealmente il monumento nella forma di un podio circolare con balaustra, pozzo[22] e due statue di culto, cui si addossa una struttura quadrangolare, forse la scala d'accesso alla sommità del podio.[23] Ritorneremo in seguito sul *sacrum* di Venere Cloacina per un aspetto del culto che mostra significative tangenze con quello di Apollo Medico.

Circolare era anche il *mundus* o *sacellum Ditis*, ora identificato con l'*umbilicus Urbis*,[24] di cui è ancora visibile il podio restaurato in laterizio, su cui insisteva un *monopteros* in travertino, databile in base ai frammenti conservati alla fine del II secolo a.C.[25] Dal podio si penetrava in un ambiente cilindrico nel quale si doveva aprire un vano, o un pozzo, sotterraneo, appunto il *locus saeptus religiose*.

Circolari erano anche le demarcazioni delle aree colpite da fulmini che, come nel caso del *puteal Libonis*[26] o del *puteal in Comitio*,[27] erano delimitate da strutture simili a vere di pozzo.

La struttura circolare rinvenuta da Colini dovrebbe essere invece la fondazione di un *monopteros* (con scala di accesso?), di cui credo di aver individuato i frammenti della decorazione architettonica nei magazzini del portico d'Ottavia.[28] Sono riconducibili a questo piccolo edificio due capitelli corinzi (fig. 5) e numerosi resti di una trabeazione ricurva (figg. 6-8), composta da un architrave a tre fasce e da un fregio, decorato all'interno con girali d'acanto (fig. 8), all'esterno con frondosi

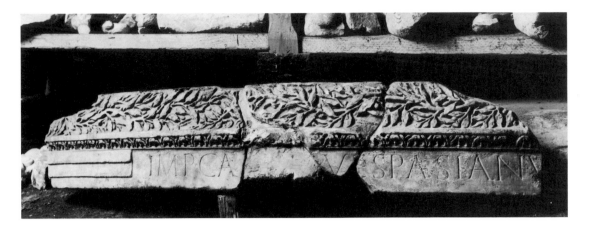

6. *Perirrhanterion* dinanzi al tempio di Apollo Medico, Roma, veduta esterna dell'architrave e del fregio
Fotografia: Barbara Malter

rami d'alloro sorretti dalle corna di bucrani (figg. 6–7): è un partito ornamentale dalle precise analogie iconografiche con il fregio esterno del tempio di Apollo Sosiano. Architrave e fregio sono eseguiti in uno stesso blocco di marmo. Sul fregio poggiava, a sua volta, una cornice con piccole mensole e soffitto decorato a rosoni (figg. 7–8). In base al materiale superstite, si può ricostruire ipoteticamente un *monopteros* circolare con colonnato corinzio. Sull'architrave esterno, in un settore dove le fasce sono state resecate, è leggibile una dedica (fig. 6), purtroppo frammentaria: *Imp. Caesar Vespasianus.*

Pur nella sua limitatezza, l'iscrizione permette di riferire l'erezione del *monopteros* all'imperatore Vespasiano; l'ipotesi più verosimile è che si tratti di una dedica a seguito delle vittorie di Vespasiano e Tito sui Giudei, e del successivo trionfo del 71 d.C. L'impossibilità di procedere per il momento ad una revisione approfondita dei saggi stratigrafici di Colini, purtroppo non pubblicati, non permette di fornire maggiori dettagli circa la funzione e la cronologia dell'edificio; comunque le sue fondazioni, in base a quanto si può desumere dai rilievi eseguiti all'epoca degli scavi, sono state considerate anteriori alla pavimentazione in travertino di età augustea. Ma c'è un altro motivo che spinge a considerare il *monopteros* di Vespasiano una ricostruzione o un restauro di un edificio preesistente: esso risulta esattamente tangente all'anello esterno del teatro di Marcello (fig. 2), una posizione singolare per una struttura ese-

guita *ex novo*, ma assolutamente logica se il campo circolare era reso inviolabile da una interdizione religiosa.

Le fonti letterarie aiutano forse a risolvere la questione. Credo che le fondazioni siano riferibili al celeberrimo *perirrhanterion*, il contenitore d'acqua lustrale posto davanti al tempio di Apollo Medico dove Catilina si lavò le mani sporche di sangue dopo aver mostrato di persona a Sulla la testa dell'avversario politico Mario Gratidiano.[29] Catilina procedeva in questo modo ad una sorta di purificazione rituale.[30] Sul *perirrhanterion* le informazioni sono assai scarse; anzi si limitano alla descrizione del barbarico comportamento di Catilina, avvenuto proprio mentre Sulla procedeva ad una riunione del senato nel tempio di Bellona.[31] Del termine greco non conosciamo l'equivalente latino; ma è certo che la parola non si riferisce esplicitamente ad un bacino, bensì in primo luogo ad uno strumento destinato ad aspergere, come si desume dalla sua etimologia, ed in secondo luogo ad un utensile, oggetto o vaso contenente acqua per lustrazione.[32]

Si può considerare verosimile che l'acqua lustrale avesse una parte non secondaria nelle cerimonie che avvenivano presso il tempio di Apollo.[33] Il dio venerato nel Circo Flaminio aveva una forte connotazione salutare;[34] potrebbe anche ipotizzarsi che il *monopteros* segnalasse il luogo miracoloso dove sgorgava in origine acqua sorgiva, destinata a dare l'avvio al culto nell'area;[35] cosa non improbabile, visto che lungo le pendici del Campi-

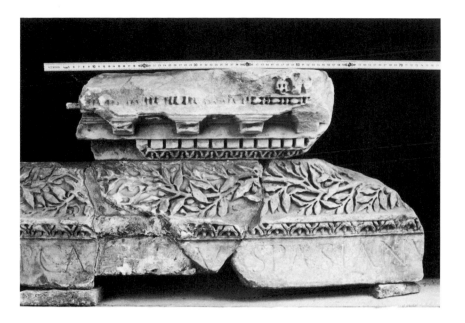

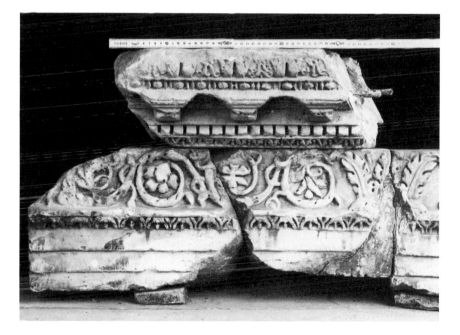

7. *Perirrhanterion* dinanzi al tempio di Apollo Medico, Roma, particolare della trabeazione con la cornice vista dall'esterno
Fotografia: Barbara Malter

8. *Perirrhanterion* dinanzi al tempio di Apollo Medico, Roma, particolare della trabeazione con la cornice vista dall'interno
Fotografia: Barbara Malter

doglio, sul lato verso il Foro Olitorio, erano situate altre sorgenti cui erano legati culti antichissimi.[36] Come ho ricordato, piccole strutture a *tholos* delimitano molto spesso pozzi o fontane o particolari fessure del terreno considerate segno della manifestazione divina. Nel caso in questione, e sempre in attesa di un saggio di scavo che possa parzialmente sciogliere i nodi irrisolti, nelle piante dell'area eseguite al momento dei lavori si osservano sul terreno i segni di un canale sotterraneo, il cui tracciato è visibile

dall'angolo sud-orientale del tempio di Apollo fino all'altezza della fondazione circolare cui è tangente a nord (fig. 2); potrebbe trattarsi di una conduttura idrica destinata ad incanalare o ad alimentare la fonte d'acqua lustrale.[37]

Effettivamente Frontino, parlando all'inizio della sua opera sulle acque e gli acquedotti romani delle fonti salutari esistenti a Roma, ne cita una di Apollo: "*(fontes) salubritatem aegris corporibus afferre creduntur, sicut Camenarum et Apollinis et Iuturnae.*"[38] Il brano dà adito a due possibili letture, o interpretando '*fons Camenarum et Apollinis*' come un'unica fonte, quella un tempo situata presso la Porta Capena;[39] oppure lasciando distinti i due termini. In questo caso il riferimento ad una sorgente situata presso il tempio di Apollo Medico[40] sarebbe possibile, sebbene non siano mancate altre proposte.[41] La presenza di una fonte salutare spiegherebbe anche l'inamovibilità del così detto *perirrhanterion*, che si trovò sovrastato dalla mole del teatro di Marcello.

È possibile quindi che il *perirrhanterion* dove Catilina si lavò le mani debba intendersi, se la proposta fosse presa in considerazione, come una struttura più complessa dove l'acqua lustrale, sgorgante da una fonte o da un canale sotterraneo, fosse raccolta entro un contenitore.

Non si può precisare quando il *perirrhanterion* cadde in disuso. In avanzata età imperiale, probabilmente tra il IV ed il V secolo d.C.,[42] il teatro di Marcello era ancora in piedi. Forse a questo periodo risalgono alcune tamponature del lastricato in travertino con basoli e lastre di marmo rozzamente tagliate.

Davanti al tempio riconosciuto da Coarelli come tempio di Bellona, la situazione non era diversa. Dalle fonti sappiamo che qui era la *columna Bellica*, una piccola area esclusa dalla proprietà dello Stato romano, simbolicamente terra nemica, destinata alle cerimonie della dichiarazione di guerra da parte dei feziali.[43] Lo stato disastroso di conservazione del tempio di Bellona ha impedito di studiare a fondo il problema. Eppure anche in questo caso sulla pavimentazione di fronte al tempio,[44] e tangente al

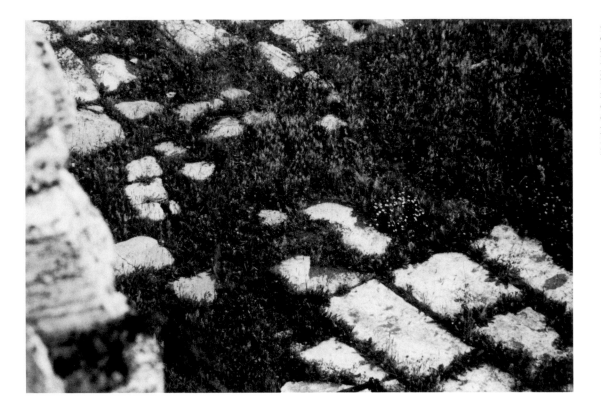

teatro di Marcello, sono i segni di una ostruzione a forma pressappoco circolare con blocchi di travertino, circoscritta da filari di lastre in travertino ad andamento regolare (fig. 9): potrebbe trattarsi della delimitazione dell'area destinata alla *columna Bellica*.[45] Durante la guerra contro Pirro, a seguito della difficoltà di procedere ad una dichiarazione di guerra secondo il costume atavico,[46] contro nemici ormai sempre più spesso lontani dal territorio romano, si provvide allo scopo con uno stratagemma. Si costrinse un prigioniero dell'esercito di Pirro ad acquistare un lembo di terreno nel Circo Flaminio, dinanzi al tempio di Bellona; proclamato territorio nemico (cosa possibile, in quanto la zona è fuori del pomerio), qui i feziali svolgevano i rituali della dichiarazione di guerra lanciando la *hasta* contro una piccola colonna (una *columella*) eretta nel centro della piccola area, "*veluti conspecto hoste issent.*" La cerimonia, che si svolse anche in occasione della dichiarazione di guerra contro Cleopatra,[47] è ricordata ancora all'epoca di Marco Aurelio.[48] L'area era *brevis*,[49] ed era situata *ante aedem Bellonae*.[50] La testimonianza di Ovidio offre gli elementi più precisi per l'ubicazione:

Prospicit a templo summum brevis area circum:
Est ibi non parvae parva columna notae.
Hinc solet hasta manu belli praenuntia mitti
In regem et gentes cum placet arma capi

Il primo verso è alquanto oscuro. Sembra desumersi che dalla *columna Bellica* si potesse vedere il lato d'ingresso, quello rettilineo, del Circo Flaminio; ed è questa l'opinione vulgata.[51] Ma resta un mistero, in questo caso, il riferimento al circo piuttosto che al teatro di Marcello, che si addossa e sovrasta l'area della *columna Bellica*.[52] Si potrebbe forse superare la difficoltà supponendo che si tratti di una citazione dotta, riferita ad un periodo in cui il teatro di Marcello ed il portico di Ottavia non coprivano ancora, con la loro mole, l'ingresso al Circo Flaminio. D'altronde Ovidio stesso impedisce una differente lettura (ad esempio interpretando la frase *summum circum* come la sommità dell'anello semicircolare del teatro di Marcello), con una successiva

integrazione, che Hercules Custos dal suo tempio proteggeva la *altera pars circi*;[53] e questo verso non pare ammettere equivoci. Si dovrà perciò supporre che il poeta abbia dato per scontati i più ovvii elementi topografici. Il riferimento colto prendeva il sopravvento sull'informazione topograficamente più chiara.

Se fosse vero—ma solo uno scavo eseguito correttamente potrebbe forse rispondere alla questione—avremmo non solo l'implicita dimostrazione della giustezza dell'ipotesi di Coarelli circa l'ubicazione del tempio di Bellona, ma sarebbe nello stesso tempo provata la presenza, dinanzi ai due templi contigui di Apollo e di Bellona, di due aree circolari, tra loro simmetriche, delimitanti due zone di importanza eguale e contraria, l'una destinata ai rituali preliminari all'avvio della guerra, l'altra a cerimonie di lustrazione dell'esercito vincitore invero non documentate dalle fonti letterarie, che ricordano solo le lustrazioni presso l'ara di Marte, ma ipotizzabili sia in base all'episodio di Catilina (tutto fa credere che Catilina abbia proceduto ad una purificazione rituale come dopo una battaglia[54] o dopo un sacrificio) che alla funzione di Apollo Medico, il dio che storna i mali, ed alla simbologia dell'alloro, adoperato per tale motivo durante le processioni trionfali (i soldati erano coronati d'alloro ed il trionfatore aveva un ramo d'alloro nella mano)[55]

Non può sfuggire l'analogia con la situazione del *sacrum* di Venere Cloacina, destinato anch'esso a cerimonie di purificazione, ma con il mirto in luogo dell'alloro.[56] In ambedue i casi il rito avveniva in prossimità dell'acqua (nel caso di Apollo Medico lo si desume dal nome della struttura; nel caso di Venere Cloacina dalla posizione del monumento presso la cloaca Massima), come purificazione dal sangue versato. Né mi sembra fortuito che le fronde di mirto e di alloro fossero destinate a coronare i vincitori durante processioni a carattere trionfale.

In età augustea, con il completamento del teatro di Marcello, si provvide ad una risistemazione dell'area antistante. In mancanza di saggi stratigrafici non si può escludere che anche in origine il *perirrhanterion* e la *columna Bellica* fossero

inscritti in un perimetro circolare.[57]

Il percorso trionfale era perciò impedito lungo i templi di Apollo e di Bellona non solo a causa dell'obiettiva ristrettezza del passaggio, ma a più forte ragione per la presenza delle due aree circolari.

Il brano nel quale Flavio Giuseppe descrive l'avvio della processione trionfale di Vespasiano e Tito nel 71 d.C., offre tuttavia una interessante soluzione al problema. Secondo lo scrittore, la pompa passava "per i teatri" in modo da permettere ad un gran numero di spettatori di partecipare allo spettacolo. Le letture del brano sono state molteplici; ed alcuni studiosi hanno inteso *theatra* nel senso di più generici spazi destinati ad accogliere gli spettatori, forse palchi lignei approntati allo scopo nelle piazze e lungo le strade, più o meno come avviene ancor oggi in occasione di particolari celebrazioni pubbliche a carattere popolare.[58] Questa chiave di lettura, che mi sembra forzare il testo di Flavio Giuseppe, si basa sulla descrizione plutarchea della pompa trionfale di Emilio Paolo, di età repubblicana; in quell'occasione furono eretti palchi nel circo Flaminio e nel Circo Massimo. Plutarco dice testualmente che i palchi furono eretti nei "teatri ippici, detti circhi."[59]

In realtà, osservando con attenzione la situazione topografica dell'area *in circo Flaminio*, non si prospettano molte possibilità: la processione doveva passare effettivamente per le *parodoi* del teatro di Marcello, come si desume da Flavio Giuseppe. In tal modo si otteneva il duplice risultato di permettere ad un grande numero di spettatori (tra 10,000 e 14,000[60]) di assistere alla celebrazione; dall'altro di ampliarne la valenza scenografica e spettacolare certo vivificata dal fastoso fondale costituito dalla scena.[61]

Potrebbe essere suggerito forse che a Roma, in una fase avanzata, dopo l'erezione dei tre grandi teatri del Campo Marzio e dell'anfiteatro di Statilio Tauro, la processione trionfale, non legata all'esterno del pomerio da specifiche clausole sacrali, compisse un percorso tortuoso per i teatri stessi prima di oltrepassare le mura urbane all'altezza del Foro Olitorio. Ma le fonti letterarie su questo argomento sono

completamente mute; e mancano purtroppo le misure delle *parodoi* d'ingresso alle orchestre di uno almeno dei teatri romani.

Come spesso avviene in casi simili, non si può far altro che avanzare alcune ipotesi aventi qualche fondamento storico ed archeologico, ed attendere il fortuito rinvenimento di nuovi documenti.

NOTE

Presento in questa sede una versione leggermente ridotta di due capitoli di un lavoro sull'avvio della processione trionfale dal circo Flaminio. L'articolo, pubblicato qui di seguito, di Emilio Rodríguez-Almeida, offre un ulteriore supporto archeologico ad alcune delle mie proposte.

Desidero ringraziare per l'aiuto ricevuto durante le ricerche Giuseppina Pisani Sartorio, Alessandro Viscogliosi, Luigi Messa, Marina Bertoletti, Marilda De Nuccio, Danila Mancioli, Carlo Buzzetti. Le fotografie sono state eseguite da Barbara Malter. Il lavoro è stato parzialmente effettuato con un finanziamento del Consiglio Nazionale delle Ricerche.

1. Sull'arco di Germanico, si veda da ultimo Sandro De Maria, *Gli archi onorari di Roma e dell'Italia Romana* (Roma, 1988), 277–278. Il testo delle *tabulae Siarenses* su cui si basa l'ipotesi è offerto da Julian Gonzales, "Tabula Siarensis, Fortunales Siarenses et Municipia Civium Romanorum," *ZPE* 55 (1984), 55–100. Per i numerosi problemi connessi con le *tabulae*, si vedano Julian Gonzales e Fernando Fernandez, "Tabulae Siarenses," *Jura* 32 (1981, pubblicato nel 1985), 1–36; Jacques Gascou, "La *Tabula Siarensis* et le problème des municipes romains hors de l'Italie," *Latomus* 45 (1984), 541–554; David Potter, "The *Tabula Siarensis*, Tiberius, the Senate and the Eastern Boundary of the Roman Empire," *ZPE* 49 (1987), 269–276; *Estudios sobre la tabula Siarensis* a cura di Julian Gonzales e Javier Arce (Madrid, 1988); Claude Nicolet, "La *Tabula Siarensis*, la *Lex de Imperio Vespasiani*, et le *jus relationis* de l'empereur au Sénat," *MEFRA* 100.2 (1988), 827–866; Augusto Fraschetti, "La *Tabula Hebana*, la *Tabula Siarensis* et il *Iustitium* per la morte di Germanico," *MEFRA* 100.2 (1988), 867–869.

2. Misura desunta da Richard Brilliant, *The Arch of Septimius Severus in the Roman Forum*, *MAAR* 29 (1967), tav. III. Sull'arco, si veda inoltre De Maria 1988, 305–307.

3. Per la misura, desidero ringraziare Paolo Ciancio Rossetto, che sta conducendo da alcuni anni una campagna di scavo nell'area. Sull'arco, si veda De Maria 1988, 285–287.

4. Misura desunta da Michael Pfanner, *Der Titusbogen* (Mainz 1983), tavole fuori testo. Si veda inoltre De Maria 1988, 287–289.

5. Antonio Maria Colini, "Aedes Apollinis," *BC* 68 (1940), 228–229.

6. La bella pianta della Falconi è ancora incompleta. Oltre la pavimentazione dinanzi al teatro di Marcello, vi sono sovrapposte strutture di periodo differente, tanto da non essere chiara nei dettagli.

7. La circostanza si ripropone, con qualche variazione, nelle fondazioni del *sacrum* di Cloacina nel Foro Romano (si veda sotto).

8. Sul problema, si veda da ultimo Wilhelm von Sydow, "Eine Grabrotunde an der via Appia Antica," *JdI* 92 (1977), 241–321 e soprattutto 312–319. L'altare rotondo preso in esame da Sydow, un esemplare a funzione funeraria di età augustea sulla via Appia, ha un diametro massimo di 86.3 cm ed un'altezza preventivata di 176.5 cm circa, misura eccezionale per monumenti di tal genere.

9. Constantine G. Yavis, *Greek Altars* (Saint Louis, 1949), 142–146; Hans-Volkmar Herrmann, *Omphalos* (Münster, 1959), 65–67.

10. Walter Altmann, *Die römischen Grabaltäre der Kaiserzeit* (Berlino, 1905), 1–8; Hanns Gabelmann, "Oberitalienische Rundaltäre," *MdI. Römische Abteilung* 75 (1968), 87–105; von Sydow 1977, 314, nota 273.

11. Marinella Montagna Pasquinucci, "L'altare del tempio del Divo Giulio," *Athenaeum* 52 (1974), 144–155; Filippo Coarelli, *Il Foro Romano II. Il periodo repubblicano e augusteo* (Roma, 1985), 231 233.

12. Maria Conticello De' Spagnolis, *Il tempio dei Dioscuri nel circo Flaminio* (Roma, 1984); Ferdinando Castagnoli, "Un nuovo documento per la topografia di Roma antica," *Studi Romani* 33 (1985), 205–211; Emilio Rodríguez-Almeida, "Un frammento di una nuova pianta marmorea di Roma," *Journal of Roman Archaeology* 1 (1988), 120–131.

13. Proprio nei paraggi correva il condotto sotterraneo d'acqua che inglobava il tratto finale della celebre *amnis Petronia*, che in età arcaica non poteva essere attraversata senza aver preso gli *auspicia peremnia*: Servius *ad Aen.* 9.24. Si veda Theodore Mommsen, *Römisches Staatsrecht* I (Lipsia, 1887), 3a edizione, 110 nota 6, 118 nota 3; André Magdelain, *Recherches sur l'imperium* (Parigi, 1968), 47, 48. Sulla *amnis Petronia* si veda Rodolfo Lanciani, *Topografia di Roma antica. I comentarii di Frontino intorno le acque e gli acquedotti*, *MemLinc* 4 (serie III, 1881) (ristampa anastatica con il titolo *Le acque e gli acquedotti di Roma antica* [1975]), 227–230.

14. Il termine normalmente adoperato per definire la recinzione di queste aree è *sacellum*, su cui si veda "sacellum," *Real Enzyklopädie* I A 2 (Stoccarda, 1920), colonne 1625–1626 (Rosenberg); Helge Lyngby, *Beiträge zur Topographie des Forum Boarium-Gebietes in Rom* (Lund, 1954), 20–24; Filippo Coarelli, *Il Foro Romano* I. *Il periodo arcaico* (Roma, 1983), 214. Per la verità, il termine non è preciso in quanto secondo le fonti letterarie il *sacellum* è *sine tecto* (Festus, edizione Wallace Lindsay [Lipsia, 1913], 422), oppure è un *locus parvus deo sacratus cum ara* (così Aulus Gellius, *Noctium Atticarum* VII.12, 5). Forse il termine più esatto è *sacrum*, come tramandato per la sede del culto di Cloacina (si veda sotto).

15. Come si desume da Cicero, *De Divinatione* II.41, 85 a proposito del pozzo delle *sortes* a Praeneste.

16. Paolino Mingazzini, "Note di topografia prenestina. L'ubicazione dell'Antro delle Sorti," *Archeologia Classica* 6 (1954), 295–301; Heinz Kähler, *Das Fortunaheiligtum von Palestrina-Praeneste* (Saarbrücken, 1958) (ristampato in *Studi su Preneste* [Roma, 1978]), 202; Filippo Coarelli, *I santuari del Lazio in età repubblicana* (Roma, 1987), 48–50.

17. Wilhelm Dörpfeld, *Troja und Ilion I* (Atene, 1902), 228–229, figg. 91–92. La struttura circolare ricopre un pozzo sicuramente in funzione già da secoli (Dörpfeld, 177–181).

18. August Mau, *Pompeii, Its Life and Art* (New York, 1899), 133, e dello stesso autore, *Pompeji in Leben und Kunst, Anhang* (Lipsia, 1913), 27; Antonio Sogliano, "Gli scavi di Pompei dal 1878 al 1900," *Atti del Congresso Internazionale di Scienze Storiche* 5 (1903), 298; Giuseppe Spano, "L'hekatonstylon di Pompei e l'Hekatonstylon di Pompeo," *Atti dell'Accademia Pontaniana* 49 (1919), 44–45; Antonio Sogliano, *Pompei nel suo sviluppo storico* (Roma, 1937), 213–215; Hans Eschebach, *Die Städtebauliche Entwicklung des antiken Pompeji* (Heidelberg, 1970), 22 e nota 31; Monika Verzar, "L'umbilicus Urbis," *DialArch* (1976–1977), 378–398 e soprattutto 395–398.

19. Malgrado dubbi espressi già da August Mau, per la mancanza di segni di corda sul *puteal*, la funzione di pozzo per acqua era stata ribadita, in base ad alcuni saggi di scavo, da Antonio Sogliano, si veda nota 18.

20. Plinius, *Historia Naturalis* XV.119. Si confronti Servius *in Aeneida* I.720. Sul *sacrum*, si veda Heinrich Dressel, "Das *sacrum Cloacinae*," *WS* 24 (1902), 418–424; C. C. van Essen, "Venus Cloacina," *Mnemosyne* 14 (serie 4, 1956), 137–144; Ernest Nash, *Pictorial Dictionary of Ancient Rome*, vol. 1 (seconda edizione, New York, 1968), 262–263; Robert Schilling, *La religion romaine de Venus depuis les origines jusqu'au temps d'Auguste* (seconda edizione, Parigi, 1982), 210–215; Coarelli 1983, 83–89; *Archeologia a Roma nelle fotografie di Thomas Ashby 1891–1930* (Napoli, 1989), 67–68, figg. 21.10, 21.11 (R. Turchetti).

21. Larissa Bonfante Warren, "Roman Triumphs and Etruscan Kings: The Changing Face of the Triumph," *JRS* 60 (1970), 49–66. Secondo Coarelli (1983, 116–118), si tratterebbe dell'originaria cerimonia trionfale che passava per il *tigillum Sororium*.

22. Durante gli scavi nell'area, sotto l'anello circolare del sacello, si rinvenne quella che fu ritenuta la fondazione della struttura, anch'essa circolare, in ricorsi di blocchi di tufo, profonda circa 4 m. Esther Boise Van Deman ("The Sullan Forum," *JRS* 12 [1922], 1–31 e soprattutto 21) vi leggeva tre livelli distinti. Ma dalle fotografie di Thomas Ashby (si veda nota 20) sembra desumersi che si trattasse del paramento esterno di un pozzo.

23. Günther Fuchs, *Architekturdarstellungen auf römischen Münzen der Republik und der frühen Kaiserzeit. Antike Münzen und Geschnittene Steine* I (1969), 31–32, tav. 4, nn. 46–47; Michael H. Crawford, *Roman Republican Coinage* (Cambridge, 1974), 509–511, nn. 494, 42–43, tav. LX, 11–12.

24. Verzar 1976–1977, 378–398; Filippo Coarelli, "Ara Saturni, Mundus, Senaculum," *DialArch*, 9–10 (1976–1977), 346–377; Coarelli 1983, 199–226. Ma si veda Patrizia Verduchi, "Lavori ai rostri del Foro Romano: L'esempio dell'Umbilicus,'" *RendPontAcc* 55–56 (1982–1984), 329–340; Ferdinando Castagnoli, "Il *mundus* e il rituale della fondazione di Roma," *Festschrift Gerhard Radke* (Münster, 1986), 32–36.

25. Verzar 1976–1977, 378–398; Coarelli 1983, 210–226.

26. Erik Welin, *Studien zur Topographie des Forum Romanum, Acta Instituti Romani Regni Sueciae* 6 (serie 8, 1953), 9–74; Coarelli 1985, 166–189.

27. Coarelli 1985, 39.

28. Marina Bertoletti, che sta studiando con Luigi Messa il monumento, ha rinvenuto una fotografia dei materiali rinvenuti dinanzi al teatro di Marcello, su cui è scritta la data "21 ottobre 1931." Tra gli elementi architettonici è riconoscibile un frammento d'architrave pertinente al *monopteros*.

29. Plutarchus, *Sulla* 32. Sulla vicenda, si vedano inoltre Asconius *in Ciceronis orationem in toga candida*, 80; Orosius, *Adversus Paganos* V.19. Plutarco parla di una *agora*; ma è evidente dal contesto che si

riferisce non al Foro Romano, bensì al Foro Olitorio. Sull'argomento si veda Filippo Coarelli, "Il tempio di Bellona," *BC* 80 (1965–1967), 37–72 e soprattutto 43–44, 66.

30. Jean Gagé, *Apollon romain*, BEFAR 182 (1955), 436.

31. Gagé (1955, 45) osservava che nel tempio di Bellona Sulla doveva avere il suo *"tribunal de vengeance."*

32. Sulla parola *perirrhanterion*, si veda *Thesaurus Graecae Linguae* VI, 910; si veda inoltre Gagé 1955, 74. Margherita Guarducci, "Il Santuario di Bellona e il Circo Flaminio in un epigramma greco del Basso Impero," *BC* 73 (1949–1950), 55–76, suppone che il termine in Plutarco possa significare "Bacino donde l'acqua lustrale venga spruzzata intorno" (69).

33. Si vedano le note 34 e 55.

34. Gagé 1955, 60–61; Eugenio La Rocca, *Amazzonomachia. La decorazione frontonale del tempio di Apollo Sosiano* (Roma, 1985), 79–82. Sono noti moltissimi esempi sull'uso lustrale dell'acqua in templi e santuari dedicati ad Apollo, sia in Grecia (si veda Susan Guettel Cole, in *Early Greek Cult Practice. Acta Instituti Atheniensis Regni Sueciae* 38 [1988], 161) che in Etruria (si veda Giovanni Colonna, "Note preliminari sui culti del santuario di Portonaccio a Veio," *Scienze dell'Antichità* I [1987], 431–446, specialmente 441). In età romana basterà ricordare il culto di Apollo a Vicarello, ove sgorgavano *aquae Apollinares* a carattere salutare: Gagé 1955, 60, 166.

35. La possibilità é appena accennata in Gagé 1955, 61, 73–74.

36. L'argomento ancora attende un'indagine esaustiva. Basterà ricordare, in questa sede, che Carmenta è divinità oracolare (*carmen* come "incantesimo," "oracolo"), ed anche ninfa delle acque, sottolineato dal collegamento con Giuturna nella festività dell'11 gennaio. Durante gli scavi lungo le pendici occidentali del Campidoglio, verso via Tor dei Specchi, si rinvennero i resti di un grande edificio di età adrianea, che aveva inglobato strutture più antiche, e che subì in seguito vari restauri, fino alla fine del IV secolo d.C. (Antonio Maria Colini, "Le Antichità della pendice ovest del Campidoglio," in Antonio Muñoz, *Campidoglio* [Roma, 1930], 29–76 e specialmente 68–76). Colini vi riconobbe un *balneum*; ma la sua posizione, tra il Campidoglio e i templi di Apollo Medico e di Bellona, presuppone forse una funzione differente. Non si è lontani, infatti, dalla sede del culto di Carmenta.

37. La conduttura era forse collegata al supposto *balneum* alle pendici del Campidoglio? Si veda nota 36.

38. Frontinus, *De Aquis* I.4.

39. Sulla *fons Camenarum* si vedano Lanciani 1881, 223–225; Henri Jordan e Christian Hülsen, *Topographie der Stadt Rom im Alterthum* I 3 (1907), 206–208. In realtà la fonte è conosciuta con il solo nome delle Camene.

40. Guarducci 1949–1950, 69.

41. Lanciani 1881, 225, tav. 1, fig. 4; Jordan e Hülsen 1907, 206, nota 12; Gagé 1955, 73, 74.

42. Il culto di Apollo è ancora testimoniato dalla dedica di una statua la cui base è stata rinvenuta proprio presso il portico di Ottavia (*CIL* VI, 45): *Apollini Sancto Memmius Vitrasius Orfitus v.c. bis praef. urbi (356–359) aedem providit curante Fl(avio) Claudio Euangelo v.c. comite.* Non può dirsi, naturalmente, dove fosse in origine la statua, e se la *aedes* citata nell'epigrafe fosse un'edicola o un edificio di più grandi dimensioni. Ma la dedica documenta la persistenza del culto ancora nei primi decenni dopo la metà del IV secolo. Per quanto riguarda il teatro di Marcello, esso riceve cure e restauri nel V secolo: Paola Ciancio Rossetto, "Le maschere del teatro di Marcello," *BC* 88 (1982–1983), 9, 10.

43. Jordan e Hülsen 1907, 554, 555; Samuel Ball Platner e Thomas Ashby, *A Topographical Dictionary of Ancient Rome* (Oxford, 1929), 131. Sulla cerimonia, si vedano Georg Burck, "Altrom im Kriege," *Die Antike* 16 (1940), 215–226; Franz Altheim, *Italien und Rom I* (Amsterdam, 1941), 225–228; Franz Bömer, *P. Ovidius Naso, Die Fasten II* (Heidelberg, 1958), 348. Francamente mi sembra poco plausibile la recente ipotesi di Thomas Wiedemann, "The *Fetiales*: A Reconsideration," *CQ* 36 (nuova serie, 1986), 478–490, che il rito presso la *columna Bellica* sia una innovazione di Ottaviano, impostata al momento della dichiarazione di guerra contro Cleopatra (si veda nota 47). È vero che la simbologia del lancio di una *hasta* in territorio nemico ha molti confronti in Grecia e nel mondo ellenistico (Alessandro, giunto in vista dell'Asia Minore, *"iaculum velut in hostilem terram iecit"*: Iustinus, XI.5, 10). Ma, malgrado talune assonanze, non vuol dire che il rito romano, di per sè complesso e ampiamente documentato in età repubblicana, derivi da quello ellenistico.

44. In attesa di un rilievo preciso, non si può dire se l'area circolare sia assiale al tempio.

45. Si vedano, su questo argomento, le importanti osservazioni di Emilio Rodríguez-Almeida: sotto, 42.

46. Secondo la tradizione il *pater patratus*, pronunciando una specifica formula, lanciava una *hasta* dal confine del territorio romano nel territorio nemico. Si veda nota 43.

47. Cassius Dio L.4, 5.

48. Cassius Dio LXXI.33, 3.

49. Ovidius, *Fastorum* VI.205.

50. Servius, *in Aeneida* IX, 52; Festus edizione 1913, 33; Placidius, p. 14 nell'edizione di Deuerl.

51. Christian Hülsen (Jordan e Hülsen 1907, 554 nota 131) rapportava il termine *summus*, per analogia, al termine *infimus* che in Varrone (*De Lingua Latina* V. 154) avrebbe designato il lato curvo del circo Massimo, dove era, secondo l'autore, il sacello di Murcia. Pertanto, in base a questa ipotesi, il *summus circus* ovidiano non sarebbe da interpretare come il lato curvo, come di solito avviene: Guarducci 1949–1950, 61–63; Coarelli 1965–1967, 50–53, 61. Purtroppo l'ipotesi di Hülsen poggia su una corruzione del testo

di Varrone non documentata dai codici, dove è adoperato, invece, il termine *intumus*, accettato in tutte le più recenti edizioni critiche del testo. L'erudito latino dice cioè che il sacello di Murcia era all'interno, nel cuore del circo Massimo. Una recente rilettura critica delle fonti sull'argomento ha permesso di localizzare con più esattezza l'edificio sacro presso il tempio di Cerere, quindi nell'area dei *carceres*: Mario Torelli, *Lavinio e Roma* (Roma, 1984), 78–80. Si potrebbe interpretare *summus circus* anche in modo differente, come "sommità," o "fastigio del circo." Se l'orientamento dei circhi a Roma fosse sempre secondo l'asse nord-ovest/sud-est con la curvatura a sud-est, questa interpretazione potrebbe anche essere presa in considerazione, sempre tenendo conto che in età imperiale l'area del circo Flaminio era divenuta una piazza monumentale, e quindi che Ovidio si riferisce ad una situazione topografica anteriore.

52. A meno che non si accetti la terza possibilità di cui alla nota 51.

53. Ovidius, *Fastorum*, VI.209.

54. Lo ricorda bene Gagé (1955, 436); Catilina *"parodiait brutalement les lustrations d'un soldat revenant pour le triomphe."*

55. È noto dalle fonti letterarie che l'alloro aveva la funzione simbolica di purgare dal sangue umano versato durante la guerra. Si veda Festus, edizione Lindsay, 104: *"laureati milites sequebantur currum triumphantis, ut quasi purgati a caede humana intrarent urbem."* Inoltre: Plinius, *Historia Naturalis* XV.135 (che riferisce, pur non accettandolo integralmente, un'opinione di Masurio Sabino secondo cui il lauro *suffimentum sit caedis hostium et purgatio*). Sull'argomento si veda William Warde Fowler, *The Religious Experience of the Roman People* (Londra, 1922), 214–218; Kurt Latte, *Römische Religions-*

geschichte (Monaco di Baviera, 1970), 117–119. Sulla funzione del trionfo come *lustratio* dell'esercito ha espresso opinione contraria Hendrik Simon Versnel, *Triumphus* (Leiden, 1970), 146–163; ma è stata ribadita, con buoni argomenti, da Domenico Musti, "Recensióne a H. S. Versnel," *JRS* 62 (1972), 164–166, e da Maxime Lemosse, "Les éléments techniques de l'ancient triomphe romain et le problème de son origine," *Aufstieg und Niedergang der römischen Welt* I, 2 (1972), 442–453.

56. Bibliografia a nota 20.

57. Nel caso del *perirrhanterion* la prova sarebbe fornita dai dati dello scavo di Colini. Una pianta degli strati archeologici sottostanti alle strutture di età augustea sembra testimoniare che l'anello circolare di delimitazione della struttura, in lastre di travertino, sia di età repubblicana: *BC* 90 (1985), 365, fig. 84 b.

58. Si veda Filippo Coarelli, "La Porta Trionfale e la Via dei Trionfi," *DialArch* 2 (1968), 55–103 e specialmente 70–71.

59. Plutarchus, *Aemilius Paulus* 32.

60. Il *Curiosum* parla di 20,000 *loca*; la *Notitia* di 25,000: Roberto Valentini e Giuseppe Zucchetti, *Codice topografico della città di Roma* I (Roma, 1940), 123, 176. È normalmente considerata esatta l'informazione offerta dalla *Notitia*: si veda Christian Hülsen, "Il posto degli Arvali nel Colosseo e la capacità dei teatri di Roma antica," *BC* 22 (1894), 312–324. Ad Hülsen si deve l'esatta interpretazione di *loca*.

61. Il plastico di Roma nel Museo della Civiltà Romana non può essere d'aiuto per suggerire i modi dell'eventuale passaggio in quanto mancano dati archeologici che suggeriscono almeno la misura in larghezza dei passaggi alle *parodoi* del teatro.

EMILIO RODRÍGUEZ-ALMEIDA

Escuela Española de Historia y Argueologia, Roma

De la Forma Urbis Marmorea, *en torno al* Collis Capitolinus

1. Nuevos datos para los accesos, muros perimentrales y templos del Capitolio

Fuertemente usado y corroído, el fragmento *Forma Urbis Marmorea* 499 (fig. 1) presenta a un atento examen datos topográficos pasados hasta ahora completamente inobservados. Por razones que veremos enseguida, estos datos son de grandísima importancia.

El pegueño bloque marmóreo se presenta con el aspecto de un prisma de base vagamente triangular de cerca de 13 x 9 cm y con espesor de poco menos de 7 cm. La superficie aparece dañada por calentamiento, como sucede con tantos otros fragmentos. Se trata de uno de los varios centenares de fragmentos que, recuperados originalmente en 1562, pasados enseguida a las colecciones Farnese y (por varias razones) olvidados y dispersos, fueron descubiertos casualmente en los muros del "Giardino Segreto Farnese" en la rivera izquierda del Tíber entre 1882 y 1891. En la edición *La Pianta Marmorea severiana* aparece esta descripción del pequeño fragmento: "A izquierda, trazas de ambiente con una escalera. Al centro, rampa o escalinata; a la derecha, comienzo de una fila de columnas."[1]

Las nuevas observaciones permiten excluir el primer elemento, porque a la izquierda son visibles solo tres espacios poco definidos, divididos entre sí por muros que apoyan a la línea de limitación de la escalinata; pues es una escalinata, ciertamente, no rampa, la que, a la parte contraria aparece limitada en todas sus tres series de escalones y doble rellano intermedio por una doble línea que indica claramente un grueso muro de contención o de terrazamiento, a la otra parte del cual, en posición perpendicular, comienza la "fila de columnas." Ahora bien, no ha sido nunca notado que entre la primera de dichas columnas (señaladas por quadrados) y el muro a doble línea existe en la superficie del mármol un surco o abrasión de 1 cm de anchura que corre a lo largo del grande muro, comenzando exactamente detrás de la columna y perdiéndose en la fractura; otra abrasión idéntica se encuentra a 90° con la primera exactamente al interior de la fila de columnas, perdiéndose en la fractura de la parte superior del mármol. La abrasión es una de las que encontramos con frecuencia en la *Forma Urbis Marmorea* para representar gruesos muros, especialmente los de las celdas templares. A pesar de la degradación física sufrida por el mármol, el dato no ofrece duda alguna; es perfectamente observable a la luz rasante y se reconoce claramente incluso al tacto.

Otras características físicas del mármol: el revés es liso y "zigrinato," esto es, con el característico rayado prieto y fino de los dientes de la sierra; tal rayado es más neto y visible hacia la derecha, tendiendo a desaparecer hacia la izquierda. No hay venadura

visible, como suele suceder con los fragmentos que, habiéndola tenido débil y sufrido un fuerto calentamiento, tienden a perderla del todo o hacerla escasamente observable.

Todos los datos físicos (independientemente de los topográficos, que veremos a continuación) indican que el fragmento debe pertenecer con grandísima probabilidad a la lastra 31 de los Pórticos de Octavia y de Filipo, del Circo Flaminio y del Teatro de Marcelo: una lastra muy quemada en ciertas partes de su superficie y de su revés, con espesores entre 68 y 73 mm, con rayado del revés exactamente como lo hemos visto precedentemente en el fragmento 499 (esto es, más fuerte al centro y derecha, débil o inexistente en las cercanías del margen izquierdo). Pero, al margen y en apoyo a estas características físicas del todo semejantes, los datos topográficos vienen a darnos el resto de la certeza.

La lastra 31 se compone de numerosísimos fragmentos de muy diverso estado de conservación: algunos quemados, erosionados en superficie y alterados en el color; otros, substancialmente bien preservados, de color lácteo, con venadura bien visible y substancialmente transversal a la vertical de la lastra. En líneas generales, al primero grupo pertenecen los fragmentos bajos de los Pórticos y del Circo Flaminio, al segundo, los altos del Teatro de Marcelo y, menos (leve evidencia de calentamiento), el pequeño grupo alto-izquierdo de los *Centum Gradus*. Este último grupo, aislado físicamente del resto, pero ciertamente colocable en alto al margen izquierdo de la lastra, lleva un diseño del todo semejante al que nos ha ocupado precedentemente: dos grandes escalones con rellanos, convergentes sus márgenes hacia la parte alta, separados por un muro central y apoyados, a la parte alta, a lo que debe ser el grande muro de terrazamiento y defensa del Capitolio en su lado occidental; encima de este murallón, dos templos de diversa forma y dimensiones (notar los muros de las celdas templares, representados mediante el rebajamiento de la superficie entre dos líneas). Téngase sólo presente que, no siendo arqueológicamente documentado el sistema de escalones en la pendiente

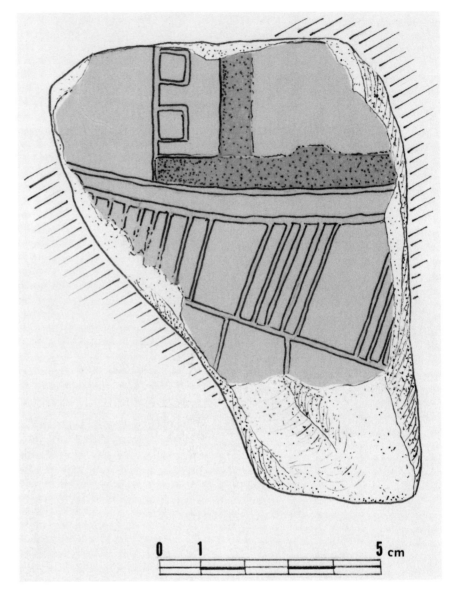

capitolina, la posición del grupo 31a–c no es fija y precisa al 100 por ciento, pudiendo deslizarse levemente a lo largo de las partes altas del margen izquierdo de la lastra (fig. 2). La seguridad en la atribución del fragmento e identificación de la topografía fué demostrada ampliamente ya por Lucos Cozza en su lúcido y puntilloso análisis.[2] Justamente Cozza no se pronuncia en cuanto a la identificación del doble edificio templar visible en este grupo, limitándose a notar que ambos están substancialmente alineados (a suroeste) como el templo de Júpiter Capitolino. Tampoco hace intento alguno para identificar el arco colocado a caballo de una de las dos escalinatas. Una cosa resulta evidente en

1. El fragmento *Forma Urbis Marmorea* 499, según nuevas observaciones

2. Parte medio-alta de la lastra *Forma Urbis Marmorea* 31, con los fragmentos de los *Centum Gradus* capitolinos (indicados por la flecha). De Emilio Rodríguez-Almeida, *Forma Urbis Marmorea, Aggiornamento Generale 1980, tav. 23*

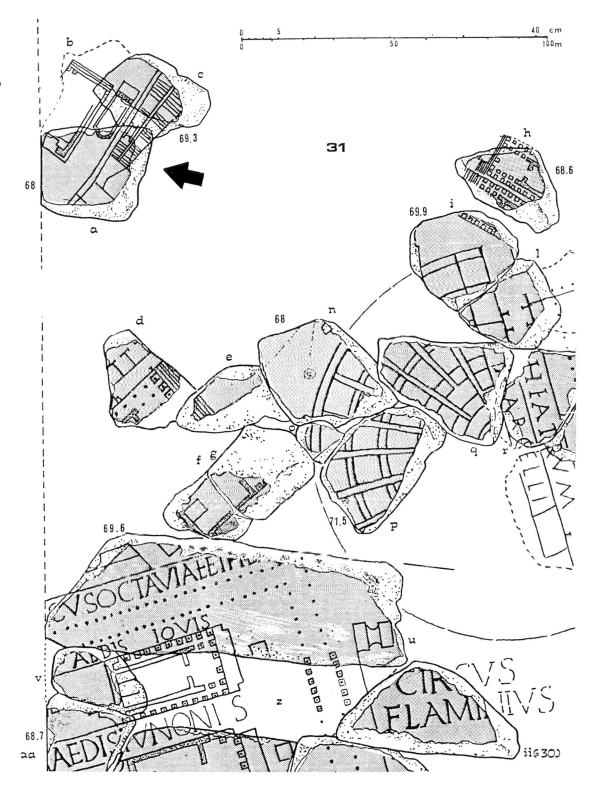

el diseño topográfico: que las partes convergentes de las escalinatas son ciertamente indicativas de las partes altas; por tanto, a sus extremidades debe entenderse situado el resíduo de muro de la fortificación original capitolina.

Hemos dicho ya que el rayado de sierra en el revés de esta lastra es bien visible en el margen derecho (donde un "diente" resíduo indica que la operación de serradura del mármol comenzó al lado opuesto), aparece bien observable en el centro y va desapareciendo progresivamente hacia el lado izquierdo. En el grupo de los *Centum Gradus* se ven leves restos en los estremos de la parte interna, mientras en el borde izquierdo no se conserva. Pues bien: en el fragmento 499 se observa la misma disminución o el mismo aumento progresivo, demostrando que el fragmento debía encontrase en la inmediata vecindad del grupo 31*a–c*. La comparación de los datos obliga a establecer más o menos la relación espacial que vemos en la figura 3.

Por tanto, es evidente que: el fragmento 499 debe incorporarse a la lastra 31 y transformarse en 31*kk* en el futuro; va a colocarse a las partes altas de la izquierda de la lastra, junto a los *Centum Gradus*; representa un nuevo elemento del sistema de accesos al *Collis Capitolinus* que los antiguos llamaban con tal nombre ("cien escalones"), que se manifiestan como más imponentes de lo que hasta ahora suponíamos en base a la *Forma Urbis Marmorea*; en fin, el nuevo fragmento documenta un nuevo templo capitolino hasta ahora no reconocido.

Una segunda importante constatación es que, dada la posición atribuíble en la realidad arqueológico-topográfica capitolina al grupo 31*a–c*, la nueva topografía definida por 31*kk* (ex-499) nos lleva a un punto bien preciso del collado: inmediatamente al sur de la actualmente llamada Salita di Monte Caprino (Via Tempio di Giove; también hoy un grande sistema de escalones, único "elemento de pervivencia urbanística") y al esperón rocoso angular que domina el *Vicus Iugarius* y la llamada "área sacra di S. Omobono." Hecha esta primera observación, se deriva incidentalmente de ella otra muy importante: el templo parcialmente visible en el nuevo fragmento resulta orientado oblícuamente respecto al de Júpiter Capitolino. Actualmente el espolón rocoso en cuestión se presenta terrazado con un muro moderno de contención de los movimientos de desplome de la roca, parcialmente ocupado por uno de los edificios de flanqueo

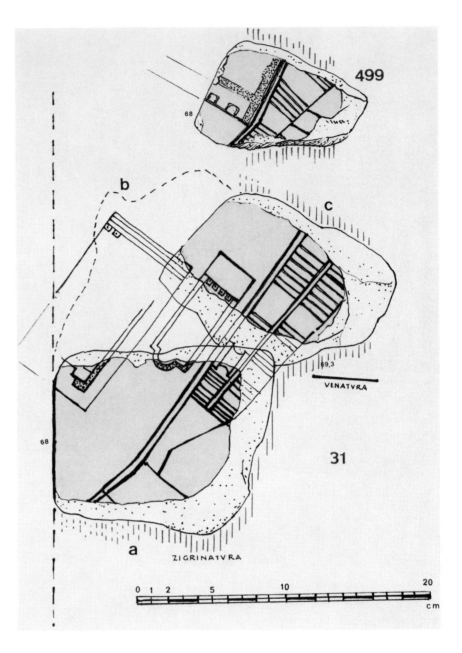

de la subida de Monte Caprino y en buena parte todavía libre y dedicado a jardín, lo que autoriza pensar que una indagación arqueológica in situ es perfectamente posible (fig. 4).

El templo que vemos en el ex-fragmento 499 (repito, ahora numerable 31*kk*) es substancialmente definible en sus características esenciales. Se trata con grande claridad de un períptero *sine postico* (esto es, con el lado posterior sin columnas, con solo el muro de fondo, al cual se apoyan las alas laterales; por hacer un ejemplo conocido, como el "templo C" del Largo

3. Relación posicional mútua entre el precedente grupo de los *Centum Gradus* y el nuevo fragmento. Notar la "zigrinatura" (trazas de los dientes de sierra sobre el revés de los mármoles lisos), indicada con el rayado vertical periférico a los fragmentos

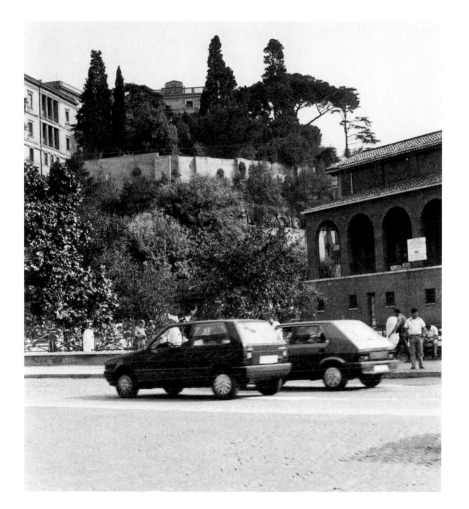

4. Angulo del Capitolio (a Sur del escalón actual entre Via di Monte Caprino y Via Tempio di Giove) en que debe situarse el nuevo templo del fragmento *Forma Urbis Marmorea* 499

nas cuya base (si se presta fe a la incisión) deben ser de cerca de 1.20 m de lado (intercolumnios de ca. de 1.90 m) y una encandidura de tipo picnóstilo.

A este punto estamos en condición de afirmar que los restos de poderosas columnas de travertino que, rodadas ciertamente del Capitolio, han sido descubiertas en el área sacra de S. Omobono (fig. 5) y en ella se conservan, son precisamente del templo que nos ocupa. El cual era, tal vez, un templo de una divinidad femenina, visto que otro de los elementos "rodados" es un fragmento de una gigantesca cabeza femenina de estilo helenístico atribuíble a una estatua cultual (fig. 6). Se trata de un importante primer paso para el restringimiento de las hipótesis de identificación del santuario. Veremos luego que exiten otros datos arqueológicos que deberían restringir ulteriormente las posibilidades hasta eliminar prácticamente los márgenes de error; mas veamos antes en breve síntesis los santuarios capitolinos entre los que hay que hacer la selección. Por ahora, dejemos fuera el elemento "femenino."

En el Capitolio existían, entre pequeños y grandes (*aedes, aediculae, signa*), una cantidad inverosímil de monumentos sagrados, hasta el punto que a veces resulta difícil dar credito a las fuentes. La mayor parte de ellos, por otra parte, son fácilmente eliminables en relación con nuestra búsqueda; algunos, porque ya claramente identificados en el pasado (*Iuppiter Optimus Maximus Capitolinus, Veiovis, Iuno Moneta in Arce*); otros, porque *humiliores* (a nivel inferior) respecto a la cima del collado (*Concordia*, identificado, y *Honos et Virtus*); otros, porque simples *aediculae, arae* o *signa* (*Febris, Genius Populi Romani, Iuppiter Africus, Iuppiter Pistor, Mithra, Sabazis, Valetudo, Venus Victrix*); algunos, porque directamente y localmente asociados a *Iuppiter Optimus Maximus* (*Mars, Iuventas, Iuppiter Tonans*). Habría que excluir dos santuarios "femeninos," *Mens* y *Venus Erycina*, dos santuarios emparejados, *canali uno discreta*[3] (las dos *aedes* emparejadas que vemos en 31*a–c*?). Inciertos y poco documentados, *Iuppiter Depulsor, Iuppiter Victor* y *Bellona. Isis et*

Argentina), esquema característico de una buena parte de los más venerables templos del período republicano en Roma. Su perbolo es de columnas de buenas dimensiones, cuyos centros paracen distar ca. 3.20 m; el número de columnas de flanqueo debe ser al menos 12 por lado, lo que sugiere una fachada probablemente hexástila. Del muro de fondo de la celda se ven restos equivalentes proximadamente a 13 m sin que se aprecie indicio de la vecindad del ángulo opuesto. Un pequeño engrosamiento de este muro a una cierta distancia del ángulo visible parece indicar, tal vez, una lesena o pilar aplicado (pero el estado de consunción del mármol no permite prestar demasiada fe al dato, que podría ser accidental). En resumen, del diseño conservado se trasluce un edicio religioso de tipo republicano, poderoso y macizo, con colum-

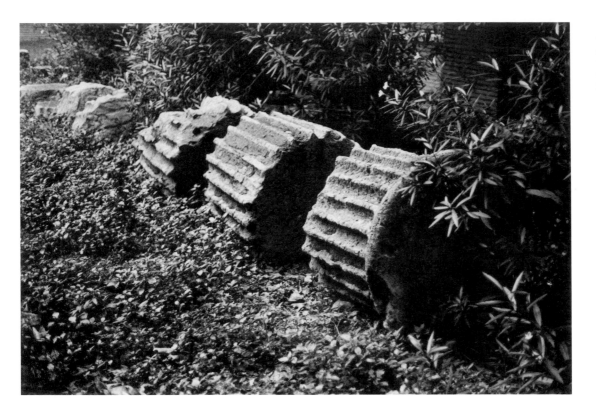

5. Una de las columnas de travertino de un templo republicano, rodadas al área sacra de S. Omobono desde el desplomado ángulo de la fortaleza capitolina

Serapis, pese a un conocido paso de Suetonio que parece implicar que existiese al final del s. I d.d.C., es probable que haya desaparecido ya después del 48 d.d.C.[4] Hay que excluir (vistas las características constructivas de nuestro santuario en la *Forma Urbis Marmorea*) la *Indulgentia* costruída por M. Aurelio en el 180 d.d.C.[5] Por la regla de la "divinidad femenina," tanto como por el hecho de que las monedas nos lo muestran tetrástilo y, por tanto, pequeño, se excluye también *Iuppiter Feretrius*.

Quedan cuatro santuarios posibles y son todos "femeninos":

1. *Ops*. Se trata de un venerable templo atribuido por la tradición a Tito Tacio.[6] Si fuese el nuestro, su posición aislada al ángulo suroeste del Capitolio podría explicar por qué razón, al momento de la celebración de los *Ludi Saeculares* de Augusto, su espacio circunstante, o área sacra, fue destinada a las mujeres y niños;[7] pero por un escoliasta de la Eneida[8] sabemos que tenía un espacio póstico, lo cual es difícilmente imaginable apoyado como aparece el templo con su parte posterior al muro de contenimiento y terrazamiento.

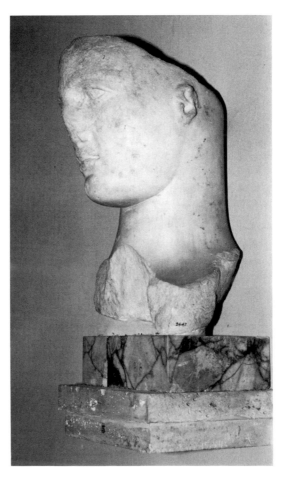

6. Acrolito femenino de una estatua cultual, caída del ángulo del Capitolio al área sacra de S. Omobono (*Fides?*)
Musei Capitolini, Roma

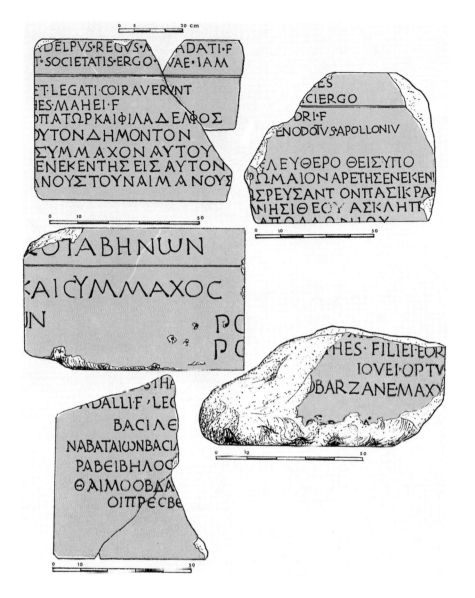

ADELPVS·REGVS·A ADATI·F
T·SOCIETATIS·ERGO· VAE·IAM

ET·LEGATI·COIRAVERVNT
IES·MAHEI·F
ΟΠΑΤΩΡ ΚΑΙ ΦΙΛΑΔΕΛΦΟΣ
ΥΤΟΝ ΔΗΜΟΝ ΤΟΝ
ΣΥΜΜΑΧΟΝ ΑΥΤΟΥ
ΕΝΕΚΕΝΤΗΣ ΕΙΣ ΑΥΤΟΝ
ΝΟΥΣ ΤΟΥΝΑΙΜΑΝΟΥΣ

ΕΣ
ΟΙΕΡΓΟ
ΟΡΙ·F
ΕΝΟΔΟΤΥΣ ΑΠΟΛΛΟΝΙΥ
ΛΕΥΘΕΡΟ ΘΕΙΣ ΥΠΟ
ΡΩΜΑΙΟΝ ΑΡΕΤΗΣ ΕΝΕΙΚΕΝ
ΕΡΕΥΣΑΝΤ ΟΝ ΠΑΣΙ Κ ΡΑ
ΝΗΣΙ ΘΕΟΥ ΑΣΚΛΗΠ
ΑΠΟΛΛ

ΟΤΑΒΗΝΩΝ

ΚΑΙ ΣΥΜΜΑΧΟΣ
ΩΝ
PO
PO

ΤΗΑ
ΑΔΑΛΙΦ·ΛΕΟ
ΒΑCΙΛΕ
ΝΑΒΑΤΑΙΩΝ ΒΑCΙ
PΑΒΕΙΒΗΛΟC
ΘΑΙΜΟΟΒΔΑ
ΟΙ ΠΡΕCΒΕ

ΗΕΣ·FILIEI·EOR
IOVEI·OPTV
OBARZANEMAXY

7. Epígrafes capitolinos con atestaciones de amistad y fidelidad a Roma de algunos pueblos orientales (licios, nabateos, y otros)
Musei Capitolini, Roma

2. *Felicitas*, un santuario antiguo, nombrado por los calendarios "Anziate maggiore," "Anziate minore" y "Amiternino," así como por los *Acta Fratrum Arvalium*.[9] De su posición respecto a otros santuarios del monte no tenemos más indicación que la de S. Agustín (cit., nota 6), que parece indicar que se encontraba al menos a la misma altura de Iuppiter Optimus Maximus. Bastaría este dato para excluírlo de nuestra lista, visto que el punto que nos interesa es notablemente más bajo.

3. *Fortuna Primigenia*, una de las varias *Fortunae* "de Servio Tulio" en Roma.[10] En este caso no tenemos indicaciones de posi-

ción respecto a otros lugares o monumentos definidos del collado.

4. *Fides*, edificado entre el 254 y el 250 a.d.C. por Atilio Calatino y citado muchas veces (por su significado sacro-político, especialmente) por Cicerón, Plinio el Viejo, Valerio Máximo, Obsequente, Dión, y otros, y nombrado directamente por al menos tres diplomas militares cuyas copias estaban fijadas en las paredes del templo.[11] Representante de la fidelidad de Roma a los tratados con los pueblos vecinos y lejanos,[12] por ella, y a través de ella a *Iuppiter Optimus Maximus*, debían estar dedicadas las inscripciones de tales pueblos que sabemos estaban fijadas en el Capitolio. Diversas de estas inscripciones, verdaderos atestados de fidelidad y devoción a Roma, han sido recuperadas en diversas ocasiones al pie del Capitolio, *la mayor parte de ellas precisamente en el área sacra de S. Omobono* (fig. 7).[13]

Todo coincide, pues, en señalar el templo de *Fides* como el más titulado para dar nombre al templo períptero *sine postico* que ahora, por primera vez, podemos colocar en el conjunto de la *Forma Urbis Marmorea*, lastra 31*kk* (ex-fragmento 499), e imaginar en sus características constructivas generales. La figura 8 da una idea aproximada de la posición que el fragmento debe venir a ocupar respecto a la topografía actual y respecto al ángulo alto izquierdo de la lastra *Forma Urbis Marmorea* 31.

N.B. Una ampliación de este estudio, con nuevos datos y más amplia exégesis, a aparecido recientemente en el *Bollettino di Archeologia del Ministero dei Beni Culturali e Ambientali*, vol. 8, 1991, 33–44.

2. Lastra *Forma Urbis Marmorea* 31: Un "pentimento" significativo

Hace ya años que me he ocupado de las deformaciones que se constatan en las planimetrías sectoriales de la *Forma Urbis Marmorea*,[14] aclarando que estas deformaciones se explican con la mecánica de redacción y de montaje de todo el tejido topográfico, obra de diversos *teams* de *mensores* de Septimio Severo. La base cartográfica general *está constituida por* una

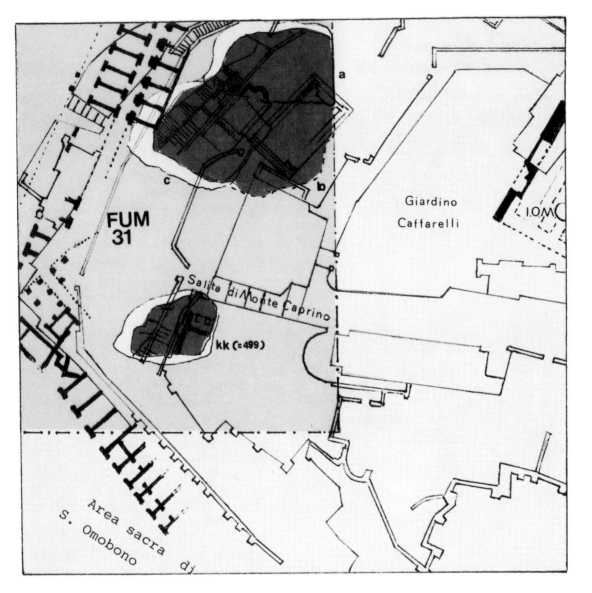

red de puntos fijos bien visibles y situables trigonométricamente. Establecido este cañamazo general, se ha procedido a dividir el campo en sectores; la redacción planimétrica de estos sectores, obra de diversas escuadras, ha hecho largo uso de medios empíricos, capaces de producir, a partir de pequeños errores que se van sumando, notables diferencias de alineamiento, especialmente (pero no sólo) en las partes periféricas del mapa. La consecuencia inmediata de estos errores, incluso mínimos, es que, al momento de realizar el montaje "a mosaico" de los sectores, hubo que hacer correcciones y

ajustes, comprimiendo aquí, ensanchando allí, girando de algunos grados un gran monumento público. En líneas generales, las medidas a grande distanzia, condicionadas por el precedente *layout* de puntos trigonométricamente establecidos, son sorprendentemente exactas, mientras, por el contrario, entre dos edificios o alineamientos vecinos pueden apreciarse errores de posición u orientación incluso desconcertantes, como en el *Templum Divi Claudii* (si no dispusiésemos de la correspondiente didascalia incluída en el rectángulo, probablemente no habríamos podido identificarlo, apareciendo movido

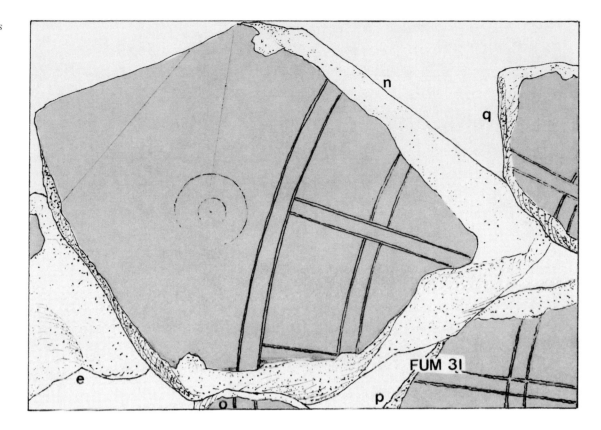

9. El fragmento *Forma Urbis Marmorea* 31*n*, con un doble círculo cancelado posteriormente

de eje hasta 21° respecto al vecinísimo, frontero *Amphitheatrum*).

Sobre esta base, de vez en cuando pueden hacerse nuevas observaciones, como las que se derivan del caso que ahora analizaremos. Pero la más importante consequencia a tener presente es de tipo general y propedéutico. Pretendemos muchas veces de la *Forma Urbis Marmorea* que nos dé respuestas concretas por comparación directa de sectores topográficos "reales" y "representados en el mármol"; muchas veces tratamos incluso de prever cuál puede ser la representación de un sector arqueológicamente conocido en el caso que éste pueda estar representado en fragmentos *Forma Urbis Marmorea* todavía no colocados o en una de las lagunas que las lastras con topografía identificada todavía presentan. Pues bien: a tener presentes todos los puntos fijos de ciertas lastras, las deformaciones topográficas antedichas hacen que las proyecciones sobre el terreno real no sean (como en las lastras de mármol) rectangulares casi en ningún caso; por tanto, no se podrá nunca pretender que incluso las lastras más

"plenas," más completas (por ejemplo, la 31 del Pórtico de Octavia) sean transcritas exactamente sobre las planimetrías arqueológicas seguras sin la intervención de mil ajustes y correcciones.

Hay todavía otros aspectos derivados que explorar; por ejemplo, el de las líneas-guía del dibujo original que han sobrevivido a la pulimentación final del mármol. Algunas han dado ya resultados notables para la integración de ciertos fragmentos; valga por todos el caso del grupo del *caldarium* de las *Thermae Traiani*, colocado egregiamente por Lucos Cozza en 1968.[15] Otras veces, tales líneas, contradiciendo o desviándose de la incisión definitiva, presentan problemas de "lectura" e interpretación del documento. Correcciones de "puesta al día" respecto a un documento cartográfico precedente? Error material y consiguiente "pentimento"? Nos ocuparemos ahora de uno de estos casos a medio camino entre la línea-guía y la incisión verdadera y propia.

En el fragmento de la lastra del Pórtico de Octavia 31*n* (fig. 9), junto al margen externo de la *cavea* del *Theatrum Mar-*

celli, casi de frente a los templos de Apolo y Bellona, existen restos de un di-seño original de la planta no observado precedentemente, a cuanto me resulta. De trata de un doble círculo concéntrico con relativo punto céntrico, del diámetro de 3 y 1 cm. Estos círculos han sido cancelados por fuerte pero incompleta operación de abrasión. De la parte alta del fragmento, divergentes hacia las cercanías del doble círculo, vienen dos líneas-guía, dependientes, tal vez, de los alineamientos del monte Capitolino.

El claro intento de cancelación del doble círculo demuestra que éste era parte original del diseño. Debe, por tanto, tratarse de un monumento menor que, habiendo sido *posicionado* previamente en *el diseño no definitivo*, haya resultado a los sucesivos controles encontrarse fuera de sitio; de aquí, abrasión y reincisión definitiva (en lugar no conservado en nuestros mármoles).

Digamos ahora de la posición aparente del monumento en cuestión (esto es, la posición que ocuparía entre los edificios conocidos en la lastra, si verdaderamente hubiese sido realizado en la incisión definitiva). A pesar de las muchas lagunas de la lastra 31 no es difícil precisar que el monumento se alinearía casi exactamente al centro de un triángulo equílatero formado por las proyecciones hacia el Sur del eje del templo de Apolo Sosiano, de la del margen Norte del Circo Flaminio prolongada a Este y de la de un eje a + 45° respeto al radio medio del Teatro de Marcelo (fig. 10).

Ahora bien, hay que recordar que en esta lastra 31, además de otros datos de menor entidad, resulta anómala (adaptada como está por una razón precisa) la posición de Teatro de Marcelo, que ha sido "movido" a Oeste unos 30 m y "girado" en sentido horario de cerca de 13°. Como en otros casos semejantes (destaca, entre ellos, el Circo Máximo, dispuesto perfectamente en vertical), adaptación y giro han sido efectuados para evitar que la planta del teatro (de su pórtico *post scaenam*, en particular) se encontrase a pasar y repasar varias veces en pequeño espacio entre los límites de contacto con la lastra 32 de la *Insula Tiberina*. En su posición real sobre el terreno, el radio medio del teatro no es, como resulta en la *Forma*

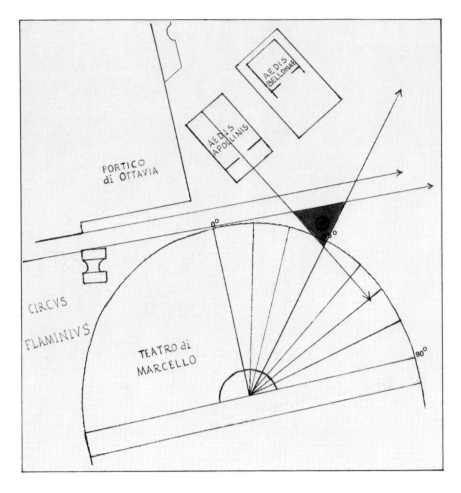

Urbis Marmorea, paralelo al lado Este del Pórtico de Octavia. En consecuencia, distancias y ángulos (entre nuestro pequeño monumento y los edificios vecinos) necesitan una verificación particular.

Nuestra figura 11 nos evita de perder tiempo en consignar todos estos datos a una explicación larga y aburrida: en ella resultan las "distancias aparentes." Si de la planimetría *Forma Urbis Marmorea* pasamos, para los monumentos conocidos y preservados, a la realidad arqueológica, incluyendo el pequeño monumento en el lugar teórico que la *Forma Urbis Marmorea* le atribuye, tendríamos la "distancias reales," como da a ver nuestra figura 12. La comparación entre ambas figurs es iluminante y nos dice que, si bien en el lugar que la *Forma Urbis Marmorea* le atribuye no existe absolutamente tal edificio redondo, bien difícilmente éste puede ser diverso del que, en posición diversa, pero cercana, encontramos en la

10. Situación del doble círculo respecto a los monumentos vecinos en la *Forma Urbis Marmorea*

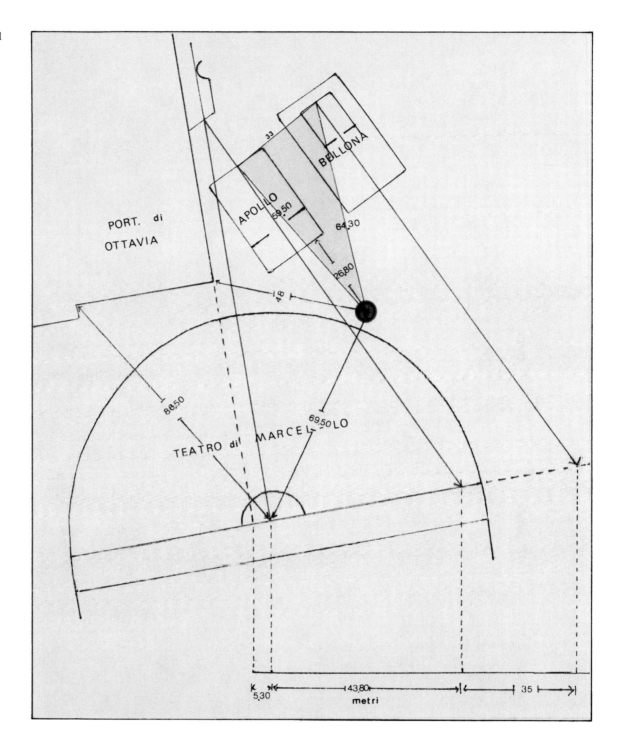

11. Distancias aparentes del monumento redondo a los otros monumentos

realidad: un pequeño monumento a base circular, de cerca de 5 m de diámetro, colocado junto a la curva externa del teatro, a Noreste de él, en eje y a 7 m de distancia del podio de fachada del templo de Apolo Sosiano. Cierto que el monumento "real" es un poco menor que el "ideal" de la *Forma Urbis Marmorea*;

cierto que de los 7 m "reales" de distancia con Apolo Sosiano se pasa a la distancia "aparente" de 26 m y a una posición no axial respecto al templo. Son éstas la diferencias que dependen precisamente de las operaciones de adaptación del diseño previo (la incisión del doble círculo no fué nunca profunda, como definitiva: se trata

claramente del dibjuo del boceto) para que pudiera entrar en el campo de la lastra.

Que ésta sea la correcta mecánica de la operación lo muestra un dato de hecho que bien difícilmente puede ser casual: contra las grandes diferencias de otros datos de distancia, debidas, sobre todo, al giro de la planta del teatro, las distancias real y aparente del centro de la orquesta del teatro al monumento circular son sorprendentemente semejantes: 65.30 y 69.50 m respectivamente.

Ultima nota. Mientras tenían lugar estas observaciones, los estudios que bajo la dirección de Eugenio La Rocca tenían lugar en torno al complejo de Apolo Sosiano preveían, entre otras cosas, la publicación de los materiales decorativos y epigráficos del pequeño monumento redondo, estudio que ejecutaba Marina Bertoletti. Ignoro al momento presente (encontrándome lejos de Roma) si la publicación ha tenido ya lugar.

N.B.: Cuando se redactaban estas notas no existía todavía noticia alguna del nuevo monumento redondo existente en eje con el templo de Bellona, del cual Eugenio La Rocca, su descubridor, da ahora noticia en otro trajabo de este mismo volumen. Por tanto, la entera cuestión debe ser re-examinada a la luz del nuevo hallazgo.

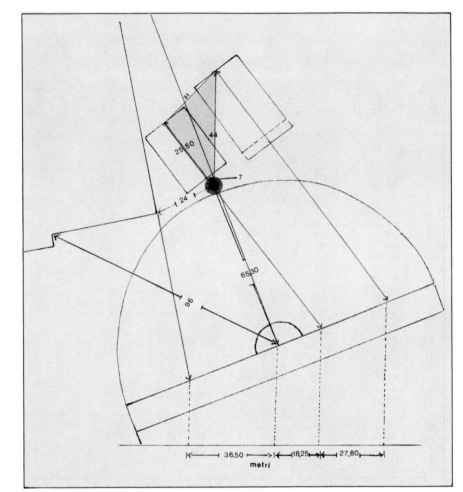

12. Distancias reales entre el pequeño monumento redondo situado ante el templo de Apolo Sosiano y los monumentos circunstantes (comparar con la figura precedente)

NOTE

1. Gianfilippo Carettoni, Antonio Maria Colini, Lucos Cozza, y y Guglielmo Gatti, *La Pianta Marmorea severiana di Roma* (Roma, 1960). V, 145.

2. Cozza 1960, 91. Las escaleras son nombradas expresamente por tal nombre en Tacitus, *Historiae* 71.3.

3. T. Livius, 23.31.9.

4. Suetonius, *Vita Domitiani* 1.4.

5. Cassius Dio, *Xiphilinus* 71.34.3.

6. Sanctus Augustinus, *De Civitate Dei* 4.23.

7. *Corpus Inscriptionum Latinarum*, 18 tom. (Berlin, 1862–1989) (= *CIL*), 6:32.323; 73–75.

8. *Scholia Veronensia in Aeneida* 2.47.

9. La festividad es el 1º de Julio o el 1º de octubre, según diversos calendarios.

10. Plutarchus, *De Fortuna Romanorum* 10; Clemens Alexandrinus, *Protrepticus* 4.51; *CIL*, 14 2852.

11. *CIL*, 16:1, 2 y 26.

12. Cicero, *De Officiis* 29: "Fides, quam in Capitolio vicinam Iovis O.M. maiores nostri esse voluerunt."

13. Véase Attilio Degrassi, "Le dediche di popoli e re asiatici al Popolo Romano e a Giove Capitolino," *Bullettino della Commissione archeologica comunale di Roma* 74 (1951–1952), 19–47.

14. Véase, sobre todo, Emilio Rodríguez-Almeida, *Forma Urbis Marmorea. Aggiornamento generale 1980* (Roma, 1981), 44–53, que condensa una parte de un mio precedente trabajo, "*Forma Urbis Marmorea*: Nuovi elementi di analisi e nuove ipotesi di lavoro," *Mélanges de l'Ecole Française de Rome. Antiquité* 89 (1977), 219–256.

15. Lucos Cozza, "Pianta marmorea severiana: Nuove ricomposizioni di frammenti," *Quaderni dell'Istituto di topografia antica della Università di Roma* 5 (1968), 9–22.

FAUSTO ZEVI
Università degli Studi di Napoli

Gli altari di Lavinio: un'ipotesi

La prima grande scoperta degli scavi intrapresi a Lavinio negli anni 1950 fu, come noto, quella del santuario degli altari, oggetto di una sollecita e penetrante edizione preliminare di F. Castagnoli[1] e poi pubblicati, con accurata analisi ed eccellente apparato grafico, nel secondo volume della serie *Lavinium*;[2] il catalogo della mostra *Enea nel Lazio* ha offerto occasione per ulteriori precisazioni.[3]

Quella scoperta, che riproponeva la storicità delle tradizioni connesse con un sito così famoso, ebbe logicamente una profonda risonanza, quasi a risvegliare un Lazio arcaico archeologicamente ancora quasi ignorato e, per così dire, soffocato, nella storiografia antica e moderna, dalla soverchiante presenza di Roma; senza le scoperte di Lavinio e dei suoi altari, un libro come lo *Early Rome and the Latins* dell'Alföldi avrebbe avuto intonazione certamente ben diversa.

Il ritrovamento aprì subito il campo alle congetture ed alle proposte di interpretazione; di questa breve, ma densa storia degli studi basterà accennare ad alcuni momenti principali.[4]

Dopo un'ipotesi di R. Bloch (tempio di Cerere, Libero e Libera) che direi pioneristica perché formulata quando ancora non era stato effettuato lo scavo e solo rinvenimenti sporadici indicavano la presenza di un santuario,[5] ebbe breve fortuna la identificazione con il tempio dei Penati,[6] destinata peraltro a cadere di fronte alla osservazione che, mentre il santuario degli altari è situato fuori delle mura urbane, i Penati avevano certamente sede all'interno della città.[7] L'ubicazione extramuranea è sembrata invece all'Alföldi particolarmente adatta per un santuario federale; con particolare ricchezza di argomenti egli ne ha sostenuta la identificazione con lo *Aphrodision* di Lavinio,[8] in cui egli riteneva associati, a quello di Venere, i culti dei Penati, di Vesta, di *Indiges*. Per i Penati, si è già detto come l'ipotesi appaia poco fondata; anche il sacro focolare di Vesta è ben difficile fosse posto fuori città. Ma, per il culto di *Indiges* una inattesa conferma sembrò venire dalla bella scoperta del tumulo-*heroon* di Enea, effettuata pochi anni dopo.[9]

Con poche voci discordi, dunque, l'identificazione del santuario degli altari con l'*Aphrodision* ha finito con il raccogliere ampi suffragi. Ho già espresso altrove perplessità, che nascono in primo luogo da quella che mi sembra una mancanza di corrispondenza tra la topografia del sito e i requisiti d'ambiente postulati dalla tradizione, né penso vi siano nuovi elementi per ritornare sul problema.[10] Certo è che, se è corretta l'interpretazione fornita del tumulo-*heroon*, come io ritengo, il culto di *Indiges*, cioè il *pater* come *ghenarches*, capostipite, implica valenze comuni al *nomen* latino. C'è una straordinaria cor-

rispondenza, anche cronologica, tra il momento "serviano" di Roma e le omologhe manifestazioni a Lavinio, tra l'altro con forme di culto e tipologie anche monumentali molto simili; quando cioè alla strutturazione della città e alla definizione e sacralizzazione dei suoi centri di aggregazione politica (a Roma con il santuario del Comizio al *lapis niger*, recentemente interpretato come *Volcanal*,[11] a Lavinio probabilmente con il tempio dei Penati, situato, come quello, ἐν τῷ κρατίστῳ della città) corrisponde, come proiezione 'esterna' verso il mondo latino, un santuario che possiamo dire 'federale' o 'panlatino' a seconda delle valenze che si vogliono evidenziare, naturalmente extrapomeriale (se non necessariamente extramuraneo), come a Roma Diana Aventina e a Lavinio il santuario degli altari.

L'Alföldi accennava alla possibilità che la pluralità delle are consentisse un sacrificio simultaneo e collettivo da parte dei *populi* aderenti alla Lega Latina, e l'idea ha trovato qualche epigono.[12] Il Pugliese Carratelli, a sua volta, ha avanzato l'ipotesi di un *dodekatheon*, un'area di culti ellenici istituita dai Lavinati per favorire i rapporti con i Greci che frequentavano le coste del Lazio.[13] Ipotesi più recenti sono quelle della Dury-Moyaers (dodici altari dedicati ad altrettante divinità agrarie)[14] e quella, singolare, di R. Turcan,[15] il quale, ricordando che il calendario lavinate contemplava un anno di 374 giorni con tredici mesi, immagina (se ben ho inteso il suo pensiero) che il santuario fosse dedicato a *Iuno Kalendaris*, e che alle calende di ogni mese un sacrificio venisse compiuto per la dea su un altare diverso.

Senza entrare nel merito delle diverse argomentazioni prodotte, sottolineo invece, ancora una volta,[16] come tutte queste ipotesi nascano dalla profonda sensazione suscitata dalla sequenza degli altari, tutti più o meno della stessa grandezza ed analoghi per forma, identicamente orientati ed allineati, quasi una parata di entità uguali, corrispondessero essi ai dodici dèi dell'Olimpo o ai mesi del calendario lavinate o, ancora, ai *populi* della Lega Latina chiamati ad un sacrificio comune. Ma sin dall'inizio gli scavatori di Lavinio hanno messo in guardia contro questa impres-

sione superficiale: in realtà gli altari non furono eretti tutti insieme, ma via via in un lungo spazio di tempo che si protrasse per almeno duecento anni, dal VI al IV secolo a.C. (fig. 1); né mai funzionarono contemporaneamente, ché almeno il più antico era già interrato quando furono costruiti gli ultimi della sequenza, uno fu smantellato per ignote ragioni, solo alcuni (non tutti) furono rinnovati a quota superiore sui resti di precedenti monumenti, e così via. In altre parole, non vi fu *mai* un livello o piano di calpestio comune, né in alcun momento si palesano gli esiti di una, diciamo così, progettazione unitaria; ogni altare, pur correlato con gli altri, ebbe tuttavia una sua storia indipendente.

Occorre dunque fornire una interpretazione che, salvando il carattere "egualitario" dell'insieme, tuttavia rispetti la consequenzialità dei tempi, il senso storico di una vicenda architettonica che, a mio giudizio, colpisce non per una sua unità di tempo, che non avrebbe per sé nulla di sensazionale, ma, al contrario, per il senso di fedeltà alla tradizione, di continuità e direi quasi di ripetitività tipologica e formale prolungata nei secoli, che promanano evidentemente da un conservatorismo fortissimo. Vengo quindi alla mia ipotesi che, pur se non comprovabile nel dettaglio, mi sembra corrispondere, più di altre, alle esigenze prospettate: che si tratti cioè di altari innalzati in occasione della fondazione delle colonie deliberate dalla Lega Latina, anteriormente cioè al 338, quando lo scioglimento della Lega non solo rimise a Roma ogni decisione politico-militare in merito alle deduzioni ulteriori, ma comportò anche la assunzione dei *sacra* comuni da parte della dominante.[17] Si tratta beninteso, di una suggestione, cui, per fornire la necessaria dimostrazione occorrerebbero prove concrete, cioè precise concordanze tra le date di fondazione delle colonie e quelle degli altari che con ciascuna di esse si vorrebbero correlati. Va da sé che, le incertezze, sull'uno e sull'altro versante, sono tali da non consentire i desiderati riscontri puntuali, ma, semmai, solo l'evidenziazione di una grossolana ed approssimativa corrispondenza di cifre e di epoche storiche, globalmente considerate. In effetti, le

1. Santuario dei tredici altari, Lavinio: seriazione degli altari: *A* alla metà del VI secolo a.C., *B* alla metà del V secolo, *C* ad un momento precedente la fine del IV secolo a.C., *D* alla fine del IV secolo a.C. A tratteggio le ricostruzioni di età successiva

Da Cairoli Giuliani, *Enea nel Lazio* (Roma, 1981)

notizie degli antichi sulle operazioni coloniarie della Lega Latina sono, specialmente per l'età antica, particolarmente confuse e spesso contraddittorie; non vi è neppure sempre accordo, ad esempio, sulla natura di colonia romana o latina da attribuirsi alle singole fondazioni.

Collazionando tutte le testimonianze, si vengono a riunire i nomi di una quindicina di città, escludendo dal novero Bola, che fu oggetto, sembra, solamente di una proposta di colonizzazione non attuata, e inclusa invece *Fidenae*, che le fonti assegnerebbero addirittura a Romolo, e gli studiosi sono inclini ad espungere. Una possibile duplicazione è rappresentata da *Suessa Pometia* e *Satricum*, ove fossero identificabili fra di loro secondo una proposta recente.[18]

In un ordine cronologico presuntivo, si tratterebbe dunque di: *Fidenae* (età romulea); *Signia* e *Circeii* (Tarquinio il Superbo, ricolonizzate nel 495; *Circeii* ancora nel 393); *Cora* e *Suessa Pometia* (anteriori al 505/504); *Velitrae* e *Norba* (494 e 492); *Vitellia* (ricolonizzata nel 395);

Antium (467); *Ardea* (442); *Labici* (416); *Satricum* (385: se non è *Suessa Pometia*); *Sutrium* e *Nepete* (383); *Setia* (382).

Le date riportate sono quelle della vulgata corrente basata principalmente sulla cronologia liviana; non entreremo qui in discussioni di dettaglio, limitandoci a segnalare l'esistenza, in qualche caso, di cronologie alternative, non solo in quanto rappresentate in diversi sistemi cronografici (per esempio in Diodoro), ma derivate da tradizioni differenti; così, per un esempio, contrariamente a Livio che le dice contemporanee, Velleio pone la fondazione di *Nepete* dieci anni dopo quella di *Sutrium* (quindi nel 373).

Alcune di queste fondazioni coloniarie sono ritenute dai moderni storici dubbie; "most improbable," ad esempio, appare al Salmon la colonizzazione di Anzio nel 467, che, in effetti, stando al racconto liviano, risultò popolata quasi soltanto da Volsci e mantenne costantemente un atteggiamento ostile verso Roma; escludendo Anzio e, per altre ragioni, *Suessa Pometia*, il Salmon fa ascendere a tredici il numero delle colonie

latine.[19] Più drasticamente, altri, come il Kornemann, negano storicità alla colonizzazione romulea di Fidene, ma anche, per diversi motivi, a quella di Labico,[20] e considcrano con sospetto quelle di *Cora, Suessa Pometia, Antium, Vitellia,* giungendo così alla cifra di sole nove città sicure e quattro incerte.[21] Altri studiosi hanno soluzioni diverse, non più cogenti e più argomentate delle altre.

Per riassumere, due o tre colonie apparterrebbero all'età dei re; cinque o sei andrebbero collocate tra gli estremi anni del VI ed il 442 a.C.; le rimanenti cinque o sei tra la fine del V e la prima metà del IV. Naturalmente, il quadro è complicato dalle duplicazioni e ricolonizzazioni successive.

La cronologia degli altari è parimenti soggetta ad incertezze di lettura; alcuni sono stati rifatti, sovrapponendo nuove strutture a quelle originarie, in qualche caso previa riutilizzazione dei blocchi dell'ara precedente come materiali da costruzione. Nel già segnalato caso dell'ara III, lo smontaggio integrale del piccolo monumento non fu seguito da ricostruzione, quasi si trattasse di una sorta di cancellazione, una sorta di *damnatio*; come scrive Lucos Cozza, "la sparizione dell'ara è totale e voluta."[22] L'ara XIII, non sappiamo perché, non venne rialzata o ricostruita a differenza di altre più o meno coeve. Al di sotto di alcuni altari non si è scavato, e non è sicuro che non ne abbiano sostituito di più antichi. Infine, le sequenze cronologiche proposte danno l'impressione di una certa casualità nella distribuzione dei monumenti, quasi che si fosse iniziato ad erigere altari in ordine sparso e a distanze irregolari (ma pur seguendo un certo allineamento) e solo più tardi provvedendo a riempire gradualmente gli intervalli ed i vuoti residui. Le più recenti trattazioni di insieme[23] forniscono dunque i seguenti dati: al periodo più antico (VI secolo a.C.) appartengono gli altari XIII, VIII e IX inferiore, correlati verosimilmente con donari, ad uno dei quali va riferita la celebre la-mina bronzea con la dedica ai Dioscuri. Alla prima metà del V secolo, certificata dalla presenza, in strato, di scarsa ceramica attica a figure rosse, apparterrebbero gli altari I, II, III, IV, V. La fase successiva, tra la seconda metà del V e l'avanzato IV secolo a.C., comprenderebbe i rimanenti altari, dapprima i numeri VI e VII con una regolarizzazione dell'intero complesso, infine le are X, XI, XII posanti su di un'unica platea. Ad un rifacimento finora ascritto agli inizi del II secolo a.C., ma la cui datazione va forse rialzata, sono da attribuire infine le ricostruzioni, diverse per tecnica e qualità della pietra impiegata, degli altari I, II, VIII, la cui quota presuppone ormai sostanziali modifiche nei livelli del santuario.

C'è, come si vede, se non una corrispondenza, una grossolana compatibilità cronologica tra le sequenze delle colonie latine e degli altari di Lavinio; unica discrepanza considerevole resta quella della data finale, che, se per la serie delle colonie si arresta ben in alto nel IV secolo, per i più tardi fra gli altari scenderebbe verso la fine del secolo stesso. Tuttavia, nell'ipotesi, comunemente accettata, di un santuario "federale," pur assegnando al termine un valore restrittivo, mi sembra difficile un prosieguo di attività edilizia, nel senso di ulteriori ampliamenti del complesso, dopo la guerra latina del 340/338 ed il conseguente scioglimento della Lega; e ricordo che, inizialmente, il Castagnoli aveva collocato verso la metà del IV secolo il termine del processo di formazione del santuario lavinate degli altari, che gli studi successivi sembrano inclini ad abbassare. Non resta che affidare a chi meglio di me conosce il terreno di Lavinio, il giudizio se i dati di scavo possano consentire o meno una data di qualche decennio anteriore, e così suffragare, o respingere definitivamente, un'ipotesi come la presente, che forse avrebbe incuriosito l'illustre scavatore della Regia, e che mi sarebbe piaciuto discutere con lui.

NOTE

1. Ferdinando Castagnoli, "Sulla tipologia degli altari di Lavinio," *BullCom* 77 (1959–1960), 3–30.

2. Autori vari, *Lavinium II: Le tredici are* (Roma, 1975).

3. Cairoli F. Giuliani, in *Enea nel Lazio: archeologia e mito* [catalogo della mostra, Campidoglio] (Roma, 1981), 169–177.

4. Sintetizzo quanto ho esposto in "Il mito di Enea nella documentazione archeologica: nuove considerazioni," in *L'epos greco in Occidente, Atti del 19 Convegno di Studi sulla Magna Grecia, Taranto 1979* (Napoli, 1989), 247–290.

5. Raymond Bloch, in *CRAI* (1954), 203–219.

6. Mario Torelli, "Un *templum augurale d'età repubblicana a Bantia*," *RendLinc* 21 (1966), 20; e in *Dialoghi di archeologia* 7 (1973), 400–402.

7. Fausto Zevi, "Note sulla leggenda di Enea in Italia," in *Gli Etruschi e Roma. Incontro di studio in onore di Massimo Pallottino 1979* (Roma, 1981), 145–158. Si veda ora sui Penati a Roma e a Lavinio: Annie Dubourdieu, *Les origines et le développement du culte des Penates à Rome* (Roma, 1989).

8. Andreas Alföldi, *Early Rome and the Latins* (Ann Arbor, Mich., 1965), 265; Ferdinando Castagnoli, in *Lavinium II*, 1975, 5; Mario Torelli, *Lavinio e Roma* (Roma, 1984), 157–173.

9. Paolo Sommella, "Das Heroon des Aeneas und die Topographie des antiken Lavinium," *Gymnasium* 81 (1974), 273–297; Cairoli F. Giuliani e Paolo Sommella, "Lavinium," in *Parola del Passato* 32 (1977), 356–372; (Roma, 1981), 172–175.

10. Zevi 1981, 147.

11. Filippo Coarelli, *Il Foro Romano* I. *Periodo arcaico* (Roma, 1983), 161–178.

12. Annie Dubourdieu, "Le sanctuaire de Vénus à Lavinium," *RÉL* 59 (1981), 83–107.

13. Giovanni Pugliese Carratelli, "Lazio, Roma e Magna Grecia prima del IV sec. a.C.," in *Scritti sul mondo antico* (Napoli, 1976), 325–350.

14. Geneviève Dury-Moyaers, *Enée et Lavinium, Coll. Latomus* 174 (Bruxelles, 1981).

15. Robert Turcan, "Enée, Lavinium et les treize autels," in *RHR* 200 (1983), 41–66.

16. Zevi 1989, 253.

17. Ettore Pais, "Serie cronologica delle colonie romane e latine dall'età regia . . . all'impero," in *MemAL* (serie 5, 1923), 311–319.

18. Conrad Stibbe, "Satricum e Pometia: due nomi per la stessa città?" in *Meded* 47 (1987), 7–16.

19. Edward Toga Salmon, *Roman Colonisation under the Republic* (Londra, 1969), 40–54; Edward Toga Salmon, *The Making of Roman Italy* (Londra, 1982), 183 n. 22.

20. Diversamente Robert Maxwell Ogilvie, *A Commentary on Livy Books I–V* (Oxford, 1965), 605: "The capture of Labici and its colonisation are the only genuine events of the whole year. . . ." (418 a.C.).

21. Ernest Kornemann, "coloniae," in *Real-Enzyklopädie* IV (Stoccarda, 1900), colonne 511–520. Si veda anche Ethella Hermon, "Réflexions sur la propieté à l'époque royale," in *MEFRA* 90 (1978), 7–31.

22. *Lavinium II*, 1975, 104.

23. Oltre agli studi citati alle note 2 e 3, ho consultato, per gentilezza dell'autrice, la voce *Lavinium* di Maria Fenelli per il quinto volume della *Bibliografia Topografica della Colonizzazione greca in Italia* (in stampa).

STEFANIA QUILICI GIGLI
Consiglio Nazionale delle Ricerche—Istituto
per l'archeologia etrusco-italica

Segni e testimonzianze dell'antico paesaggio agrario nel territorio falisco

L'appassionata ricerca condotta da Pasqui e Cozza alla fine dell'Ottocento per la redazione della *Carta archeologica d'Italia* segna, a mio avviso, una delle pagine più belle nella storia dell'archeologia italiana. Con una ampiezza di vedute che ancor oggi stenta ad affermarsi, lo studio della topografia antica veniva da essi connesso da un lato alla ricostruzione della storia del territorio, dall'altro alla tutela dei monumenti riconosciuti nelle perlustrazioni.[1] Alla mancata pubblicazione allora di quest'opera non devono essere stati estranei la grande novità e la provocazione insita nei criteri ispiratori: meglio condurre scavi, specie di tombe o templi, che restituiscono oggetti di prestigio, da esporre nei musei, che proporre alla conoscenza i monumenti di un territorio, i quali, una volta noti, vanno tutelati e pongono limiti alla urbanizzazione.

Non sembri fuori luogo questo richiamo alla *Carta archeologica d'Italia* ed alle difficoltà che troppe volte, non solo allora ma ancor oggi, si prospettano negli studi di topografia antica, in un convegno in ricordo di Frank Brown: vi è un preciso significato.

Non molti sanno infatti come negli anni in cui era difficile per chi si occupasse di topografia antica trovare il sia pur semplice supporto di una borsa di studio universitaria, egli seppe sopperire, con signorile discrezione, offrendo, attraverso le borse di studio presso l'Accademia, un costante sostegno a questo genere di studi.

Il richiamo alle ricerche di Pasqui e Cozza è poi d'obbligo in quanto il tema che affronto trae origine ed approfondisce uno degli spunti che esse offrono. Quegli studiosi infatti, specie nella perlustrazione dell'agro falisco, che essendo stata condotta per ultima risente della maturità ed esperienza acquisita in anni di faticosa indagine sul terreno, posero grande attenzione alla ricostruzione del paesaggio antico, rilevando non solo le grandi opere di urbanizzazione condotte nel territorio, ma anche tanti interventi "minori," che incidono tuttavia sul suo assetto.

Tra gli interventi di carattere "locale" notati da Pasqui e Cozza appare di particolare interesse una serie di opere di ingegneria idraulica, tra cui alcune strutture di sbarramento dei fossi, "serre" per usare il loro termine, le cui segnalazioni si concentrano nei territori di Corchiano e Civita Castellana, fino al loro digradare sul Tevere.

Quegli studiosi ne lasciarono aperta la datazione, quanto alla funzione in alcuni casi non si pronunciarono, in altri ritennero che questi apprestamenti fossero stati costruiti in relazione ai ponti, a monte cioè di essi per proteggerli dall'impeto delle acque.

E' questo il caso della "serra" sul fosso del Purgatorio, riconosciuta nell'ambito delle ricerche sulla viabilità facente capo a

Falerii Novi e posta in diretta connessione con essa:[2]

a difesa dei ponti che conducevano le antiche vie alle porte sul lato meridionale di Falerii troviamo presso l'angolo sud ovest della cinta il Fosso del Purgatorio chiuso da ripa a ripa con una larga serra di tufi squadrati e commessi senza calce. . . .

In effetti il Rio del Purgatorio, che scorre a sud di Falerii Novi, rappresenta con il suo letto incassato un ostacolo obbligato per le comunicazioni della città antica: le strade facenti capo ad essa da meridione, tuttavia, nelle ricostruzioni proposte da Pasqui e Cozza ed in quelle successive e diverse di Frederiksen e Ward Perkins, appaiono superarlo in più punti,[3] secondo le varie direttrici, sia ad oriente che ad occidente del solo ponte su cui consentono: il ponte della via Amerina, ancora parzialmente conservato.

L'indagine condotta per rintracciare la "serra" segnalata da Pasqui e Cozza, ma non puntualizzata graficamente sulle loro carte, ha pertanto riguardato un lungo tratto del Rio del Purgatorio, da Piano di Cava fino all'altezza del limite orientale di Falerii Novi, permettendo di riconoscere come questa si inserisse in un contesto quanto mai articolato. A valle della confluenza del Rio Secco, fin oltre quella con il Fosso della Badessa, la riva destra del Rio del Purgatorio è apparsa contenuta da un poderoso muraglione in opera quadrata di tufo, con contrafforti (fig. 1, sito 1).

Si segue per circa 120 m di lunghezza e si conserva fino a 2.50 m di altezza, impostandosi a circa 2 m al di sopra del letto attuale del fosso.[4] I blocchi misurano m 1.75–1.80–1.85 di lunghezza; sono alti 45–50 cm;[5] i contrafforti sono larghi cm 55 e lo spazio tra due contrafforti è di m 5.55–5.75.

Poco più di 500 m a valle, sulla riva sinistra del fosso rimangono cospicui avanzi di una sua opera di sbarramento, nella quale è da riconoscere la "serra" segnalata da Pasqui e Cozza (fig. 1, sito 2).[6]

Essa consiste in una struttura in opera quadrata di tufo, con andamento lievemente convesso, che si aggancia alla riva sinistra del

1. Falerii Novi ed il corso del Rio del Purgatorio: veduta aerea del 1979
Fotografia: Società italiana di aereofotogrammetria topografica (pubblicata su concessione dello Stato Maggiore dell'Aeronautica Militare)

2. Opera di sbarramento del Rio del Purgatorio, ad ovest di Falerii Novi
Fotografia: autore

3. Opera di sbarramento del Rio del Purgatorio, ad ovest di Falerii Novi
Fotografia: autore

nesche. La struttura, in opera quadrata di tufo, poggia su un *letto di pietrame*, è lunga m 10.20 ed ha un'altezza di m 3.90, con uno spessore per almeno tre filari di blocchi di m 2.85. Per quanto riguarda la tecnica costruttiva, i blocchi, in genere di cm 55 x 60 x 120, appaiono nel filare più esterno disposti di testa, nel secondo di taglio e così presumibilmente nel terzo più esterno. L'opera viene a costituire la fronte di un poderoso terrapieno, costruito a valle ed a ridosso di essa, che porta la struttura ad uno spessore complessivo oggi di circa 11 m in sommità, oltre la controscarpa che scivola nel fondofosso a valle (fig. 4).

Circa 100 m più a valle si riconosce un'altra struttura in opera quadrata di tufo, sempre sulla riva sinistra del Rio del Purgatorio (fig. 1, sito 3).

Si conserva bene la facciata a valle, su una fronte di circa 5 m, con una altezza fino a m 4.50, costruita con blocchi disposti alternativamente per testa e per taglio (m 0.75–0.85–1.00– 1.20 x 0.42–0.44–0.45 x 0.55 di altezza) (fig. 5). Il muro ha uno spessore di m 1.60, ma subito al suo interno si riconosce un potente riempimento in pezzame di tufo, che ne porta lo spessore a circa 14 m, oltre i quali si riconoscono le tracce di un altro muro, in opera quadrata, che doveva costituirne la fronte a monte.

Mancano resti in corrispondenza sulla riva destra del Rio del Purgatorio, ove la morfologia dei luoghi è tale però da fare escludere che la struttura rispondesse alla funzione di ponte stradale.

Meno di 100 m a valle, sul letto del fosso, sono blocchi di opera quadrata di tufo (cm 55 x 55 x almeno 90), dei quali due forse in opera sulla riva sinistra (fig. 1, sito 4).[7] Passato il ponte attuale sul Rio del Purgatorio, si riscontrano sulla riva destra del fosso una serie di canalette, in parte anche costruite in blocchetti di tufo, da porre in relazione con un mulino ed una chiusa moderni;[8] più a valle sono i resti del ponte della via Amerina (fig. 1, sito 5).[9] Poco a monte di esso, sulla riva destra del fosso, è un canale scavato nella rupe che fiancheggia il corso d'acqua, circa m 2.20 sopra il suo letto attuale (fig. 6).[10] Seguono, lungo la stessa riva del fosso, uno stretto cunicolo di difesa della rupe (fig. 1, sito 6)[11] e, sulla riva opposta, un muro di argine in opera quadrata di tufo.[12] Infine, di fronte ormai a Porta Puteana, si riscon-

fosso con una spalletta trasversale, mentre alla riva destra si appoggia ad un grande masso roccioso (figg. 2, 3). Il fosso oggi aggira quest'opera, lasciando sulla sinistra il masso roccioso, oltre il quale si è riaperto il letto. Anticamente doveva invece fermarsi a ridosso di essa, accumulandosi in un piccolo bacino: un cunicolo (altezza m 1.55, larghezza 52 cm), ricavato nel masso roccioso al quale si addossa la struttura e con la base a m 1.70 al di sotto della sommità attuale, doveva assicurare il deflusso dell'acqua prima che la sua altezza superasse quella dell'opera; la regolamentazione poteva avvenire tramite saraci-

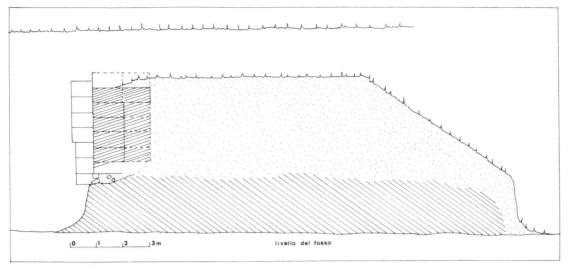

4. Sezione dell'opera di sbarramento del Rio del Purgatorio, ad ovest di Falerii Novi
Rilievo di Lorenzo Quilici e autore, 1989

trano nel fondofosso alcuni blocchi in opera quadrata di tufo e spezzoni di selce che riterrei conferma di un ponte (fig. 1, sito 7).[13]

Pur nella complessità della situazione appare da scartare in via preliminare che lo sbarramento riconosciuto sul Rio del Purgatorio sia da porre in relazione alla difesa dei ponti, che sorgono ben più a valle e sono comunque di tale mole—mi riferisco a quello della via Amerina—da reggere ben altro urto delle acque, sia pur anticamente più copiose, del Rio del Purgatorio. E' inoltre da rilevare come allo smaltimento delle acque in eccedenza potrebbe aver assolto quell'ampio canale riconosciuto lungo la riva destra del fosso, che ha origine proprio a monte del ponte.

Lo sbarramento deve pertanto aver risposto allo scopo per cui usualmente tali opere vengono costruite: quello cioè di raccolta delle acque. La sua tecnica costruttiva mostra analogie con quella utilizzata per il ponte della via Amerina e soprattutto per le mura di Falerii Novi, dalle quali si discosta invece, per le ben maggiori dimensioni dei blocchi, il muraglione a contrafforti presso il Rio Secco.

Una relazione con la difesa dei ponti era stata avanzata da Pasqui e Cozza anche per la "serra" sul Rio della Tenuta, a Ponte del Ponte a nord di Corchiano.[14] Già Frederiksen e Ward Perkins avevano notato come in quella poderosa struttura fosse tuttavia da riconoscere un acquedotto, gettato a corpo pieno attraverso il fosso, il cui corso era stato portato a correre in cunicolo all'interno della rupe cui si addossa l'opera.[15] L'indagine condotta ha posto in evidenza come quest'acquedotto si inserisca in un contesto quanto mai vario: in particolare è stata riconosciuta a valle di esso un'opera di sbarramento del fosso, in blocchi d'opera quadrata, e sul fosso Russi, immediatamente a nord, i resti di un'altra "serra," già segnalata da Pasqui e Cozza, che appare costituita da un potente muraglione in opera quadrata di tufo, che ne sbarra il corso.[16]

Per quanto riguarda la cronologia di queste opere, vale ricordare come Frederiksen e

5. Struttura in opera quadrata di tufo sul Rio del Purgatorio ad ovest di Falerii Novi, 1989
Fotografia: autore

6. Canale di alleggerimento del flusso d'acqua del Rio del Purgatorio, lungo la riva destra, a sud di Falerii Novi, 1989
Fotografia: autore

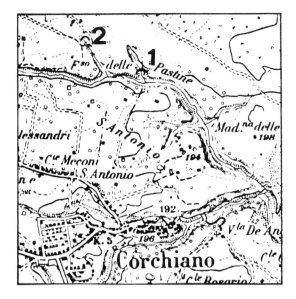

8. La zona di Corchiano (scala 1:25,000)
Instituto Geografico Militare, Foglio 137 II S.E. Galese, stralcio

7. Muraglione di terrazzamento, per recupero di terreno agricolo, impostato su una precedente via gradinata, nella zona di Ponte del Ponte, a nord di Corchiano, 1989
Fotografia: autore

Ward Perkins avessero posto l'acquedotto in relazione con un piccolo abitato che ipotizzarono sorgesse sul poggio a sudest: un collegamento di particolare rilevanza in quanto, essendo stato l'insediamento, secondo quegli studiosi, abbandonato con la conquista romana o poco dopo, l'acquedotto sarebbe necessariamente risalito ad epoca anteriore, costituendo un riguardevole esempio di ingegneria idraulica falisca. L'occupazione del poggio, tuttavia, ad un approfondimento di ricerca, è apparsa risalire in buona parte ad epoca medioevale e se essa si è venuta ad inserire o ha sfruttato strutture precedenti, queste potrebbero meglio configurarsi come quelle di una villa di epoca tardo repubblicana-imperiale. La perlustrazione topografica, estesa alla zona contermine, ha permesso di riconoscere inoltre un potente muraglione che può confrontarsi con queste strutture di sbarramento dei fossi: si tratta tuttavia di un'opera di contenimento non delle acque, ma delle terre di una vallecola, per impedirne lo scivolo nel fondofosso. La struttura è alta fino a m 6.50 e con andamento a semicerchio accompagna per circa 15 m il ciglio naturale: permetteva così di recuperare un ampio spazio, che poteva essere stato colmato e reso pianeggiante, per lo sfruttamento agricolo. E' da rilevare il suo inserimento in una situazione precedente del tutto diversa di assetto del territorio: essa infatti si imposta, bloccandola e ponendola fuori uso, su una stradina gradinata che saliva dal fondo fosso (fig. 7).

Analoga funzione doveva assolvere una poderosa struttura tuttora conservata in una vallecola sulla sinistra del fosso delle Pastine, a sud-est dei Casali di Musate[17] (fig. 8, sito 1): l'opera, costruita in blocchi di tufo posti per testa, è alta circa 9 m e secondo lo schema della "diga a volta" trattiene le terre a monte, che ricolmano, livellandolo, l'invaso della vallecola che sbarra (figg. 9, 10). Un cunicolo che sbocca lateralmente ad essa doveva assicurare il drenaggio e lo spurgo delle acque dal terreno retrostante (fig. 11).

Una stradina gradinata scavata nella roccia, sul lato orientale dell'opera, permetteva di risalire dal fosso Pastine ai pianori sovrastanti: larga originariamente m 1.75, si presenta oggi con approfondimenti dovuti all'incanalamento delle acque.[18]

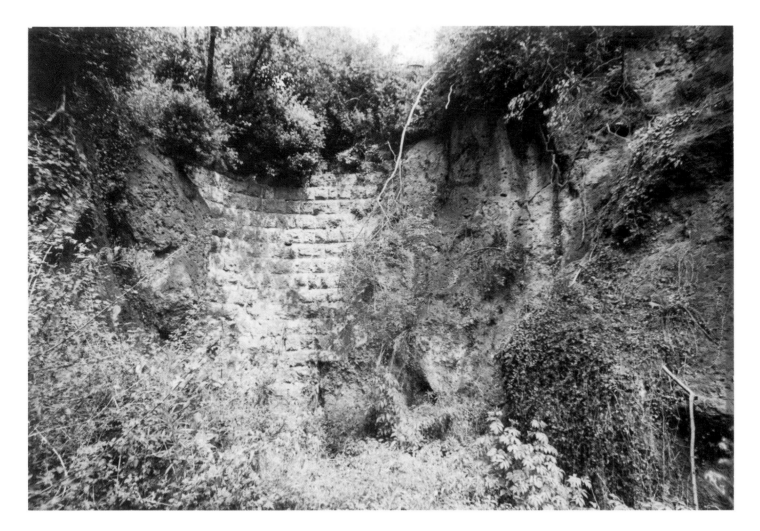

Un muro in blocchi di tufo, che si intravvede all'imbocco del fossatello ad occidente di quello ora descritto (fig. 8, sito 2), potrebbe pure aver servito per il contenimento delle terre a monte: si segue per tutto l'arco del ciglio, che ha una corda di 35–40 m, facendo scarpa per quasi due metri d'altezza al terreno verso monte.[19]

Accanto a questi impianti più complessi, ricordo come si possano riconoscere nel territorio altri interventi simili,[20] dei quali, a titolo d'esempio, ricordo la diga che presso Civita Castellana sbarrava il fosso immediatamente a nord del Convento dei Cappuccini, nella sua parte più a monte.[21]

E' visibile sulla riva sinistra del fosso: costruita in blocchi in opera quadrata di tufo, dei quali rimangono quattro filari di altezza su una fronte di circa 2.50 m. La struttura poggia su uno strato di ghiaione naturale, alto circa 2 m, cui segue, a contatto di essa, uno strato alto fino a 50 cm di terra e pietrame di tufo. I

blocchi, messi per lo più di taglio, misurano m 0.75–0.82–0.92 di lunghezza e circa m 0.40 di altezza. Lo scivolo delle terre che la ricopre impedisce di rilevarne lo spessor (figg. 12, 13).

Caratteristiche analoghe a quelle rilevate in questa serie di strutture appaiono infine ricorrere in un'opera connessa con un ambiente sacrale: la diga sul fosso dei Cappuccini, legata alla famosa stipe del Ninfeo Rosa. Sappiamo che constava di un muro in opera quadrata, a monte del quale l'acqua si raccoglieva in un bacino; il deflusso era assicurato da un canale a cielo aperto, intagliato direttamente nel tufo della parete destra del vallone, che la incanalava a valle.[22] L'opera riveste pertanto un interesse particolare per lo studio architettonico e l'inquadramento cronologico. Il suo esame tuttavia non è stato possibile ed è ormai precluso: la diga è andata infatti distrutta nel 1987, quando il fondovalle del vallone nel quale sorgeva è

9. Diga di contenimento della vallecola sovrastante il Fosso delle Pastine, a nord di Corchiano, 1989
Fotografia: autore

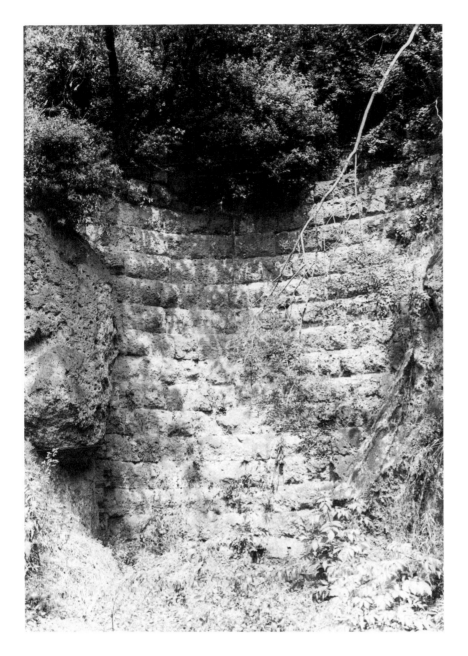

10. Diga di contenimento della vallecola sovrastante il Fosso delle Pastine, a nord di Corchiano, 1989
Fotografia: autore

dramento topografico, ha permesso di riconoscere una serie di apprestamenti per la raccolta e distribuzione delle acque: una diga di sbarramento del fosso, una seconda diga poco più a valle e più modesta, canali e bacini ad essa connessi.[23] In particolare le dighe qui riconosciute appaiono rispondere a quello schema di *"basin irrigation"* per cui il terreno lungo il corso d'acqua viene suddiviso in bacini da chiuse perpendicolari ad esso. Mentre un canale deriva l'acqua dal fosso al campo, un altro canale, perpendicolare allo sbarramento, ad una quota pari alla sua tenuta ottimale, conduce l'acqua in eccedenza al bacino più a valle e così di seguito. Uno schema che permette di comprendere ora il doppio sbarramento sul Rio del Purgatorio, illustrato per primo, la cui interpretazione avevo lasciato sospesa e che proporrei di ricondurre a questo modello.

Ma soprattutto le opere lungo il fosso di Fustignano aprono—a mio avviso— interessanti prospettive per l'inquadramento storico-funzionale di questo genere di strutture. Quegli interventi infatti, devono essere in relazione con l'iscrizione rupestre sopra ricordata: dobbiamo ritenere che siano stati condotti da *C. Egnatius* nel II sec. a.C.—questa è la data dell'iscrizione— per la realizzazione dei *prata*, ai quali assicuravano l'irrigazione.

Si tratta di un ampio intervento di trasformazione fondiaria che mi sembra possa essere considerato una risposta a quei problemi di utilizzazione del territorio aperti nell'agro falisco dalla conquista romana. Sotto questa ottica, le analogie che spesso abbiamo notato per varie strutture con la tecnica costruttiva delle mura di Falerii Novi non possono essere ritenute casuali.

E' stato più volte posto in evidenza come i Romani, dopo la conquista del 241, adottarono nel territorio falisco misure di una severità senza precedenti nell'Etruria meridionale: provvedimenti che archeologicamente trovano il loro punto focale nella nuova poleografia determinata dall'abbandono forzato di Falerii in funzione della nuova città di Falerii Novi, e che dovettero essere stati altrettanto drastici per il territorio. Per quanto concerne quest'ultimo, i *surveys* della British School da un lato hanno rivelato un definitivo

stato sbancato per il passaggio di un grande collettore fognario: rimane oggi visibile solo il canale di deflusso scavato lateralmente nel tufo.

Un' inatteso apporto alla comprensione e cronologia di questi apprestamenti che ho sia pur velocemente illustrato è venuto invece dalle indagini condotte per il recupero di un altro monumento segnalato dalla *Carta archeologica*: l'iscrizione rupestre che ricorda come *C. Egnatius prata faciunda coiravit* (*CIL* XI, 7505). La perlustrazione condotta lungo il corso del fosso di Fustignano, per il suo inqua-

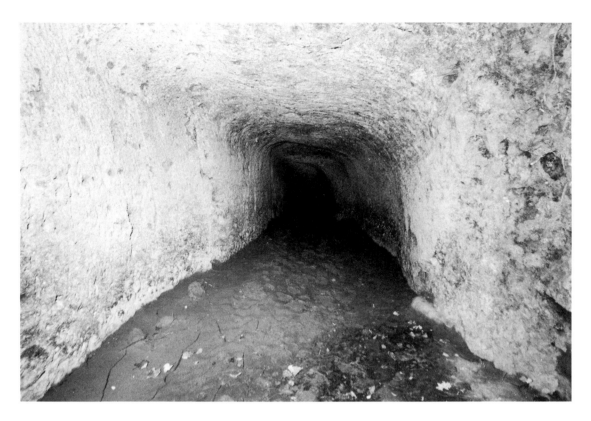

11. Cunicolo sul lato della diga nella vallecola sovrastante il Fosso delle Pastine, a nord di Corchiano, 1989
Fotografia: autore

iato nella vita degli insediamenti falisci, dall'altro hanno posto in evidenza come ad esso segua una rioccupazione del territorio in siti nuovi e soprattutto una occupazione di circa 1/3 maggiore, che ritengono "a true reflection of the much greater exploitation of the land in this time" secondo un modello che vede "an urban decentralization combined with rural growth."[24]

In questo contesto mi sembra si possano ben inserire gli organici interventi di ingegneria idraulica che ho illustrato: essi, che verrebbero a seguire i drammatici eventi della confisca e ridistribuzione delle terre,[25] a mio avviso devono considerarsi finalizzati ad una trasformazione incisiva del paesaggio agrario, attraverso il recupero, l'incremento della produttività dei suoli e l'introduzione di colture diverse.[26] Di un processo parallelo di "land reclamation" mi sembrano significativo esempio i muraglioni di contenimento dei campi a Ponte del Ponte e presso il fosso Pastine.

Tutte queste opere, per l'immediato corrispettivo in termini economici che prospettano, appaiono ben compensare l'investimento finanziario che richiesero, da riferire pertanto a ceti con adeguate disponi-

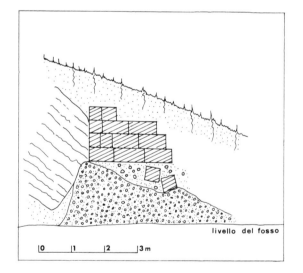

12. Sezione dei resti dell'opera di sbarramento del fosso a nord del Convento dei Cappuccini, a Civita Castellana
Rilievo di Lorenzo Quilici e autore, 1989

bilità economiche. In alcuni casi tuttavia, come sembrerebbe proporre l'iscrizione di *Egnatius*, esse potrebbero anche riflettere quelle forme di promozione personale che dovettero caratterizzare i tentativi di affermazione sociale e politica di *gentes* emergenti, tanto più impegnate nella ascesa in questo territorio che aveva visto sì drastici sovvertimenti nella sua organizzazione.

13. Veduta dei resti
dell'opera di sbarramento
del fosso a nord del Convento
dei Cappuccini, a Civita
Castellana, 1989
Fotografia: autore

Quanto al nuovo paesaggio agrario che segue a questi interventi, nel caso di Corchiano l'iscrizione stessa ci prospetta distese di verdi *prata*, destinati forse allo sfalcio per l'allevamento bovino; in altri casi le opere potrebbero aver risposto ad altre esigenze e in particolare presso Falerii Novi si potrebbe pensare all'introduzione di colture intensive destinate al mercato cittadino.

Per concludere, proporrei che questi interventi per la raccolta e la distribuzione delle acque e per il recupero di terreno agricolo, accanto alla costruzione delle grandi infrastrutture pubbliche, caratterizzando la trasformazione dell'assetto del territorio falisco successivamente alla conquista romana, testimonino per altro verso quanto e come i mutamenti politici possano influire anche sui paesaggi delle campagne: essi sarebbero così uno dei molteplici segni, che ancor oggi possiamo cogliere, della "forma romana nel paesaggio agrario italiano."[27]

LORENZO QUILICI
Istituto di Archeologia dell'Università di Bologna

Il porto di Civitavecchia—L'antica Centumcellae

Mi è giunto particolarmente gradito l'invito avuto a partecipare in ricordo di Frank Brown, una persona che ha tanto amato l'Italia ed uno studioso al quale tanto Roma deve. Cercando un tema che avrebbe potuto fargli piacere, ho pensato al porto di Civitavecchia, un porto "romano" per eccellenza, non lontano dalla sua Cosa e con Cosa in un certo qual modo legato, in quanto Centumcellae venne a succedere al declinare del porto di quella città.

In età imperiale Roma aveva aggiunto alle attrezzature fluviali di Ostia, alle foci del Tevere, i grandi porti di Claudio e di Traiano. Lo spazio metropolitano della città aveva però acquistato un respiro immensamente più ampio già in età augustea, con l'eccezionale sviluppo impresso al porto di Pozzuoli, l'antica Putèoli, che si era andato di poi ulteriormente potenziando sempre in funzione di Roma, raggiungendo la massima efficienza in età flavia.

Subito dopo il regno di Domiziano, che coronò questi interventi sul versante meridionale ed in concomitanza con la realizzazione del porto di Traiano che si era sommato al Claudio alle foci del Tevere e con la ristrutturazione di quello di Terracina sulla rotta meridionale, lo stesso Traiano venne a creare il porto di Centumcellae a nord, l'attuale Civitavecchia.

Si completava così, nei primi anni del II secolo, il sistema degli allacci marittimi in funzione della capitale dell'impero che, in aggiunta agli apparati portuali centrali collocati alla foce del Tevere, vedeva come altre sue teste di ponte Putèoli a sud, per le comunicazioni con l'Africa e con l'Oriente, e Centumcellae a nord, per le comunicazioni con la Gallia e con la Spagna.[1]

L'impianto portuale. L'impianto portuale di Civitavecchia costituisce, nel quadro delle esperienze dell'ingegneria portolana di tutti i tempi, un vero modello: esso infatti non è venuto a sfruttare particolari condizioni naturali di riparo costiero, come un golfo, una rada, un promontorio, ma è una costruzione del tutto artificiale, realizzata su di un'aperta costiera, gettando direttamente le sue dighe in mare aperto.

Esso, inoltre, non fu il prodotto di molteplici interventi, protrattisi nell'arco di tempo di più generazioni, tesi a potenziare ed a migliorare l'opera: ma fu il risultato ordinato di un'unica ideazione. La bontà del progetto e della sua esecuzione è provata dall'uso plurimillenario che di poi del porto si è fatto, ininterrotto nel tempo. Da quando fu costruito a tutt'oggi, Civitavecchia costituisce uno dei più sicuri porti del medio ed alto Tirreno. Così i papi, fin dal Rinascimento, ebbero ben chiara l'importanza del porto di Civitavecchia per la città di Roma, impegnando nelle opere di restauro e potenziamento delle antiche strutture grandi ricchezze e la mente dei massimi architetti del loro tempo: Bra-

mante, Leonardo, Michelangelo, Sangallo il Giovane, Bernini, Carlo Fontana, Vanvitelli si avvicendarono in un'impresa che, senza alterare l'equilibrio delle forme romane, venne anzi grandemente ad arricchirle, aggiungendo man mano l'impronta di ogni periodo senza turbare il godimento del loro insieme.[2]

Il porto antico, si può dire, è rimasto così tale e quale fino all'inizio di questo secolo quando, con il declinare della navigazione a vela e con l'imporsi delle diverse esigenze della navigazione a motore, si erano già avviati i lavori intesi al suo ingrandimento ed ammodernamento.[3]

Così le strutture portuali romane, pur sopravvivendo, vennero inglobate tra opere più massicce e, in particolare, l'antemurale che era in mare aperto fu collegato alla terraferma con un braccio che prolungava la diga sud-orientale, chiudendo l'antica bocca di levante (figg. 3-5).[4]

Particolarmente disastrosa è stata per Civitavecchia l'ultima guerra, il cui porto, data l'importanza, andò distrutto sotto i bombardamenti per oltre l'80 per cento delle sue strutture. Le stesse più importanti opere romane, rimaste fino ad allora in evidenza, come le torri-faro (un documento eccezionale di perpetuazione dall'antico), sono andate allora cancellate dalle fondamenta, salvo la torre del molo di ponente, per quanto gravemente diroccata, ed altre strutture, alcune delle quali scoperte proprio a causa dei bombardamenti. Ma il tutto è rimasto però in seguito slegato dal contesto storico dell'abitato.

Purtroppo, infatti, non meno disastrosa della guerra è stata la ricostruzione che di poi si è fatta della città, in quanto le generazioni alle quali è spettata tale impresa si sono dimostrate così prive d'intelligenza per quanto essa ancora possedeva. Dopo che Civitavecchia è stata nei secoli scorsi uno dei più bei porti del Mediterraneo, oggi, per lo sfruttamento massimo che si è voluto fare in essa di ogni spazio, non vi si riconosce oramai quasi più alcun tessuto storico connettivo.

Lo stesso porto antico non è più facilmente leggibile in mezzo a tanti moli, col bacino interrato dai nuovi attracchi, il prolungarsi smisurato della diga di levante, l'affastellarsi delle strutture di servizio, a

volte gigantesche, che non rispettano neppure il forte del Bramante.

Tuttavia lo studioso ancora vi può riconoscere l'impronta d'origine, che è rimasta a condizionare anche tutto il recente sviluppo (fig. 6).

Il porto romano, per la mirabile sua risoluzione tecnica e le strutture così conservatesi in efficienza oltre i secoli dell'antichità e del medioevo, è stato infatti con gran cura studiato e rilevato fin dal Rinascimento, così che per la sua comprensione e conoscenza ce ne rimangono accurati rilievi, quali quello di Leonardo da Vinci che mostra ancora sul porto un grande edificio a tre piani, preceduto da colonnato e con scalèa discendente da questo alla marina;[5] o quello del Sangallo riguardante la dàrsena, che ne mostra perfino le quote di pescaggio.[6]

Come orgoglio dello Stato della Chiesa, disegni e rilievi lo rappresentano in tutti i secoli dell'evo moderno, con scenografiche prospettive a volo d'uccello e rilievi di dettaglio che ne illustrano le parti antiche tra il fasto delle nuove costruzioni pontificie.[7] Tra le più significative figurazioni del porto in generale, ricordo un dipinto murale del tardo Cinquecento dei Palazzi Vaticani, che mostra ancora conservate entrambe le torri-faro dell'antemurale; un disegno acquarellato di Gibelli, della fine del Seicento, conservato alla Biblioteca Vaticana (fig. 1); un disegno dell'inizio del Settecento conservato all'Archivio di Stato di Roma (fig. 2): in questi ultimi due appaiono figurati con gran cura anche i dettagli, con quelli delle torri-faro, dei moli con gli archetti del molo di ponente ed il Lazzaretto, la dàrsena, il forte e l'arsenale pontifici.[8]

Cercando la forma antica del porto, già Carlo Fontana nel 1699 ne andava rilevando le strutture.[9] Una ricostruzione spettacolare ne ha proposto Luigi Canina all'inizio del secolo scorso, che prospetta una forma ad anfiteatro del bacino, echeggiando la descrizione fattane da Rutilio Namaziano.[10]

Un lavoro che rimane fondamentale sul porto antico di Civitavecchia è quello di Bastianelli, del 1954, anche e soprattutto come sintesi del problema urbanistico.[11] Conguagli gli si sono aggiunti successivamente[12] ed è assai importante una mono-

1. Civitavecchia, visuale
del XVII secolo, disegno
acquerellato
Biblioteca Apostolica Vaticana

grafia sulla città pubblicata recentemente da Correnti:[13] importante per la vecchia documentazione fotografica che raccoglie e per la stampa delle piante degli scavi condotti dalla Soprintendenza archeologica subito alle spalle del porto nel dopoguerra, altrimenti inedite.[14]

Le scoperte avvenute sulla terraferma subito dietro la fronte del porto hanno registrato sulla posizione del forte del Bramante vasti edifici, perpetuati in parte nel perimetro della stessa forma quadrangolare del forte ed il più interno dei quali di particolare rappresentanza: in esso si è proposto di riconoscere la sede del comando della flotta, la caserma dei marinai e, sul lato esterno, l'arsenale. Il porto ebbe anche carattere militare, come sappiamo dalle iscrizioni della necropoli settentrionale, che informano come fossero distaccati a Centumcellae i classiarii delle flotte misenate e ravennate. L'identificazione non è tuttavia suffragata da elementi precisi e resta, come si vedrà ancora, assai dubbia.

Sulla fronte proprio del bacino si conservano in parte, riusati, vasti magazzini voltati, con struttura in opera mista di reticolato e laterizio. Il loro impianto si dimostra a rastrelliera ed almeno per un settore in doppia serie parallela. Sappiamo che erano preceduti da un portico su colonne di granito rosso e nero con capitelli dorici di marmo. Al centro era un edificio a più piani, nel quale si tende a identificare quello monumentale già accennato, disegnato da Leonardo da Vinci. Dietro la fronte dei magazzini che prospettavano il suo lato destro, gli scavi del dopoguerra hanno riconosciuto riguardevoli impianti termali. Strade e scalèe scendevano trasversalmente dalla città al porto ed una di queste scale monumentali è ancora visibile tra le rovine dei magazzini che allacciavano al braccio di terra che delimita l'imbocco della dàrsena. Un acquedotto doveva rifornire direttamente gli attracchi, proseguendo quello che proveniva dai monti della Tolfa e che alimentava la città.

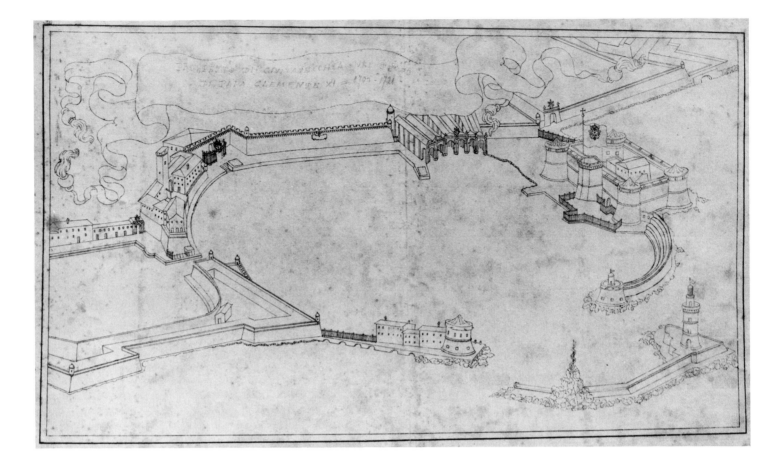

2. Civitavecchia, visuale
del XVII secolo, disegno
Archivio di Stato di Roma

La dàrsena, il bacino chiuso collaterale al porto, così oggi chiamato per aver avuto in passato tale funzione, appare ancora perfettamente riconoscibile nella perimetrazione antica, di forma trapezoidale di circa 350 x 300 m di diagonali massime. E' profonda oggi da 4 a 6 m e la misura massima dovrebbe corrispondere a quanto doveva esserlo in antico: nel Cinquecento infatti, quando si iniziò a spurgarlo dopo tanti secoli, dai disegni del Sangallo già menzionati sappiamo che conservava ancora una profondità massima di 5.5 m. Il bacino conserva sott'acqua l'antica muratura in opera reticolata, dapprima condotta verticalmente e poi in scarpa, così da documentare come la sua costruzione sia stata condotta con uno scavo originariamente in terraferma. Il suo imbocco è largo 18 m. Si ritiene che, esternamente, il bacino fosse stato perimetrato da una muraglia,[15] che si apriva sul lato lungo orientale con una serie di porte in opera quadrata di travertino, le quali davano accesso ad una serie di magazzini posti ancora a rastrel-liera sulla fronte dello specchio d'acqua. Su di una grande piazza che pare si aprisse sul lato corto settentrionale dello stesso bacino sono stati intravvisti i resti di un vastissimo edificio, impostato su tre navate.

In questo bacino si è pensato di riconoscere il luogo più riparato del porto antico, dove sarebbero avvenute le operazioni di carico e scarico delle merci, e nel muro perimetrale che lo cingeva la barriera doganale. L'edificio a tre navate, interpretato come basilica d'uso civile, sempre di età traianea, è stato pure poi proposto come basilica cristiana.[16]

Anche tutte queste identificazioni restano comunque assai incerte. Prima di tutto, anche se Bastianelli ebbe a vedere assai meglio queste strutture, la fronte dei magazzini che si conserva sul lato orientale della dàrsena, con muro in scarpa di blocchetti parallelepipedi disposti orizzontalmente e due porte delle quali una conserva l'arco lapideo, non è sicuramente antico, ma cinquecentesco. Lo studioso deve essere stato tratto in inganno, forse, dalla tecnica

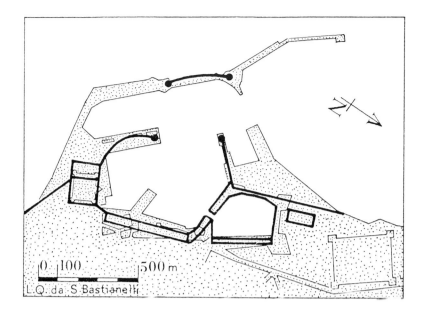

3. Civitavecchia, il porto
nel 1941, con evidenziate le
strutture dell'impianto
romano
Rielaborazione da Salvatore
Bastianelli

cio di porto interno, mentre lo specchio direttamente ridossato dall'antemurale poteva funzionare da avanporto, accessibile, secondo la direzione del mare e del vento, dall'una o dall'altra delle due bocche.

La posizione fu certo scelta proprio per la natura aperta della costa, bassa e rocciosa, la prima che si incontra a nord di Roma libera dalle sabbie di provenienza tiberina, in quanto protetta subito prima dal pronunciarsi del promontorio di capo Linaro (Santa Marinella).[18] Le correnti vi sono determinate in prevalenza dallo scirocco, che le spinge a maestro spazzando il litorale.[19] Sfruttando una lieve insenatura offerta dalla presenza di frange costiere e condizioni favorevoli di pescaggio, furono avanzati in mare aperto due moli: quello di levante con andamento ad arco di cerchio che veniva così ad abbracciare il lembo di mare ed a proteggerlo dalle correnti dominanti; ed un altro a ponente più breve e rettilineo, a difesa del versante meno esposto. Avanti ai due fu gettato in mare profondo l'antemurale, ad andamento ancora un poco curveggiante, a difesa dell'imbocco.

L'antemurale ed il molo di levante, lunghi circa 350 m ciascuno, furono costruiti gettando in acqua una solida scogliera, sulle quali vennero elevate le banchine. Un tratto di paramento dell'antemurale, in blocchetti parallelepipedi di arenaria disposti orizzontalmente sul nucleo cementizio, è archeologicamente documentato.[20]

Abbiamo, famosa, la descrizione dell'opera in corso di costruzione da una lettera di Plinio, che ne fu testimone oculare:

huius sinistrum brachium firmissimo opere munitum est, dextrum elaboratur. In ore portus insula adsurgit, quae inlatum vento mare obiacens frangat, tutumque ab utroque latere decursum navibus praestet. Adsurgit autem arte visenda: ingentia saxa latissima navis provehit contra; haec alia super alia deiecta ipso pondere manent ac sensim quodam velut aggere construuntur. Eminet iam et adparet saxeum dorsum impoctasque fluctus in immensum elidit et tollit; vastus illic fragor canumque circa mare. Saxis deinde pilae adiciuntur quae procedente tempore enatam insulam imitentur.[21]

Come accenna lo stesso Plinio, a differenza dell'antemurale e del molo di levante,

similmente usata nelle strutture effettivamente romane del porto, ma vedremo ad esempio proprio nella torre del molo di ponente come queste fossero imitate in età rinascimentale. La stessa cornice a cordone di travertino che scandisce al di sopra la scarpa richiama chiaramente quest'epoca e sicuramente il nucleo murario dell'opera, in friabile grossolano conglomerato di ghiaia, non trova riscontro nelle opere romane.

Anche per l'interpretazione generale, sarebbe possibile riconoscere, nella dàrsena, il porto militare: in tal senso potrebbe spiegarsi, se è esistita, proprio la perimetrazione del complesso[17] e la stessa necropoli dei classiarii si trova subito fuori questo versante portolano. In questo quadro si aprirebbero nuove prospettive nell'identificazione della così detta basilica, della quale per altro, al di là della pianta parziale, non disponendo di alcuna indicazione a riguardo della tecnica edilizia, non abbiamo nessuna idea per un rimando cronologico. Va comunque notato, per la forma proprio del suo impianto, che potremmo riconoscervi l'arsenale.

Ma dopo questo rapido conguaglio delle attrezzature site sulla fronte interna del porto, veniamo alle opere di difesa sulla fronte marittima, che era a moli convergenti e bocca protetta da antemurale (fig. 3).

La disposizione intendeva assicurare a tutto il bacino chiuso tra i due moli l'uffi-

costruiti a banchina piena, il molo di ponente, lungo 250 m, fu alzato su pile in calcestruzzo collegate mediante arcuazioni, che fornendo la continuità della banchina permettevano alle correnti marine di passarvi al di sotto. Il gioco prevalente delle correnti, quindi, provenendo da sud-est, urtava dapprima il molo e poi l'antemurale, già attutendosi e distraendosi sull'andamento curvilineo di quelli: la corrente, che entrava dalla stessa bocca di levante del porto, ne usciva poi da quella posta sull'opposto versante, mentre la corrente che ancora entrava nel bacino ne poteva pure fuoriuscire, in parte, attraverso le arcuazioni del molo di ponente. Il molo di ponente, con la sua particolare tecnica costruttiva, consentendo alla corrente di attraversarlo, permetteva a questa di spazzare continuamente il fondale, impedendo l'interro del bacino; inoltre, in caso di mare mosso, ne riduceva la risacca.

La profondità del bacino nei secoli scorsi, prima cioè dei grandi lavori contemporanei, variava da 5 a 7 m, ed anche oggi non muta molto da quelle misure, avendo un pescaggio di 6–8 m.[22]

E' assai utile valutare le vecchie descrizioni portolane per stimare la bontà del sistema di approccio al porto da parte dell'antico naviglio a remi o a vela. Riporto ad esempio gli apprezzamenti di un noto esperto di marineria portolana del secolo scorso, Alessandro Cialdi:

Civitavecchia [è] posseditrice del piccolo sì ma del più bello e meglio costituito porto del mondo. . . . Questa disposizione del presente antemurale . . . è . . . una conferma dell'alta mente e della profonda pratica dell'uomo che ne dettò l'insieme. Difatti, per entrare in porto con mare grosso è necessario che il bastimento riceva le onde in fil di rotta e si tenga ben prossimo alla testata dell'antemurale: ed essendo questa poco protratta a scirocco in confronto di quella del molo del Bicchiere (cioè di levante), il bastimento può con superabile difficoltà entrare felicemente in porto; ma se l'antemurale fosse più protratto a scirocco, e peggio ancora più a levante, il bastimento stesso, per la mancanza di acqua verso la riva, dovrebbe ricevere un vivo, più alto e spesso franto mare, e così sarebbe irreparabilmente perduto.[23]

Nel sistema d'ingresso al porto venivano quindi ad assumere grande importanza le testate sia dell'antemurale che dei moli, distanti tra loro tra bocca e bocca meno di 200 m e che furono resi ben visibili con quelle torri che ancora esistevano fino all'ultima guerra (per quanto le due dell'antemurale rinnovate dagli interventi ponti-fici, una all'inizio del Seicento e l'altra alla fine del Settecento). Sono le torri che vide e cantò Rutilio Namaziano, approdando a questo porto sicuro:

Ad Centumcellas forti defleximus austro;
Tranquilla puppes in statione sedent.
Molibus aequoreum concluditur amphitheatrum.
Angustoque aditus insula facta tegit.
Attollit turres bifidoque meatu
faucibus artatis pandit utroque latus.
Nec posuisse satis laxo navalia portu:
ne vaga vel tutas ventilet aura rates,
Interior medias sinus invitatus in aedes
Instabilem fixis aera nescit aquis. . . .[24]

Non vi è ricordo o traccia archeologica del faro antico che si ipotizza al centro dell'antemurale, ma è plausibile che non sia là mai esistito. Tale funzione deve averla assunta una o entrambe le torri poste all'estremità dell'isola: forse, come le si era ristrutturate in età pontificia, quella di levante ebbe il ruolo di faro e l'altra ufficio di lanterna.[25] Un semplice ufficio di lanterna dovevano avere invece le torri alle testate dei moli.

E' presumibile che le torri, collocate così due per due alle bocche del porto, servissero anche al suo eventuale controllo militare, avendo avuto il porto tale disciplina. La bontà delle posizioni per il controllo del porto è comprovato dall'uso che di esse poi si è fatto in età pontificia, quando furono trasformate in fortini armati di cannoni. Ce ne restano diverse figurazioni in questa loro veste moderna e le migliori sono quelle già ricordate per la rappresentazione del porto: la stampa di Antonio Aquaroni del 1819 che mostra l'imbocco del porto da ponente e quella di Annavozzi del 1853 che mostra i moli e l'antemurale dall'interno del porto: a queste è da aggiungere una stampa conservata al Gabinetto Nazionale delle Stampe, del 1840, nella quale si vede particolarmente bene la torre di ponente.[26] Le rappresentano in forma cilindrica, con il muro basso in scarpa: quella alla testata del molo di levante, detta del Bicchiere per la

4. Civitavecchia, panoramica all'inizio del secolo, con evidenti le strutture dell'impianto portolano romano
Fotografia: Giacomo Brogi e Domenico Anderson

5. Civitavecchia, panoramica in un'immagine anteriore al 1941, con ancora in evidenza le strutture dell'impianto portolano romano
Fotografia: da Salvatore Bastianelli

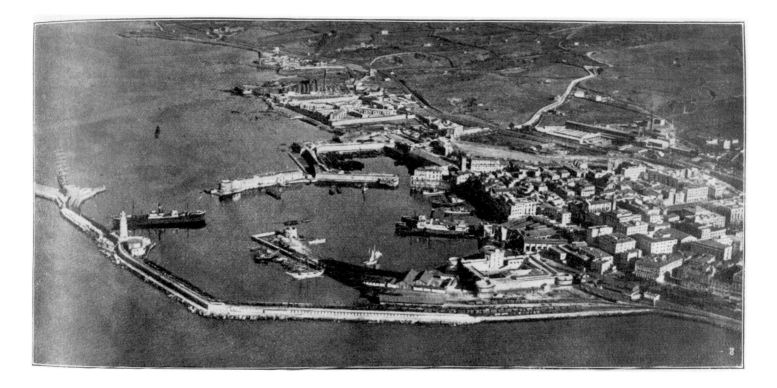

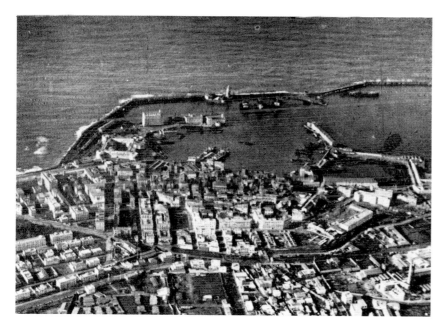

forma a campana rovesciata, appare elevata di un solo piano sopra terra e traforata da finestre a bocca di lupo per il tiro delle artiglierie, mentre la sommità, piana, presenta i parapetti aperti a ventaglio dalle troniere ed è fornita di una garitta centrale.[27] La torre sul molo di ponente, detta di Lazzaretto per gli edifici che contiguamente le si svilupparono sulla banchina,

poi trasformati in ospedale, presentava invece altri due piani oltre quello terreno ed ai due livelli inferiori vi appaiono due o tre ordini di bocche da fuoco, mentre la sommità, prima coperta con tetto a più spioventi, dal 1840 appare a cortina sopraelevata e traforata da feritoie per il tiro di fucileria, nonchè sormontata da garitta. La stessa tavola dell'Annavozzi mostra anche assai bene le torri riedificate sull'antemurale, non solo quella del faro, assai nota per altre rappresentazioni, ma anche quella di fronte al molo di Lazzaretto, ricostruita assai similmente al fortilizio di quest'ultima. Tutte queste figurazioni, per quanto preziose, non mostrano però nel particolare la tecnica costruttiva delle strutture e, per questo, assai più preziose appaiono le vecchie fotografie che le riprendono, per altro assai rare.

La raccolta della vecchia documentazione fotografica è, a proposito, un fondamento estremamente utile alla conoscenza non solo di questi monumenti, ma di tutto il porto antico di Civitavecchia. Non vi è certo bisogno che stia a ricordare come questo genere di documentazione sia, infatti, diretta, ferma nel tempo ed assolutamente fedele nella resa degli elementi complessivi ed insieme particolari, così da

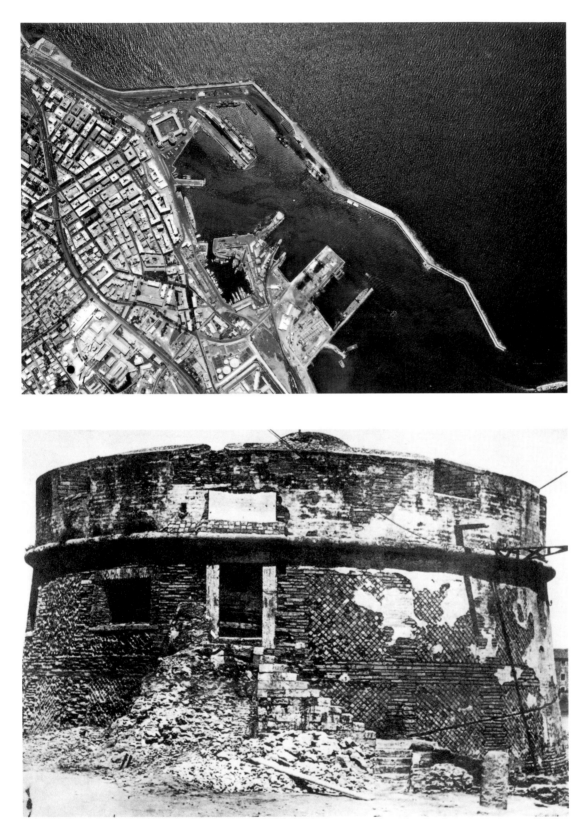

6. Porto, Civitavecchia,
fotografia aerea allo stato
attuale (1973), con ancora
riconoscibile l'impronta
datagli dall'impianto
romano
Fotografia: Società Internazionale
Aerofotogrammetria e Topografia

7. Torre del Bicchiere,
Civitavecchia, fotografia
d'inizio secolo
Fotografia: da Francesco Correnti

rendere la sua testimonianza eccezionale.
Basta per questo considerare come appaia
fondamentale alla comprensione di tutta la
storia del porto la fotografia aerea Brogi-
Anderson di Civitavecchia, ripresa a volo
d'uccello agli inizi del secolo e pubblicata

sull'*Enciclopedia Italiana* (fig. 4): o quella che ne presenta ancora lo stato pre-bellico, sempre aerea e vista dall'entroterra, pubblicata nel lavoro di Bastianelli (fig. 5).[28] La collezione Alinari conserva una documentazione eccezionale del vecchio porto,[29] tra le cui fotografie segnalo un'immagine aerea del forte bramantesco sul versante sud orientale, del 1929, che mostra ancora conservato avanti a questo, per quanto interrato dalla creazione dello scalo ferroviario, il lungo muro in calcestruzzo che costituiva il banchinamento antico su questa fronte marittima, poi andato distrutto.[30] Questo stesso banchinamento lo si vede meglio in una ancor più antica fotografia, anteriore alla creazione dello scalo ferroviario che avvenne nel 1905-1906, pubblicata da Correnti: lo mostra ancora percosso dal mare, lasciato come antemurale del forte, mentre le onde raggiungono pure la base di quello.[31] De Paolis e lo stesso Correnti hanno rintracciato un'immagine di primo piano della torre del molo del Bicchiere (fig. 7), che si aggiunge assai preziosa alle uniche fotografie note, riguardanti la stessa torre e quella di Lazzaretto, pubblicate rispettivamente da Bastianelli e da Martinori

(figg. 8, 9).[32] Un'altra del molo del Bicchiere, con la torre non in primo piano, ne ha pubblicata la Foschi[33] ed un'altra ne segnalo, con tutto il molo ed ancora la torre, dal fondo Alinari.[34]

A riguardo della torre del Bicchiere sappiamo da Bastianelli che aveva un diametro di 16 m ed un paramento in opera mista con specchi di opera reticolata.[35] Il paramento a specchi, ben valutabile nelle stesse vecchie fotografie, è particolarmente interessante per la conduzione delle maglie che lo riquadrano, a fasce regolari orizzontali e verticali, e che appaiono eseguite non in laterizio ma in opera retta di tasselli parallelepipedi di arenaria (figg. 7, 8). Così, ben diversa dalle altre bocche da fuoco aperte dall'utilizzazione pontificia, sembra antica una finestra riquadrata egualmente in tasselli di arenaria, riprodotta nella fotografia di Bastianelli (fig. 8). Particolarmente interessante anche, per la tecnica non frequente, l'andamento in lieve scarpa della stessa muratura antica. Moderna appare la porta, sopraelevata per la difesa, e sembra moderna anche tutta o quasi la parte al di sopra della cornice, a cordone in aggetto di travertino, che scandisce l'elevarsi del piano superiore poi coronato dalle troniere.[36]

La torre di Lazzaretto. La torre sul molo di ponente, detto di Lazzaretto, è l'unica delle antiche torri che ancora si conserva, per quanto anch'essa colpita dai bombardamenti e diroccata su tutta la fronte volta al mare aperto. È', questa, proprio la fronte ripresa dalla miglior fotografia che di essa possediamo di prima degli eventi bellici, recuperata da Correnti e, quindi, tantopiù preziosa (fig. 9).[37] La torre presenta alla base, in scarpa, 20 m di diametro e conserva un'altezza media di 11 m (al massimo 12) invece dei 12.5 m circa che doveva avere prima della guerra (figg. 11-13). All'esterno la stessa altezza si divide in tre zone scandite da una cornice eguale a quella vista nella torre precedente, a cordone aggettante di travertino, rinascimentale: la zona inferiore si presenta in leggera scarpa come nell'altra, ma qui il paramento è laterizio di età papale: presenta una porta sulla fronte orientale prospettante il molo, un'altra porta a nord per la comunicazione interna con gli edifici che

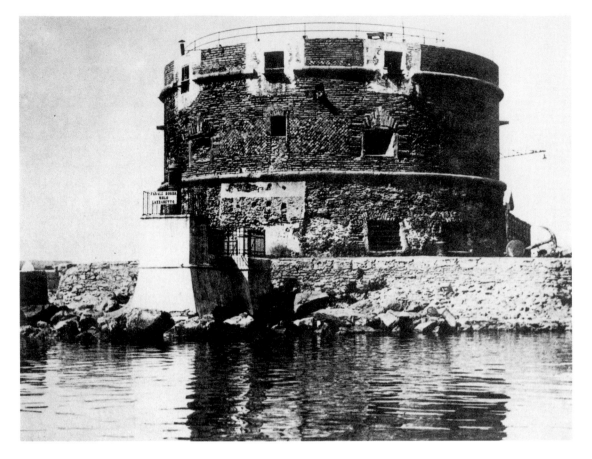

9. Torre di Lazzaretto, Civitavecchia, fotografia anteriore al 1941
Fotografia: Edoardo Martinori

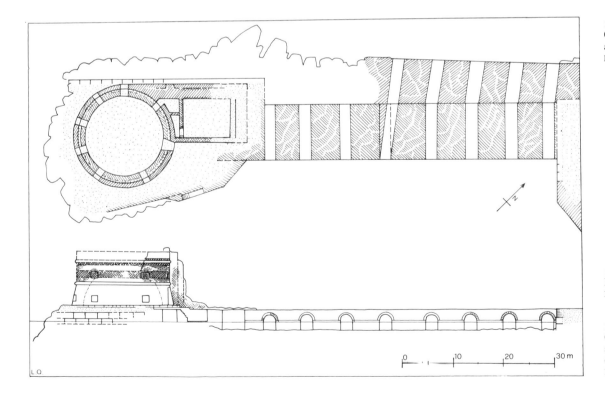

10. Torre di Lazzaretto, Civitavecchia, pianta ed alzato del molo
Disegno di Lorenzo Quilici

11. Molo e torre di Lazzaretto, Civitavecchia
Fotografia: autore

12. Torre di Lazzaretto, Civitavecchia, visuale con le strutture addossate sul lato di nord-est
Fotografia: autore

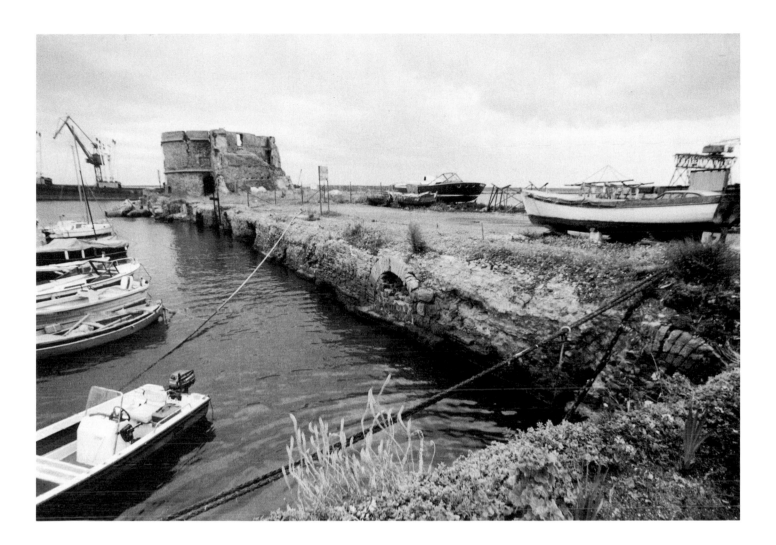

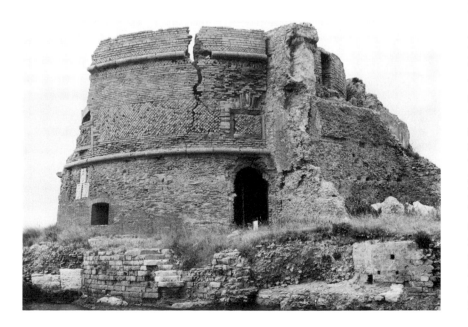

le si addossavano sul lato stesso del molo (figg. 10, 12). La medesima scarpa presenta basse finestre per le bocche da fuoco, alcune ancora aperte ed altre murate oggi per motivi statici (figg. 9–11,17): si aprivano due a due a lato della testata prospettante la bocca del porto, un'altra guarda a sud-est l'interno dell'antico bacino, un'altra a nord-ovest dov'era il mare aperto sulla costa di ponente (fig. 18): a quest'ultima se ne affianca un'altra nel prolungamento che faceva la stessa struttura rinascimentale su quella fronte del molo. Le due bocche a nord-ovest, che conservano il paramento di cornice pontificia (le altre sono rifasciate da una ripresa dei muri condotta nel dopoguerra), voltavano una copertura ad arco schiacciato, sempre laterizio; e la stessa struttura riquadrava anche le finestre sul lato meridionale, documentate dalla fotografia prebellica già

ricordata. Solo la bocca da fuoco posta sul lato nord-ovest della torre mostra anche di aver ricevuto un vecchio restauro, essendo riquadrata su uno stipite in masselli, architravata e sormontata da un basso archetto di scarico in laterizio. La stessa cortina laterizia della torre conserva affissi, sulla fronte che guarda il porto interno, tre stemmi di Clemente VIII (fig. 12), che però debbono essere stati ricollocati nel dopoguerra, dato che non compaiono nella fotografia di Martinori (fig. 9).

Il piano superiore, scandito tra le due cornici rinascimentali ancora conservate, presenta, antica, una larga fascia orizzontale in accurata opera reticolata di tufo, compresa sotto e sopra tra murature con paramento in opera retta di tasselli parallelepipedi di arenaria (fig. 12). La cornice in alto è compresa tra due piccole fasce di accurata opera reticolata, che però non è antica ma messa in opera con quella, come si vede dal tassellato che è di maggiori dimensioni e non usurato dalle intemperie. La parte ancora al di sopra è in tasselli parallelepipedi di arenaria disposti orizzontalmente, più grandi di quelli sottostanti e pure moderni. La malta delle strutture antiche è di color bianco-sporco, tenacissima, con inclusi grani di pozzolana grigia: quella rinascimentale usa invece pozzolana rossa.

Un elemento caratteristico del piano intermedio è dato, all'altezza della fascia di reticolato antico, da una serie di finestre, per lo più acciecate dalla medesima opera reticolata, riquadrate da cornici di arenaria semplicemente sagomate verso l'interno, a loro volta incorniciate sui lati da stipiti in masselli parallelepipedi di egual materiale ed al di sopra da un archetto ribassato quasi a piattabanda, questo in piccoli conci pentagonali sempre di arenaria, più rilevati a scopo ornamentale in chiave di volta (figg. 9, 12, 13). Quest'ultimo motivo è senza dubbio rinascimentale e comprovato dal fatto che la bocca da fuoco che prosegue questo allineamento sull'edificio che si addossa alla torre medesima sul versante settentrionale, tutto in laterizio pontificio, ne ripete in arenaria eguale il motivo degli stipiti e della copertura ad arco ribassato, con apertura però più stretta e mancante della grande cornice

più interna di arenaria, che riterrei antica, e, naturalmente, della tamponatura in reticolato. Tutte queste finestre attorno alla torre appaiono essere state cieche, non essendone occlusa oggi solo una sul lato ovest, in quanto quasi tutta diroccata, ed essendone stata aperta solo un'altra sul lato sud, oggi distrutta, documentata nella vecchia fotografia già ricordata (fig. 9). Inoltre le finestre non furono sicuramente in uso neppure in tempo moderno, dato che in età rinascimentale l'ambito interno della torre fu coperto da una cupola in calcestruzzo, che venne ulteriormente ad acciecare, con il suo spessore, le finestre su quel lato (fig. 10). Invece l'opera reticolata che accieca le finestre costituisce col suo nucleo in calcestruzzo, entro le cornici che le riquadrano, un masso unico strombato (come si vede bene dalla finestra orientale diroccata dal bombardamento), che non fa dubitare così della sua antichità, come di quella del suo primo riquadro (fig. 13): pertanto riterrei queste finestre, non funzionali, come un elemento ornamentale nel paramento della torre romana o, almeno, un pentimento del progetto in fase di esecuzione dell'opera. Anche per quanto riguarda il riquadro rinascimentale delle finestre si potrebbe pensare ad un progetto poi non attuato per la collocazione delle bocche da fuoco, dato che sono rimaste chiuse, o ad una rielaborazione ornamentale delle finestre antiche. Queste comunque, salvo quella ricordata, sono rimaste sempre cieche, nonostante che alcune delle figurazioni della metà del secolo scorso, forse a scopo scenografico, le rappresentino funzionali.[38]

Erano invece altre vere troniere, al di sopra di queste finestre cieche, ulteriori bocche pure rappresentate in queste ed altre figurazioni della torre nei secoli scorsi, poste sullo stesso corpo cilindrico subito sotto la cornice più alta. Nella fotografia d'anteguerra più volte ricordata, invece, l'ordine più alto delle bocche da fuoco appare rialzato subito sopra la cornice stessa, che viene ad interrompere, presumibilmente per una ristrutturazione di quote attuata assai più di recente (fig. 9).

Anche la sommità della torre ha avuto nei secoli moderni diverse ristrutturazioni: mentre la cortina al di sopra della

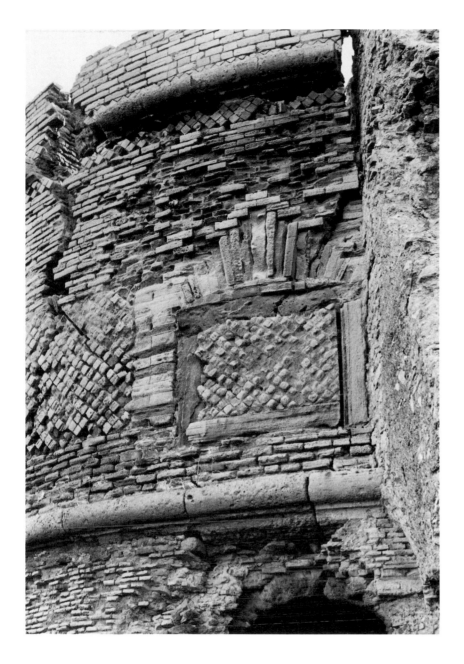

13. Torre di Lazzaretto,
Civitavecchia, particolare
di una finestra cieca
Fotografia: autore

dalla sezione offerta attraverso il suo spessore dalle finestre sul lato occidentale), esso pare costituito, sulla grossezza di base di 2.4 m, dall'aggiunta di un muro esterno larga 80 cm che è quello che appunto costituisce la scarpa e presenta il paramento laterizio, e di un muro interno spesso circa 35 cm, i quali contengono un muro originario, che dovrebbe essere quello romano, spesso 1.2 m (fig. 10). Questo pare essere dotato di un suo paramento esterno in tasselli parallelepipedi di arenaria, disposti orizzontalmente. Tale riscontro pare escludere che anche la torre antica fosse strombata in basso, come fa oggi e come faceva sicuramente invece la torre antica del molo del Bicchiere. Questa torre era quindi abbastanza diversa dall'altra per struttura, come si è anche visto per l'ampiezza del diametro e la tecnica edilizia del paramento, là costituita da specchi di muratura chiusi da fasce verticali ed orizzontali, qui a fascioni orizzontali sovrapposti.

Riguardo all'ambito interno della torre, questo doveva avere in antico un diametro di circa 16 m considerando il rivestimento attuale che le dà un volume circolare di 15.35 m e non doveva essere certo coperto a cupola come nel Rinascimento, considerando la sua ampiezza in proporzione allo spessore della cortina perimetrale (fig. 10). La copertura a volta è presumibilmente il risultato di due successive fasi di intervento, dato che presenta diverse tecniche costruttive, che vennero probabilmente ad adattarla all'uso delle artiglierie al piano superiore.[40] Riguardo al coronamento, esso non è oggi accessibile.

Alla torre si addossano, sul lato del molo, le strutture di un edificio del quale avanzano consistenti muri in opera reticolata sempre di arenaria, molto rimaneggiato dalle ristrutturazioni pontificie che occuparono il molo stesso (figg. 10–12): largo 11 m e lungo forse 18 m, alto almeno due piani, ne ha lasciato una pianta Bastianelli, che le interpreta ad uso del presidio incaricato della difesa della bocca del porto, con una lunga scala perimetrale che consentiva di accedere in sommità di quella.[41] Mi permetto tuttavia di dubitare di quest'ultima interpretazione, che riguarda invece solo la soluzione moderna

seconda cornice appare bassa e coperta da tetto a più spioventi fino alla figurazione di Aquaroni del 1819, in quelle del 1840 e del 1853 più volte ricordate la cortina appare fortemente rilevata e traforata da feritorie per il tiro di fucileria, mentre la copertura potrebbe essersi fatta a terrazza: senza più questo alto coronamento e coperta a terrazza appare nelle fotografie d'anteguerra.[39]

Riguardo al muro che costituise la parte inferiore della torre, quello in scarpa (per quel che si può intravvedere da uno squarcio del paramento sul lato meridionale e

del complesso, essendo stato il muro di ponente rifasciato all'esterno da un rifacimento papale ed anche le scale, per quel che ne avanza, sono tali (fig. 10). Forse le scale antiche erano nell'intercapedine che collega l'edificio stesso alla torre e che oggi è innaccessibile. Comunque, tuttavia, l'edificio antico addossato alla torre doveva essere a servizio di questa, così come ha indicato quello studioso.

E' di interesse notare che tutto il complesso della torre con il suo annesso veniva ad occupare anticamente come uno scoglio avanzato e più largo sulla punta del molo, dato che ha dimensioni assai più larghe di quello. Se ne vede assai bene la fondazione artificiale sul lato di nord-ovest, fin oltre la testata della torre stessa, con un doppio ordine di colossali blocchi tra loro sovrapposti per lungo, di travertino o arenaria grigia, lunghi mediamente 2.1 m ed alti 1.2 (figg. 10, 14).[42] L'inferiore appena affiora dall'acqua e manca presumibilmente un filare ancora al di sopra, data la differenza di circa 1.4 m che separa la sommità del secondo filare da quello di base della torre stessa.[43] Il resto del bordo è nascosto dai nuovi massi frangiflutto accatastativi e dai crolli, nonchè dai rifacimenti: solo sul lato orientale della torre si intravvedono altri grandi blocchi parallelepipedi di travertino che non è sicuro ritenere antichi (fig. 12).

Veniamo ora alla descrizione del molo, almeno nei suoi primi 100 m di lunghezza visibile dei circa 250 m originari (figg. 10–11, 15–16): i fianchi di questo, fortunatamente non ristrutturati in tale tratto ma solo coperti dai crolli e dall'interro fino ad alcuni anni fa, sono stati ora ripuliti, specie quello sul versante di levante, per facilitarne l'uso all'attracco per le piccole barche. Ciò mi ha permesso di rivisitarlo con assai maggior profitto di quanto era possibile in passato.

Prima di tutto il molo non appare antico in tutto il suo spessore, ma fu allargato a ponente per accogliere al di sopra la schiera di edifici rinascimentali che poi diedero corpo al Lazzaretto (fig. 10). Lo spessore complessivo si allarga oggi da 19 a 20 m mentre anticamente ne era di solo 11. L'opera antica è in calcestruzzo di tufo più minuto e curato nella regolarità dei piani di posa e la malta più tenace, dato

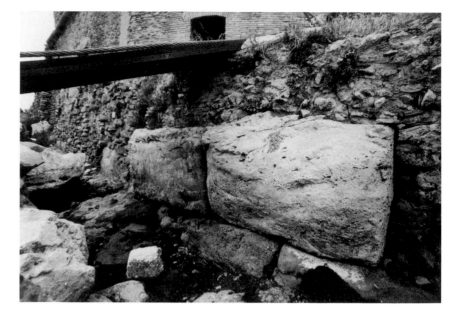

che il moderno è più usurato dal mare. La struttura si conserva alta in media, sulle acque, circa 2.5 m, 3–3.5 m sul fondo attuale di interro, ed è traforata da arcuazioni (se ne vedono otto, alcune oggi murate), che scandiscono luci di 2.3 m tra pile larghe 5.3 m, eccetto una pila centrale leggermente più ampia e che è di 6.7 m. I sottopassi antichi sono ortogonali al senso del molo, eccetto uno centrale che fu deviato modernamente in senso obliquo, grattando la struttura da una parte e rimurando dall'altra: è lo stesso senso dato anche al prolungamento delle bocche romane nell'ampliamento del molo voluto in età moderna, per edificarlo al di sopra (fig. 10). Il nuovo accorgimento fu presumibilmente dettato dalla necessità di attutire le correnti al di sotto del molo, essendo stato questo occupato da tanti edifici. Il molo romano era rivestito di tasselli parallelepipedi di arenaria, come si riconosce da resti per altro scarsissimi sulla fronte sud-orientale, e gli archi da un'accurata raggiera di piccoli conci di egual materiale, lunghi da 30 a 40 cm in genere, profondi 33–37 cm, questi meglio conservati sullo stesso lato (fig. 15). La fronte degli stessi archi si conserva poi perfettamente dal lato opposto murato dall'ampliamento moderno, dato che il cavo moderno è leggermente più ampio dell'antico per cui ne mostra la facciata (fig. 16).

14. Molo di Lazzaretto, Civitavecchia, fondazione in opera quadrata della testata
Fotografia: autore

15. Molo di Lazzaretto, Civitavecchia, lato orientale, fronte del settimo archetto dalla torre
Fotografia: autore

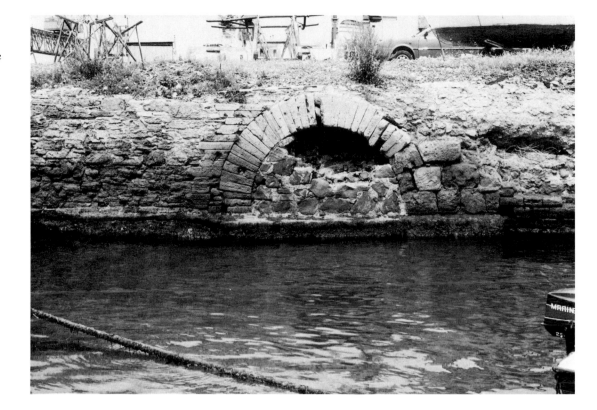

16. Molo di Lazzaretto, Civitavecchia, lato occidentale, fronte del settimo archetto inglobata nell'allargamento rinascimentale
Fotografia: autore

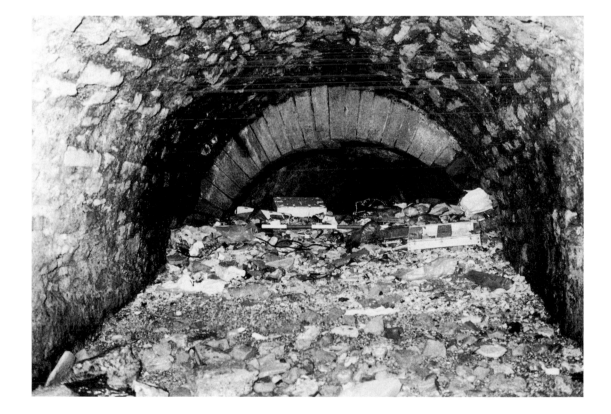

Dove si finisce di vedere il molo ad archetti, lo stesso è ampliato in direzione della dàrsena da numerosi e massicci rifacimenti; non è antico, sul versante di nord-ovest, un lungo muro in opera quadrata di grossi blocchi di travertino che ne prosegue il lato allargato modernamente (fig. 10). Dalla parte opposta, verso l'antico porto interno, il molo si amplia invece con un largo sperone avanzato, fondato in grossi blocchi di travertino, che corrisponde all'ultimo residuo della scalèa d'attracco che si pronunciava sulla fronte ed al centro dei magazzini pontifici già posti sul molo romano. Oltre questa scalèa i vecchi rilievi del Lazzaretto documentano altri due archi del molo,[44] che oggi risulta coperto dall'avanzamento di una nuova banchina.

Concludendo nel particolare di questo molo, così straordinariamente conservato, richiamiamo un altro simile e celeberrimo *opus pilarum*, quello di Pozzuoli, che comunemente è riferito ad età augustea.[45] Al molo di Pozzuoli si riferisce di solito un noto dipinto antico, conservato al Museo Nazionale di Napoli, che mostra appunto a lato di una città una simile struttura protesa in mare su arcuazioni, e così per confronto ricordo il famoso mosaico policromo, rinvenuto sul Quirinale, raffigu-

rante col faro un molo di tal fatta, che si conserva ai Musei Capitolini.[46]

Riguardo al faro, per quanto esso sia stato una torre di segnalazione secondaria nell'ambito dell'antico porto di Centum-

cellae, è da rilevare come esso appaia (come l'altro del Bicchiere) essere stato ben costruito, sia nel senso della solidità che dell'estetica: la sua costruzione risponde pienamente a quei principi di *firmitas, utilitas, venustas*, che Vitruvio annovera come propri dell'architetura romana.[47] Come la sua eleganza sia stata apprezzata nel Rinascimento è dimostrato dalla cura con la quale nei restauri ne sono state imitate le strutture originali. Esso si affianca degnamente ai rari altri monumenti di questo genere conservatici dall'antichità, superstiti dalle coste atlantiche a quelle dell'Africa:[48] *moles necessariae* nelle quali si configurano gli aspetti più significativi della civiltà di Roma antica.[49]

E' drammatico tuttavia constatare come esso sia stato lasciato così diroccato dall'ultima guerra e in condizioni statiche talmente critiche da farne temere per la sopravvivenza.[50] Mi viene in mente a proposito un altro monumento a torre, la Canocchia di Capua, per la felice epigrafe che invece la orna: *Me superstitem antiquitatis molem/ senio confectam et iam iam ruituram/ rex Ferdinandus IV, pater patriae,/ ab imo suffultam reparavit.*[51] Forse anche tra i politici e gli amministratori di oggi vi può essere qualcuno che sappia smuovere le cose, cosicchè si possa giungere alla tutela di un simile eccezionale monumento.

NOTE

1. Per un conguaglio della situazione portolana accennata si veda Hans Dietrich Friedrich Viereck, *Die romische Flotte, Classis Romana* (Bielefeld, 1975), 260–270; Michel Reddé, *Mare Nostrum. Les infrastructures, le dispositif et l'histoire de la marine militaire sous l'empire romain (BEFAR 260)* (Roma, 1986), 164–171, 186–203; Jean Rougé, "Routes et ports de la Méditerranée antique," *RSLig* 103 (1987) 157–158. Sulle funzioni metropolitane dei porti citati si veda Pietro Romanelli, "La funzione del porto di Centumcellae," in *Civitavecchia, pagine di storia e di archeologia* (Civitavecchia, 1961), 19–23; Martin W. Frederiksen, "Puteoli e il commercio del grano in epoca romana," *Puteoli* 4–5 (1980–1981), 5–27. Sullo spazio metropolitano di Roma antica si veda Lorenzo Quilici, "La Campagna Romana come suburbio di Roma antica," *La Parola del Passato* (1974), 410–438; Lorenzo Quilici, "Rome, L'espace urbain et l'espace rural relayés par le suburbium dans l'antiquité tardive," in *Rome, L'espace urbain et ses représentations* (Paris, 1991), 97–110.

2. Si vedano Vincenzo Annavozzi, *Storia di Civitavecchia* (Roma, 1853); Carlo Calisse, *Storia di Civitavecchia* (Firenze, 1936); Pietro Manzi, *Stato antico e attuale del porto, città e provincia di Civitavecchia* (Prato, 1937); *Civitavecchia da salvare* (Civitavecchia, Mostra fotografica) (Civitavecchia, 1971); Rossella Foschi, "Il porto di Civitavecchia: vicende d'un fulcro urbano," *Quaderni dell'Istituto di Storia dell'Architettura* 97–114 (Roma, 1975), 141–160; Alfonso Gambardella, *Architettura e committenza nello Stato Pontificio tra barocco e rococò* (Napoli, 1979); Rossella Foschi, "Sull'arsenale di Civitavecchia, precisazioni dai documenti," *Antiqua* 7 (3–4 1982), 43–50; Francesco Correnti, *Chome lo papa vole . . . Note per una rilettura critica della storia urbanistica di Civitavecchia* (Civitavecchia, 1985); Fabiano T. Fagliari Zeni Buchicchio, "La Rocca del Bramante a Civitavecchia: Il Cantiere e le Maestranze da Giulio II a Paolo III," *Römisches Jahrbuch für Kunstgeschichte* 23/24 (1988), 273–383; Giovanna Curcio e Paola Zampa, "La torre di levante dell'antemurale di Civitavecchia: trasformazioni della struttura portuale agli inizi del XVII secolo," *L'Architettura a Roma e in Italia (1580–1621), Atti XXIII Congresso di Storia dell'Architettura Roma 1988*, 1, Roma 1989, 373–385, 561–564.

3. Alessandro Cialdi, "Quale debba essere il Porto di Roma e ciò che meglio convenga a Civitavecchia e ad Anzio," *Giornale Arcadico* 109 (1846), 3–60; Alessandro Cialdi, "Disegno per l'ingrandimento e il miglioramento del porto di Civitavecchia," *Giornale Arcadico* 163 (1861), 3–42. Nel primo lavoro, tav. 2, è riportata una significativa piantina delle quote di pescaggio del porto: nel secondo lavoro, tav. 1, è una piantina più dettagliata delle stesse quote (5–7 m di pescaggio entro il porto, 5–6 m alla banchina, 5.8–6 m nella darsena).

4. Una magnifica riproduzione aerea del porto, dell'inizio del Novecento (fotografia di Giacomo Brogi e Domenico Anderson), è pubblicata nell' *Enciclopedia Italiana* (Milano, 1931), 10:517 (ripubblicata da Foschi 1975, 152), ed un'altra anteriore all'ultima guerra da

Salvatore Bastianelli, *Centumcellae (Civitavecchia), Castrum Novum (Torre Chiaruccia)*, (Roma, 1954), tav. 1 (qui riprodotte alle figg. 4, 5).

5. *Il codice atlantico di Leonardo da Vinci nella Biblioteca Ambrosiana di Milano* (Roma, 1902), folio 63 verso b: riprodotto anche in *Enciclopedia Italiana* (Roma, 1933), 20:875, fig. 39: da Correnti 1985, 109.

6. Si vedano anche Foschi 1975, 150–151; Fagliari 1988, 315–316. Più in generale, su questi rilevamenti, oltre ai lavori degli stessi, si vedano quelli di Gambardella 1979 e di Correnti 1985.

7. Conguagli significativi sono nelle opere di Foschi 1975, di Correnti 1985, di Fagliari 1988, e ricordo ancora le figurazioni edite da Vittorio Vitalini Sacconi, *Gente, personaggi e tradizioni a Civitavecchia dal Seicento all'Ottocentro* (Civitavecchia 1982), 1, e da Henri Stierlin, *Hadrien et l'Architecture romaine* (Paris, 1984), 47. Tra queste raffigurazioni va particolarmente notato il magnifico disegno del porto dell'inizio del Settecento, conservato all'Archivio di Stato di Roma, *Disegni e Mappe*, n. 271, qui riprodotta a fig. 2, presentata già da Giovanni Maria De Rossi, *Torri costiere del Lazio* (Roma, 1971), fig. 20, e nel lavoro di Foschi 1975, 141; un'accurata panoramica dell'imbocco del porto da ponente, dovuta ad Antonio Aquaroni, del 1819, pubblicata nei lavori di Vitalini Sacconi 1982, 252, e di Correnti 1985, 105. Ricordo ancora, come più significative, due belle figurazioni, una della fine del Cinquecento e l'altra della fine del Seicento, conservate nella Biblioteca Vaticana ed edita la prima da Roberto Almagià, *Monumenta Cartographica Vaticana* (Città del Vaticano, 1950), 4: tav. 28: l'altra da Bodo Ebhardt, *Die Burgen Italiens* (Berlino, 1916), 3: tav. 12, e da Vitalini Sacconi (1982), 1:251 (qui riprodotta, fig. 1). Per altre immagini, si veda la figurazione cinquecentesca, ripresa a volo d'uccello, riprodotta nella Galleria delle Carte Geografiche in Vaticano, edita da Roberto Almagià, *Le pitture murali della Galleria delle Carte Geografiche* (Città del Vaticano, 1952), tav. 36; disegno della città e del porto del secolo XVII, riprodotto da De Rossi, 1971, fig. 18: disegni dell'arsenale e del porto di Jean Grandjean, del 1779, riprodotti in *Møde med Italien, Hollandske, tyske og skandinaviske tegninger 1770–1840* (Copenhagen, 1971), tavv. 7–8; una pianta del porto del XVIII secolo riprodotta da Roberto Almagià, 2a ed. (Torino, 1976), 545: una simpatica tempera del porto, del 1836, riprodotta da Antonio Muñoz, *Roma cent'anni fa* (Roma, 1939), tav. 28: e con la "Veduta generale della città e porto di Civitavecchia," soprattutto l' "Antemurale del porto di Civitavecchia" riprodotti da Annavozzi 1853, tavola a fronte di 462 e tavola finale. Interessante anche, per la figurazione delle fortificazioni interne al porto, un quadro circa del 1930, pubblicato da Rinaldo Santini, "1867: anno triste per Roma e per l'Italia," *Strenna dei Romanisti* 51 (1990), 467. Ricordo anche che una pianta marmorea del porto fu murata alla bocca della darsena nel 1727 da Benedetto XIII, ma è andata perduta nelle vicende dell'ultima guerra e non mi risulta ne esistano riproduzioni.

8. Citate in particolare alla nota precedente.

9. Carlo Fontana, *Pianta antica del porto ed acquedotto di Civitavecchia* (Roma, 1699).

10. Luigi Canina, *Gli Edifizi di Roma antica cogniti per alcune reliquie, descritti e dimostrati nell'antica loro architettura* (Roma, 1856), 6: tavv. 192–193.

11. Bastianelli 1954. Prima di lui ricordo ancora Domenico Annovazzi, "Civitavecchia," NS (1877), 123–124, 264–265; Raniero Mengarelli, "Civitavecchia, Scoperte di antichità nell'area antica di Centumcellae," NS (1909), 79; Salvatore Bastianelli, "Civitavecchia, Rinvenimenti nell'area della città," NS (1940), 183–193; Raniero Mengarelli, "Civitavecchia, Edificio romano del Porto Traianeo di 'Centumcellae' rinvenuto nel cortile del forte detto di Michelangelo," NS (1941), 179–186. Ricordo anche i plastici del porto eseguiti a Roma per la Mostra Augustea della Romanità, nel 1937, oggi conservati nel Museo della Civiltà Romana: uno a semplice pianta (pubblicato da Correnti 1985, 133), l'altro in alzato e particolarmente suggestivo (attualmente molto rovinato e non esposto: pubblicato da Bastianelli 1954, 16; riedito da Carlo De Paolis, "Il porto di Centumcellae: motivi storico-economici della sua costruzione," in *Il Lazio nell'antichità romana* [*Lunario Romano* 12] [Roma, 1982], tav. 30a: da Correnti 1985, 136).

12. Romanelli 1961; Renato Bartoccini, "L'antico porto romano di Centumcellae," *Civitavecchia* 1961, 13–18; Mario Torelli, "Civitavecchia," in *Enciclopedia dell'arte antica, classica e orientale*, Supplemento 1970 (Roma, 1973), 233–235; De Paolis 1982, 137–154; Reddé 1986, 197–201.

13. Correnti 1985.

14. Una menzione di questi lavori, rimasti inediti, è in *Repertorio degli scavi e delle scoperte archeologiche nell'Etruria meridionale (1939–1965)* (Roma, 1969), 36–37, e (1966–1970) (Roma, 1972), 42–43.

15. Bastianelli 1954, 43 e tav. 8a.

16. La proposta è stata avanzata da Torelli 1973, 234, e sostenuta da Correnti 1985, 123: nel caso sarebbe suggestivo pensare qui allo xenodochio, l'ospedale, cioè, annesso alla grande chiesa, dove si ricoveravano i pellegrini ammalati o i poveri, e che conosciamo esistente nel tardo impero in tutte le maggiori città (si veda ad esempio Giuseppe Lugli e Goffredo Filibeck, *Il porto di Roma imperiale e l'agro portuense* [Roma, 1935], 106–110; Marco Bonocore, *Le iscrizioni latine e greche* (Città del Vaticano, 1990), 2:29. Nell'ambito degli studi su Civitavecchia paleocristiana la proposta non ha tuttavia trovato favore, dato che è stata ignorata: Danilo Mazzoleni, "Testimonianze epigrafiche cristiane dal territorio di Centumcellae," in *Il Paleocristiano nella Tuscia, Il Convegno, Viterbo 1983* (Viterbo, 1984), 61–63; Danilo Mazzoleni, *Centumcellae* (*Inscriptiones Christianae Italiae*) (Bari 1985), ix–x. Correnti 1985, 123, ha posto anche il quesito che le rovine di questo edificio non possano riguardare quelle di un arsenale e la proposta mi sembra sia quella più probabile da prendere in considerazione.

17. Come questo bacino potrebbe essere stato utile allo scopo è indiziato dal fatto che Sangallo ne studiò la rimessa in uso, nel Cinquecento, proprio per adibirlo

ad arsenale (Foschi 1975, 150) ed in esso figurano ormeggiate le galere pontificie nel ricordato disegno secentesco del porto, conservato alla Biblioteca Vaticana (fig. 1).

18. Su questa costa ed il promontorio di Santa Marinella si veda Giovanni Maria De Rossi, Pier Giorgio Di Domenico e Lorenzo Quilici, "La via Aurelia da Roma a Civitavecchia," *QITA* 3 (1968), 13–73; Piero Gianfrotta, *Castrum Novum* (Roma, 1972).

19. Sulle condizioni portolane del sito si veda Cialdi 1846 e 1861: *Portolano del Mediterraneo* (Genova, 1930), 1:259–266; Portolano del Mediterraneo (Genova 1947), 1: 261–267; Giulio Schmiedt, *Il livello antico del Mare Tirreno* (Firenze, 1972), 68–89, 256–260; Almagià 1976, 544–549; *Nauticus* 9 (1983), 143; Correnti 1985, 101–102.

20. Bastianelli 1954, 43 e tav. 8b.

21. *Epistularum* VI, XXXI, 15–17 (ed. Loeb Classical Library, 1922).

22. Si veda anche Civitavecchia 1971, tav. 6 (pianta del 1798); Cialdi 1861 (si veda a nota 3); *Portolano* 1930 e 1947.

23. Il primo brano è tratto da Cialdi 1846, 36; il resto da Cialdi 1861, 16.

24. *De reditu suo*, I, 237–244 (si veda John H. Pryor, "The Voyage of Rutilius Namatianus: From Rome to Gaul in 417 CE," *Mediterranean Historical Review* 4 [1989], n. 2, 274).

25. Si veda Civitavecchia 1971, tav. 7, o Correnti 1985, 131, che riportano un bel rilievo dell'antemurale nel 1815, tratto dall'Archivio di Stato di Roma, *Disegni e Mappe*, cartella 19 f. 279; Camillo Manfredini e Antonio Walter Pescara. *Il libro dei fari italiani* (Milano, 1985), 104–106; Curcio e Zampa 1989.

26. Rispettivamente riprodotte da Vitalini Sacconi 1982. 252, e Correnti 1985, 105; da Annavozzi 1853, tav. finale; Vitalini Sacconi 1982, 8.

27. Nel disegno pubblicato da Annavozzi 1853, tav. finale, la torre appare fornita da feritoie da fucileria anzichè di troniere: forse una modifica del momento, che ne aveva allora così fatto ridurre le aperture (per analogia si può rilevare che nella stampa del 1840 pubblicata da Vitalini Sacconi 1982, 8, la vicina torre di Lazzaretto appare rilevata per accogliere una simile disposizione di tiro). Noto anche che in una stampa di Durand-Brager del 1860, pubblicata da Vitalini Sacconi 1982, 12, il coronamento della torre appare posto su un aggetto sostenuto da mensole, cosa che mi pare da interpretare come una libertà artistica, non essendo altrimenti documentata questa soluzione architettonica. Sempre a proposito della torre e soprattutto del suo molo, ricordo il disegno assai chiaro, ricostruttivo per la situazione al XVIII–XIX secolo, pubblicato in Civitavecchia 1971, tav. 8.

28. Si veda nota 4. La terza fotografia aerea qui presentata, fig. 6, rilevamento Società internazionale Aero-fotogrammetria e topografia del 1973, è pubblicata su concessione dell'Aeronautica Militare n.164 del 6.5.1974.

29. Si veda Foschi 1975 e 1982. Ricordo ancora una foto del molo di Lazzaretto, della fine del secolo scorso e della collezione Consoni alla Fondazione Besso, pubblicata da Vitalini Sacconi 1982, 15.

30. Fuori catalogo, negat. 41249.

31. Correnti 1985, 107.

32. De Paolis 1982, tav. XXXIa; Correnti 1985, 130, figg. 188–189; Edoardo Martinori, *Lazio turrito* (Roma, 1932), 1:194 (riedita da Correnti 1985, 130, fig. 188); Bastianelli 1954, tav. 4a. De Paolis, tav. XXIX, pubblica un'altra fotografia della torre del molo di Lazzaretto subito dopo il bombardamento, dal versante del molo, non diversa sostanzialmente dalla situazione attuale; tale foto può essere più utile per l'edificio che le si addossava, che si vede di fianco parzialmente in stato di crollo.

33. Foschi 1975, 145, fig. 11.

34. Alinari, negat. 20270.

35. Bastianelli 1954, 39–40.

36. Nella foto pubblicata da Bastianelli, nella quale la parte superiore della torre si vede di sghimbescio, sembra di riconoscere un paramento in tasselli parallelepipedi di arenaria, disposti orizzontalmente, ma la cosa non è sicura.

37. Dopo i danneggiamenti dell'ultima guerra la torre è stata ripresa in basso con tratti di cortina laterizia, ad integrazione di quella papale (fig. 12), e sul versante sud occidentale, sopra l'imposta della cupola, da un grossolano intervento in traverse di cemento armato. Le murature di sommità sono tutte fessurate longitudinalmente e trasversalmente da crepe paurose, che la lasciano in un equilibrio quantomai precario. La sommità è inaccessibile.

L'interno presenta la copertura voltata con tecniche diverse, che presuppongono due fasi costruttive: dal tamburo aggetta la volta vera e propria, generalmente in scapoli di tufo ben stratificati, che si interrompe in sommità lasciando un grande "occhio" di quasi 11 m di diametro. questo a sua volta è delimitato da un grosso anello di circa 1 m di spessore, il quale si imposta a imbuto trasversalmente al senso della volta, come se si fosse impostato, in origine, su di un gran pilastro cilindrico centrale oggi scomparso; la luce rimanente, in sommità, è chiusa da una volticella ribassata in laterizi concentrici. Il particolare tipo di copertura deve aver corrisposto alla necessità di sostenere, al piano superiore, il rinculo delle artiglierie. Il sottovolta è oggi tutto puntellato da una vecchia centina lignea. Rilievi della torre e del molo, eseguiti negli anni 1965–1968, prima degli interventi "di restauro" accennati, sono pubblicati in Civitavecchia 1971, tav. 17, e da Correnti 1985, 102–103.

Questo straordinario monumento giace così abbandonato da oltre quarant'anni, per la controversia sorta sul criterio di restauro tra la Soprintendenza archeologica ed il Genio Civile per le Opere Marittime, che ne stava conducendo il massiccio ripristino per la riutilizzazione. In questa irresponsabile presa di posizione da parte delle autorità portolane, la torre romana accentua sempre di più, paurosamente, la situazione di pericolo statico. La torre è, oltretutto,

MARIO TORELLI
Università degli Studi di Perugia

Regiae *d'Etruria e del Lazio e immaginario figurato del potere*

Le ricerche di scavo e di tavolino che da oltre vent'anni conduco hanno incrociato più volte la persona e le opere di Frank Brown e il debito mio e di quanti si occupano di antichità romano-italiche è senz'altro assai grande, come spero trasparirà da questa mia nota dedicata alla sua memoria.

Mescolando ricordi e considerazioni scientifiche, comincerò con il rievocare il mio primo incontro con lui nel 1966, quando la fortuna mi portò a scoprire, nel piccolo santuario costiero di *Menerva* a Punta della Vipera, sito nell'estremo settentrione del territorio cerite, una replica di un tipo di antefissa di stampo ceretano attestato[1] anche da un esemplare dalla *regia* di Roma, reso noto purtroppo solo sommariamente:[2] un primo, fuggevole incontro con Frank Brown e Susan Downey, incaricata di studiare l'antefissa di Roma, fu seguito poco dopo da una (per me) memorabile visita alla *Regia* con Brown e l'amico Darby Scott e da un interessante scambio di opinioni con lo stesso Brown attorno al tema del *templum augurale*, alla luce delle mie scoperte di quegli stessi giorni a Bantia[3] e di quello riconosciuto da Brown a Cosa,[4] vera e propria pietra miliare per la ricostruzione delle forme religiose dell'arcaismo romano e delle pratiche urbanistiche a queste forme connesse. Entrambe i filoni di interessi, l'architettura e la religione arcaiche, che io, giovane ispettore di Soprintendenza, in quegli anni andavo

coltivando e che avrei continuato a coltivare per lungo tempo a venire, tutt'altro che casualmente venivano ad incrociarsi con quelli di uno studioso, Frank Brown, cui era chiarissimo il nesso tra archeologia, religione e storia.

Da questi interessi fu per me non solo facile, ma strada obbligata muovere verso un altro grande scavo americano in Italia, quello condotto a Murlo dal compianto Kyle M. Phillips (che pure mi piace in questa stessa sede ricordare), scavo nel quale queste stesse tematiche dell'architettura e della religione arcaiche venivano a trovare quasi un luogo geometrico e i fondamenti per una svolta nelle ricerche: invitato da Ranuccio Bianchi Bandinelli a recensire per i *Dialoghi di Archeologia* la grande mostra organizzata a Siena nel 1970[5] per presentare per la prima volta le scoperte di quel luogo che a buon diritto reca il nome popolare di "Pian Tesoro," fui stimolato a rileggere lo straordinario complesso monumentale di Poggio Civitate all'interno di un quadro interpretativo nuovo, ben diverso da quello corrente.

Questa rilettura, se non confluì nella recensione promessa ai *Dialoghi*, si concretò tuttavia nel primo riconoscimento di strutture quali quelle di Murlo stessa, della zona F di Acquarossa e della *regia* di Roma come "palazzi" o *anaktora* o, meglio ancora, alla latina, *regiae*, in un intervento su questi edifici al convegno tenuto nel

85

1972 ad Orvieto sul tema "Aspetti e problemi dell'Etruria interna," intervento non a caso consonante con quello presentato nello stesso convegno a proposito di Acquarossa (e limitatamente a questo sito) da Giovanni Colonna.[6]

Dopo questo mio intervento, che per la prima volta proponeva in maniera globale, anche se di necessità sintetica, l'interpretazione di quegli edifici come "palazzi" e non come santuari (contro cioè l'opinione allora diffusa) subito si sono levate voci di entusiastico consenso, come quella di Mauro Cristofani, il quale—anche sulla base dell'esegesi delle figurazioni delle lastre fittili—parla di un recupero di questi edifici ad una dimensione "civile,"[7] o di un prudente riserbo rispetto alla corrente lettura come santuari, quale quella di Friedhelm Prayon, che nel 1975 descrive l'edificio F di Acquarossa come "Hauscomplex," mentre si limita a definire l'edificio di Murlo nei termini vaghi di "Monumentalbau."[8]

A partire da quel momento, però, la certezza sulla funzione abitativa e politico-sacrale di quegli edifici si consolida e a considerare le due *regiae* come santuari collettivi restano, tenacemente affezionate all'idea, solo alcune isolate voci di retroguardia, forse non a caso quelle degli scavatori di Murlo, Kyle Philips, Eric Nielsen,[9] ed Ingrid Edlund,[10] e dell'editrice delle terrecotte architettoniche dell'edificio F di Acquarossa, Margaretha Strandberg Olofsson.[11] Frank Brown, sia pur in forma indiretta, ma con il peso della sua *auctoritas*, contribuisce alla discussione, parlando ancora una volta dell'edificio-chiave della discussione, la *regia* di Roma, e pronunciandosi in maniera netta contro l'assioma "terracotta architettonica = tempio,"[12] già sfatato qualche anno prima da Carl Eric Oestenberg alla luce dell'inequivocabile testimonianza di Acquarossa,[13] ove quasi ogni casa (almeno nella fase più antica, come vedremo) è fornita di terrecotte architettoniche.

Il contributo di Brown è stato in qualche misura ancora una volta determinante, come si è avuto modo di constatare nell'interessante seminario (purtroppo mai pubblicato) tenuto poco più tardi, nell'inverno tra 1975 e 1976, presso l'Accademia Americana sul tema delle terrecotte architettoniche arcaiche, con l'intervento di Charles Williams III, di Kyle Phillips, di Friedhelm Prayon e di chi scrive, incontro dal quale sono però derivati alcuni articoli dei partecipanti direttamente attinenti al nostro problema.[14] Ricordo Frank Brown in quell'occasione alludere scherzosamente alla mia interpretazione come *theôn agorà* (in contrapposizione con quella di Mauro Cristofani come "gruppo familiare") delle lastre di Murlo (e di Velletri) con personaggi seduti e muniti di lituo e altri attributi. La sua allusione si concretò in maniera silenziosa con una sorta di rinvio al celebre gesto di Platone nella raffaellesca "Scuola di Atene." Proprio questo problema di una corretta interpretazione—non modernizzante e al tempo stesso coerente con i significati ragionevolmente attribuibili alle iconografie—della funzione non meramente "civile," ma—in modo volutamente ambiguo—sacra e politica, collettiva e familiare di quegli *anaktora*, diventava pochi anni più tardi, nel 1980, soggetto della mia relazione al convegno dell'Ecole Française de Rome *Architecture et société*.[15] Nel 1985, la mostra di Siena dell'"Anno degli Etruschi" sul tema "Case e Palazzi"[16] sanciva i termini reali della discussione[17] e riservava alla *regia* di Roma il ruolo di rilievo che le scoperte di Brown meritano.[18]

Partendo proprio da queste scoperte e dalla discussione finora riassunta in un vario intreccio con i ricordi personali dello studioso che qui stiamo onorando, cercherò di sviluppare proprio questa tematica degli *anaktora-regiae*, verificandone estensione e portata in Etruria e nel Lazio, con particolare riguardo alla decorazione figurata, come possibile spia delle funzioni dell'edificio da loro decorato e dell'ideologia della committenza.

Come già osservava Giovanni Colonna nel corso della dicussione rimasta purtroppo inedita del convegno "Architecture et société" a proposito del frammento di acroterio dalla *regia* di Roma con piede di statua maschile, tale frammento non solo offre una stretta analogia con le sculture acroteriali di Murlo, ma assieme a queste può essere messa in rapporto con la descrizione che Virgilio fa della *regia* di Picus

e di Latinus a Laurentum,[19] descrizione che conviene qui riportare per intero, tanto appare rilevante per il nostro problema:

Tectum augustum, ingens, centum sublime
 columnis
urbe fuit summa, Laurentis regia Pici,
horrendum silvis et religione parentum.
Hic sceptra accipere et primos attollere fascis
regibus omen erat; hoc illis curia templum,
haec sacris sedes epulis; hic ariete caeso
perpetuis soliti patres considere mensis.
Quin etiam veterum effigies ex ordine avorum
antiqua e cedro, Italusque paterque Sabinus
vitisator curvam servans sub imagine falcem
Saturnusque senex Ianique bifrontis imago
vestibulo astabant aliique ab origine reges
Martiaque ob patriam pugnando volnera passi.
Multaque praeterea sacris in postibus arma,
captivi pendent currus curvaeque secures
et cristae capitum et portarum ingentia claustra
spiculaque clipeique ereptaque rostra carinis.
Ipse Quirinali lituo parvaque sedebat
succinctus trabea laevaque ancile gerebat
Picus, equom domitor, quem capta cupidine
 coniunx
aurea percussum virga versumque venenis
fecit avem Circe sparsitque coloribus alas.

Il bel testo virgiliano contribuisce in modo soprendente al chiarimento del nostro problema. La *regia* di Picus, nella ricostruzione che la fantasia di Virgilio elabora sulla scorta delle conclusioni della grande antiquaria romana, è un *tectum augustum, ingens, centum sublime columnis*: nella sineddoche sono evidenti sia il rinvio alla nuova e grandiosa *Regia* romana nella ricostruzione di Domizio Calvino (*centum sublime columnis*) che l'enfasi sulla parola e sul concetto di *tectum*, naturalmente *augustum*, come elemento monumentale centrale atto a colpire lo spettatore, qualcosa che è assai evidente proprio nelle *regiae* arcaiche dell'Etruria e del Lazio.

Lo spettacolo procede dal *tectum* alle *effigies ex ordine avorum* che *vestibulo astabant*, per poi muovere dal *vestibulum* alle armi appese *sacris in postibus*: la "lettura" della sequenza logico-visiva *tectum-vestibulum-postes* si conclude ben all'interno della *regia* con la statua seduta dell'eroe capostipite Picus, vestito di corta tunica succinta e munito nella destra del *Quirinalis lituus* e nella sinistra dell'ancile. La teoria delle figure ancestrali viene giuocata ambiguamente fra esterno ed interno: le *effigies*, lignee, non possono che essere dentro la *regia*, nelle *alae*, dove si conservavano tradizionalmente le *imagines maiorum*,[20] ma sono viste dall'esterno, dal *vestibulum (vestibulo astabant)*, né più né meno di quanto avviene con le prede belliche affisse proprio ai *postes* del *vestibulum*.[21]

Non meno chiara è la piccola *pièce* antiquaria di Virgilio sulle funzioni della *regia*, che sono al tempo stesso "politiche," religiose e familiari, come è logico attendersi per la mentalità sottesa a queste strutture (e per il livello di sviluppo socio-economico raggiunto) e come stentano a capire i partigiani sia della lettura esclusivamente "religiosa" che della lettura altrettanto esclusivamente "civile" delle *regiae* etrusche e latine. Non troppo diversamente dall'omerico *anàktoron* di Alcinoo,[22] evidente modello per Virgilio, la *regia* di Picus e di Latino è la sede della investitura dei re, nella *regia* è la *curia* e la *sedes* di *epulae sacrae* con il banchetto sacrificale dei *patres*: come dire quasi la didascalia delle lastre decorative e degli acroteri di Murlo, di Acquarossa o di molte altre *regiae* del Lazio e di Etruria.

Similmente, per questo stesso motivo, contro chi propone una lettura desemantizzata delle figurazioni a rilievo o a tutto tondo delle terrecotte architettoniche della così detta Prima Fase, vale la pena sottolineare che proprio dalle terrecotte architettoniche, dalla loro forma e dalle scene in esse ritratte riusciamo sovente a tracciare un qualche confine—là dove confine esiste—tra le due possibili destinazioni dell'edificio, come *regia* o come *aedes*. Molto spesso le stesse terrecotte sono adoperate per edifici dalle funzioni sicuramente diverse: proprio l'antefissa dalla *regia* di Roma si trova impiegata nel *naiskos* isolato di Punta della Vipera nel territorio cerite, come abbiamo visto, o a Ficana,[23] in un contesto sconosciuto, ma forse "domestico," come lo è l'edificio della stessa Ficana associato ad un'altra terracotta della così detta Prima Fase[24] e come potrebbe essere "domestica" la destinazione delle antefisse dello stesso stampo, trovate a Caere assieme a numerosissime altre terrecotte architettoniche coeve in uno scarico a Vigna Parrocchiale, secondo lo

scavatore pertinenti "a case e a templi."[25]

Ma le antefisse, tranne rarissimi casi (penso qui alle celebri antefisse del tempio A di Pyrgi, tanto discusse), non intendono veicolare contenuti precisi e significati "forti," al pari di quanto accade per fregi o acroteri con raffigurazioni, poniamo, di animali reali o fantastici, ai quali lo spettatore antico difficilmente avrà attribuito messaggi più complessi di un generico valore apotropaico.[26] Altra cosa sono invece i fregi fittili ove compaiono scene figurate con personaggi in qualche modo identificabili e con evidenti intenti narrativi, che rappresentano invece una guida di norma abbastanza solida per identificare l'edificio di pertinenza, soprattutto quando i fregi appaiono composti da più tipi derivanti da un unico 'progetto' e da un unico atelier e quindi tendenti a costituire un 'ciclo' o 'programma' di decorazione: la *regia* di Murlo è al riguardo emblematica, dal momento che il 'ciclo' unitario di quattro tipi di lastre, una volta messo in opera, avrebbe potuto celare un nesso tra scene figurate sulle lastre ed uso delle parti della *regia* da quelle lastre decorate, lastre che comunque contribuiscono a definire una scansione assai precisa dei grandi momenti cerimoniali della vita collettiva svolta all'interno dell'edificio, il banchetto, le nozze, i giuochi, e una significativa più forte sottolineatura in chiave religiosa nella rappresentazione del potere, legittimato negli dei-antenati delle lastre della *theôn agorà*, e delle venti e più statue acroteriali poste sul tetto.[27]

Tutti questi temi riemergono in molti dei complessi di così detta Prima Fase: anzi, nel corso del terzo venticinquennio del VI secolo a.C., alcuni temi del 'racconto' cerimoniale scompaiono o si precisano, come nell'edificio della zona F di Acquarossa, dove in luogo di *ludi* e *nuptiae* compare un *komos*, conclusione necessaria della scena contigua con il banchetto-simposio e dove agli dei-antenati si sostituisce l'incarnazione mitica della nuova mobilità sociale, l'eroe Eracle (fig. 1). Vale allora la pena di esaminare le quasi coeve lastre del così detto tempio di Santa Maria della Neve di Velletri,[28] che si pone come il modello più compiuto di 'programma' figurativo di un edificio deco-

rato in questo momento seriore della così detta Prima Fase, con stringente analogia con quanto Murlo rappresenta per il momento più antico della stessa tradizione decorativa (figg. 2, 3). A Velletri abbiamo, come a Murlo, dei *ludi*, in questo caso una corsa di una triga e di due bighe: la scelta appare, come vedremo, gravida di significati, se si mette questo dato in rapporto

1a. Lastra di rivestimento con scena di processione ed Eracle con il toro di Creta, Acquarossa, 550–540 a.C., terracotta
Fotografia: Istituto Svedese di Studi Classici, Roma

1b. Lastra di rivestimento con scena di processione ed Eracle con il leone di Nemea, Acquarossa, 550–540 a.C., terracotta
Fotografia: Istituto Svedese di Studi Classici, Roma

1c. Lastra di rivestimento con scena di convivio, Acquarossa, 550–540 a.C., terracotta
Fotografia: Istituto Svedese di Studi Classici, Roma

1d. Lastra di rivestimento con scena di *komos*, Acquarossa, 550–540 a.C., terracotta
Fotografia: Istituto Svedese di Studi Classici, Roma

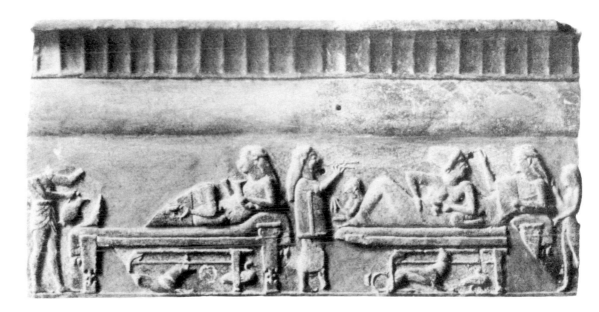

2a. Lastra di rivestimento con scena di giuochi, Velletri, 530–520 a.C., terracotta
Fotografia: Museo Nazionale, Napoli

2b. Lastra di rivestimento con scena di convivio, Velletri, 530–520 a.C., terracotta
Fotografia: Museo Nazionale, Napoli

2c. Lastra di rivestimento con scena di assemblea divina, Velletri, 530–520 a.C., terracotta
Fotografia: Museo Nazionale, Napoli

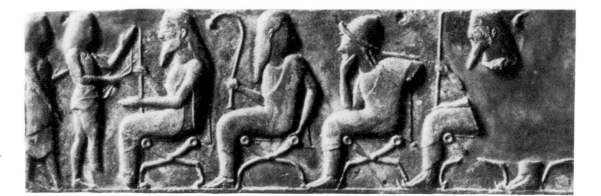

3a. Lastra di rivestimento con scena di cavalieri al galoppo, Velletri, 530–520 a.C., terracotta
Fotografia: Museo Nazionale, Napoli

3b. Lastra di rivestimento con scena di processione destrorsa, Velletri, 530–520 a.C., terracotta
Fotografia: Museo Nazionale, Napoli

3c. Lastra di rivestimento con scena di processione sinistrorsa, Velletri, 530–520 a.C., terracotta
Fotografia: Museo Nazionale, Napoli

con quanto sappiamo del *Trigarium* di Roma e del carattere dei giuochi in esso celebrati;[29] a Velletri, sempre come a Murlo, troviamo un simposio promiscuo con donne e uomini[30] ed una *theön agorà*,[31] resa celebre dalle pagine di Santo Mazzarino.[32]

Ma accanto a queste tematiche note e comuni ai due 'cicli,' se ne aggiungono due che vale la pena discutere. La prima, molto esplicita, è di indubbio significato militare, dal momento che esibisce una teoria di opliti montati al galoppo, accom-

pagnata da una teoria parallela, ma in secondo piano, di cavalieri disarmati;[33] più volte ho richiamato per questa iconografia il lemma di Festo *paribus equis* e il peso politico-militare assunto nel corso del VI secolo a.C. dalla cavalleria.[34]

La seconda scena, al contrario delle altre, è stata assai poco discussa: si tratta di una teoria di carri preceduta da un araldo con caduceo e lungo bastone e composta da una triga e da una biga, quest'ultima con cavalli alati. La teoria, con un andamento da sinistra a destra, reca sui carri, oltre agli aurighi, due uomini,[35] mentre quella con andamento opposto presenta sulla triga un personaggio identificato da Andrén come un uomo, ma in realtà da identificare come donna in ragione della lunga veste (i due uomini della lastra contrapposta presentano due corti chitoni e uno anche un mantello), e sulla biga una donna, alle cui spalle un uomo, appiedato e vestito di corto chitone, è colto in atto di salutare e al tempo stesso di sospingere la donna in partenza, con un gesto che è molto simile a quello dell'Atena nelle lastre di Velletri con *theôn agorà*, ma che stranamente lo stesso Andrén interpreta come atto destinato a trattenere la donna.[36] Completano le due teorie due figure maschili di accompagno in secondo piano rispetto ai cavalli della triga, l'una colta in atto di salutare (?), l'altra armata—sembra—di una lancia.

Questa iconografia appare inscindibile dalla coeva processione sinistrorsa raffigurata nelle lastre del rampante destro della sima frontonale appartenente alla seconda fase decorativa del tempio di Sant'Omobono,[37] che così si presenta: appiedato con lunga asta terminata da pomo; triga, dietro i cui cavalli è un appiedato munito di lancia, con carro trasportante auriga e donna vestita di lungo chitone e *tutulus*; biga trainata da cavalli alati con auriga e donna simile alla precedente, ma in atto di posare la mano sulla spalla dell'auriga; figura maschile stante, dall'iconografia identica a quella in egual posizione nella lastra di Velletri (fig. 4). Le differenze sono minime: la figura di testa di Sant'Omobono, ad esempio, è equipollente all'"araldo" di Velletri, ma è privo di caduceo, sostituito da un bastone terminato da un grosso

pomo e compare all'inizio della processione sinistrorsa, laddove a Velletri è all'inizio di quella destrorsa.

Pochi resti infine del tipo di lastra dell'altro spiovente, quello sinistro, del frontone,[38] ma sufficienti per farci concludere che anche qui era una processione destrorsa di un triga con traino di cavalli senza ali e di una biga dai cavalli alati, il cui occupante, oltre all'auriga, è un uomo. Le due processioni di Roma–Sant'Omobono sono dunque identiche nella sostanza alle due di Velletri.

Le implicazioni di questa sostanziale identità sono molte e di grande portata. Innanzi tutto, ad un'attenta lettura si conferma quanto già detto, contro l'avviso di Andrén, a proposito degli occupanti dei carri nella lastra con processione sinistrorsa di Velletri, due donne a mio avviso, un uomo e una donna secondo l'autorevole studioso svedese. Il personaggio che conclude la teoria di Roma–Sant'Omobono–lastra di destra e Velletri–lastra di destra, è assolutamente identico nell'iconografia, nei due significativi gesti di saluto e di "accompagno," e dunque riveste le medesime funzioni in ambedue le processioni; identici sono attributi e posizione del personaggio in secondo piano dietro i cavalli della triga nelle processioni di Roma–Sant'Omobono e Velletri–lastra di destra e così anche la successione triga–biga con traino terreno e traino alato, come avremo modo di riscontrare più avanti. Siamo dunque in presenza di un insieme di segni comuni che creano per le due scene una sorta di "gabbia semantica" identica.

Ma qual'è il significato di questa comune "gabbia (iconografico-) semantica"? A livello strutturale elementare l'idea-guida è quella del "viaggio–trasporto con scorta." A ben vedere, questo è anche il significato di base della lastra di Murlo con corteggio matrimoniale, ove gli elementi fondamentali della struttura rappresentativa e narrativa sono assolutamente gli stessi (un carro recante una o due donne, preceduto da un "araldo" e da un giovane di scorta) e identico è il messaggio elementare della figurazione, quello appunto di un "viaggio–trasporto con scorta" (fig. 5).

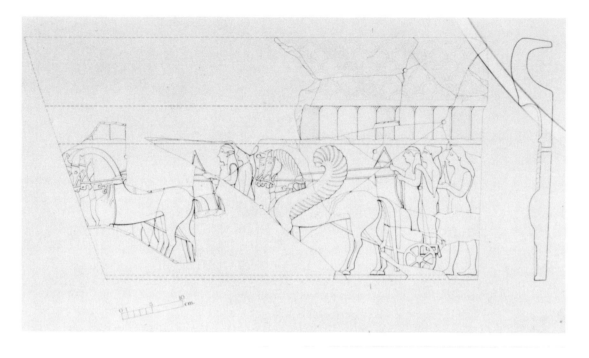

4a. Disegno ricostruttivo
di sima frontonale (?) con
scena di processione
sinistrorsa, Roma, santuario
di Sant'Omobono,
530–520 a.C., terracotta
Disegni dei Musei Capitolini,
Roma, da Anna Sommella Mura,
"La decorazione architettonica del
tempio arcaico, in *La Parola del
Passato* 22, 1977

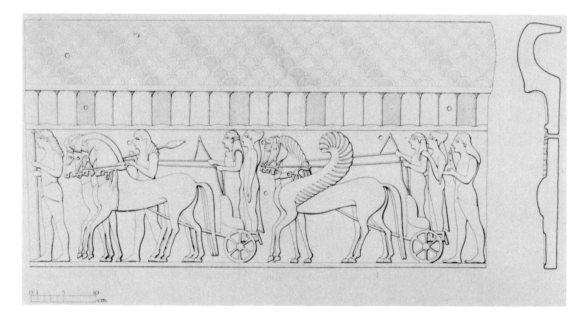

4b. Disegno ricostruttivo
di sima frontonale (?) con
scena di processione identica
alla precedente, Roma,
santuario di Sant'Omobono,
530–520 a.C., terracotta
Disegni dei Musei Capitolini,
Roma, da Anna Sommella Mura,
"La decorazione architettonica del
tempio arcaico, in *La Parola del
Passato* 22, 1977

Nella lastra di Murlo tuttavia, gli elementi accessori della narrazione hanno una forte funzione connotante e concorrono in maniera del tutto inequivoca ad indicare che quel "viaggio–trasporto" non è che la *pompé* matrimoniale (tutte le altre interpretazioni, come "scena teatrale," ad esempio, o come anticipazione di eventi successivamente mostrati nelle lastre, non hanno fondamento alcuno sul piano dei nessi tra iconografie consolidate e significati ad esse attribuiti nel mondo antico): non solo la *klinìs*, il caratteristico carro a due ruote, e la *nymphikè kathédra*, il seggio su quel carro poggiato, sono appannaggio esclusivo del trasporto matrimoniale, ma anche altri segnali contribuiscono a rendere assolutamente certo il contenuto nuziale del trasporto, l'araldo con "bastone" e la seconda scorta—verosimilmente il *pàis amphithalés*—con le redini del carro, le ancelle con il corredo della sposa.[39]

L'iconografia della lastra di Murlo è autenticamente greca in tutti i suoi particolari, anche minimi, mentre quella di Velletri e di Roma–Sant'Omobono introduce variazioni, che non solo "italicizzano" le forme del rituale, ma, raddoppiando i carri, facendo alati i cavalli della biga e aggiungendo il trasporto di uomini nella lastra opposta, consentono letture ulteriori, connotanti in maniera particolare, come si vedrà più avanti, il rituale del trasporto matrimoniale. Ma, aldilà dell' "aggiornamento" dell'iconografia, la sostanza della rappresentazione nelle tre serie di lastre, Velletri, Roma–Sant' Omobono e Murlo è del tutto identica, un trasporto di donna (o meglio, di donne) guidato da un araldo—evidente 'segnale' delle future pattuizioni—che può essere soltanto una pompa nuziale.

A questo punto la simmetria dei temi "narrativi" tra le lastre di Murlo e di Velletri (eccezione fatta per la processione militare) è completa, come si può desumere

5a. Disegno ricostruttivo di lastra di rivestimento con scena di convivio, Murlo, 570–560 a.C., terracotta
Disegni di Margaret George, da "Poggio Civitate," *Archaeology* 21:4, 1968

5b. Disegno ricostruttivo di lastra di rivestimento con scena di processione nuziale, Murlo, 570–560 a.C., terracotta
Disegni di Margaret George, da "Poggio Civitate," *Archaeology* 21:4, 1968

da questo prospetto:

Murlo	**Velletri**
1. Cavalieri in corsa e lebete-premio	Corsa di una triga e di due bighe
2. Due coppie, una maschile e una mista, su *klinai*	Due coppie miste su *klinai*
3. Coppia supera e triade infera sedute	Quintetto di dei sedute e due personaggi stanti
4. Due donne su *klinis*, scorta e seguito con corredo	Teoria di triga e biga con uomini, donne e scorta

Confrontando i significati avremo:

1. *Ludi*

2. *Convivium*

3. *Concilium deorum* (vedremo essere piuttosto *Consecratio*)

4. *Nuptiae*

Fermiamoci a questo punto a considerare brevemente le differenze iconografiche tra la serie di Murlo e quelle di Velletri (e Roma–Sant'Omobono).

Per la scena dei *ludi*,[40] la differenza più

vistosa è senz'altro quella del tipo di agone, corsa di cavalli a Murlo, di carri a Velletri. La differenza, alla luce di quanto sappiamo dei *ludi* etruschi raffigurati sui coevi monumenti tardo-arcaici,[41] non sembra particolarmente significativa. Tuttavia, la presenza della triga è abbastanza interessante per poter leggere il senso di questi giuochi, dal momento che il *Trigarium* di Roma, come ha dimostrato Filippo Coarelli, è legato con il vicino *Tarentum*, con i *ludi Taurei*, gli *Equirria* e l'*Equus October*, ossia con riti di carattere infero e funerario, così come funeraria è la cerimonia omerica dell'uccisione del cavallo *pareoros*.[42]

Ciò rende possibile, se non probabile, la connotazione funeraria dei giuochi, così come funeraria potrebbe essere la *decursio* dei cavalieri dei *ludi* di Murlo, forse vicina o identica al *lusus Troiae*.[43] La cosa renderebbe ragione della presenza simultanea della triga (una) e delle bighe (due) sulle lastre di Velletri, spiegazione preferibile a quella della eventuale convenzione "riassuntiva" della rappresentazione, che farebbe apparire simultanea una corsa svolta in tempi diversi. Vedremo come la connotazione funeraria si attagli meglio al significato complessivo delle lastre come sistema rappresentativo di valori aristocratici di epoca arcaica.

Per la scena del *convivium* è possibile ripetere quanto già constatato per la scena delle *nuptiae*.[44] L'iconografia del simposio di Murlo è assai più coerentemente "greca" di quella, peraltro anch'essa improntata alla tradizione greco-orientale, delle lastre di Velletri, per la presenza del citaredo fra i recumbenti (l'altra è una coppia mista, essendo la donna caratterizzata dall'attributo dello stelo con frutti, come nel *concilium deorum*), laddove il simposio di Velletri presenta donne sdraiate su ambedue le *klinai* ed un auleta stante.

Quanto al *concilium deorum*,[45] le differenze sono più marcate ancora: quello di Murlo, un quintetto di dei (in numero forse solo casualmente pari a quello degli dei della lastra di Velletri), risponde ad una concezione "totalizzante,"[46] cosmica, delle presenze divine, la coppia urania (dio barbato su *diphros* con lituo e attendente munito di armi; dea su trono nel gesto dell'*anakalypsis* con attendente munita di *mundus muliebris*) e la triade infera (dio con *labrys* fra dea con stelo fiorito e dea con stelo munito di frutti, tutti su *diphros*; attendente recante bastone forcuto) compresenti a significare la totalità del cosmo, secondo una visione molto raffinata ed astratta; il *concilium deorum* di Velletri appare di assai più difficile lettura, composto com'è da "Zeus" (dio barbato con alto scettro), "Apollo" (dio giovanile con l'attributo mantico del lituo), "Hermes" (dio giovanile con petaso) e altre due (difficilmente tre, come vuole Andrén) divinità giovanili (?) maschili (?), ancor meno connotate per attributi e gesti (scettro la prima e gesto di saluto la seconda), ma è raffigurato in un ben preciso momento mitico-narrativo, quello—come ha visto già da tempo Aakerström[47]—dell'ingresso nell'Olimpo di Eracle, impersonato dalla figura stante vestita di corto chitone e armata di arco e freccia, con i buoni uffici di Atena, che dietro di lui—con gesto identico a quello dell'ultimo personaggio delle lastre di Roma–Sant'Omobono e Velletri con processione nuziale sinistrorsa—lo sospinge, mentre il consesso divino fa mostra di accoglierlo, come prova il gesto dell'ultima divinità.

Congruenze e modificazioni tra le due serie di lastre sono estremamente significative. Le congruenze sono tali da garantirci l'identità dei significati; al tempo stesso, le modificazioni, mentre aiutano a chiarire con l'una lastra quanto nell'altra e simmetrica era poco perspicuo, illustrano le profonde trasformazioni intervenute nell'ideologia e nelle mentalità fra prima e seconda metà del VI secolo a.C. Così l'inserzione dell'apoteosi di Eracle nella lastra di Velletri ci chiarisce che i *concilia deorum* di Murlo e di Velletri non sono semplici presenze numinose, ma sono funzionali a ribadire il destino divino (in vita e *post mortem*) della classe dominante nel contesto pregnante dei riti gentilizi praticati nelle *regiae*, come avevo a suo tempo supposto; al contrario, l'unica processione incontestabilmente nuziale di Murlo contribuisce a dimostrare in maniera altrettanto incontestabile il carattere matrimoniale della duplice processione di Velletri e Roma–Sant'Omobono, peraltro intuibile per la presenza di personaggi femminili, dell'araldo e delle scorte.

Sul piano delle trasformazioni, la cosa più evidente e significativa è la perdita di alcuni tratti "greci" dell'iconografia a vantaggio di altri di origine "nazionale" connessi con l'elevato statuto femminile in Etruria e Roma arcaiche nelle circostanze dei banchetti e delle pompe nuziali, d'altro canto nelle lastre più recenti vediamo inserirsi elementi "greci" nuovi, sia pur in una cornice locale più definita (corse di trighe e bighe; mito di Eracle all'Olimpo; divinità iconograficamente più greccizzanti); ma l'equipollenza dei significati resta. In particolare, acquista ancor più valore l'equipollenza—con tutto il significato che rivestono i mutamenti dei simboli in senso "tirannico"—a suo tempo da me notata tra il *concilium deorum* di Murlo e le due lastre di Acquarossa con le fatiche di Eracle: l'interpretazione della lastra di Velletri con *concilium deorum* come ingresso di Eracle all'Olimpo viene a costituire un *trait-d'union* (in senso non strettamente cronologico, ma puramente ideale) tra Murlo e Acquarossa, contribuendo a spiegare il passaggio dai *concilia deorum* senza interlocutori eroici o umani di Murlo a quelli con l'Eracle di Velletri e di qui agli *athla* di Eracle puri e semplici di Acquarossa.[48]

Il fatto poi che questi ultimi siano inseriti entro un corteo di opliti, ci aiuta a capire il significato delle lastre con teorie di armati su carri o a cavallo, tema non a caso assente a Murlo, ma presente in lastre separate a Velletri e ripetuto nella stragrande maggioranza degli altri fregi di così detta Prima Fase: la *virtus* guerriera (lastre con teorie di carri, opliti e/o cavalieri) è lo strumento che garantisce l'apoteosi (lastre con *concilium deorum*, che meglio chiameremo perciò con *consecratio*), *virtus* ideologicamente equipollente all'*areté* e agli *athla* dell'eroe greco, presenti in effige (Acquarossa) o in forma allusiva o simbolica (l'arco e la freccia di Eracle nella lastra di Velletri). Usando ancora un altro linguaggio a conferma di quanto altrove già detto, si può concludere che dominio e divinizzazione dei *reges* di Murlo sono per diritto divino, garantito già dalla sola lunga genealogia dei *reges* troneggianti sul tetto, come garantito è il *regnum* di Latino dalle statue lignee degli avi nella sua *regia* laurentina, mentre il dominio dei *reges* e dei *principes* di Velletri o di Acquarossa si poggia sulla *virtus* e sugli *athla*, incarnati dalla potenza guerriera o dalle gesta eroiche degne di Eracle. Pur nel permanere dei valori della ritualità tradizionale (*convivium, ludi, nuptiae, consecratio*), possiamo dire che i *reges* di Murlo conquistano il cielo fin dalla nascita, laddove quelli di Velletri e Acquarossa, nel periodo dell'intensa mobilità sociale "serviana," possono aspirarvi solo mostrando di meritarlo come Eracle.

Alla luce di queste considerazioni e proseguendo nella ricerca attorno al nostro tema principale, torniamo ora alle lastre di Roma–Sant'Omobono. Se integriamo infatti le lacune della processione dell'una serie con i dati dell'altra e completiamo i dati sul sesso dell'occupante della prima triga della processione destrorsa di Sant'Omobono e della prima triga della processione sinistrorsa di Velletri sull'evidenza del corrispondente dell'altra serie, possiamo concludere che le due processioni di Velletri e dei rampanti di Roma–Sant'Omobono dovevano presentare come protagonisti due uomini nella processione destrorsa e due donne nella processione sinistrorsa.

Che genere di *nuptiae* a Velletri e a Roma–Sant'Omobono? A prima vista la duplicità delle coppie e dei carri può essere interpretata come un'iterazione puramente decorativa, atta a far risaltare il carattere di teoria ripetitiva, di processione, della rappresentazione. Tuttavia, la duplicità dei protagonisti appare tutt'altro che casuale, come ci confermano le differenze esistenti tra le "scorte," fra i carri (una triga prima e una biga poi) e fra i cavalli (senz'ali prima e alati poi), differenze che si ripetono sui due tipi di lastre, e la presenza, nella processione dei carri con donne, del personaggio che alla fine della processione medesima fa lo stesso gesto di saluto e di "accompagno," compiuto da Atena alla volta di Eracle nella lastra della *consecratio* di Velletri, con l'evidente significato di sollecitazione o di particolare favore.

D'altro canto, le differenze di dettagli di una stessa iconografia all'interno di una medesima lastra sono significanti e non meri espedienti a fini di retorica *variatio*: così nella scena di simposio di Murlo le diversità tra gli occupanti della prima e della seconda *kline* certamente attingono la sfera del significato, come si può affermare a proposito delle differenze tra gli occupanti della triga e della biga nelle lastre di Cisterna con processione di armati.

Che il primo tiro dunque sia composto da cavalli mortali—la triga—e il secondo da cavalli alati e perciò divini—la biga—è argomento che ci obbliga a riflettere e infine a concludere che l'antica *pompa nuptialis* della lastra di Murlo, in apparenza tutta terrena e composta da un unico carro, è qui divenuta una duplice processione, maschile e femminile, terrena l'una e celeste l'altra, diretta verso la celebrazione di un doppio matrimonio, l'uno in cielo e l'altro in terra. Non possiamo fare a meno di ricollegare questo dato con la tradizione che collocava nel santuario di Sant'Omobono il luogo della mitica ierogamia di Servio Tullio con la dea Fortuna, tradizione di recente analizzata con nuove prospettive da Filippo Coarelli, cui rinvio per tutti i dettagli della discussione.[49]

Ma per comprendere in maniera compiuta tutta la questione, occorre ricordare che negli scavi dello stesso santuario, oltre alle lastre della sima frontonale, sono venuti alla luce frammenti delle la-

blema che stiamo discutendo. E infatti, sempre Filippo Coarelli[55] ha mostrato quale fosse il significato complessivo, politico, religioso e topografico, del santuario di Sant'Omobono per la celebrazione del *reditus* militare ritualizzato, ossia del *triumphus*, così come la *porta triumphalis* lì eretta, attraverso il mito normativo della partenza dei Fabii per l'infausta spedizione contro Veio, ricordava a tutti con il suo *ianus duplex* il *mos* per la "giusta" *profectio* militare. La decorazione fittile di così detta Prima Fase del tempio di Sant'Omobono veniva così a celebrare ambedue i riti all'origine di quella fondazione templare, la ierogamia con la processione effigiata sui rampanti e la celebrazione simmetrica di *profectio* e *triumphus* con i fregi delle lastre poste sull'architrave.

Una volta di più, in questa prospettiva, assume un particolare rilievo la presenza di cavalli alati, questa volta solo nella triga della processione destrorsa e non nell'una e nell'altra biga delle lastre con processione matrimoniale. Come la stessa tradizione antica più volte registra, il trionfatore, con la sua *toga purpurea*, la sua *corona aurea*, il suo *sceptrum* e soprattutto con il volto dipinto di minio impersonava nella processione il ruolo di Iuppiter, con un'assimilazione completa tra *triumphator* e *pater deorum*.[56] Il senso della triga con cavalli alati *in una sola delle due processioni* è appunto quello di spiegare, con l'aiuto di quello specifico simbolo, il rango divino del trionfatore e solo di costui, laddove la stessa persona nell'opposta processione (che dunque dobbiamo chiamare *profectio*), non avendo ancora compiuto le *res gestae* capaci di meritargli l'apoteosi, non è fornita di attributi "divini."

Del pari, il fatto che solo alle spalle della triga con cavalli alati compaia la figura del portatore armato di lituo, serve a farci comprendere che costui, in quanto armato, non è augure, ma è soltanto il portatore dello strumento augurale, appannaggio del personaggio precedente, il quale a sua volta risulta in questo modo definito come unico detentore di *auspicia* e *augur* lui stesso, così come munito di lituo è lo "Zeus" della lastra del *concilium deorum*

di Murlo ed *augur* di se stesso è ovviamente Romolo.[57]

Ma le lastre di Cisterna e di Roma–Sant' Omobono ci insegnano altre cose ancora. Il *triumphator*—altro dettaglio assai significativo—della lastra sembra infatti accompagnato (così certamente nella lastra di Palestrina, identica sul piano iconografico alla nostra di Cisterna) da una donna che funge da auriga della triga celeste (fig. 7). Questa figura di divina conduttrice di carro è per noi inseparabile dall'immagine, posta a fare da tragica conclusione della saga serviana, di Tullia alla guida del carro, e dall'*aition* della *porta scelerata*, ricordo dell'antica dea del santuario scaduta a protagonista umana—come ancora una volta ha ribadito lo stesso Coarelli—della vicenda mitistorica ruotante attorno al santuario stesso.

Quanto alla processione opposta sinistrorsa, le varianti che vi compaiono non sono affatto casuali, dall'assenza di cavalli alati e dell'auriga femminile della triga all'abito non militare (e dunque fortemente cerimoniale) del personaggio della biga, fino all'apparente mancanza del portatore di lituo, tutti dettagli che ben si inseriscono nella lettura della processione come *profectio*.

Le lastre con scene consimili da altro stampo e da altre località concorrono a confermare la ricostruzione ora proposta. Come abbiamo già visto, la rappresentazione più simile (ma con andamento opposto) a quella della processione destrorsa di Cisterna proviene dalla necropoli della Colombella di Palestrina.[58] L'edificio di pertinenza va localizzato presso la chiesa di San Rocco, dove, poco tempo dopo la scoperta della lastra della Colombella (area peraltro assai vicina a San Rocco) è stato scoperto un grosso frammento, ma con processione destrorsa, dello stesso tipo di lastra.[59] Pubblicando appena l'anno scorso uno studio sulla "topografia sacra" di Preneste, avevo supposto[60] che proprio al termine della strada di San Rocco, e cioè nell'area di trovamento delle due lastre, doveva sorgere una *porta triumphalis* della città di Preneste, e ciò sulla base del luogo di trovamento di un rilievo con scena di *reditus* trionfale dell'imperatore Traiano, pubblicato poco

7. Sima frontonale con scena di processione, Palestrina, 510–500 a.C., terracotta
Fotografia: Museo di Villa Giulia, Roma

prima da Luisa Musso;[61] l'ipotesi, occorre dire, prescindeva del tutto dalla presenza nello stesso contesto di queste lastre architettoniche arcaiche, che non avevo ancora studiato in questa prospettiva. Questo dato rafforza enormemente tanto la proposta di identificazione della *porta triumphalis* prenestina, grazie alla possibile vicinanza di un santuario legittimante l'apoteosi di *reges* e di *principes* di una città ove Fortuna ha messo antiche e potenti radici, quanto l'interpretazione del fregio come *triumphus*.

L'altro confronto molto stretto—pur nella forte diversità dello stile—è con la serie di Tuscania, rinverdita di recente dalla scoperta di molti frammenti scaricati sopra il riempimento di tombe arcaiche a tumulo datate fra la fine del VII e la fine del VI secolo a.C. (figg. 8, 9)[62] (forse lo stesso luogo dove nel secolo scorso sono state trovate le terrecotte di Parigi e di Monaco).[63] Oltre a due fregi con cavalieri armati e ai quattro tipi di Acquarossa, sono venute in luce lastre con due processioni di armati, una destrorsa ed un'altra sinistrorsa, dello stesso stampo di quelle scoperte in passato, contribuendo così a chiarire molte delle lacune dell'iconografia complessiva del fregio.

La processione destrorsa (tipo C Ricciardi) reca, nell'ordine, un *parabates*, un auriga, due opliti e un portatore di lituo (un

augur, dunque), mentre nella sequenza sinistrorsa (tipo D Ricciardi) troviamo, sempre nell'ordine, un *parabates*, un auriga e tre opliti, senza però il portatore di lituo, che viene invece recato sulle spalle dell'oplita più vicino al carro.

Ciò sembra voler significare che quest'ultima processione è quella del *triumphus*, da confrontare per questo dettaglio del lituo (il *rex*-Iuppiter è *augur* di se stesso) con la processione pure destrorsa di Cisterna. Si noti che in questa serie tuscaniese, più antica di Cisterna e di Palestrina (che rappresenta peraltro l'estremo cronologico della serie della fine del VI secolo a.C.), la biga è unica e non vi sono cavalli alati.

La serie tuscaniese è particolarmente importante perchè consente di raccordare gli esemplari di seconda metà del VI secolo a.C. con altre più antiche o coeve a quelle di Tuscania, dove troviamo in forme estremamente essenziali lo stesso concetto o "racconto," che nel corso del tardo arcaismo si andrà via via sviluppando mercè l'aggiunta di particolari e di simboli capaci di meglio precisare o specificare quanto già espresso molti decenni prima in forma appunto essenziale. Tra gli esempi maggiormente famosi di questa serie più antica, possiamo senz'altro annoverare le lastre di Piazza d'Armi di Veio con processione sinistrorsa e destrorsa di oplita, *parabates*, oplita e cavaliere[64] e le lastre ceretane con solo *parabates* (fig. 10).[65] E' evidente che l'idea-guida di questa iconografia, che, con pochissime varianti da sola occupa—come risulta dal tabulato pubblicato in appendice—quasi due terzi dei fregi di così detta Prima Fase, è quella della celebrazione della partenza del *princeps–rex* con l'eventuale seguito di armati a piedi o a cavallo.

Gli sviluppi nel senso della più complessa iconografia di Cisterna–Palestrina sono tuttavia comprensibili, non solo con l'intermezzo di Tuscania (ove compaiono simboli fortemente specificanti come il lituo), ma grazie all'ancora una volta cruciale documentazione delle lastre di tipo A e B di Acquarossa, nelle quali la figura di Eracle, referente simbolico mitico, appare come una vera e propria zeppa inserita a separare le due teorie di armati dalla biga

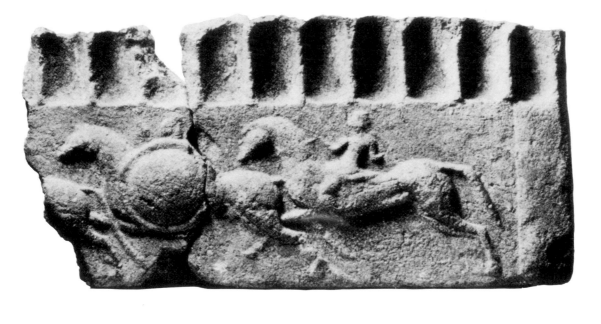

8a. Lastra di rivestimento con scena di cavalieri al galoppo, Tuscania, 540–530 a.C., terracotta
Da Arvid Andrén, Osservazioni sulle terracotte architettoniche etrusco-italiche," in *Opuscula Romana* 8, 1974

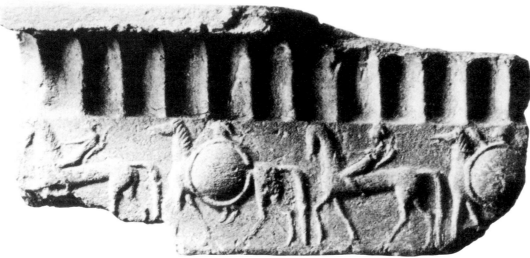

8b. Lastra di rivestimento con scena di cavalieri al galoppo, Tuscania, 540–530 a.C., terracotta
Da Arvid Andrén, Osservazioni sulle terracotte architettoniche etrusco-italiche," in *Opuscula Romana* 8, 1974

con *parabates* (tipo B)[66] o con personaggio inerme stante (tipo A),[67] evidente referente simbolico rituale. In altre parole, nelle lastre di Acquarossa il gruppo di Eracle e il mostro da lui combattuto isolano il carro dalla teoria di armati per segnalare il nesso concettuale strettissimo tra il personaggio sulla biga e l'eroe: è difficile, credo, trovare miglior commento all'idea arcaica di trionfo e la presenza di gruppi scultorei con l'introduzione di Eracle all'Olimpo nel santuario "trionfale" di Sant'Omobono a Roma[68] e di quello, forse anch'esso di carattere "trionfale" (oltre che oracolare, come pure lo fu quello di Sant'Omobono attraverso il culto delle Carmente), di

Portonaccio a Veio (figg. 11, 12).[69]

Nelle lastre di Acquarossa, tuttavia, la raffigurazione di Eracle e, più in generale, la struttura della rappresentazione assumono il carattere di testimonianza dirimente circa i significati delle rappresentazioni delle lastre con teorie di armati e di carri. Nella lastra A con processione destrorsa la testa del corteo è costituita dalla biga con cavalli alati, recante, oltre all'auriga, una figura con lunga veste non cinta, accolta con gesto di saluto, munita di un bastone forcuto, un oggetto simile a quello tenuto dall'ultimo "attendente" nel *concilium deorum* di Murlo e forse funzionalmente simile al caduceo; seguono

8c. Lastra di rivestimento
con scena di processione
destrorsa, Tuscania,
540–530 a.C., terracotta
Da Arvid Andrén, Osservazioni
sulle terracotte architettoniche
etrusco-italiche," in *Opuscula
Romana* 8, 1974

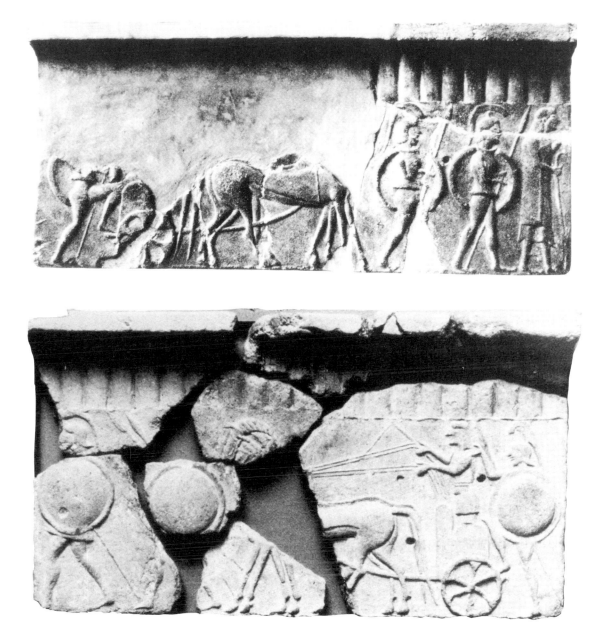

8d. Lastra di rivestimento
con scena di processione
sinistrorsa, Tuscania,
540–530 a.C., terracotta
Da Arvid Andrén, Osservazioni
sulle terracotte architettoniche
etrusco-italiche," in *Opuscula
Romana* 8, 1974

Eracle e il toro e i due opliti appiedati. E'
evidente che si tratta di un arrivo e non di
una partenza e per di più di un arrivo trion-
fale, come denunciano, oltre al gesto di
accoglimento del personaggio con bastone
forcuto, il traino di cavalli alati della biga e
la veste non cinta del "trionfatore."

Al contrario, il "viaggio–trasporto"
dell'altra processione con andamento
sinistrorso è una *profectio*, come provano
la posizione della biga, alla fine e non alla
testa del corteo, l'atto di salire sul carro
del protagonista, questa volta armato, e la
natura non divina del traino animale.

Si conferma perciò che l'iconografia

della processione con carro (o carri) ed
oplita, un motivo che già dall'uovo di
struzzo di Vulci[70] e dalla situla della
Pania[71] è senza dubbio centrale nell'ideo-
logia aristocratica, si svela come rap-
presentazione del rituale della *profectio*
(con figura di *parabates*) e del *reditus/
triumphus* (con traino di cavalli alati ed
eventuale presenza di accompagnatore/
accompagnatrice divini e di abiti non
militari), rituale ben incarnato dagli *aitia*
fondanti romani. Come non a caso, secoli
più tardi, l'ideologia del trionfo diventa
metafora della condizione imperiale sia in
vita che in morte, così il *reditus* è a sua

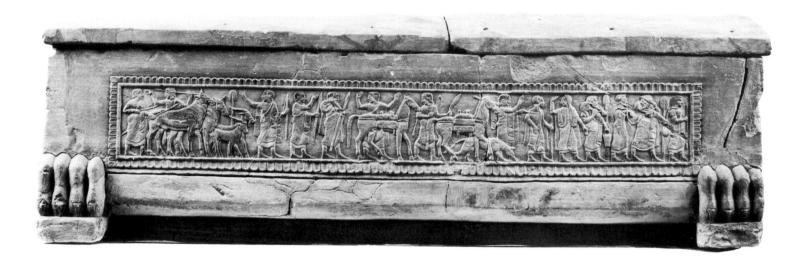

spalle del cavaliere senza lance nell'*oinochoe*. L'iterazione su tutte le lastre "rituali," *convivium*, *nuptiae* e *profectio/adventus*, si conferma perciò come significativa, finalizzata a sottolineare la continuità gentilizia, come ancora secoli più tardi, nelle tombe dipinte con banchetto dove per le iscrizioni o per motivi esterni i protagonisti sono ben individuabili, le tombe dell'Orco l e degli Scudi, al fondatore della tomba si affianca la figura del padre defunto.[74]

Non è infatti un mistero che tutte le società aristocratiche sono ossessionate dal problema della continuità del lignaggio e da quelli, associati a questo, della potenza riproduttiva e del carisma da tale possesso derivante. Tutte queste immagini non sono altro che poderosi strumenti di rassicurazione sociale: *ex contrario*, è interessante notare che nella serie di lastre Veio-Velletri-Roma la lastra con i cavalieri al galoppo presenta tre cavalieri e non due (riflesso della struttura ternaria della cavalleria?) e, cosa ancor più significativa, nella lastra con i *ludi* i carri sono tre e non due, a chiara dimostrazione che non si tratta di iterazione casuale o decorativa (quanti archeologi hanno parlato per figurazioni come queste, di "gioia del racconto" o di "horror vacui"!), ma di iterazione pienamente significante.

In questa prospettiva, le crisi del passaggio vengono circoscritte definendo il ciclo della preparazione giovanile del

futuro re attraverso la dimensione mitica dell'impresa cretese di Teseo e l'acquisizione del *regnum* alla scomparsa del vecchio sovrano mediante la dimensione rituale delle danze "in parallelo," l'una che celebra la conclusione della "prova" (la *géranos*)[75] e l'altra il compianto per il sovrano scomparso (il *lusus Troiae*),[76] mentre alla "prova" di preparazione si contrappone la "prova" di investitura celebrata dalla ierogamia, nel tempio-*thalamos*[77] per il nuovo re, nell'aldilà per il sovrano scomparso.

Ciclicamente, tuttavia, secondo il millenario modello dei sovrani orientali senza dubbio ben noto ai *reges* e ai *principes* etruschi e latini di VII e VI secolo a.C.[78] per antica consuetudine con il Levante, l'*athlon*, la "prova" (le imprese di Eracle nelle lastre di Acquarossa), va ripetuto (e con esso la ierogamia), perchè la forza, il carisma del re si rinvigoriscano: la partenza (le imprese) e il ritorno del re, la *profectio* (le *res gestae*) e il *reditus triumphalis* delle lastre, non sono nient'altro che un ripercorrere le stesse tappe del "viaggio" di qualificazione dell'aspirante sovrano dell'*oinochoe* della Tragliatella, dove sono narrati appunto partenza, imprese e ritorno di Teseo (con la morte del padre e suo predecessore sul trono), come nelle lastre è dimostrato dal fatto che solo nel *reditus* sono presenti i cavalli alati e il lituo, assenti di certo i primi, spesso il secondo nella *profectio*, ma meritati attraverso gli *athla*, simbolicamente rievocati o con lo strumentario mitico delle imprese di Eracle o attraverso la rappresentazione "realistica" dei cortei di opliti e delle galoppate di cavalieri armati.

In questa prospettiva appare infine perfettamente comprensibile il fatto che tutte le scene dei nostri fregi possano essere lette *anche* in chiave funeraria: non solo è palese la concezione ciclica dell'esistenza e del potere, ribadita dall'iterazione e dal "calco" dei rituali (le processioni della 'partenza,' del matrimonio e del funerale fra loro omologhe e pertanto richiamate a coprire più significati), ma appare chiaro anche che l'evocazione dei diversi riti nelle nostre lastre è funzionale proprio a tale esigenza espressiva di natura polisemica.

Il cerchio su queste figurazioni si è dunque chiuso. Alcune di esse, legate ad espressioni più dirette della sfera pubblica, possono essere considerate dei veri e propri incunaboli di quelle rappresentazioni "storiche" romane, che io stesso ho distinto da quelle autenticamente narrative e storiche,[79] dando loro la definizione di rappresentazioni di *status*, in particolare di quelle di *profectio* e di *reditus/triumphus*, ma anche di quelle di *consecratio* e di *ludi*. Come tali, queste rappresentazioni hanno una sorta di continuità con le espressioni della mentalità celebrativa repubblicana, pur nel mutamento profondo (ma non radicale) dei segni e dei simboli imposto dal mezzo millennio di distanza tra questi incunaboli e le prime raffigurazioni "storiche" giunte fino a noi; altre invece, come le scene di *consecratio* o le pompe nuziali–icrogamie o i simposi, indissolubilmente legate alla sfera privata e soprattutto alla autocelebrazione dei *principes* dell'età serviana, tutti ugualmente aspiranti al *regnum*, vengono a scomparire dagli edifici collettivi a partire dal tardo VI secolo a.C., con l'affermazione dell'isonomia patrizia e degli ordinamenti repubblicani.

Tutto ciò ha portato all'obliterazione di quelle manifestazioni di cultura politico-religiosa di schietta matrice orientale (soprattutto nota attraverso la mediazione cipriota),[80] come la ierogamia, sopravvissuti nella forma di miseri frammenti leggendari appiattiti sulla sola figura di Servio Tullio, e all'attenuazione di altre tradizioni di origine locale, ma ugualmente pericolose per l'oligarchia come la trasformazione del *triumphus* in *ovatio*, e più in generale alla decisa pubblicizzazione di tutto quanto era legato ad usi religiosi collettivi, come i *ludi*, e all'altrettanto decisa privatizzazione di quanto invece non era compatibile con l'ordinamento isonomico, come il culto gentilizio e i *convivia*.

Coarelli ha raccolto le testimonianze più significative di questa radicale rimozione,[81] al pari delle sparute sopravvivenze nella storia mitica delle pratiche rituali così efficacemente obliterate dalla giovane repubblica, dai racconti di Tanaquil, di Servio, di Tullia[82] fino al *bel-*

lum privatum dei Fabi contro Veio:[83] a queste testimonianze posso aggiungere quanto emerge dalla particolare ottica che si è qui prescelta.

La fine di questi fregi figurati e la parallela nascita di decorazioni di così detta Seconda Fase con grandi racconti di natura mitica non sono soltanto l'effetto di un superficiale cambiamento di moda, bensì il prodotto di una rivoluzione profonda che nella sfera pubblica sostituiva in forma definitiva e radicale il mito al rito, dal momento che l'uno—il mito—sembrava possedere quel carattere normativo universale necessario alla sospirata "equality of peers" repubblicana, a differenza dell'altro—il rito—troppo specificamente collegato a livello pubblico al *rex* e a livello privato alle aspirazioni tiranniche coltivate dai *principes* con l'ausilio di clientele gentilizie o di *sodalitates* vaste e potenti sul piano militare e politico.

Non è necessario spiegare, alla luce dell'esegesi fin qui fatta delle figurazioni, perchè il semplice possesso di queste decorazioni fittili "private" da parte dei capi di potenti *gentes* fosse vissuto come fortemente conflittuale con gli ordinamenti repubblicani che vediamo diffondersi rapidamente in tutta l'area tirrenica dalla Campania all'Etruria a cavallo tra il VI e il V secolo a.C. Basterà infatti qui ricordare il piccolo centro di Acquarossa, prezioso come riflesso su scala ridotta di quanto nelle grandi concentrazioni urbane si andava in quei cruciali anni verificando (e che la successiva storia edilizia di quelle città ha finito quasi sempre per cancellare), dove vediamo che le terrecotte architettoniche più antiche[84]—quelle sovradipinte in bianco, per intenderci—sono usate per decorare quasi tutte le case (zone A, B, F, G, H, L, M, O); al contrario le lastre della così detta Prima Fase più avanzata sono appannaggio esclusivo di un'unica residenza, quella della zona F, certo la *regia* del *rex* locale,[85] cancellata con il resto dell'abitato nell'ultima tappa del secolare processo sinecistico e di concentrazione delle popolazioni nelle metropoli del Lazio e dell'Etruria, verificatasi appunto nel tardo VI secolo a.C.[86]

I due grandi scarichi di terrecotte architettoniche rinvenuti a Cerveteri, quello scoperto il secolo corso a Vigna Marini[87] e quello scavato negli ultimi anni dal Consiglio Nazionale delle Ricerche a Vigna Parrocchiale,[88] sono forse da considerare come un esempio significativo di questa "cancellazione" di pericolose emergenze monumentali e ideologiche gentilizie, non sappiamo se dovuto all'iniziativa di una giovane repubblica o di un tiranno come Thefarie Velianas. Le lastre fittili rinvenute negli scavi regolari, assieme a quelle clandestinamente emigrate a Copenhagen, ma con grande verosimiglianza scoperte nello stesso luogo (fra le quali ultime figurano lastre con teorie di opliti su carri, con *ludi* e con cavalieri in corsa), gettate verso il 480 a.C. a riempire una cisterna mescolate ad importantissime lastre dipinte (di cui si attende una pubblicazione esauriente), ne sono la testimonianza più cospicua, con una significativa sovrapposizione allo scarico di un edificio templare, ovviamente decorato con terrecotte di così detta Seconda Fase (fig. 15).

L'uso di terrecotte di così detta Prima Fase è dunque promiscuo, dal momento che ne vengono adornate tanto le *aedes* degli dei quanto le *regiae* di *reges* e *principes*. Quale dunque il criterio di distinzione circa la destinazione delle terrecotte? Già poc'anzi abbiamo notato l'esistenza di un ampio spettro di significati e valori "politici," che va da un massimo di "pubblico" ad un massimo di "privato," da un'enfasi maggiore sugli aspetti meno integrabili in un regime isonomico, come l'apoteosi o la ierogamia, alle espressioni di forme ideologiche derivate dalla religione tradizionale collettiva, come il trionfo o i giuochi pubblici, in quanto tali destinate ad essere conservate con la necessaria "attenuazione" anche nei nuovi statuti repubblicani.

Entro questo spettro si collocano i soggetti delle nostre lastre: il massimo del "privato" si tocca nei banchetti, difficilmente pensabili (soprattutto per quelli promiscui, con uomini e donne) come banchetti sacri collettivi consumati su *klinai* entro *hestiatoria* di santuari, ammesso che essi esistessero nell'Etruria e nel Lazio arcaici; all'altro estremo è il ritorno trionfale, con l'antecedente delle *res gestae* incarnato da opliti e/o cavalieri

15a. Lastra di rivestimento frammentaria con raffigurazione di carro guidato da auriga e *parabates*, Cerveteri, 540–530 a.C., terracotta
Fotografia: Musei Nazionali, Berlino

15b. Lastra di rivestimento frammentaria simile alla precedente, Cerveteri, 540–530 a.C., terracotta
Fotografia: Musei Nazionali, Berlino

sulla stessa o su altre lastre, che trae origine dal rituale antichissimo, molto verosimilmente panitalico, del *triumphus*. Non è un caso che il *convivium*, opportu-namente ricacciato nella dimensione pri-vata, costituisca, assieme ai giuochi, il perno della documentazione pittorica e scultorea di monumenti privati, mentre la

Decidere circa la pertinenza di terrecotte di così detta Prima Fase a *regiae* piuttosto che ad *aedes* o viceversa può perciò essere azzardato, anche se, come abbiamo visto, esistono maggiori probabilità che soggetti a carattere più nettamente "privato" (il banchetto o l'apoteosi, ad esempio) o la compresenza di tutti i temi dei fregi, *ludi*, *convivium*, *consecratio*, *nuptiae*, *reditus/adventus* (con l'eventuale aggiunta di *equites* e/o *pedites*), rappresentino un indizio—ma soltanto un indizio—in favore della pertinenza delle lastre in questione ad una *regia*. Per rispondere all'interrogativo di fondo, occorre dunque disporre di molti elementi di giudizio, e segnatamente della pianta e delle caratteristiche architettoniche dell'edificio e di tutti quei documenti che parlano della prevalente funzione di questo, quantunque, per la persistente, voluta ambiguità tra le varie sfere, anche in questi documenti spesso si stenti a riconoscere il segno della pertinenza alla sfera civile o alla sfera sacra.

Per questi motivi gli edifici monumentali di Murlo, di Acquarossa, di Velletri o la *regia* di Roma sono certamente grandi residenze regie o patrizie, perchè il loro aspetto architettonico complessivo è confacente a quello di una *regia*, come anche i fregi fittili con la loro complessità e i loro temi fanno largamente presagire; lo stesso può forse dirsi per l'edificio cui si riferivano le terrecotte architettoniche di Tuscania, oggetto di uno scarico sui tumuli della necropoli dell'Ara del Tufo,[98] che ha tutto il sapore di un *piaculum* per le distruzioni intervenute nel tardo VI secolo a.C. in occasione del già ricordato momento finale del sinecismo delle metropoli etrusche e ben documentato a Murlo, ad Acquarossa, a Caere, a Veio–Piazza d'Armi.

Altrove i dati sono troppo scarni per consentire conclusioni, non dico certe, ma solo dotate di un minimo di sicurezza. Fregi come quello cui apparteneva il frammento ora al British Museum con due citaredi danzanti, detto proveniente da Capua (?) e dimenticato dalla recenti fervide ricerche sulle terrecotte di così detta Prima Fase,[99] lasciano pensare ad una *regia* per noi sconosciuta. Analogamente,

la scoperta sul Palatino di lastre del tipo Veio-Roma-Velletri con *nuptiae*, *ludi*, *convivium* ed *equites*,[100] quasi una serie completa perciò, potrebbe puntare in direzione della presenza, nell'area delle *scalae Caci* (luogo del trovamento) di una grande residenza gentilizia (fig. 17).

Per altro verso, l'accurato studio di Riemer R. Knoop sul tetto "ionico" di Satricum, ove figura un fregio con arcieri al galoppo,[101] rende virtualmente sicura la pertinenza di questo tetto al "sacello" di Mater Matuta, attorno al quale le grandi residenze a cortile (i così detti "South," "West," e "East Courtyard Buildings") appaiono prive di decorazioni fittili.[102] Alla luce di questa attribuzione, l'edificio di Veio-Piazza d'Armi può ben essere considerato come (prevalentemente) "sacro," malgrado l'assenza di altari formali—sono noti nei pressi dell'edificio soltanto 'focolari'—[103] e di altra documentazione (prevalentemente) "sacra" nel contesto: la sua struttura a *megaron*, ricca di confronti nell'arcaismo italico, magnogreco e siceliota, la coincidenza del suo centro con quello che appare essere il perimetro di una precedente capanna e la pertinenza alla decorazione di un solo fregio con opliti, cavalieri e *parabates*, sono tutti tratti comuni al "sacello" di Satricum, che consentono di attribuire funzioni religiose all'edificio veiente.

Il caso del sacello di Piazza d'Armi può essere anzi straordinariamente importante per riconoscere i possibili tratti di un culto gentilizio. Il *megaron* infatti sorge all'interno di un "isolato" assai grande, delimitato da strade, che a sua volta si colloca presso una grandiosa cisterna destinata all'approvvigionamento idrico di molte persone, in posizione enfaticamente al centro di un vasto "villaggio," distrutto e abbandonato, come abbiamo appena visto, nel momento finale del lungo processo sinecistico della città di Veio.[104] L'edificio può essere paragonato alla struttura rettangolare al centro del cortile della *regia* di Murlo; come accade all'edificio di Murlo e a quelli di Acquarossa, Tuscania, Ficana, Poggio Buco, Cisterna (?), assieme ai rispettivi abitati, venne distrutto senza lasciare continuità del culto in esso praticato. Ciò costituisce un indizio in più in

favore del riconoscimento della natura gentilizia del sacello: se torniamo per un attimo alla situazione arcaica presso le *scalae Caci* del Palatino a Roma, un ulteriore elemento in favore dell'ipotetica presenza di un edificio monumentale gentilizio nell'area può essere offerto dall'esistenza sul posto di una grande cisterna arcaica, tratto che accomuna la zona palatina al "villaggio" di Piazza d'Armi di Veio.[105] Ancora un altro interessante caso di culto gentilizio in area urbana, a quanto sembra non proseguito dopo il VI secolo a.C., potrebbe essere quello indiziato dai frammenti di lastre con *convivium* e *profectio/adventus* rinvenuti presso la così detta Porta Romanelli di Tarquinia.[106]

Tuttavia non sempre distruzioni e trasformazioni urbanistiche e politiche ebbero destini altrettanto radicali. Al contrario, a Roma sappiamo della sostituzione di abitazioni di re con sacelli consacrati tutt'altro che casualmente a culti di tipo domestico:[107] proprio per questa insistenza della cultura dominante di VI secolo a.C. sull'ideologia proto-trionfale incarnata dai fregi con *profectio/adventus*, molto significativo mi sembra il fatto che il culto succeduto sul luogo della casa del quasi-tiranno Publicola ebbe caratteri tutt'altro che domestici, consacrato come fu all'arcaicissima dea "trionfale" Vica Pota.[108]

Molti sono infatti gli esempi di continuità di culto tra edifici ornati di lastre di così detta Prima Fase e templi di epoca classica: tra i più notevoli ricordo qui i casi dei templi dell'Ara della Regina a Tarquinia,[109] donde provengono lastre con processioni di armati e di carri, e di Veio-Campetti, dove sono venute alla luce lastre con *profectio/adventus* e armati.[110] Tale constatazione rende possibile un accostamento tra vecchi trovamenti di lastre di così detta Prima Fase ad un santuario noto per altra via. Penso qui alla vecchia e dimenticata scoperta di lastre del tipo Veio-Roma-Velletri con *nuptiae* (ossia identiche a quelle da Roma–Sant'Omobono) da una "vigna presso Piazza d'Armi"[111] e di una lastra del tipo *profectio/adventus* della medesima serie nella località "Quarto della Comunità,"[112] ossia dalla stessa zona: viene così a ricostituirsi un piccolo contesto, che potrebbe ben riferirsi alla fase arcaica del santuario di Iuno Regina, indiziato dal rifacimento augusteo.[113]

Similmente, la nota lastra dall'Esquilino con il tipo delle *nuptiae*, anche se forse trovato in giacitura secondaria, potrebbe ben riferirsi al non lontano santuario di Libitina,[114] di una dea cioè i cui caratteri, al pari di quelli della Iuno Regina veiente, non appaiono dissimili da quelli della dea di Sant'Omobono. E così c'è da chiedersi se l'elusivo, quanto arcaico culto palatino di Iuno Sospita,[115] localizzato in prossimità dell'ingresso della casa di Augusto e dunque nell'area delle *scalae Caci*, non possa essere il relitto di un culto gentilizio collegato strettamente con l'edificio ricordato poc'anzi decorato con lastre di così detta Prima Fase.

Ma volgiamoci ormai alle conclusioni. Al tramonto del dominio assoluto della società gentilizia, dominio che nello specifico qui discusso può essere incarnato dal ciclo figurativo di Murlo, subentra una voluta ambiguità della decorazione esteriore di residenze gentilizie e di templi, segnale—non meno dell'affiorare di temi mitici in funzione simbolica—dell'imminente crisi di questo assetto politico-sociale e culturale: le radici di tale ambiguità sono al tempo stesso retaggio del passato e frutto di una nuova scelta delle classi dominanti in funzione di controllo sociale.

La crisi vera e propria si consuma tra l'estremo VI e l'iniziale V secolo a.C., con gli ultimi "sinecismi" (in realtà fase finale e cruenta delle lotte fra *gentes* e fra città e campagna) e con il mutamento in senso repubblicano (e l'arroccamento oligarchico che poco dopo ne consegue) degli ordinamenti di gran parte delle metropoli etrusche: la decorazione fittile dei tetti, che, dopo essere divenuta dalla seconda metà del VII e la seconda metà del VI secolo a.C. appannaggio esclusivo delle grandi famiglie, abbelliva tanto le residenze patrizie quanto gli edifici di culto gentilizi direttamente o ideologicamente collegati a quelle residenze e a quelle famiglie, viene ora considerata privilegio delle sole case degli dei.

Si genera così un costume di "austerità" nella sfera edilizia, che verosimilmente produce (per volontà oligarchica o per imposizione tirannica non sappiamo) quei

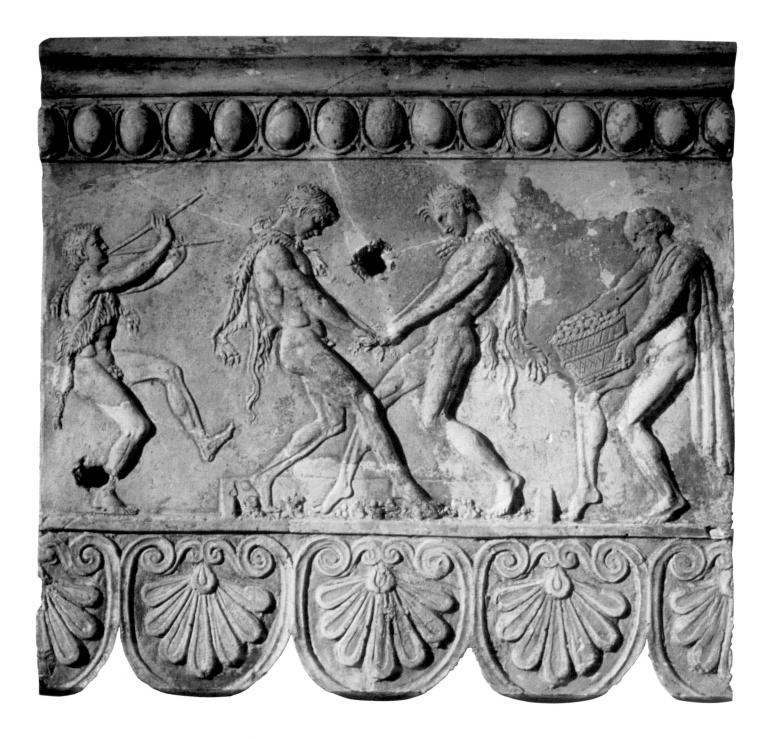

MARIA TERESA MARABINI MOEVS

Rutgers University (emerita)

Ephemeral Alexandria: The Pageantry of the Ptolemaic Court and Its Documentation

The word *ephemeral* in the title of this essay is to be understood not so much in its pejorative and qualitative sense of transitory and elusive, as in its etymological sense, "the duration of one day." The action of historical events is rightly considered to be the principal cause of the almost total disappearance of Alexandrian monuments, but I believe another factor must also be given serious consideration. In Ptolemaic Egypt many artistic manifestations were not intended to be lasting; rather, they were the expression of an ideal of happy transience, similar to the state the Cyrenaic School defined as μονόχρονος εὐδαιμονία.[1] This "pleasure of the ideal now"[2] became spectacularly evident in the festivities of the Ptolemaic court. This essay focuses on the recovery, through hypothesized archival documentation, of the most famous of these festivals. As an outgrowth of a study of the Arretine pottery from Cosa, it is also a fitting tribute to the memory of Frank Brown.

Alexandria, winter, 275–274 B.C.: this, according to a recent astronomical calculation, was when the *Pompe*, or Grand Procession, of Ptolemy Philadelphus took place.[3] The event, handed down in a detailed description by ancient sources, typifies the festivals of the Ptolemaic era; destined like these to spend itself even as it unfolded, it was literally "ephemeral."

The Grand Procession was occasioned by the celebration of the second Ptolemaieia, a penteteric (quinquennial) festival instituted by the reigning sovereign in honor of his father, Ptolemy I Soter. It is described in the fifth book of the *Deipnosophistae* of Athenaeus of Naucratis, written in the first half of the third century A.D.[4] His source, which he quotes largely verbatim, is a lost periegesis of Alexandria, *About Alexandria*, by one Kallixeinos of Rhodes, who probably lived in Alexandria in the third century B.C.[5] Kallixeinos in turn indicates that he has consulted the accounts of the penteteric festivals probably included in the βασιλικαὶ ἀναγραφαί that were established, according to Appian, by Philadelphus for the benefit of posterity.[6]

"Ἀι τῶν πεντετηρίδων γραφαί," the wording used by Kallixeinos,[7] suggests the existence of illustrated documentation—not a surprising circumstance in Ptolemaic Egypt, the heir and continuator of a tradition of papyrus-roll illustration that reaches back at least as far as the Middle Kingdom. Since the New Kingdom, the tradition has been most frequently associated with the *Book of the Dead*.[8]

In the Twenty-first Dynasty the linear hieroglyphic script was replaced by the hieratic, written in columns of short horizontal lines from right to left. At this time the illustrations, by now subordinate to the

4. Corpus Christi celebration, Valencia, 1987, processional float: Expulsion from the Garden of Eden
Photograph: Robert Moevs

modern-day Spain, such as the celebration of Corpus Christi at Valencia (fig. 4), ancestral religion, national epic, and local folklore all combine in a joyous exuberance, remote in time, but not so much in spirit and form, from the Grand Procession of Ptolemy Philadelphus.

Out of the sections of the procession that I have identified, three will be presented to demonstrate the various kinds of rela-

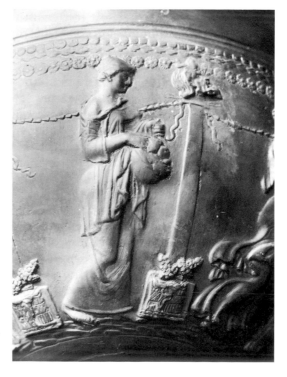

5. Ateius (signed), Arretine crater, detail: Hora with flower and wreath, late Augustan period
British Museum, London

6. Ateius (signed), Arretine crater, detail: Hora with fruit in her lap, late Augustan period
British Museum, London

tion that can occur among event, text, and illustration.

The first illustration corresponds to the description of the personifications of time, Penteteris, the penteteric festival, and the three Horai who stride forward preceded by Eniautos, the Year, at the head of the procession of Dionysos. Since I have already published the results of this study, only its essential features will be reviewed here.[22]

The text of Kallixeinos, as quoted by Athenaeus, reads as follows: "A very beautiful woman of the <same> height followed him, adorned with much gold and a magnificent <costume>, holding in one of her hands a crown of persea, in the other a palm branch. She was called Penteteris. Four Horai followed her, elaborately dressed, and each carrying her own products."[23] It can be stated at the outset that the existence of four Horai, instead of three —foreign both to the pharaonic tradition and to that of early Hellenistic Greece, and above all contrary to the climatic reality of Egypt, which knows only three seasons —is a late manipulation of the text. In spite of this, four Horai, each characterized by her particular attributes—flower and wreath (fig. 5), fruit in her lap (fig. 6), *phiale* and kid (fig. 7),

small game suspended from a *lagobolon* and shoat (fig. 8)—appear on an Arretine crater from Capua, now in the British Museum, London, signed by Cn. Ateius.[24]

Some fragments of the same cycle, but from a different workshop, found in the excavations of Cosa, furnished the first clue to a possible Alexandrian origin of the group. On one of these fragments there appears the head of the Hora with fruit in her lap (fig. 9),[25] executed with such accuracy in respect to the Ateius version that it is possible to establish precise comparisons in the type of hairstyle and facial features with portraits of the first Ptolemaic queens. In particular, this Hora can be compared with the portrait of Berenice I on a gold emblema from Corfu, now at Oxford (fig. 10),[26] and with those of her daughter Arsinoe II on coins (fig. 11),[27] in faience,[28] and on bone bezels (fig. 12).[29]

A fragment of a mold in the Museo Archeologico, Arezzo, helps restore the Hora with flower and wreath to her proper role as Penteteris, substituting for the flower the original palm branch (fig. 13).[30] Taken together, the palm and the wreath came in this way to represent the traditional prizes of the pan-Hellenic festivals and the elevation of the *Pompe* to Olympic

7. Ateius (signed), Arretine crater, detail: Hora with *phiale* and kid, late Augustan period
British Museum, London

8. Ateius (signed), Arretine crater, detail: Hora with small game and shoat, late Augustan period
British Museum, London

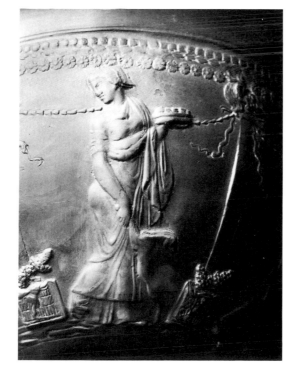

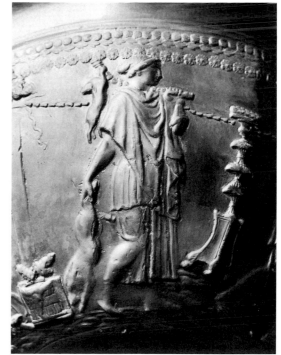

14. Wall decoration, Mastaba of Ptahhetep, Saqqarah, Fifth Dynasty, bas-relief, sketch of detail: harvesting and treading grapes
From Norman de Garis Davies, *The Mastaba of Ptahhetep and Akhethetep at Saqqareh* (London, 1900), 1: pl. 21

15. Wall decoration, Mastaba of Mereruka, Saqqarah, Sixth Dynasty, bas-relief, detail: scene of grape treading with musical accompaniment
From Prentice Duell et al., *The Mastaba of Mereruka*, (University of Chicago Oriental Institute Publications, 31; Chicago, 1938)

Kingdoms[35] and, on the other, to comparable scenes on the Greek ceramics of the archaic and early classical periods.[36]

At Saqqarah during the Fifth Dynasty, in the reliefs of the Mastaba of Ptahhetep, one finds, already associated, the two scenes of harvesting and treading the grapes (fig. 14).[37] In the first, two harvesters squat beneath a pergola in a symmetrical arrangement on either side of the central stem of the grapevine and a basket; in the second, five men in a low press-bed tread the grapes rhythmically, supporting themselves by means of a horizontal pole. Through the presumed side of the press-bed their feet appear in a "false transparency."

In the Mastaba of Mereruka, during the Sixth Dynasty, the musical accompaniment is graphically represented by a circle that encloses two squatting personages intent on beating time for two groups at their right who are treading the grapes, facing one another inside a low press-bed (fig. 15).[38] The caption proclaims, "Beating time."

During the Twelfth Dynasty, in Tomb 2 of the Beni Hasan necropolis (the Tomb of Amenemhat), five grape-treaders have their feet buried in grapes, which appear in "false transparency" through the front side of a low press-bed.[39]

Scenes of harvesting and treading the grapes, remaining virtually unchanged in

their essential features, appear frequently during the New Kingdom in the necropolis of Thebes, in scenes where the dead "rejoice contemplating the good things, the products of the open fields and the papyrus thickets," as an inscription declares in the Tomb of the scribe Nakht. Here two men standing beneath the natural arch of a grapevine gather bunches of grapes, while at the left two facing groups with profiles almost entirely superposed tread the grapes in the press-bed, which by now has become deeper and architecturally elaborate.[40]

In Tomb 261 of the same necropolis the press-bed, shallow and elongated, with the treaders in two opposite groups holding onto straps attached to a wooden pole, has a flavor of archaic simplicity that recalls features of the Old Kingdom. Similarly, the two harvesters kneeling by the sides of a basket under a trellis are a striking reminder of the same scene in the Mastaba of Ptahhetep (fig. 16).[41] The press-bed in the Tomb of Apy, from the beginning of the Ramesside period, is similar.[42]

Song and music are still part of the tradition, as the Tomb of Rekh-mi-Rè in the same necropolis, from the Eighteenth Dynasty, shows; here, between two facing groups who are treading the grapes with a dance step, a caption provides the propitiatory words of the workers' song to the goddess Ernutet.[43]

At the end of the fourth century B.C., the reliefs of the Tomb of Petosiris at Tuneh el Gebel, with a luxuriant vineyard at the right, a very high press-bed at the left, and an inscription containing the harvesters' song of praise to their lord, testify to the longevity of this iconographic tradition.[44]

The Egyptian version of the grape-treading scene does not seem to have influenced Greek ceramics of the sixth century B.C., where this scene appears only sporadically outside the Attic region.[45] In Attic pottery scenes of harvesting and treading the grapes are often met with in the period between about 560 and 430 B.C.[46] Grape treading in particular appears for the first time in black-figure pottery on a Siana cup, now at Bochum,[47] and in the canonical version on two amphorae by the Amasis Painter, one at Basel,[48] the other in Würzburg (fig 17).[49] Notwithstanding some variations in the groups of partici-

a long time. Their persistence is demonstrated, for example, by a small bronze *Dancing Satyr* from Alexandria, now in the Cleveland Museum of Art (fig. 21),[63] or a Satyr *auletes* in a Dionysiac group from Lower Egypt, now in the Musée du Louvre, Paris,[64] dated variously from the third to the first century B.C.

The survival of this grape-treading iconography in the art of northern Africa in the fourth century A.D. is demonstrated by a mosaic from Cherchel, where three grape-treaders inside a solid, rectangular press-bed full of grapes are stamping with all their might, holding one another up with their hands.[65]

A different problem arises in the graphic reconstruction of the Thalamus of Semele, the scene that follows the great parade for the celebration of wine and begins the series of episodes concerning the life of Dionysos. The text, an incomplete abridgment of Kallixeinos at the hands of Athenaeus, reads as follows: "After these things he tells in detail of 4-cubit-long tables on which many spectacles, sumptuously arranged and worthy of being seen, were caused to circulate; among these also was the Thalamus of Semele in which some figures were wearing chitons embroidered in gold and set with precious stones of the highest cost."[66]

The absence of means of locomotion, as well as the scanty dimensions of the tables—more suitable to distribute the refreshments, mentioned a few lines before, to the spectators in the stadium[67] than to house a mythological scene—lead us to emend the text, separating the tables from the Chamber of Semele and mounting the latter upon a float like the one that bears the next scene, closely connected with it, that of the Infancy of Dionysos.[68]

The compendium of Athenaeus gives a general impression, as opposed to the detailed descriptions of Kallixeinos that have so far guided the constructive process of our mental images. Any attempt to identify an original illustration must start by visualizing the reaction of Athenaeus to his source. His impression was dominated by the luxurious display of the personages represented.

20. Campana revetment plaque, Augustan period, terra-cotta, detail: grape-harvesting scene
Palazzo Colonna, Rome
Photograph: Università degli Studi, Rome

21. *Dancing Satyr*, Alexandria, Hellenistic period, bronze
Cleveland Museum of Art

The occasion is offered by a rare portrayal of the myth on an Attic red-figure hydria from the last quarter of the fifth

century B.C., now in the Lowie Museum of Anthropology, Berkeley (fig. 22).[69] In this work by the Semele Painter, the successive phases of the myth—the apparition of Zeus, the death of Semele, the rescue of Dionysos by Hermes, and the failed attempt by Hera to take possession of the child—all appear simultaneously in a grandiose synoptic construction. Previous and future developments, such as the passion of Zeus and the bringing-up of Dionysos, are alluded to by the presence of Aphrodite, Erotes, and bearers of nuptial gifts, as well as a solitary nymph of Nysa. It is not, however, the variety of episodes or the complexity of their relations that finds a response in the text of Athenaeus, but rather the idiom in which they have been expressed. The high bed with sumptuously decorated covers and pillows on which sleeping Semele lies and the group of divine figures, dressed in the ornate style of the late fifth century, that surround her correspond to the synthesis of

Athenaeus and betray the opulence of the pictorial model that must have inspired both the Semele Painter and the choreographers of the *Pompe*. Among the personages present, two stand out as protagonists: Zeus, who looms over the bed at the right, surrounded by winged Erotes, close to the lightning bolt that is about to strike the sleeping Semele, and Hermes, who moves away from the bed toward the left, carrying off the infant Dionysos. The vine branches that frame the bed transport the scene from its traditional setting, the palace of Cadmus at Thebes, to place it under a luxuriant bower, like the one conceived by Euripides in the *Phoenissae*.[70] Such a vision, Dionysiac and free of any evidence of tragedy, was well suited to the atmosphere of the *Pompe*. Thus one may suppose that the scene of the Thalamus of Semele on the processional cart mirrored faithfully the pictorial model recorded on the vase.

The relationship between this imagery, suggested by Athenaeus and by the Semele

24. Terence, *Adelphoe*, early
ninth-century manuscript
derived from an original of
the fourth century A.D.,
detail: miniature
Biblioteca Apostolica Vaticana,
Vatican codex lat. 3868

sarcophagi, already suggested by Adolf Greifenhagen,[79] and its possible derivation from an illustrated book, as proposed by Matz, lead me to think that the illustrations of the Dionysiac episodes in the archives of the *Pompe* are relevant even to these late versions of the myth.

Exceptionally faithful to the classical iconography that would have been adopted by the Alexandrian illustrator is the representation of the Thalamus of Semele on a painted muslin veil now in the Musée du Louvre, Paris, which can be dated to the Theodosian renaissance, around A.D. 400.[80] Here a principal zone with the Dionysiac *thiasos* is separated by a frieze of vegetable scrolls from a band with successive scenes from the life of Dionysos. In the first scene on the left Semele, reclining on a couch with richly

decorated covers, turns her gaze toward Zeus at the right, who arriving in flight looms over the bed, gripping the lightning bolt in his fist (fig. 25). The provenance of the veil, which comes from Antinoe, guarantees the long survival on Egyptian soil of the version promulgated by the *Pompe* and confirms at the same time the validity of the interpretation of the Finding of Ariadne on the Alexandrian sarcophagus as the Thalamus of Semele.

The transition from the linear idiom of archival illustrations to the naturalistic idiom of the iconographic repertory of Hellenistic and Roman art would have been greatly facilitated by the toreutic works commemorating great events of the Ptolemaic kingdom. An example is a rare survival of third-century Alexandrian silverware, the Palagi kalathos now in the

25. Veil painted with scenes of Dionysos' life, from Antinoe, c. A.D. 400, muslin, detail: Death of Semele
Musée du Louvre, Paris

26. Kalathos showing scenes related to cult of Artemis, from Alexandria, c. 225 B.C., silver
Museo Civico Archeologico, Bologna

Museo Civico Archeologico, Bologna (fig. 26).[81] By scanning its decoration into symmetrical groups, one may discern once again the influence of illustrative vignettes.

To recapitulate, the visual representation of the Grand Procession would have consisted of two elements, scenography and archival illustration. In the scenography the choice and organization of the imagery answered both to the demands of the present and to the persistence of a dual tradition reaching back to pharaonic art and to Greek art of the archaic and classical periods. In the illustration the imagery created in the scenography and transmitted through the account would have been adapted to the requirements of the text, in a physical sense since it had to respect its format, and in a conceptual sense since it had to reflect the essential elements of the narration. Within these limits, nonetheless, it seems to have dis-

tions, trans. Arthur Fairbanks (London and Cambridge, Mass., 1960); above all to the well-known *ecphrases* of Lucian. On Lucian, see Jacques Bompaire, *Lucien écrivain* (*BEFAR*, 190; Paris, 1958), 707–735; Valeria Andò, *Luciano critico d'arte* (Quaderni dell'Istituto di Filologia Greca dell'Università di Palermo, 7; Palermo, 1975), 16–55. On the documentary validity of the *ecphrasis*, see Karl Lehmann-Hartleben, "The *Imagines* of the Elder Philostratus," *ArtB* 23 (1941), 16–44.

17. The most obvious examples are the cup of Thyrsis and the works of art at the festival of Adonis in Theocritus, *Idylls* 1.27–56, 15.80–86; and the mantle of Jason in Apollonius Rhodius, *Argonautica* 1.721–767.

18. Horace, *On the Art of Poetry* 361–365. The expression was mistakenly interpreted as a "precept." What Horace really intended to say was that some poems, like some paintings, are more or less satisfactory, according to the circumstances. A commentary of Plutarch on Simonides of Ceos (*Moralia* 346F–347A) that states, "Simonides calls painting poetry without words, and poetry verbal painting," also acquired a preceptorial significance. On the theory and its tradition, see Mario Praz, *Mnemosyne: The Parallel between Literature and the Visual Arts* (Princeton, 1970), 3–27; Jean H. Hagstrum, *The Sister Arts: The Tradition of Literary Pictorialism and English Poetry from Dryden to Gray* (Chicago, 1958), 3–36. It is common knowledge that this theory was opposed by Lessing, who in his *Laocoön* upheld the fundamental difference between the temporal art of literature and the spatial art of painting.

19. Whether or not Kallixeinos himself was there, the original account seems to have been compiled from the point of view of somebody who was situated in the stadium of Alexandria, possibly with the precise task of writing the document. The presence of the narrator does not necessarily imply that of the illustrator, who could have interpreted the text without any memory of the real event. On this issue, see Rice 1983, 169–171.

20. On the Renaissance festivals and their documentation I have consulted the following: Roy Strong, *Art and Power: Renaissance Festivals 1450–1650* (Woodbridge, Suffolk, 1984), 42–50; Jean Jacquot, "Présentation," in *Les Fêtes de la Renaissance*, ed. Jean Jacquot, 3 vols. (Paris, 1973–1975), 3:7–51; George R. Kernodle, "Déroulement de la procession dans les temps ou espace théâtral dans les fêtes de la Renaissance," in Jacquot 1973–1975, 1:443–449; W. McAllister Johnson, "Essai de critique interne des livres d'entrées français au 16ᵉ siècle," in Jacquot 1973–1975, 3:187–200.

21. Maria Teresa Marabini Moevs, "Penteterìs e le tre Horai nella Pompè di Tolomeo Filadelfo," *BdA* 42 (March–April 1987), 10–12.

22. Moevs 1987, 1–36.

23. *Deipnosophistae* 5.198A–B; Rice 1983, 8–11. For this and the following passages from Athenaeus I have slightly revised Rice's translation.

24. Henry B. Walters, *Catalogue of the Roman Pottery in the Department of Antiquities, British Museum* (London, 1908), 20, L 54, pl. 6; August Oxé, *Arretinische Reliefgefässe vom Rhein* (Frankfurt am Main, 1933), 78–80, no. 132 a–g, pls. 32–34; Moevs 1987, 1–3, figs. 2, 3, 5, 6, 8.

25. Moevs 1987, 7, figs. 4, 17. Recently, Paola Porten-Palange (personal communication, 12 November 1988) has cast some well-documented doubts on my attribution of the Cosa fragments to the workshop of Perennius (Moevs 1987, 5–6). According to her unchallenged expertise they present affinities with the products of C. Cispius, L. Avilius Sura, and Publius, and might be attributed to a minor Arretine workshop. I am grateful to Porten-Palange for her corrections and help in the attribution of the Arretine ceramics from Cosa.

26. John Boardman and Marie-Louise Vollenweider, *Ashmolean Museum, Oxford: Catalogue of the Engraved Gems and Finger Rings 1, Greek and Etruscan* (Oxford, 1978), 78–79, no. 282, pl. 44.

27. Ioannes N. Svoronos, Τὰ νομίσματα τοῦ κράτους τῶν Πτολεμαίων (Athens, 1904–1908), 3: pl. 15, 1–17, 18–20, pl. 16, 1–11; Helmut Kyrieleis, *Bildnisse der Ptolemäer* (Berlin, 1975), 78–79, pl. 70, 1, 2.

28. Small faience head in the round from Naucratis in the British Museum, London: Dorothy Burr Thompson, *Ptolemaic Oinochoai and Portraits in Faience: Aspects of the Ruler-Cult* (Oxford, 1973), 83–84, no. 270, 198–199, pls. A, 64; Kyrieleis 1975, 86, 180, J12. Also, oinochoe from Canosa in the British Museum, London, identified by inscription: Thompson 1973, 125–126, no. 1, pls. 1, 2. Fragment of oinochoe from Alexandria in the Metropolitan Museum of Art, New York: Thompson 1973, 167, no. 126, pl. 45.

29. A female head characterized by recurrent features, such as the royal band on the "melon" hairdo and the large disk of braided hair on the nape, is incised on the bezel of rings in bone or ivory, mostly from Cyprus and Alexandria: Lila Marangou, "Ptolemäische Fingerringe aus Bein," *AM* 86 (1971), 163–171, pls. 78, 1, 79, 80. Two of these heads have been recognized as possible portraits of Arsinoe II: Ashmolean Museum, Oxford, inv. 1891.237 (fig. 12 in my essay), and British Museum, London, inv. R 1619 (see Boardman and Vollenweider 1978, 81, no. 286, pl. 47).

30. *M. Perennius Bargathes: Tradizione e innovazione nella ceramica aretina* [exh. cat., Museo "Caio Cilnio Mecenate," Arezzo] (Rome, 1984), 119, no. 105; Moevs 1987, 6–7, fig. 14.

31. On the equation of the Ptolemaieia to the Olympic festivals, in dignity and prizes assigned to the winners, see Peter M. Fraser, "Two Hellenistic Inscriptions from Delphi," *BCH* 78 (1954), 49–62.

32. Moevs 1987, 15–22.

33. The Nike on the reverse of gold staters and hemistaters of Pyrrhus minted in Sicily in 278–276 B.C. is a good comparison: *British Museum, Department of Coins and Medals: A Guide to the Principal Coins of the Greeks* (London, 1965), 66, no. 16, pl. 37; Peter R. Franke and Max Hirmer, *Die griechische*

Münze (Munich, 1972), 105, no. 475, pl. 151. The three Horai appear among the divinities going in procession to the wedding of Peleus and Thetis on the François vase in the second quarter of the sixth century B.C.: *Materiali per servire alla storia del vaso François, BdA*, special ser. 1 (1981), figs. 81, 132. At the end of the same century on a kylix by Sosias in the Antiquarium, Berlin, three Horai, in processional sequence and carrying each a gift from the earth, are witnesses to the entrance of Heracles into Olympus. See George M. A. Hanfmann, *The Season Sarcophagus in Dumbarton Oaks*, 2 vols. (Cambridge, Mass., 1951), 1:95–96, 2:135, no. 6; Ernst Pfuhl, *Malerei und Zeichnung der Griechen*, 3 vols. (Munich, 1923), 3: pl. 137, fig. 418.

34. Athenaeus, *Deipnosophistae* 5.199A; Rice 1983, 12–13. One cubit equals 0.464 m.

35. Pierre Montet, *Les scènes de la vie privée dans les tombeaux égyptiens de l'ancien empire* (Strasburg and Paris, 1925), 265–268; Montet, "La fabrication du vin dans les tombeaux antérieurs au Nouvel Empire," *Recueil de travaux relatifs à la philologie et à l'archéologie égyptiennes et assyriennes* 35 (1913), 117–124; Montet, *La vie quotidienne en Égypte au temps des Ramsès* (Paris, 1946), 107–110.

36. The most exhaustive discussion of the theme of treading the grapes in Greek ceramics can be found in Brian A. Sparkes, "Treading the Grapes," *BABesch* 51 (1976), 47–64. To the vases examined and the bibliography listed (particularly 47, n. 3), the following works can be added in which the grape-treading theme is often associated with the vintage theme: Henri Metzger, *Fouilles de Xanthos 4, Les céramiques archaïques et classiques de l'acropole lycienne* (Paris, 1972), 122; Jaap M. Hemelrijk, *Caeretan Hydriae* (Mainz, 1984), 20–21, no. 9, pls. 48–89; Dietrich von Bothmer, *The Amasis Painter and His World* (Malibu, New York, and London, 1985), 113–118, color pl. 1; Thomas H. Carpenter, *Dionysian Imagery in Archaic Greek Art. Its Development in Black-Figure Vase Painting* (Oxford, 1986), 90–95; Angelika Schöne, *Der Thiasos: Eine ikonographische Untersuchung uber das Gefolge des Dionysos in der attischen Vasenmalerei des 6. und 5. Jhs. v. Chr.* (Göteborg, 1987), 121–128, 289–292, nos. 391–418.

37. Norman de Garis Davies, *The Mastaba of Ptahhetep and Akhethetep at Saqqareh*, 2 vols. (London, 1900), 1:9–10, pls. 21, 23.

38. Prentice Duell and others, *The Mastaba of Mereruka*, 2 vols. (Chicago, 1938), 2: pls. 114, 116.

39. Percy E. Newberry, *Beni Hasan*, vol. 1 (London, 1893), 31, pl. 12.

40. Norman de Garis Davies, *The Tomb of Nakht at Thebes* (New York, 1917), 69–70, pls. 22, 23; Kazimierz Michalowski, *Art of Ancient Egypt* (New York, n.d.), fig. 415.

41. Arpag Mekhitarian, *Egyptian Painting* (New York, 1978), 19.

42. Norman de Garis Davies, *Two Ramesside Tombs at Thebes* (New York, 1927), 62–63, pls. 31A, 33.

43. Norman de Garis Davies, *The Tomb of Rekh-mi-Rè at Thebes*, 2 vols. (New York, 1943), 1:41–42, pl. 45.

44. Gustave Lefebvre, *Le Tombeau de Petosiris* (Cairo, 1924), 60–63, pl. 12; Montet 1946, 109–110; Michalowski n.d., 313, fig. 635.

45. A Middle Corinthian column-crater of the beginning of the sixth century B.C. in the Musée du Louvre, Paris, and a Caeretan hydria in the Museo Nazionale di Villa Giulia, Rome, seem to be the rare exceptions. On the Corinthian crater, see Sparkes 1976, 48, fig. 1; on the Caeretan hydria, Sparkes 1976, 48–49; Hemelrijk 1984, 20–21, no. 9, pls. 48–49. The treading scene on the Caeretan hydria is intriguing in spite of its basic adherence to the Attic tradition. The leg of a Satyr who has leaped into a basket seems to appear in false transparency in the Egyptian fashion, supporting the Egyptian connection of the workshop. On this possible connection, see Hemelrijk 1984, 201.

46. Sparkes 1976, 47.

47. H.A.G. Brijder, *Siana Cups 1 and Komast Cups* (Amsterdam, 1983), 260, no. 255, pl. 48.

48. Antikenmuseum, Basel, inv. 420; Sparkes 1976, 49, fig. 4. To the bibliography listed in n. 16, add Carpenter 1987, 93, pl. 20B; von Bothmer 1985, 115–116.

49. Martin von Wagner-Museum der Universität Würzburg, inv. 265 and 282; Sparkes 1976, 50, fig. 5; Carpenter 1987, 92, pl. 20A; Schöne 1987, 124–126, pl. 16; von Bothmer 1985, 113–118, no. 19, color pl. 1, 117–118 (bibliography).

50. On the use and meaning of the *lenos* in the Greek world, see Darrell A. Amyx, "The Attic Stelai," *Hesperia* 27 (1958), 241–246.

51. John Boardman, "The Amasis Painter," *JHS* 78 (1958), 1–3; Sparkes 1976, 49. Since Amasis is the Greek version of the name of the philhellenist Pharaoh A-ahmes, Boardman has advanced the hypothesis that the potter-painter might have been born in Naukratis and grown up in Egypt. On the Egyptian origin of the grape-treading theme, see John Boardman, "A Greek Vase from Egypt," *JHS* 78 (1958), 9; Sparkes 1976, 49.

52. Museum of Fine Arts, Boston, inv. 01.8052; Sparkes 1976, 50–51, fig. 6; Heide Mommsen, *Der Affekter* (Mainz, 1975), 77–79, 109, no. 102, pls. 13, 113, 114.

53. For the terms related to wine making, see Sparkes 1976, 49–50; Clotilde Ricci, "La coltura della vite e la fabbricazione del vino nell'Egitto greco-romano," *Studi della Scuola Papirologica* 4, 1 (1924), 52–57.

54. British Museum, London, inv. D 543; Henry B. Walters, *Catalogue of the Terracottas in the Department of Greek and Roman Antiquities, British Museum* (London, 1903), 389; Hermann von Rohden and Hermann Winnefeld, *Die antiken Terrakotten 4, 1–2, Architektonische römische Tonreliefs der Kaiserzeit* (Berlin and Stuttgart, 1911), 65, 247, pl. 15. A contemporary relief in the Musée du Louvre, Paris, inv. 3888 (see Rohden and Winnefeld 1911, 65), is probably the same one published in Goffredo

può però essere sostenuta con argomenti archeologici (bisognerebbe riaprire gli scavi, pochissimo documentati, fatti da Boni all'interno dell'Oratorio).[26] Il muro in reticolato potrebbe essere nato in connessione con la costruzione della sala, ma difficilmente le appartiene: l'andamento, infatti, è quello della parte media e superiore della rampa.

Dalle esili tracce rimaste nella zona di Giuturna non è facile dedurre l'entità dei danni causati dall'incendio neroniano. Sembra però che la ricostruzione sia stata affrontata senza fretta e sotto la spinta delle profonde trasformazioni operate nelle aree limitrofe: il *lacus* e gli edifici circostanti dovettero essere inseriti in un quadro architettonico totalmente rinnovato. La rampa si trova in una posizione particolarmente esposta. Essa viene infatti coinvolta in tutte le radicali ricostruzioni della Casa delle Vestali, della *Nova via*, della *domus Tiberiana* e del Palazzo di Caligola, nonché nella ristrutturazione della cornice architettonica del *lacus*. I lavori di consolidamento effettuati negli anni 1984–1985 hanno creato le condizioni per un esame più approfondito delle strutture delle varie fasi della rampa. Le osservazioni fatte in questi anni completano e correggono le ipotesi che nel contempo vennero pubblicate nella relazione preliminare aggiornata all'inizio del 1984, ma soprattutto si è rafforzata la convinzione che molti dei problemi rimasti aperti possono essere risolti solo in stretta collaborazione con chi sta studiando i suddetti complessi.

Gli elementi utili per una cronologia assoluta sono pochi anche nelle fasi di età postneroniana. La cronologia relativa può essere ricostruita in parte, ma la ricostituzione di un quadro d'insieme rimane incerta a causa della mancanza di alcuni anelli di congiunzione fra le varie successioni accertate. Cominciando dalla parte bassa della rampa, si può notare che un primo consolidamento e allargamento è avvenuto prima della costruzione della sala 5, che occupa il posto di due *tabernae* (denominate 5a e 5b) e del corridoio antistante (13, 14). Il corridoio, o forse portico, fu creato proprio in questa fase, come parte di un nuovo sfondo monumentale del *lacus*. I pavimenti del corridoio-porticato e

della sala 5 sono modesti (*opus spicatum*); la cortina della sala 5 è in parte in opera mista (muri laterali, dei quali è conservato solo quello settentrionale), in parte in opera laterizia, realizzata con mattoni ricavati dalle caratteristiche "tegole" prodotte, per quanto sappia, solo nelle *figlinae Brutianae* e *Caepionianae* nell'età traianea e nella prima età adrianea.[27] Con mattoncini dello stesso tipo venivano rifoderate le pareti delle *tabernae* 3 e 4 e chiuso l'accesso al vano 2. In mancanza di bolli laterizi il materiale fornisce limiti cronologici piuttosto ampi. Va tenuto presente che proprio le *Brutianae* hanno fornito gran parte dei laterizi usati in cortina nella ricostruzione traianea della Casa delle Vestali, ricostruzione che Bloch data, con argomenti incontestabili, negli anni 110–113 d.C.[28] È possibile che la fase della sala 5 rientri nello stesso progetto di ricostruzione, ma non mancano motivi per ritenerla leggermente più tarda.

In ogni caso è certo che c'è stato almeno un intervento anteriore sulla rampa. La facciata occidentale è stata rinforzata con una serie di piloni posti davanti alle pareti divisorie delle *tabernae* 2–4. I piloni non sono stati legati alla muratura repubblicana, ma sono collegati con degli archi rampanti. Quello situato davanti alla *taberna* 5a è stato tagliato alla base quando fu costruita la sala 5. Si tratta quindi di due progetti diversi e non solo di due interventi successivi all'interno della stessa fase di costruzione.

Una situazione analoga si vede nelle strutture del piano superiore, anch'esse tagliate dal muro settentrionale della sala 5. In una fase anteriore è stato creato un piano inclinato, in parte rifinito con dei bipedali e ricoperto con cocciopisto. Fino a poco tempo fa mi era sembrato ovvio collegare il piano con l'allargamento della rampa e datare il tutto in età domizianea: l'inclinazione del piano trova infatti corrispondenza nell'andamento delle arcate della facciata, l'abbondante uso di materiali di recupero nei cementizi sarebbe bene giustificato in una ricostruzione successiva ad un incendio, e l'identificazione dell'unico bollo ritrovato sembrava fornire la prova decisiva, dato che L. Lurius Proculus ha fornito molto materiale per le fasi

domizianee della *domus Tiberiana*.[29] Il solido piano avrebbe infine dato la necessaria stabilità alle arcate che, come si è notato sopra, non erano state legate alle strutture preesistenti.

Durante i recenti restauri ho però dovuto constatare che il piano dei bipedali era collegato con dei muri di sostegno laterali che devono aver sostenuto un normale pavimento, il cui andamento orizzontale è in contrasto con quello, in salita, degli archi. Si tratterebbe quindi di una fase posteriore all'allargamento della rampa e anteriore alla sala 5, evidentemente contemporanea alla ricostruzione dell'ala sud-ovest della Casa delle Vestali, con la quale la rampa risulta collegata non solo dalla scala del così detto forno, come già avevo messo in evidenza nella relazione preliminare,[30] ma anche da un passaggio al piano superiore. All'altezza del pavimento costruito sopra la rampa si vedono infatti pochi filari dello stipite di una porta che attraversava il grosso muro fra la rampa e la Casa delle Vestali. Questa fase della rampa è certamente posteriore all'età domizianea: il bollo del piano inclinato, in verità molto mal ridotto, non va attribuito a L. Lurius Proculus, bensì a D. Laelius (o L. Aelius) Demetrius (*CIL* XV 1234= *S.* 329), officinatore conosciuto solo da timbri che non sono databili sulla base di ritrovamenti in situ.[31] Il tipo è però posteriore all'età flavia, anche se non di molto. È quindi possibile che il piano superiore della rampa sia stato inglobato nella Casa delle Vestali in connessione con la ricostruzione traianea, ammesso che quest'ultima abbia interessato anche l'ala nord-ovest.[32]

L'accesso dal così detto forno fu mantenuto anche dopo la costruzione della sala 5, e la scala fu ricostruita, alzandone il livello, durante i restauri effettuati in età severiana. Proseguendo verso sud troviamo un ulteriore accesso, più comodo, nella scala 48,[33] che ci riporta ad ulteriori problemi cronologici nel rapporto tra rampa e Casa delle Vestali. Se le terme situate nell'angolo sud-ovest della casa risalgono all'età domizianea,[34] dobbiamo datare in età flavia anche l'intercapedine che le circondano sui lati sud e ovest, e la pressoché completa ricostruzione del tratto medio della rampa. Le terme e l'intercape-

dine furono infatti costruite demolendo in parte o del tutto i vani 7 e 8 est e ovest. Il vano 7 ricevette una nuova apertura verso ovest dopo lo spostamento o la riduzione del sacello di Giuturna; il vano 6 fu rifoderato con mattoni e munito di un ingresso, che deve essere definito monumentale, soprattutto tenendo conto delle ridotte dimensioni dell'ambiente, che continua a distinguersi dalle *tabernae* del tratto inferiore per forme architettoniche più complesse.

La sala 10, che più tardi sarebbe stata trasformata in un oratorio cristiano (Oratorio dei XL Martiri) potrebbe essere datata negli ultimi anni di Domiziano o nella prima età traianea sulla base di bolli degli anni 93/4–108/9;[35] per una datazione ancora in età domizianea fa propendere il suo perfetto inscrimento nel complesso che l'imperatore non fece in tempo a portare a termine. Il muro di fondo, obliquo, si adatta perfettamente all'andamento della rampa, segno che quest'ultima fu pienamente rispettata in questa fase. Per la costruzione della sala 10 furono parzialmente demoliti due muri laterizi (vano 9), il primo dei quali sembra seguire un orientamento predomizianeo (Palazzo di Caligola), mentre il secondo è orientato come il tratto superiore della rampa domizianea.[36]

Attualmente sono conservati solo pochi dei gradini osservati anche da Lanciani[v] nel tratto fra la *Nova via* imperiale e l'ingresso alla *domus Tiberiana*, che è stato murato per ragioni di sicurezza. L'andamento della scala è però perfettamente leggibile nei suoi muri laterali. Quello occidentale continuava ininterrotto dal vano 9 in su; il largo varco che ora unisce la nostra rampa con quella nuova creata in connessione con la costruzione del complesso di Santa Maria Antiqua è stato infatti aperto in un momento posteriore. Su questo tratto le due rampe correvano parallele, ma non comunicanti; esse raggiungevano piani diversi del palazzo e avevano con ogni evidenza funzioni ben distinte.

Il tratto finale della nostra rampa è stato conservato attraverso tutte le fasi postdomizianee della *domus Tiberiana*, segno che la scala continuava a mantenere la sua funzione, almeno come ingresso dalla *Nova*

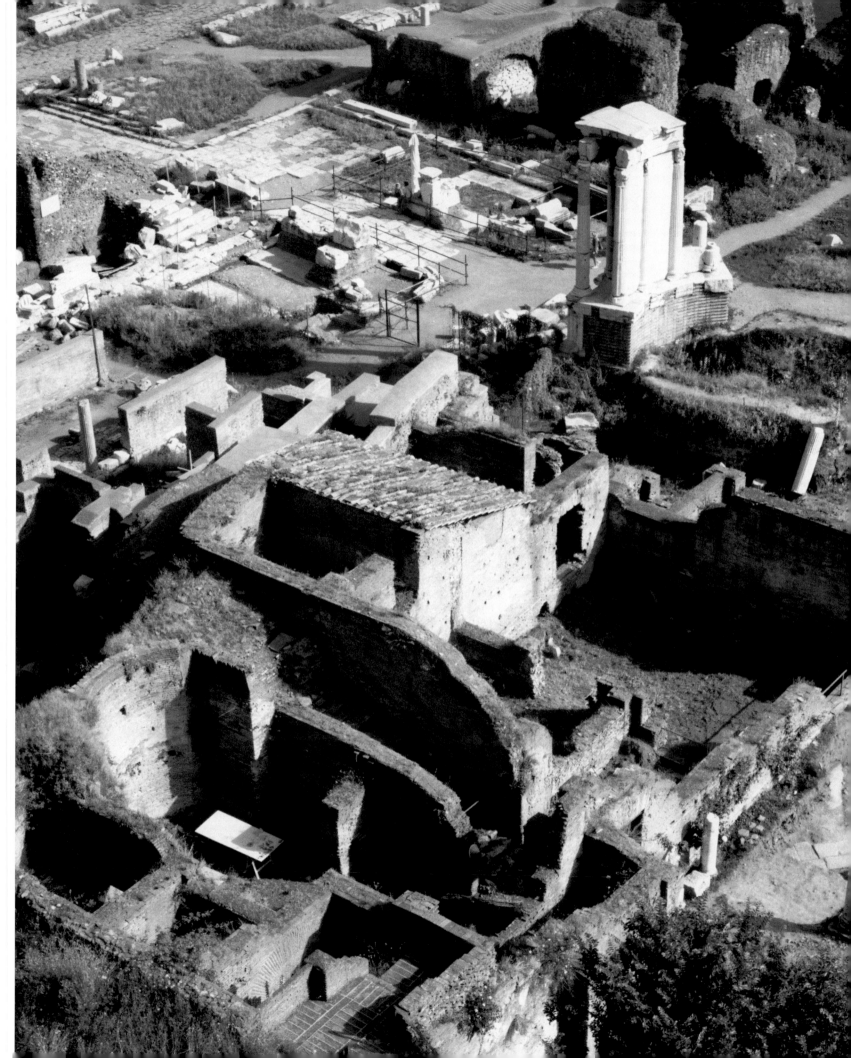

RUSSELL T. SCOTT
Bryn Mawr College

Excavations in the Area Sacra *of Vesta, 1987–1989*

In his *Pictorial Dictionary of Ancient Rome*, Ernest Nash recorded this entry for the Atrium Vestae: "The residence of the Vestal Virgins, with its large court surrounded by columns and decorated with three water basins, was built after the Neronian fire of 64 A.D., and restored and enlarged under Domitian, Trajan, and Septimius Severus. Remains of the pre-Neronian structure were brought to light under the north-western part of the imperial Atrium Vestae. Their orientation, parallel to the Regia and Domus Publica, differed from that of the imperial buildings."[1]

This description is largely based on a study made by Esther Van Deman, who was able to observe Giacomo Boni's excavations in the Roman Forum at the turn of the century. Her interpretation of the site was published in 1909 and, notwithstanding a fundamental challenge made to it by Herbert Bloch in 1936, has remained the standard reference work on the *area sacra* to the present day.[2]

This essay summarizes the results of new excavation now being carried out in the area by the American Academy in Rome. While the work of excavation and interpretation is far from complete, enough has been done to demonstrate that the fortunes of Vesta and the adjacent Regia were inseparably linked from the rise of "regal" Rome in the seventh century B.C. to the end of the republican era, with major phases of development occurring in the sixth, late third/early second, and first centuries B.C. In the empire, however, the Regia lost its importance as the official residence of the pontifex maximus—this title being appropriated by the emperor, whose residence was the Palatine—with the result that only the area of Vesta participated fully in the architectural development of the forum end of the Palatine, and that most notably in the early years of emperor Trajan.

In what follows I propose additions and corrections for the entry in Nash. But this interim report is above all to be understood in the context of the unusual impetus to collaborative archaeological investigation in the city of Rome that has been provided in the past decade by the Italian government and in particular by Adriano La Regina, archaeological superintendent for Rome.[3] The project of the academy is a collaborative one in every sense. It borders on and, as will be evident, has profited from other excavations, either in progress or just completed, at the Lacus Iuturnae, the Arch of Augustus, and the Temple of the Castors on the west; in the Vicus Tuscus and Horrea Agrippiana on the southwest; and on the east and southeast at the "Clivus Palatinus" and on the Via Nova (fig. 1).[4]

The excavators involved in these several projects are all much indebted to La Regina for the opportunity that has been

Domus Virginum Vestalium and Temple of Vesta viewed from the Palatine to the north
Photograph: Martinis

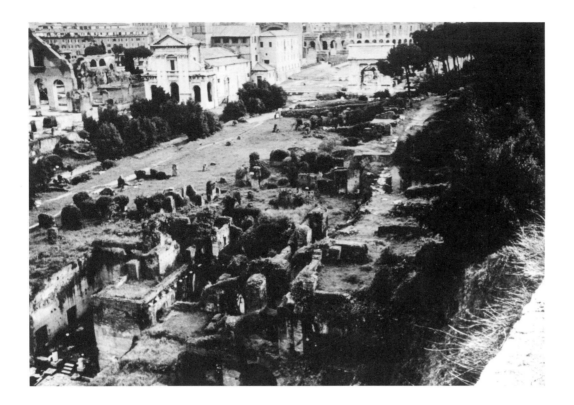

made available, but we must also acknowledge a common debt to Frank Brown, whose example in the 1960s served to lead archaeologists and historians back to the heart of ancient Rome in the 1980s. Certainly the Vesta project could not have come about without the precedent of his work in the Regia, whose pre-archaic and archaic phases especially have greatly aided the interpretation of our own evidence for those periods.[5]

Despite the progressive cutting back of the northwestern slope of the Palatine Hill (fig. 1), its general contour in the eighth and seventh centuries B.C. in the area later occupied by the sanctuaries of Vesta and the Regia can be plotted by reference to the remains of the small huts and hutlike enclosures that have been uncovered under the Regia, the cella of the Temple of Julius Caesar, the street separating the Regia from the *area sacra* of Vesta, and the north wall of the precinct of the Temple of Vesta of mid-republican date (figs. 2, 3).[6]

These modest structures representing the extension of the Palatine settlement down into the valley of the forum respect the line of fall of the slope to the north and west, and stop short of the gully that ran diagonally from southeast to northwest on a line that can be approximately visualized as extending from the "Clivus Palatinus" below the Arch of Titus to the Temple of Antoninus and Faustina. On the west they are disposed along the shelf of land arcing toward the Temple of Julius Caesar (fig. 4). The rising slope on the south provided the western approach to the Palatine, as the Clivus did on the east. Found in association with these huts was a pebble street that may have connected them to others located farther uphill to the east and south (fig. 5).[7]

Rude and battered as the remains of these huts appear (fig. 6), they nevertheless document a stage in the development of early Rome that can be dated in the early seventh century B.C. A corrected radiocarbon date of 679 B.C. was obtained for the felling of a timber from one of the huts under the Regia, and the latest pottery from another floor under the series of streets separating the Regia from Vesta dates to the same period, Latial IV A.[8]

While the huts and/or annexes to huts that have been found on the Palatine itself and those found above the forum valley

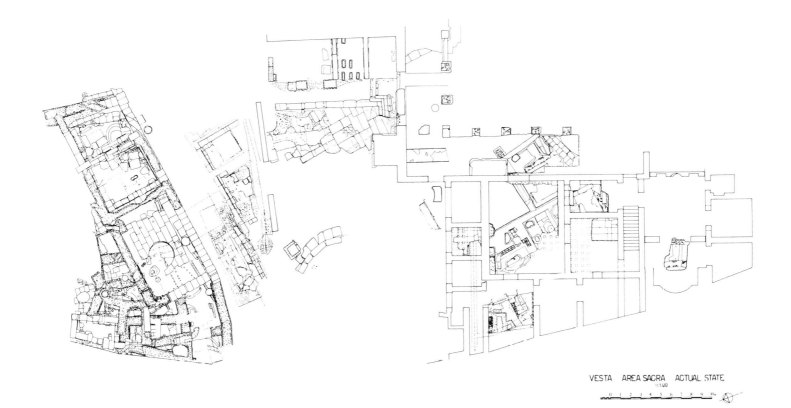

VESTA AREA SACRA ACTUAL STATE
0 1 2 3 4 5 6 7 8 9 10

3. North precinct wall, central sounding, of *area sacra* of Vesta, Rome, 1989, looking north, with post holes, floors, and organic debris of seventh century B.C. Author photograph

most complete hut found under the Regia measures 4.00 x 2.70 m (excluding a small addition against its south side).[9] Nonetheless, the richness of the organic remains uncovered in 1989, from the hut habitation level beneath the north precinct wall of the sanctuary of Vesta and the presence of infant burials under the huts located at the northeast limit of the excavation under the Regia, leave no room to doubt the reality of human occupation in the area in the seventh century.[10]

Recent work suggests that the northwestern slope of the Palatine underwent appreciable change in the seventh and sixth centuries. The huts in the area of the Regia and Vesta were suppressed in the late seventh century, as one of the steps in a steady process of urbanization that continued throughout most of the following century. The objectives were the taming of the forum gully and thereby the reclamation of the forum valley, and the creation of a set of axes for movement and development respecting both the natural configuration of the terrain and orientation to the cardinal points. Thus the

invite comparison with others known from elsewhere in Latium—Ardea, Ficana, Lavinium, and Satricum—the Roman versions, although tending to a more regular rectangular shape, are quite small: the largest hut that has been found on the Palatine measures 4.90 x 3.60 m, and the

of blocks of Grotta oscura tufa running nearly due north and south from the Palatine toward the Via Sacra (fig. 13).[25] Recall that on the west the *area sacra* had previously terminated on the line of the natural ascent up the Palatine, but this feature was now substantially replaced by the first ramp up the hill, which likewise took its alignment from the compass, running north and south from the Via Sacra and separating Vesta from the sanctuary of Iuturna on the west.[26] A general limit will have been made on the south by the rising slope of the hill, but better definition must await the outcome of work by colleagues in the Soprintendenza Archeologica on the history and location of the Via Nova.[27] On the northwest the course of the Via Sacra and the Regia marked another limit, while shops and storage rooms giving onto the Via Sacra delimited the area of Vesta farther northeast.[28]

The shape of the central precinct underwent significant change at this time. First, the Via Sacra itself was enlarged to more normal street dimensions and equipped with drains, and a new precinct wall was built along it, with an access stair from the street in *opus quadratum* (fig. 14).[29] The base blocks of the stair are in a compact grade of *cappellaccio* and exhibit a rustication technique similar to that of the boundary wall with the Domus Publica on the east. The new precinct wall on the Via Sacra had foundations in blocks of Grotta oscura tufa that survive to a height of several courses.[30] Behind this wall the elevation in the precinct appears to have been uniformly about 14.30 m asl. The main features that have been uncovered to date along its north side are the remains of two rooms, one of which was certainly open to the south and contained the reset blocks in *cappellaccio* already described commemorating archaic features in the precinct. The other, small and squarish, was adjacent to the first on the east and shared with it an interior wall in *opus caementicium*. It may have been part of a sequence of rooms extending along the east side of the precinct and accessible from it.

To the south of these rooms was another well, which was suppressed in the next major phase of development. The open

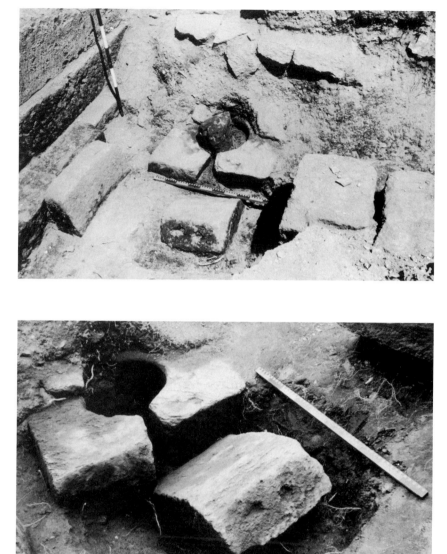

area of the precinct was bounded on the south by a building set at a higher elevation, whose design of rooms opening off the rear of an enclosed courtyard recalls, even as it improves upon, the archaic house-type preserved in the Regia (fig. 15). This has long been identified with the residence of the Vestals in the republican period.[31] The south end of this building lay over the remains of the earlier street that had probably linked the old approaches up to the Palatine on the east and west, so it is most likely that access to the building was from the precinct. The stair leading up from the Via Sacra to the precinct is approximately centered on the north-south axis of this building, and the remains

11. North precinct wall, central sounding, *area sacra* of Vesta, Rome, 1989, view toward east showing suppressed well of sixth century B.C. as found: above and to east, paving flags of republican period; foreground, *cappellaccio* blocks of sixth century reset at republican level they surrounded
Author photograph

12. North precinct wall, central sounding, *area sacra* of Vesta, Rome, 1989, view toward east of wellhead after removal of tufa shaft plugging it
Author photograph

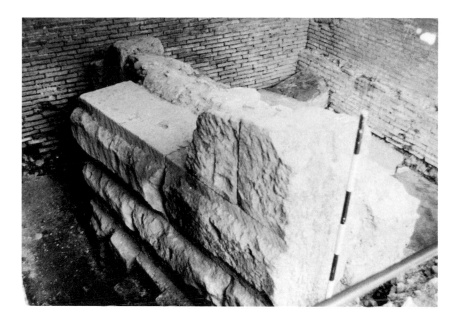

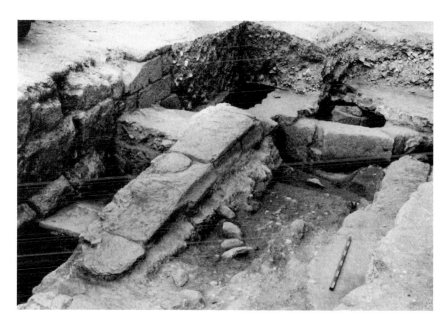

13. Dividing wall between area of Vesta and Domus Publica, Rome, 1989, view looking southwest
Author photograph

14. Street with stair between the Regia and precinct of Vesta, Rome, end of third century B.C., view toward west-southwest: background, shoulder blocks of subsurface drain
Author photograph

of what may prove to be another stair lead up from the level of the precinct toward its northwest corner.[32]

Elements of this building that appeared on the plan of Boni's excavations drawn by the architect Leonardo Paterna Baldizzi in 1903 (fig. 8) have since been lost to view because of the reactivation in recent times of the pools in the peristyle of the imperial complex and the creation of a garden area around them. The measurements of the two rooms excavated in 1988 made it possible, however, to restore the missing

elements to their proper place within the perimeter of the walls of the building, as shown on the restored plan (fig. 15).

Inconsistencies remain between the restored plan and Baldizzi's, some of which seem to be the result of modification and embellishment of the building in the first century B.C., but there is essential agreement on overall dimensions and the number of rooms.[33] The perimeter foundations of the building were in *opus quadratum*, the blocks in Grotta oscura tufa, while the interior walls were in *opus caementicium* of hard, red-brown tufa wedges set in mortar with pozzolana of a light violet hue.

What is remarkable about all these bits and pieces is the way they connect to one another, preserving all the while the orientation to the cardinal points inherited from an earlier time. The materials and construction techniques employed, combined with the evidence of the pottery from our soundings in the street and in the precinct thus far, place this building activity in the context of the late third and early second centuries, a time specified by the ancient sources as one in which the special importance of Vesta to the survival of the Roman community was greatly appreciated.[34]

The increasing architectural articulation of the *area sacra* at this time raises the question of what sort of temple there should have been in the precinct, a question we are not yet in a position to answer. The written sources also report a burning of the Temple of Vesta in 241 B.C., and coins (issued, however, in the first century B.C.) commemorating the activities of the famous champion of *libertas*, L. Cassius Longinus Ravilla, *tribunus plebis* in 137 and special prosecutor of delinquent Vestals in 113, do show a round temple of somewhat old-fashioned aspect that is generally taken to be that of Vesta, whose inscribed portrait also appears on the obverse of the coins (fig. 16).[35]

The reference to coins of the first century B.C. that make specific reference to the cult-place of Vesta introduces the next significant period of development there. The results of work in 1989 indicate that, while the area occupied by Vesta and the activities that went on in proximity to the

15. Residence of Vestals, Rome, republican period, hypothetical restored plan: heavy lines mark portions of building excavated in 1988
Drawing by Martha Hoffman

16. *Denarii* of C. Cassius Longinus, minted 55 B.C., commemorating significant activities of his ancestor L. Cassius Longinus as *tribunus plebis* and later special prosecutor: obverse, left, portrait of Vesta, right, portrait of Libertas (both identified by name); reverse, left and right, Temple of Vesta with prosecutor's bench before it
Photograph: Andrew Alföldi

area sacra in the first century remained essentially the same as in the previous century, the articulation of the space changed markedly to reflect development at the time, while retaining the impress of the ancient shape of the area and its associations.

The Via Sacra between the Regia and the precinct of Vesta was again enlarged and its level raised about 1.5 m, with the concomitant suppression of the stair and the north precinct wall in *opus quadratum*.[36] The new precinct wall was built in *opus caementicium* with a facing in broken pantiles. It was pierced by a broad entryway some 3 m wide opening into the precinct, which now received a paving in slabs of travertine that were laid so that the long seams of the joints ran due north and south to harmonize with the alignment of the earlier atrium building that still stood at the rear of the precinct (fig. 17). The alignment of the new north wall of the precinct and the Via Sacra in front, however, did not preserve the old orientation, but rather responded to the axis created by the establishment of a regular rectangular

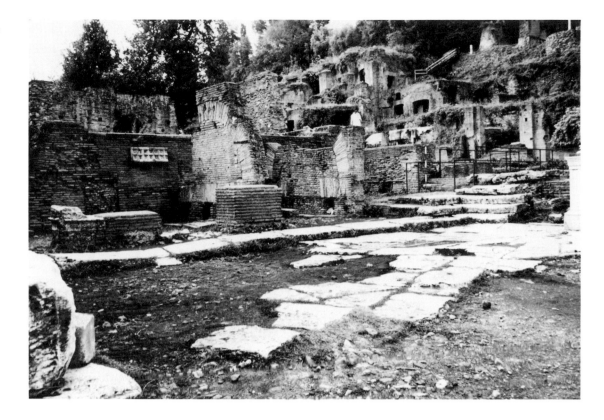

17. Travertine paving slabs, precinct of Vesta, Rome, first century B.C., view looking south

Author photograph

shape in the central area of the forum in the late second and first centuries.[37]

The area of the precinct underwent further architectural elaboration at this time in the form of additions and modifications to existing structures, especially on the east toward the Domus Publica and on the west toward the ramp to the Palatine. In this direction the rising contour of the terrain mandated terracing, for which abundant evidence survives, despite the large-scale rebuilding of imperial date. The intention seems to have been to create additional space for activities connected with the old atrium building and to regularize the approach to it from the temple precinct.

The evidence of excavation shows that a rectangular suite of three rooms was built against the west wall of the original atrium building. The southernmost of these apparently served a ritual purpose. The other two are to be read as a small vestibule flanked on the north by another room containing a *cella ianitoris* protecting the entry into the building on the west. The full dimensions of the northernmost room and the terminal west wall of the addition have been lost to later construction, but the route of approach from the precinct is finished by a parallel set of small chambers that opened onto it from the west, built against the ramp to the Palatine. Two of these rooms have been partially recovered below the imperial level. The width of the addition to the atrium building may be calculated at about 3 m; the width of the passage between the addition and the rooms built against the ramp was variable: about 1 m at the narrowest point near the exit from the precinct, wider farther south.

Scraps of floors in black and white mosaic with simple geometric designs survive in the vestibule and what resembles a *cella ianitoris*, and the network of stout foundations in mortared rubblework underlying them is impressive (fig. 18). The voids in the boxlike pattern were filled with a mixture of building debris, including spalls from working travertine blocks, rammed hard from top to bottom against subsidence. Given such solidity, it was perhaps only to be expected that the imperial builders later on would carry their dismantling operations to this level and then

press these foundations into service anew for their own constructions. The reuse happily ensured the survival of the foundation deposit of first fruits made at the *constitutio* of the addition to the old building, which we had the good fortune to recover in 1988. This consisted of organic remains contained in the bottom half of an amphora set below foundation level.[38]

A similar deposit was found in the southernmost room of the addition. It was contained in a coarseware pot that had been set into the floor of the room at the time of its construction and had been warped by exposure to intense heat. That the room had continued to serve some ritual purpose was indicated by the treatment it received later at the hands of the imperial builders. While razing the republican atrium, they appear to have broken a second vessel in this same room, a vessel that had been set into the floor near the east wall, while the surviving one had been set close to its south wall. Or so the evidence would suggest: what we found was a typologically later form of the vase in situ, which had been carefully placed in the ground and covered over in a sort of rubblework box, the sides of which reproduced the alignment of the destroyed east wall of the room (figs. 19, 20).[39] It is not possible to say exactly what purpose the room served at this point, but we can hazard the identification of the two pots with a type of vessel used for ritual purposes by the Vestals known from ancient sources: the *futis*.[40]

The system of foundations used to support the addition to the old atrium building on the west was also used to support the weight of the travertine pavement laid in the precinct, where the same problem of a fall-off to the northwest existed. The evidence of pottery recovered from the soundings made beneath the pavement in 1988 reinforced what was already available to date these works to about the mid-first century B.C.—pottery from the second well excavated by Alfonso Bartoli in the precinct in 1930, which had been closed by the laying of the travertine pavement.[41]

The pavement moreover clearly extended farther east, beyond what now survives in the reduced area of the imperial precinct,

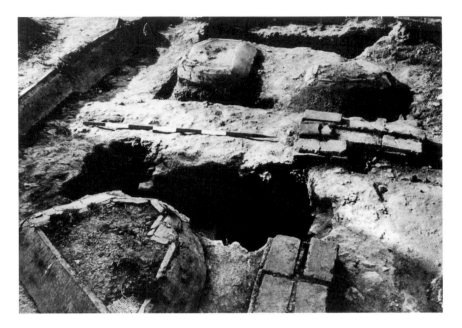

18. Foundations under vestibule and cella of western addition to Atrium Vestae, Rome, 1988, view toward south
Photograph: Barbara Bini

probably as far as a portico in marble and travertine that ran due north and south, elements of which were first exposed by Lanciani in the 1870s and recorded by Middleton in 1886 (fig. 21).[42] This portico may have closed the precinct architecturally on the east, and although its exploration must await the next excavation season, its connection with the pavement preserved farther west can already be reckoned as very probable: the upper margins of the gutter blocks below its stylobate are at the same level as the paving slabs preserved to the west.[43] The elements of the portico and the remains of some rooms lying between it and the wall in *opus quadratum* dividing the area of Vesta from the Domus Publica on the east survive, in mutilated form, under the foundations of the Neronian arcade on the south side of the Via Sacra. It was built following the fire of A.D. 64 and took its point of departure eastward immediately to the east of the eastern end of the Regia, which accounts for many of the present lacunae in our knowledge of this side of the precinct, a situation we hope to remedy in the future.[44]

Even so, the program of works carried out in the *area sacra* in the mid-first century B.C. as presently if imperfectly known is sufficiently systematic in its design to warrant inquiry about a builder. A name

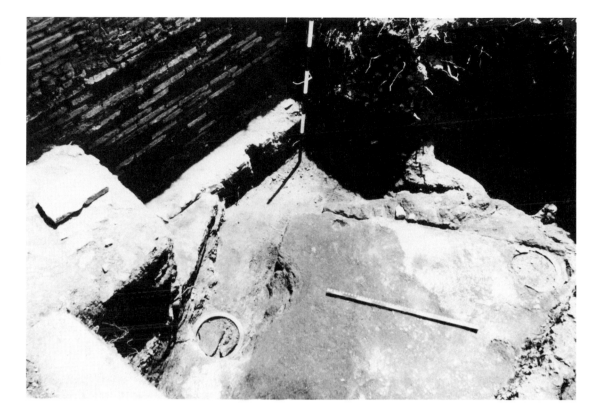

may not be hard to come by.[45] Van Deman assigned a rebuilding of the round Temple of Vesta to Augustus, but without advancing very strong arguments in support of that view.[46] And Augustus' only known activity in the area was the ceding to the Vestals of the Domus Publica, the actual dwelling of the pontifex maximus, when he attained the office in 12 B.C. after the death of Lepidus.[47]

As Attilio DeGrassi shrewdly observed, it is not likely that Augustus would have kept quiet about anything he did in connection with Vesta, but DeGrassi did nonetheless accept Van Deman's thesis of

a rebuilding of the temple at that time, modifying it to the extent of hypothesizing that the work she credited to the emperor was carried out by others at his instance (as happened on other occasions).[48] This may be, but the evidence available at this point for the work in the *area sacra* that I have been describing favors a date earlier in the century; none of our soundings, for example, has produced any red-slip ware later than pre-Arretine.

We know from the testimony of Suetonius and Pliny the Elder that Julius Caesar, when in Rome, lived next to Vesta in the Domus Publica from the time of his election as pontifex maximus in 63 until his death.[49] That he set great store on that position is indicated by Varro's dedication of the *Antiquitates rerum divinarum* to him as pontifex in 47, and by his own account of his enemies quarreling before Pharsalus over who should have the office once he had been put out of the way.[50] And the realignment of the Via Sacra and the north wall of the precinct of Vesta is in accord with Caesar's other known building activity in the forum.[51] The conclusion is tenta-

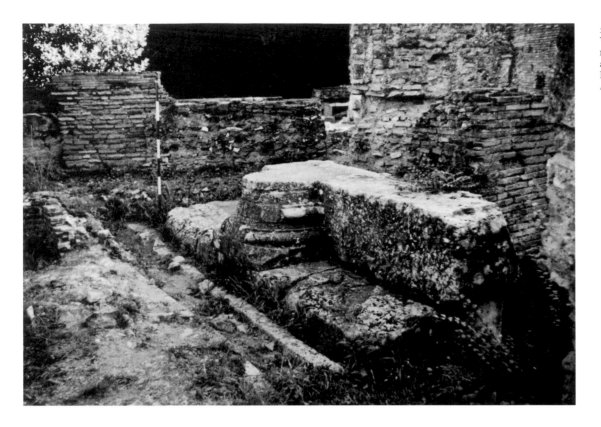

21. East side of precinct of Vesta, Rome, view toward northeast showing marble and travertine portico beneath Neronian arcade
Author photograph

tive; it may be strengthened by projected work on the eastern side of the precinct.

Between 1936 and 1938 there appeared in the *Bullettino della commissione archeologica comunale di Roma* a series of articles by Herbert Bloch on Roman brick stamps that revolutionized the study of buildings of the high empire.[52] One of the major complexes dealt with in his study was the imperial Atrium Vestae, which he concluded did not show the multiplicity of phases in its development posited by Van Deman in her book of 1909, but was rather to be considered on the whole a work of the Trajanic period.[53] The recent excavations have confirmed and amplified his view: Trajanic stamps in situ are now known from all four sides of the building behind the great peristyle court.

The new stamps come from hypocaust floors in the western wing of the complex, that is to say, from the structure that replaced the old atrium building of the republican period and which, because of its close proximity to the temple, is identified as the imperial residence of the Vestals. It shows signs of later modification, but its essential plan is of the time of Trajan. (The aedicula immediately adjacent on the east is of the time of Hadrian.)[54]

In Room 50, to the south of the large central room, approximately half the floor remained intact after later modification. The stamps were found on the undersides of upper hypocaust tiles. Because of difficulties of access and the problematic stability of the floor with overburden, the recorded sample of seven stamps must be considered incomplete.[55] In Room 56b, one of those fronting on the precinct, four stamps were preserved in situ, although in more ruinous condition as a result of modern intervention in the room.[56]

The cumulative testimony of the stamps, along with the pottery recovered in our soundings and the uniformity of construction technique throughout the *domus*, points to the *optimus princeps* for the realization of the imperial Atrium Vestae, even though here as elsewhere in the city he may well have completed and transformed Domitianic initiatives.[57] It is known, for example, that Domitian rebuilt the ramp to the Palatine marking the western end of the *area sacra* of Vesta and began an elaborate project to the south of the sanctuary

of Iuturna that was in large part converted to the use of the *annona* after his death.[58]

In the absence of a biography of Trajan, his work at the shrine of Vesta receives confirmation in the coinage where, especially from the *decennalia* in 108 onward, the goddess appears with the emperor as patron and guarantor of the *annona*, her types linked with those of its operations: *alimenta Italiae, restitutio Italiae,* and the like. These also find their literary voice in the *Panegyric* of Pliny the Younger,[59] and abundant physical confirmation in the extraordinary program of public works carried out by the emperor in Rome and Ostia at the time to ensure the security and efficiency of the food supply to the capital and Italy. Further, the Atrium Vestae of Trajan stands at the point of juncture between the forum and the area coming up from his docks below the Aventine and through the Forum Boarium, whose long established character as the warehousing and distribution center of the city received his special attention.[60]

It is no coincidence that in this process the millers and bakers of Rome, the faithful of Vesta, whose activities in the area are attested from the time of Plautus, also came in for special consideration from the emperor, along with other agents of the *annona*.[61] His actions on their behalf are known from legal sources in which the rewards of full citizenship for loyal service to the *annona* are spelled out, culminating a development spanning the time from Tiberius to Trajan: "Latini ius Quiritium consequuntur his modis: beneficio principali, liberis, iteratione, militia, nave, aedificio, pistrino."[62] It is the last four items in the sequence that relate to service in the *annona. Militia* means service for an appropriate term in the *vigiles urbani; nave* involves the construction and running of a ship of 10,000 *modii* capacity to bring grain to Rome for six years; *aedificio* is to be connected with what we should loosely call warehouse construction and management for a specific period of time; and *pistrino* means the operation of a flour mill in the city for three years, processing 100 *modii* of grain per day.[63]

It would go beyond the limits of the archaeological investigations we have set ourselves to explore the ramifications for the perception of the Vestals and their activities caused by Trajan's reorganization of the *annona* and its association with Vesta. But we may note that it is from this date that the *pistores* become more visible in the offices of the Vestals.[64] The physical consequences for the old *area sacra* were dramatic: the former residence of the priestesses was demolished with care, as we have seen, and while the ground level of the first century B.C. was maintained in the precinct, its open space was apparently somewhat reduced. The travertine paving showed its orientation to the cardinal points as before, and the round temple kept its location and orientation as well. And although they were now on the axis of the new wing, a stair and corridor still ran up from behind the temple on the south to maintain the essential communication between temple and *domus.*

Measured against the great Trajanic construction, the temple precinct by itself seems completely overwhelmed.[65] Yet it could still be read satisfactorily in combination with the Regia standing to the north, its setting still guaranteed by the pattern of isolating streets. At this time the two areas became spatially comparable, as they had always been in orientation and function. The sense of scruple toward remote antiquity was not compromised after all.[66]

I am well aware that this account of our work does not square with much that is contained in Van Deman's book, *The Atrium Vestae,* which, as we have seen, has found its place in the literature dealing with the archaeology of ancient Rome. Nor does my account agree with some of the brief remarks made by Boni about the results of his excavations in the precinct of Vesta at the turn of the century. Lest my own remarks be read as ad hominem, let me urge the following considerations.

First, the history of the temple has yet to be reinvestigated, and many of the hypothesized interventions in the *area sacra* of Vesta with which assorted emperors in the first three centuries of the empire have been credited have to date been evidenced only by representations of the temple in their coinages.

Second, the work of Van Deman remains important precisely because it exists. Boni became early on a prisoner of his own extraordinary vision of an ancient Rome that he was determined to see realized in the context of the still evolving postantique city, and while he dug much, he published little. Few of those to whom he gave responsibility for supervising excavations did either. Van Deman's work remains valuable in consequence as a record of what was being done in those heady days; its limitations derive both from the state of the discipline at the time and, to an extent, from the restrictions that were imposed on her by his authority.[67]

I should also point out, however, that the major periods of development of the site for which I believe we now have good evidence in no way stand apart from the other historical sources that document the fortunes of ancient Rome and its people over time. That is to say, there is a close correspondence between the stages of physical evolution of the *area sacra* of Vesta and conspicuous moments of affirmation or reaffirmation of particular cultural traditions. Such moments may be those of the late monarchy and the nascent republic, or those of the aftermath of the Second Punic War (when the Vestals themselves took on heightened political relief in the city), or those associated with the political fragmentation of the first century B.C., or finally those of the empire at its zenith under the *optimus princeps* (which, as regards Vesta, were to be invoked anew in the third and fourth centuries, as the statues and inscribed pedestals that have been set up in the courtyard of the Trajanic building remind us).[68]

To some this melding of literary tradition and archaeological evidence may seem at best unscientific and at worst irresponsible. After all, as Nicholas Purcell has written, "the cautious would still like an answer to the old query, 'How did the Romans of the period represented by Roman literature know . . . so much about what had happened four or five centuries previously?'" He rightly goes on to observe that the most eloquent texts about the origins of the city available to the Romans of the middle and late republic should have been "the terracotta-clad buildings themselves, their interrelationships, and the rites that articulated them." It is the *interpretatio Romana*, or the exegetical tradition about the physical remains and the rites that bothers him, I think, as it has others from antiquity onward.[69]

Now our excavations at the site of the sanctuary area of Vesta and the Regia seem to show that the Romans remained for some centuries profoundly attached to the earliest remains that can be taken to attest the performance of religious cult there following the removal of huts in the seventh century and went to considerable trouble to save that early imprint. But it does not seem to me sufficient to invoke mechanical religious conservatism by an elite as the explanation for the phenomenon in the long run. The "exegetical tradition" about the antiquity of the cult of Vesta and its importance for the survival of the community must have its place here, too, and that tradition is no more static than the physical remains themselves. The dynamics of development for both are rather to be sought in the course of Roman history, a record of growth and change that in its variety can only be known imperfectly.[70]

No one perceived this better than the scholar this volume honors; nor can anyone now working in Rome fail to appreciate the importance of his example for summoning archaeologists and historians to return to work together in the heart of the ancient city.

NOTES

1. Ernest Nash, *Pictorial Dictionary of Ancient Rome*, 2d rev. ed., 2 vols. (New York and Washington, 1961–1962), 1:154.

2. Esther B. Van Deman, *The Atrium Vestae* (Washington, 1909); Herbert Bloch, "I bolli laterizi e la storia edilizia romana," *BullCom* 64 (1936), 141–225.

3. See David Whitehouse, "The Future of Ancient Rome," *Antiquity* 57 (1983), 38–44.

4. See the volumes published by the archaeological superintendency, *Roma: Archeologia nel centro 1: L'area archeologica centrale*, and *Roma: Archeologia nel centro 2: La città murata* (Rome, 1985).

5. Our debts and obligations are already numerous. In the archaeological superintendency for Rome, we acknowledge gratefully the encouragement and support willingly given to the project by Adriano La Regina, Irene Iacopi, and Giovanna Tedone. Likewise it would not have been possible for the project to go forward without the material support of the Samuel H. Kress Foundation and the American Express Foundation, to whose enlightened officers in New York, especially Marilyn Perry, president of the Kress Foundation, and Stephen Halsey, president of the American Express Foundation, go profound thanks. In Rome the constant support of American Express, Italy, through the good offices of division head Alberto Rossi and director for external affairs Isabella Cordero di Montezemolo, has been invaluable. To the officers and trustees of the American Academy in Rome go particular thanks for their commitment to archaeology in the life of the academy; and to the Fellows and visiting members of the academy, who have done all the work of these past seasons with enthusiasm and good humor, gratias quam maximas ago, habeo.

6. See Frank E. Brown, "Of Huts and Houses," in *In Memoriam Otto J. Brendel: Essays in Archaeology and the Humanities*, ed. Larissa Bonfante and Helga von Heintze (Mainz, 1976), 5–12. Russell T. Scott, "Regia-Vesta 1987," *Archeologia laziale* 9, 18–23.

7. The variations in mean elevation for the huts in the sample are 12.95 m above sea level (asl) to 10.50 m asl from south to north and 11.60 m asl to 11.90 m asl from west to east. The pebble street in the excavated tract rises from 11.80 m asl to 12.21 m asl from west to east.

8. See Frank E. Brown, "La protostoria della Regia," *RendPontAcc* 47 (1974–1975), 15–36, especially 19; Scott 1988, 23, n. 12.

9. See Giovanni Colonna, "I latini e gli altri populi del Lazio," in *Italia omnium terrarum alumna* (Milan, 1988), 411–528, especially 450–451.

10. The analysis of the botanical remains from the excavations continues to be done by Lorenzo Costantini of the Istituto Italiano per il Medio ed Estremo Oriente, Rome, and John Giorgi of the Museum of the City of London. The sample to which reference is made in the text is still being sorted quantitatively, but the spectrum of cereals and fruits already distinguished suits the integrated agricultural system attested for Etruria and Latium in the orientalizing period (Latial IV A).

11. See Filippo Coarelli, "Il Comizio dalle origini alla fine della repubblica: Cronologia e topografia," *PP* 32 (1977), 166–258; Brown 1976, 10; Inge Nielsen and Jan Zahle, "The Temple of Castor and Pollux on the Roman Forum: Preliminary Report on the Scandinavian Excavations 1983–1985 (1)," *ActaArch* 56 (1985), 1–29, especially 9–13. Andrea Carandini presented a preliminary account of his excavations on the Clivus Palatinus at the symposium dedicated to Frank Brown held in Rome on 6 June 1989, which will appear in expanded form in the new series *Bollettino di Archeologia* of the Ministero per Beni Culturali e Ambientali.

12. Frank E. Brown and Russell T. Scott, "La Regia nel Foro Romano," in *Case e palazzi d'Etruria* (Milan, 1985), 186–188. For the decorations of the last two of these buildings, see Susan B. Downey, *Architectural Terracottas from the Regia*, in press. For the Lacus Iuturnae, see Eva Margareta Steinby, "Lacus Iuturnae 1982–1983," in *Roma: Archeologia nel centro 1: L'area archeologica centrale* (Rome, 1985), 73–91, especially 82–83.

13. Alfonso Bartoli, "I pozzi nell'area sacra di Vesta," *MonAnt* 45 (1959), 1–68; Einar Gjerstad, *Early Rome 3: Fortifications, Domestic Architecture, Sanctuaries, Stratigraphic Excavations* (Lund, 1960), 359–374.

14. The paving slabs of the sidewalk of the new street, on which the south wall of the Regia building of the end of the sixth century B.C. is partly footed, are at 12.40–12.54 m asl. The width of the street from its southern curb to the margins of the sidewalk is 2.45 m.

15. See, for example, Carmine Ampolo, "La nascità della città," in *Storia di Roma 1: Roma in Italia* (Turin, 1988), 153–180, especially 156–157. The earliest dedication to Vesta found in excavations to date is the graffito *VIS* scratched on the foot of a plate in *bucchero pesante* that has recently been dated to the second half of the sixth century B.C. See Giovanni Colonna, "Appendice: Le iscrizioni strumentali latine del 6 e 5 secolo a.Cr.," in Conrad Stibbe et alia, *Lapis Satricanus: Archaeological, Epigraphical, Linguistic and Historical Aspects of the New Inscription from Satricum* (Dutch Archaeological Institute in Rome, Scripta Minora, 5; Rome, 1980), 55–56. The fragment in question comes from Boni's excavations in the precinct, more precisely from the area of what he termed a sacrificial deposit between the foundations of the round temple and the northeast corner of the ramp to the Palatine on the southwest: Giacomo Boni, "Il sacrario di Vesta," *NSc* (1900), 172–183. The chronological limits of this deposit have yet to be established. Colonna reads *VIS* as equivalent to *VES[tai]*.

16. Figure 8 reproduces the 1903 plan of Boni's excavation by the architect Leonardo Paterna Baldizzi.

On it the *cappellaccio* outcropping is visible at two o'clock in the octagonal fountain in the center of the court. Additional paving slabs are visible running east-west to either side of the westernmost basin. They average 0.68 m–0.70 m x 0.55 m–0.58 m. They are 0.15 m–0.18 m thick. See also Gianfilippo Carettoni, "La Domus Virginum Vestalium e la Domus Publica del periodo repubblicano," *RendPontAcc* 51–52 (1978–1980), 325–355.

17. The wellhead, somewhat jostled, is at about 13.55 m asl. The *cappellaccio* blocks and the paving flags have subsided over time (and in consequence of Bartoli's work in the area in 1930) and are now at 14.23 m asl. Even so, the elevation compares favorably with the general surface level estimated for the precinct after the rebuilding in the late third and early second centuries B.C.: about 14.30 m asl with some slope from south to north and east to west.

18. Brown 1976, 11–12: "Once, after damage by fire, the whole building was somewhat enlarged. Not only was the archaic plan maintained, the archaic foundations were reverently conserved wherever possible beneath or beside the new. Moreover it was made evident to all who entered that the old building had been incapsulated in the new. Into the brown tufa pavements of the new building were let strips of the grey tufa of the old, so as to mark the outlines of the former rooms." The reference is to the lines of walls and floor slabs set into the east room of the Regia, probably the shrine of Ops Consiva.

19. The extremely narrow draw-shaft opening of the well (diam. 0.45 m) made its excavation in a conventional fashion impossible, so resort was made to boring. The narrow opening was intended to draw the water feeding the well as high as possible, and once it had been cleared, water returned. At the bottom, in breccia at 7.40 m asl, there was a small fragment of a revetment plaque in terra-cotta in the fabric of the decorations of the third building that preceded the historical Regia.

20. Frank E. Brown, "New Soundings in the Regia," *Les origines de la république romaine: Entretiens de la fondation Hardt pour l'étude de l'antiquité classique* 13 (1967), 55. Note, however, that the road dividing the Regia from Vesta at the end of the sixth century was narrower than its predecessor, whereas its successor of the late third and early second centuries B.C. seems to have exceeded the standard width for the period (12 Roman feet).

21. Carettoni 1978–1980, 328.

22. "In the orientation of monuments of that period . . . the supremacy of the religious formalism of the Etruscans over the practical sense of the Romans is clearly evident" (Esther B. Van Deman, "The Neronian Sacra Via," *AJA* 27 [1923], 383–424, quotation on 389). See also Ferdinando Castagnoli, "Topografia romana e tradizione storiografica su Roma arcaica," *ArchCl* 25–26 (1973–1974), 121–131. Without in the least wishing to resuscitate the "reality" of *Roma quadrata*, which Castagnoli to my mind has persuasively argued may be connected in a general sense with the rise of Roman colonization

from the late fourth century onward, I must point out that the antiquarian tradition about *Roma quadrata* already existed in the second century B.C. and could very well have been based on such operations as those we have seen went on then in the *area sacra* of Vesta and the Regia, and in the construction of the ramp to the Palatine to preserve the orientation to the cardinal points of earlier structures on the lower slope of the hill. In the sequel it would not have required much imagination to project such a configuration onto the Palatine itself and so still further back in time to Romulus, the first practitioner of augural science in connection with the layout of a settlement.

23. For appreciations see, among others, Esther B. Van Deman, *The Atrium Vestae* (Washington, 1909), 9–14; Erik Welin, *Studien zur Topographie des Forum Romanum* (Acta Instituti Romani Regni Sueciae, 6; Lund, 1953), 210–215; Filippo Coarelli, *Il Foro Romano: Periodo arcaico* (Rome, 1983), 56–57.

24. See Filippo Coarelli, *Il Foro Romano: Periodo repubblicano e augusteo* (Rome, 1985), 125–166; Eva Margareta Steinby, "Il lato orientale del Foro Romano: Proposte di lettura," *Arctos* 21 (1987), 139–184.

25. See Carettoni 1978–1980, 325–355. It is a striking fact that, while remains of mid-republican and later date have been visible in the area since the time of Lanciani, the progress of archaeology along the slopes of the Palatine toward the forum has been fitful at best until the past decade, and an adequate plan of the area remains a desideratum.

There is no official report on the excavations made between 1899 and 1901 on the south side of the Via Sacra, nor are they mentioned in the unpublished notebooks of Boni. See Domenico Palombi, "Contributo alla topografia della via sacra, dagli appunti inediti di Giacomo Boni," *QITA* 10 (1988), 77, n. 1. In 1947 Giuseppe Lugli wrote as follows, "È stata trascurata tutta la *facies* delle pendici del Palatino nell'età repubblicana che sono così ricche di avanzi. Nella zona fra la casa delle Vestali e l'arco di Tito, anzichè scavare, si e fatta alcuni anni fa una colmata che ha tutto ricoperto e livellato, senza neppure riprenderne la pianta." (Giuseppe Lugli, *Monumenti minori del Foro Romano* [Rome, 1947], vii). But see Andrea Carandini, "*Domus* e *insulae* sulla pendice settentrionale del Palatino," and Carandini and others, "Pendici settentrionali del Palatino," *BullCom* 91 (1986), 263–273 and 429–438.

26. For the construction of the ramp, see Steinby 1985, 73–91.

27. On the Via Nova see Maria Antonietta Tomei, "Ambienti tra la via Nova e clivo Palatino," *BullCom* 91 (1986), 411–416.

28. This area was also examined in the excavation seasons of 1990 and 1991. A report is forthcoming in *Belletino di Archeologia*.

29. The width of the street, including the drain along its south side, is something over 13 Roman feet (3.90 m–4.10 m). In part reconsolidated by Boni, it is the last in the series of streets between the Regia and Vesta to survive Boni's excavations, although the

level of the next street in the sequence, that of the first century B.C., can be calculated by reference to the north precinct wall of Vesta of that date, which is still preserved.

30. To the modern viewer this wall presents a somewhat patched-up appearance, which might be attributed to further consolidation work by Boni but in the opinion of Rodolfo Lanciani seemed connected with the robbing of blocks and other materials of spoil from the area of the Regia, Vesta, and the temple of the Castors that went on with some regularity in the 1540s. See Rodolfo Lanciani, *Storia degli scavi di Roma* (Rome, 1903), 196–203. In a caption to a photograph of a portion of this wall, Boni reported that it was rendered with a coat of fine white plaster: Giacomo Boni, "Il sacrario di Vesta," *NSc* (1900), 184, fig. 41.

31. Van Deman 1909, 1, 9–14.

32. The elevation of the courtyard is at 15.50 m–15.55 m asl; the floors of the rooms at the rear are some 0.10 m higher.

33. The situation of the courtyard is different from that in the Regia, which was always open to the sky and collected rainwater in open runoff drains. The courtyard in the Atrium Vestae had a fine lithostratum paving of which sufficient remains exist to suggest that the courtyard was mostly covered and may have had the compluvium-impluvium arrangement characteristic of an atrium. A drain that may, when first built, have been connected with such a system was discovered in 1899, but was later lost to view. We located it in 1990. See Guglielmo Gatti, "Notiziario," *NSc* (1899), 50. Russell T. Scott, "Lavori e ricerche nell'area sacra di Vesta 1990–1991," *Archeologia Laziale* XI (1993), 11–17.

34. See for example Livy, 26.27.1–4, 14.

35. For the burning of the temple in 241, see Livy, *Periocha* 19. "Cum templum Vestae arderet, Caecilius Metellus, pontifex maximus, ex incendio sacra rapuit." See also fragment 2a of book 1 of Varro's *Antiquitates rerum divinarum*, ed. Reinhold Agahd (Leipzig, 1898). On L. Cassius Longinus Ravilla, see Jane M. Cody, "The Coins of the Cassii" (Ph.D. diss., Bryn Mawr College, 1968), 10–11, 124–148.

36. The paving stones of the first-century street have not survived into the modern era, but its approximate elevation can be calculated by reference to the closed subsurface drain built against the offset of the new north precinct wall and the elevation of the entrance to the Regia of first-century date opposite. See Frank E. Brown, "The Regia," *MAAR* 12 (1935), 79–82, 85–86.

37. Despite his own disclaimers, the discussion by Coarelli remains substantial and important: Coarelli 1985, 125–219. For the central area of the forum, see Cairoli Fulvio Giuliani and Patrizia Verduchi, *L'area centrale del Foro Romano* (Florence, 1987).

38. The scientific analysis of the offering was again made by Costantini and Giorgi. The organic remains were of young olives, pine nuts and scales, fine bread wheat, and other cereal grains, which had been exposed to intense heat.

39. The replacement vessel contained a bronze coin, a comparatively rare issue of Drusus Caesar of A.D. 22–23, for the identification of which I am grateful to Theodore Buttrey of the Fitzwilliam Museum, Cambridge University. See further Harold Mattingly, *Coins of the Roman Empire in the British Museum*, 2 vols. (Oxford, 1923), 1:134, no. 99.

40. For the *futis* see *Thesaurus linguae latinae* 6.1.1661–1662. (The form *futilis* is also attested from Servius on *Aeneid* 11.339.) Gloss: "futis: quoddam vas in templo Vestae, ubi reponebantur quaedam sacrificia." The tippy shape of the vessel is also conveyed by the following gloss: "Futis: vas lato ore, fundo angusto."

41. Jean-Paul Morel has dated the latest contents of the republican well in the precinct to the mid-first century B.C. See his *Céramique à vernis noir du forum romain et du palatin, MélRome*, suppl. 3; (Rome, 1965), 74–85.

42. John Henry Middleton, "The Temple and Atrium of Vesta and the Regia," *Archaeologia* 49 (1886), 391–423.

43. The elevation toward the south end of the gutter as preserved is 15.49 m asl.

44. See Esther B. Van Deman, "The Neronian Sacra Via," *AJA* 27 (1923), 383–424. But see Susanna Buranelli LePera and Luca D'Elia, "'Sacra via': Note topografiche," *BullCom* 91 (1986), 241–262, particularly 258–262, for criticism of the view that the Neronian constructions functioned as monumental approaches to the Golden House.

45. The Regia underwent further modification as well at this time. See Brown 1935, 79–82; Welin 1953, 60–64.

46. Esther B. Van Deman, "Methods of Determining the Date of Roman Concrete Monuments," *AJA* 16 (1912), 387–432, especially 393. The text of Cassius Dio (54.24.2) that she cites in support of the idea that the fire of 14 B.C. destroyed the Temple of Vesta says no such thing; the historian goes on to specify the rebuilding of structures damaged by the fire "by Augustus and the friends of Paulus," a passage in which there is no mention of the area of Vesta. See also Pierre Gros, *Aurea templa, BEFAR* 231 (1976), 20, n. 46.

47. Cassius Dio, 54.27.

48. Attilio DeGrassi, "Esistette sul palatino un tempio di Vesta?" *RM* 62 (1955), 144–154, especially 152–153. For Vesta on the Palatine, see Russell T. Scott, "Providentia Aug.," *Historia* 31 (1982), 436–459, especially 458–459.

49. Suetonius, *Julius* 47; Pliny, *Nat. Hist.* 19.1.23.

50. On Varro's dedication of the *Antiquitates rerum divinarum* to Caesar, see Stefan Weinstock, *Divus Julius* (Oxford, 1971), 180–182; for Caesar's picture of his enemies, see *Civil War* 3.82–83.

It is also possible that this contestation is reflected in the only other pre-imperial representation of the Temple of Vesta, on coins issued in 49–48 by one of Caesar's colleagues in the pontifical college, C. Fannius, who was at the time, however, his bitter opponent and Pompeian propraetor in command of Asia.

His titles of pontifex and praetor appear on cistophori minted at Ephesus, Tralles, and Laodicea, which also have the representation of the round temple. See Thomas R. S. Broughton, *The Magistrates of the Roman Republic*, 2 vols. (New York, 1952), 262; Lily R. Taylor, "Caesar's Colleagues in the Pontifical College," *AJP* 63 (1942), 385–412, especially 398; on Fannius, Cody 1968, 119–124.

In a previous generation Lucius Cornelius Sulla, with an unusual gold issue struck in Asia in 84–83, had made explicit reference to his augurate (of which he had been deprived by his enemies during his absence from Rome). In consequence Fannius' assertion of his priesthood in Rome from the same area is not so unusual as it might appear at first glance. See Bruce W. Frier, "Sulla's Priesthood," *Arethusa* 2 (1969), 187–199 with bibliography.

But the explicit representation of the Temple of Vesta ought not to call to mind *a* pontifex, but *the* pontifex maximus, who at the time was, of course, Caesar. Inasmuch as the staunch conservative Fannius was among the leading Pompeians, I think he might well have been making a claim for consideration to succeed Caesar with these issues.

51. See Gianfilippo Carettoni, "Le gallerie ipogee del Foro Romano e i ludi gladiatorii forensi," *BullCom* 76 (1956–1958), 23–44; Nino Lamboglia, "Uno scavo didattico dietro la 'Curia Senatus' e la topografia del Foro di Cesare," *RendPontAcc* 37 (1964–1965), 105–126; Lamboglia, "Prime conclusioni sugli scavi nel Foro di Cesare dietro la Curia (1960–1970)," *Quadernos de trabajo de la escuela española in Roma* 14 (1980), 123–124. See also, in general, Coarelli 1985, 233–237.

52. Herbert Bloch, "I bolli laterizi e la storia edilizia romana," *BullCom* 64 (1936), 141–225; 65 (1937), 83–187; 66 (1938), 61–221.

53. Bloch 1936, 207–225.

54. Bloch 1936, 224–225. The numbering of rooms is after Van Deman.

55. For the same reasons it was unfortunately not possible to carry out photography or to execute casts of the stamps successfully. They are found on the undersides of upper hypocaust tiles. The transcriptions follow, with references to Dressel/Bloch numbers in parentheses: (1) P. RAIV/EX PRAEDISAN (822); (2) (on tile overlying no. 1) EX FIGLIN MACEDONIANIS (281); (3) EX FIGLI; (4) NTONAE MANL (822); (5) C. CESENVS CLEMEN/EX FIGLIN MACEDONIANIS (285). The sixth stamp visible was broken and illegible; a seventh, which presumably comes from the same floor, was reset face up in a later modification of the room that despoiled approximately half of the original floor. It reads: L. LVRIVS PROCVLVS (1253b).

56. The stamps are on the undersides of the upper tiles of the floor, which has largely been destroyed. It was possible to make casts of them, and I am grateful to the restorers of the Soprintendenza Archeologica di Roma for their willing cooperation. The transcriptions follow, with references to Dressel/Bloch numbers in parentheses: (1) DOMITIA RES[TI]TVTA (1126); (2) DOLANTEROT.SEV [ERIANUS] (8111); (3) CN DOM [ITI] [E]VARISTI (1096); (4) (broken top tile) CN DOMITI EVARISTI (1096). Nos. 1 and 2 are Trajanic/Hadrianic, 3 and 4 late Flavian.

57. "Adhuc Romae a Domitiano coepta forum atque alia multa plusquam magnifice coluit, ornavitque [sc. Traianus] et annonae perpetuae mire consultum reperto firmatoque pistorum collegio" (Aurelius Victor, *On the Caesars* 13.5.)

58. See Steinby 1985, 78–80; Henry Hurst, "Nuovi scavi nell'area di Santa Maria Antiqua," *Archeologia laziale* 9 (1985), 13–17; Hurst, "Area di S. Maria Antiqua," *BullCom* 91 (1986), 470–478. Our exploration of a rebuilt drain in the vicinity of the northern end of the ramp revealed a stamp of M. Allius Clemens (989), while in the area of the connecting stairs to its elevated southern end a drain contained a stamp of Arignotus (1094), and a hypocaust floor nearby contained one of Greius Ianuarius (118a) now displayed on the west wall of the room. All three stamps are common in the late Flavian period. See Bloch 1936, 217.

59. On the coinage see Paul Strack, *Untersuchungen zur römischen Reichsprägung des zweiten Jahrhunderts* 1 (Stuttgart, 1931), 72–75, 185–190; compare Bloch 1936, 222–225. See also Pliny, *Panegyric* 26–29, and the passage of Aurelius Victor quoted above, note 57.

60. In the valuable series of articles gathered in *The Seaborne Commerce of Ancient Rome: Studies in Archaeology and History*, *MAAR* 36 (1980), ed. John H. D'Arms and E. Christian Kopff, see especially Ferdinando Castagnoli, "Installazioni portuali a Roma," 35–42; Antonio Maria Colini, "Il porto fluviale del Foro Boario a Roma," 43–51; Silvio Panciera, "Olearii," 230–250; and Geoffrey Rickman, "The Grain Trade under the Roman Empire," 261–275.

61. Plautus, *Capt.* 795, is a useful reference. The area on the south side of the forum toward the Forum Boarium and the river has the millers and bakers (who also feed pigs), whereas the fish market is situated to the north of the forum. It is not clear, however, that there is a reminiscence of the Plautine situation in the late reference in the Regionary catalogue to a *forum pistorum* in Reg. XIII. See Otto Richter, *Topographie der Stadt Rom* (Munich, 1901), 380; Platner-Ashby, 231.

62. Ulpian, 3.1. Other sources are Gaius, 1.34; and the *Fragmenta Vaticana* 233–238.

63. The role the *pistores* could play is attested from the time of Augustus in the monument of Marcus Virgilius Eurysaces, *pistor et redemptor*, on which see Paola Ciancio Rossetto, *I monumenti romani* 5,

Il sepolcro del fornaio Marco Virgilio Eurisace a pta. Maggiore (Rome, 1973). A relief panel from the Arch of Trajan at Benevento, a generic celebration of the virtues of the princeps, very likely represents a group of these agents of the annona. Like Eurysaces, they are shown togate, as befits their citizen status, receiving the congratulations of the emperor in the Forum Boarium. In addition to the studies of Ferdinando Castagnoli and Antonio Maria Colini cited above, note 60, see Filippo Coarelli, *Il Foro Boario* (Rome, 1988), 197.

64. On the emergence of the *fictores* of Vesta, see Georg Wissowa, *Religion und Kultus der Römer*, 2d ed. (Munich, 1912), 518–519.

65. This has been well expressed by Henri Jordan, *Der Tempel der Vesta und das Haus der Vestalinnen* (Berlin, 1886), 36–38, although he favored a Hadrianic date for the complex as then known.

66. Brown's detailed studies of the Regia finished with the Calvinian rebuilding of 36 B.C. In its vicinity in the empire there would have been the schola of the Kalatores Pontificum et Flaminum, who made a dedication to Trajan in 101–102 in witness to some interest manifested by him in the area of Vesta and the Regia overall: *CIL* 6.2184a, b. Many of the names of the *kalatores* and *fictores* figuring in the inscription are of freedman origin, like those of the *fictores* of Vesta. See Lanciani 1903, 200; and Brown 1935, 80.

It was Jordan's opinion that the raised lip in the travertine paving running due north and south, if projected throughout the precinct, would have been in line with the northwest side of the entrance to it from the Via Sacra and so would have oriented those entering directly toward the stairs leading up into the peristyle of the Trajanic building at its northwest corner; the subsequent placement of the aedicula of Hadrian may support this. By the same token, its projection northward beyond the entrance would have carried one naturally to the Regia. Although it is not possible to determine just how the lip in the pavement would have been read in the time of Trajan, two interpretations suggest themselves for the first century B.C. One is that it helped the natural line of drainage from south to north in the precinct, the other is that it marked the existence of features from the previous phase of development that were suppressed at that time. These alternatives are not mutually exclusive. See Jordan 1886, 59.

67. For appreciations of Van Deman, see most recently Karin Einaudi, "Esther Van Deman and the Roman Forum," *Places* 5 (1988), 62–70; and Antonio Maria Colini, "Esther Boise Van Deman," *BullCom* 66 (1938), 323–324. On Boni, see Gianfilippo Carettoni, "Giacomo Boni nel cinquantenario della sua scomparsa," *StRom* 24 (1976), 49–56.

68. For Vesta and the Vestals, see in general Carl Koch, "Vesta," in *RE* 6.8.A.2, cols. 1717–1776; Angelo Brelich, *Vesta, Albae Vigiliae* 7 (1949). By periods see Hildebrand Hommel, "Vesta und die frühömische Religion," in *ANRW*, 1:397–420; Francesco Guizzi, *Aspetti giuridici del sacerdozio romano: Il sacerdozio di Vesta* (Naples, 1968); Arthur Darby Nock, "*A Dis Electa*: A Chapter in the Religious History of the Third Century," *HThR* 23 (1930), 251–274. For the discovery of the statues of Vestals and the inscribed bases of the third and fourth centuries A.D. in 1497, see Rodolfo Lanciani, *NSc* (1882), 231–232.

69. Nicholas Purcell, "Rediscovering the Roman Forum," *Journal of Roman Archaeology* 2 (1989), 155–166.

70. Jacques Poucet, *Les origines de Rome: Tradition et histoire* (Brussels, 1985).

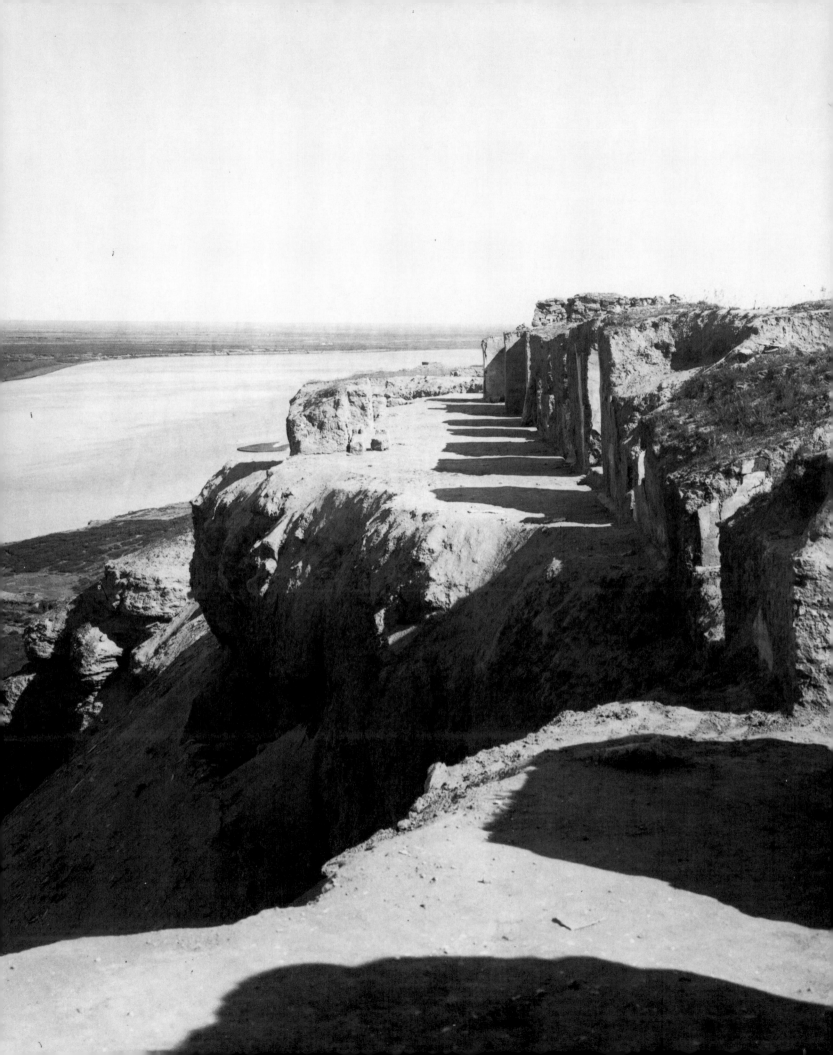

SUSAN B. DOWNEY

University of California, Los Angeles

The Palace of the Dux Ripae at Dura-Europos and "Palatial" Architecture of Late Antiquity

The Palace of the Dux Ripae at Dura-Europos has a dramatic location on the bluff overlooking the Euphrates in the northern section of the city. Its identification as the official residence of a Roman military commander in charge of the troops on the Euphrates is based on *dipinti* naming one Domitianus Pompeianus, Dux Ripae.[1] A *dipinto* that has been restored as containing the name and filiation of Elagabalus (ruled A.D. 218–222) gives a terminus ante quem for the construction.[2] The palace is one of a small number of buildings in the Roman Empire that can be identified with fair certainty as an official residence;[3] this fact, coupled with the relatively precise dating, confers on the structure an important place in the history of late Roman architecture.

The Palace of the Dux Ripae was excavated in 1935–1936 by Du Mesnil du Buisson; the plan was drawn by A. Henry Detweiler, who also published a description of the building, along with an interpretive study by Rostovtzeff, in 1952 as part of volume 9, part 3 of the *Preliminary Reports on the Excavations at Dura-Europos*.[4] New evidence provided by cleaning in April–May 1988 under the auspices of the joint Franco-Syrian mission to Dura-Europos shows that the accepted reconstruction of the building needs to be modified.[5] In this essay, I will first discuss the new evidence and then present a comparative study.[6]

New Evidence

The palace appears to be divided into two sections, one largely official, the other primarily residential. As was noted in the excavation report, the building is organized around two peristyle courts (fig. 1).[7] Court 58, on the southeast side, provided the main entrance from the city and probably served largely for public functions. Rostovtzeff compares the court to the principia of Roman camps but states that it differs from principia in having only one exedra (59), rather than several surrounding rooms.[8] Superficial study suggests that Detweiler's tidy plan omitted some remains, clearly visible in aerial photographs taken in March 1936 (fig. 2) and still to be seen on the ground today. To the east of Exedra 59 are the remains of two rooms placed at an oblique angle to the palace. The differing orientation suggests that these rooms predated the construction of the palace, but because the walls, made of rubble masonry, are still preserved to a height of at least 1 m, it seems likely that they continued in use during at least part of the life of the palace. No traces of access remain, however, between these rooms and Court 58.

The residential areas of the building are arranged in a rectangle around Court 1. The most important unresolved questions about the palace concern the wing facing the river, which includes an imposing

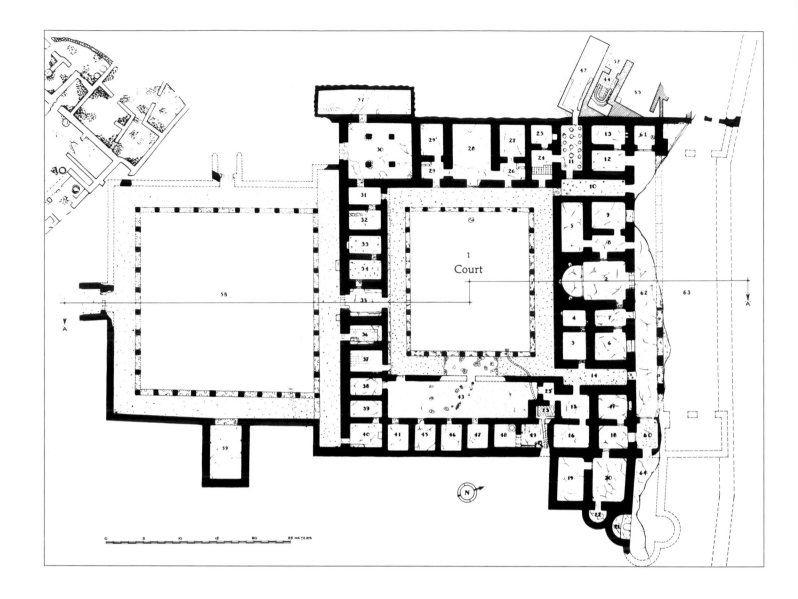

1. Palace of the Dux Ripae,
Dura-Europos, plan
Drawing by A. Henry Detweiler
Yale University Art Gallery,
Dura-Europos collection

suite of rooms centered on an apsidal room and opening onto a portico and a terrace; only small portions of the terrace remain (figs. 3, 4). The excavation report restored the terrace as extending out to the line of the city wall, which is missing in this sector.[9] Two rooms (19 and 20/22) and a paved area (64) with an apse (21) project from the northeastern corner of the rectangular block. The plan shows the rear (south) wall of Area 64 continuing for a short distance (1.80 m) to the east of Apse 21 before breaking off. The excavators used this wall stub to restore Area 64 as a triapsidal room opening onto an exedra (60) at the west.[10] In spite of the wholly conjectural character of two of the three apses, this room as restored has been

cited as an early instance of a type of reception room that became common in buildings of the late Empire.[11] Study at the site has raised serious questions about the restoration of Terrace 63 and its relation to the missing fortification wall, as well as about the form of Area 64. Unfortunately, so much of the river wing of the building has fallen into the Euphrates that certainty about its form is impossible. Furthermore, additional damage since the plan was drawn makes checking its accuracy difficult.

In their restoration of the badly destroyed Terrace 63, the excavators made use of two wall fragments shown in the upper left-hand corner of their plan (fig. 1), which they interpreted as belonging to the city wall; they argued that the city wall

2. Northeast corner of Dura-Europos, 1936, aerial view
Yale University Art Gallery,
Dura-Europos collection

also formed the outer wall of Terrace 63.[12] The plan accurately shows that these constructions are not aligned with the outer north-south wall of the palace, but it does not show that they are also at a much lower level (approximately 4 m) and are thus unlikely to be connected with it (fig. 4, lower right). The inner "wall fragment" is in fact a pier made of blocks of limestone with a coating of mortar; it is sepa-

rated by a doorway 0.81 m wide from a fragment of a wall constructed in blocks of gypsum with a great deal of mortar, a type of construction that does not occur in the palace. The relatively narrow thickness of this wall (1.20 m) suggests that it did not form part of the city wall. It might, however, be remains of a supporting terrace for either the palace or the bath next to it. The relationship of the palace to the fortification wall cannot be determined, in view of the complete destruction of the latter, but the wall is likely to have passed some distance to the north.[13]

The most substantial remaining portion of the terrace is its northwest corner, in front of Exedra 61. A fragment of an east-west wall (measurable length without excavation 1.35 m), which meets the end of the outer north-south wall of the palace at a right angle, is indicated on the published plan as belonging to the bath adjacent to the palace (fig. 1). This wall, however, forms a clear corner with the north-south wall and uses the same type of rubble construction; therefore, it belonged to the palace (fig. 5). It seems possible that this corner marks the outer line of Terrace 63. If so, the terrace would have been approximately 4 m

wide, rather than the 7.55 m postulated by the excavators (fig. 6). However, there are no indications that the line of this wall continued to the east. If the masonry pier and gypsum wall fragment are not part of the palace, there is no reason to restore a terrace with corner projections, as shown on

3. Palace of the Dux Ripae, Dura-Europos, at time of excavation in 1935–1936, view along Arcade 62 to east
Yale University Art Gallery, Dura-Europos collection

4. Palace of the Dux Ripae, Dura-Europos, 1988, view along Arcade 62 and Terrace 63 to west
Author photograph

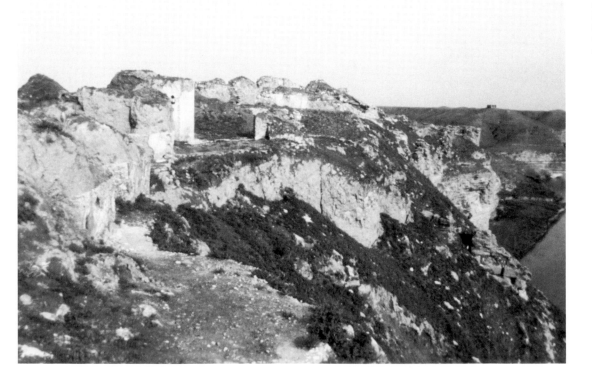

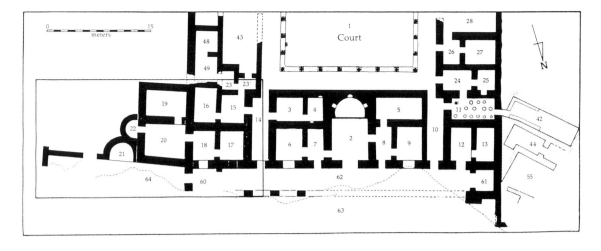

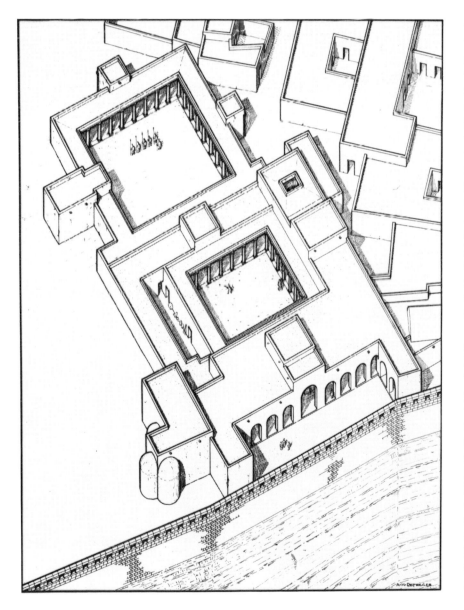

the 1952 published plan and reconstructions.[14] The southeast end of the terrace, already completely destroyed at the time of the excavation (fig. 7), was restored as roughly symmetrical with the northwestern end. Detweiler also drew an alternate reconstruction (fig. 8), which did not use the dubious wall fragments at the northwestern end.[15] This produced an asymmetrical river wing with a large rectangular room at the southeastern end, apparently enclosing Area 64, Rooms 19 and 20, and Apses 21 and 22. At the northwestern end of the terrace he drew a narrow rectangular room placed obliquely to the rest of the building; this reconstruction eliminates Exedra 61 at the west end of the terrace, the walls of which still stand to a considerable height.

At the eastern end of Portico 62 the excavators restored an exedra (60), more or less symmetrical with Exedra 61 at the western end.[16] It is now destroyed, but photographs taken at the time of the excavation show that it did exist (fig. 7), though in a more ruined state than the corresponding room at the other end of the terrace.[17] The two rooms appear to have had a somewhat different character, however. Exedra 61, with its solid back wall, forms a clear terminus to the portico, whereas there appears to have been a door in the east wall of Exedra 60. Furthermore, the wall of Exedra 60 on the north side facing the river looks quite thin on the photograph, which suggests that it

may have been a secondary construction.

Close observation of construction techniques provides clear evidence of rebuilding, an indication that the entire block of rooms projecting from the eastern side of the rectangular residential section may be a later addition (fig. 9). The excavators noted that "the northeast wall of room 20 was oblique to the similar walls of the main mass of the building," but they attributed this obliquity, which also characterizes Room 19 and the wall stub beyond Apse 21, to the wall's having been laid out roughly parallel to the (missing) city wall.[18] The pier forming the eastern jamb of the doorway leading from Exedra 60 to Room 18 is made of rubble up to a height of c. 0.46 m and of mud brick above that. In contrast, the southeast pier of Exedra 60 consists of mud brick faced in plaster down to the level of the pavement (fig. 10), a type of construction also used in the wall between this pier and Apse 21; investigations did not go below the floor. The published plan accurately shows the southeast pier of Exedra 60 as larger than the southwest one (1.10 x 0.775 m, as opposed to 0.80 x 0.42 m); this discrepancy, together with the change in construction techniques, supports the hypothesis of secondary construction. Confirmatory evidence is found in a change in flooring material in Exedra 60 at about the edge of the pier, from plaster with inclusions of heavy pebbles to fine white plaster. The most striking evidence for the idea that the eastern suite is an addition, however, is provided by the treatment of the wall between Room 20 and Room 18. The mud brick in the northern end of this north-south wall was cut back by about 0.05 m, and its eastern face was constructed of much rougher mud brick (figs. 5, 9); all surfaces in this area also show that the plaster coating was applied in two stages. Furthermore, the western pier of the doorway between Rooms 20 and 19, constructed in rubble, does not bond with the north-south wall shared between Rooms 18–16 and 20–19. The southwest corner of Room 19 has been destroyed down to the level of the foundations, but troweling suggests that the southern wall of that room does not

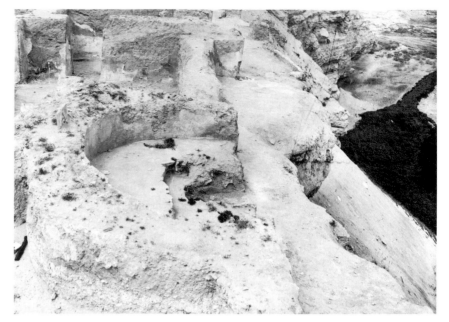

bond with the north-south wall either.

At Apse 21, the wall construction changes abruptly from mud brick cased in plaster to rubble, a type of construction also used for Apse 22 (fig. 7). The cleaning carried out in 1988 demonstrates that the south wall of Area 64, shown on the plan as continuing for only 1.80 m east of Apse 21, is broken through on the surface for a distance of 1.85 m (fig. 11) but then continues to the east for an additional 4.20 m after the break (fig. 12), where it is met by a cross wall. This east-west wall, preserved to a maximum height of 0.41 m, is quite deeply founded and was constructed of rubble mixed with plaster, in the form both of large chunks and of fragments of fine wall or floor plaster—an indication that it was made in part of reused material, probably from the demolition of earlier structures in the area. Remains of such structures, most notably a heavy pavement of plaster mixed with stones, were clearly visible in the section where the wall was broken through (fig. 12). Other traces of earlier structures in the area include part of a mud brick wall in the section of the excavation closest to the river. Finding several traces of earlier structures in such a small area raises questions about whether this part of the city really was largely empty before the Roman period, as has sometimes been assumed.[19]

7. Palace of the Dux Ripae, Dura-Europos, at time of excavation in 1935–1936: Apse 21, Room 20, Area 64, and Exedra 60
Yale University Art Gallery, Dura-Europos collection

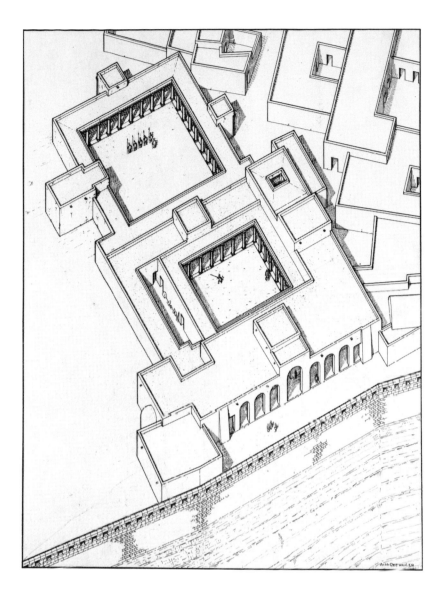

The area in front of the newly cleaned portion of the east-west wall was paved with fine white plaster like that used for the flooring of Area 64 (fig. 12). In addition, substantial remains of wall plaster painted with panels of bright colors—predominantly red and yellow, sometimes with black or white stripes—were found along the whole length of the wall, including its corner with the cross wall (fig. 13). Some fragments of unbaked brick adhering to the plaster show that the wall, like many in the palace, was constructed of mud brick above the rubble socle. Heavy inclusions of charcoal in the debris and abundant traces of burning on the plaster show that this part of the building at least was destroyed by fire.

The fine white plaster floor and the presence of colored plaster on the walls suggest that the area was covered. The floor is preserved to a maximum north-south width of 1.90 m. Since the width of Portico 62, measured from the north wall of the rooms to the inner face of the piers, is 2.85 m, it seems reasonable to suggest that the portico continued in front of the newly discovered section of wall, forming a long, narrow corridor with an apse facing the river. The east-west length of the added section, measured from the south-eastern pier of Exedra 60 to the new north-south cross wall on the east, would be approximately 18.68 m. This corre-

8. Palace of the Dux Ripae, Dura-Europos, isometric reconstruction. alternate version
Drawing by A. Henry Detweiler
Yale University Art Gallery, Dura-Europos collection

9. Eastern part of river wing of Palace of the Dux Ripae, Dura-Europos, isometric drawing showing construction techniques
Drawing by Tim Seymour

sponds remarkably well to the calculation
of 18.60 m published in the excavation
report for the length of the room or corri-
dor to be restored if Apse 21 were inter-
preted as a central feature rather than as
one of three apses.[20]

The north-south cross wall connected
to the east-west continuation of the south
wall of Area 64 is the easternmost wall
that clearly formed part of the palace in
its expanded phase. Heavy rains in the
spring of 1988, however, revealed traces of
at least one additional wall farther to the
east and of others along the northeast side
of the palace. These walls probably were
not connected with the palace, but in the
absence of excavation their relationship to
the building cannot be determined.

Comparative Study

In his 1952 study, Rostovtzeff interpreted
the palace as a whole as combining a peri-
style intended for military use with a resi-
dential portion that included both a
peristyle section and a porticus villa.[21]
This description remains valid, though as

I have already pointed out, the new inves-
tigations have cast doubt on the recon-
struction of the latter as a porticus villa
with corner projections ("Portikusvilla
mit Eckrisaliten").[22]

Several features, including the use of the
Roman foot as a unit of measurement,[23]
set the building apart from local tradition
and suggest that it represents an intrusion
of imperial Roman architecture into Dura.
In plan the Dux Palace differs from other
houses on the site,[24] including large and
luxurious ones such as the House of the
Frescoes.[25] Even the house identified as
that of the Roman military commander
conforms in general to the local pattern.[26]
The fact that some important rooms in the
Dux Palace had ceilings consisting of false
vaults also suggests an attempt to imitate
Roman architectural traditions.[27]

Rostovtzeff noted parallels to the Dux
Palace in villas in the western provinces of
the Roman Empire, but he also drew much of
his comparative material from Pompeii and
Herculaneum,[28] and his comparisons
remain largely valid. In the years since the
publication of his interpretation, however,
knowledge of late antique villa and palace
architecture in the Roman world has in-
creased dramatically, and the excavations of
Apamea have revealed a large corpus of lux-
urious houses dating from the third through
the fifth centuries A.D. It is now possible to
situate the Dux Palace more accurately

12. View across cleaned area to east, Palace of the Dux Ripae, Dura-Europos, 1988, showing newly discovered wall and floor
Photograph: Mission franco-syrien de Doura-Europos

13. Fall of plaster in north-east corner of newly discovered wall, Palace of the Dux Ripae, Dura-Europos
Author photograph

within the development of domestic and palatial architecture.

To this end, I will discuss the residential sector of the Dux Palace as a whole, with particular attention to the suites that appear to have been designed as living and reception areas. The investigations of 1988 have demonstrated that in its original form the northern part of the palace consisted of a peristyle court with rooms disposed in a rectangle around it. The rooms on the south, west, and east are oriented toward the peristyle; those on the north open instead onto a portico facing the river. In its original form, the block appears to have included two suites, each consisting of a large central room flanked by subsidiary rooms: one on the west (Rooms 26–29') facing the peristyle; the other (Rooms 2, 5–9) on the north, centered on the prominent apsidal Room 2, with rooms opening onto the portico fronting the river.[29] The suite of rooms beside the peristyle is more accessible to the public than the one facing the river, though sinkings for a wooden grill in the opening from peristyle Court 1 into Room 28 suggest a desire to limit access. Two narrow corridors (10, 14), on the other hand, provide the only approach from Court 1 to Suite 2, 5–9. The suite forms a rectangle, with rooms disposed in an essentially symmetrical fashion around the apsidal central room, which is flanked on each side by two smaller rooms that originally opened onto the portico facing the river. The entire space behind the two smaller rooms on the west side (8, 9) con-

sists of a single room (5), which originally opened both onto Corridor 10 and onto Room 8 in front of it. The corresponding space on the other side is divided into two rooms (3, 4) that have no doors connecting them to the rest of the suite. The outer one (3) opens onto Corridor 14, while the inner room (4) is accessible only from Room 3. The latter is relatively luxurious, since it has a false vault;[30] nonetheless, the fact that the rooms are accessible only from Corridor 14 suggests that they may have served as guard rooms. In the original plan all of the rooms facing Portico 62 (2, 6–9) opened onto it, but subsequent modifications restricted access to the suite. The doors leading from the portico into Rooms 6 and 9 were converted into windows. The doorway from Corridor 10 into Room 5 was also blocked, so that Room 5 could be approached only indirectly.[31] With these modifications, the suite could be entered only by the three doors opening onto Portico 62 from the apsidal Room 2 and the two narrow rooms (7, 8) flanking it. The desire for security already evident in the provisions for limited access from Court 1 may have led to these modifications.

On the other side of Corridor 14, the doorway opening from Room 17 onto Portico 62 was also walled up, in this case completely, and shelves were built on the inside.[32] It seems probable that this closure was made in connection with the building of Rooms 19 and 20, Area 64, and Apses 21 and 22. With the new addition, Rooms 17 and 18, originally a two-room unit balancing a similar unit (12, 13) at the other end of Portico 62, became part of a new four-room suite that could be entered only through one doorway leading from Exedra 60 of the portico. All four rooms have false vaults. The new investigations have demonstrated that the triapsidal room originally considered to be part of this suite[33] cannot have existed, and that instead Area 64 probably was an open portico with a single apse (21) facing the river.

Thus the residential sector of the palace appears to have included three groups of relatively large rooms. All three suites are distinguished by having false vaults in plaster. In the west suite (26–29') a further distinction is made between the large central room (28), which was vaulted, and the side rooms, which were not. Vaults are also used in the two rooms and exedra at the west end of the portico facing the river (12, 13, 61) and in the long corridor (43) on the east side of Court 1. Of the three suites described above, two (26–29'; 2, 5–9) seem likely, by their placement and the disposition of their rooms, to have had a semi-official character; they may have been used for receptions. Unusually, the most luxurious suite (2, 5–9) faces away from the peristyle court and toward the river. This oddity is doubtless to be explained by a desire to take advantage of the view over the Euphrates. To the parallels for this arrangement, which I have listed elsewhere, can be added the building in Cologne identified as the praetorium of the city; this building, like the others cited, faces water, in this case the Rhine.[34] In the Palace of Diocletian at Spalato, too, the main reception rooms are oriented toward the sea façade.[35]

The third suite (17–20), which opens onto Portico 62 through Exedra 60, was probably more private. Behind it is a fourth suite, a group of smaller rooms that includes a bath (15–16, 23–23', 48–49);[36] this suite is accessible both from Corridor 14 and indirectly from the long corridor (43) on the east side of Court 1. These rooms apparently were not decorated with wall paintings, and they lacked the false vaults that characterized many of the rooms in the three other, more luxurious suites. Rostovtzeff suggests that the suite may have been the quarters of a procurator or *vilicus* in charge of the slaves, who he believes were housed in the file of rooms on the east side of Corridor 43.[37]

As stated above, the Dux Palace differs from the domestic architecture of Dura, not merely in its plan, but also in the organization of the living rooms. The typical Durene house had a diwan, a long room facing onto an uncolonnaded courtyard and connected to it by a narrow doorway. Even in the rare houses, such as one in E4, that also include a long room flanked by narrower ones, the arrangement is quite different from that of Rooms 26–29' in the Dux Palace.[38] Fur-

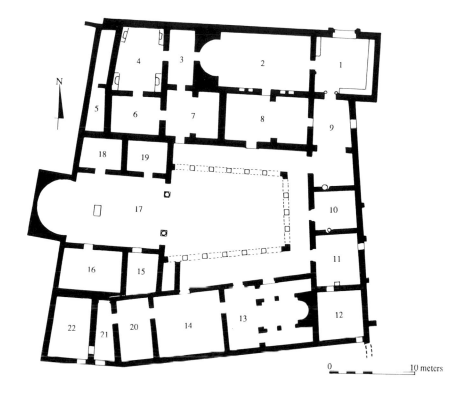

14. Palace, Apollonia
(Cyrenaica), plan
Drawing by Tim Seymour
after Richard G. Goodchild,
"A Byzantine Palace at Apollonia
(Cyrenaica)," Antiquity 34 (1960)

the large outer peristyle on the north of the Palace of the Giants, with its rectangular and apsidal exedrae, is foreign to the traditions of Greek domestic architecture. The rooms of the southern, residential section are ranged around two peristyle courts of different sizes. On the axis of the larger court is a suite consisting of a large central room (14) whose wide opening onto the court includes two columns; this room is flanked on each side by pairs of smaller rooms that open only onto it (15–18). Thompson compares this suite to the group centered on the apsidal room (2) at Dura, but in fact the arrangement of the rooms in the Athenian palace, as well as their axial placement and openness to the court, also relates them to Suite 26–29' at Dura. Another feature that links the two palaces is the presence in both of suites that appear to have been designed for public functions (14–18 at Athens; 26–29' and 2, 5–9 at Dura) and of others that are also luxurious but more private. In the Athenian building, a suite of rooms (38–41) opening off a corridor (37) next to the smaller peristyle (22) seems to me analogous to Suite 17–20, constructed in a later phase of the Dura palace.

Thompson also cites a large building of the late fifth to early sixth century at Apollonia in Cyrenaica as an example of a structure that includes a domestic sector clearly separated from rooms intended for formal use (fig 14).[42] The latter includes a suite that closely resembles the central section of the river wing at Dura: a central apsidal room flanked on each side by two smaller ones. The suite is placed at one end of a colonnaded court, and, as at Dura, two of the smaller rooms apparently originally opened onto this public space, but the doorways were later blocked up, so that the side rooms (15, 19) became accessible only from the apsidal room (17). A group of rooms (14, 20–22) in the corner of the building, to the south of this large suite, barely discussed by Goodchild,[43] seems to me likely to have constituted a more or less private suite analogous to Rooms 17–20 of the river wing in the Dura palace.

Late antique houses in various parts of the Roman Empire provide abundant par-

thermore, the presence of two suites of reception rooms differentiates the Dux Palace from the few houses known at Palmyra, which seem to belong to the Hellenistic peristyle type,[39] and also from those at Antioch, which though poorly known also seem to lack such suites.[40]

On the other hand, the Dux Palace as a whole can be compared to many large urban dwellings throughout the Roman world, some of which probably served as official residences. Homer Thompson finds in the Dura building the most cogent parallel to a large building of the fifth century A.D. in the Athenian agora, dubbed the Palace of the Giants, which he identifies as an official residence maintained by the imperial government for the use of the emperor or other high officials on visits to Athens.[41] Thompson notes that the Athenian palace shares with the Dura structure the organization around two large peristyle courts: one with only a few exedrae around it, which probably served a largely public function; the other clearly residential, although including some features suggestive of public use. According to him, the latter is based on the typical Athenian house type, while

SUSAN B. MATHESON
Yale University Art Gallery

The Last Season at Dura-Europos, 1936–1937

Frank E. Brown joined the archaeological expedition to Dura-Europos in October 1932.[1] The Dura excavations, which were then under the direction of Clark Hopkins of Yale University, were in the sixth season of a cooperative project sponsored by Yale and the Académie des Inscriptions et Belles-Lettres, Paris. Fresh from the American Academy in Rome, Brown signed on as an experienced architect and a fledgling archaeologist, and by the time the excavations were closed down in 1937, he had succeeded Hopkins as field director. In this essay I will first review Brown's contribution to the Dura excavations, which was significant from the start, and I will then focus on the tenth and final season of the Yale-French expedition. Although this last season was never formally published, the Dura excavation archives, housed at Yale, contain sufficient information to permit a reconstruction of the work that Brown and his colleagues undertook during that year.

From the start of his association with Dura, Brown's work at the site encompassed not only the city's three historical levels (Hellenistic, Parthian, and Roman), but also a wide range of locations within the city walls (fig. 1). Important finds were made during the first season of work, including the synagogue with its well-known wall paintings;[2] a cache of armor;[3] and the Persian mine under one of the de-

fensive towers, whose collapsed wooden structure entombed soldiers with pouches of coins that date the fall of the city.[4]

Brown's own work during this season was concentrated in the Roman military sector of the city, focusing on a Parthian house that had been converted into barracks[5] and a bath that incorporated an amphitheater.[6] Among Brown's significant finds was the wall painting of Nike from this bath, now in the National Museum, Damascus.[7] He also undertook a comparative study of the city's Roman baths[8] and, later in the season, worked on the citadel.

Brown's work in the seventh season at Dura concentrated on two important temples. Over two months beginning in early November 1933, he and his crew excavated the Temple of Adonis.[9] Among his finds was an inscription on a door lintel giving a date of A.D. 152. The sculpture found in the temple was dedicated to deities other than Adonis: a relief of the military god Arsu riding a camel (fig. 2), quite probably a dedication to request or acknowledge the god's protection of a lucrative caravan,[10] and a fragment of a fine Palmyrene relief showing the goddess Atargatis enthroned, her mural crown linking her to Tyche and referring again to the idea of divine protection.[11]

A surface find of a fragment of wall painting led Brown and his crew next to the Temple of Zeus Theos, south of the

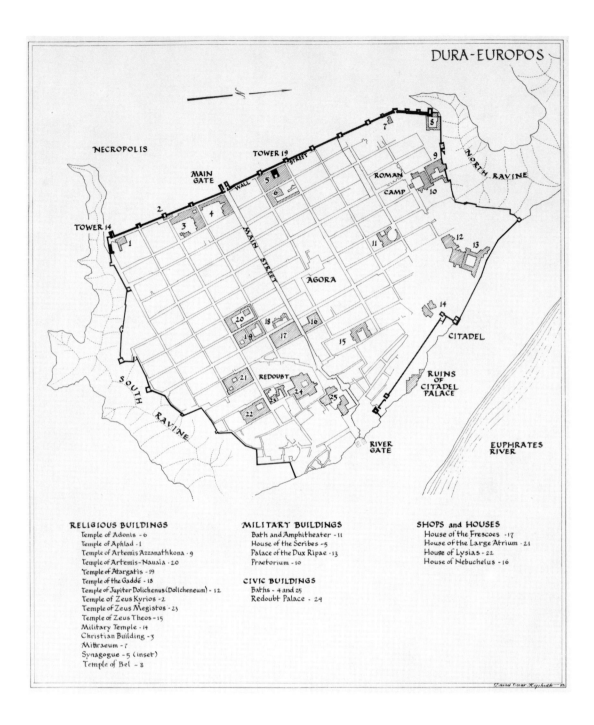

1. Dura-Europos, plan based on A. Henry Detweiler's plan of 1938
Drawing by David O. Kiphuth
Dura-Europos archive, Yale University Art Gallery

DURA-EUROPOS

NECROPOLIS

TOWER 19

MAIN GATE

TOWER 14

WALL STREET

MAIN STREET

NORTH RAVINE

ROMAN CAMP

AGORA

SOUTH RAVINE

REDOUBT

CITADEL

RUINS OF CITADEL PALACE

RIVER GATE

EUPHRATES RIVER

RELIGIOUS BUILDINGS
Temple of Adonis - 6
Temple of Aphlad - 1
Temple of Artemis Azzanathkona - 9
Temple of Artemis-Nanaia - 20
Temple of Atargatis - 19
Temple of the Gaddé - 18
Temple of Jupiter Dolichenus (Dolicheneum) - 12
Temple of Zeus Kyrios - 2
Temple of Zeus Megistos - 23
Temple of Zeus Theos - 15
Military Temple - 14
Christian Building - 3
Mithraeum - 7
Synagogue - 5 (inset)
Temple of Bel - 8

MILITARY BUILDINGS
Bath and Amphitheater - 11
House of the Scribes - 5
Palace of the Dux Ripae - 13
Praetorium - 10

CIVIC BUILDINGS
Baths - 4 and 25
Redoubt Palace - 24

SHOPS and HOUSES
House of the Frescoes - 17
House of the Large Atrium - 21
House of Lysias - 22
House of Nebuchelus - 16

agora.[12] Its foundation was dated by inscription to A.D. 114, and the temple itself featured an extensive program of wall paintings. Instead of the usual cult relief, a monumental wall painting honored the god. Brown reconstructed this painting on paper from the surviving fragments, and although the evidence for this reconstruction is incomplete at best, enough does remain to show that the basic scheme, a large figure of the god with smaller figures of mortals, was correct.

The Mithraeum (now at Yale) was the most publicized find of this season,[13] and news of its discovery brought Franz Cumont to join Michael Rostovtzeff, the excavation's guiding spirit, in examining it (fig. 3). Other visitors to Dura that season included Max Mallowan and with him, of course, Agatha Christie.[14]

Brown returned to his excavations in the Roman quarter at the start of the eighth season. Two hoards of more than one hundred coins each were among his finds in this area.[15]

But around this time dark clouds of insolvency were beginning to gather. By Christmas 1934, Rostovtzeff was already concerned because the Rockefeller Foundation, which had been funding the excavations up to that point, had not responded to a request for further support. He wrote to Hopkins expressing his fear that the expedition might have to be closed down at the end of the season.[16] The situation remained the same at the end of January, but in the last week of the season, in one of those flukes that motivate archaeologists in the bleakest periods of arid digging, the Temple of the Gaddé was discovered.

Brown (fig. 4) agreed to stay on with twenty men for an extra two weeks to clear the temple (work was done rather more quickly in those days). Once again he found inscriptions that helped to date the building. The inscriptions were on cult reliefs dated A.D. 159, thus providing a date for the naos in which they were found. One relief shows the Tyche (or *gad* in Semitic) of Palmyra (fig. 5),[17] with an echo, albeit frontal and flattened, of the famous *Tyche of Antioch* by Eutychides. The other shows the Tyche of Dura (fig. 6),[18] rather

unusually a male, but crowned by Seleucus Nicator, the titular founder of Dura, showing his continued importance in the popular vision of the city's history more than four centuries after its foundation.

Brown became field director of the Dura excavations in 1935 after Hopkins left Yale for the University of Michigan and its excavations at Seleucia. As Brown began his first season as director, Rostovtzeff wrote to the Rockefeller Foundation estimating that three more seasons of work were needed and requesting $125,000 to pay for them and for the next five years of publications.[19] In fact,

funds were available for only two seasons, and Brown directed both of them.

The most important architectural finds of these seasons were the Palace of the Dux Ripae and the adjacent Dolicheneum.[20] The bulk of the work on these buildings was done during the ninth season, but largely by others than Brown. In addition, Nicholas Toll began excavating the Necropolis in earnest,[21] and the clearing of the agora continued.[22]

In January 1936, Du Mesnil du Buisson wrote to Rostovtzeff that Brown had just discovered another temple.[23] This was the Temple of Zeus Megistos, of which Brown

3. Franz Cumont (left) and Michael I. Rostovtzeff in the Mithraeum, Dura-Europos, 1932
Dura-Europos archive, Yale University Art Gallery

made an exhaustive study over the next two years. This study was never published,[24] but it has been thoughtfully examined and reevaluated by Susan Downey in her book *Mesopotamian Religious Architecture*.[25] As reconstructed by Brown, the Seleucid temple, aside from the Greek elements of its entrance, was Mesopotamian in style. This combination is characteristic of the fusion of Greek and Near Eastern styles at Dura.

A wide variety of sculpture was found in the Temple of Zeus Megistos. The over-life-size head of a statue (fig. 7) found in a naos of the temple is one of the few free-standing works of this scale at Dura, a scale that argues strongly for calling this work a cult statue.[26] The polos headdress confirms the identification, echoing a simi-

lar use of this headdress on a figure of Zeus-Baalshamin on an earlier relief from the Temple of Zeus Kyrios at Dura, where Zeus is identified by an inscription.[27]

Fragments of another large cult statue, not easily interpreted in themselves, were found together with a fragmentary bull *protome* that may suggest identification of the cult statue as Bel or Baalshamin.[28] Heracles, never particularly heroic in any of his numerous Dura manifestations, appears with the Nemean lion in a relief from this temple.[29]

The armed god Arsu, seen elsewhere riding a camel, appears as a standing figure on a small relief from the temple,[30] here identified by an inscription. A relief of a nimbate god was also found (fig. 8), his head unfortunately missing and even his nim-

bus only a ghost.[31] The style of this relief is clearly Palmyrene, a reminder that the Palmyrene influence at Dura was artistic as well as commercial and religious.

Work on the Temple of Zeus Megistos continued in the 1936–1937 season, the tenth and final season of the Yale-French excavations. It is to this season that I will now turn, in order to complete, at least in outline form, the published record of the Dura excavations, based on the archival material available at Yale. Virtually all the publications on Dura that mention the tenth season state that its results were never published, and while it is true that there is no volume of the excavation reports called *The Tenth Season*, the situation is not as simple as it first appears.

In comparing the field records of the tenth season with the published reports of the ninth, it became clear to me that a good deal of the work of the last season was assimilated with that of its predecessor in the publications of the earlier season. This was actually quite natural, given the nature of the last season and the plans for its publication that are preserved in the Dura archives at Yale. Brown stated in his report to the president of Yale after the tenth season[32] that it was not a season of new exploration, but rather one of continued work on existing projects and of completion of the study of certain major monuments. Thus, it was not a season that needed to stand on its own as a separate publication. Moreover, in his request to the Rockefeller Foundation for funds in 1935,[33] Rostovtzeff had outlined Brown's plans for one or at most two reports to cover the three additional seasons they intended to undertake, suggesting that Brown had already given up the idea of a separate report for each season. It seems clear, then, that Brown intended the work of the tenth season to complete that of the ninth, and that he viewed the two seasons as a unit when it came to the publication of the results.

It is equally apparent that the format for the excavation reports was already evolving in Brown's mind from an annual record of finds to a series of interpretive studies of individual monuments, even before the last seasons of field work were

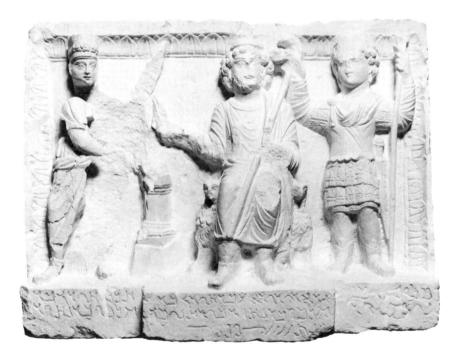

finished. Brown himself confirmed this in the revised outline of publications he submitted to the Yale president after the tenth season,[34] an outline listing fourteen separate sections on individual blocks and buildings, all representing the combined

5. Relief showing the Tyche of Palmyra, Dura-Europos, A.D. 159, limestone
Yale University Art Gallery

6. Relief showing the Tyche of Dura, Dura-Europos, A.D. 159, limestone
Yale University Art Gallery

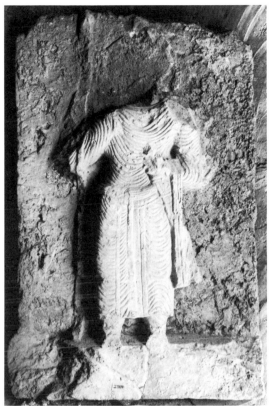

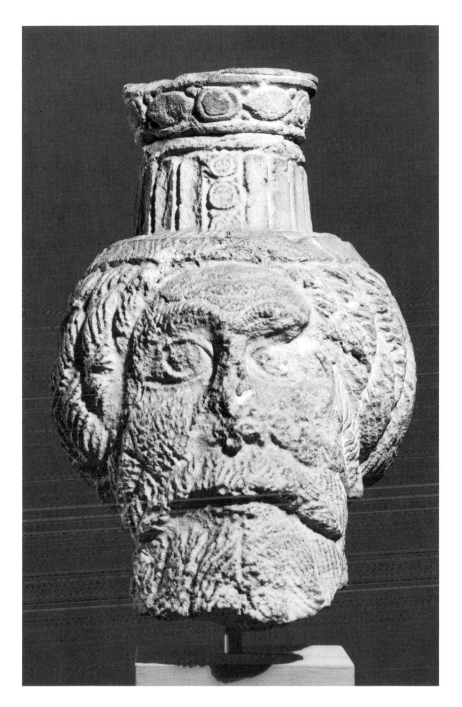

7. Head of Zeus Megistos,
Dura-Europos, c. A.D.
169–170, limestone,
from a cult statue
Yale University Art Gallery

8. Relief showing a nimbate
god, Dura-Europos, c. A.D.
169–170, gypsum
Yale University Art Gallery

work of the ninth and tenth (and some-
times even earlier) seasons.

Some of these results remained unpub-
lished, as is generally known. Brown's
absence in Syria during World War II and
the military duties of other excavation
members left the completion of the publi-
cations in the hands of those on the home
front,[35] who were properly reluctant to
compile definitive reports from the field

notes of the excavators. This fact, com-
bined with the death of Henry Detweiler,
who was to have collaborated with Brown
on the Fortifications report, the evapora-
tion of funding, and finally the loss of
essential archival material,[36] made it sim-
ply too difficult to carry on.

The excavations themselves were also
discontinued for lack of money, as Rostovt-
zeff noted in his report to the Académie
Française after the tenth season of work.[37]
The Rockefeller Foundation, which had
been funding the excavations since 1931,
voted in February 1935 to give Yale
$30,000 toward the cost of two additional
seasons of field work (1 July 1935 through
30 June 1937), but with the clear state-
ment that this was the final grant the
foundation would make for work at
Dura.[38] Brown's appeal for further funding,
submitted in the fall of 1935, was rejected.

Had funding been available, the excava-
tions could have continued. Correspon-
dence between President Charles Seymour
of Yale and Henri Seyrig, director of the
Service des Antiquités in charge of archaeo-

logical permissions in Syria, resulted in an extension of the Yale-French permit until 1946.[39] Seyrig wrote to the Yale president in March 1940 to say that he hoped work at Dura would be resumed without delay.[40] But in spite of this goodwill, plans for the liquidation of the expedition had already been formulated by Brown in October 1936 and approved by Roland Angell, then president of Yale.[41] A guard was paid to remain at the site, but the expedition's equipment was dispersed, the antiquities remaining in the expedition house divided, and the excavators' attention subsequently devoted exclusively to completing the maps, plans, object files, and publications of the site.

The focus of the tenth season was then, in Brown's words, "the completion of the records of the site and, in particular, of important buildings excavated in previous campaigns in preparation for their definitive publication."[42] Brown was particularly interested in obtaining evidence about the Hellenistic levels of the city, buried under or embedded in the often more spectacular remains of later buildings.

To this end, the palaces on the citadel and the redoubt were studied closely. In Brown's view, the redoubt palace and the adjacent Temple of Zeus Megistos, which he had excavated in the ninth season, "constituted the acropolis of the Macedonian colony." The citadel, he concluded, was the military center of the colony, remaining so until its partial collapse into the Euphrates in the first century B.C.[43] The palace on the redoubt was the headquarters of the strategos. Opinions differed on the dates of the two palaces and the sequence of their different building programs, and both palaces are now the focus of renewed investigation by Susan Downey[44] and the Franco-Syrian expedition.

Brown himself undertook a study of the agora, mapping out its Hellenistic appearance and its conversion in the Parthian period to a dense oriental bazaar. His plan and reconstruction of the Hellenistic agora were published as part of the ninth-season report in his extensive study of all phases of the marketplace.[45]

A. Henry Detweiler, the expedition's other architect, completed a detailed survey of the fortifications during the tenth

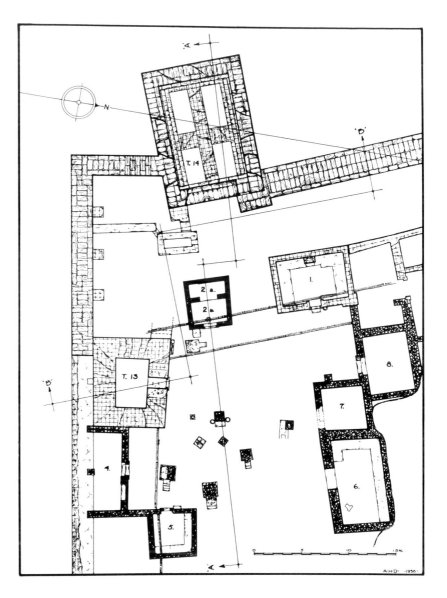

season, with new drawings and measurements for each of the towers (fig. 9).[46] Detweiler confirmed the conclusion of Cumont, the city's first excavator, that the stone walls and the rectangular block plan were of Hellenistic date. This work was never published, and the fortifications have once again been examined by the Franco-Syrian team, resulting in new conclusions about the three stages of construction of the walls.[47]

Some of the later buildings were reexamined as well. The Temple of Atargatis, south of the agora, yielded three new inscriptions from its latest level (A.D. 31). These were published by Rostovtzeff in

9. Southwest tower, Dura-Europos, 1938, plan
Drawing by A. Henry Detweiler
Dura-Europos archive, Yale University Art Gallery

10. Relief of Heracles, Dura-Europos, second–third century A.D., gypsum
Yale University Art Gallery

11. Thymiaterion, Dura-Europos, third century A.D., green-glazed pottery
Yale University Art Gallery

his report to the Académie Française in 1937.[48] A cistern in the temple courtyard produced numerous finds, including a female head,[49] two Heracles sculptures (fig. 10),[50] and a green-glazed thymiaterion (fig. 11).[51]

The gradual development of the Temple of Bel (also called the Temple of the Palmyrene Gods) was carefully followed (fig. 12), and the records of the temples of Zeus Kyrios, Azzanathkona, and the Gaddé were completed. The Christian Building was also studied in detail, and the results of this work were incorporated in Carl Kraeling's *Final Report* in 1967.[52] The records of the praetorium were also put into final form.

Intensive work continued in the necropolis, where the clearing of tombs yielded fine examples of green-glazed pottery, along with more pedestrian pottery types, glass vessels, and gold, silver, and bronze jewelry. Tombs 44, 46, 47, 49, 50, 54, and

55 were excavated in the tenth season, although they were published and their finds illustrated in the ninth-season report on the necropolis.[53] Many of the finds from these tombs are now at Yale; accession numbers for them are given in the ninth-season report.

Finds in other areas, especially the residential area near the agora, supplemented those of the tomb groups. Two bronze statuettes of musicians (a syrinx player and a piper), now in the National Museum, Damascus, were found on the lowest floor of a house.[54] Two reliefs of Heracles and the lion were found in another house, each in a different room.[55] A stele probably representing the goddess Allât was found in a third house.[56] A female equivalent of the male armed gods, Allât was apparently fused with Athena at Dura as she was at Palmyra. These objects were all included in the ninth-season report.[57]

In all, more than a thousand small finds

are listed in the object register for the tenth season, including coins, small bronzes, bone objects, and pottery of various types, all consistent with finds of earlier seasons. Many of these objects—including glass, commonware, brittleware, Greek and Roman pottery, green-glazed pottery, lamps, coins, and textiles—are published in the final reports on classes of objects. The bone objects, arms and armor, jewelry, many varieties of small bronze objects, a pair of leather shoes and a pair of boots, and the terra-cotta figurines from the tenth season, however, remain unpublished.[58]

Important as these finds are, it is clear that Brown's primary focus in this last season was on architecture rather than on material culture. This reflected his personal interests and expertise, of course, but it also revealed an approach to archaeology that was more systematic and scientific than that of his predecessors. In the tenth and last season in particular, the temptation of new discoveries was renounced in favor of the completion of the existing record. In his report to the Yale president, Brown described "exhaustive topographical studies of the site, the verification of inscriptions and graffiti, the revision of pottery sequences, and the completion of the photographic record."[59] This topographical work and the photographic record, which included an aerial survey by the French army, provided the basis for most of the final site and building plans, completed in New Haven over the following decade. Both the photographic record from the tenth season and the resulting plans and drawings are available for study at Yale.

The aerial views of the excavations taken by the French air force in the last season provide evidence that will help solve a small archaeological mystery that recently came to light. In his first communications with Yale at the start of the Franco-Syrian expedition to Dura, Pierre Leriche, the expedition's director, wrote asking about a building north of the Palace of the Dux Ripae that was fully excavated but appeared in none of the published site plans or photographs.[60] Even the last published plan of the site, drawn in 1938 and included in the ninth-

season report, shows no evidence of excavation in this area. My examination of unpublished aerial photographs of the site in the Yale archives, however, revealed an indisputable record of the existence of this building: although invisible in the air view of 15 September 1934,[61] it is clearly visible and fully excavated in the air view of 6 March 1936 (fig. 13).[62] Faced with this incontrovertible evidence one returns to the 1938 site plan, only to find its legend stating that it was drawn from a survey made in 1935.

The "mystery" building also appears, although very schematically, on a map drawn by the French army.[63] The magnetic readings of this map are dated 1 January

12. Temple of Bel (Temple of the Palmyrene Gods), Dura-Europos, plan of three stages of development, 1938 or after
Drawing by Henry F. Pearson
Dura-Europos archive,
Yale University Art Gallery

13. Dura-Europos, 6 March 1936, aerial view, looking south

Photograph: French air force Dura-Europos archive, Yale University Art Gallery

1936; it is thus possible to confirm that the building was excavated sometime between 1 January 1935 (the earliest possible date for the 1935 survey) and 1 January 1936.

It is possible to be even more precise, however. The object register recording the finds from the ninth season (1935–1936) lists forty-six objects, including thirty-eight coins, found in the block that encompasses this building. The objects other than coins consisted of a plaster beardless male head (fig. 14),[64] a Pergamene plate,[65] a green-glazed jug,[66] four common-ware vessels (fig. 15),[67] and a bead assortment. These objects represent the only listing of finds from this area from the entire expedition; thus the building must have been dug during the 1935–1936 sea-

son. Unfortunately, specific dates for the finds are not recorded, and although they come near the end of the season's list, it is unclear whether or not their position in the list reflects their relative position in the chronology of the excavation.

Even more unfortunate is the fact that the thirty-eight coins are not identified by type in the object register. The Dura archives at Yale do contain an unpublished list of types by find-spot, which should make identification of these coins possible, but it does not include the block in which the "mystery" building stands. Nor does the *Final Report* list the coins by find-spot,[68] making it impossible to correlate these specific thirty-eight coins with the thousands referred to in that volume. Thus, sadly, the

ANNE LAIDLAW
Hollins College

Excavations in the Casa di Sallustio, Pompeii: A Preliminary Assessment

Façade, Casa di Sallustio,
Pompeii, 1859, color
lithograph
Copy after woodcut from
William Dyer, *Pompeii: Its History,
Buildings, and Antiquities*, 2d ed.
(New York, 1870), 331

Throughout the nineteenth century the Casa di Sallustio (6.2.4) in Pompeii was justly famous, both for its canonical architectural plan and for its well-preserved First Style wall paintings. The building, however, had undergone numerous modifications before the eruption of Vesuvius in A.D. 79, and it has fared even worse since its excavation during the Napoleonic wars, not least from being hit by a bomb in World War II. Although the war damage was sketchily patched up in 1948, the house was largely ignored by both the authorities and the tourists until the late 1960s, when Vincent Bruno and I, using its wall decorations as a starting point, initiated a comprehensive study of all the First Style paintings in the town. This paper is a preliminary report on the stratigraphical excavations begun in 1969 in the Casa di Sallustio in order to clarify certain problems that arose in connection with reconstruction of its First Style wall paintings.[1]

According to the published reports, the original excavation was carried out between 1805 and 1809.[2] The excavators had been working rather haphazardly down the Via Consolare from the Via dei Sepolcri (fig. 1), sometimes investigating the interior of a building on one side of the street, sometimes one on the other, depending on how promising the hope of spoils. Since the modern identification system by region, insula, and door number had yet to be established, the general location was identified, if at all, by a significant architectural feature or find (painting, mosaic, statue, or the like). Thus it is often impossible to decipher where the excavators were digging at any given time. For the Casa di Sallustio, however, it is possible to determine three separate periods of excavation by the identification of significant finds described in the reports. First, from May through July 1780, part of the façade on the Via Consolare, including a thermopolium, was uncovered (fig. 6).[3] The report for 18 May 1780 also mentions a capital on a pilaster, which should be the figured capital (now lost) that Piranesi and Mazois drew.[4] Second, during 1806 a major part of the house was cleared. Some of the work must have been done earlier, since the report starts in medias res with the house identified simply as "where the painting of Actaeon is located."[5] Unfortunately, there are no published records for 1804 and 1805. In fact, it is perhaps surprising that we have as much information as we do for 1806: in the vicissitudes of the Napoleonic wars, the Bourbon queen Maria Carolina fled from Naples to Palermo on 11 February, taking a convoy of ships loaded with royal possessions.[6] Joseph Bonaparte, close on her heels, entered Naples behind the French army on 15 February,[7] and by 2 March he had already made a formal visit to the excavations.[8] Apparently the digging

state of disrepair. The side gardens and the bakery were an overgrown jungle, and the south apartment was a heap of rubble (fig. 5), set off from the main part of the house by a hastily rebuilt circuit wall. The protective roofs leaked, and vigorous plants had eaten away almost the entire pavement of the atrium and had made a good start in the cracks along the edges of the walls in the garden oecus (22). Surprisingly, the famous First Style wall painting on the north wall of the atrium, which August Mau had used as his exemplar of this style in the 1880s (figs. 7, 8),[19] was still relatively well preserved, as were the companion paintings in the left ala (17), tablinum (19; fig. 9), and garden oecus (22; fig. 10); even the upper zone with the molded colonnettes in Cubiculum 15, at the edge of the bomb crater, had survived. Consequently, when we began our collection of First Style wall paintings we decided, like Mau before us, to use the examples in the Casa di Sallustio as our models.[20]

Our initial intention was to draw the basic Pompeian patterns, to be used as a basis for reconstructing similar paintings from some hundreds of fragments that we had excavated at the Roman town of Cosa in Tuscany in 1966–1967.[21] Thus the first soundings made in the Casa di Sallustio in June 1969 (figs. 11, 17 [1–4]) were intended

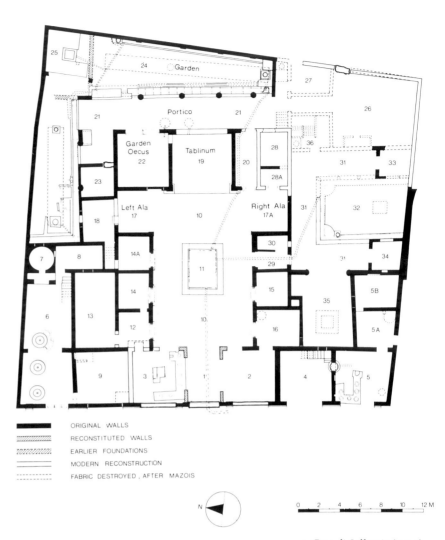

ORIGINAL WALLS
RECONSTITUTED WALLS
EARLIER FOUNDATIONS
MODERN RECONSTRUCTION
FABRIC DESTROYED, AFTER MAZOIS

N

0 2 4 6 8 10 12 M

3. Casa di Sallustio (6.2.4), Pompeii, 1970, plan
Drawing by René Diaz and Anne Laidlaw

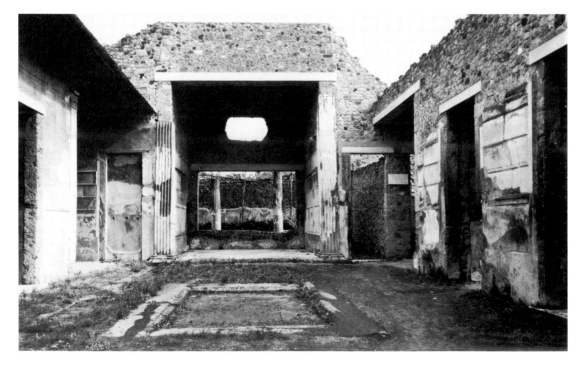

4. Atrium, Casa di Sallustio (6.2.4), Pompeii, 1969, view toward east before latest restoration
Photograph: Johannes Felbermeyer

5. South apartment, Casa di Sallustio (6.2.4), Pompeii, 1970, view toward west: removal of rubble from bomb damage of September 1943
Photograph: Johannes Felbermeyer

to answer specific questions about patterns and proportions of the surviving paintings

Sounding 1 (plan, fig. 11):

One of the most obvious problems concerned the painting on the back (W) wall of Oecus 22 (fig. 10), the large room to the left (N) of the tablinum. According to Mau, the left half of this wall had a realistic representation of a door painted on it (now obliterated), which he assigned to the period of the Second Style;[22] the right half has a standard First Style pattern of molded isodomic blocks with drafted margins, neatly finished next to the space for the painted door. In place of the usual high yellow socle, however, there is a narrow yellow stripe 0.14 m high just above the pavement.[23]

When the oecus floor was cleaned and the weeds removed, it became apparent that the yellow plaster continued below the level of the pavement, at least near the southwest corner of the room by the painted door and behind a travertine step leading up from the back left (NE) corner of the tablinum, where a small doorway had been cut through the First Style patterns on both sides of the wall (fig. 9). The cleaning also uncovered an irregular rectangular outline in the pavement directly in front of the painted door (fig. 10, bottom left).

In the left ala (17), on the opposite side of the wall with the painted door in Oecus 22, there is a large niche that was being used as a lararium in 79 (fig. 9). Since it corresponds in placement and general dimensions to the doorway in the other ala (17A) that opens onto Andron 20, it has generally been supposed that this was the original entrance to Oecus 22, which was

6. Façade, Casa di Sallustio (6.2.4), Pompeii, 1830, woodcut
From William Dyer, *Pompeii: Its History, Buildings, and Antiquities*, 2d ed. (New York, 1870), 331

7. Atrium, Casa di Sallustio (6.2.4), Pompeii, 1969, left (N) wall with First Style decoration

Photograph: Johannes Felbermeyer

8. Atrium, Casa di Sallustio (6.2.4), Pompeii, 1882, water-color restoration by August Mau showing First Style decoration on north wall

From August Mau, *Geschichte der decorativen Wandmalerei in Pompeji* (Berlin, 1882), pl. 2a

walled up at a later period. Our Sounding 1 was designed to test this theory, so that we could reconstruct the First Style wall painting on the back (W) wall of Oecus 22 with accurate dimensions.

With the kind permission of Alfonso De Franciscis, then superintendent of antiquities for Naples and Campania, we removed a small square of the paving in the southwest corner of Oecus 22. Almost immedi-

ately we discovered that the rectangular outline in the pavement defined the boundaries of a filled-in stairwell, 1.60 m long x 0.68 m wide x 0.60 m deep (fig. 12), plastered on the sides and floored with the original pavement of the room: a fine red signinum decorated with equidistant rows of even white tesserae spaced 0.04 m apart to form a pattern of squares. This is a standard design found in association with

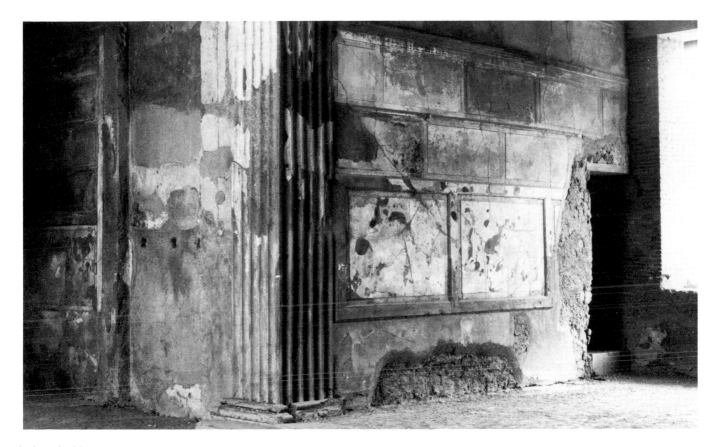

9. Left ala and tablinum, Casa di Sallustio (6.2.4), Pompeii, 1980, view from atrium toward northeast: left, niche for lararium; far right, later doorway to Oecus 22
Photograph: Barbara Bini

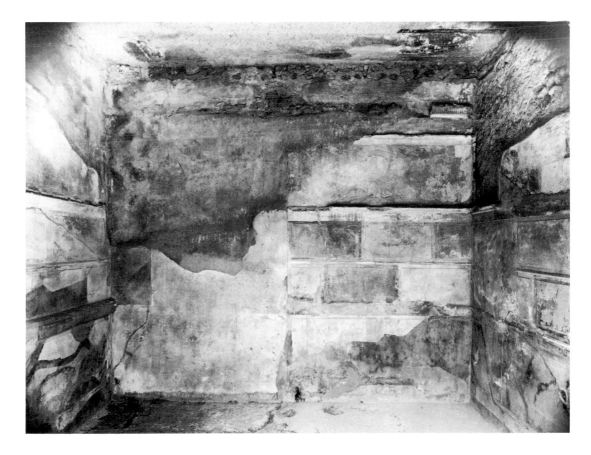

10. Oecus 22, Casa di Sallustio (6.2.4), Pompeii, 1969, back (W) wall with original First Style decoration
Photograph: Johannes Felbermeyer

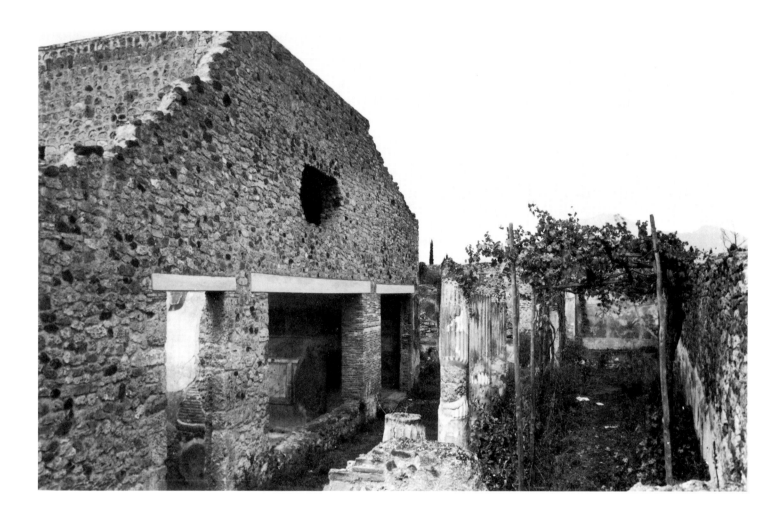

[f]) leading up into the back garden between the column at the end of the parapet and the basin.

Sounding 3 was undertaken to determine, if possible, the relative date of this portico and its relationship to Oecus 22: we wanted to know whether the portico was part of the original nucleus of rooms around the atrium, or a later addition connected with the realignment of the oecus. Sounding 4 was made to corroborate the conclusions drawn from Sounding 3.

We began by digging a trench 1.50 m wide between the main threshold of the oecus and the fourth column to the north in the portico. In the front of the threshold we dug 1.10 m into the yellow tufaceous earth below the threshold bedding. By the column we excavated 0.46 m to the bottom of the foundation for the column (fig. 15). The only significant finds were a pile of fragments of painted wall plaster (Third Style?), which had evidently been dumped just below the surface of the portico pavement, and twenty-four sherds of red-glazed pottery.

As a cross-check, we opened Sounding 4, a rectangular trench 1.40 x 0.90 m at the south end of the portico, in order to examine the foundation block of the first column to the south (fig. 16). Running obliquely across the portico directly in front of the column is a box drain that emptied into the cistern in the back garden. The earth at this end of the portico had been thoroughly disturbed, presumably during the repairs made after the bombing, for the drain was covered with modern Neapolitan rooftiles.

We concluded that the original level of the portico was the same as its present level, 0.30 m above the earlier signinum pavement in the oecus. The portico must thus be a later addition, presumably built in conjunction with the first remodeling of the oecus (Phase Two) and designed to

14. Back portico and garden, Casa di Sallustio (6.2.4), Pompeii, 1969, view toward north

Photograph: Johannes Felbermeyer

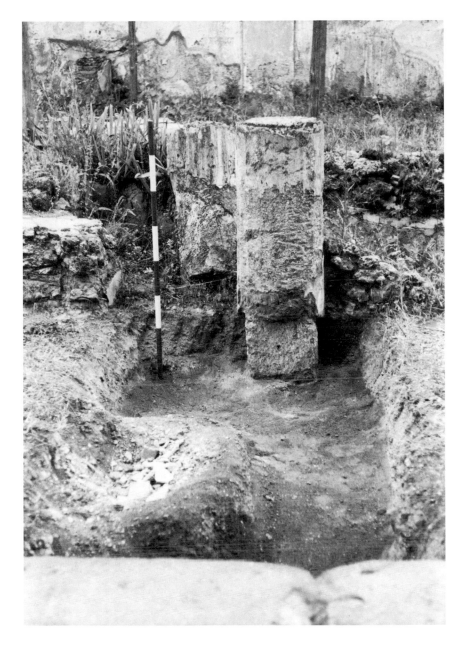

15. Back (E) portico, Casa di Sallustio (6.2.4), Pompeii, June 1969, Sounding 3, view toward east across plaster deposit to foundation of fourth column from south
Photograph: Johannes Felbermeyer

Phase Three when the access from the oecus to the front of the house was rearranged. The hasty workmanship of the rebuilt right (N) wall of the oecus, with its sloppy copy of the original First Style painting on the back (W) wall, would fit nicely into this third phase, and it is tempting to explain such an extensive remodeling as the result of damage in the earthquake of 62.[27]

Sounding 2 (plan, fig. 17):

Although Mau's restoration of the pattern on the north wall of the atrium is well known (fig. 8), the fact that he omitted the last doorway and the section at the northwest corner is not. Such an omission is understandable, because none of the painted stucco survives on that part of the wall (fig. 7). In our investigation, however, we were particularly interested in what happened to First Style patterns at the corners. In the northwest corner of the atrium, our problem was compounded by the fact that at some point a thermopolium had been installed in the shop (3) next to that corner of the room, with its counter opening into both the fauces and the atrium (figs. 3, 18). Clearly this was not part of the original house; it has usually been interpreted as evidence for the conversion of the building from an elegant patrician residence into a cheap inn or a private club.[28] Originally there should have been a doorway between the atrium and Shop 3, corresponding in size and placement to the one on the other side of the fauces that opens into Shop 2, but the only traces of this were a line of possible foundation stones at grass level.

In order to determine the original structure of that corner of the atrium, directly in front of the thermopolium we opened a trench, 2.40 x 1.20 m, which extended 0.40 m into the rooms on either side of the putative doorway (fig. 17). By the north wall of the atrium the sounding was eventually slightly enlarged to make room to examine the foundations, and it was dug down 1.35 m to the bottom of the ancient foundation trench.

Directly below grass level the original doorway appeared, defined at its north end

protect the new wide entrance to the back garden. The date of this first remodeling should be Augustan or somewhat later, since the red-glazed sherds have been tentatively identified as Augustan or Julio-Claudian.[26] The plaster deposit found in Sounding 3 and the broken pavement built into the parapet between the columns may represent the original decoration of the portico. The basin set on top of the tufa water channel, the parapet, and the new rooms built into the north side of the portico will then have been added in

by a large rectangular foundation block of Sarno limestone, set vertically and notched at the upper corner to make a bedding for a threshold block. To the south the large ashlar blocks of Sarno limestone forming the west wall between the atrium and the fauces are still extant, abutting the corner of the counter (fig. 18).[29] Set into the door opening, 0.30 m below the level of the atrium floor, there is a narrow supporting wall, 0.20 m thick and 0.50 m high, made of mortared reused rubble (lava, limestone, and roof tiles), which forms part of the foundation of the thermopolium counter (fig. 19).

The counter itself is made out of the remnants of the west atrium wall and its First Style decoration, which were destroyed when the doorway was widened. At least two ashlar blocks of Sarno limestone, presumably from the north doorpost, are built into the fabric of the counter, bedded on numerous fragments of painted wall plaster: yellow, cinnabar, and marbling of red, green, and yellow speckles on a black ground, which is identical to the marbling in the upper zone of the atrium decoration on the north wall between the second and third doorways (shown in Mau's restoration, fig. 8). Many plaster fragments, including cyma reversa and dentil moldings, were found in the fill on both sides of the doorway as well.

In Shop 3, just beyond the narrow supporting wall, there is a box drain, lined with amphora sherds and roofed with gray volcanic lava, which runs on a north-south line under the thermopolium counter. This lies in a very disturbed level: a deposit of kitchenware sherds was found next to it, and the north wall of the shop was probably completely rebuilt when the Bourbon excavators immured the compluvium tiles with the lion's head spouts in it.[30]

In the northwest corner of the atrium the foundations consist of large ashlar blocks: in the north wall, one upright block of Sarno limestone (0.56 m wide x 0.95 m high) with its right upper corner notched to support the travertine threshold above it and bedded on a horizontal block (0.40 m high) projecting 0.20 m into the atrium beyond it; in the west wall,

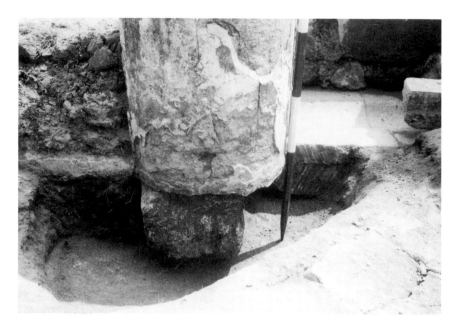

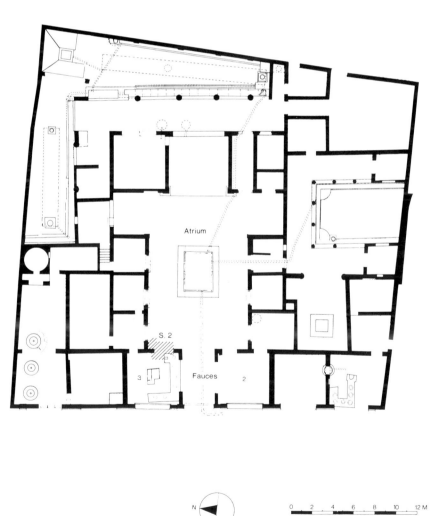

16. Back (E) portico, Casa di Sallustio (6.2.4), Pompeii, June 1969, Sounding 4, view toward east: foundation of first column on south
Photograph: Johannes Felbermeyer

17. Casa di Sallustio (6.2.4), Pompeii, June 1969, plan showing location of Sounding 2
Drawing by Kevin Sarring

18. Atrium, Casa di Sallustio (6.2.4), Pompeii, June 1969, northwest corner, view toward west: fauces and thermopolium before excavation
Photograph: Johannes Felbermeyer

gray Vesuvian lava on top of a block of Sarno limestone. Evidently recent repairs were also made here, for both sides are smeared with modern cement to a depth of 1.00 m. The blocks were set into a foundation trench 1.35 m deep and of varying width (averaging c. 0.70 m), which had been cut through a stratum of yellow tufaceous earth down to one of hard black cinders, evidently from a prehistoric eruption of Vesuvius.

Both these strata were free of finds; the foundation trench, on the other hand, was filled in its upper half with dark brown earth mixed with potsherds, roof tiles, fragments of wall plaster, and small stones. In the fill by the narrow wall supporting the counter there was also a quantity of limestone chips just above a hard-packed surface, which must be the level on which the builders of the thermopolium worked. A silver denarius of Marcus Antonius[31] was found lying on this surface. Below it, the fill consisted of a mixture of compact yellow-brown volcanic soil and, just above the black cinders, brown earth with some sherds of commonware. This will have been the fill that was shoveled back into the trench when the foundations were laid originally. On top of the black cinders a second coin, a small Oscan bronze of Irnum,[32] was found, and another bronze coin, this one from Syracuse,[33] turned up in our dirt pile, probably from the upper levels in the atrium foundation trench.

Our investigations in the atrium have shown in the original plan that there was a doorway in the west wall by the northwest corner, which opened into Shop 3 and corresponded to the one leading to Shop 2 on the other side of the fauces. The First Style decoration originally continued around the northwest corner of the atrium and corresponded in pattern and colors to the design between the second and third doorways on the north wall. The marbling in the upper zone presented alternate sections of speck-

1. I owe particular thanks to the late Alfonso De Franciscis who, as superintendent of antiquities for Naples and Campania, obtained the permissions for me to conduct these excavations, lent me workmen in 1969 and 1971, and encouraged me throughout the project. Thanks are also due to Giuseppina Cerulli, then director and subsequently superintendent of Pompeii, and to my assistants, Domenico Pelli and Albenzio Cirillo, for their help no matter what the difficulty. For technical assistance I am grateful to Theodore Buttrey and Fred Kleiner, who identified the coins; to Kevin Sarring who redrew the plans; and to the following persons who were members of the staff: James Packer, associate director (1970); René Diaz, James Guthrie, and John Stubbs, architects; the late Johannes Felbermeyer and Mercedes Collins, photographers; Edra Diaz, artist; and Sharon Dwyer, general assistant.

An interim report for the 1970 season was given by Packer and myself at the annual meetings of the Archaeological Institute of America in New York in December 1970; the summary is published in *AJA* 75 (1971), 206–207. An exhibition of the finds with an explanatory lecture entitled "An Early Pompeian House: An Archaeological Description of the House of Sallust, circa 300 B.C.–A.D. 79," was held at the American Academy in Rome, 24 January–11 February 1973, under the sponsorship of the Superintendency of Antiquities for Naples and Campania.

2. Giuseppe Fiorelli, *Pompeianarum antiquitatum historia*, 3 vols. (Naples, 1860–1864), 1:1:310–313; 1:2:77–80, 83–85, 164, 175–176; 1:3:7–10, 14–16, 226; 2:220–221. See also Fiorelli, *Descrizione di Pompei* (Naples, 1875), 82.

3. Fiorelli 1860–1864, 1:1:310–313.

4. François Piranesi, *Antiquités de la Grand-Grèce: Antiquités de Pompeïa*, 2 vols. (Paris, 1804), 2: pls. 44, 57, 58; François Mazois, *Les ruines de Pompéi*, 4 vols. (Paris, 1824–1838), 2: pl. 36, fig. 2. For further commentary on this capital, see Anne Laidlaw, *The First Style in Pompeii: Painting and Architecture* (Rome, 1985), 136 n. 53.

5. Fiorelli 1860–1864, 1:2:175–176 (addenda by Aloysius Ribau made in 1829): on 24 January 1806 four rooms and two shops are being excavated in the "Casa di Atteone," and on 17 May they are still working "nell'abitazione ove resta la già detta pittura dell'Atteone." The regular report by La Vega for 24 May (1:2:78) begins, "Si è lavorato alla casa ove resta la pittura di Atteone, e propriamente nella parte occidentale della medesima."

6. Harold Acton, *The Bourbons of Naples* (London, 1956), 532–533. The bronze fountain statue of Hercules and the stag, which is usually said to be from the Casa di Sallustio and is presently in the Museo Regionale Archeologico, Palermo, was presumably part of the queen's royal possessions, which evaded the French to arrive safely in Sicily at this time.

7. Acton 1956, 537.

8. Fiorelli 1860–1864, 1:2:77 (2 March 1806): "Mercoledì ad ore 21 il Principe Giuseppe Bonaparte andò a vedere lo scavo, e dopo di avere con piacere il tutto osservato regalò due luigi di oro e carlini 48 ai soldati."

9. Fiorelli 1860–1864, 1:2:83–84 (12 July–16 August 1806).

10. Fiorelli 1860–1864, 1:2:84 (6 September 1806). For a discussion of the significance of the name, see Matteo Della Corte, *Case ed abitanti di Pompei*, 3d ed. (Naples, 1965), 38–40.

11. Fiorelli 1860–1864, 1:2:86 (3 October 1806).

12. Fiorelli 1860–1864, 1:3:14 (28 January 1809): "Ieri si è principiato l'altro lavoro ordinatomi da lei, alla casa ove si trovò la cerva di bronzo, con essersi presa a levare la terra da sopra, che trovasi molto alta, e così verrà tutta ad isolarsi tale casa, e sarà del tutto ricercata."

13. Fiorelli 1860–1864, 1:3:15 (25 February 1809): "Si è terminato di scavare il peristilio, che restava da ricercasi nella casa ove si trovò la cerva di bronzo, e con lo scoprimento di questo non resta altro da ricercasi di tale casa. È composto di quattro colonne, con canale per ricevere lo scolo della grondaja; e questo canale resta chiuso in un angolo, che forma quasi una bagnaruola con ispilli di acqua all'intorno. Somministrava l'acqua una conserva, che resta al muro opposto al colonnato. Immediato al detto canale vi resta un'ara dipinta all'intorno con arabeschi ed uccelli. All'angolo sinistro di detto peristilio vi resta un locale che pare un triclinio. Dirimpetto alle colonne vi è un muro, ch'è quello che cinge la casa da tale parte, distante dalle colonne una decina di palmi, con pilastri dirimpetto alle corrispondenti colonne. Fra pilastro e pilastro vi resta dipinto in campo d'aria una zoccolatura formata da incannucciata, con in mezzo un fonte con piede, come quei dei fonti lustrali, e sopra dell'incannucciata si vedono degli arboscelli fronzuti con fiori. Più in alto vi resta un grosso festone composto da spesse frondi, che pajono di fico. Sopra gli arboscelli, i festoni, e per l'aria vi restano dipinti degli uccelli al naturale in mosse corrispondenti alla specie che rappresentano, benissimo dipinti. Nel riquadro che resta dalla parte del triclinio vi è un fregio con conigli morti, e varie sorte di pesci e polli. Quello che rincresce si è, che tali pitture sono molto patite; ma ad ogni modo meriterebbero che fossero ora disegnate, prima che vadano maggiormente a smarrirsi."

14. Mazois 1824–1838, 2:75–79, pls. 35–39.

15. Halsted B. Van der Poel, *Corpus topographicum pompeianum*, 5 vols. (Rome, 1981), 5:188–189, hypothesizes that this entrance had not been cleared in Mazois' time, since Sir William Gell and John Gandy (*Pompeiana* [London, 1817–1819], pl. 27) do not show it either. In view of the number of mistakes in Mazois' plan, however, this may well be simply another error on his part, which was then copied in the later plans.

16. Amedeo Maiuri, "Restauri di guerra a Pompei," *La vie d'Italia* (1947), 215–221; Maiuri, "Pompei e la

guerra," in *Pompei ed Ercolano: Fra case ed abitanti*, rev. ed. (Milan, 1964), 306–307.

17. For example, Gell and Gandy 1817–1819, 151, 170–178, 262–264; William Dyer, *Pompeii: Its History, Buildings, and Antiquities*, 2d ed. (New York, 1870), 328–343.

18. Vittorio Spinazzola, *Pompei alla luce degli scavi nuovi di Via dell'Abbondanza (anni 1910–1923)*, 2 vols. (Rome, 1953).

19. August Mau, *Geschichte der decorativen Wandmalerei in Pompeji* (Berlin, 1882), pl. 2a (see fig. 8 of this essay); for Mau's complete description of the First Style paintings in the house, see 17–33.

20. Anne Laidlaw, "Reconstructions of the First Style Decorations in the House of Sallust in Pompeii," in *In Memoriam Otto J. Brendel: Essays in Archaeology and the Humanities* (Mainz, 1976), 105–113, pls. 18–22; Laidlaw 1985, 43–45, 118–137, 1g,j,l, 3b–c, 8a–b, 9a, 12, 15a, 16b, 23a, 33a, 36a–b, 41a–b, 60a–b, 62–67.

21. Frank E. Brown, "Scavi a Cosa-Ansedonia, 1965–66," *BdA*, 5th ser., 52 (1967), 37–39; Brown, *Cosa: The Making of a Roman Town* (Ann Arbor, 1980), 73–74.

22. Mau 1882, 29.

23. The average height of a First Style socle in Pompeii is plus or minus 1.00 m. In the Casa di Sallustio the preserved socles vary between 0.75 m and 0.91 m (atrium, 0.91 m; left ala, 0.87–0.89 m; tablinum, 0.75–0.77 m), depending on the relative levels of the pavements and proportions of the individual rooms.

24. For example, House 1.13.2, left ala 7. See Laidlaw 1985, 81.

25. In July 1970 we dug underneath the two threshold blocks between Oecus 22 and the portico to examine how the lower signinum pavement was finished along that side of the room. We found that the yellow plaster socle continues along the whole length of the east wall, thus ruling out the possibility of an earlier door opening in that wall.

26. The sherds were examined by Helen Russell White in 1970. A complete study of the pottery from all thirty-seven soundings, by Paul Arthur of the Università degli Studi—Lecce, will be included in the formal excavation report.

27. For a full discussion of the relative chronology of the First Style paintings in Oecus 22, see Laidlaw 1985, 130–133. For possible earthquake damage, see Amedeo Maiuri, *L'ultima fase edilizia di Pompei* (Rome, 1942), 98–99.

28. Arnold and Mariette De Vos, *Pompei, Ercolano, Stabia* (Guide archeologiche Laterza, 11; Rome and Bari, 1982), 225; Lawrence Richardson, Jr., *Pompeii: An Architectural History* (Baltimore and London, 1988), 290.

29. During the rebuilding of the house in the spring of 1970 these ashlar blocks were disassembled so that the workmen could ascertain the strength of the underlying foundations in relation to the projected roof. The reassembled blocks are now set into a modern cement foundation.

30. The roofers removed the compluvium tiles in 1970, tore down this wall entirely, and replaced it with a modern rubblework wall set into a poured cement foundation.

31. Dating from 32–31 B.C.; Michael Crawford, *Roman Republican Coinage*, 2 vols. (Cambridge, 1974), 1:539, cat. no. 544/8.

32. Dating from the fourth–third century B.C.; Arthur Sambon, *Les monnaies antiques de l'Italie* (Paris, 1903), 848–849.

33. Dating from 400–350 B.C.; S. W. Grose, *Catalogue of the McClean Collection of Greek Coins*, 3 vols. (Cambridge, 1923–1929), 1:330, nos. 2762–2769.

34. When we cleaned around the threshold between the atrium and Shop 2, across the fauces from the thermopolium, we found some plaster fragments of the oval marbling on a light ground. These must have fallen from that section of the decoration, and they thus confirm our theory about the alternation of the two patterns of marbling in the upper zone.

VINCENT J. BRUNO
University of Texas at Arlington

Mark Rothko and the Second Style: The Art of the Color-Field in Roman Murals

In the course of my association with Frank Brown in the excavations at Cosa, the conversation on many occasions turned to the problems of Roman wall painting, since fragments of mural decoration had been found in various parts of the site. On one of these occasions, as we drove together from Cosa to Rome, Frank interrupted his train of thought concerning the Cosa fragments and said, "Of course, eventually you will have to forget about individual examples and simply explain why Roman walls look the way they do." As soon as he said this, I knew what he meant, and this essay is my attempt to come to terms with the larger problem.

If there is any single distinguishing feature that sets apart the art of the Roman mural, most scholars would probably agree that it has to do with color. Specifically, the problem is to explain how it happens that we are made to feel so strongly the impact of large, two-dimensional fields of color as elements in a three-dimensional pictorial image. Modern parallels spring to mind, and there is no special reason why they should be avoided. In the history of mural painting, there is no parallel but the modern for the great sheets of intense, deeply saturated monochromatic fields of color that characterize Roman murals. The sheer force of pure, abstract color in the Roman walls is made to dominate whole spaces and environ-

ments, just as it does in modern art. The best parallel is found in the work of Mark Rothko, whose invention of the color-field, treated as a plane within an abstract yet pictorially convincing spatial atmosphere, has proven to be one of the most powerful and most frequently imitated statements of the modern movement.

Rothko disliked to hear himself compared with other artists of the modern movement, yet he was the first to recognize, and to admit, that there exists a common ground between his color-field designs and the mural designs of the ancient Romans. In Rothko's moment of recognition of this common factor, he probably understood more clearly than anyone else ever has what it is that makes Roman walls "look the way they do." We can do no better in our own attempts to comprehend the underlying principles of the ancient murals than to try to reconstruct precisely what Rothko saw.

In the summer of 1959, Rothko walked through the Villa of the Mysteries at Pompeii and came out exclaiming upon the "deep affinity" he felt between his own work and the ancient style. Fortunately, there was a witness to this extraordinary event, who later described the incident at some length: John Fischer, then the editor of *Harper's Magazine*, whom Rothko and his daughter had met on shipboard between New York and Naples, and who, with his

own daughter, accompanied them on their visits to the ancient sites.[1]

Rothko always resisted attempts to describe his work as either abstract expressionist or surrealist.[2] He felt his work to be linked somehow with remote antiquity, with the communication of primeval meanings that lie beyond pure form. An early instance of this preoccupation was expressed in the draft of a letter addressed to E. A. Jewell of the New York Times in 1943: "To say that the modern artist has been fascinated primarily by the formal relationship aspects of archaic art is, at best, a partial and misleading explanation The truth is . . . that the modern artist has a spiritual kinship with the emotions which these archaic forms imprison and the myths which they represent."[3] In the late 1940s, after he had developed the color-field paintings for which he became famous, Rothko told Robert Motherwell that there was always "automatic drawing" underneath the larger forms. Automatic drawing, an offshoot of the automatic writing of the dada and early surrealist movements in Europe, is something about which the New York group appears to have learned through Meyer Shapiro, who introduced Motherwell to the French surrealists then residing in New York.[4] Years later, according to Dore Ashton, the poet Stanley Kunitz said of Rothko, "I felt definite affinities between his work and a kind of secrecy that lurks in every poem . . . an emanation that comes only from language."[5] I believe that Rothko may have been drawn toward the Roman Second Style initially by its clear suggestion—often contained in quite empty architectonic designs—of a kind of transcendental dialogue. This could have happened early in his career when he discovered the architectural mural fragments from Boscoreale in New York, with their eloquent sheets of brilliant red framed by golden pilasters.[6]

If Rothko's perception of the ancient murals was influenced by his long preoccupation with the expression of transcendental thought, his moment of recognition at Pompeii seems to have been triggered by the simple fact that he had received his first mural commission the previous year.

The Villa of the Mysteries, with its reconstructed roof, provides a unique opportunity to experience ancient compositions as complete designs within the actual spaces for which they were originally created, and Rothko's visit took place in the midst of his own first efforts to create a similarly complete system of environmental design, similarly dominated by abstract color.

There is little doubt that the commission to paint a set of murals for Mies van der Rohe's Seagram Building in New York in 1958 represented a turning point in Rothko's career. Dan Rice, Rothko's assistant, expressed this clearly in an interview with Arnold Glimcher. Speaking of Rothko, Rice said, "I believe he actually felt that he had gone as far as he could in painting until the proposal for the Seagram Building murals was presented to him. . . . For many years, he had the concept that his work must or should hang together in a permanent environment, fixed only by the work itself."[7] This phrase, "fixed only by the work itself," applies equally well to the ancient murals, which cover the walls completely from floor to ceiling, a rare phenomenon in later periods, even in the sixteenth century. In other words, Rothko's own preoccupation with the problems of mural composition had prepared him in a special sense to see and understand the artistic solutions of the ancients, especially with regard to color; he had already come to some of the same solutions himself during the months preceding his trip to Pompeii. He had created a room within a room in a New York loft, filling it with great panels of color, abandoning the basic vertical, tripartite design of his "classical" period in the process. His two studies for the murals in gouache in the National Gallery of Art in Washington show designs in which the earlier vertical compositions seem to be turned on end (figs. 1, 2). New forms appear: great horizontal areas of brilliant red, interrupted by narrow uprights, some of them like pillars; and openings suggesting windows and doors. One of these openings is surrounded by black, another by a brighter orange-red. There are spaces of light in an otherwise uninterrupted row of solid colors and architectonic supports—in short, sequences of

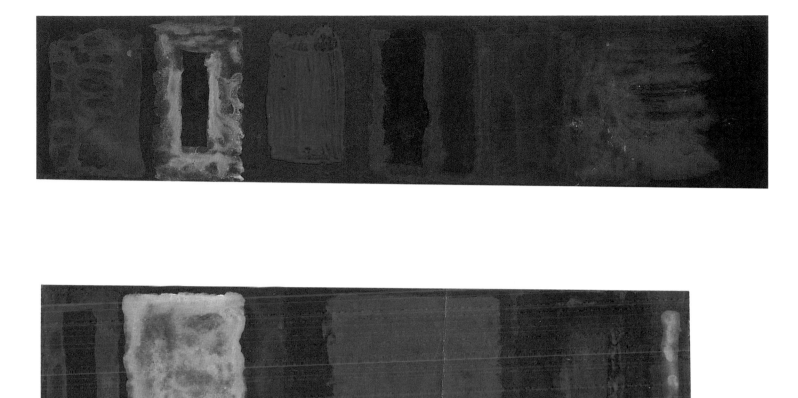

1. Mark Rothko, *Study for Seagram Building Murals*, 1958–1959, gouache on paper
National Gallery of Art, Washington, Rothko Foundation Collection

2. Mark Rothko, *Study for Seagram Building Murals*, 1958–1959, gouache on paper
National Gallery of Art, Washington, Rothko Foundation Collection

monochromatic color-fields, pillars, and openings closely resembling in basic conception the sequences of paneling and architectural enrichment found in ancient walls of the Second Style, some of the best preserved examples of which are in the Villa of the Mysteries.

Dore Ashton, who visited Rothko's studio at this time, vividly described his preparatory studies: "Some of these sketches initiated a movement on lateral lines, climaxed by images of fiery doorways. Some had bright blue gateways to a relatively atmospheric ground. In some there were yellows and crimsons, and flares of blue flame. It was evident that he was bent on moving beyond the stately containments of his large paintings, imagining perhaps a 'corridor' or corridors through which his viewers would enter Rothko's universe."[8]

In the Villa of the Mysteries Rothko saw, for example, a room with murals present-ing large black and yellow color-field panels (two of his favorite colors), interrupted by pilasters and columns and by a doorway painted in creamy white tones imitating marble.[9] One of these doors is placed, not in the middle of the wall to create a symmetry, as is often the case, but off to one side near the end of the sequence—something that Rothko had done in his gouache sketches. In the Hall of the Great Frieze, he saw behind the figures great sheets of a color very close to his own deeply saturated red, here in the form of panels divided from each other by pilasters of dark purple, another Rothko color.[10] In some of the smaller rooms, dominated by the same intense red, there are unexpected glimpses of a brilliantly lit world beyond the panels of red that enclose us, with an occasional flash of blue in the sky. It is not surprising that Rothko emerged from the villa stunned by the

does not ordinarily extend beyond certain limits within a given mural design. In the colonnades and entablatures surrounding the color-field panels are the traditional polychromatic decorations commonly found in Hellenistic architectural orders. A seemingly endless variety of multicolored ornamental friezes, moldings, projecting cornices, acroteria, and other decorative accents offsets the austerity of the color-field design. Polychromatic coloring of carved architectonic ornaments had been traditional in monumental structures since archaic times; it was an essential part of the architectural landscape throughout classical antiquity, and especially in the Hellenistic age. For this reason, a completely monochromatic room in the Second Style is astonishing, particularly since the decoration represented is by no means restricted to paneling and other flat elements. On the contrary, the painters of such rooms delighted in filling them with illusionistic representations of the richly carved friezes and other ornamentation that would normally have been painted in several colors in Hellenistic buildings.

Lehmann calls attention to three monochromatic rooms in the Second Style, including one in the Villa of the Mysteries (figs. 3, 4) and one in the House of the Cryptoporticus (figs. 5–7), of about the same date, near the middle of the first century B.C.[21] One might imagine that so small a number of examples at Pompeii must be an indication that the type was a rarity, but in fact Pompeii preserves comparatively few important Second Style decorations, since many were covered over in later styles, especially in the period after the earthquake of A.D. 62. Thus the appearance of monochromatic rooms in as many as three Pompeian houses suggests that these are not exceptional cases. Rather, monochromatic rooms appear to be a regular feature of the Second Style and, no doubt, of Hellenistic palace decoration—if, as is generally assumed, that was the source of many of its decorative conventions.[22]

In the Villa of the Mysteries, the monochromatic cubiculum (Room 3) is only a step away from the cubiculum with two alcoves (Room 4) through which one passes from the Tuscan atrium into the

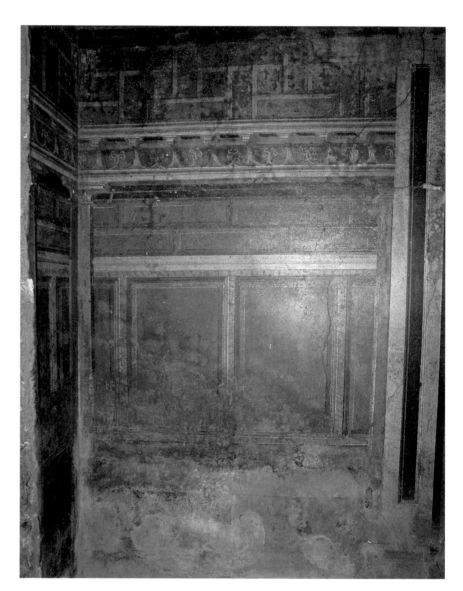

3. Room 3, Villa of the Mysteries, Pompeii, mid-first century B.C., green sitting area
Photograph: Soprintendenza Archeologica di Pompei

Hall of the Great Frieze. In the earlier Tufa period, Rooms 3 and 4 formed a single large hall with an entrance off the southwestern corner of the atrium. About the middle of the first century B.C., the large rooms on either side of the atrium were subdivided into smaller units and were redecorated in the Second Style. The decorations in Room 4 echo the Dionysiac theme of the Great Frieze. Thus the monochrome environments of Room 3 that form part of this justly famous complex of spaces should be seen not as a minor curiosity but rather as part of one of the most interesting and distinctive mural programs of the mature Second Style.

The monochrome cubiculum in the Villa of the Mysteries is divided into two differ-

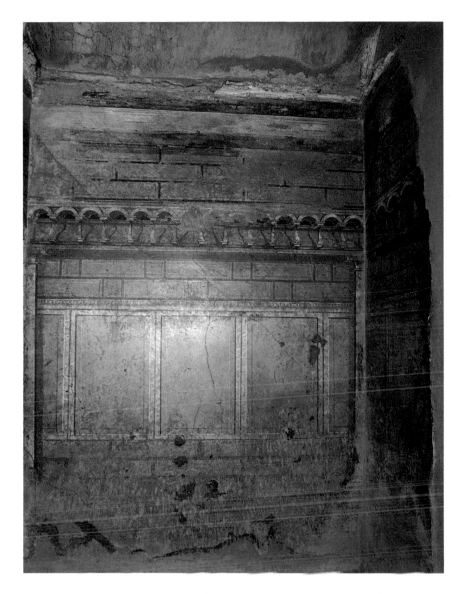

4. Room 3, Villa of the
Mysteries, Pompeii,
mid first century B.C.,
yellow alcove
Photograph: Soprintendenza
Archeologica di Pompei

tone somewhat too dark to be taken as a version of the green; yet the dark tone acts merely as a deeper shadow and need not strike the viewer as a second color. On the other hand, a dark green stripping outlines each of the raised panels, and a very pale green is used for the most important ornamental moldings and for the cornice. These should probably be understood as deliberate differences, representing darker and lighter types of stone chosen from the general range of green-tinted marbles available in antiquity, which includes four or five different kinds.[23]

Such variations do not affect the viewer's surprise upon walking into a space devoid of normal coloring. Great pains were taken to maintain the sense of a totally monochromatic space. In the yellow alcove there are the same complex relationships of light and dark in the projecting elements of a cornice of small arched vaults with slender S-curved uprights acting as supports. These uprights rest on protruding bases that cast shadows on the wall below. The shadows on the wall are distinctly lighter than the tone used to fill the lunettes, which can only be seen as openings; all is carefully arranged to create a convincing trompe-l'oeil effect without appearing to involve actual changes of hue. In the paneling, however, there is a real departure. As in the green zone, so also in the yellow alcove, the recessed stripping surrounding the individual blocks is a much darker tone than the raised, drafted-margin surfaces, so that it does seem intended as a contrasting color. It is definitely brown, a color that the eye cannot quite interpret as a darker version of the yellow of the panel surfaces themselves. The shadows cast by the pilasters in the corners of the room fall across both the yellow drafted panels and their frames of brown stripping, darkening both, and making it clear that the stripping is, in fact, not a darker yellow seen in shadow, but a different color. This is an interesting touch: There is no escaping the fact that the brown is a contrasting color, yet the overall aesthetic quality of the monochromatic system remains unaffected. In fact, the contrasting frames seem to enhance the effect, the golden tones of the overall

ently colored parts, corresponding to the division of the space into a sitting area and a bed alcove. The larger sitting space is colored entirely in imitation of bluish green marble, a beautiful stone usually reserved for smaller decorative accents, while in the alcove the overall color is a golden yellow. The walls in both areas are covered with complex arrangements of carved architectonic designs, including drafted-margin blocks, moldings, and cornices, which are illusionistically rendered in darker and lighter tones of the basic color to suggest their sculptured, three-dimensional elements. In both sections of the room there are departures from absolute monochrome. For example, a coffered cornice in the green section has the coffers painted in a

design becoming more noticeably nuanced and, at the same time, more delicate.

There are other pleasant subtleties: A wide, flat string course in the yellow alcove runs along above the orthostates and provides a border for an egg-and-dart molding whose high relief casts an intricate and irregular line of shadow along its smooth surface. The string course itself is decorated by a narrow edge of beading along its lower edge. Repeating the same principle observed in the green alcove, these finely carved elements appear to be of a distinctly lighter color than the yellow used in the flat areas of the paneling and frieze. The change in tone is sufficiently marked to suggest a different kind of marble, not quite yellow but golden white, perhaps a more costly stone of the kind that would have been reserved for the moldings in a built prototype because it could be carved in finer patterns. In any case, the distinction between paler and deeper elements in the monochromatic scheme imparts a sense of realism to the architectural forms, a sense of carefully observed structural distinctions. The variations in light and dark also provide contrasts that prevent the architectonic design from becoming monotonous. The vivid sense of the splendor that a real marble room of this kind must have afforded depends upon the mural painter's awareness of such refinements in the original buildings and his ability to render them with the brush.

The general effect of these meticulously painted designs is one of extreme sophistication. The anomaly of monochromatic architectural decoration was surely recognized by the ancient viewer, and the surprise felt by a visitor on entering such a space must have been part of the pleasure. The luxury of so much marble inlay even in a palace was itself remarkable, no doubt. To have it meticulously copied in paint on plaster may have seemed an amusing kind of objective realism in the midst of the mythological imagery in the murals of the adjacent rooms.

The monochrome room in the House of the Cryptoporticus (Room g) offers several interesting features of a kind that could not have been seen in an actual built interior,

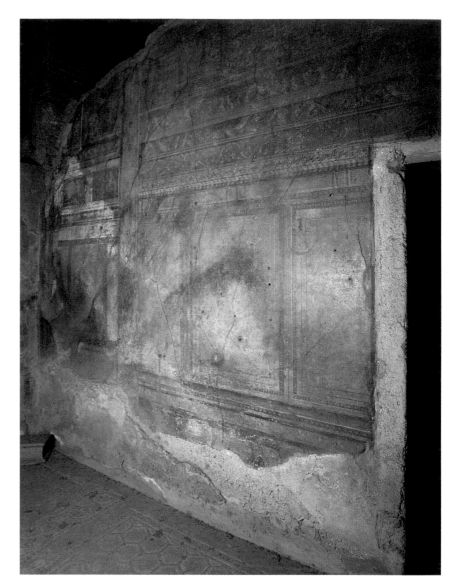

introducing a note of what might be termed surrealism (figs. 5–7), in contrast to the realistic effects of the example just considered. This room is of one color throughout, with an alcove marked off only by a pilaster in a contrasting hue (and, as is usual, by a change in design in the mosaic pavement).[24] The main color is a rather unusual dark red, not one of the standard Pompeian colors, with the dividing pilaster in green (fig. 5). In both alcove and living space a darker stripping is used to outline the orthostates—a feature now recognizable as a convention—while the main architectonic articulations appear lighter, as before. In the main section of the room, a remarkable sequence of friezes is grouped above high orthostates, among them an

5. Room g, House of the Cryptoporticus (House of the Lararium), Pompeii, mid-first century B.C.
Photograph: Soprintendenza Archeologica di Pompei

6. OPPOSITE, TOP: Room g, House of the Cryptoporticus (House of the Lararium), Pompeii, mid-first century B.C., upper zone with tragic masks and painted scenes
Photograph: Soprintendenza Archeologica di Pompei

7. Room g, House of the Cryptoporticus (House of the Lararium), Pompeii, mid-first century B.C., Dionysiac scene with Silenus and flute player
Photograph: Soprintendenza Archeologica di Pompei

surmounts the Nereid frieze (fig. 6). Tragic masks rest on the shelf formed by the cornice. In the green and yellow room of the Villa of the Mysteries, all the three-dimensional motifs were architectural reliefs; in this room, however, the masks are free-standing objects. In addition, in this same zone in the red room, above the cornice, there are framed paintings with mythological subjects that appear to be painted upon the flat wall surface. An element of the surreal begins to make itself felt as the viewer realizes that the deep red color of the background seems to bleed equally through all these different elements—through the pictures and the free-standing masks as well as the carved architectural reliefs. One might expect that the basic premise of a monochrome room would necessarily confine the monochromatic system to the carved architectural reliefs and paneling, since the viewer is made to think of their color as that of the stone or marble in which real walls might be veneered. What happens to this illusion when paintings and masks, which are obviously not part of the marble work, and which must be thought of as polychromatic objects, seem equally affected by the monochromatic atmosphere? The initial strangeness of the monochromatic effect is deepened in a manner that boldly defies any rational explanation. The result is a kind of virtuoso performance, in which the idea of the monochrome seems to be pushed to an extreme, an effect both playful and a little frightening. The ancient painter is tampering with pictorial states of being, like some of the visual tricks in early surrealist films, for example, in Jean Cocteau's *Blood of the Poet*, when an artist at his easel draws in the lips of a face, and as he draws them they come to life and begin to speak, though still in colorless charcoal.

There is also something about the dark, almost blood red coloring that is more than a little disturbing. This is not the exciting scarlet of Second Style paneling. An explanation for what seems an odd choice of color may perhaps be found in the alcove, where two framed metope designs appear in the frieze (fig. 7). This is a unique type of figural representation, in which the figures are carried out in white monochrome

inclined meander, a frieze of shields, and a peopled frieze of Nereids and sea monsters. All these friezes are convincingly painted to look like raised reliefs, including the Nereid frieze, which, like the meander and the shields, shows highlights and shadows following the contours of each form.

A somewhat unusual situation is found in the zone above the dentil cornice that

on a background of dark red, the same dark red that here infuses the entire space of the room. This white-on-dark technique became a conventional decorative formula in late Hellenistic mural painting in Greece.[25] As far as I am aware, there is no other example of it in the Second Style in Italy.[26] In this example, the Second Style muralist evidently adopted the background color of the metopes—designs he had no doubt copied from a Greek model—as the overall color of the room, perhaps without foreseeing the strangeness of the result.

The presence of the white-figure technique in the House of the Cryptoporticus is interesting as an indication that the Second Style workshops in Italy must have been thoroughly familiar with earlier Greek precedents; in Greece this particular technique was a characteristic of the earlier Masonry Style, the Greek equivalent of the Pompeian First Style, when murals were still largely dominated by a system of plaster reliefs imitating stone-carved forms. In the white-figure method, the figures are rendered in a manner that suggests at first a carved relief. The milky pigment against the dark red creates a sculptured effect reminiscent of a cameo like the Tazza Farnese.[27] The unique quality of the technique has to do with its ability to suggest three-dimensional form simply by varying the degree of opaqueness in the white pigment as it is drawn by the brush over the dark neutral red of the background. Whether the actual intention was to imitate a type of sculptured decoration, perhaps one in common use,[28] it is difficult to say, for the rendering involves another of those painterly anomalies that seem to have been the special delight of the Hellenistic age. The white figures at first look two-dimensional, as though sculptured in ivory or cameos, but they do not lie flat on their dark red background. Instead they cast shadows behind them and move about in an atmospheric space like living creatures.

There can be little doubt that in Italy in the mid-first century B.C. the white-figure technique would have been seen as an evocation of an earlier Hellenistic method. Beyen referred to a white-figure centaur and Lapith frieze in a Fourth Style decora-

8. Green oecus, House of Menander, Pompeii, c. A.D. 62–70, detail: white-figure centaur frieze
Photograph: Soprintendenza Archeologica di Pompei

tion in the House of Menander in this light (fig. 8),[29] but it is also true of the alcove metopes in the Second Style paintings of the red monochrome room, and in the latter example it must be said that the special qualities of the original Greek method are far more accurately reproduced. The Fourth Style version has something of the appearance of a caricature when compared with the examples of the red room, where the painter, exploiting the contrast between arbitrary coloring and realistic handling of light and shadow, captured more successfully the character of the original Greek method. Especially important to a successful rendering in the white-figure technique is the manner in which the rendering of space must be understated so as not to seem too obvious. The viewer should have to look twice to perceive the discrepancy between the artificiality of the white, colorless figures and the natural and convincing way they move in space. The Second Style painter who rendered the metopes of the red room blended these incompatible states of being gracefully, and with full conviction. In the Dionysiac scene (fig. 7), the painter captured the precise weight of the heavy Silenus, the lightness of step of the flute player; in the scene with Ariadne and the

departing Theseus he portrayed perfectly in a few strokes the utterly relaxed pose of the reclining woman. These figures seem to be alive, despite their abstract coloring. Overstated, as in the Fourth Style frieze of centaurs, the detachment of the figures from the background produces a bizarre effect. Since the poses and actions of the centaurs and their victims in the House of Menander seem deliberately comical, however, perhaps the white-figure technique was knowingly exaggerated here as a means of adding to the humor.

The Second Style features several ways in which Hellenistic art, as reflected in the murals, delighted in misleading the eye and indulging in deliberate confusion between artifacts and living creatures. Sculptured figures used as caryatids or acroteria are often rendered so as to seem alive. In some instances they appear to turn their heads to glance at the passing viewer, like Cocteau's herm pilasters in the Beast's castle in *Beauty and the Beast*. In fact, Cocteau's herms had a much closer parallel in the Hellenistic age than anything to be found in the murals: the golden guardian lions on either side of the entrance door of the burial chamber on the funeral car of Alexander, which according to Diodorus Siculus (18.27.1) actually did turn their eyes to glance at anyone wishing to enter. The effect must have been exactly the same for the ancient as for the modern manifestations; first we feel a shock, and then we laugh.

In ancient mural painting, then, a kind of surrealistic entertainment was sometimes achieved by using distinctly unreal colors as pictorial backgrounds. In Greece, it is clear from the context of the Masonry Style that such backgrounds originally represented friezes of colored stone. But Italy boasts a wider variety of monochromatic techniques, which show little evidence of any connection to a tradition of architectural decoration. Some of these monochromes are strictly pictorial. Whether or not they too derive from a Hellenistic context would be difficult to say in the present state of knowledge; there is no existing example that can be traced to a Greek source, but that may easily be an accident of preservation. When artists like Miró and Chagall used unexpected color-fields as backgrounds for figures that seemed to float in space, it signaled a revolutionary movement. In antiquity, the idea may easily have developed naturally out of a long history of brilliantly painted walls and bold juxtapositions of rich colors in architectural environments. At a certain point, mural painters began to see these same colors as the backgrounds for pictorial designs, as they did in the case of the white-figure technique. Evidently from this point they went on to create more truly pictorial compositions, using the same seemingly unnatural colors to create all sorts of exotic atmospheres for figural scenes and landscapes.

Scholars have identified several types of monochrome and oligochrome in ancient mural painting, but a basic distinction must be made between two main categories: one in which the intention is simply to copy a carved sculpture made of deeply colored stone, and one in which a pictorial atmosphere is suggested within a field of artificial color in such a way as to create a deliberately unreal effect, often poetic or romantic in quality.[30] There is nothing surrealistic about the dark red Nereid frieze in the red cubiculum in the House of the Cryptoporticus; it is to be thought of as a standard type of carved architectonic decoration. But a scene like the yellow landscape in the cubiculum from Boscoreale in the Metropolitan Museum of Art, New York,[31] involves an entirely different set of rules and, most probably, a different tradition. Here the colored background no longer may be seen as stone. Instead it forms an atmospheric setting for a picture with naturalistic space, but with an apparently impossible color. An effect of surrealism is unavoidable at the outset.

One of the most remarkable examples of such a surrealistic monochrome can be seen in the fragments from Boscoreale now in the Musée Royal de Mariemont (figs. 9, 10).[32] Two separate panels once were parts of a wall in Room N, adjacent to the cubiculum (Room M) now in New York. Room N was originally described as a triclinium but, as Lehmann explains, it could not have been designed as a dining

room, for it was connected by a door to the antechamber (Room O) leading into the neighboring cubiculum from the peristyle. This configuration suggests the kind of suite Pliny the Younger describes in his villas, in which a *cubiculum diurnum*, simply a living room, is placed beside and connected to a *cubiculum nocturnum*, or bedroom.[33]

Room N was roughly the same shape as the cubiculum in New York, though slightly wider and longer, since it lacked the separate antechamber of Room M. The two panels at Mariemont show an elaborate entablature above a red-paneled *scaenae frons* partition of the kind typical of the Second Style; in fact, this is a motif repeated in several other rooms at Boscoreale. Only bits and pieces of the scarlet panels are preserved along the bottom of the entablature, but these are sufficient to show what they were. In the entablature, a typical collection of architectonic friezes was grouped together beneath the usual projecting cornice. A similar arrangement of friezes is found in the monochromatic red room at Pompeii, but in the Mariemont fragments the details of the architectonic decorations are presented in their full, traditional coloring rather than in monochrome. The molding bordering the red panels of the main zone is the color of a green stone of a type already noted in the Villa of the Mysteries. Above this is a porphyry frieze with carved floral motifs. Next comes a yellowish white frieze suggesting marble or ivory carved with raised disks; above that is another example of the Nereid frieze in porphyry like the one in the red room of the House of the Cryptoporticus, only this time better preserved and more skillfully rendered. In this example, it is possible to see much that is difficult to make out in the frieze in Pompeii (fig. 6). Here the Nereids are accompanied by winged Erotes, who seem to be helping them to drive the sea horses. It is clear that these sea horses are not the handsome, human-torsoed creatures familiar in other monuments: They are strange-looking orientalizing monsters, with dragon heads and long undulating bodies. Only the forelegs are recognizable as those of a horse. Such beasts might wander about carrying the

Nereids over the sea indefinitely, were they not guided by the Erotes, who ensure, perhaps, that Thetis arrives on time for her wedding, or that she is sped back to Troy with the replacement for her son's lost armor. In any case, it is fortunate that a rendering of a sculptured porphyry frieze is preserved so well in these fragments, because it reveals how different it looks from the pictorial monochrome that appears above the cornice in this same design.

Fortunately, some of the missing parts of the wall represented in the fragments at Mariemont can be reconstructed by referring to the drawing of one of the long side walls in the same room made during the excavation of the villa by Barnabei's artist.[34] From the drawing in Barnabei it is clear that the entablature preserved at Mariemont repeated the same arrangement once to be seen on the west wall recorded in the drawing. The exception is the red monochromatic landscape under discussion. In the Mariemont fragments (figs. 9, 10), this landscape is located above the dentil cornice that crowns the partition wall entablature. The drawing from Barnabei shows that there was no such landscape in the corresponding space on the long side wall of the room.

This seems difficult to understand, so it will be necessary to look further. In addition to the friezes of the entablature, which are all clearly indicated in Barnabei's drawing, it is clear that another element unified the design of the west and north walls. The drawing shows two colonnades running along in front of the partition wall. One of these was a row of Corinthian columns, their bases supported on the usual podium. There is no trace of this colonnade on the fragments at Mariemont. But the second colonnade shown in the drawing does appear in the Mariemont fragments, though just barely. This colonnade, which stood in front of the podium, had unfluted column drums decorated with rectangular bosses, and these bosses are, by the merest chance, partially preserved along the broken vertical edges of the Mariemont panels. In figure 9, on the right edge of the panel, one of the bosses overlaps the red frieze just above the top of the cornice. In figure 10, on the left edge of

the other fragment, is a boss seen at a slightly lower level, overlapping the cornice itself and a bit of the red zone of the frieze above; another boss is visible still lower, overlapping the white frieze with disks. The yellowish white strips along the vertical edges must be the edges of the column drums themselves. It is also clear that the bosses in the two panels belong to different columns, for they are not aligned with each other. We must therefore reconstruct two columns and three intercolumnations along the north wall. The Mariemont fragments, then, contain the partition wall entablatures and upper zone decorations from two out of three intercolumnations; the center intercolumnation was interrupted by a window, which Barnabei mentions in the north wall.

Bossed columns like those in Room N also appear at Boscoreale in the Hall of Aphrodite, where they served to unify the various elements of the design, framing symmetrical units of the mural scheme around the walls of the room. If the columns served a similar purpose in Room N, it would be safe to say that an architectural scheme more or less identical with that of Barnabei's drawing originally covered all four sides of the space, except for the one outstanding difference of the monochromatic frieze. On the long wall, following the design as it was recorded by Barnabei's artist, the area above the entablature of the partition wall was treated as an opening with a perspective view into a colonnaded peristyle, understood to be behind the *scaenae frons* structure, an arrangement paralleled by the murals from Boscoreale's large triclinium (Room G). On the wall in question, however, as we have it from the panels at Mariemont, what should have been a continuation of this open colonnaded space is quite illogically filled with a red color-field. Floating mysteriously in this red environment is a landscape with temples and shrines shown receding into depth, yet bearing no relation whatever, either in scale or in perspective point of view, to the architectural scheme of the room as a whole.

In the well-known yellow frieze in the House of Livia on the Palatine Hill in Rome[35] the color-field does not simply

disappear behind a cornice. Its frame of porphyry and marble is explained as having a definite position in the solid wall that rises behind the row of columns, similar to the columns of the Boscoreale decorations. In contrast to this, in Room N at Boscoreale the entire space above the cornice is treated as a picture-field, as though the space has nothing to do with the architectonic arrangement of the room, in spite of the fact that the continuation of the bossed colonnade leads the viewer to expect a continuation of the normal architectural elements seen on the side wall. The red of this picture-field is not an architectural color. It differs in quality and hue from the color of the sculptured Nereid frieze in the same decoration. The dense purple of the porphyry Nereid frieze is an opaque color, while the clear red of the landscape is treated as a transparency in which forms move in and out of a space that has no definition, no horizon line, no limits.

Parallels are difficult to find. For the general scheme, one might think of the Odyssey landscapes in Rome.[36] In Room N, the bossed columns must have divided the frieze into the segments now in the Mariemont fragments. These segments would have been seen as continuing without interruption behind the columns. The same was undoubtedly true of the Odyssey Frieze in its original setting, where elegant red pilasters took the place of our bossed columns. But in the Odyssey Frieze, the coloring of the landscape is natural. The sky is blue, the landscape rich in a variety of colors. In the Mariemont frieze, land and sky are all rendered in the same unnatural red.

The closest parallel to the red landscape frieze is the yellow monochromatic panel mentioned earlier from the cubiculum once next door to it, now in New York.[37] Phyllis Lehmann noticed the similarity between these two, and it was she who realized that they show sufficiently specific characteristics of style and handling to be considered as representing a distinct class, which she describes as pure monochrome (in contrast to oligochromatic versions like the yellow frieze on the Palatine, in which a second color is used in the

modeling of the figures, in addition to lights and darks).[38]

The yellow panel in the New York cubiculum, like the red landscape at Mariemont, has no relation to the elements in the mural design around it, so that, as Lehmann explains, it looks as though it were painted on a screen placed arbitrarily in front of the scene depicted in the rest of the wall, a screen that partially interrupts the view into a garden. Unfortunately, an opening made for a window in the end wall of the room cuts away the upper left corner of the yellow monochrome, so that the impact of its spatial composition is somewhat diminished. The portion remaining shows a coastal landscape filled with buildings, as the coast around the Bay of Naples undoubtedly was. A bridge on the lower left is much like a bridge in the red frieze (fig. 10) and links the two works iconographically. But there are also differences.

Most important is the fact that the red frieze at Mariemont has no identity as an object. The yellow painting in the New York cubiculum is a framed rectangular panel, an identifiable object. The yellow frieze on the Palatine also has a frame, an inlaid porphyry molding made to look like part of a sequence of ornamental elements set in a masonry wall: again, it is an identifiable object. But the Mariemont frieze occupies a space that the viewer is forced by the surrounding composition to interpret as open air. We are deliberately led to think of the space it occupies as an opening by the continuation of the bossed colonnade and other elements of the design that are carried across from the lateral wall, where the zone above the dentil cornice represents a well-defined and familiar type of open space surrounded by columns in perspective. Thus the viewer comes upon the red frieze as something out of place, an enigmatic scene intruding upon an architectural design where it is least expected.

This very fact lures us into its strange aura, as we might enter the realm of a dream. Pure red color, like a fog, seems to suffuse the three-dimensional space implied by the sacred buildings in the scene, making forms indefinite. Without a horizon or the formal limits of a frame, the

11. Room N, Boscoreale,
c. 40 B.C., red frieze from
north wall, detail
Musée Royal de Mariemont

color-field assumes the quality of infinity, as in Rothko, evoking the impression of a state of transcendental experience.

Contributing to this effect in the red frieze at Mariemont is the small figure of a woman in the foreground, who has walked down alone to the edge of her universe (fig. 11). She leans over the top of the projecting cornice, as though it were the top of a parapet belonging to her own world. Very much relaxed, she seems to admire the view, which includes ourselves. In this way, the cornice becomes more clearly defined as the boundary that separates our physical world from the supernatural realm portrayed in the frieze. Her presence underlines, as nothing else could, the contrast between reality and fantasy. For a moment her world seems more real than our own.

When monochromatic rooms come back into fashion in the Transitional and Third Styles as a regular feature of the Roman dwelling, their decoration becomes gradually simpler, until in the end it is as though the walls had been wiped clean of the carved ornamentation that had literally covered them. This development can be followed very well in the series of black rooms dating from the beginning of the transition to the Third Style, c. 30 B.C. to about the end of the century. The earliest of these is from the House of Augustus on the Palatine.[39]

It is a small room decorated in large panels of pure black, separated by narrow pilasters bordered in red with central fasciae of violet. Against the violet background of the pilasters are rendered delicate stylized floral motifs that anticipate those of the "candelabra style," a name originating with Vitruvius in a well-known passage criticizing the new style for its lack of architectural realism (7.5.3). The black panels preserve touches of color that may be reconstructed as "sacred landscapes," the earliest of this type so far known.[40] In addi-

12. Triclinium, Villa of the Mysteries, Pompeii, late first century B.C. to early first century A.D.
Photograph: Soprintendenza Archeologica di Pompei

tion, a garland of green leaves hangs in swags across the tops of the panels.

The next black room in the series, also in Rome, occurs in the ancient villa found along the Tiber in the garden of the present Villa Farnesina.[41] This dwelling, about a decade later than the House of Augustus, has a large black triclinium, but while the scale of the room has increased, the design shares some important features with the modest oecus on the Palatine. In both the imitation of architectural relief ornamentation has vanished utterly; even the drafted margins, so common in earlier stages of the Second Style, have simply disappeared. Instead of architectural carving, there is painting, in the form of the sacred landscapes rendered against the black, a genre that Roger Ling associates with the Roman painter Studius.[42]

The Palatine evidence for these sacred landscapes is of great value, for it places the invention of the genre well within the scope of a royal workshop. Perhaps the same workshop may be credited with the unexpected change in aesthetic orientation from carved to surface decoration, a change that would eventually transform the entire character of the murals. Peter

von Blanckenhagen deduced long ago that an imperial workshop might have been responsible for the introduction of the Third Style, which he described in its purest form in the Villa of Agrippa Postumus at Boscotrecase.[43] The Farnesina Villa, he thought, must have been an earlier product of the same workshop. Now, on the Palatine, the first indication of this new direction in Roman murals can be identified a decade earlier in a dwelling belonging to the emperor himself.

The culmination of the new aesthetic may be seen in the beautifully preserved Third Style black tablinum in the Villa of the Mysteries, where the color black runs almost unrelieved from floor to ceiling (fig. 12). This is the final stage of a gradual diminishing of the decorative elements almost to the point of extinction. The extent of the change can be appreciated by comparing the treatment of the hanging garlands from one example to the other.

In the black room of the House of Augustus, the garlands that hang across the panels between the pilasters are still fairly heavy, with thickly bundled leaves (Carettoni tentatively suggests they may be plane leaves) and a scattering of flow-

13. Triclinium, Villa of the Mysteries, Pompeii, late first century B.C. to early first century A.D., detail: center of garland cross
Photograph: Soprintendenza Archeologica di Pompei

have lost entirely their former naturalism and have become a kind of minimalist design (fig. 13). In the central panel on each wall, thin lines of tiny leaves and stylized flowers form a geometric cross held taut at the center by what seem to be delicate metallic rods. A circle of red drawn in a single line places a degree of emphasis on the center of each cross. In this room, there is no narrative painting and no landscape, and the garland decoration has become geometric and abstract, with only a whisper of its earlier naturalism in the delicate touches of jewellike colors that form the leaves and flowers, now barely suggestive of something living. Of course, there will soon be a sharp reaction in the Fourth Style, but for the moment the Third Style monochromatic room has succeeded in reducing the elements of design to a level of austere simplicity that has much in common with twentieth-century developments in the art of painting.

In the Transitional and Third Style examples of the black room, one sees the interest in environmental color gradually pushed to its limits in a way that leaves little doubt about the correctness of Rothko's impressions concerning the color awareness of the ancient muralists. It must now be clear that Rothko's experience in the Villa of the Mysteries was founded upon an accurate, intuitive reading of the aims and aesthetic predilections that had guided the ancient artists. The Roman walls in the Villa of the Mysteries struck a chord in Rothko; he was able to relate the ancient walls quite naturally to some of the most important artistic concerns of the twentieth century. This happened because Rothko was able to see at a glance what the murals were all about. He knew at once what made them "look the way they do," and the experience was overwhelming and unforgettable. From that point on Rothko never lost his interest in antiquity. William MacDonald has a note in a diary of the early 1960s recording a day when Rothko sought him out in Rome and spent hours making him talk about ancient buildings.[46] The late Peter von Blanckenhagen recalled a conversation with Rothko in New York, when a

ers.[44] In the Villa Farnesina, the garlands are already reduced to far less bulky double strands of vine leaves, thinned to the point where each separate leaf is silhouetted individually against the polished black.[45] A Third Style black room at Boscotrecase eliminates the garlands altogether, but a vestige of the original concept survives in the black room of the Villa of the Mysteries. In this example, the garlands

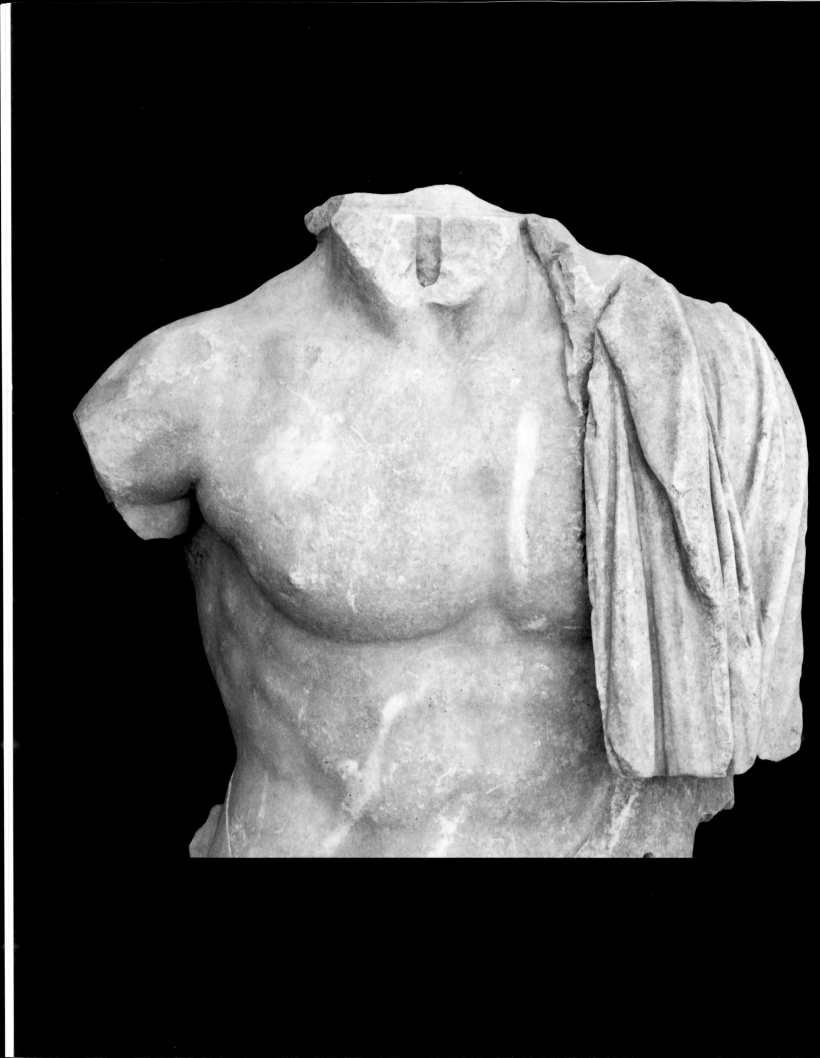

JACQUELYN COLLINS-CLINTON
Wells College

A Hellenistic Torso from Cosa

In 1950, after scarcely two seasons of work, Frank Brown was able to write about the second century B.C. at Cosa: "[It] was probably the most flourishing of the colony's existence. Cosa will have shared in the intensified economic life which followed the great eastern conquests."[1] Subsequent excavations have revealed the architectural development and material wealth that verify his observation. In addition, my own work on the sculpture and furniture in stone has furnished even more evidence to show that Cosa does reflect the extent to which the wealth and luxury arriving in Rome from the east at that time had spread to outlying towns. In this context I here present a more-than-life-sized, partially draped male torso, which for some time was thought to be an imperial portrait statue,[2] but which, under closer scrutiny, can now be shown to be of Hellenistic workmanship and a Greek import.

The torso was found in 1950 built into the medieval wall around the arx (fig. 1).[3] It was carved of a fine- to medium-grained white marble, probably Pentelic, in a lively Hellenistic style.[4] Missing are the head (once attached separately), the right arm, the lower left arm and elbow with related drapery, the separately made back (fig. 2), and the entire lower body. The right arm is broken just below the shoulder, but traces of fingers and thumb indicate that the hand was on the hip. A separately worked piece of the draped left shoulder and upper arm shows that that arm was lowered. The torso was made for attachment to a separate lower body at the hips.[5]

Enough is preserved to allow a reconstruction of the pose. The torso bends strongly to its right, so that the right shoulder is lowered and the right hip raised. This means that the figure stood with its weight on the right leg. The flex of the right neck tendon indicates that the head turned to its left, away from the weight leg. Thus the statue must have assumed a chiastic contrapposto stance with dual viewpoints, from the front and from a slightly oblique angle that would have allowed a full view of the face.

Reconstructing the draping of the mantle is more difficult. On the right side it must have slipped down to mid-hip level, for the right hand rests on bare flesh. It then swept around the hips and up the back, so that one end hangs forward, overlapping the other end while covering most of the left breast and all of the upper arm. The layered folds must have hung straight down toward the left hip and thigh, perhaps covering much of the lowered arm. The preserved folds are arranged in two systems. On the chest the mantle folds over on itself and hangs nearly vertically. The deeply drilled channels enhance the impression of bulk at this point. These are interrupted in the upper half by the under-

cut diagonal edge of the mantle, folded toward the chest and lying on top of the innermost folds. On the outer shoulder and upper arm, however, the mantle is less bulky. The folds there are shallower and appear more as ridges than do the deeply cut folds along the breast. They slant toward the diagonal border framing the lower abdomen and disappear under the thickened edge that hangs vertically. All these folds belong to the forward end of the mantle, which must have hung down for some distance below the preserved portion. Their inner edge must have rested against the raised vertical cutting defining an edge of the attachment surface just below.

Both pose and manner of wearing the mantle have their closest parallels among statuary types of Asclepius. Since this healing deity was very popular from the late fifth century B.C. on, the corpus of statues representing him is large and complex. The torso from Cosa belongs to a family of statuary types called the Este type, which originated in the first half of the fourth century B.C. and was very prolific over a long period.[6] In this type, Asclepius places his weight on his right leg while leaning on a staff on his left. The leftward lean results in a dynamic movement in the torso and a certain rightward displacement of the hips. But only the pose of the present statue belongs to this type, as comparison with the best preserved example of the type reveals. This is the "name" piece, a statuette in the Kunsthistorisches Museum, Vienna (fig. 3).[7] Here Asclepius leans on a long snake-enwrapped staff tucked into his left armpit. He looks to his left. His left arm hangs down along the staff, the forearm bent slightly forward. His right hand rests on his hip, counterbalancing the activity on the left. The Vienna statuette shows the position of the bent left leg, whose knee protrudes strongly under the mantle. It also shows the draping of the mantle over the legs and the triangular overfall covering the left thigh. The arrangement of folds on the left shoulder and upper arm is very different from that of the Cosa example, however. The mantle is forced into a pattern of radiating folds by the pressure

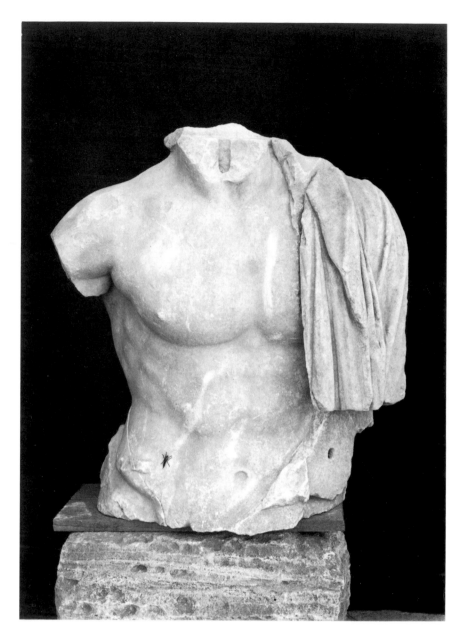

of the staff under the armpit.

In the Cosa statue the staff does not disrupt the fall of the mantle covering chest, armpit, and forearm. A variant known as the Velia type, named after a statuette from Velia in Lucania (fig. 4),[8] shows a draping of the mantle on the left side that more closely resembles that of the Cosa torso. In the Velia type Asclepius leans rather differently on his staff. The resulting system of folds presents the quiet effect that we see in the Cosa torso. Among the best preserved examples of this

1. Torso, from Cosa, second century B.C., Pentelic marble, front view

Antiquarium, Cosa
Photograph: American Academy in Rome

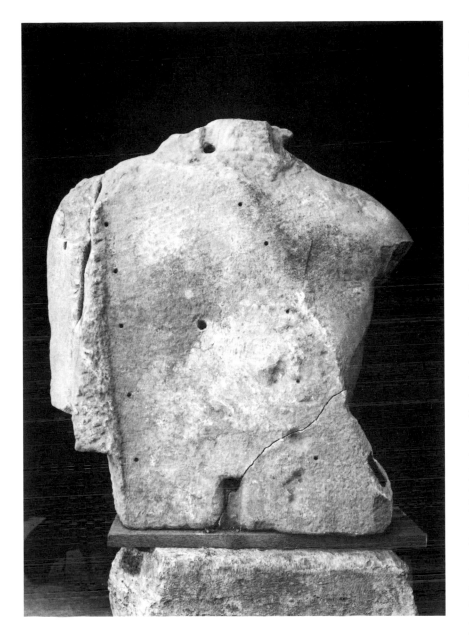

2. Torso, from Cosa,
second century B.C.,
Pentelic marble, back view
Antiquarium, Cosa
Photograph: American Academy
in Rome

Although the remaining piece of drapery on the Cosa torso is fragmentary, it nevertheless preserves the most critical point—the shoulder and armpit area, where the folds are clearly not disrupted by the staff. This permits the Cosa torso to be associated with the Velia type.

The neck of the statue preserves a flat, horizontal surface pierced by a vertical dowel hole that served either to secure a separately made head or to repair a break. The attachment surface is unusual in that it preserves two different levels (fig. 5). The flat portion was first smoothed and then pitted slightly with a point to ensure adhesion. The front half of this is broken away, revealing the depth of a cylindrical dowel hole with a diameter of 0.017 m and a depth of 0.068 m. This surface does not slice completely through the neck but stops just short of a rough portion across the back of the neck that juts unevenly upward. This is badly chipped. The back of the neck is rather thickened and shows a roughly picked surface (fig. 2). Visible are several rough, horizontal striations left by the point. This suggests either that the back of the neck and head were purposely left unfinished or that this area was reworked at a later time. Especially unusual here are the two rectangular cuttings for clamps. The one in the center back is rather roughly worked and reveals a round hole for attachment running perpendicular to the bed of the slot, with a diameter of 0.023 m and greatest preserved depth of 0.063 m. The one to the right is more carefully finished, with a length of 0.06 m, width of 0.02 m, and greatest preserved depth of 0.023 m. There are four tiny holes for pins at the bottom of the cutting. These clamps must have been intended to secure a fastening; I suspect that this was the fastening of a broken neck rather than that of a head designed to be made separately. Thus, it is possible that the head was originally carved in one piece with the torso, and that it broke off and was repaired in antiquity.

The head must have been large and unwieldy enough to require extra support from behind when it was repaired. This strongly suggests a head with long hair and most likely also a beard. Proof that

type are a statuette from Epidaurus, now in the National Archaeological Museum, Athens, and a statue from Cyrene, in which the arrangement of the drapery is closest to that of the Cosa statue.[9] In these parallels the forward hanging corner of the mantle continues to the level of the upper thigh (Epidaurus) or falls all the way to the foot (Cyrene). This fall of vertical folds is radically different from the energetic, radiating folds of the Este type: the swing and movement of the latter have given way to calm and stability in the former.[10]

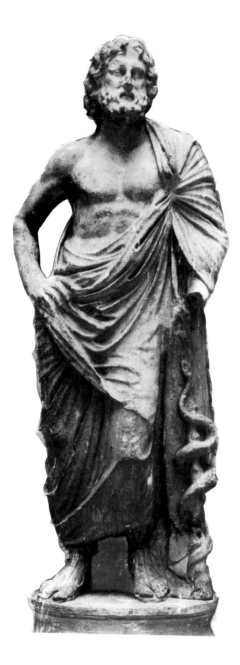

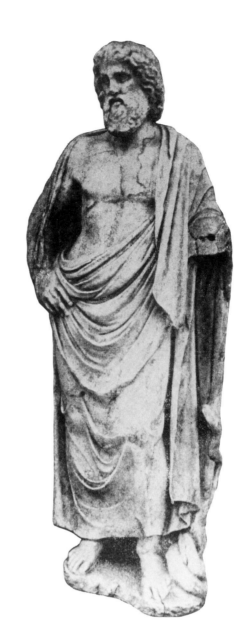

3. Asclepius, Roman copy after Greek original of first half of fourth century B.C., statuette, Greek marble
Kunsthistorisches Museum, Vienna

4. Asclepius, from Velia, Roman copy of first century A.D., statuette, Italian marble
Lapidario, Velia
From Alfonso De Franciscis, "Sculture connesse con la scuola medica de Elea," *PP* 25 (1970), 278, fig. 6

the head did in fact have long hair survives in the damaged, but nevertheless obvious, bit of marble projecting from the right side of the neck at the break (visible in figure 5). This cannot belong to the mantle, which, although missing, was demonstrably not drawn up to the back of the neck. The position of the mantle is clear on the back in the diagonal edge of the well-preserved attachment surface (fig. 2). Here the upper back edge of the garment descends sharply from the center back toward the right hip. Thus the piece of marble preserved on the right side of the neck can only belong to hair. How long the hair was in back cannot be deter-

mined for certain, but it must have been at least shoulder-length. To judge from the preserved right side of the neck, the hair would have been trimmed on the sides and tapered toward the back so as to leave the sides of the neck bare. An idea of this effect can be gained from a head whose back is unfinished: the late Hellenistic torso of Asclepius from his sanctuary at Munychia in the Piraeus, now in the National Archaeological Museum, Athens (fig. 6).[11] Whether the back of the neck of the Cosa statue as it now appears was unfinished originally or was reworked later for the insertion of the clamps mending the broken neck or both cannot be

5. Torso, from Cosa,
second century B.C.,
Pentelic marble,
detail: neck
Antiquarium, Cosa
Author photograph

6. Torso of Asclepius,
from Munychia in the
Piraeus, second century B.C.,
white marble
National Archaeological
Museum, Athens
Photograph: TAP Service

determined. A certain amount of reworking must have taken place in removing the bulk of the hair to make way for the clamps.

The complex assembly of the original statue from several separate pieces of marble is the most striking feature of this torso and warrants close scrutiny. The major join is that across the hips, indicating that the statue was made essentially from two main blocks of marble, one for the torso and one for the lower body. This join is straight and horizontal. It apparently cut along the upper edge of the mantle around the right hip and then ran straight across the missing drapery on the left side. The attachment surface, which I know only from a photograph, is flat and finished with a claw chisel (fig. 7). There is no anathyrosis. Instead, the rear half was pitted with a large point, the front half left plain. A roughly picked indentation extends from the proper right side toward the center where there is a large, square dowel hole. This may correspond to the channel for pouring the lead needed to secure the dowel in the attachment surface of the missing lower body. If this is so, the end of the channel would have been hidden by an edge of the mantle or by the hand. The edges of the dowel hole were also roughly picked; the toolwork resembles that on the back of the neck. One wonders whether these roughly treated areas are all signs of ancient repairs.

Arrangements for the fitting of the separately made back with left shoulder, arm, and related drapery of the upper body are particularly complicated. The left shoulder and arm were made in several separate pieces attached by dowels along that side of the torso (fig. 8). Two attachment surfaces, one much larger than the other, slant toward the front. The larger surface is the upper one, which accommodates the preserved piece of drapery. This contains two roughly triangular holes, 0.02 m across and 0.07 m (upper) and 0.068 m (lower) deep. The surface was smoothed and then pocked with shallow drilled depressions to give purchase for the adhesive. Below this surface is the second, offset from the first so that it tilts more downward. In the center of this is a rounded dowel hole, with a diameter of

0.02 m and depth of 0.053 m. The surface here was finished with a claw chisel. Immediately below this is a very small attachment surface, deeply countersunk. Adjacent to that is a second small surface near the navel below a projecting, triangular lump of a very battered remnant of drapery. Both these small surfaces were smooth-picked. A third small attachment surface faces the back, immediately under the projecting bottom of the large, upper surface to which the preserved drapery belongs. This was rough-picked and has the ends of shallowly drilled holes all over. All these small surfaces below the preserved piece of drapery must reflect the attachment of a separately worked piece or pieces corresponding to the elbow and the related drapery that falls between arm and body, covering the elbow and forearm.

The inner attachment surface of the piece of drapery is worked like that on the torso. The bottom is cut horizontally where it would meet the missing drapery below. Behind the outer edge of shoulder and upper arm is yet another attachment surface (visible in figure 2). This was smoothed with a claw chisel and has a dowel hole near the top, with a diameter of 0.015 m and depth of 0.045 m.

The back, except for the right shoulder, was worked flat for the attachment of the mantle (fig. 2). The plane of this surface is vertical, but it slants inward toward the left, where a roughly picked, projecting ridge of marble forms an edge, wider toward the bottom, that overhangs the inset attachment surface below it. The surface of the back was finished with a claw chisel. A round dowel hole is placed just above the center, with a diameter of 0.015 m and depth of 0.067 m. Along both left and right edges are five small holes for pins, not very evenly spaced, with diameters varying from 0.006 m to 0.007 m. In the middle of the bottom edge is a vertical cutting for a clamp, with a length of 0.06 m, width of 0.04 m, and depth of 0.02 m, in whose end is a round hole still preserving the iron dowel. This clamp doubtless assisted in fastening the separate upper back to both the torso and lower body. The back of the right shoulder is bare and was roughly finished with the claw chisel near

the drapery but smoothly finished near the top. At the lower right, corresponding to the level of the hand on the hip, there is yet another small, flat attachment surface, set well behind the hand and probably related to the drapery behind the hip.

The extensive use of piecing in this torso is remarkable but not without parallels. This practice was used to a greater or lesser extent throughout the history of Greek and Roman sculpture. It involves primarily the separate working of heads, arms, hands, and even feet in draped statues, any of which could sometimes be carved of a finer grade of marble than the draped portion of the body, perhaps as an economy of execution or material or both.[12] Separate heads and the attachment of forearms projecting from the mass of the block of marble have a long history in Greek sculpture. Examples can be found as early as late archaic times, especially among the maidens from the acropolis in Athens.[13] Less common is the practice of making a statue from two main blocks of marble, in which the main pieces are joined through the hips.

In its technique of piecing, the Cosa torso compares most closely to three figures, all partially draped over life-sized males, all Hellenistic works dating to the second century B.C., and all assembled from several pieces of marble, including

7. Torso, from Cosa, second century B.C., Pentelic marble, underside
Antiquarium, Cosa
Photograph: American Academy in Rome

the two major blocks for torso and lower body joined at the hips. These are the Asclepius from the sanctuary at Munychia and the Poseidon from Melos, both in the National Archaeological Museum, Athens, and the "Zeus" from the Sanctuary of Hera Basilea at Pergamum erected under Attalus II (159–138) in the Archaeological Museums, Istanbul.[14] The Asclepius is a particularly close parallel in many ways (fig. 6). It was assembled from at least six different pieces: the torso with head, the lower body, the top of the skull, the right arm from just below the shoulder, the left arm including part of the shoulder and left side with associated drapery, and the back of the left shoulder. A vertical attachment surface makes up the torso's entire left side.[15] This has been described as "roughly flattened with long strokes of a coarse point, and occasionally picked as well with vertical blows from the same tool."[16] In the center appears the remnant of a metal dowel.[17] The underside forms another flat attachment surface at a level just below the navel. As far as can be deter-

mined from the incomplete state of preservation, the seam of the join ran across bare flesh. The join is basically horizontal from side to side but slopes slightly downward from back to front. In the center there is a rectangular dowel hole for fastening torso to lower body.[18]

The Asclepius shows obvious similarities to the Cosa torso in the treatment of the join of torso to lower body and in other ways as well. The separate attachment of its entire left side is one of these. That this was also covered in some way by drapery is proved by the remnant preserved on the front at the shoulder.[19] There is a similar, though larger, remnant near the neck of the Cosa piece. But the Munychia Asclepius presents still more resemblances. The pose is strikingly similar: the torso curves in the same way; the head turns in the same direction; the shoulders similarly slant down toward his right; the stump of the right upper arm shows it was held at the same angle; the right hip seems to have been thrust similarly outward. Unfortunately, the lower right corner has broken away—interestingly, at exactly the same place where a break occurs on the Cosa torso. One expects that this Asclepius likewise rested his right hand on his hip. The musculature exhibits the same strongly plastic rendering. Even more, the head has long hair trimmed in such a way as to leave the sides of the neck bare, the ends of the curly hair are roughly finished, and the center back of the head is not finished at all. Finally, the beard, which is not very long, grows down the neck in such a way as to correspond to the broken zone on the Cosa statue's neck. These details suggest that this head might serve as a model for the Cosa statue's missing head, particularly in the trim of the beard and hair.

The Poseidon from Melos also provides some significant parallels (fig. 9). This statue has been thoroughly published with a complete set of photographs that includes many details of the piecing.[20] Furthermore, its excellent state of preservation makes it a vital document for illustrating the intricacy of joining practices in late Hellenistic statuary. The statue was put together from nine pieces: torso with

head and left arm; upper left side of the skull (missing);[21] right arm joined near the shoulder; right hand attached through the wrist; lower body, including the legs, the fall of drapery below the left hand, and the dolphin; two pieces of the diagonal rolled edge of the mantle on the right hip attached to the lower corner of the torso;[22] and the head fin (missing) and tail fin on the dolphin. The major join through the hips is treated with great care. It is strictly level and horizontal, as it is in the Cosa statue. The seam is well hidden among the folds in the rolled edge of the himation. It runs just below Poseidon's left hand, which holds his garment in place. On his right side the two separate pieces of the himation's rolled edge correspond to the place where the himation rises up the back (fig. 10). Figure 11 shows these pieces removed to reveal the attachment surfaces. The smaller surface tilts toward the front and has no dowel hole. It was finished flat with a claw chisel. The other tilts toward the back and has two small dowel holes in its flat surface. It seems to have been smoothed with a small pick. These two small attachment surfaces, whose planes are angled away from each other, recall the small attachment surfaces on the Cosa torso, likewise associated with drapery, also facing in different directions, both with and without dowel holes.

The attachment surfaces that join Poseidon's torso and lower body are meticulously worked (figs. 12 and 13). Both exhibit anathyrosis, not found in the Cosa torso. The perimeters were finished with the claw chisel, the inside slightly hollowed with a fine or medium point. The edges of the pour channel and of the rectangular dowel holes are still sharply defined. Traces of shallow tooling are barely visible along a line in the torso corresponding to the alignment of the pour channel in the lower body. This recalls the much more coarsely rendered "shadow" of the pour channel on the attachment surface of the Cosa torso, due perhaps to an ancient repair. Thus, Poseidon's attachment surface may preserve the original effect of this detail in the Cosa piece.[23]

The third parallel, the "Zeus" from Pergamum, also exhibits the joining of

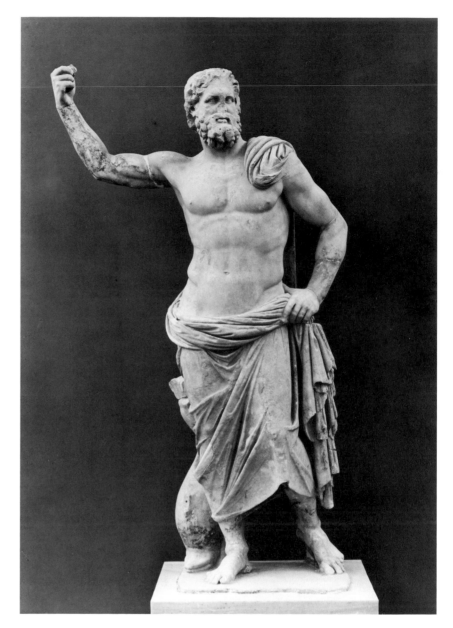

several pieces of drapery along the major seam separating torso from lower body (fig. 14). It was made from four main pieces: head (missing), raised right arm (missing), torso, and lower body.[24] The major seam occurs below the left hand, which holds his mantle against his hip in a way that recalls the Poseidon from Melos. The seam is straight and horizontal. Also as in the Poseidon, it cuts through the fall of drapery below the hand. It is not, however, hidden in the rolled edge of the himation but runs below it. This makes the

9. Poseidon, from Melos, second century B.C., Island marble
National Archaeological Museum, Athens
Photograph: DAI, Athens

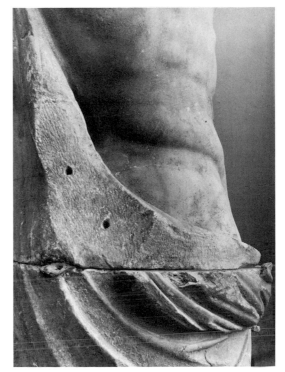

10. Poseidon, from Melos, second century B.C., Island marble, detail: right side
National Archaeological Museum, Athens
Photograph: DAI, Athens

11. Poseidon, from Melos, second century B.C., Island marble, detail: right hip with separately attached pieces removed
National Archaeological Museum, Athens
Photograph: DAI, Athens

seam rather more visible and obtrusive than it is on the Poseidon. To compensate for this, the sculptor made an effort to hide the seam by working separately some pieces of the rolled edge in front and on the right hip as well as a small segment of the folded-up edge of the triangular overfall on the right thigh—five pieces altogether.[25] One of those in front actually covers the main join. The precise shapes of these pieces and the methods of attaching them have not been made known.[26]

The excavator describes the joining of Zeus' torso and lower body: "Unter- und Oberkörper waren ähnlich wie Säulentrommeln zusammengefügt" (fastened together like column drums).[27] He also mentions a rectangular dowel hole in each attachment surface and a short pour channel leading in from the back of the lower body. He even describes anathyrosis: the inside of each attachment surface is hollowed out within a border of uneven width.[28] The photograph of the torso in situ when excavated shows most of its attachment surface. The anathyrosis is barely visible, and the dowel hole is definitely off-center.[29]

These last two statues provide a clue for the interpretation of one of the small countersunk attachment surfaces at the lower left side of the Cosa torso (figs. 1, 8). It is likely that the smaller of the two, in the front, belonged to a small piece of drapery possibly designed to help mask the join at the left hip, after the manner of some of the separate pieces of drapery preserved on the right hip of the "Zeus." This surface on the Cosa torso invites this interpretation because of its more exposed location, set in the front and below an

actual remnant of drapery. The second countersunk surface is embedded well under the missing elbow and related fall of drapery. It must have served to support the elbow and the drapery that continued from the preserved drapery above.

None of the three statues just discussed supplies a parallel for the separate attachment of the back (fig. 2), but a few parallels do exist. The closest is a torso of a draped woman from Pergamum in the Staatliche Museen, Berlin.[30] Here there is evidence for the attachment of two different parts of the back (fig. 15). One is a flat surface behind her left elbow and upper arm, where a rectangular dowel appears in the elbow portion. Around the edges of the attachment surface are numerous small pinholes.[31] This fastening arrangement is exactly like that used for securing the back of the Cosa figure. The surface is finely roughened all over. Franz Winter, who published this statue, does not describe the tool used for this, but in his photograph it looks as though it was the claw chisel, again just as on the Cosa torso's back. There is a streak down the center, above the dowel hole, where the surface was gone over with a pick.[32] In addition, a second attachment surface appears where the buttocks should be. This is flat and cut smooth. A small area on the right was gone over with a pick. Most important, however, is the rectangular cutting for a clamp that helped fasten the torso to a missing, separately made, lower body.[33] The buttocks were made separately and fastened by means of this clamp. The clamp, in fact, served a dual function, much as did the clamp at the bottom of the back of the Cosa torso: it secured with a single fastener the attachment of the separate piece to both the torso and the lower body.

A second example is the torso of a standing male figure in a hip-mantle from the odeum at Cos. Here the entire back side with the mantle was worked separately and attached by one dowel hole to a vertical surface flattened with the claw chisel. The lower body of this statue was also made from a separate block.[34]

These statues all date to the second century B.C., specifically to the second half of

the century. The Asclepius from Munychia has been placed in the second century on technical and stylistic grounds by Andrew Stewart, who dates it after 166.[35] The Poseidon from Melos is later, perhaps c. 125–110.[36] The "Zeus" from Pergamum is dated to the reign of Attalus II (159–138) by epigraphic evidence recording the construction of the Temple of Hera Basilea, where it was found in situ.[37] Finally, the female torso from Pergamum has been

12. Poseidon, from Melos, second century B.C., Island marble, detail: attachment surface at top of lower body
National Archaeological Museum, Athens
Photograph: TAP Service

13. Poseidon, from Melos, second century B.C., Island marble, detail: attachment surface on underside of torso
National Archaeological Museum, Athens
Photograph: TAP Service

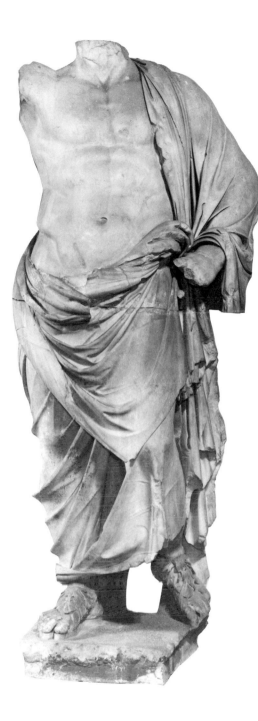

14. "Zeus," from Pergamum, second century B.C., marble
Archaeological Museums, Istanbul
Photograph: DAI, Istanbul

15. Torso of draped woman, from Pergamum, second century B.C., marble, back view
Staatliche Museen, Berlin

dated to the period c. 159–133, and the statue from Cos to c. 180/170.[38]

All these statues contribute information that helps in the correct interpretation of certain aspects of the style, the technique, and even the original appearance of the torso. The Asclepius from Munychia may provide a model for the Cosa statue's missing head, perhaps only in part. The female torso from Pergamum furnishes a parallel for the piecing of the back. And

the "Zeus" from Pergamum may supply a clue for the proper function of one of the small attachment surfaces near the navel, to mask the join at the hip. In terms of the technique of piecing, moreover, all the statues exhibit a very common method of joining torso to lower body in standing statuary carved from two major blocks of marble, a method practiced most often in the second century B.C., when piecing in general seems to have been carried out increasingly frequently in most Hellenistic art centers.[39] Another example is the *Venus de Milo* in the Louvre, dated in the second half of the second century.[40] She was made from at least six pieces of Parian marble: torso, lower body, a wedge-shaped piece between torso and lower body, both missing arms, and her missing left foot with plinth.

One can find a great number of additional examples by studying the illustrations in Andreas Linfert's *Kunstzentren hellenistischer Zeit* (1976); Winter's *Altertümer von Pergamon*, 7, *Die Skulpturen*, 1 (1908); and Renate Kabus-Preisshofen's *Die hel-*

lenistische Plastik der Insel Kos (1989). Although the history of piecing in marble statuary in Greek and Roman art has yet to be written,[41] it is possible to say that the practice of making standing statuary from two main blocks of marble according to the technique exemplified by the statues discussed in this essay is a Hellenistic one that seems to begin in the fourth century B.C. at the earliest and continues at least through the first century A.D.[42] Roman standing statues, mostly from the western portion of the empire, when they are made in two main blocks tend to exhibit a different method of forming the join between torso and lower body. This could be described as a contoured mortice-and-tenon technique as compared to the Hellenistic architectonic "column drum" technique.[43] Examples of the Roman method are the Augustus from Thessalonica or the lower body of a draped woman from Tarragona.[44] In this technique, the underside of the torso is convex and may include a large tenon projecting downward, as in the Augustus. The edge of the join follows the edge of the mantle wrapped around the body. The top of the lower body is concave and, if necessary, contains a hole for a tenon. This type of joint uses the edge of the mantle to hide the join.

The evidence seems to indicate that the Cosa torso also dates to the second century B.C. Examining the style confirms this and helps determine its place within the century. The musculature is strongly rendered with rippling modulations over the ribcage and abdomen below the fleshy breasts. The piece of drapery is treated with a similar sense of plasticity, enhanced by the deeply worked grooves and undercut edges of the major folds. The whole composition is further enlivened by the play of light and shadow over nude and draped surfaces and by the vigorously bending chest counterbalanced by the opposite turn of the neck. Despite all this activity, the torso presents a self-contained and upright composition. It is enclosed left and right by the curves of the (restored) bent arm and the drapery moving from the opposite shoulder to the navel. Only the leftward turn of the head penetrates this self-containment. There is thus a careful

balance of opposites in all aspects of the composition: between the vigorous rendering of the musculature and drapery and the quiet fall of the forward bunch of drapery folds, between the bent right arm and relaxed left arm, between the self-contained torso and the outward-turned head (the first meant to be seen from the front, the second from the viewer's right), between the motion within the torso and the stasis in the upright stance (as restored), and finally between the opposing directions of the turn of the head and the bend in the torso.

The movement, plasticity, and pictorial contrasts are well within the "baroque" tradition of Hellenistic sculpture, a phase that lasted from the end of the third century through the second. It is best exemplified in the well-known frieze depicting the Battle of Gods and Giants from the Altar of Zeus at Pergamum (c. 180–160).[45] The statue of "Zeus" discussed above displays this style in a free-standing figure. Closer still in the movement and vigorous modeling of the torso is the Asclepius from Munychia, whose sloping shoulders and leftward-turning head repeat those of the Cosa torso.[46] On the other hand, the juxtaposition of these "baroque" qualities with the static tranquility found in the stance and in certain passages of the drapery hints at a certain tension between the "Hellenistic baroque" and the classical—a tension that indicates the Cosa statue's place on the threshold of a renewed classicism and, ultimately, eclecticism that does not become common until nearer the end of the second century and into the first. Thus a date at, or a little before, the middle of the second century B.C. seems reasonable for the torso, contemporary with the Asclepius from Munychia but earlier than the Poseidon from Melos and perhaps also the "Zeus" from Pergamum.

How and when did the statue arrive at Cosa? Before attempting to answer this question it is necessary to outline the economic and urbanistic situation there, in order to establish the times most likely to have favored the arrival of the statue. The earliest moment would have been the middle of the second century, given the date of its execution between c. 175 and

150. This coincides with the beginning of the greatest civic and commercial activity in Cosa. Shortly after 197, one thousand new colonists were granted after Cosa's apparently severe loss of manpower during the Hannibalic Wars.[47] With the arrival of the new families the town began to finish urban projects that had been delayed. The forum and the arx received their final form during the first half of the century. In the forum were completed the basilica, curia and comitium, Temple "B," the jail-house, a series of atrium buildings, and cisterns for storage of water, all serving the municipal, religious, commercial, and practical needs of the town. In front of these a portico encircled the open rectangular "piazza." These architectural forms reflect the impact of new, Hellenistic ideas upon Roman urban design and provide a glimpse of Roman colonial architecture.[48] On the arx, the same period saw the construction of the major temple, the Capitolium that looks down over the town and the forum from its high vantage point, just as in Rome.[49] Associated with one of the temples on the arx is an inscribed limestone "holy water" basin, of a Hellenistic type for purificatory water, that was dedicated by a member of a prominent Cosan family, the Tongilii, in the second century.[50]

Around the beginning of the first century at least two families built or remodeled comfortable houses in town. One of these, the House of the Skeleton, had an elegantly finished room with an inlaid floor and walls done in the latest Hellenistic "masonry" style overlooking a large garden with a shady pergola in one corner. Numismatic evidence gives a construction date in the 80s.[51] The other, the House of Quintus Fulvius, the earlier of the two and a more modest house, is notable for the hoard of some two thousand denarii that were buried beneath the pantry floor around 70, to judge from the latest coins in the jar. The coin evidence suggests that this house was renovated at the end of the second century. This house may have belonged to a Quintus Fulvius, who scratched his name on two black-glazed vessels found in the house, and who was apparently involved in the supply of commodities to the Roman government.[52]

Both homes reflect increasing wealth in the town. This prosperity came from Cosa's port, which enjoyed increasing commercial activity during the second and much of the first century. Great quantities of amphorae bearing the stamps of the firm belonging to the Sestius family have been found in both port and town.[53] They were shipped all over the Mediterranean, especially in the western portion, from the second to the end of the first century. The Sestius family was apparently the mainstay of this activity, which must have consisted of producing both the amphorae themselves and their contents, presumably wine, garum, and other fish products. The production of this firm peaked from the late second to the mid-first century. It is also very likely that the Sestii of this period are the same family to which belonged Publius Sestius, a resident of Rome in the middle of the first century who owned an estate near Cosa. An even wealthier family that had extensive landholdings in the area in the first century was the Domitius Ahenobarbus family, which may have been linked with the Sestius enterprise by the late first century.[54] To these we must add also the Tongilius family, relatively unknown, a member of which dedicated the lustral basin already mentioned.[55]

Excavations in both port and town indicate a turn in Cosa's fortunes by the middle of the first century. Portions of the town were burned, and the city was apparently abandoned for a short period from perhaps as early as the 60s to c. 30. Activities in the port continued until c. 40, after which a decline can be observed there, too.[56]

During the reign of Augustus and the Julio-Claudian period Cosa was rehabilitated. The Capitolium was repaired and the forum fixed up. When the basilica collapsed in the principate of Claudius, a small odeum was constructed in its shell by Nero just before he became emperor, according to epigraphic evidence. This was decorated with at least three portrait statues of members of the imperial family.[57] There is also considerable evidence, primarily epigraphical, that an imperial cult flourished at Cosa. Some large and for the most part fragmentary marble portrait

that a statue of the size and scope of this one was a prime candidate for public use, especially if it arrived in Italy in the second century B.C., close to the time of Polybius' remark and when there was no documented art market in Rome. If, however, the statue did end up on the Roman art market in the first century B.C., it was either related to Sulla's depredations or sold by a private person who had owned it in the second century.[83] Since there were well-to-do families connected with Cosa during the first centuries B.C. and A.D., any of these could have purchased the statue and dedicated it there, either early in the first century B.C. or after 30 B.C.[84]

How and where was this statue displayed at Cosa? The answer to this question is difficult to ascertain since it was not found in situ. Its size and bulk may indicate that it was not moved far from its ancient location, and it may well have been set up somewhere on the arx near where it was found.[85] Also, its size and identity suggest that it was a dedication in a public place, perhaps but not necessarily in a religious setting. A religious setting would have to have been one suitable for Asclepius, since the Romans were careful about dedicating statues of deities appropriately.[86] Yet no trace of a sanctuary of Asclepius has been found in or near Cosa.[87]

There are two possible solutions to this problem. First, the statue is not the only statue of Asclepius known to have arrived in Italy from Greece. Pliny the Elder recorded two images of Asclepius in Rome, both of which were erected in religious settings that, by Pliny's time, housed a large collection of Greek art—that is, settings that were not sanctuaries of Asclepius. One was a bronze statue of Asclepius along with his consort, Hygia, both made by the third-century Athenian sculptor Niceratus for the sanctuary of Asclepius at Pergamum. These were in the Temple of Concordia overlooking the Roman Forum.[88] The other was a statue set up in the Portico of Octavia, which surrounded the temples of Juno Regina and Jupiter Stator.[89] Here the image of Asclepius found an appropriate home near a temple of Jupiter. Considering the statue's find-spot near the Capitolium, it is possible

that it was dedicated in the Capitolium.

Second, it is also possible that the statue sustained damage in transit (the damage to its head has already been noted) or was altered, either in an effort to repair damage or to make it more attractive or useful.[90] In fact, statues of Asclepius and of Zeus/Jupiter are very difficult to distinguish in the absence of an attribute, since both are mature, bearded, and fatherly figures.[91] Most of the time, the motive of placing one hand directly on the hip can be interpreted as a hallmark of Asclepius, considering the great number of such statues that unquestionably represent the healing god.[92] A few statues of Zeus/Jupiter placed one hand on the hip, mainly according to numismatic evidence in which coins represent a well-known local divinity. These are Zeus Ourios/Jupiter Imperator taken from Syracuse by Verres,[93] possibly the Zeus Ourios standing at "the straits leading into the Black Sea,"[94] and the image of Jupiter Latiaris from his temple on the Alban Mount near Rome.[95] Of these the Jupiter Imperator types wear a himation and place their left hand on the hip, but their poses otherwise differ: they have different weight-bearing legs, their heads turn in different directions, their right arms holding the scepter are either raised or lowered. The pose of the Jupiter Latiaris matches that of the Cosa statue, insofar as the latter is preserved, but the Jupiter is completely nude. Unfortunately nothing is known of it other than the representation on the Antonine coin. Since the Cosa statue does not lean with his staff under his left armpit but merely holds his staff with his lowered left hand, it is not difficult to envision damage to or removal of Asclepius' snake and a substitution of a scepter for the staff: Behold, a statue of Jupiter! What better place to dedicate it at Cosa than in the Capitolium on the arx?

In sum, this statue was made in Greece shortly before the middle of the second century B.C.[96] It was either sent to Cosa by Mummius between 145 and 142 B.C., or it was dedicated by a wealthy resident of Cosa either between c. 100 and 70 B.C. or in the Augustan or Julio-Claudian period. It may now take its place among the statues of Greek origin found in Italy.

NOTES

1. Frank E. Brown, *Cosa I: History and Topography* (*MAAR*, 20; Rome, 1951), 18.

My paper has benefited from discussions with and suggestions from many friends and colleagues, specifically Judith Ginsburg, Erich Gruen, William V. Harris, Olga Palagia, Homer A. Thompson, Nikolaos Yalouris, Paul Zanker, and my husband, Kevin Clinton. Any errors remaining are entirely my own.

I am grateful to many persons who supplied photographs and permission to publish them: Emin Basaranbilek, deputy director of the Istanbul Archaeological Museums; Alfred Bernhard-Walcher, Kunsthistorisches Museum, Vienna; Huberta Heres, Staatliche Museen zu Berlin; and Olga Tzahou-Alexandri, director, Athens National Museum. Very special thanks go to the late Barbara Bini, photographer for the American Academy in Rome.

I would also like to express thanks to the Institute for Advanced Study, Princeton, for generously facilitating my initial research during my husband's membership there in 1987/1988 and also to the National Endowment for the Humanities for a Travel to Collections grant during the summer of 1989.

2. The torso was presented as such in my doctoral dissertation; see Jacquelyn Collins, *The Marble Sculptures from Cosa* (Ann Arbor, 1978), cat. no. 4.

3. It was found near the western cella wall of Temple D; see Frank E. Brown, *Cosa: The Making of a Roman Town* (Ann Arbor, 1980), foldout plan of the town. Nearby was a separate piece of draped shoulder and upper arm.

4. The marble has the warm surface tonality and the sparkly, fine crystalline structure that distinguish it from Carrara marble. A long micaceous streak appears in the drapery over the left arm; this is characteristic of certain qualities of Pentelic. The measurements are as follows:

H., 0.74 m; L., sternal notch to navel, 0.47 m.

D. (maximum), front to back at lower abdomen, 0.305 m. The missing back may have supplied up to one-quarter of the total depth of the torso, depending on how summarily the drapery was treated.

H. (restored total), c. 2.10–2.20 m. This measurement is based on the closest stylistic parallels whose torsos are the same size as those of Cosa: torso of Asclepius from Munychia, H., with head, 1.0 m; statue of Poseidon from Melos, H., with head, 2.17 m; statue of "Zeus" from Pergamum, H., without head, 2.31 m. On these see below, note 14.

5. A large piece of the right hip is broken and reattached. There is a large chip in the right shoulder, the front of the neck is broken away, and minor chips appear on flesh and drapery, and at the edges of the neck. The surface shows minimal signs of weathering. There are some white stains on the front, blackened places on the back, traces of mortar, lime encrustations especially on the back, and root marks.

6. The most recent classification of images of Asclepius is that of Bernard Holtzmann in *LIMC*, 2:1:863–897, with bibliography, and 2:2: pls. on 631–667. The

Este type and variants are discussed in *LIMC*, 2:1:886–889, cat. nos. 320–378, and 2:1:893–895; they are illustrated in 2:2:661–666, nos. 320–378.

7. This was formerly in the Este collection in Italy. See Holtzmann in *LIMC*, 2:1:886, no. 320; see also Arnold Schober, "Asklepiosdarstellungen des vierten Jahrhunderts," *ÖJh* 23 (1926), 8–15, fig. 3. The feet with base and lowermost part of the staff and snake are restored; the left hand is missing.

8. Holtzmann in *LIMC*, 2:1:888, nos. 355–360; there are only a few examples of this variant. The "name" statuette is no. 356; see also Alfonso De Franciscis, "Sculture connesse con la scuola medica di Elea," *PP* 25 (1970), 268, 272, 283, fig. 6. This statue exhibits certain differences not seen in the others: the opposite turn of the head and the partially covered right arm.

The number of examples Holtzmann lists under his Velia type can be increased by including the four examples from Cyrene that he has classified as variants of the "Tunis" type (*LIMC*, 2:1:885, nos. 285–288). The Cyrene pieces fulfill more precisely Holtzmann's criteria for this type, especially the motive of the right hand on the hip that is symptomatic of the type. The position of the left arm and the system of folds covering left shoulder, chest, and arm also fit into the scheme of the Velia type.

9. National Archaeological Museum, Athens, inv. no. 264; Holtzmann in *LIMC*, 2:1:888, no. 355. Cyrene Museum, inv. no. 14.148, from the agora; see Enrico Paribeni, *Catalogo delle sculture di Cirene* (Rome, 1959), 83, no. 200, pl. 111. This is listed by Holtzmann in *LIMC*, 2:1:885, no. 285, but illustrated incorrectly (the illustration is that of Paribeni 1959, no. 205).

10. The calmness of this system of folds comes close to that seen in the Campana type, which is otherwise completely different; see Holtzmann in *LIMC*, 2:1:884, nos. 261–275, and comments on 896.

11. National Archaeological Museum, Athens, inv. no. 258; Holtzmann in *LIMC*, 2:1:887, no. 346; also Andrew Stewart, *Attika: Studies in Athenian Sculpture of the Hellenistic Age* (*JHS* Supplementary Paper, 14; London, 1979), 48–50, pls. 10–11, 15a,c,e. For hair of the same length but finished in the back, see another late Hellenistic torso of Asclepius from Ostia; on this see most recently Hans Günther Martin, *Römische Tempelkultbilder* (Studi e materiali del Museo della Civiltà Romana, 12; Rome, 1987), 228–229, cat. no. 11, with bibliography. It was found in the *area sacra* near the Temple of Hercules.

12. The most recent study of piecing in Greek and Roman marble statuary is that of Amanda Claridge, "Ancient Techniques of Making Joins in Marble Statuary," in *Marble: Art Historical and Scientific Perspectives on Ancient Sculpture*, ed. Marion True and Jerry Podany (Malibu: J. Paul Getty Museum, 1990), 135–162. See also Amanda Claridge, "Roman Statuary and the Supply of Statuary Marble," in *Ancient Marble Quarrying and Trade*, ed. J. Clayton Fant (BAR International Series, 453; Oxford, 1988), 139–152.

13. Claridge 1990, 137–142; Claridge 1988, 139, n. 1. For additional archaic statues from Ionia with separately made heads set into sockets, see Nikolaus Himmelmann-Wildschutz, "Beiträge zur Chronologie der archaischen ostionischen Plastik," *IstMitt* 15 (1965), 24–42, examples in pls. 2, 6, 7, 9.

14. Asclepius from Munychia: National Archaeological Museum, Athens, inv. no. 258; H., 1.0 m. See most recently Stewart 1979, 48–50, pls. 10–11, 15a,c,e.

Poseidon from Melos: National Archaeological Museum, Athens, inv. no. 235; H., 2.17 m. See most recently Jörg Schäfer, "Der Poseidon von Melos (Athens, NM. 235)," *AntP* 8 (1968), 55–68, pls. 38–41.

Zeus from Pergamum: Archaeological Museums, Istanbul, inv. no. 2767; H., 2.31 m. Albert Ippel, "Die Arbeiten zu Pergamon 1910–1911, III: Die Einzelfunde," *AM* 37 (1912), 316–325; Margarete Bieber, *The Sculpture of the Hellenistic Age*, rev. ed. (New York, 1961), 118–119, figs. 471–472; Jerome J. Pollitt, *Art in the Hellenistic Age* (Cambridge, 1986), 110, fig. 112; and Renate Kabus-Preisshofen, *Die hellenistische Plastik der Insel Kos* (*AM*, Beiheft 14; Berlin, 1989), 111, with further bibliography in n. 419.

15. This is best illustrated by Semni Karouzou, *National Archaeological Museum: Collection of Sculpture*, trans. Helen Wace (Athens, 1968), pl. 44.

16. Stewart 1979, 49.

17. Paul Wolters, "Darstellungen des Asklepios," *AM* 17 (1892), 10.

18. No photograph of the underside has been published. Wolters 1892, 11, provides the only description of this surface, and he does not describe the toolwork. The dowel hole measures 0.08 m on a side and is 0.07 m deep. Nikolaos Yalouris, who is completing a study of this torso for publication, has very kindly answered my questions concerning problems of piecing. He has confirmed that there are indeed traces of anathyrosis on the attachment surface.

Wolters also notes that this surface was not designed to be strictly level. A roughly contemporary parallel for a nonlevel join at this anatomical location, not cited by Wolters, is the *Venus de Milo* in the Louvre; see Jean Charbonneaux, *La Vénus de Milo* (Bremen, 1958), 2–8, fig. 1. This statue is a somewhat special case. Two other examples come from the Anticythera wreck: figures of Achilles and Odysseus in active stances, possibly a pair. See Peter C. Bol, *Die Skulpturen des Schiffsfundes von Antikythera* (*AM-BH* 2; Berlin, 1972), 78–79, nos. 27, 28, pls. 44–47.

19. This is easily seen in the illustration mentioned above, note 15.

20. Schäfer 1968; the piecing is discussed on 57.

21. Schäfer 1968, figs. 6, 8.

22. Schäfer 1968, figs. 9, 11.

23. Attachment surfaces joining torso to lower body are rarely illustrated in publications. For a similarly careful treatment of such attachment surfaces, see a group of portrait statues found in the Sanctuary of Poseidon on the island of Tenos, now in the museum there. These are Claudian or Neronian in date but clearly continue this Hellenistic technique. They have recently been published by Roland Etienne, Jean-Pierre Braun, and François Quéyrel, *Tenos 1: Le Sanctuaire de Poseidon et d'Amphitrite* (*BEFAR*, 263; Paris, 1986), 289–292, nos. 30–33, and 297–298, nos. 54–55; pls. 143,4 and 153,5 illustrate two of these attachment surfaces.

24. Ippel 1912, 317. The missing head was attached at a straight and level cut through the neck. The hair is short (see Ippel's fig. 15), and this has led to doubts that the statue really represents Zeus. On this see Ippel 1912, 324; and Arnold Schober, *Die Kunst von Pergamon* (Vienna, 1951), 140.

25. Ippel 1912, 317.

26. The photograph in Ippel 1912, fig. 11, which shows the torso in situ at the time of excavation, reveals a flat edge cutting off an arc of the circumference of the attachment surface at a point where one of these pieces of drapery would have been attached.

27. Ippel 1912, 317.

28. Ippel 1912, 317.

29. Ippel 1912, fig. 11.

30. Franz Winter, *Altertümer von Pergamon 7; Die Skulpturen*, 1 (Berlin, 1908), 90–91, no. 57; front and back illustrated in pl. 9; Schober 1951, 136, fig. 127 (front).

31. Described in Winter 1908, 90.

32. On the toolwork see Winter 1908, 90.

33. Winter 1908, 90; he does not describe the underside.

34. Kabus-Preisshofen 1989, 197–198, no. 24. Another example, which unfortunately is badly damaged at the back, is the torso of Asclepius in the Museo Ostiense, Ostia, inv. no. 114; see above, note 11. At the lower edge of the back, in the center, is a large clamp hole. I thank the Soprintendenza at Ostia for permission to examine this torso in July 1989 while the museum was closed for repairs.

Pinholes bordering smaller attachment surfaces for joining separate limbs are found in two other Hellenistic statues. One is the torso of a male statue in a hip-mantle from Cos, dated c. 220 B.C.; see Kabus-Preisshofen 1989, 191–193, no. 21. The attachment surface has a round dowel hole in the center. The other is a statue of Isis from Cynthos on Delos, which shows a similar series of pinholes bordering the broad surface for attaching the protruding left foot; in the center of the surface is a rectangular dowel hole. See Jean Marcadé, *Au Musée de Délos: Étude sur la sculpture hellénistique en ronde bosse découverte dans l'île* (*BEFAR*, 215; Paris, 1969), pl. 57.

35. Stewart 1979, 49–50.

36. Andreas Linfert, *Kunstzentren hellenistischer Zeit: Studien an weiblichen Gewandfiguren* (Wiesbaden, 1976), 117–118.

37. Wilhelm Dörpfeld, "Die Arbeiten zu Pergamon 1910–1911, I: Die Bauwerke," *AM* 37 (1912), 263–264; and Paul Schazmann, *Altertümer von Pergamon 6, Das Gymnasion: Der Tempelbezirk der Hera Basileia* (Berlin, 1923), 110.

38. Torso from Pergamon: Schober 1951, 137, fig. 128; the dates are those of the combined reigns of Attalus II and Attalus III. Statue from Cos: Kabus-Preisshofen 1989, 198.

39. On the increasing use of piecing in late Hellenistic times, see Claridge 1988, 139, n. 1. The technique used in Hellenistic times actually originated in the archaic period where it is found in some of the statues of maidens from the acropolis in Athens; see Claridge 1990, 140–142.

40. On the statue in general, including the piecing, see Charbonneaux 1958; see also Claridge 1990, 145, and 146, caption to fig. 13. On the date, see Linfert 1976, 99, 117–118; the statue is attributed to an artist from a center in Asia Minor near Tralles.
It is interesting to note the unorthodox joining of torso to lower body, noted by Charbonneaux 1958, 7. The bottom edge of the torso was finished along the slanting edge of the mantle; this meant that the plane of the attachment surface slanted accordingly. Since the result would have been an obviously unstable join to a correspondingly slanting attachment surface on the lower body, a separate, wedge-shaped piece was made to provide a transition to a level attachment surface, running through the drapery around the hips.

41. Claridge 1990, 135–162; Claridge 1988, 139–152.

42. The earliest examples cited in Claridge 1990, 144–145, are two statues from the Mausoleum at Halicarnassus, one of which is an equestrian statue, the other a standing female. These may possibly date in the fourth century B.C. Another early example is a statuette possibly representing Hades from the Sanctuary of Demeter Cyparissi on the island of Cos. See Renate Kabus-Preisshofen, "Statuettengruppe aus dem Demeterheiligtum bei Kyparissi auf Kos," AntP 15 (1975), 33, 56–60. Some of the latest are a series of four cuirassed statues and two draped females from the Sanctuary of Poseidon on the island of Tenos, datable to Claudian or Neronian times (Etienne, Braun, and Quérel 1986, 289–292, nos. 30–33, and 297–298, nos. 54–55); the lower body of a possibly Augustan or Hadrianic statue found at Sardis (George M. A. Hanfmann and Nancy H. Ramage, Sculpture from Sardis: The Finds Through 1975 [Cambridge, Mass., 1978], 107–108, no. 112, fig. 238); and a statue from Cos of the Antonine period (Kabus-Preisshofen 1989, 213–215, no. 35). To judge from published descriptions and illustrations of their attachment surfaces, the latest statues continue the Hellenistic technique of joining upper to lower body well beyond the end of the Hellenistic period proper in the eastern half of the Roman Empire.

43. Amanda Claridge describes the "column drum" technique as a "horizontal butt join"; see Claridge 1990, 140, 141, fig. 6b, 145, and 146, figs. 12 and 13.

44. Augustus: Thessalonica Museum, AA 55 (1940), 265–266, figs. 71–73, illustrating the pieces individually; fig. 72 shows the treatment of the torso's underside. See also Hans G. Niemeyer, Studien zur statuarischen Darstellung der römischen Kaiser (Berlin, 1968), 102–103, cat. no. 76, pl. 24, 3; Claudian in date.

Statue from Tarragona: Eva M. Koppel, Die römischen Skulpturen von Tarraco (Madrider Forschungen, 15; Berlin, 1985), 38–39, no. 57, pl. 18; second half of the first century A.D.

45. The most recent discussion of the Hellenistic baroque style is in Pollitt 1986, 111–126. For the Altar of Zeus frieze, see Pollitt 1986, 97–110.

46. The Asclepius of Munychia exhibits a far more "hip shot" pose than does our torso: although both thrust their right hips outward, the Munychia figure also moves his hip forward, creating an effect of greater movement; see the comments of Stewart 1979, 50. This means that the rhythms of the torsos are very different, despite similarities in other details.

47. Livy 27.10.8–9; 32.2.7; 33.24.8–9. See also Brown 1980, 32; Brown 1951, 18. The most recent summary of the history of Cosa is that of John E. Stambaugh, The Ancient Roman City (Baltimore, 1988), 255–259.

48. Cosa and Alba Fucens are the only two Latin colonies that have been extensively excavated, and they provide the only comprehensive evidence for colonial design and building forms. See most recently Mario Torelli, "Edilizia pubblica in Italia centrale tra Guerra Sociale ed età augustea: Ideologia e classi sociali," in Les "bourgeoisies" municipales italiennes aux IIe et Ier siècles avant J.-C. (Naples, 1983), 242–245, where the relationship between architectural forms of the urbs and the colony are stressed. See also Brown 1980, 43–44; Axel Boethius, Etruscan and Early Roman Architecture, 2d rev. ed. (Harmondsworth, 1978), 146; and Frank Sear, Roman Architecture (Ithaca, 1982), 16–17.

49. Frank E. Brown, Emeline Hill Richardson, and Lawrence Richardson, Jr., Cosa II: The Temples of the Arx (MAAR, 26; Rome, 1960), 49–109 (Capitolium), 25–48, 111–120; Brown 1980, 47 56.

50. On the Tongilius family, see Brown 1980, 45 n. 4 and 76 n. 11; also Edward J. Bace, Cosa: Inscriptions on Stone and Brickstamps (Ann Arbor, 1986), 94 96, no. IIIA3. Similar, uninscribed basins have been found in Pompeii, two in the Sanctuary of Apollo and one in the Triangular Forum; see Erich Pernice, Die Hellenistische Kunst in Pompeji 5, Hellenistische Tische, Zisternenmündungen, Beckenuntersätze, Altäre und Truhen (Berlin, 1932), 48–49, nos. 2–3, pl. 32, 1 and 5.

51. Brown 1980, 67–69; Vincent Bruno, "A Town House at Cosa," Archaeology 23 (1970), 232–241.

52. Brown 1980, 66–67. On both of these houses, see also Vincent J. Bruno and Russell T. Scott, Cosa IV: The Houses (MAAR, 38; University Park, Pa., 1993), 6, 79–97 (Quintus Fulvius), 99–152 (Skeleton). I thank Scott for allowing me to read a draft of his portion before publication.

53. Brown 1980, 71–72.

54. On the port, see Anna Marguerite McCann and others, The Roman Port and Fishery of Cosa (Princeton, 1987), 32–35, 321–342. On the Sestius amphorae and the activities of the Sestius and

Domitius Ahenobarbus families, see Elizabeth L. Will, "The Roman Amphoras," in McCann and others 1987, 170–177. See also Brown 1980, 49–51, 58–60. On the Sestii and the Domitii Ahenobarbi, see further Israel Shatzman, *Senatorial Wealth and Roman Politics* (Collection Latomus, 142; Brussels, 1975), 339, no. 139 (L. Domitius Ahenobarbus), and 398, no. 198 (Publius Sestius), with references to literary sources; also McCann and others 1987, 133–134, 329. On the landholdings of the Domitii Ahenobarbi near Cosa, see also Bace 1986, 27–28.

55. See above, note 50.

56. On the fate of town and port at this period, see Brown 1980, 73–75; and McCann and others 1987, 27–29, 177, 331. The differing opinions held by Brown and McCann concerning the causes and extent of the disaster that befell the town at or just before the middle of the first century B.C. do not affect the basic fact that a decline began at this period, from which Cosa never fully recovered. On the date of the resumption of activity in town c. 30 B.C., see Bruno and Scott 1993, 161.

57. On the renewal of Cosa in this period, see in general McCann and others 1987, 27; Bace 1986, 41–47; Scott 1971, 213; and Collins 1978, 16–17, 27–31, 36–40, 46–48. For repairs to the Capitolium, see also Brown and others 1960, 127–140. For the odeum, see Bace 1983, 43–44, 75–76, no. IIA2; for its sculptural decoration, see Collins 1978, 31, 36–37.

58. See the unpublished paper by Jacquelyn Collins-Clinton, "Evidence for an Imperial Cult at Cosa," summarized in *AJA* 92 (1988), 270. See also Bace 1986, 74–75; Russell T. Scott, "The Arx of Cosa 1965–1968," *AJA* 73 (1969), 245; and Collins 1978, 27, 34, 38–40.

59. On the Titinii at Cosa, see Bace 1986, 44, 99–106 (inscriptions IIIB1–6), 145–146, 160–162 (brick stamps A22a–t); and Lawrence Richardson, Jr., personal communication, 21 March 1988. On the Augustan house, see Russell T. Scott, "Excavations at Cosa 1969–70: The Houses," *AJA* 75 (1971), 213; and Bruno and Scott 1993, 161–191.

60. For post–Julio-Claudian Cosa, see Bace 1986, 45–51, 59–63; and McCann and others 1987, 27, 33, 332.

61. For the most recent general treatment of this subject, see Pollitt 1986, 150–163; see also Donald E. Strong, *Roman Art* (Harmondsworth, 1978), 12–13.

62. On the plundering of Greek works of art, see Pollitt 1986, 153–159; Jerome J. Pollitt, "The Impact of Greek Art on Rome," *TAPS* 108 (1978), 155–174; Magrit Pape, "Griechische Kunstwerke aus Kriegsbeute und ihre öffentliche Ausstellung in Rom" (diss., Hamburg, 1975); Götz Waurick, "Kunstraub der Römer: Untersuchungen zu seinen Anfängen anhand der Inschriften," *JRGZM* (Festschrift für Hans-Jürgen Hundt, pt. 2) 22 (1975), 1–46; Jerome J. Pollitt, *The Art of Rome, c. 753 B.C.–337 A.D.* (Englewood Cliffs, N.J., 1966), 32–34, 40–48, 63–65; Olof Vessberg, *Studien zur Kunstgeschichte der römischen Republik* (Skrifter utgivna av Svenska Institutet i Rom, 8; Lund,

1941), 59–61, for a collection of ancient texts. Most recently see Leena Pietilä-Castrén, *Magnificentia Publica: The Victory Monuments of the Roman Generals in the Era of the Punic Wars* (Commentationes humanarum litterarum, 184; Helsinki, 1987).

63. Pollitt 1978, 156–157.

64. For Paullus, see Plutarch, *Vit. Aem.* 32; for Mummius, see Pausanias 7.16.8. See also Pape 1975, 12–14 (M. Fulvius Nobilior), 14–15 (L. Aemilius Paullus), 16–19 (L. Mummius).

65. Pollitt 1978, 157; Pape 1975, 21–22 (Sulla), 22–24 (Lucullus), 24–25 (Pompey).

66. On the shipment collected by Q. Caecilius Metellus, see Velleius Paterculus 1.11.25. On the campaigns of Lucullus and Pompey, see Pape 1975, 22–25. The major sanctuaries of Asclepius in or near this area, at Cos and Pergamum, were not affected during these campaigns.

67. See Pape's list of sites in Greece from which works have been documented as having been taken: Pape 1975, 209–212, with references to the sources. Of course, the statue could just as well have been taken from a less well-known site that escaped notice in the primary sources. For a list of Asclepieia on the mainland of Greece, see Pietschmann in *RE*, 2:1662–1670.

68. For Sulla's robbery of the sanctuary of Asclepius at Epidaurus, see Plutarch, *Vit. Sul.* 12.3. Description of Epidaurus: Livy 45.29.3. See further Pape 1975, 21; also R. A. Tomlinson, *Epidauros* (Austin, 1983), 31.

69. Pape 1975, 21–22, nn. 170–173. On Sulla's plundering in general, see also Waurick 1975, 46, map on 44, fig. 4. Although the Asclepieium at Athens seems too small to have accommodated a work of the size of the Cosa statue, it could have stood outside the temenos.

70. Carl Roebuck, *Corinth* 14, *The Asklepieion and Lerna* (Princeton, 1951), 38, 83, 155. This is also a rather small sanctuary of Asclepius; see comment above, note 69.

71. *De viribus illustribus* 60. See Pollitt 1986, 158; Pollitt 1978, 157. On the *tituli Mummiani*, see Pape 1975, 17–18; Waurick 1975, 14–15, 23–24, 27–28, 29, 35, also figs. 2, 3; see also Edward T. Salmon, *The Making of Roman Italy* (Ithaca, 1982), 126, n. 377; Pietilä-Castrén 1987, 16, 139–144; and Leena Pietilä-Castrén, "Some Aspects of the Life of Lucius Mummius Achaicus," *Arctos* 12 (1978), 115–123.

72. On this see Pietilä-Castrén 1978, 115–123, especially 121. The inscription recently discovered at San Giovanni Incarico, near the Latin colony of Fregellae, lends credence to her theory. This is the only one of the *tituli Mummiani* that departs from the standard formula, an indication that the inscription, on a statue base of *peperino*, identified a portrait statue of Mummius originally set up at Fregellae. See also the remarks of Filippo Coarelli in *The Imperialism of Mid-Republican Rome*, ed. William V. Harris (Rome, 1984), 131.

73. On the distribution of booty outside Rome, see Salmon 1982, 126, n. 377; William V. Harris, *War and Imperialism in Republican Rome* (Oxford, 1979), 76; Waurick 1975, 13–15; Pape 1975, 10–11, 13–14, 54. Mummius' refusal to profit from the spoils of war was an attitude advocated earlier by Cato the Censor; it was shared by Aemilius Paullus after Pydna in 168 and by his son Scipio Aemilianus after Carthage in 146. See Harris 1979, 75–76; Alan E. Astin, *Cato the Censor* (Oxford, 1978), 90; Pietilä-Castrén 1987, 135. On Mummius' generosity, see further Leena Pietilä-Castrén, "New Men and the Greek War Booty in the 2nd Century B.C.," *Arctos* 16 (1982), 138–143; and Erich S. Gruen, *The Hellenistic World and the Coming of Rome*, 2 vols. (Berkeley, 1984), 1:266. On the date of Mummius' adornment of towns outside Italy, see Pietilä-Castrén 1978, 118–121.

74. Cicero, *Verr.* 2.1.55; Pliny, *N.H.* 34.36. See also Shatzman 1975, 255, no. 31, with further literary references; and Pietilä-Castrén 1987, 139–144.

75. One of the principal obligations of Latin colonies, of which Cosa was one, was to provide manpower in times of war; see Claude Nicolet, *Rome et la conquête du monde méditerranéen*, 2 vols. (Paris, 1977–1978), 1:278–279, and Edward T. Salmon, *Roman Colonization under the Republic* (Ithaca, 1970), 52, 85–87. On the basis of this, one must assume that Cosa provided its share of manpower as the needs of Rome arose. For example, it is generally accepted that Cosa supplied manpower during the Second Punic War, although this is not documented. Cosa's request for more colonists in 199, granted two years later, is attributed to a depletion of its population from that cause. See Brown 1951, 18; Brown 1980, 32; and P. A. Brunt, *Italian Manpower, 225 B.C.–A.D. 14* (Oxford, 1971), 84. Although it has been pointed out that Rome did not require a large military force in the second century B.C. (Brunt 1971, 75), this need not preclude the service of Cosans in the eastern conquest under Mummius. See also Mary Beard and Michael Crawford, *Rome in the Late Republic* (Ithaca, 1985), 74–75. The benefits of joining the armies in the east were obvious to common soldiers; see Erich Gruen, "Material Rewards and the Drive for Empire," in Harris 1984, 59–61; William V. Harris, "The Italians and the Empire," in Harris 1984, 97–98; and Gruen 1984, 1:288–315.

On the relationship between self-glorification and the embellishment of Rome and other towns with spoils of war, see Pietilä-Castrén 1987, 15; Gruen in Harris 1984, 59–61; Gruen 1984, *Hellenistic World*, 1:266; Harris 1979, 76; Pape 1975, 53–54; and Waurick 1975, 39.

76. Israel Shatzman, "The Roman General's Authority over Booty," *Historia* 21 (1972), 177–205, especially 202–205; Pape 1975, 27–34. See also Erich Gruen, *Studies in Greek Custom and Roman Policy* (Leiden, 1990), 133–140, who considers evidence of the second century B.C. that is indicative of changing attitudes. I am grateful to Gruen for making his work available to me.

77. Shatzman 1972, 202.

78. On the art market in Rome and on private collections, see Pollitt 1986, 159–162; Elizabeth Rawson, *Intellectual Life in the Late Roman Republic* (London, 1984), 194; Pollitt 1978, 161–164; Strong 1978, 14; Pollitt 1966, 74–85. Private collecting apparently did not occur in Rome until the first century B.C. On the changed attitude toward works of art as trophies of war, resulting in fewer public dedications in the first century B.C., see Waurick 1975, 46.

79. Pape 1975, 36–37; see also Brunilde S. Ridgway, *Roman Copies of Greek Sculpture* (Ann Arbor, 1984), 58. For dedications, see the lists compiled by Ridgway 1984, 109–111; Pollitt 1978, 170–172; and Pape 1975, 143–193, with references to literary sources.

80. Livy 26.34.12.

81. Ridgway 1984, 58; Pape 1975, 36–37 (a thorough discussion of this issue), also 42. Pertinent to this discussion is Cicero's report that Mummius refrained from taking a statue of Eros by Praxiteles from Thespiae because it was consecrated (*Verr.* 2.4.4), although he did take unconsecrated ones. The same restraint was not observed for Corinth.

82. Polybius 9.10.13. See Pape 1975, 33.

83. See above, note 78.

84. Another way this statue could have arrived at Cosa in the first century B.C. is through an unscrupulous collector like Verres. In his second oration against Verres, Cicero cites many instances in which he confiscated sacred objects, including statues, from sanctuaries and temples in Sicily. These references have been collected by Pollitt 1966, 66, 69–73; see also the map drawn by G. Waurick 1975, 45, fig. 5. Moreover, Cicero in one passage implies that Verres' collection was destined to be sold (*Verr.* 2.1.61). If Verres is not an exception, it is possible that statuary more suitable for public than private display could have become available on the art market in this way.

85. The medieval inhabitants of Cosa are known to have moved things about, so the possibility that it came from elsewhere in town, perhaps the nearby forum, must be kept in mind. On this see further Collins 1970, 27–29; and Bace 1983, 5–6.

86. Ridgway 1984, 58.

87. According to Plutarch (*Moralia* 286C), sanctuaries of Asclepius should be located outside the city; Vitruvius (*De arch.* 1.2.7) adds that they should be established near a spring or source of fresh water. This precludes the siting of an Asclepieium anywhere on the hilltop of Cosa that lacks springs. See Brown 1951, 84–88; and Brown 1980, 11. Although at least one spring has been found at the foot of the hill, no traces of the characteristic votive plaques representing parts of the human body dedicated by grateful patients have ever been found there.

88. Pliny, *N.H.* 34.80. See Pape 1975, 155. Details of its transfer to Rome are not known. See also Pollitt 1978, 171; and Ridgway 1984, 109. For the Temple of Concordia as a "museum" containing images of many divinities by famous artists assembled for Tiberius' restoration of the temple between 7 B.C. and A.D. 10,

see Pierre Gros, *Aurea templa: Recherches sur l'architecture religieuse de Rome à l'époque d'Auguste* (*BEFAR*, 231; Rome, 1976), 159–160. See also Platner and Ashby, 138–140; and Pape 1975, 155–156.

89. Pliny, *N.H.* 36.23. See Pollitt 1966, 109; Platner and Ashby, 424, 426; Ernest Nash, *Pictorial Dictionary of Ancient Rome*, 2 vols. (London, 1961–1962), 2:254–258; and Pollitt 1978, 172. Pape 1975, 15–16, and Pietilä-Castrén 1987, 133, consider that the Asclepius decorated the Portico of Metellus, which, along with the temples of Juno Regina and Jupiter Stator, was erected by Q. Caecilius Metellus from the spoils of his defeat of Andriscus of Macedonia after 148 B.C. (Velleius Paterculus 1.11.2–5). Cicero's reference to the statues in the Portico of Metellus does not identify them, however (*Verr.* 2.4.126).

90. Ridgway 1984, 64, n. 62; see also Horst Blanck, *Wiederverwendung alter Statuen als Ehrendenkmäler bei Griechen und Römern* (Rome, 1969).

91. Holtzmann in *LIMC*, 1:866, with bibliography; Eugen Thiemann, *Hellenistische Vatergottheiten: Das Bild des bärtigen Gottes in der nachklassischen Kunst* (Orbis antiquus, 14; Münster, 1959), 9; Arthur B. Cook, *Zeus: A Study in Ancient Religion*, vol. 2 (Cambridge, 1925), 1081–1082.

92. This motive is striking whenever many images of Asclepius are seen together; see especially the illustrations collected by Holtzmann in *LIMC*, 2:631–667. For other divinities or heroes who place one hand on or near the hip, see the discussion of Philip Oliver-Smith, "The Houston Bronze Spearbearer," *AntP* 15 (1975), 100–105.

93. Cicero, *Verr.* 2.4.130. See Hans Riemann, "*Iupiter Imperator*," *RM* 90 (1983), 233–338, especially 233–236, 255–326, pl. 78, 2 (a coin from Syracuse of 215–212). The stance is similar to that of the "Zeus" from Pergamum discussed above. See also the heavily restored Zeus Ourios from Tindari: Biagio B. Pace, *Arte e civiltà della Sicilia antica*, 4 vols. (Milan, 1935–1949), 2:132, fig. 124.

94. Cicero, *Verr.* 2.4.129. See Cook 1925, 2:707, fig. 639, a coin of Antoninus Pius from Amastris in Asia Minor: left weight leg, lowered right hand holds spear, head turned to his right. This pose resembles that of certain variations of the Campana type of Asclepius; see Holtzmann in *LIMC*, 1:884–885, nos. 276–296 (Tunis type), and 885–886, nos. 297–309 (Museo Nuovo type). Compare also the Dresden Zeus whose identification has vacillated between that of Zeus and Asclepius in modern literature. Most recently this has been reidentified as Asclepius; see Evelyn B. Harrison, "A Classical Maiden from the Athenian Agora," *Hesperia*, suppl. 20 (1982), 44–47. To her list of examples of Asclepius wearing his himation in a shawllike manner can be added the statuette from Velia.

95. Philip V. Hill, "Aspects of Jupiter on Coins of the Rome Mint," *NC*, ser. 6, 20 (1960), 122, 127, pl. 8, no. 15: an *as* of Antoninus Pius issued c. A.D. 143–144.

To these three images of Zeus/Jupiter can be added Lysippus' Zeus from Argos mentioned by Pausanias (2.20.3) and known only from Roman coins; see Oliver-Smith 1975, 104, fig. 30, with bibliography.

96. It is unlikely that the statue was made in Rome in the second century B.C. by an immigrant Greek artist working in the style and technique in which he was trained and using imported Pentelic marble, even though Greek sculptors are known to have worked in Rome this early (on this see most recently Pollitt 1986, 162–163, with bibliography). If this were the case, a statue of the size and scope of this one would almost certainly have been commissioned for dedication in a sanctuary of Asclepius elsewhere and would not have been available for acquisition by the residents of Cosa.

EMELINE RICHARDSON
University of North Carolina at
Chapel Hill (emerita)

The Types of Hellenistic Votive Bronzes from Central Italy

Asatisfactory date for the beginning of the Hellenistic period at Rome is 296 B.C., the year when the aediles Quintus and Gaius Ogulnius set up a statue group in the forum, "ad ficum Ruminalem simulacra infantium conditorum urbis sub uberibus lupae posuerunt."[1] This group is usually referred to as *The Wolf and the Twins*, but Livy put the emphasis where the Romans would have wanted it, on the "infant founders of the city."

This group is one of the very few public monuments of the republican period whose appearance is known. The bronzes themselves are long lost, but the group was used as a device on Rome's first silver coinage, the ROMANO Group (fig. 1);[2] with minor variations, it appears on many imperial reliefs, an instantly recognizable symbol of Rome.[3] The style is Hellenistic; the three figures make a single compact group, the wolf stands with legs braced to form a protecting shield for the babies, her head turned back and down to sniff affectionately at the head of the nearest child. The twins really do look like very young children, soft and chubby, strong and active, but not yet old enough to stand on their feet. One may wonder where the artist who designed this group came from; I think not Rome, but perhaps Etruria where outstanding bronze figures of animals had been cast in the classical period. Two of them still remain—the *Capitoline*

Wolf, probably of the mid-fifth century, and the *Chimaera* from Arezzo, dated in the first half of the fourth.[4] But it seems to me that the artist was most likely Greek, perhaps from Tarentum. Rome and that city were allies, having signed a treaty in 334, several years after the end of the first Samnite war.

If the *Wolf* of the Ogulnii was indeed the work of a Greek artist, it was nevertheless not the first Greek statue set up in Rome. Pliny the Elder states that during the first Samnite war (343–341) the oracle at Delphi told the Romans to set up in a conspicuous place statues of the bravest and wisest of the Greeks.[5] So they placed a statue of Alcibiades and one of Pythagoras on the cornua of the Comitium. The Romans must have consulted someone from Magna Grecia about the choice of Greeks to be honored. Naturally, Pythagoras of Rhegium was the wisest of the Greeks to a western Greek; as for Alcibiades, the Greeks of Italy, evidently, had not forgotten that he had once been their champion in the war with Syracuse, that persistent menace to Greek and Italic peoples alike.

In the decade after the third Samnite war (298–290) Thurii, the youngest of the Greek colonies in the west, became a protectorate of Rome, and in gratitude for the protection it gave the city bronze figures (presumably portraits) of C. Aelius, tribune of the plebs in 285, and C. Fabricius,

consul in 282, who were responsible for driving away the Lucanians and Bruttians from Thurii.[6] In the course of this struggle Rome's fleet entered the harbor of Tarentum, against the agreements of the treaty of 334, and Tarentum declared war on Rome.

The Tarentines considered themselves the patrons and protectors of the Greeks of Magna Grecia, but had recently found it necessary to ask the cities of Greece for help against the constant attacks of the Lucanians and Bruttians. In 338, Archidamus of Sparta came to their help; in 334, Alexander the Molossian; in 303, Cleonymus of Sparta. Now in 280, Tarentum asked Pyrrhus of Epirus for help against Rome.

Pyrrhus was cousin to Alexander the Great, and the idea of founding an empire in the West to rival his kinsman's in the East intrigued him. He came to Italy with 25,000 men and 20 elephants and defeated the Romans in 280 at Heraclea. In 279 he defeated them again at Asculum. After an interval in Sicily, where he tried without success to drive out the Carthaginians, he met the Romans for the third time at Beneventum. It was a drawn battle, but Pyrrhus had had enough; he withdrew from Italy, leaving behind him the memory of his elephants,[7] and leaving Rome a free hand in the south. By 270 Rome controlled the whole Italian peninsula, and the "Hellenistic Period" in Italy was well under way.

The statues of Pythagoras and Alcibiades and the Thurian portraits of C. Aelius and C. Fabricius are the earliest recorded honorary statues by Greek artists in Rome, but there were many earlier honorary statues there, presumably cast by Etruscan or Roman artists. Pliny discusses in some detail the bronze statuary in the city, among them the images brought home as booty from foreign wars (for example, Mummius' plunder of Achaea) and from the earlier conquests of Etruscan cities—the most devastating that of Volsinii, taken in 264 supposedly for the sake of its two thousand bronze statues—and, particularly, Roman statues of Roman divinities and of distinguished Roman citizens.[8]

These included statues of men wearing the toga; in Pliny's words, "togatae effigies antiquitus ita dicabantur." Among

them were statues of the kings on the Capitolium, which suggests that they were dedications to Jupiter rather than honorary statues, but the line of demarcation is always vague.[9] After all, the comitium, where the figures of Pythagoras and Alcibiades were to stand, was as much a *locus sacer* as the temenos of Jupiter Capitolinus.

The toga was an Etruscan garment, the all-purpose cloak that in Etruria took the place of the Greek himation; instead of being rectangular, like the himation, it was semicircular (according to Dionysius of Halicarnassus, the himation is τετράγωνον, the toga ἡμικύκλιον). Etruscan bronze figures of the late archaic period wear this semicircular cloak.[10]

According to Livy, Romulus introduced the Etruscan insignia of honor to Rome: the *toga praetexta*, the *sella curulis*, and the fasces of the lictors. Other authors say that these and other symbols of power were offered by the Etruscans to Tarquinius Priscus, a tradition that seems to me to make better sense. In any case, the toga became the badge of Roman citizenship; Virgil says of the men of Rome, "Romanos, rerum dominos, gentemque togatam." I think we may assume that togate statues were as old in Rome as the Etruscan dynasty of the Tarquins and that the statues on the Capitoline looked like late archaic togate figures from Etruria.[11]

The Etruscans, of course, went on wearing the toga, and there are quite a few handsome classical *togatae effigies* from Etruria. Incidentally, the Samnites also wore the toga: so much for the Roman *gens togata*![12] In Etruria, the toga was usually worn *sine tunica*, as Pliny says the statues of Romulus and Titus Tatius wore theirs; Sabellian figures wear a belted tunic under the toga, presumably like the tunics worn by Campanian and Lucanian warriors and gladiators in tomb paintings from Capua and Paestum.[13]

Togate bronze figures are common in the Hellenistic period, particularly in Etruria and Latium, but there are also some among the Sabellian peoples. One can usually recognize an Etruscan Hellenistic bronze by the treatment of the hair: for male figures the preferred style was the

1. Didrachm, Rome, after 269 B.C., silver, reverse showing Wolf Nursing the Twins
American Numismatic Society, New York

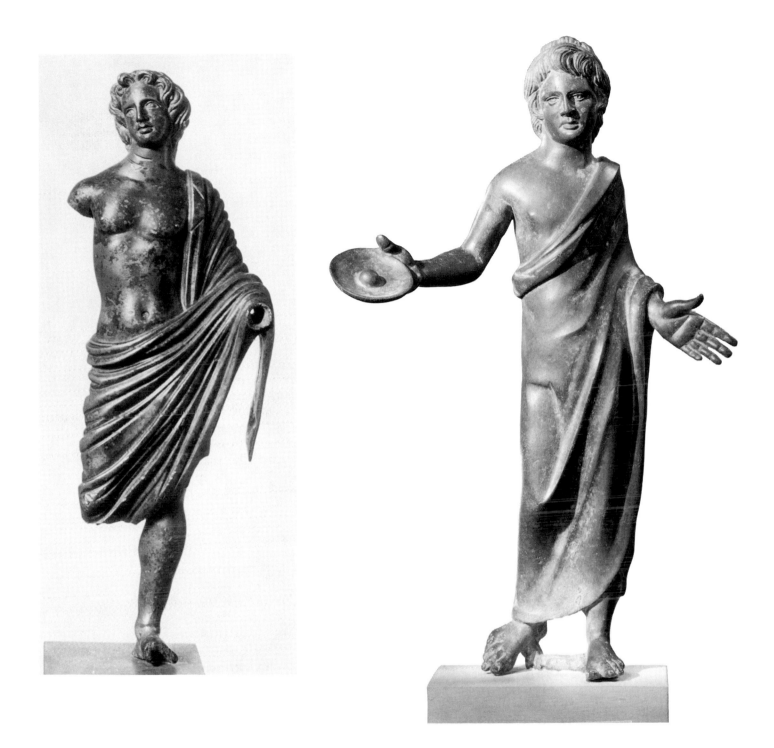

2. Togate figure, 300–200 B.C.
Staatliche Antikensammlung,
Munich

3. Togate figure, 250–150 B.C.
Metropolitan Museum of Art,
New York, Rogers Fund, 1916

"Alexander," with curls swept up from the midpoint of the forehead in imitation of Alexander's *anastole* (cowlick),[14] or the "Seleucus," with heavy, waving locks brushed forward over the forehead and covering the ears and the nape of the neck.[15] The figures themselves are usually, not always, exaggeratedly tall and slender, with long legs and arms, too long for the rather abbreviated torso. Like their forerunners, the classical togate bronzes, they stand with the weight on one leg, the hip thrown out in a moderate contrapposto. Unlike the classical bronzes, which with one exception[16] stand with both heels firmly planted on terra firma, the Hellenistic figures have the knee of the free leg bent, the foot drawn to the side, heel lifted, only the toes touching the ground. The figures as a whole, from head

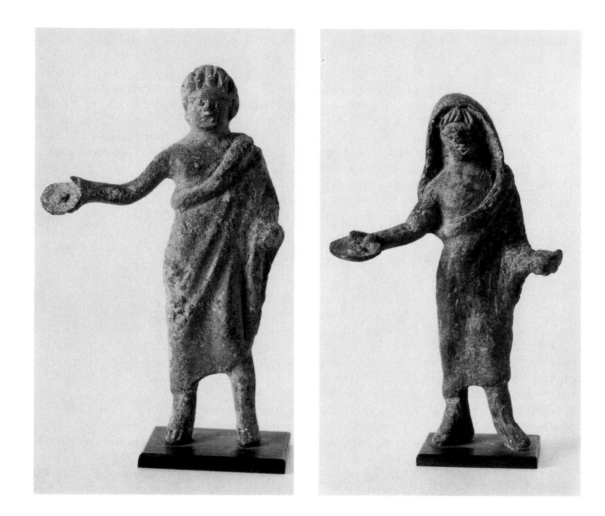

4. Togate figure, from Carsoli, early third century B.C.
Museo Nazionale di Antichità degli Abruzzi e del Molise, Chieti
Photograph: Soprintendenza Archeologica dell'Abruzzo, Chieti

5. Togate figure *capite velato*, from Carsoli, early third century B.C.
Museo Nazionale di Antichità degli Abruzzi e del Molise, Chieti
Photograph: Soprintendenza Archeologica dell'Abruzzo, Chieti

to heel, describe a graceful, if rather monotonous, double curve, less vigorous and more mannered than the swing of the classical bronzes, enhanced by the unrealistic proportions of the Hellenistic figures. This curve is, in fact, a stereotype for the Etruscan figures of the period.

The toga worn by these bronzes may be of almost any width; that of figure 2, now in Munich,[17] is compressed into many narrow folds so that it sags low on the right hip and covers the right knee, while that of figure 3, now in New York,[18] falls smoothly to cross the right instep and leaves only the left ankle bare. A handsome example in London[19] wears a narrow toga that reaches only to mid-thigh. These bronzes usually represent worshippers with their hands open in prayer or libation pourers with a patera in the right hand, or they may carry offerings in one or both hands. The best of them, for all their finicky mannerisms, are truly handsome bronzes.

The first togate figures that can be called Roman date from the early Hellenistic period. None has yet been found in Rome itself, but there is one from Nemi, the site of the great Latin sanctuary of Diana,[20] and its twin was found in the votive deposit of the Latin colony of Carsoli, founded in Aequian territory in 295, at the beginning of the third Samnite war (fig. 4).[21] They are stocky figures with broad faces, and their hair is cut short, brushed over the forehead in heavy straight locks. Their feet are bare; a toga whose hem leaves the ankles and most of the left shin uncovered is slung back over the left shoulder and arm. There is a patera in the right hand; the bronze from Nemi holds an incense box (*acerra*) in the left.

A second bronze figure from Carsoli[22] wears his toga wrapped around his body; its upper border is pulled over his head from behind so that he is *capite velato*, that particularly Roman arrangement used

by a man performing a sacrifice (fig. 5).[23] This bronze looks like the other two Roman *togati*: stocky figure, broad face, short straight hair, wearing a plain toga of medium length, and carrying patera and *acerra*. The head is bent and turned to the right, the hip is outthrust, revealing a touch of Etruscan mannerism. A second togate figure *capite velato*, now in Verona,[24] carries the Etruscan influence further (fig. 6). Its provenience is not known, but I think this bronze must also be Roman (or Latin), with its stocky figure and broad face, and the stiff, straight locks of hair that frame the face. But the rhythm of the figure, and of the toga whose folds accentuate it, is far more sophisticated than that of the little bronzes from Nemi and Carsoli. There are quite a few small togate figures, *capite velato*, in Italian museums—not only in Rome, but in Florence and the Po valley —none of which has a provenience, and I suspect that they all are Latin rather than Etruscan. The only bronze of this type that I know of possessing the Hellenistic elongated proportions and accentuated curves is in the Bibliothèque Nationale, Paris,[25] and even this figure has a virtual twin from Carsoli.[26] In the advancing Hellenistic years, central Italy seems to have taken over more of Etruria's style than it had been willing to accept at first.

The Etruscans had another way of wearing the toga, kilted about the hips, generally used for figures pouring libations or offering gifts. This style also appears first in the late archaic period; its earliest example is the libation pourer from Monteguragazza (Monte Acuto Ragazza).[27] A late archaic figure of Turms (the Etruscan Hermes) found at Uffington, Berkshire, wears his toga in the same way.[28] Classical Etruscan bronzes also wear the hip cloak; a large statuette found on Monte Falterona in 1838[29] wears his cloak in this way, though not because he is praying or sacrificing. Rather, he stands erect, right fist on hip, left hand closed and pierced vertically to hold some rodlike object, staring rather truculently at the observer. His toga is narrow, leaving both knees uncovered. Two other classical bronzes wearing the hip cloak have inscriptions dedicating them to the Etruscan god Selvans. One now in London[30] wears a cloak that falls to mid-calf. His right hand is on his hip, the left hand at his side; he turns and bends his head to the right, wearing a pleasant expression. The other, now in the Biblioteca Vaticana, Vatican City,[31] comes from Marche, from the ancient Picenum, but he and his inscription are Etruscan. He is tall and lean, and he stands erect with head bent; the left hand once held an offering, while the right hangs loose, closed on the stub of a rodlike object. His cloak sags low on the right hip, and its hem covers both knees and the upper part of the right calf.

Hellenistic figures wearing the hip cloak are rather provincial—at the best, country cousins. The fashion seems to have run its course, and such figures were no longer designed by the best artists. One now in Florence is a good example of the period (fig. 7).[32] The body is thin and elongated, with narrow shoulders and long thin legs. The round face has bulging eyes and a small delicate mouth; the hair is straggly, with long, wavy locks brushed to

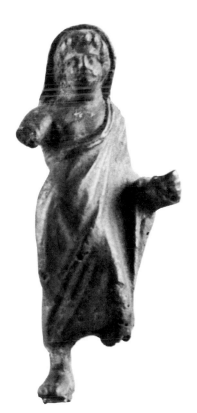

6. Togate figure *capite velato*, probably Roman or Latin, late third century B.C. Museo Archeologico, Verona

each side of a central part, framing the high forehead, covering the ears, and dangling on the neck. The weight is on the right leg, and the left foot is drawn to the side and back, only the big toe touching the ground. The arms swing forward, both hands open in a gesture of worship.

No "Roman" bronzes wear the hip cloak, but it was worn among the Sabellian peoples. Giovanni Colonna has assembled a number of bronzes, his "Gruppo Cosenza" of the late fourth century, several of whom wear the hip cloak with its ends thrown over the left forearm.[33] While the Etruscan bronzes stand quietly, these raise the right arm to brandish a weapon—a truculent attitude that seems most injudicious considering the loose drapery they are wearing. Colonna calls them "Giove in assalto," but perhaps it is a ritual assault. Could these figures be fetiales? The best of them is Colonna's number 610 (fig. 8).[34] Tall and lean, he stands erect, weight evenly distributed, the right arm stretched to the side at shoulder height, forearm up, fist pierced to hold his weapon, while the left arm goes out to the side and down. He has a round face, small eyes shaded by overhanging brow ridges, a thin nose, and a tiny mouth. The hair is short, brushed out from the crown of the head, arched over the forehead, covering the ears. He wears a short-sleeved tunic under the cloak.

To return to Pliny's list, "placuere et nudae tenentes hastam ab epheborum e gymnasiis exemplaribus; quas Achilleas vocant. Graeca res nihil velare."[35] Pliny does not say whether such figures carried the spear as the *Doryphorus* does, resting on the left shoulder as he moves forward, or whether they stood quietly, leaning on the spear grasped by one raised hand, like the *Hellenistic Ruler* in Rome.[36]

To my knowledge, the *Doryphorus* type does not appear in central Italy at any time, but the nude leaning on his spear was very popular there in the Hellenistic period. In Greece, the type is classical. A white-ground lecythos in Boston shows a pair of young athletes in this pose;[37] they are the lateral acroteria of the gable roof of a funeral monument. On a stamnos by Hermonax, now in Munich,[38] Hephaestus, naked except for a scarf that hangs forward over his shoulders, leans on his staff as he watches the birth of Ericthonius. His right hand is on his hip, and his head is bent. This is the pose, and the costume, of Oenomaus on the east pediment of the Temple of Zeus at

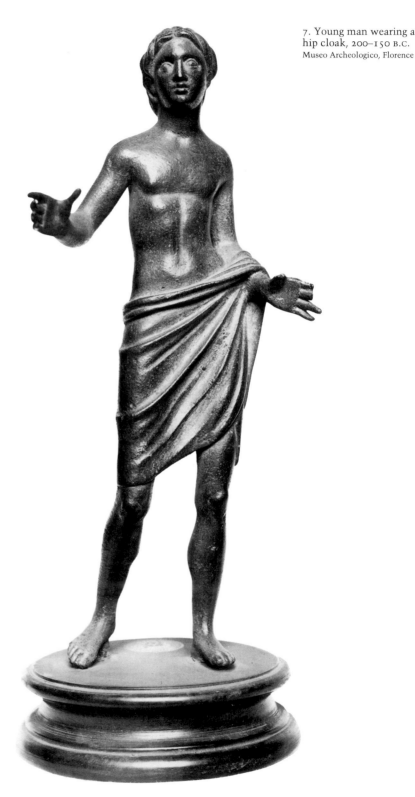

7. Young man wearing a hip cloak, 200–150 B.C. Museo Archeologico, Florence

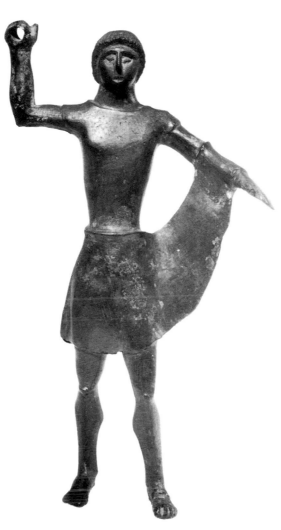

8. Young man wearing a hip cloak, end of fourth century B.C. Museo di Villa Giulia, Rome

Olympia,[39] apparently the first monumental sculpture of this type.

I know of only one classical Etruscan bronze figure of a nude holding a spear. It is the crowning figure of a candelabrum from Vulci,[40] a young man standing erect, spear grasped in the right hand: clearly an imitation of athlete figures, such as those on the white-ground vase in Boston.

The Hellenistic bronzes from central Italy, figures that Pliny would call "nudae tenentes hastam," imitate a later Greek type, the Heroic Ruler, of which the *Hellenistic Ruler* in the Museo Nazionale, Rome, is the finest surviving example. It is generally said that the type goes back to Lysippus' statue, *Alexander with the Lance*, which is supposed to have been reproduced in a little bronze now in the Musée du Louvre, Paris.[41] The Greek fig-

ure is tensely alive and in motion—if he leans on his lance, it is a momentary pause—but the bronzes from central Italy are stereotypes, frozen with minor variations in the same theatrical "heroic" pose.

A bronze now in Stuttgart is a good example of these heroes; I think it is not Etruscan, more likely from Taranto or somewhere in Puglia (fig. 9).[42] The tall slender body is heavily muscled, the legs as usual too long and heavy for the torso. The relatively small head has a choppy version of the Alexander haircut, bound with a flat ribbon. Crumpled drapery hangs from the left forearm, the right arm is raised to lean on a spear or scepter, and the head is lifted and turned to the left. The weight is on the right leg, with the left foot drawn back; only the first three toes touch the ground.

The addition of a bit of drapery to an otherwise nude figure is not uncommon in the Hellenistic world.[43] In central Italy it seems to be almost obligatory if the figure is leaning on a spear. A smiling bronze from Carsoli (fig. 10)[44] is a little brother of the bronze in Stuttgart; he has the same tall, slender, long-legged, muscular form as the larger figure, and his weight is on the right leg with the left foot drawn back, only the toes touching the ground. The left arm is raised, the hand curved to hold a spear, and one end of narrow drapery rests on the left shoulder, while the rest is looped over the upper arm so that a long end hangs down. Clearly, the artists who were providing Carsoli with votive figures had by this time (mid-second century?) given up the down-to-earth "Roman" style in favor of the histrionic late Hellenistic Greek.

"Graeca res nihil velare," said Pliny, "at contra Romana ac militaris thoraces addere." His statement is somewhat misleading, since he seems to leap from nude athletes to soldiers in armor. The Greeks did sometimes produce armed warriors in heroic nudity except for helmet and spear; the *Heroes* of Riace are outstanding examples of this type.[45] But most Greek warrior images wear full defensive armor.

By the early sixth century, Etruria had adopted Greek hoplite armor, round shield, helmet, and corselet. When the Greeks wore the archaic bell cuirass, so

did the Etruscans.[46] The later linen cuirass, with its broad shoulder-guards and skirt of overlapping tags (*pteryges*) came to Greece toward the end of the century; it was the cuirass of Marathon and of the great wars of the fifth century.[47] There seem to be no classical Greek free-standing figures wearing this corselet, but some of the young men shown on the Parthenon frieze wear it.[48] In Etruria it is worn by many small bronzes: the handsomest, a figure found on Monte Falterona; the best known, the *Mars* of Todi.[49]

A handsome newcomer to the classical repertory of body armor was the so-called "muscle cuirass" (German *Muskelpanzer*), molded in the shape of a nude male torso, the front and back fastened together down the sides by hinges and hooks.[50] It appears first in Greek art on a cup by Douris, dated c. 490.[51] Later Attic monuments show the cuirass with a skirt of lappets something like those of the leather cuirass, but with rounded tips,[52] perhaps because the wearers are foot soldiers; riders shown on the Parthenon frieze wear it without lappets.[53]

Perhaps the first sculptured example in Italy of such a cuirass is worn by one of the terra-cotta "pedimental" figures from the Belvedere temple at Orvieto, now dated in the late fifth century.[54] This cuirass, like those of the Parthenon frieze, is worn without lappets and without shoulder-guards.

A few late classical Etruscan bronze warriors wear the muscle cuirass: one such figure in Verona brandishes a weapon in his raised right hand, while two in Berlin lean gracefully on their lances.[55] It continued to be popular in central Italy in the early Hellenistic period. A handsome bronze in London has been dated by Sybille Haynes in the first quarter of the third century (fig. 11).[56] He stands erect, the weight on the right leg though the left hip is outthrust, the left foot to the side with heel raised; the right arm was raised to lean on his spear. The sober face is still classical, as are the clustering curls that frame it, but the proportions of the body—impossibly tall, with slender legs too long for the torso—and the lifted heel are characteristics of the Hellenistic period. The beautiful corselet is worn over a short tunic, its

sleeves pushed up on the shoulders, its skirt neatly covering the sex.

Most Hellenistic cuirassed figures from central Italy are small and rather provincial. One from Carsoli presents the "Roman" version of this type (fig. 12).[57] It

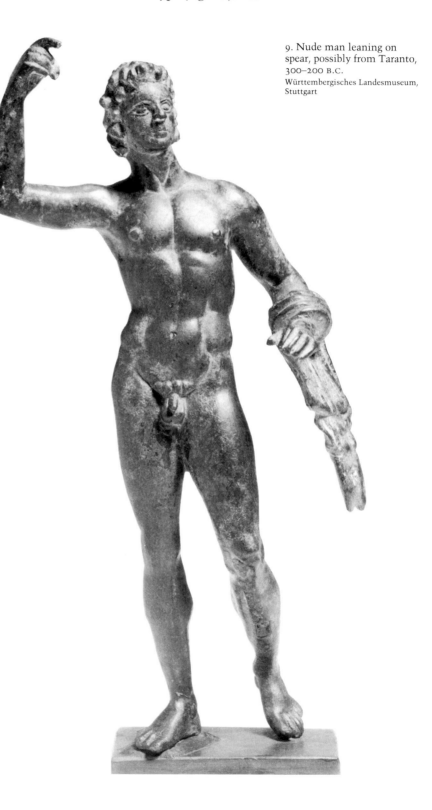

9. Nude man leaning on spear, possibly from Taranto, 300–200 B.C. Württembergisches Landesmuseum, Stuttgart

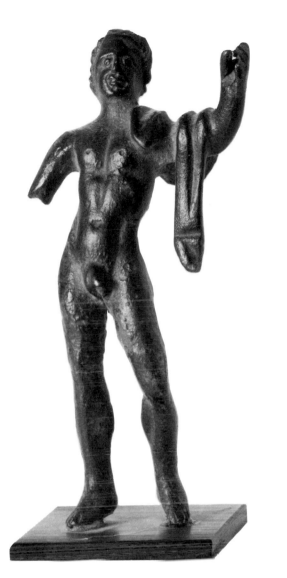

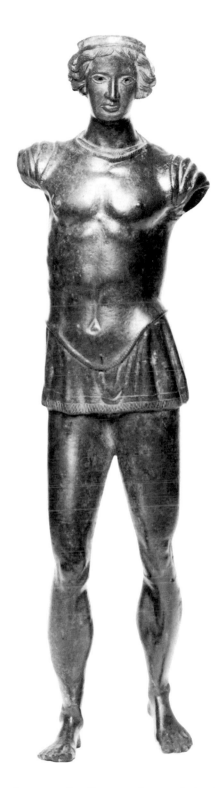

combines an approximation of the Etruscan rhythm with the sturdy proportions of the "Roman" figures. The weight is on the right leg, the hip thrust out, the left foot extended to the side and forward. The torso curves to the left, while the head is turned to the right and bent so that the eyes are turned toward the ground. The right arm may have hung loose at the side, the left is raised to lean on a spear. The big head is crowned by an enormous parade helmet, and the cuirass is worn over a full skirt. Both of these figures, the bronze in London and the warrior from Carsoli, could be described as "hastam tenentes," and this pose was, in fact, the most popular for portrayals of men in armor in Hellenistic central Italy.

In Greece, the linen cuirass of the Hellenistic period was worn with two rows of lappets, the upper very short, the lower reaching at least to mid-thigh. A fine example is worn by a horseman on the frieze of Aemilius Paullus' monument at Delphi.[58] The Romans of the late Republic

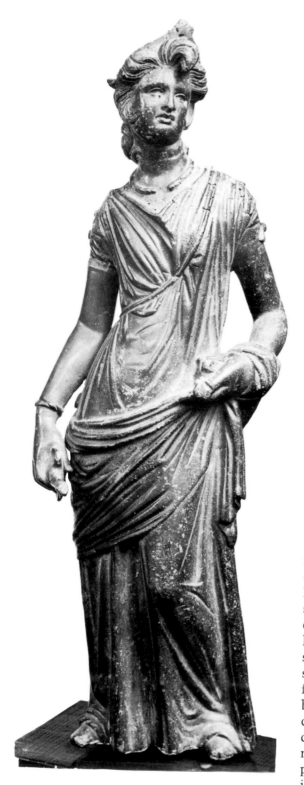

of the hair seems to be purely Etruscan. Whether the diadem indicates that the figure is a divinity, as it would in Greece, is debatable; I think not. It seems to me to be part of the parure of a wealthy and important lady, like the *sphendone* worn by figures of the archaic and classical periods. A female figure carved on one narrow end of an urn in Volterra wears the Etruscan Hellenistic dress and jewelry, including a diadem. She stands beside an armed warrior; their right hands are clasped, and they turn toward one another in the Warrior's Farewell. Their names are carved beside them: Thafaalki Lathunikai and Thania Iiulathi Lin. Thania cannot be a goddess; she is the wife or the betrothed of Thafaalki, and her diadem clearly indicates wealth, not divinity.[66]

A female bronze from Carsoli represents the "Roman" tradition (fig. 15).[67] She wears a peplos with a long overfold that covers the hips; it is not belted, but is drawn in under the breasts as if the belt were meant to be there and the artist had forgotten to model it. She stands with the weight on the right leg, hip out, left knee bent, foot drawn to the side. In her right hand she holds out a patera, while her left arm is raised, the hand closed to lean on a lance or, more probably, a tall scepter. Her head is turned to the right and bent so that she is looking at the patera. Her hair is apparently short, and she wears a crescent diadem fastened behind by a ribbon. Is she goddess or mortal? In Greece the scepter, like the diadem, would be a sign of divinity. The two Greek goddesses who lean most frequently on a tall, slender support are Athene and Hera; Athene's support is, of course, a spear. Athene also favors the peplos with belted overfold,[68] but she does not wear the crescent diadem. The Roman Juno does wear a crescent diadem,[69] but neither Hera in Greece nor Juno at Rome wears the Hellenistic peplos. A handsome Roman bronze now in Vienna stands like the figure from Carsoli, the left hand raised, the right stretched forward (it once held a patera).[70] She wears the crescent diadem, but her dress is a Roman version of the classical Greek chiton, with a wide shawl drawn up over her head and falling down her

14. Woman wearing chiton and himation, from Montecchio, 300–250 B.C., found with three other bronzes inscribed with dedications to a divinity named Thufltha
Rijksmuseum van Oudheden, Leiden

point of beauty.[65] The torque, like the "jockey cap" helmet, came to Italy with the Gauls, and many female bronzes of the Hellenistic period wear it. The treatment

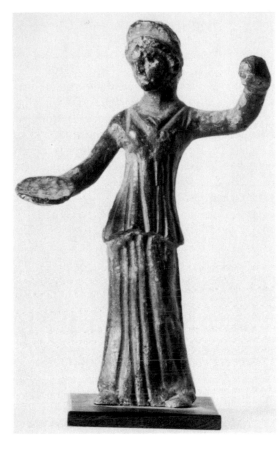

15. Woman wearing peplos with belted overfold, from Carsoli, early third century B.C.
Museo Nazionale di Antichità degli Abruzzi e del Molise, Chieti
Photograph: Soprintendenza Archeologica dell'Abruzzo, Chieti

back. The Carsoli figure and her like might conceivably be a forerunner of this imperial Roman type, but I find it hard to see her as Hera-Juno, and at Latin Carsoli she could hardly be the Etruscan Uni. In Greece, the peplos with the long, belted overfold may have been a prerogative of Athene, but at Taranto in Magna Grecia it is worn by Maenads, companions of Persephone, and other women carved on the friezes of Hellenistic tombs.[71] I think that in the "Roman" Hellenistic context the dress was worn by young ladies, and the crescent diadem, like that worn by classical Etruscan ladies,[72] was part of their normal costume.

Not surprisingly, there seem to have been no honorary statues of children set up in Rome, with the exception of the group dedicated by the Ogulnii in 296. But plenty of votive figures of children have been found in central Italy, from babies in swaddling clothes to boys of twelve years or more. Most of these votives are figures of boys; very few images of girls have been found, and presumably few were dedicated. Most such offerings are of terra-

cotta, but in Etruria there are handsome bronzes as well. One of these, found near Tuoro, north of Lake Trasimene, in 1587, represents a cheerful little boy, perhaps a year old or a little older (fig. 16).[73] He is sitting on the ground, his left foot tucked under his right knee, both arms forward, a fruit (?) in the left hand, a bird in the right. His soft fine hair is brushed forward in a graceful swirl on his forehead. He wears a large bulla hanging from a twisted chain around his neck, a bracelet on each wrist and one on the right ankle. An inscription on the right leg tells us that the figure is dedicated to the god Tec[um], who governs the third house on the Liver of Piacenza and is mentioned once on the Zagreb mummy wrapping and also, apparently, on the Iguvine tablets. Tecum is a male god, perhaps an Etruscan, possibly an Umbrian Divus Pater—Jupiter in his quality as Father.[74]

A bronze in Princeton represents an older child (fig. 17).[75] He is a boy of about twelve and stands erect, the weight on the right leg in a gentle contrapposto and the left knee bent, foot drawn back, heel raised. The head is long and high crowned, the face oval, with full cheeks, a broad nose, and a fleshy chin. The eyes are half-closed, unfocused, and the small mouth is sober. Big ears are set close to the head, and wavy strands of rather short hair are brushed tightly over the skull. The effect is anything but Etruscan; this must be a Roman boy, probably of the last years of the republic.

The bronze boy is wrapped in a himation worn over a tunic, and he wears high shoes or boots fastened by leather thongs. A bulla hangs by a cord around his neck. The himation is pulled over both shoulders and arms, so that its doubled upper border forms a sort of sling in which his right forearm rests; the left arm is pulled back so that the hand, covered by the cloak, rests on the left buttock. This pose, and this arrangement of the himation, can be seen in a statue of Sophocles, formerly in the Lateran Museum, Rome, and one of Aeschines, now in Naples.[76] The boy is one of Margarete Bieber's "Romani Palliati," Roman men wearing the Greek himation, a type popular in Rome during

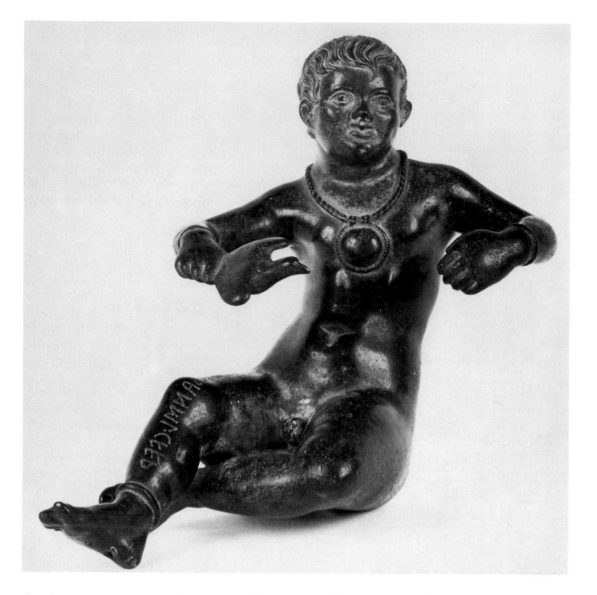

16. Seated child, from Trasimene, c. 300–200 B.C., with inscription on right leg, a dedication to Tecum
Museo Gregoriano Etrusco, Vatican City

the first century B.C. and often used for funerary monuments.[77] The arrangement of the cloak can be called the "Aeschines drape," but at Rome the cloak is the toga as often as it is the himation.[78] This is also true of Etruscan figures in the same pose. Why this boy is wearing a himation instead of a toga is far from clear, but recall that the splendid bronze of a Julio-Claudian prince, now in New York, is also wearing a himation.[79]

A curious assembly of votive figures, almost all of them Hellenistic, seems to have no stylistic connection with any other Hellenistic ex-votos from central Italy, though the subjects are similar— male and female worshippers, priests, possibly divinities, a child. These bronzes

are the "Ex–Voto Allungati" published by Ornella Terrosi Zanco.[80] Immensely elongated, the figures stand rigidly erect in a frontal pose, the body either reduced to a flat, narrow bar like a yardstick or more or less tubular, like a stalk of asparagus or a cluster of knitting needles. They come from different parts of central Italy; one is from the sanctuary of Diana at Nemi, a female figure who wears the crescent diadem and curl-toed shoes of the classical period. Her head is a handsome example of the classical type, and she seems to be the earliest of this group.[81] Another female figure comes from the neighborhood of Ancona.[82]

Several male figures were found in votive deposits near Perugia. One of these,

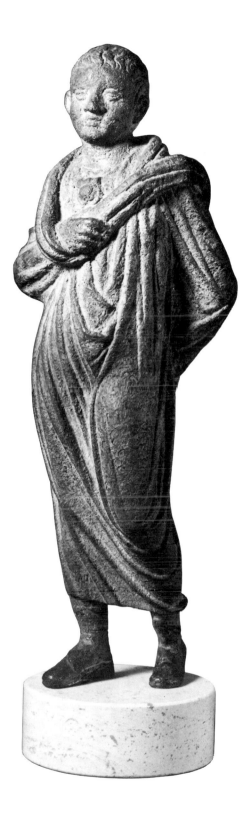

missing (fig. 18).[83] The bronze represents a young man, apparently wearing a V-necked tunic, with a wreath of rather conventionalized leaves on his head. His right hand holds a libation bowl; the left hand is missing. The body is reduced to a yardstick, and the arms are like strands of spaghetti. Another of these bronzes was found at Volterra (fig. 19).[84] It is the figure of a child, a naked boy with a snub-nosed face, wavy hair brushed forward to curl on his round cheeks and domed forehead. This is the only child among the Allungati, and the only nude figure.

Why central Italy produced these bronzes in the middle of the Hellenistic period is a puzzle. They may be late imitations or descendants of figures like the wooden ones found in the sanctuary of Mefitis at Rocca San Felice in the Valle d'Ansanto,[85] or like a terra-cotta "yardstick" from the sanctuary of the Dea Marica at the Foce del Garigliano.[86] They must be evidence of a rebirth of a primitive idea of power in images of the human form that are not human in appearance—perhaps like the stone heads of the Easter Island people or the kachinas of the Pueblos.

The last Hellenistic bronze type to be created in Italy, far from being an echo of a lost native culture, could have been produced in no other period. The finest of the many bronzes of this type have a flamboyant elegance that seems more Greek than Italic, but the type was not borrowed from Greece, or even from Magna Grecia. It shows a young man with luxuriously waving hair that frames his face and covers his ears and the nape of his neck. The broad, handsome face has big eyes with incised pupils that seem to be looking into infinity and a mouth whose curving lips recall those of young men shown on the Parthenon frieze. The body is lean and muscular but not markedly athletic. The figure wears a semicircular toga that leaves the upper torso bare but covers the left shoulder and arm. He stands with the weight on one leg, the knee of the free leg strongly bent, the foot drawn back, heel raised. A bronze now in Baltimore is a fine example of this type (fig. 20).[87] The body is twisted so that the right shoulder comes forward, the left is drawn back, and the head is

from the votive *stips* of Callegiana near Lake Trasimene, would have been the tallest of these surviving figures; his preserved height is 0.455 m, and the lower section of the figure (from mid-thigh?) is

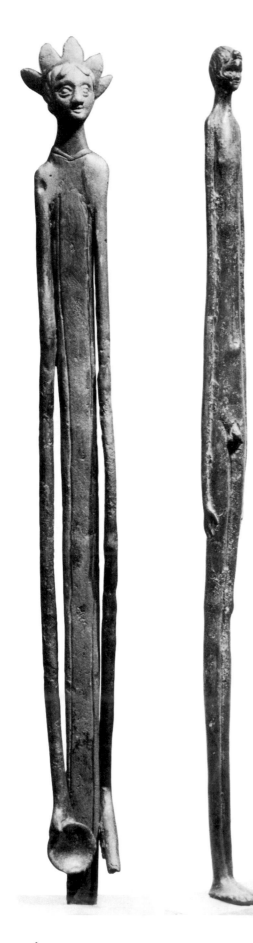

turned to the right. He holds a patera in the right hand, an incense box in the left. Like the other figures of this type, his head is crowned with a wreath of vine leaves.

Several handsome examples were found at Nemi,[88] and two clumsier examples come from a Hellenistic house in Vetulonia.[89] The type seems to have been at home only in Etruria and Latium. It also seems to have been a latecomer. No such figures have been found at Norba, the Latin colony founded some time after 338, or at Carsoli, founded in 298. Some negligible figures, however, were excavated at Bolsena, which was founded after Volsinii Veteres was sacked by the Romans in 264. Sybille Haynes thinks the type did not appear till the second century, but Mauro Cristofani believes it first appeared in the third.

There is doubt, too, about whom or what the figure represents. His vine-leaf wreath should connect him with Dionysus, and his appearance in a house at Vetulonia suggests an early lararial cult. I have always thought he might represent a Genius, since the Roman Genius, like the Greek Agathos Daimon, was sometimes identified with Dionysus or his Roman counterpart, Liber Pater.[90]

Most of these Hellenistic types survived the creation of the Roman empire: the togate figure, the nude leaning on his lance, the man in armor, the lady, and the child. But their style underwent a change; the Hellenistic must never be confused with the Graeco-Roman. The eccentric was outlawed, the toga took on the dimensions of a parachute, divinities wore Roman dress. In fact, divinities were Roman throughout Italy; even the Genius, if that is what he was, became a Roman paterfamilias.

18. Elongated male figure, from Callegiana,
C. 300–200 B.C.
Museo Archeologico Nazionale dell' Umbria, Perugia

19. Elongated nude male figure, from Volterra,
C. 300–200 B.C.
Museo Guarnacci, Volterra

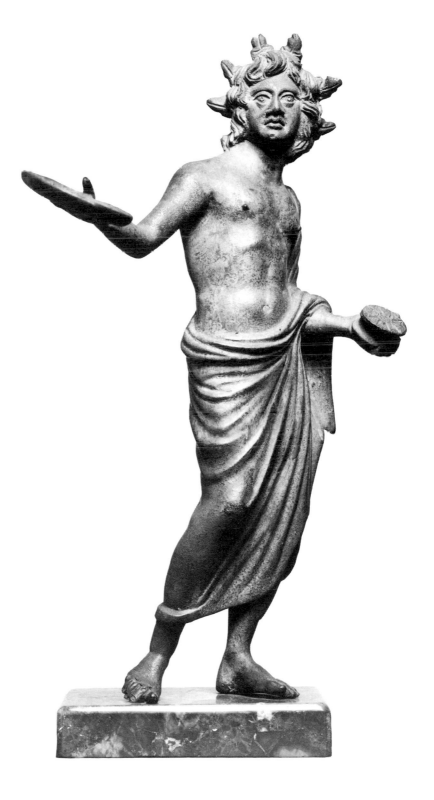

20. "Genius" crowned with
vine leaves, Etruria or
Latium, second century B.C.
Walters Art Gallery, Baltimore

RICHARD BRILLIANT

Columbia University

Hairiness: A Matter of Style and Substance in Roman Portraits

Since the Renaissance, Roman portraits have enjoyed a well-merited reputation as a major art form, consisting of a great variety of objects and images that could be followed without serious interruption for many centuries. The huge corpus of these portraits--in effect a portrait of Roman society through the ages—survives in various media and in different scales, ranging from colossal statues to numismatic miniatures. The portraits come from all parts of the Roman world, were the products of public and private commissions, and were intended for both public and private use. They seem to convey an unequaled sense of the living persons who, in all their individuality, constituted the Roman community during its long history. Above all, they bear the signs of contemporary attitudes—both those held by the subjects about themselves and their role in society and those held by the portraitists about their subjects—that can be interpreted by an acute observer of the human condition and of art.

The popularity of portraits, out of the entire figural repertory of Roman art, may acknowledge the portrait's power in presenting a satisfactory image of Roman men and women themselves, in their own likenesses and in their own times, with all the specific human characteristics "typical" of members of their society. Indeed, the Roman portrait, with its direct reference to the manifested worth of the individual portrayed, has provided generations of connoisseurs and scholars with an extraordinary opportunity to comprehend the psychology of the ancients through their images and to give that comprehension a historical dimension. It is possible, therefore, to consider the Roman portrait as a highly charged artwork, as an image of a once-living person, and as a culturally sensitive instance of artistic interpretation. It grants moderns immediate access to the ancients with an intensity that more than complements the ancient texts. For the responsive viewer, the personal image and the portrait often seem to coalesce without further reflection in the immediate experience of the work and of the person behind the work.

Of course, scholars like to bring order to these survivors from the Roman past, apparently so dependent upon the establishment of identity for their historical significance. Partly for this reason portraits of the imperial family have received special attention: They can be accurately identified and dated on the basis of numismatic evidence; subsequently, they can serve as an excellent standard for dating otherwise unknown portraits that resemble them stylistically and in the nature of their imagery. Traceable to Renaissance antiquarians and their catalogues, the dedication to the identification of the portrait subject and to the dating of the artwork

still governs most studies of Roman portraits, which have been effectively categorized by the rigors of German classical scholarship since the mid-nineteenth century. In recent decades, the analysis of Roman portraits has developed several thematic and critical approaches of considerable interest, well represented in the scholarly literature of the last twenty years.[1] They include a sensitive appreciation of the relationship between an original portrait, perhaps the lost work of a master that made a specific entrance and then stimulated the creation of numerous copies, and the invention of an authoritative type as a model that led to the production of many adaptive versions. In both cases, the establishment of the prototype, its dissemination, and the distinction between metropolitan and provincial ateliers are in issue. Further considerations of the Roman portrait as an object and an instrument of patronage are currently in vogue, expressions of a growing interest in the exercise of patronage in the Roman world, and its objectives, patterns of performance, and limits. These attempts to contextualize portrait production and to define its ideological properties, subject to distinctions of class, have become more sophisticated as they have sought to uncover the forces that shaped the portrait's style and determined the appropriateness of its representations.

All the while, scholars have continued to refine the stylistic criteria that give credence to the location of a portrait in Roman history—a history characterized not only by evident stylistic change but also, in late antiquity, by a profound shift in the conception of the individual that extravagantly enlarged or sorely diminished his apparent worth in the eyes of his contemporaries. Surely the hermeneutic properties of Roman portraiture have never been more appreciated, but the many interpretive agendas so much in fashion now seem to concentrate almost exclusively on the reception of and response to these portraits. In emphasizing this approach to the work of art, its advocates appear to relegate the artist's making of the portrait to a secondary level of importance, almost as if ideological considerations had guided the

hand of the artist, rather than his own talents, the conventions of his art, the task before him, and the formal demands of his craft. Formalist concerns still have their recognized place in the connoisseurship of Roman portraits as general and individual stylistic markers; in the artist's mind, they shape the ultimate product, the artwork, as it comes into being and provide observers with the source of aesthetic pleasure and the very object of their interpretation.

The human head is the most important element in portraiture, and the human head comes with hair, which is, alas, all too often taken for granted by the living bearer or the complacent witness. Hair occurs naturally on various parts of the head; its character, color, texture, abun-

1. Funerary altar, early second century A.D., marble, showing portrait busts of Lucius Tullius Diotimus and his wife Brittia Festa
Villa Borghese, Rome
Author photograph

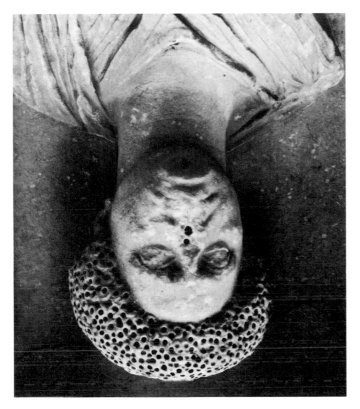

2. Funerary altar, early
second century A.D., marble,
detail (shown upside down):
portrait bust of Brittia Festa
Villa Borghese, Rome
Author photograph

behavior of Roman women, who appear to
have changed their hairstyles frequently
and dramatically (figs. 1–5).[2] It was assumed
that these distinct hairstyles reflected actual
fashions of hairdressing and thus could
serve as reliable evidence for dating, their
relative chronology being confirmed by ref-
erence to numismatic portraits. This was a
somewhat circular argument, since only art-
works were available as evidence for the
assumed shifts in fashion. Still, the fre-
quency and consistency of the representa-
tions of hair in artworks of the same
period (otherwise established) enhanced
the plausibility of this assumption.

Men's and women's hairstyles were also
significant bearers of meaning, a highly
visible way of delivering political, ideolog-
ical, or cultural messages. Romans might
adopt a special coiffure associated with
the gods: so the Serapis locks displayed
prominently on his forehead by Septimius
Severus, or the Venus-coiffure worn by
matrons in search of some approximated
apotheosis.[3] Members of imperial fami-
lies, such as the Julio-Claudians and the
Antonines, often wore the particular and
recognizable hairstyle of a famous dynas-
tic relative, such as Augustus or Marcus
Aurelius, to assert their connection to him.
Others were more inventive, as demon-
strated by Constantine, who consciously
invoked Trajan, a distant predecessor, by
using his familiar soldier's haircut in his
own portraits (fig. 8).[4]

The manifest choice of a particular hair-
style is a significant, even subtle, aspect of
Roman portrait iconography, and one that
has been insufficiently explored as a topic
worthy of systematic research in its own
right. The study of hair symbolism extends
beyond portraiture to the larger considera-
tions of hairiness as an ethnic indicator,
as a sign of a forceful character in physiog-
nomic doctrine (for example, the *leonine*
individual), or as a marker differentiating
the civilized Roman from the unruly, sav-
age barbarian.[5] Human hair is much more
than the filaments growing from the skin,
at least when it is shaped by the hand of
an artist.

When connoisseurs and scholars pay
close attention to the artist's handling of
his material in representing hair, they tend

dance, and curl depend on genetic, sexual,
and age differences in the human popula-
tion. The location, prominence, and treat-
ment of hair in the portrait depends,
however, as much on art and fashion as on
nature's bounty. This applies particularly
to the sculpted portrait because the physi-
cal substantiality of carved or modeled hair
is apparently so similar to its actual coun-
terpart in nature; yet sculpted hair is totally
artificial, a product of art and not of nature,
despite its descriptive realism. Cranial and
facial hair are as much a part of sculpted
portraits as they are of the human head: In
both hair is represented three-dimension-
ally and with the tactile effects of texture,
curl, and weight, and in both hair contrasts
with skin, the former rough and irregular,
the latter smooth and closed.

The importance of hair is not fully
reflected in the literature on Roman por-
traits since the Renaissance, even among
the German scholars who invented color-
ful descriptive terms, such as *Nestfrisur* or
Scheitelzopf-Frisur, to identify specific
Roman hairstyles. With philological zeal
these scholars created a fairly detailed,
rigid classification of styles, carefully
sequenced and largely dependent on the

to either characterize the sculptor's skill as a carver (figs. 3, 4, 6, 7, 9, 10) or to evaluate his mastery of naturalistic illusion (figs. 1–4, 6, 7). Technique also has an important place as a stylistic marker, whether the hair is carved three-dimensionally (figs. 3, 4), superficially incised (figs. 9, 11, 12), or emphatically drilled (figs. 1, 2, 8), or whether it projects in heavy masses from the surface (figs. 1–4, 6), lies close to the surface of the head (figs. 9, 10), or has suffered a loss of its materiality through negative, extractive modeling (fig. 8). The formal properties of cranial and facial hair, however—its texture, abundance, and location, and the concomitant artistic problems they pose—also deserve the closest attention. For the portraitist who must display the indexical elements of his subject's physiognomy in order to ensure recognition, the hairy fringe around the head and the hairy cov-

3. Head of Marciana, sister of Trajan, from Subiaco, early second century A.D., marble
Museum of Fine Arts, Boston

4. Head of Marciana, sister of Trajan, from Subiaco, early second century A.D., marble, profile
Museum of Fine Arts, Boston

5. Head of Faustina Minor, mid-second century A.D., marble
Musei Capitolini, Rome
Photograph: DAI, Rome

ering on the face (fig. 6) complicate his task, however truthful they may be to the person's actual appearance.

In portraying a heavily bearded man, a case where hair serves as a kind of mask (fig. 8), the artist has very little room left to convey the interior life of his subject, once the indexical possibilities of hair have been exhausted. Hairiness, qualified by fashion and gender, interferes with the perception of a person's face and head as an organic whole, because it interrupts and obscures the continuous mantle of skin, and its projections, like solar flares, draw attention away from the clear outline of the head. For the portrait sculptor, hair becomes a major, if necessary, diversion, a digressive element, and a screen through and around which he must try to visualize the personality of his subject and make it known to the beholder.

The formal problems presented by hair are not simple, even when at first glance they appear to be so. An early Trajanic funerary altar now in the Villa Borghese, Rome (fig. 1), portrays a clean-shaven man and a smooth-cheeked woman.[6] Both are middle-aged, and they are informed by the *gravitas* typical of their respected status in Roman society and by the old Republican traditions of portraiture employed to express that status and their sober character. The man, Lucius Tullius Diotimus, freedman and consular agent (*viator*), and his worthy wife, Brittia Festa, have been treated in a remarkably similar manner by the sculptor, their faces clear of all but the slightest signs of gender distinction. The man's bust portrait has been set a little higher in the rectangular frame, perhaps to indicate his superior position in the marital relationship. On formal grounds alone, however, the sculptor might have felt compelled to do this in order to compensate for the greater volume of the spongy hair mass in the late Flavian style that adorns Festa's head, since Diotimus himself wears the short, straight hair favored by men in the Trajanic period.

More than a simple spatial adjustment is involved here. Because the beholder's eye registers Brittia's hair so quickly (the

6. Head of Lucius Verus, c. A.D. 164–169, marble
Toledo Museum of Art, Gift of Edward Drummond Libbey

7. Head of Venus, c. A.D. 164–169, marble
Toledo Museum of Art, Gift of Edward Drummond Libbey

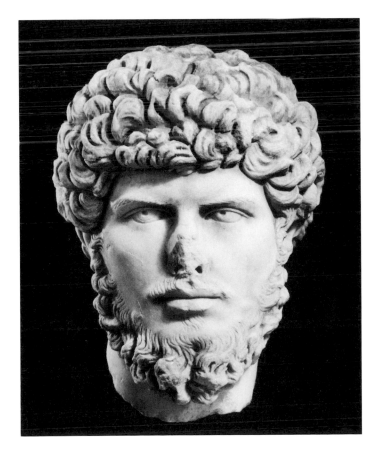

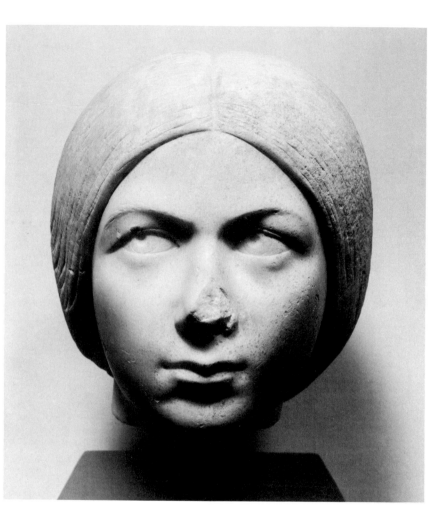

connoisseur recognizes the frizzy style of the Flavian coiffure as well as the drill-work that visualizes it), the intrusive bulk and stony mass of the hair are not fully

comprehended. When Festa's head is turned upside down, for the purposes of analysis (fig. 2), her hair, reinforced visually by its spongy texture, gains considerable compositional importance as an aerated mass set off against the closed, stony oval. Still, the competent sculptor of the Borghese grave relief did not fully exploit the possible range of formal contrasts, constrained as he must have been by the conventions of his commission.

The gifted artist who carved the marble portrait of Marciana, Trajan's sister, now in the Museum of Fine Arts, Boston, was not so limited (figs. 3, 4).[7] He did exploit the formal and representational contrasts between hair and face, and yet he maintained a tighter balance between these disparate elements, setting rough against smooth; convoluted forms against a simple, flowing surface; the artificiality of elab-

8. *Triumph of Marcus Aurelius*, c. A.D. 175, relief panel, marble, detail: head of Marcus Aurelius
Palazzo dei Conservatori, Rome
Photograph: DAI, Rome

9. Head of a man, mid-third century, marble
Ny Carlsberg Glyptotek, Copenhagen

10. ABOVE: Head of a woman, mid-third century, marble
Private collection, Rome
Photograph: DAI, Rome

rately dressed hair against the well-composed face with its naturally restrained expression. Unlike Festa's portrait, where the contrast between hair and forehead is stark (fig. 2), Marciana's portraitist has related these elements more closely, anticipating the roughness of the hairdo in the deliberately incised eyebrows, while girdling the forehead with a form-fitting band of hair, set simply beneath the tight ringlets.

Marciana's portrait also exhibits the tendency toward abstraction evident in many Roman female portraits of the second and third centuries (figs. 2, 3, 5, 10). First, the previously mentioned contrast between hair and face becomes progressively more schematic, as the coiffure gradually encircles the contours of the face while losing its former height and splendor. Then, the face itself seems to become more symmetrically composed, as if the natural imperfections that mod-

ify the intrinsic symmetry of the human face were barely tolerated (fig. 10). In this process, gender does not make a difference. Faustina Minor's frozen mask in the Musei Capitolini, Rome (fig. 5),[8] when compared with a contemporary bust of Lucius Verus, now in the Toledo Museum of Art (fig. 6),[9] shows how much more readily subject to abstract treatment is the female portrait. Despite the blankness of Lucius' expression, his portrait does retain a certain level of energy, dependent on the visible irregularities imparted by the curl of his hair, the unequal fall of his moustache hairs, and the tufted swirls of his beard. Hairiness alone is not enough to make the portrait a major work of art, however, and Verus' portrait cannot compete with the visual richness of another sculpture of the period, the head of Venus, also in the Toledo Museum of Art (fig. 7).[10] This Venus is a good example of the

gender distinctions to be made among contemporary works of art. The sculptor fully exploited the female appearance in exaggerating the contrast between the very smooth skin and the vibrantly textured hair piled irregularly on top of her head, and he gave life to his idealized, divine subject by complicating the vertical connection between her head and neck. Upon close examination, the Toledo Venus and the Capitoline Faustina Minor (fig. 5), and the Toledo Lucius Verus (fig. 6), fully demonstrate the very different compositional problems presented to a Roman sculptor by the female or male head in the second century. Whether hair or gender with its associations comes first in his considerations may be an unresolvable question. In any case, the viewer's perception of hairiness as a product of representational needs and artistic performance is not influenced solely by quantity—the ladies have full heads of hair—but by the amount of surface cover and by the orderliness of its dressing. Facial hair offers concealment; what is left exposed then requires the closest scrutiny.

Hairy Lucius Verus (fig. 6) reveals how much of the surface of face and head has been concealed by his curls, how much, therefore, the sculptor had to concentrate physiognomic and psychological expression in the relatively small open area, and how important in that regard the eyes, even the dull eyes of Verus, have become. The eyes serve as punctuation points, interrupting the beholder's visual passage over the face and framing, almost parenthetically, the interior life of the human being portrayed. How much could be done with this opportunity by a greater artist, even within the limits of a very hairy visage, is apparent in the moving portrait of Marcus Aurelius on the Triumphal Panel in the Palazzo dei Conservatori, Rome (fig. 8).[11] Shaggy-haired but not unkempt, the surface of the skin profoundly weathered by life (both hair and flesh deeply cut by the running drill), all these elements have been contained in a composition that stresses axiality as the armature for expression. The strong vertical axis clarifies the effect of bilateral symmetry (compare fig. 5), while the rising and falling curves on either side

evoke the character of the man and make poignant his experience.

Crossing that vertical axis at right angles is the line of sight established by Marcus Aurelius' heavy-lidded, deeply drilled, staring eyes. Despite their natural liquidity, these eyes are the stable focus of attention in a highly structured facial composition that nevertheless seems to move and shift as light flickers over the richly textured surface of the hard stone. This artist undercut the obstacle of hairiness when he undercut and extracted its apparent substance. He then turned the texture of hair to his advantage by contrasting its coarseness first with the closed

13. Head of Constantine the Great, c. A.D. 320, marble
Palazzo dei Conservatori, Rome
Author photograph

surface of skin and then with the solidity of an eye, marked by a single point of entry into the interior.

Solving the problem of hair and taking advantage of the opportunities for expression that followed were important factors influencing the progressive abstraction evident in Roman portraits from the Antonines to the late third century and beyond. Two superb portraits from the middle of the third century show this process at work. In one, possibly a portrait of Trebonianus Gallus, now in the Ny Carlsberg Glyptotek, Copenhagen (fig. 9),[12] the hair has been reduced to a vestigial cipher. So closely cropped is it in soldier-style that the sculptor has resorted primarily to incision to suggest the stubble of beard and the short bristles of cranial hair. In the other, a sensitively modeled, disturbing female portrait in a private collection in Rome (fig. 10),[13] the impression is dominated by her disquieting eyes, the only release from the straitjacket of her tightly combed hair. Although these two portraits are differentiated by indications of gender, the compositional treatment of hair is not so different, perhaps because by the mid-third century hair itself played a much less prominent role as the artist's interest in the depiction of natural form diminished.

The corollary to that lessening interest in naturalistic depiction in late antique art is the heightening of an abstract imagery of permanence and with it the concentration of effects upon a frozen, immutable visage, the mouth tightly closed as if in denial of life, the eyes fixed and staring (figs. 11–13). Distinctions of gender seem to matter less, especially in the case of a female portrait in the Palazzo dei Conservatori, Rome, that has lost the pieces of its coiffure, the nearly gratuitous additions that once provided the gloss of tetrarchic fashion (figs. 11, 12).[14] Chance may have enhanced the compatibility of this female portrait with that of Constantine the Great, also in the Palazzo dei Conservatori, Rome (fig. 13),[15] but their similarity is not fortuitous: the contemporary conception of the person seems more and more to disregard such transient distinctions as irrelevant.

Hair did not disappear from the human head in late Roman times. It merely became less conspicuous in life and art and, therefore, less of a problem for the portraitist. The study of hairiness in Roman portraits and of the rise and fall of its prominence goes beyond the investigation of the retreat from naturalism that informs so much of late Roman art. Formalist concerns were critically significant in the creation and reception of Roman portraits, and how to deal with human hair was one of those concerns. The solutions developed by Roman artists in response to that concern, that artistic problem, profoundly affected the making of portraits as works of art. The study of hair in portraits and of the phenomenon of hairiness contributes to the understanding of the semiotic nature of that process at work beneath the curls and coiffures worn by generations of Roman men and women.

NOTES

1. Walter Trillmich, "Zur Formgeschichte von Bildnis-Typen," *JdI* 86 (1971), 179–213; Rolf Winkes, "Physiognomonia: Probleme der Charakterinterpretation römischer Porträts," *ANRW* 1.4 (Berlin, 1973), 899–926; Ulrich W. Hiesinger, "Portraiture in the Roman Republic," *ANRW* 1.4 (Berlin, 1973), 805–825; Helga von Heitze, ed., *Römische Porträts* (Darmstadt, 1974); Sheldon Nodelman, "How to Read a Roman Portrait," *Art in America* 63.1 (January–February 1975), 26–33; James D. Breckenridge, "Roman Imperial Portraiture from Augustus to Gallienus," *ANRW* 2.12.2 (Berlin, 1981), 477–512; Wolfgang Schindler, ed., *Römisches Porträt: Wege zur Erforschung eines gesellschaftlichen Phänomens* (Wissenschaftliche Zeitschrift der Humboldt-Universität zu Berlin, Gesellschafts- und Sprachwissenschaftliche Reihe 2/3; Berlin, 1982); Jean-Charles Balty, "Style et facture: Notes sur le portrait romain du IIIe siècle de notre ère," *RA* (1983.2), 301–315; Luca Giuliani, *Bildnis und Botschaft: Hermeneutische Untersuchungen zur Bildniskunst der römischen Republik* (Frankfurt, 1986).

2. Max Wegner, "Datierung römischer Haartrachten," *AA* (1938), 276–325; Klaus Wessel, "Römische Frauenfrisuren von der severischen bis zur konstantinischen Zeit," *AA* (1946–1947), 62–76; L. Furnée–van Zwet, "Fashion in Women's Hair-Dress in the First Century of the Roman Empire," *Bulletin van de vereeninging tot bevordering der kennis van de antieke beschaving* 31 (1956), 1–22.

3. For Septimius Severus, see Anna M. McCann, *The Portraits of Septimius Severus* (*MAAR* 30; Rome, 1968), nos. 46–99; for the Venus-type, see Henning Wrede, *Consecratio in formam deorum: Vergöttlichte Privatpersonen in der römischen Kaiserzeit* (Mainz, 1981), nos. 295–297.

4. See Peter H. von Blanckenhagen, "Ein spätantikes Bildnis Traians," *JdI* 59–60 (1944–1945), 46–68.

5. See, for example, the implications of the shaggy barbarian in Roman imperial monuments as investigated by Anne-Marie Leander Touati, *The Great Trajanic Frieze* (Skrifter utgivna av Svenska Institutet i Rom, 4th ser., 45; Stockholm, 1987), 66–73.

6. *CIL* 6:1924; Diana E. E. Kleiner, *Roman Imperial Funerary Altars with Portraits* (Rome, 1987), no. 54; Paola della Pergola, *Villa Borghese* (Itinerari dei musei, gallerie e monumenti d'Italia, 106; Rome, 1964), 41–42.

7. Museum of Fine Arts, Boston, no. 16.286; Mary B. Comstock and Cornelius C. Vermeule, *Sculpture in Stone: The Greek, Roman and Etruscan Collections of the Museum of Fine Arts, Boston* (Boston, 1976), no. 350.

8. Musei Capitolini, Rome, Stanza degli Imperatori 33, inv. 310; Klaus Fittschen and Paul Zanker, *Katalog der römischen Porträts in den Capitolinischen Museen und den anderen kommunalen Sammlungen der Stadt Rom*, 1 and 3 (Mainz, 1985, 1983), 3: no. 23.

9. The Toledo Museum of Art, no. 76.20; Elaine Gazda, *Roman Portraiture: Ancient and Modern Revivals* (Ann Arbor, Mich., 1977), no. 7. For the portraits of Lucius Verus, in general, see Klaus Fittschen, "Zum angeblichen Bildnis des Lucius Verus im Thermen-Museum," *JdI* 86 (1971), 214–252.

10. The Toledo Museum of Art, no. 76.21; Gazda 1977, no. 8.

11. *Triumph of Marcus Aurelius*, relief panel in the Palazzo dei Conservatori, Rome, inv. 808; Inez Scott Ryberg, *Panel Reliefs of Marcus Aurelius* (New York, 1967), 15–20, figs. 9a, 15c; Max Wegner, *Das römische Herrscherbild* 2.4, *Die Herrscherbildnisse in antoninischer Zeit* (Berlin, 1939), 44, pl. 28.

12. Ny Carlsberg Glyptotek, Copenhagen, inv. 833; Vagn Poulsen, *Les portraits romains* 2 (Copenhagen, 1974), no. 173.

13. Unpublished; private collection, Rome. For similar portraits, see Marianne Bergmann, *Studien zum römischen Porträt des 3. Jahrhunderts n. Chr.* (Antiquitas, 3d ser., 18; Bonn, 1977), 89–101, pls. 26–29.

14. Palazzo dei Conservatori, Rome, Braccio Nuova 3.27, inv. 2689; Fittschen and Zanker 1985, 1983, 3: no. 175.

15. Palazzo dei Conservatori, Rome, Cortile, inv. 1622; Fittschen and Zanker 1985, 1983, 1: no. 122.

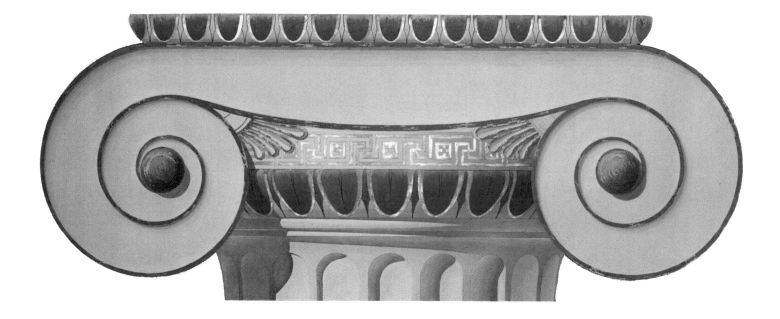

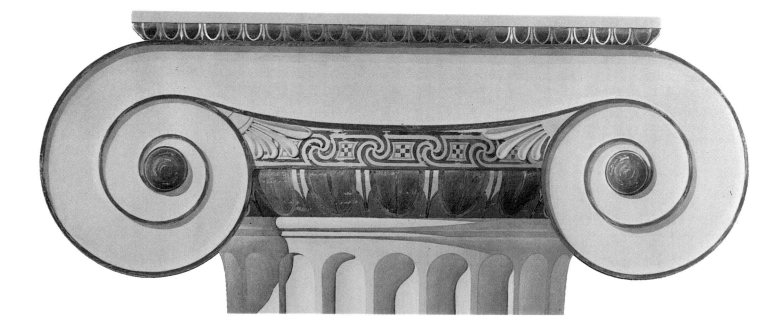

LUCY SHOE MERITT

University of Texas at Austin

The Athenian Ionic Capital

In the more than half-century of Frank Brown's scholarly life, the study of the history of ancient architecture has made greater progress than ever before in the analysis of details, which have become significant criteria for dating. Although chronology has been the principal concern in most cases, place as well as time has increasingly been recognized as of importance in analyzing the diversity of detail, particularly in the orders. As a tribute to Brown's own great contribution and mastery of detail, and in grateful memory of many years of working with him so happily over architectural problems, I offer a note on one of these details for which the evidence has grown substantially, namely, the capital of the Ionic order. It is now recognized that the once so-called canonical form as developed in Ionia in the sixth century B.C. is far from universal geographically either at that time or in the fifth century.

To understand better the Athenian version of the Ionic capital, it is helpful to recall briefly some representative capitals found in the Greek world stretching from east to west in the sixth and fifth centuries B.C., omitting Athens to which we shall return below. Much has been written by many on Ionic capitals, especially on their proportions,[1] but I shall omit most of that and concentrate rather on form and decoration.

The Artemisium at Ephesus[2] of the mid-sixth century gives what is considered canonical: a carved volute (convex at first, later concave) with a necking of ovolo profile with its proper egg-and-dart ornament carved, and a bolster divided into several flutes by rounded bands extending the full width of the bolster. An abacus usually completes capitals used in an order on a building and is regularly ovolo in profile. Similar are the fragmentary capitals from Cyzicus.[3] By the late sixth century, or later in some areas, the volute has become concave, as up in Istria in Dacia.[4] Back in Asia Minor at Phocaea[5] the same characteristics as at Ephesus occur in the second half of the sixth century, as also at Didyma[6] and Halicarnassus.[7] So too across on Samos, both in the great Heraion[8] of about 525 and in the smaller Temple B[9] of the later sixth or early fifth century. On the other offshore island of Chios,[10] the convex volute of a sixth-century capital gives way by the fifth century to concave.

Moving farther into the Aegean, we find that both of the free-standing dedicatory columns supporting sculpture, the Naxian Sphinx at Delphi[11] and the Sphinx on Delos,[12] show some variation, notably in the very strongly projecting echinus and the early use of the concave volute. The broken volute at Delos appears also on Paros (where it originated, according to Kontol-

Ionic capital from the Agora, Athens, restored drawing by Piet de Jong

Ionic capital from the Valerian Wall, Athens, restored drawing by Piet de Jong

eon) on one side only of the Archilochos[13] capital, still with convex volutes, and with concave volutes on another capital.[14] The strongly projecting, well-rounded ovolo echinus moves up from Paros to its colony Thasos with either convex[15] or concave[16] volutes. Other somewhat later Thasian capitals[17] show different treatment of the volute on the two sides (convex on one side, smooth on the other), as do the capitals on the mainland at Neapolis[18] and Thermi,[19] where the volute is convex on one side and concave on the other. When, therefore, we meet a volute convex on one side and concave on the other, along with a strongly projecting echinus, on a sixth-century capital[20] found reused in a chapel at Sykaminon on the east coast of Attica, we recognize it as an import from the neighboring islands.

If we leap over old Greece to the west, we find that in Italy both the Temple of Athena at Paestum,[21] still in the sixth century, and the temple at Locri,[22] in the mid-fifth century, show their Ionian origins. So too does the Ionic temple at Metapontum[23] with its own distinctive variations in the sharpness of the ovolo profile and of its egg-and-dart ornament and in the scaly bolster (compare Locri), typical of the local versions and large size we expect of West Greek details.[24] Gela[25] with its uniquely proportioned echinus and Cyrene[26] with its still different version (a double egg and dart on a very round echinus) confirm that expectation, but Marseilles[27] seems to stay closer to its Phocaean homeland except for its greater size,[28] hallmark of the west.

Returning to old Greece we pause first at the island of Euboea, which faces both the islands on one side and Attica with Athens on the other. It is not surprising to find the island fondness for both convex and concave volutes in an Eretrian capital[29] of the sixth century, but what of the painted uncarved echinus and only two rounded bands in the center of the bolster, two details we have not encountered in our journey around the Greek world so far?

The painted dedicatory Ionic capitals of the second half of the sixth century found on the Acropolis at Athens[30] have long been known and discussed, as scholars

have sought to see in these pieces of marble—shaped both further from the full volute form and closer to it—some answer to the eternal question of origin. The element necessary to make them Ionic capitals, the volute, is mainly painted, though its outline may also be incised. The Ameinias capital,[31] dated 530–520, and the Alkimachos capital[32] of 527–514 are typical and furnish good chronological points. The Athenian Agora has provided numerous further examples of capitals that are only painted (fig. 1),[33] often even without incision (fig. 2), sometimes with a well-projecting echinus (fig. 3),[34] like one on the Acropolis.[35] The echinus profile of one[36] of these is assurance that this style

1. Capital, found in Agora, Athens, buff poros
Agora Museum, Athens
Photograph: American School of Classical Studies at Athens, Athenian Agora Excavations

2. Volute of capital, found in Agora, Athens, marble
Agora Museum, Athens
Photograph: American School of Classical Studies at Athens, Athenian Agora Excavations

3. Capital, found in Agora, Athens, limestone
Agora Museum, Athens
Photograph: American School of Classical Studies at Athens, Athenian Agora Excavations

is not restricted to the sixth century but continues well into the fifth. Only the eye, always emphasized in Athens, is in relief on the stone.

We now have abundant examples to show that the Athenians continued to make their Ionic capitals without carved ornament throughout the first half of the fifth century and into the second half, even after carved forms appear on the Acropolis. The magnificent capital found reused in a late tower and identified by Eugene Vanderpool as belonging to the victory monument at Marathon[37] brings us firmly into the 470s. The smooth echinus, ready for paint, is still well rounded, and the volute is now indicated by a fine raised band. The bolster gives what we shall come to see as typically Athenian, one flat smooth band in the center only.

Examples from the Athenian Agora do not always have the volute border indicated by incision or a raised band on the stone; some cling to paint alone, as in one with a profile that brings it well down into the fifth century (fig. 4).[38] So too does the profile of a fragment[39] found years ago with the volute border and the palmette carved but the echinus still painted; it can now be recognized as part of another capital of the group assigned by T. Leslie Shear, Jr., to the Stoa Poikile,[40] which must date shortly before 450. From that same decade may also come the fragment of a capital that may have crowned the interior columns of the Tholos.[41] Even later in the century a painted echinus persists. Fragments have long been known of the capital from the interior order of the Stoa of Zeus Eleutherios,[42] which dates from 430 on and was perhaps completed after 421. Several other fragments found in the Agora[43] and on the Acropolis attest that the painted Ionic capital was indeed common Athenian usage throughout the century.

The most striking examples yet of Athenian capitals are the two found in a late Roman wall in the Agora along with drums of their columns and their bases (figs. 5, 6).[44] Their brilliantly colored patterns are incredibly well preserved, not only on abacus, volute, and ovolo necking, but also on another element that appears between the volute and the ovolo echinus. This plain, essentially vertical space provides for yet another ornament, the properly vertical meander or, by stretching the canon, a rounded meander, that is, a spiral. This extra profile had come into Athenian use elsewhere and perhaps earlier. The bolster (fig. 6) here keeps the decoration

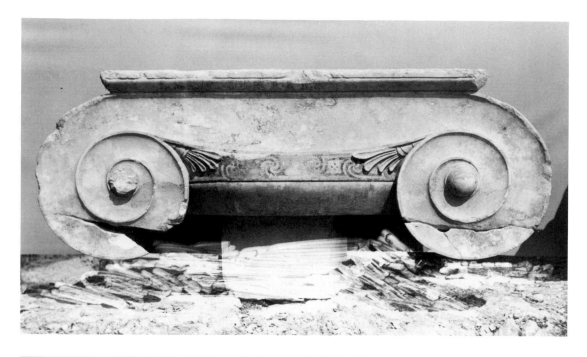

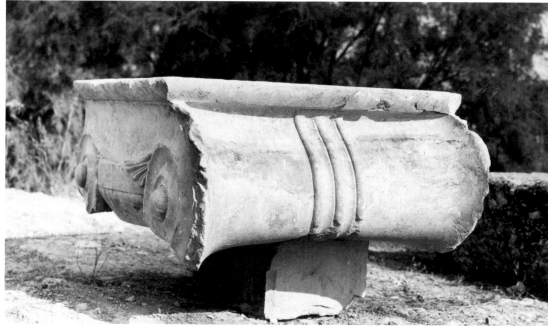

5. Capital from unknown building, found in Agora, Athens, marble
Agora Museum, Athens
Photograph: American School of Classical Studies at Athens, Athenian Agora Excavations

6. Capital from unknown building, found in Agora, Athens, marble
Agora Museum, Athens
Photograph: American School of Classical Studies at Athens, Athenian Agora Excavations

7. Capital, found at Delphi, marble, inscribed carved face
Archaeological Museum, Delphi
Photograph: Pierre Amandry

8. Capital, found at Delphi, marble, uncarved face
Archaeological Museum, Delphi
Photograph: Pierre Amandry

9. Capital, found at Delphi, marble, bolster
Archaeological Museum, Delphi
Photograph: Pierre Amandry

restricted to the center, but the flat band has become the more Asiatic round. Both the slight concavity of the volute and the profile and ornament of the ovolos of abacus and echinus suggest a date a bit after rather than before the mid-fifth century; these capitals may indeed give us the best idea we shall have of what those four Ionic columns in the Parthenon looked like.

Before we follow a second version of the Athenian painted Ionic capital that devel-oped in the fifth century, we must turn back to the last quarter of the sixth century to note an effect on Athenian archi-tecture probably from the political friend-ship between the leaders of Athens and of the islands of Naxos and Samos. Ionic sculptural style from these islands has long been recognized in Athens at this period. Two Ionic capitals—one now on the Acropolis,[45] the other damaged in reuse and found in the Agora[46]—belong

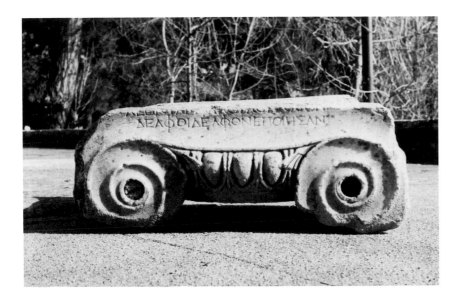

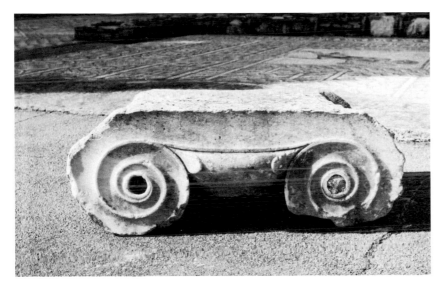

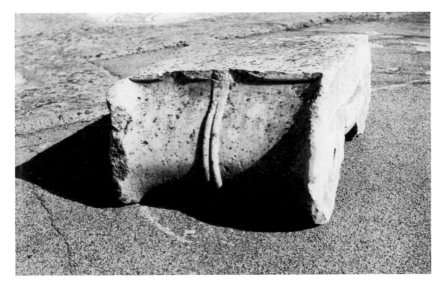

together and must come from a building of the late sixth century. The carved form typical of Asia Minor and the islands appears foreign, but a look at the other side gives reassurance that this capital is at home in Athens: the eggs are barely blocked out to be completed in paint, and the bolster has only the center accented. There are two late sixth-century buildings in the Agora known from their foundations, to either of which these capitals might belong. To be sure, there are a few Asiatic or island capitals[47] that have one side completely smooth, apparently because they were left unfinished on one side for various reasons, but the Athenian group seem to have been intentionally carved on one side and painted on the other, with both sides meant to be seen. These Athenian examples include a capital now lying in the Library of Hadrian[48] and others found at Stavro and Jeraka in Attica[49] and, most surprisingly, in Delphi (figs. 7–9),[50] where an inscription added much later gives an interesting clue (fig. 7). Pierre Amandry has generously shared with me his reading of the top line, now almost gone but certain when the capital was taken from a ruined early Christian basilica:

Λέοντα Μ[άρκ]ου ᾿Αθαιναῖον
Δελφοὶ Δελφὸν ἐποίησαν

*Leonteus son of Markos, Athenian
The Delphians made a Delphian*

When the Athenian Leonteus was made a citizen of Delphi, evidently a capital of old time from his native city was used to commemorate the event. The Athenian narrow bolster band is here as it is on a capital in Corinth (figs. 10–12),[51] which may also be an Athenian import: it is carved on one side and painted entirely on the other; note too the vertical element over the ovolo, which again appears on the capital in the Library of Hadrian and on the pair painted on both sides from the unknown building in the Agora discussed above.

In an Athenian dedication at Delphi we meet probably for the first time as now known that upper, more or less vertical element over the molded echinus, between it and the volute, which has been noted above in the pair of painted capitals

from the Athenian Agora. Amandry recognized that the high necking of the capital of the Stoa of the Athenians at Delphi[52] (which most scholars date to about 478, others to 460–450) is composed of a high upper part over not an ovolo but a cyma reversa, battered on the face but clear under the bolster, which has the favored Athenian central band (starting out flat at the top but soon broken into two rounds). The abacus also is a cyma reversa. Amandry saw too that there are capitals in Athens and Attica with this treatment of necking and bolster. On the Areopagus was found a corner capital, and the Agora excavations yielded a regular capital of the same series (fig. 13);[53] these all-painted capitals have a necking with a high vertical sloping backward toward the top over a cyma reversa with an astragal below, a single flat band in the center of the bolster, and a cyma reversa abacus. A capital in the Acropolis Museum, Athens,[54] has a necking of vertical over cyma reversa, both smooth for painting, but the palmettes in the corners and a narrow lotus in the center of the bolster are carved.

The most notable example of this type of Athenian capital crowned the columns of the peristyle of the Temple of Athena at Sounion.[55] Two were found on the site during excavation and brought to the National Archaeological Museum, Athens; one was lost for a time but rediscovered by Amandry.[56] More recently one complete capital (fig. 14), many fragments of capitals (figs. 15–19),[57] and a few bits of the entablature found in the Athenian Agora prove that much of the order of the temple was brought to Athens for reuse in antiquity, probably in Augustan times. Various patterns are painted on the upper part of the necking, which is now divided into two zones. The meander proper for the vertical is there on all the fragments (figs. 14–18), while the backward-sloping section above carries scales (figs. 14–17) or lattice (fig. 18).[58] Even the central bolster bands are painted only; three bands are recorded for the capital in the National Archaeological Museum, Athens, but are no longer visible, while an Agora fragment (fig. 19) clearly shows two bands, including some of the blue pigment.[59] The pro-

file of the abacus on that fragment shows the ovolo beginning to curve at the bottom into a cyma reversa, but it carries the ovolo's proper egg and dart. Of special interest is the cyma reversa profile (figs. 14–18) of the lower part of the echinus with its clearly defined projecting base fillet, that special characteristic of the Periclean buildings on the Acropolis and thereafter in fifth-century Athens, used regularly from the Parthenon on. The ornament painted on this profile is of unusual interest, for it varies; only some capitals have the proper ornament for a cyma reversa, namely, the Lesbian leaf (figs. 17, 18), the outline of each unit of

10. Capital, found at Corinth, white poros, carved face
Corinth Museum
Author photograph

11. Capital, found at Corinth, white poros, uncarved face
Corinth Museum
Author photograph

12. Capital, found at Corinth, white poros, bolster
Corinth Museum
Author photograph

13. Capital, found in Agora, Athens, marble
Agora Museum, Athens
Photograph: American School of Classical Studies at Athens, Athenian Agora Excavations

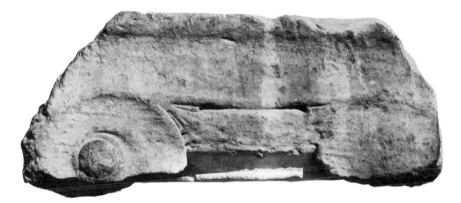

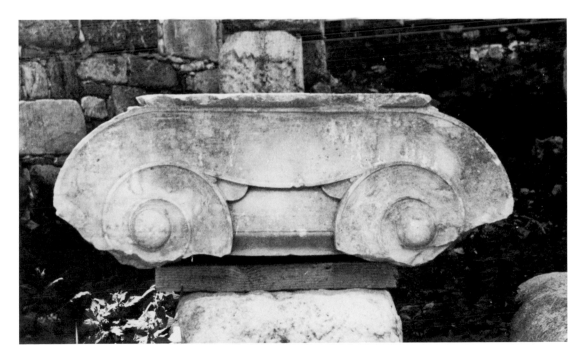

14. Capital from Temple of Athena, Sounion, found in Agora, Athens, marble
Agora Museum, Athens
Photograph: American School of Classical Studies at Athens, Athenian Agora Excavations

which follows the profile of the molding on which it is set. This is the fundamental principle of Greek moldings and their ornament. Other capitals show an egg and dart (figs. 15, 16), proper for an ovolo profile, painted on the cyma reversa.

Why does the variation occur, and why is the basic principle altered? Recall that in the earliest Ionic capitals in Ionia, and in practically every Ionic capital, except in Attica, throughout the Greek world throughout its history, the necking is always a form of ovolo. The egg and dart, therefore, whether carved or painted, was what was always seen by all those familiar with any Ionic capital. There is evidently a tug here between what ornament should be seen and what the profile demanded. The Athenians had experimented with a new profile for the necking, but some of them could not quite give up the expected pattern. One would give much to know who among those who worked on the building was responsible for the painting. Did the designer of the capital dictate to the painter what he was to paint, or was the painter left to paint what the designer expected him to know was the appropriate ornament? Or did both agree on the variation? There is variation just above, on the slanting portion of the neckings, with either scales or lattice,

but neither of these defies the law of fitting the ornament to the profile.

A capital taken to the museum in Berlin from Athens in 1844 looks suspiciously like the Sounion capitals in its form of corner palmettes and its necking in the same three parts, its trace of Lesbian leaf on the cyma reversa, and even the very distinctive tooling clear on the volute.[60] The vertical portion of the necking is lower in proportion to the cyma reversa than in most of the Sounion fragments, but there is some variation in height among them. It seems reasonably sure that this capital should be added to the Sounion capitals rather than be considered a further example of this Athenian type of capital.

This form was used also for dedicatory capitals; two on the Acropolis are probably from the fifth century. One[61] has a single element above the cyma reversa of the necking, painted with the scales over the Lesbian leaf familiar from Sounion; the cyma reversa of the abacus has its Lesbian leaf, and the vertical under it on the bolster has its meander, over the single flat band in the center. The other capital[62] has a more complicated necking and abacus over the bolster, but the elements are the cyma reversa and verticals developed in the capitals discussed above.

In Attica, capitals with a Periclean cyma reversa necking have been found reused in the chapel of Haghios Nikolaos near Menidi (fig. 20);[63] they come from a small building that must date from the second half of the fifth century, since the Periclean base fillet is clearly cut. The latest known example of this type of capital is probably that from the Stoa at Oropos.[64] Did the demes out in the country cling longer to a form favored in Athens before Pericles' architects on the Acropolis turned to a more Asiatic carved form in the Propylaea, Nike Temple, and Erechtheum? If Mnesicles or whoever designed the Ionic interior columns of the Propylaea[65] thought it time for the Athenians to embrace the carving essential to the Ionic style elsewhere in the Athenian empire and in the western Greek world, he did not abandon all Athenian details. He kept the central emphasis on the bolster, as did the designer of the capitals of the Temple of Athena Nike.[66] A bit later the

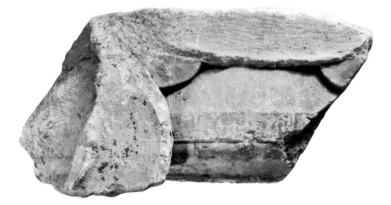

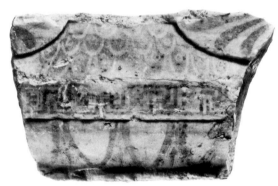

15. Fragment of capital from Temple of Athena, Sounion, found in Agora, Athens, marble
Agora Museum, Athens
Photograph: American School of Classical Studies at Athens, Athenian Agora Excavations

16. Fragment of capital from Temple of Athena, Sounion, found in Agora, Athens, marble
Agora Museum, Athens
Photograph: American School of Classical Studies at Athens, Athenian Agora Excavations

17. Fragment of capital from Temple of Athena, Sounion, found in Agora, Athens, marble
Agora Museum, Athens
Photograph: American School of Classical Studies at Athens, Athenian Agora Excavations

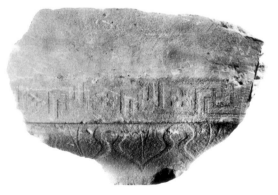

Erechtheum designers remembered that many Athenian capitals of the previous generation had included an element in the necking over the ovolo or cyma reversa, and they hung on to it.[67] The vertical becomes round and no longer an organic part harmonious with the ovolo or cyma reversa as in the earlier painted forms, but those forms do suggest an explanation for an element in the capitals of the Erechtheum that has puzzled many observers.

18. Fragment of capital from Temple of Athena, Sounion, found in Agora, Athens, marble
Agora Museum, Athens
Photograph: American School of Classical Studies at Athens, Athenian Agora Excavations

19. Fragment of bolster of capital from Temple of Athena, Sounion, found in Agora, Athens, marble
Agora Museum, Athens
Photograph: American School of Classical Studies at Athens, Athenian Agora Excavations

20. Capital, marble, reused in chapel of Haghios Nikolaos near Menidi
Photograph: Stephen G. Miller

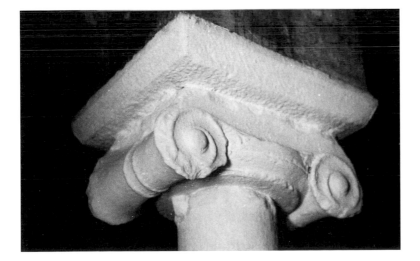

Not all Athens took up the new carved style, however; down in the Agora the Stoa of Zeus Eleutherios, in its interior Ionic order, still had the painted ornament on its echinus that Athens had preferred and made its own for over a century. Something is known of another capital, which must be considered Athenian in style even though it was set up neither in Attica nor as an Athenian dedication elsewhere. Only a few fragments of the capitals survive, but drawings of the Ionic capitals found in 1812 at the Temple of Apollo at Bassae preserve Haller von Hallerstein's record of what he had seen and remembered.[68] The profile he records for the echinus is an uncarved cyma reversa with an outward-sloping fascia above (this is unique); we recognize the cyma reversa as unusual for Arcadia, unusual for anywhere except Athens, where it has been found to be one of the regular fifth-century forms. It is not what Haller would have expected, and he is known as a careful, faithful draftsman, so his drawing may be accepted as an accurate record of what he saw. The association with Athens is not far to seek. Pausanias, whom scholars abandon at our peril,[69] wrote that the architect of the temple was Ictinus, the architect of the Parthenon at Athens. Regardless of what the most recent and current studies may discover about the date(s) of actual construction of the interior of the temple in the latter half of the fifth century, there is strong reason to believe that the unique Ionic capitals designed for Bassae were indeed the creation of Ictinus, using one of the Athenian styles of painted Ionic capital contemporary with his work in Athens.

The Ionic capital is one of the very few parts of the rigidly defined orders where originality was possible; Athenians seized that opportunity.

NOTES

1. See Lucy Shoe Meritt, "Some Ionic Architectural Fragments from the Athenian Agora," in *Studies in Athenian Architecture, Sculpture, and Topography presented to Homer A. Thompson* (*Hesperia*, suppl. 20; Princeton, 1982), 83, n. 2.

2. David G. Hogarth, *Excavations at Ephesus: The Archaic Artemisia* (London, 1908), 268, 276, fig. 30, pl. 6; William Bell Dinsmoor, *The Architecture of Ancient Greece*, 3d rev. ed. (New York and London, 1950), pl. 30.

3. Frederick W. Hasluck, "Sculptures from Cyzicus," *BSA* 8 (1901–1902), 195–196, pl. 6.5, 6.

4. Dinu Theodorescu, "Un chapiteau ionique de l'époque archaïque tardive et quelques problèmes concernant le style, à Histria," *Dacia* 12 (1968), 261–266, figs. 1–4; Roland Martin, "Chapiteaux ioniques de Thasos," *BCH* 96 (1972), 321, 323.

5. Ekrem Akurgal, "Les fouilles de Phocée," *Anatolia* 1 (1956), 7, pl. 3b; 5 (1960), 2, n. 10, 15.

6. Gottfried Grüben, "Das archaische Didymaion," *JdI* 78 (1963), 115–126, figs. 15–19.

7. Roland Martin, "Chapiteau ionique d'Halicarnasse," *REA* 61 (1959), 65–76, pl. 2; Martin 1972, 320, 321, 323.

8. Oscar Reuther, *Der Heratempel von Samos: Der Bau seit der Zeit des Polykrates* (Berlin, 1957), 51–54, fig. 7, pls. 21–23, Z2, Z39–Z47.

9. Oskar Giegenaus, "Die Tempelgruppe im Norden des Altarplatzes," *AM* 72 (1957), 106–109, Beil. 10.2, 14.1, pl. 15 left; Lucy T. Shoe, *Profiles of Greek Mouldings* (Cambridge, Mass., 1936), pl. B.1.

10. John Boardman, "Chian and Early Ionic Architecture," *AntJ* 39 (1959), 180–183, no. 29, fig. 4, pl. 27.a, 27.b.

11. Pierre Amandry, *FdD* 2, *La colonne des Naxiens et le portique des Athéniens* (Paris, 1953), 12–13, 18–26, pls. 11–15.

12. Amandry 1953, 19, pls. 15.3, 16; Martin 1972, 312, fig. 6.

13. Anastasios K. Orlandos, Τὸ Ἔργον τῆς Ἀρχαιολογικῆς Ἑταιρείας (1960), 184–185, figs. 206, 207; (1961), 196, figs. 202, 203; Nikolaos M. Kontoleon, *Aspects de la Grèce préclassique* (Paris, 1970), 68, pl. 19.2; Kontoleon, *AAA* 1 (1968), 178, fig. 5.

14. Orlandos 1962, 192, figs. 225, 226; Kontoleon 1968, 178, fig. 2.

15. Martin 1972, 303–307, figs. 1, 2, 3.

16. Martin 1972, 308–310, figs. 4, 5.

17. Martin 1972, 315–318, figs. 8–13.

18. George Bakalakis, *ArchEph* 1936 (1937), 8–14, figs. 10–21.

19. Thessalonike Museum. Bakalakis 1937, 17, n. 1, figs. 21, 22.

20. National Archaeological Museum, Athens, 4787. To be published in *Hesperia*.

21. Friedrich Krauss, *Die Tempel von Paestum* 1, *Der Athenatempel* (Berlin, 1959), 46–47, figs. 27, 28, pls. 34–36; Roland Martin, *Greek Architecture* (New York, 1988), fig. 114.

22. Dinsmoor 1950, 137, fig. 49; Martin 1988, fig. 115.

23. Dieter Mertens, "Der Ionische Tempel von Metapont: Ein Zwischenbericht," *RM* 86 (1979), 107, fig. 3, pls. 16, 17, 22.

24. Lucy T. Shoe, *Profiles of Western Greek Mouldings* (Rome, 1952), 22, 29.

25. Dinu Adamesteanu, "Archäologische Grabungen und Funde im Bereich der Soprintendenzen von Sizilien von 1949–1954," *AA* (1954), 657, fig. 102; A. W. Van Buren, "News Letter from Rome," *AJA* 59 (1955), 311, pl. 89, fig. 23.

26. Richard G. Goodchild, John G. Pedley, and Donald White, "Recent Discoveries of Archaic Sculpture at Cyrene," *LA* 3–4 (1966–1967), 192–195, figs. 3, 4, pl. 71.

27. Fernand Benoit, "Le chapiteau ionique de Marseille," *RA* 43 (1954), 17–43, figs. 1–12.

28. Shoe 1952, 6.

29. Eretria Museum, 628. Basileios Kallipolites and Basileios Petrakos, "Euboia," *ArchDelt* (1963), Χρονικά Β′1, 127, figs. 6, 7, pl. 162.b.

30. R. Borrmann, "Stelen für Weihgeschenke auf der Akropolis zu Athen," *JdI* 3 (1888), 275–276, figs. 16, 25; Anton E. Raubitschek, "Zur Technik und Form der altattischen Statuenbasen," *Bulletin de L'institut archéologique bulgare* 12 (1938), 162, figs. 20–24.

31. Anton E. Raubitschek, "Early Attic Votive Monuments," *BSA* 40 (1943), 18, figs. 6, 7; Raubitschek, *Dedications from the Athenian Akropolis* (Cambridge, Mass., 1949), 9–10, no. 5.

32. Raubitschek 1938, 168, fig. 26; Raubitschek 1943, 17–18, figs. 1–4; Raubitschek 1949, 10–12, no. 6.

33. Athenian Agora inv. A2844, A991, A3054, A3460. The Ionic capitals from the Athenian Agora will be published more fully in a forthcoming volume of *Hesperia*. I am grateful to Homer A. Thompson for assigning their study to me and for allowing them to appear here now. All are housed in the Agora Museum, Athens, exhibition rooms or storerooms.

34. Athenian Agora inv. A3054.

35. Raubitschek 1938, 166, fig. 24.

36. Athenian Agora inv. A546.

37. Eugene Vanderpool, "A Monument to the Battle of Marathon," *Hesperia* 35 (1966), 93–106, fig. 2, pls. 32, 33.

38. Athenian Agora inv. A768.

39. Athenian Agora inv. A661.

40. T. Leslie Shear, Jr., "The Athenian Agora: Excavations of 1980–1982," *Hesperia* 53 (1984), 9–12, fig. 6, pl. 3.d.

41. Homer A. Thompson, *The Tholos of Athens and Its Predecessors* (*Hesperia*, suppl. 4; Princeton, 1940), 58, n. 39; Thompson, "Building for a More Democratic Society," Πρακτικὰ τοῦ XII Διεθνοῦς Συνεδρίου Κλασικῆς Ἀρχαιολογίας (Athens, 1988), 4:201.

42. Homer A. Thompson, "Buildings on the West Side of the Agora," *Hesperia* 6 (1937), 26–27, fig. 15; Shoe 1936, pl. 21.31.

43. Athenian Agora inv. A279, A1850, A714, A546.

44. Homer A. Thompson, "Activities in the Athenian Agora: 1959," *Hesperia* 29 (1960), 351, 354–356, pl. 77; Thompson and R. E. Wycherley, *Agora* 14, *The Agora of Athens* (Princeton, 1972), 166, pl. 84.b, 84.c.

45. Meritt 1982, 82–88, fig. 2, pl. 12.b, 12.d, 12.f.

46. Meritt 1982, 82–88, fig. 1, pl. 12.a, 12.c, 12.e.

47. Meritt 1982, 86, n. 4: Chios, Samos, Halicarnassus.

48. Walther Wrede, "Ein ionisches Kapitell in Athen," *AM* 55 (1930), 191–197, figs. 1–4, Beil. 62–64.

49. Hans Möbius, "Attische Architekturstudien," *AM* 52 (1927), 167–171, fig. 3, pl. 27.

50. Georges Daux, "Chronique des fouilles en Grèce en 1959," *BCH* 84 (1960), 756. Set up in front of the Archaeological Museum, Delphi. I owe thanks to Amandry for permission to publish his photographs in figures 7–9 as well as for his reading of the inscription. It is a pleasure to acknowledge here his help and his contributions to the study of Athenian Ionic capitals over many years.

51. Published with the kind permission of the director of the Corinth Excavations, Charles K. Williams. Housed in the Corinth Museum workrooms.

52. Amandry 1953, 99–100, pls. 29, 31, 32, 1–3.

53. Corner capital: Athenian Agora inv. A1893. Regular capital: Athenian Agora inv. A1130. Amandry 1953, 100 n. 3.3, pl. 40.5, 40.6.

54. Möbius 1927, 167, Beil. 18, 7, 8; Raubitschek 1938, 172, fig. 29.

55. Amandry 1953, 99, n. 3.1, pl. 40.1; National Archaeological Museum, Athens, 4479.

56. Amandry 1953, 99, n. 3.1, pl. 40.2–4; National Archaeological Museum, Athens, 4478.

57. Amandry 1953, 99–100, n. 3.2, a and b; Homer A. Thompson, *The Athenian Agora: A Guide to the Excavation and Museum*, 3d rev. ed. (Athens, 1976), 160, 287–288, fig. 150. Athenian Agora inv. A1595 (fig. 14), A644 (fig. 15), A1132 (fig. 16), A1928, A1929 (fig. 17), A1930 (fig. 18), A3452, A1596, A1976 (fig. 19), A1615, A3453.

58. Scales: Athenian Agora inv. A644, A1132, A1595, A1929. National Archaeological Museum, Athens, 4478. Lattice: Athenian Agora inv. A1930.

59. Athenian Agora inv. A1976.

60. Otto Puchstein, *Das ionische Kapitell* (Berlin, 1887), 7, fig. 2; Raubitschek 1938, 169, fig. 27.

61. Maria S. Brouskari, *The Acropolis Museum: A Descriptive Catalogue* (Athens, 1974), 45, fig. 78.

62. Brouskari 1974, 38, fig. 51.

63. Stephen G. Miller, "An Ancient Site near Menidi," *AAA* 3 (1971), 437, figs. 4–6.

64. J. J. Coulton, "The Stoa at the Amphiaraion, Oropos," *BSA* 63 (1968), 162–163, fig. 11, pl. 49.a, 49.b.

65. Dinsmoor 1950, pl. 49; Donald S. Robertson, *A Handbook of Greek and Roman Architecture*, 2d ed. (Cambridge, 1943), 121, fig. 51; Martin 1988, fig. 198.

66. Martin 1988, fig. 67.

67. Dinsmoor 1950, pl. 49; Gorham P. Stevens and James M. Paton, *The Erechtheum* (Cambridge, Mass., 1927), 20–23, 82–86, figs. 8–10, 52, 53; pl. 36.2, 36.4.

68. William Bell Dinsmoor, "The Temple of Apollo at Bassae," *MMS* 4, 2 (March 1933), 208, fig. 5; Dinsmoor 1950, 156–157; Georges Roux, *L'architecture de l'Argolide 4e et 3e siècles avant J.-C.* (Paris, 1961), 37–38, pl. 14, and 40–41, pl. 16.1.

69. R. E. Wycherley, "Pausanias and Praxiteles," in *Studies in Athenian Architecture, Sculpture, and Topography Presented to Homer A. Thompson* (*Hesperia*, suppl. 20; Princeton, 1982), 182.

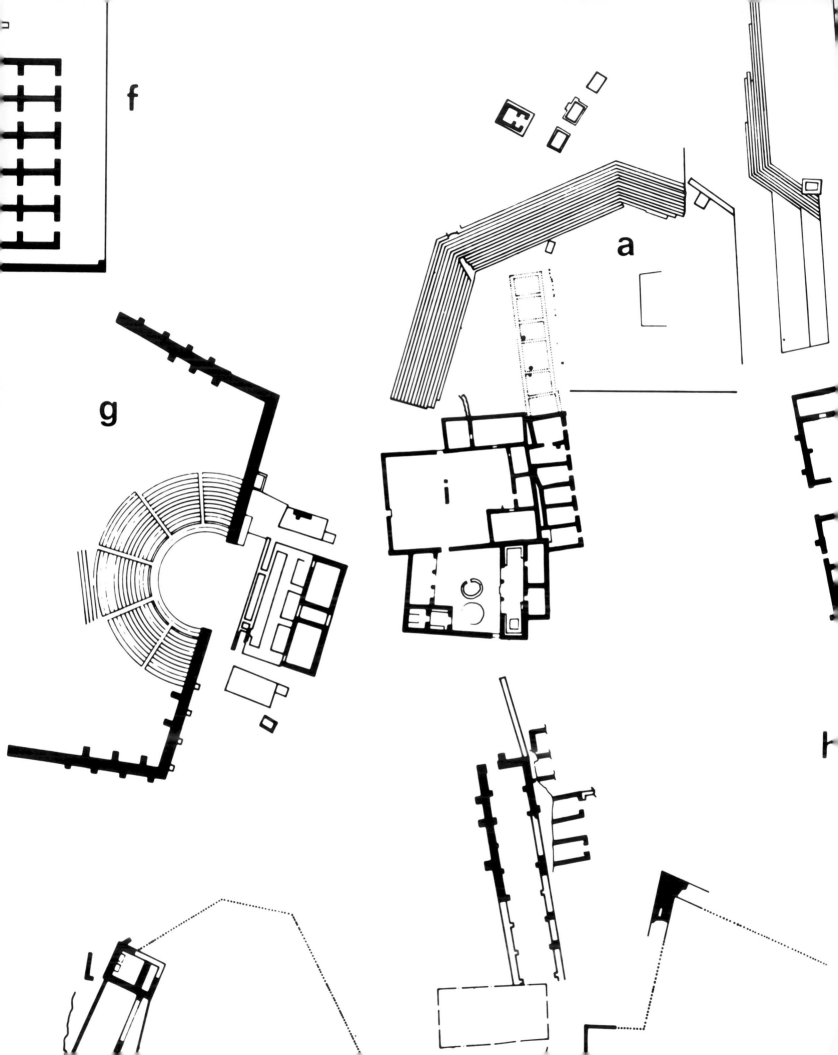

f

a

g

i

l

MALCOLM BELL III

University of Virginia

Observations on Western Greek Stoas

Like their counterparts in the Aegean world, the cities of the Greek west were the setting for public buildings that served a wide range of functions. Among these was the multivalent, free-standing stoa, which appears in a variety of circumstances in the west as on the mainland. Present-day knowledge of western stoas has been greatly enriched by the results of excavation in southern Italy and Sicily.

Although stoas were built in the west as early as the seventh century B.C., only a few examples dating from the archaic and classical periods are known (fig. 1).[1] It is probably too early to conclude that the stoa was less favored in the western Mediterranean than in the Aegean, for the evidence is not very extensive. Stoas are usually found in agoras and sanctuaries, yet in the west few early agoras have been explored, and, although the temples of western Greece may be conspicuous, the sanctuaries that surrounded them have not always attracted the interest of excavators.[2]

In the early Hellenistic era the picture changes, largely as the result of research over the past decade. It is now known that stoas were often used both to define the margins of public spaces and as secondary structures in sanctuaries. At Kamarina in eastern Sicily, large, two-aisled stoas framed the north and west sides of the agora (fig. 2), and in the west at Iaitai there seem to have been at least two stoas on the agora,

one of which had two aisles and possibly paired rooms behind (fig. 3).[3] A single example with one aisle appears at Megara Hyblaea, on the north side of the small Hellenistic agora.[4] A very long, two-aisled stoa with rooms behind occupied the west side of the agora at Thermae Himerenses.[5] A similar picture is seen at Morgantina, where four large stoas frame the upper agora and another is located nearby (fig. 4).[6] A large and complex stoa has been partially excavated at Metapontum, apparently delimiting one side of the very large agora.[7] As research continues in the public centers of other cities, it seems likely that new stoas will be found.[8]

The temenos is the other major context for the later Greek stoas in the west, as in the Aegean. Two examples have long been known in the sanctuary of Hera at the mouth of the Sele River north of Poseidonia, and to the south at Velia a stoa faces the acropolis temple on its west side.[9] At the latter site, another, larger, stoalike building lies on a terrace below the temple.[10] Other examples are now known at Metapontum in the agora temenos, at Syracuse framing the great square to the west of the altar of Hieron II, at Heloros north of the temple of Demeter, and south of the Olympieion at Acragas.[11] Also at Syracuse are two large stoas on the rock-cut terrace immediately above the theater (fig. 11), and it has recently been suggested

that a pi-shaped stoa stood on a second terrace at an even higher level above the theater.[12] Stoas could also be put to commercial uses at Syracuse, as is indicated by the Shoemakers' Stoa, recorded by Polybius as existing in the late third century B.C., near the seashore in Achradina.[13]

The four stoas of the agora at Morgantina illustrate some of the characteristic features of the architectural type of the stoa, as it was used in the western Mediterranean in the Hellenistic period. The complex of buildings to which they belong can be dated to the middle years of the third century, when an architect was evidently sent to Morgantina from the metropolis of Syracuse, with the charge of redesigning the agora of the central Sicilian town.[14] The dispatch of the architect by the royal administration in Syracuse was very likely a consequence of the treaty with Rome signed by King Hieron II in 263/262, which became the basis of an alliance that survived until Hieron's death in 215.[15]

The treaty of 263/262 defined the political realities of the island for a long period. One of its most significant consequences was the reshaping of the boundaries of the Syracusan kingdom.[16] Here archaeology supplements the meager written record. Excavations at Morgantina have produced extensive evidence indicating that the city and its territory lay along—indeed, defined—a substantial part of the internal frontier of the Syracusan kingdom. Supporting this are such circumstances as the remarkable growth of the city in the mid- and later third century and the strongly Syracusan character of its material culture.[17] An additional indication of Syracusan political authority over the city is the widespread local circulation of the Hieronian bronze and silver coinage, at a time when, had the city been autonomous, it would certainly have had a local mint.[18]

The Syracusan architect arrived, then, at a strategically located town on the frontier; his charge was to supervise the transformation of the agora of the city into a space befitting a major outpost of Syracusan power. The architect found himself in a new and perhaps unfamiliar environment, in which water was scarce and there was none of the fine white lime-

1. OPPOSITE: Agora, Megara Hyblaea, archaic period, plan: a, North Stoa; b, East Stoa
From Georges Vallet and Paul Auberson, *Megara Hyblaea* 3, *Guide des fouilles* (École française de Rome, suppl. 1; Rome, 1983), fig. 3
Drawing by Geoffrey Warner

2. OPPOSITE BELOW: Agora, Kamarina, fourth–third century B.C.: a, North Stoa; b, West Stoa
From Paola Pelagatti, "Ricerche nel quartiere orientale di Naxos e nell'Agora di Camarina," *Kokalos* 30–31 (1984–1985), pl. 139
Drawing by Geoffrey Warner

3. Agora, Iaitai, Hellenistic period, plan: a, North Stoa
From Hans Peter Isler, "Grabungen auf dem Monte Iato," *AntK* 32 (1989), 38, fig. 2
Drawing by Geoffrey Warner

stone that had determined the architectural character of the metropolis. To the east and north lay the wheat fields that gave the city its prosperity, and to the south and perhaps also to the west were forests.[19] Such conditions helped to shape the building program for the agora: the scarcity of water made a fountain house a desirable addition, and the city's cereal production created the need for a large public granary.[20] Abundant supplies of timber allowed wood to replace stone in the construction of buildings.

Among the more familiar features of the town must have been the orthogonal plan that, two centuries earlier, had been cast netlike over the ridge of land then chosen as the site of the new city.[21] The initial planner had reserved at the center of the city a vast area corresponding to six residential blocks, approximately 125 m in its east-west dimension and 250 m in its north-south dimension. It was the Syracusan architect's task to provide a master plan for this space, as well as designs for the buildings that would occupy it. In the early third century the agora was, as far as

is known, largely unbuilt—an open square where many public activities took place without benefit of architecture. Only a few buildings are known today, of which the most important include a stoa on the north side (North Stoa I, beneath the later North Stoa II), in the center a sanctuary of the gods of the underworld, and to the south a public granary (fig. 5, dark shading).[22] None is of ambitious scale or self-consciously "urban" design.

The Syracusan architect proceeded to fill in this orthogonal tabula rasa. At the center he placed a great artificial terrace, defined and sustained on the south by a monumental staircase that effectively divided the public space into upper and lower levels (fig. 4[a]). The stairs were to serve as an *ekklesiasterion*. The periphery of the upper area was defined by the long columnar façades of stoas, while the lower area was delimited on the east by a new and larger granary and on the west by a theater (fig. 5, light shading).

The original excavators believed that this assemblage of public buildings resulted from the adoption of a monumental building program.[23] There is much evidence in favor of this view, in the careful positioning of buildings in relation to one another and in the long sight lines that connect them. Some of these planning features can be noted in figures 4 and 5:

1. In the upper agora the north ends of the two flanking stoas on the east and west sides (b, e) are precisely aligned with the ends of the central North Stoa II (d), and the terrace in front of the Fountain House (c) is also aligned with the east end of the North Stoa.

2. The analemmata of the theater (g) are aligned with the westernmost flight of the central steps (a).

3. The East Granary (h) is parallel to the earlier West Granary.

4. The north end of the East Granary (h) is aligned with a terrace that extends the axis of the East Stoa (b) to the south, forming in effect a hinge that connects the two major axes of the upper and lower agora.

5. The 130° angle formed by the central steps (a) at the juncture of their original central and western sections is repeated in the

half a stade, in length, the foot measuring 0.333 m.[26] To make the long building accessible at the south where the ground fell away sharply, a stepped terrace was built along the west façade.[27] The plan is simple and functional. Two sets of rooms, 18 feet wide, frame the colonnade, which has a length of 264 feet, equivalent to forty-four interaxials of 6 feet—the axial spacing of the wooden Doric colonnade. The spacing of the interior piers is 12 feet, and the building is 24 feet deep. The use of wood for the exterior order attests both to the absence of a compact local limestone and to the presence, as if in recompense, of nearby forests.

At the northeast corner of the hall is a masonry podium, accessible by means of a flight of four steps (fig. 9). It may have been used by a magistrate and suggests that the stoa housed a law court.[28] The paired rooms at either end of the stoa were probably civic offices, perhaps associated with the judicial function of the building; those at the south were incorporated in a second phase into the East Stoa Annex (called earlier a *prytaneion*), which also must have served some major public function.

For the East Stoa there is some evidence to suggest that the building was a royal donation. A base at the center of the south end of the hall may have supported the limestone sculpture of a woman that was found in 1956 in the lower agora, immediately below the stoa (fig. 10).[29] The sculpture lay on a surface that was sealed by a rising ground level not long after the sack of Morgantina in 211 B.C., so the work must be earlier than that date. The sculpture is slightly under life-size and seems to have been intentionally damaged. It exemplifies Syracusan drapery of the later third century, in a style that can also be seen in reliefs and in figurative terracottas.[30] The subject of the sculpture may be the donor of the stoa. Hieron II was a patron of architecture, and one thinks of his wife, the *basilissa* Philistis. Although a private benefaction is also possible, a royal donation is a tempting hypothesis, given the many known cases of gifts of public buildings by Hellenistic kings and their wives.[31]

6. Central steps and East Hill, with East Stoa, Morgantina, third century B.C.
Photograph: Fototeca Unione

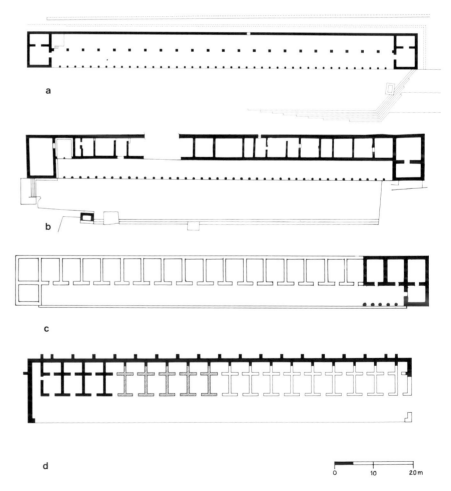

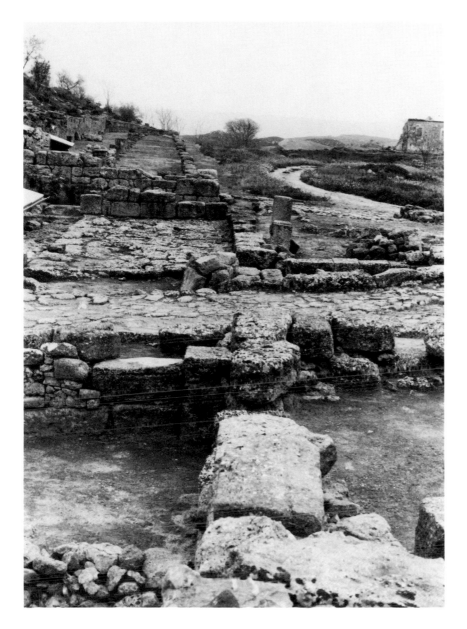

7. Stoas, Morgantina, third century B.C., plans: a, East Stoa; b, North Stoa II; c, Northwest Stoa, hypothetical original plan; d, West Stoa (dark, first building phase; hatched, second building phase; outline, unbuilt)

8. East Stoa and terrace of Fountain House, Morgantina, third century B.C., view from north: foreground, east wall of North Stoa II, showing alignment with East Stoa

The East Stoa also exemplifies the more complex sort of urban planning typical of the Hellenistic era. Only at first glance an "independent" structure, the stoa in actuality redefines the margin between the public and private sectors of the city (fig. 4). This can be seen in the several functions of the corridor behind the building, which at once protected the stoa from groundwater and carried off rainwater, even as it also terraced the hillside, its retaining wall supporting an elevated platform for the first street east of the agora (E1), which now was reoriented to follow the axis of the building. The East Stoa

thus mediates between the public and private sectors of the city.

Only the north end of the original western stoa, called the Northwest Stoa, was completed (fig. 7c). The stoa was probably planned to extend as far south as the intersection of *plateia* B, an actual distance of 104.5 m, or c. 320 feet of 0.326 m (104.23 m), and it is so drawn in figure 7.[32] As a result of a change in plan—or better, a revision in the master plan—construction on the Northwest Stoa was stopped, and a much larger structure (the West Stoa) was begun somewhat farther south on the same axis (fig. 7d). This decision was taken in the second half of the third century, well before 211, probably as a result of a reconsideration of the difficulty of terracing the hill behind the stoa. The West Stoa was also to measure 300 feet; it was to be a massive two-storied portico with seventeen shops behind a single colonnade, each set of shops two rooms deep, with the rear wall now also functioning as the retaining wall for the street behind.[33] Presumably a second row of shops opened on the upper colonnade, as in the Stoa of Attalos in Athens. In design the West Stoa is closer to two-storied stoas of so-called Pergamene type and to the east building on the south market at Miletus than to the three earlier and more lightly built stoas of the original plan for the upper agora at Morgantina.[34] The West Stoa is the only known two-storied stoa in Sicily.[35] It too was never finished, although not because of any change in architectural plans. Instead it was history that intervened when Morgantina was taken by a Roman army in 211 B.C. Construction on the West Stoa then ceased, and the master plan for the agora was abandoned.

The stoas surrounding the upper agora at Morgantina thus can be viewed as independent buildings, in the tradition of a civil architecture consisting of a mosaic of informally related structures on the margins of public spaces, and at the same time as parts of a larger whole that anticipates the comprehensive planning typical of the second century B.C. The traditional informal methods can be seen clearly in the Athenian agora, where visual order

was gradually achieved over time by adding, eliminating, or redesigning buildings along the margins of the square.[36] Stoas played the major role in this process at Athens and elsewhere. The Morgantina architect had an analogous local tradition to draw on. Stoas had been used in similar fashion in the archaic agora at Megara Hyblaea (fig. 1), and there were stoas of the classical period on the agora at Syracuse.[37] The stoas at Morgantina also have a family resemblance to other western buildings, in design as well as in siting. Like the Northwest Stoa and North Stoa II at Morgantina (fig. 4 [e, d]), the two newly discovered buildings at Kamarina frame adjoining sides of the agora on perpendicular axes, with a street passing between them (fig. 2), and one of them may have had rooms at its ends.[38] In south Italy the two buildings on the acropolis at Velia end in rooms that close their colonnades, like the examples from Morgantina, and a similar building of the fourth or third century is known at the Sele sanctuary.[39] This type of stoa is uncommon on the mainland.[40] Its popularity in Sicily and southern Italy shows that the inclusion of large rooms for public offices was considered a desirable feature in the design of a stoa in western Greece.

At Syracuse the two stoas on the terrace immediately above the theater have features in common with the buildings at Morgantina (fig. 11).[41] These two independent stoas are inserted into deep cuttings in the limestone mass of Neapolis (fig. 12). In their siting they too form a right angle, with a street passing between them. Despite a recent proposal to date their construction to the Roman imperial period, they give every appearance of belonging to the Hieronian rebuilding of the theater.[42] The better preserved stoa on the north probably had rooms at either end: a precisely defined pavement consisting of trimmed bedrock is preserved at the west, and a balancing room can be assumed to have existed at the east. A symmetrical design is also suggested by the presence of a large fountain in the center of the back wall, fed by an aqueduct flowing into a basin beneath a great barrel vault, the whole cut from the living rock like the back wall of

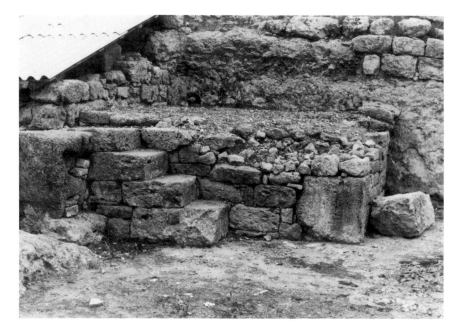

9. East Stoa, Morgantina, view from south: podium, north end of hall

10. Sculpture of standing woman, Morgantina, second half of third century B.C., limestone
Museo di Morgantina, Aidone

the stoa itself. The upper theater terrace at Syracuse demonstrates a strong interest in reshaping the landscape to create an appropriate setting for an ensemble of buildings. The resulting space strongly

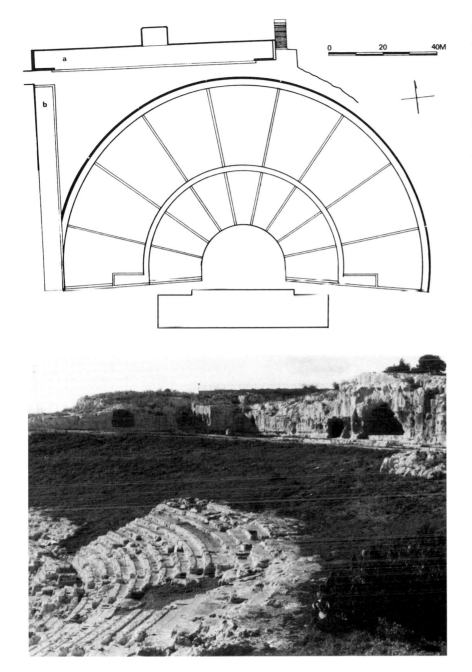

11. Theater terrace,
Syracuse, third century B.C.:
a, North Stoa, b, West Stoa
From Giulio Emanuele Rizzo, *Il
teatro greco di Siracusa* (Rome,
1923); Carlo Anti and Luigi Polacco,
Il teatro antico di Siracusa (Rimini,
1981), pl. 28
Drawing by Geoffrey Warner

12. Theater terrace,
Syracuse, third century B.C.,
view from east

recalls the terrace of the temple of Athena at Pergamon, which also overlooks a theater with unobstructed views to south and east; there also the stoa, L-shaped, closes the space on the uphill side.[43]

At Syracuse the steps and stylobate of the North Stoa on the theater terrace were in part intended to be cut from the living rock; as this work was only half completed (fig. 13), the theater terrace must have been still unfinished, though barely so, on Hieron's death in 215. The capture

of Syracuse in 212 by the Romans must have prevented completion of the project, as the Roman conquest did in the case of the West Stoa project at Morgantina. The theater terrace may thus be somewhat later than the Morgantina master plan, perhaps by as much as a quarter-century.

The siting of stoas at Syracuse and Morgantina foreshadows the comprehensive planning typical of the second century, as seen in the public spaces of Miletus and Priene in their final, late Hellenistic form.[44] The organizing device is the L-shaped or pi-shaped stoa, which is used to frame precisely rectangular spaces. The history of such buildings has been described by J. J. Coulton in his study of Greek stoas.[45] The harbingers of greater formality in planning appear already in the second half of the third century, as in the lower stoa on the acropolis at Lindos, the final version of the temenos of Zeus at Dodona, or the entrances to the forum of the Roman colony of Cosa in southern Etruria (fig. 14).[46] In such ensembles axiality and symmetry become the dominant planning features, especially when a temple or altar serves as a centerpiece. Such principles contrast with the free, scenographic qualities of the agora at Morgantina or the theater terrace at Syracuse. Yet they were probably not unknown to Hieronian Syracuse if, as seems likely, the large L-shaped stoas that framed the temenos of the altar of Hieron II are contemporary with the altar and not Augustan as asserted at the time of excavation.[47] The scale and planning of these ill-preserved stoas complement the gestural grandeur of the stade-long altar, its symmetrical ramps, and its elaborate decoration. At the end of the third century this other, more formal current also was probably known in Sicily and so potentially available to later generations of western architects. A late Hellenistic L-shaped stoa is, in fact, known in Sicily at Halaisa.[48] The agora at Morgantina thus documents a stage in the move toward comprehensive planning, in which the old and the new tendencies are apparent. That they are so successfully, and perhaps surprisingly, combined may be in some way a reflection of the political middle course fol-

lowed by Hieron II, who seems to have attempted to balance the new, centralized royal authority against the traditional concept of local autonomy.[49]

Although the ostensible topic of this essay is early Hellenistic architecture in Sicily, I would also like to consider the question of why the stoa did not prove to be a useful form for contemporary architects in central Italy. The question is implied by the comparison of two public spaces, the forum of Cosa (fig. 14) and the agora of Morgantina (fig. 4).[50] In their built form, both cities were to some degree provincial imitations of the *metropoleis* on which they were culturally and politically dependent, and both public spaces were very probably designed within the same half-century, roughly corresponding to the second half of the third century B.C.[51] Yet despite a generic likeness they are very different in conception, the one larger and less regular, bordered by independent stoas, the other a neatly defined rectangle framed on three sides by a continuous portico.

Continuous porticoes became popular throughout the Mediterranean by the beginning of the second century B.C. Early examples in non-Greek Italy include those in the forum at Minturnae and the forum at Cosa, and in several sanctuaries, including those of Juno at Gabii and Asclepius at Fregellae. These buildings all belong to the early second century, when Greek architectural styles and building types were becom-

13. Theater terrace, Syracuse, third century B.C., view: stylobate of North Stoa with quarry channels for cutting of step

ing increasingly popular in Italy as a result of the expansion of Roman power in the Mediterranean.[52] As the century progressed Italy was absorbed to some degree into the Hellenistic architectural koine.

What seems surprising, given a generally positive response to Hellenistic architectural ideas, is the absence of the free-standing stoa as an element in the planning of central Italian public and sacred places. With the exception of the pi-shaped por-

14. Forum, Cosa, second century B.C., axonometric drawing
Cosa Archives, American Academy in Rome

tico at Minturnae, J. J. Coulton's catalogue of stoas includes no central Italian buildings. A review of the sites suggests that none has been excluded, that in effect there are no central Italian stoas.[53] In their selection of Hellenistic ideas and building types, Italian architects did not choose the independent stoa, although, as we have seen, there were numerous early Hellenistic examples of the form in southern Italy and Sicily, and although in the Aegean stoas continued to be commissioned throughout the second century. Major late Hellenistic stoas are attested in the Greek world at Athens, Priene, Pergamon, Miletus, Delos, and many other cities.[54] Italian architects thus rejected a building type that had until recently been in general use in the west, and that continued to be used in the Aegean.

There are, no doubt, many reasons why the continuous portico was preferred in central Italy. Handsome and functional, the portico offered a ready solution to the problem of defining public spaces. In addition to serving as a spatial frame, the portico could also provide a façade for a variety of buildings that lay along, or even outside, the margins of the public space.[55] A good example is the forum at Cosa, and a similar role was played by the porticus of Vibius at the south end of the forum at Pompeii.[56] Further, the portico served as a convenient passage leading into those structures and connecting them, to be entered at its ends rather than from its front. Thus the porticoes at Cosa can be entered directly from the street leading into the forum.

Taking the forum at Cosa as his example, Frank E. Brown suggested some of the reasons why an Italian architect might have chosen to use porticoes in the early second century.

This was the period when the first heady impact of Hellenistic architecture was felt in Rome and Italy and when Roman architects were stimulated both to imitate and innovate, as they began to create the forms and techniques of a new imperial Roman architecture. The master plan of the Forum of Cosa belongs in this context, which is succinctly recorded for the first thirty years of the century by Livy. Porticoes ... repeatedly figure as instruments of renovation, not only in Rome but outside it.... To picture what was happening in Rome and elsewhere, we must refer to Cosa's porticoes ... [which] translated the continuous columnar screen of a Hellenistic stoa into another idiom. The stocky, widely spaced columns followed the traditional proportions of Italic temple architecture. The columnar bay was not conceived as the uniform element of a screen but as a variable axial frame for something beyond it. The deep overhang of the roofs dropped the eaves to the level of the architraves, giving them that topheavy look that Vitruvius later branded illegitimate. The bold, archaic expedient of a column on the axis of a space, both as a decisive element of closure and an axial pointer, was equally foreign to Hellenistic practice. One is tempted to think of the way Roman playwrights of this epoch handled their Greek originals.[57]

This description illuminates the Cosan porticoes as creations of their time and place, in characteristically spare and accurate prose. Brown analyzes the nature of the designer's formal language and compares it to the regularity, and by implication the proportional system, of the colonnade of the Greek stoa.

Considering the choice made by the Italian architects from the perspective of the Greek agora, one can also ask why they rejected not only the formal language of the stoa but also the building type itself. One response may lie in the peculiar nature of space in the Greek agora, and in the relationship of the stoa to that space. This is not so much a question of space that is defined by architecture, as of the space that preceded it and even for a time survived its encroachment. This is the sort of space occupied by such human institutions as markets, games, performances, religious rituals, and assemblies. It is the space in which the athlete performed and was crowned, in which animals were led to sacrifice, in which the citizen debated. It is the space that early on lay at the center of many Greek institutions, with only a secondary need for architecture. It is, most broadly, the center of the polity, *to meson*, identified by Marcel Détienne as the space that is held in common, in which all citizens have a share.[58] It is then, finally, both the physical and functional space that makes possible the autonomy of the polis, and the symbol of that autonomy.

The stoa is the architectural form that came to serve as the background for this dynamic space. It is at once a visual boundary for the space, a supplement to it, a refuge from it. The stoa was entered from the space at any point along its length, and the architectural form presumes a dynamic center, without which it would have little or no meaning. The stoa appears on the agora in the seventh century B.C., and subsequently few public spaces in the west or on the mainland lack one.

Viewed in this light, the stoa may have seemed too much a product of Greek attitudes toward public space, and in particular toward the nature of political space. It is thus, perhaps, not surprising that as an architectural form the independent stoa did not long survive the death of the polis as an autonomous political unit. In the west independent stoas were apparently not built after the Roman conquest. The Hellenistic kingdoms of the east gave the stoa an ironic revival in the second century, but their architecture was characterized even more by the continuous portico, which organizes and simplifies. This portico is an apt expression of the new order,

creating as it does a more consciously "architectural" space in place of the old, loosely bounded common center. The center has paradoxically become the periphery.

This architecture based on discrete rectilinear units had great appeal, and especially in Italy, where it was consistently used to bound public spaces that represented the new comprehensive governmental order of colony and metropolis, of alliance and dependence, of political and social stability. In such towns as Cosa the central space was diminished in scale and made more regular, as befitted the nature of the activities that took place there—processions, shows, markets, and public funerals. Many of the political and commercial activities that in the agora required free space were displaced to the periphery, beyond the portico that, streetlike, made them accessible.[59] Such specialized architectural forms as macellum, basilica, and comitium were invented to house these institutions. In this well-planned world in which open space was no longer dominant, there was little need for the ambiguous values of the stoa.

NOTES

1. Megara Hyblaea, archaic stoas: Georges Vallet, François Villard, and Paul Auberson, *Megara Hyblaea 1, Le quartier de l'agora archaïque* (École française de Rome, suppl. 1; Rome, 1976), 212–216 (North Stoa), 218–220 (East Stoa); J. J. Coulton, *The Architectural Development of the Greek Stoa* (Oxford, 1976), 256. Selinus: L-shaped stoa east of temple C, Antonino Di Vita, "Per l'architettura e l'urbanistica greca d'età arcaica: La stoà nel temenos del tempio C e lo sviluppo programmato di Selinunte," *Palladio* 16 (1967), 3–32; Coulton 1976, 281–282. Stoa next to the propylon of the sanctuary of the Malophoros: Ettore Gábrici, "Acropoli di Selinunte: Scavi e topografia," *MonAnt* 33 (1927), 88–91 (stoa with eight piers, between which runs a low curtain wall; date uncertain). Stoa (?) at Mandre

Alte near Akrai: Gaetano Curcio, "Akrai (Siracusa): Ricerche nel territorio," *NSc* (1970), 514–517; Coulton 1976, 214 (date uncertain).

2. For Syracusan stoas of the fifth century B.C. recorded by the literary sources: Diodorus, *World History* 14.41.6 (stoas in the agora, before 399 B.C.), 14.7.2 (stoa adjacent to the fortifications of Ortygia constructed by Dionysius I).

3. Kamarina: Paola Pelagatti, "Ricerche nel quartiere orientale di Naxos e nell'Agora di Camarina," *Kokalos* 30–31 (1984–1985), 683–694; Pelagatti, "L'attività della Soprintendenza alle Antichità della Sicilia Orientale," *Kokalos* 26–27 (1980–1981), 713–714. Iaitai: Hans Peter Isler, "Grabungen auf dem Monte Iato 1988," *AntK* 32 (1989), 38–39, fig. 2. The

North Stoa at Iaitai is a large structure (56.3 x 16.7 m); inner and outer colonnades have the same axial spacing. For the rooms behind, see Isler 1989, fig. 2.

4. Georges Vallet and Paul Auberson, *Megara Hyblaea* 3, *Guide des fouilles* (École française de Rome, suppl. 1; Rome, 1983), 25; Coulton 1976, 256.

5. Giuseppe Fiorelli, *NSc* (1878), 148–150; the dimensions were c. 130 x 18.40 m; now inaccessible under the west side of the Piazza Duomo at Termini Imeresi, this stoa is probably late Hellenistic. Fiorelli's plan is reprinted in Filippo Coarelli and Mario Torelli, *Sicilia* (Guide archeologiche Laterza, 13; Bari, 1984), 407. A stoalike building, probably also of late Hellenistic date, fronted on the agora at Soluntum; see Luciana Natoli, "Il teatro e l'odeon della città di Solunto," in *Odeon* (Palermo, 1971), 108, end drawing 10.

6. Malcolm Bell, "Excavations of Morgantina, 1980–1985: Preliminary Report 12," *AJA* 92 (1988), 338–339. Coulton's observation (1976, 8) concerning the "neglect of stoas" at Morgantina, and more generally in Sicily, is not accurate; it should be noted, however, that neither the north nor the east building at Morgantina was identified as a stoa in early publications.

7. Maria Teresa Giannotta, *Metaponto ellenistico-romana* (Galatina, 1980), 33, pl. 7; Liliana Giardino, "Metaponto 1977: La campagna di scavo nell'area del Castrum," in *Atti del 17° Convegno di studi sulla Magna Grecia, 1977* (Naples, 1978), 417–429; Elena Lattanzi, "L'attività archeologica in Basilicata 1980," *Atti del 20° Convegno di studi sulla Magna Grecia, 1980* (Taranto, 1981), 337; Lattanzi, "L'attività archeologica in Basilicata nel 1981," *Atti del 21° Convegno di studi sulla Magna Grecia, 1981* (Taranto, 1982), 277–278.

8. Stoas in the agora at Syracuse are mentioned by Diodorus, *World History* 14.41.6. Polybius (*Histories* 9.27.9) refers to stoas at Acragas, some of which are likely to have been in public spaces; for a stoa in the agora at Acragas, see now Ernesto De Miro, *Gli edifici pubblici civili di Agrigento antica* (Agrigento, 1990), 24.

9. Poseidonia, sanctuary of Hera at the mouth of the Silaris: Paola Zancani Montuoro and Umberto Zanotti Bianco, *Heraion alla foce del Sele* 1 (Rome, 1951), 41–43; Coulton 1976, 283. Velia: Emanuele Greco, *Magna Grecia* (Guide archeologiche Laterza 12, 2d ed.; Bari, 1981), 43.

10. Greco 1981, 43; Martin W. Frederiksen, "Archaeology of South Italy and Sicily, 1973–76," *AR* (1976–1977), 48; Werner Johannowsky, "Considerazioni sullo sviluppo urbano e la cultura materiale di Velia," *PP* 37 (1982), 236. This building is identified by Emanuele Greco, its excavator, as a roofed hall. It seems arguable, however, that it was a stoa, for the long south foundation between the two rooms at the extremities consists of a single row of blocks, as though intended to be a stylobate. The other walls are formed of two parallel rows of blocks, back to back. If the building was a stoa the columns may have been of wood, like those of the East Stoa at Morgantina, which it resembles in other ways (see below). Both buildings at Velia appear to date to the third century B.C.

11. Metapontum: Greco 1981, 154. Syracuse, Altar of Hieron: Gino Vinicio Gentili, "Siracusa: Ara di Ierone: Campagno di scavo 1950–1951," *NSc* (1954), 333–361. Heloros: Giuseppe Voza, Intervento in *Kokalos* 14–15 (1968–1969), 360–362; Coulton 1976, 242 (the space on which this stoa fronted may have been the agora of Heloros). Acragas: Ernesto De Miro, "Agrigento: Scavi nell'area a sud del tempio di Giove," *MonAnt* 46 (1962), 81–114, restored as a roofed hall with pilasters; if the restoration is correct, the building may have been influenced by the adjacent Olympieion, in the temenos of which it is located. For stoas in the temenos of Asclepius at Acragas, see De Miro 1990, 24. See also Diodorus, *World History* 11.89.8 (stoas in the sanctuary of the Palikoi).

12. Stoas above the theater at Syracuse: Julius Schubring, "Die Bewässerung von Syrakus," *Philologus* 22 (1865), 591–592; Paolo Orsi, "Sicilia," *NSc* (1909), 340; Giulio Emanuele Rizzo, *Il teatro greco di Siracusa* (Rome, 1923), 111–120, pl. 3; Carlo Anti and Luigi Polacco, *Il teatro antico di Siracusa* (Rimini, 1981), 149–150, 199–200; Luigi Polacco, Maria Trojani, and Alberto Carlo Scolari, "Il teatro antico di Siracusa, campagna 1982, la terrazza superiore, nota preliminare," *AttiVen* 141 (1982–1983), 35–49; subsequent reports in the same journal; see also Polacco, Trojani, and Scolari, "Ricerche e scavi nell'area del teatro antico di Siracusa (1970–1983)," *Kokalos* 30–31 (1984–1985), 843–844. The existence of a pi-shaped stoa on the upper theater terrace at Syracuse is suggested by Giuseppe Voza, *Syracuse, the Fairest Greek City: Ancient Art from the Museo Regionale 'Paolo Orsi'*, ed. Bonna D. Wescoat [exh. cat., Emory University Museum of Art] (Rome, 1989), 13; see also Voza, "Attività nel territorio della Soprintendenza alle Antichità di Siracusa nel quadriennio 1980–1984," *Kokalos* 30–31 (1984–1985), 674–675, where Voza suggests that architectural fragments found in the Latomia del Paradiso may have fallen from the upper terrace.

13. Polybius, *Histories* 8.3.2; see also Diodorus, *World History* 14.7.2.

14. On the dating of the Hellenistic building program, see Bell 1988, 327–331, 338.

15. For a recent discussion of the treaty and its terms, see Arthur M. Eckstein, "*Unicum subsidium populi Romani*: Hiero II and Rome, 263 B.C.–215 B.C.," *Chiron* 10 (1980), 183–203.

16. Hieron maintained his authority over the coastal plain from Leontini to Cape Pachynus (Diodorus, *World History* 23.4.1), but the question of the internal boundary of the kingdom of Hieron has only been briefly considered; see Giovanna de Sensi Sestito, *Gerone II: Un monarca ellenistico in Sicilia* (Palermo, 1977), 116; Rosalia Marino, *La Sicilia dal 241 al 210 a.C.* (Kokalos, suppl. 7; Rome, 1988), 16–19.

17. On Morgantina as a Syracusan possession in the third century B.C., see Bell 1988, 338–340; Malcolm

Bell, "Recenti scavi nell'agora di Morgantina," *Kokalos* 30–31 (1984–1985), 519–520. On the Syracusan character of material culture at Morgantina, see Bell, *Morgantina Studies* 1, *The Terracottas* (Princeton, 1981), 5–6, 24–25, 43–44 (terra-cottas); Kyle M. Phillips, Jr., "Subject and Technique in Hellenistic-Roman Mosaics: A Ganymede Mosaic from Sicily," *ArtB* 42 (1960), 243–262 (figurative mosaics). A silver treasure in the Metropolitan Museum of Art, New York, was found at Morgantina in 1981, and is likely to be of Syracusan origin; several vessels in the treasure strongly recall Sicilian pottery forms of the late third century B.C. See Dietrich von Bothmer, "A Greek and Roman Treasury," *BMMA* 42/1 (Summer, 1984), 54–59, nos. 92–106.

18. The history of the local mint is discussed by Kenan T. Erim in Theodore V. Buttrey and others, *Morgantina Studies* 2, *The Coins* (Princeton, 1989), 3–67. The suppression of the mint at Morgantina and the subsequent circulation at the site of Syracusan coinage is analogous to the adoption of the cistophoric coinage by the cities that came under Pergamene rule after 188 B.C. and had previously coined; on the cessation of the local mints in Asia Minor, see R. E. Allen, *The Attalid Kingdom* (Oxford, 1983), 109–113. The position against an interpretation of coinage as an expression of political autonomy is taken by Thomas R. Martin, *Sovereignty and Coinage in Classical Greece* (Princeton, 1985); whatever its merits in the fifth and fourth centuries B.C., the argument is not borne out in the policies of the Hellenistic kingdoms of Pergamon and Syracuse. The only city under Syracusan rule in the Hieronian period that also coined appears to have been Tauromenium, which did not, however, share a common boundary with the rest of the kingdom and must have had a special statute. None of the cities within the kingdom itself is known to have coined; see Ettore Gabrici, *La monetazione del bronzo nella Sicilia antica* (Palermo, 1927), 95.

19. Local forests in the third century B.C. are indicated by the presence of fallow deer (genus *Dama*) in a deposit of animal bones from the agora, evidently the debris resulting from a large sacrifice; the bones of at least nine individuals were identified provisionally by David Reese. On this deposit see Bell 1988, 329 (interpreted less probably as butcher's debris).

20. For the fountain house, see Malcolm Bell, "La fontana ellenistica di Morgantina," *Quaderni dell'Istituto di Archeologia dell'Università di Messina* 2 (1986–1987), 111–124. On the granaries, see Erik Sjöqvist, "Excavations at Morgantina (Serra Orlando) 1959: Preliminary Report 4," *AJA* 64 (1960), 130–131; Bell 1988, 321–324.

21. The city plan probably dates to the mid-fifth century B.C.; see Bell 1984–1985, 504–506.

22. On these buildings, see Bell 1988, 338 (North Stoa I and Central Sanctuary), 321–324 (West Granary).

23. Richard Stillwell and Erik Sjöqvist, "Excavations at Serra Orlando: Preliminary Report," *AJA* 61 (1957), 152.

24. See Bell 1988, 327–331, 338.

25. Strabo, *Geography* 4.1.4 (Massalia); Diodorus, *World History* 19.45.3 (Rhodes); Vitruvius, *On Architecture* 2.8.11 (Halicarnassus).

26. The foot length varies slightly in the three stoas, within the range 0.326–0.336 m: East Stoa, 0.333 m; North Stoa II, probably 0.336 m (the Hieronian master plan required that this stoa be aligned with the corners of the East and Northwest stoas, and its actual length [100.80 m] may have been slightly greater than 300 feet, so that its length might thus have been calculated as 310 feet of 0.326 m); West Stoa, 0.326 m. These are half-stade-long stoas; on others, see Coulton 1976, 59. For *stoai stadiaiai* at Rhodes, see Diodorus, *World History* 20.100.4 (late fourth century B.C.).

27. Such terraces were often required in order to provide access to stoas sited on sloping ground; see Coulton 1976, 138, 140–141. The North Stoa II at Morgantina is also approached from a terrace, and it seems likely that one was planned for the uncompleted project of the West Stoa.

28. On stoas as settings for courts, see Coulton 1976, 10.

29. The sculpture is provisionally published in Stillwell and Sjöqvist 1957, 159, pl. 60, fig. 32; Bell 1981, 47, pl. 147, fig. 16. The sculpture (Museo di Morgantina, Aidone, inv. 56-1749) stands on a rectangular plinth; the missing head, hands, and feet, probably of marble, were inserted. The width of plinth and masonry base is the same (0.44 m).

30. The bold treatment of the drapery, with incipient transparency in the himation, places the work in the second half of the third century B.C.

31. Apollonis, wife of Attalos I, donated stoas in the sanctuary of Demeter at Pergamon; see Coulton 1976, 66 (also with reference to the stoa at Sikyon dedicated by Lamis, mistress of Demetrios Poliorketes).

32. The length of 320 feet would result in twenty rooms of the width of the three that were actually built. These measure 5.2 m on center, or 16 feet. When the West Stoa replaced the unbuilt southern part of the original building, it was designed with seventeen shops; these, with the three existing rooms in the finished part of the original building, give a total of twenty—the number apparently intended for the original structure.

33. The evidence for the upper floor consists of beam cuttings in the rear wall and in the shop walls. Given the available building materials, a two-storied façade seems more likely than a colossal exterior order and two-storied shops in the manner of the South Stoa at Corinth. See Oscar Broneer, *Corinth* 1.4, *The South Stoa* (Princeton, 1954), 70–79, frontispiece; Coulton 1976, 57–58.

34. For stoas with single colonnades and complex shops, see Coulton 1976, 261 (East Stoa on the south market, Miletus), 248 ("tufa portico," Kos). Compare also the stoa of the Punic period at Selinous (Coulton 1976, 283) and, with a double colonnade, the North Stoa at Iaitai (above, note 3).

35. The large eastern stoa at Metapontum may also have had a second story; see Giardino 1977, 418.

36. Homer A. Thompson and Richard E. Wycherley, *The Athenian Agora* 14, *The Agora of Athens* (Princeton, 1972), pls. 4–7.

37. On Megara Hyblaea, see Vallet, Villard, and Auberson 1976; Hans Lauter, *Die Architektur des Hellenismus* (Darmstadt, 1986), 93; on Syracuse, see above, note 2.

38. On Kamarina, see above, note 3; and Pelagatti 1980–1981, 713 (room at east end of the North Stoa). The agora at Iaitai appears to be similar; see above, note 3.

39. See above, notes 9, 10.

40. On stoas with rooms at the extremities, see Coulton 1976, 81. A stoa in the temenos of Asclepius at Acragas also has terminating rooms; see De Miro 1990, 24.

41. See above, note 11.

42. Polacco, Trojani, and Scolari 1984–1985, 843.

43. Richard Bohn, *Das Heiligtum der Athena Polias Nikephoros, Altertümer von Pergamon* 2 (Berlin, 1885), pls. 2, 15, 40, 41.

44. Lauter 1986, 92–113, 290–292; Coulton 1976, 63–68.

45. On L- and pi-shaped stoas, see Coulton 1976, 63–68, 95–98, 168–175.

46. Lindos: Coulton 1976, 251–252. Dodona: Sotiris I. Dakaris, *Archaeological Guide to Dodona* (reprint of 1971 edition; n.p., n.d.), 46–49.

47. The stoas of the altar temenos were originally dated to the Augustan period, with the suggestion that they might have been planned, although not built, in the third century B.C.; see Gentili 1954, 353. For the more probable dating of the stoas to the time of Hieron II, see now Enzo Lippolis, "L'architettura," in *Fregellae* 2, *Il santuario di Esculapio*, ed. Filippo Coarelli (Rome, 1986), 38–39.

48. Gianfilippo Carettoni, "Tusa (Messina): Scavi di Halaesa," *NSc* (1961), 285–296.

49. It is interesting to note that an *ekklesiasterion* was included in the Hieronian plan for the agora at Morgantina; the existence of a popular assembly in a city within the kingdom argues for a considerable degree of local autonomy.

50. On the forum porticoes, see Frank E. Brown, *Cosa: The Making of a Roman Town* (Ann Arbor, 1980), 31–46.

51. Brown 1980, 33, 39–41. Brown considered the porticoes to be part of the original "master plan" for the forum, adopted very early in the second century B.C.

52. Filippo Coarelli, "Architettura e arti figurative in Roma: 150–50 a.C.," and Helmut Kyrieleis, "Bemerkungen zur Vorgeschichte der Kaiserfora," both in *Hellenismus in Mittelitalien*, ed. Paul Zanker (Göttingen, 1976), 21–32, 431–438; Pierre Gros, *Architecture et société à Rome et en Italie centro-méridionale aux deux derniers siècles de la République* (Collection Latomus, 156; Brussels, 1978), 34–56; Filippo Coarelli, "Architettura sacra e architettura privata nella tarda Repubblica," in *Architecture et société de l'archaïsme grec à la fin de la République romaine* (Collection de l'École française de Rome, 66; Rome, 1983), 191–217, especially 191–199.

53. If the pi-shaped portico at Minturnae is considered to be a stoa, then the other similar structures at Gabii and Fregellae could be as well. The distinction between such three-sided porticoes and the pi-shaped stoa is a fine one. In any case these are not independent structures of the type discussed previously. Emeline Richardson has pointed out to me an Etruscan terra-cotta model of a single-aisled stoa, with seven Tuscan columns between antae, from a votive deposit at Vulci, probably of the first century B.C. See Sergio Paglieri, "Una stipe votiva vulcente," *RivIstArch*, n.s. 9 (1960), 93, fig. 37; Giovanni Colonna, "Urbanistica e architettura," in *Rasenna: Storia e civiltà degli Etruschi* (Milan, 1986), fig. 399.

54. On late Hellenistic stoas, see Coulton 1976, 62–74; Lauter 1986, 113–124.

55. This *Verkleidungsfunktion* is seen in the Sacred Stoa at Priene, the Metroon at Athens, and the Doric Stoa at Morgantina; on such structures, see Lauter 1986, 124–128; Coulton 1976, 172–174.

56. Hans Lauter, "Bemerkungen zur späthellenistischen Baukunst in Mittelitalien," *JdI* 94 (1979), 416–427; Paul Zanker, *Pompeji: Stadtbilder als Spiegel von Gesellschaft und Herrschaftsform* (9. Trierer Winckelmannsprogramm; Mainz, 1987), 15–16.

57. Brown 1980, 43–44.

58. Marcel Détienne, "En Grèce archaïque: géométrie, politique et société," *AnnEconSocCiv* 20 (1965), 425–441.

59. On the uses of the forum space at Cosa, see Brown 1980, 40–41.

JOSEPH COLEMAN CARTER
University of Texas at Austin

Taking Possession of the Land:
Early Greek Colonization in Southern Italy

The history and archaeology of Greek colonization in the west has been a major focus of research in Italy for the last century. Regrettably, American scholars and archaeologists, despite their own colonial past, have not warmed to the subject to anything like the degree that their European colleagues have. Frank Brown fully appreciated the importance of the work going on in Southern Italy and Sicily, and he was a strong ally of the few Americans who did choose to study the Western Greeks. There could have been no better introduction to an ancient colony than a campaign at Cosa with this unforgettable mentor and friend.

Many of the larger questions about the Greek or any colonial movement concern the very early period of its existence. What were the relations between the colonists and the colonized? Among the colonists themselves? And between the first colonists and later waves? These questions are among the most difficult to answer. In the case of the pioneer Greek colonists, there could have been few contemporary written records. Most of what can be ascertained about colonization from ancient sources has been filtered through historians of the classical period or later and colored by the politics of the day.

What light can archaeologists shed on this obscure but extremely significant moment in history? Not as much as might be hoped, because the early settlers were few and left little material evidence of their activities. This essay deals with a particular area—the Ionian coast of Southern Italy, between the Cavone and Bradano rivers, which became in the course of time the *chora*, or territory, of the Achaean colonists of Metaponto.

Unlike the documentary sources, the quantity and quality of the material evidence is growing very rapidly. Twenty-five years ago it would have been virtually impossible to deal with the question of the relations between Greek and indigenous populations in the area under consideration. Little enough was known about the development of the Greek colony, and less still of the native populations. As a result of the vigorous program of exploration of the urban site of Metaponto, the *chora*, and the *proschoros* (the native settlements of the interior) begun by the first superintendent for antiquities of Basilicata, Dinu Adamesteanu, and carried on by his successors, this is now the most fully explored colonial area in all of Southern Italy.[1] In describing these events of the eighth through the fifth centuries B.C., I shall be drawing heavily on the results of colleagues, Italian and foreign, as well as our own.

Ancient sources indicate that relations between Greek and native populations were sometimes peaceful, but more often were characterized by conflict. Sybaris, we

"Colonial" stamnos, Incoronata, seventh century B.C., reconstruction by Eve Beckwith

343

learn from Diodorus Siculus, grew because the colonists shared citizenship with "the many," including, presumably, the surrounding native populations.[2] The Metapontine experience, according to the fifth-century Syracusan historian Antiochus, was more nearly typical.[3] The original foundation was wiped out, as he states, by natives. Then Achaean colonists were convinced by the Achaean Sybarites to resettle the abandoned site in order to thwart the ambitions of the colony of Taras to the east and to control the territory of Siris to the west. Later on, he adds, the Metapontines found themselves at war with both the Tarentines and the native Oenotrians of the interior.

Modern scholars, too, reflecting their sources, have tended to emphasize the hostility and exclusivity of the groups. Relations, however, could change with needs. At the beginning, when a settlement was small and weak, they would have tended generally to be friendly. As need for a labor force increased, in order to cultivate an expanding territory, contacts between settlers and the nearest potential source of labor would have hardened. But there is danger in generalizing, for there were important variable factors in each situation: the sex ratio and population size of the newcomers, and the concept of territoriality among the native as well as the immigrant population.[4]

We turn now to the case of Metaponto and the archaeological evidence bearing on the relations of Greek and native populations. The site of Incoronata on a naturally fortified plateau overlooking the valley of the Basento River, about 8 km from the future urban center of the colony of Metaponto, was discovered in 1970, and has since been excavated jointly by the Archaeological Superintendency, the University of Milan, and the University of Texas (fig. 1). The most extensive work has been that of Piero Orlandini and his Milanese collaborators, who from 1974 to the present have concentrated on the largest of the three spurs of the plateau.[5]

The principal feature of all three spurs is pits full of pottery (figs. 2–4), animal bones, seeds, the occasional tool, dirt, and ash. The pottery consists, in varying ratios, of Greek imported wares, principally Proto-Corinthian; locally made so-called "colonial" vessels, which are often large and decorated with bold geometric patterns inspired by various Greek centers to the east; and finally the native wares, the Bradano Geometric and Sub-Geometric with their typical "tent" pattern. Some of the native pottery antedates by a generation or two the earliest known permanent Greek settlement along this stretch of coast. Taras and Sybaris were established at the end of the eighth century B.C., and Siris slightly later. The imported Greek pottery, which is the most reliably dated, belongs predominantly to the first half of the seventh century. A cut-off date of about 640/630 has been assumed, since fine imported wares from Corinth are exclusively Proto-Corinthian. Not a single sherd of Early Corinthian has been found at Incoronata.

The abundance of large storage vessels, Attic SOS and Corinthian Type A amphorae (fig. 5), on this site, where native settlement seems continuous from the ninth century, suggested to the discoverer, Adamesteanu, that this was a mixed settlement, with Greeks and natives engaged jointly in trading the agricultural surplus of the surrounding indigenous countryside.[6]

From the very beginning of his work on the site, Orlandini adopted the working hypothesis that the Greek and indigenous material belonged to two separate settlements.[7] An earlier indigenous village was destroyed by Greek traders who, having set out from the Ionian settlement at Siris, established a commercial emporium on the site shortly after 700. They in turn were annihilated by the Achaean settlers of Metaponto around 640/630. This is the main argument for dating the colony so early. Evidence for widespread destruction is cited by Orlandini but so far nowhere clearly documented. This hypothesis has been modified in minor ways and is now a fixed—but not unchallenged—position.

Orlandini has identified "native" pits for refuse and badly damaged "native" hut sites. These he distinguishes from large "Greek" refuse and storage pits, and "Greek" houses, which are single-room,

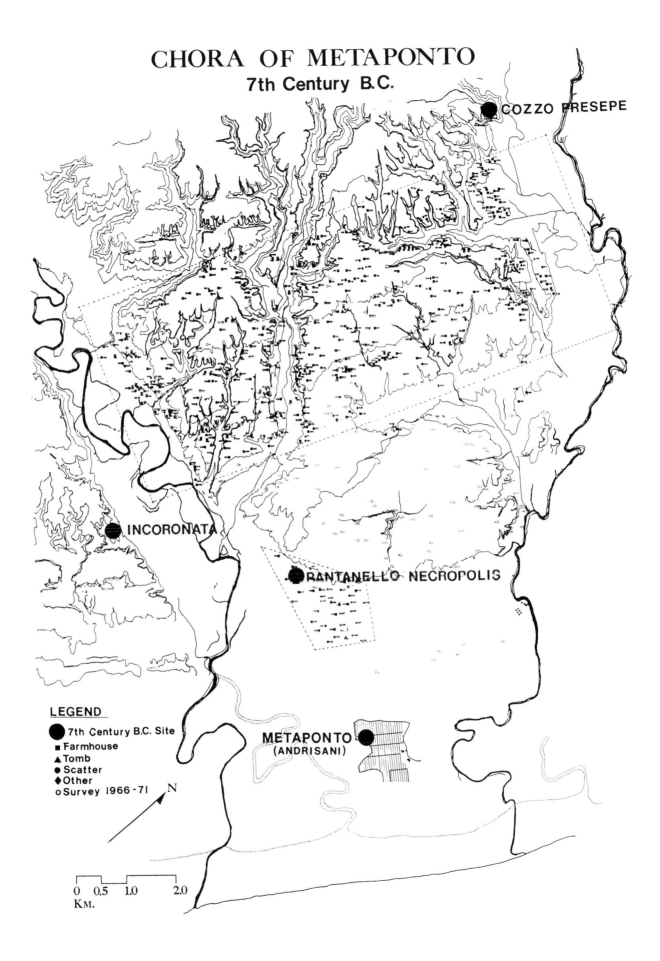

CHORA OF METAPONTO
7th Century B.C.

COZZO PRESEPE

INCORONATA

PANTANELLO NECROPOLIS

METAPONTO
(ANDRISANI)

LEGEND
● 7th Century B.C. Site
■ Farmhouse
▲ Tomb
● Scatter
◆ Other
○ Survey 1966-71

N

0 0.5 1.0 2.0
KM.

2. Pottery from Pit B ("mostly colonial") of University of Texas excavations, Incoronata, first half of seventh century B.C.: left foreground, Late Proto-Corinthian *kotyle*; remainder, locally made "colonial" fabrics

3. Shoulder and neck of stamnos from Pit B, Incoronata, locally made "colonial" ware

4. Fragment of indigenous pottery from Pit B, Incoronata, seventh century B.C., Bradano Sub-Geometric

rectangular structures. The houses are comparable in their simplicity to what is known of early Greek colonial dwellings elsewhere, for example at Megara Hyblaea in Sicily, where French excavators have discovered the dwellings of the earliest colonists.[8]

Fundamental to his interpretation of the data of the excavations is Orlandini's assertion that all the Greek pottery, with a very few exceptions, is later in date than all the indigenous pottery. When indigenous pottery is found in "Greek" pits, the explanation offered is that the Greek pits cut into a

5. Pithos from Pit B, Incoronata, first half of seventh century B.C.

6. Southwestern spur, Incoronata, site plan of University of Texas excavations, 1977–1989

preexistent indigenous context.[9] Yntema's study of the Bradano Sub Geometric has suggested that this native ware was current

throughout the seventh century,[10] so that, in fact, a considerable portion of the native pottery would be contemporary with the Greek emporium.

The excavations of the northern spur, the Orlandini spur, with two dozen of the so-called Greek pits and structures and even more of the smaller indigenous pits, represent a very sizable sampling of the hilltop. Those of the southwestern spur are not insignificant, however, and they point to some very different conclusions. The material from the University of Texas campaigns of 1977 and 1978 is now being studied for publication by Sarah Leach.[11]

The results from the southwestern spur surely indicate that pits in this part of the settlement were not exclusively Greek or indigenous (fig. 6). We found native material in "Greek" pits with no indication of the presence of an earlier disturbed feature (fig. 7).[12] In fact, as Leach has shown, there are only pits that have mostly Greek mate-

INCORONATA
1978

7th century B.C.

mostly Greek

mostly indigenous

mixed

i–vi,xi

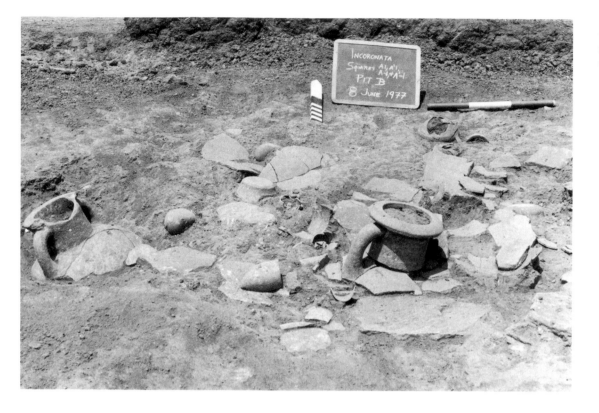

rial, those with mostly indigenous material, and those where Greek and indigenous material are in roughly equal proportions, and no chronological distinctions can be made among the three types (fig. 8).

We found no evidence of thoroughly destroyed native dwellings but instead the stone foundations of a rectangular structure, perhaps the best preserved on the entire plateau, in a context of very fragmentary mixed indigenous and Greek wares (fig. 9). Immediately outside the mud brick wall at the west end lay the fragments of a complete, undecorated, indigenous conical-necked jar, which had apparently been crushed by the collapsing structure (fig. 10). It is quite unusual, having an elliptical horizontal section, but is generally comparable to shapes classified as Sub-Geometric by Yntema, so it ought to date to the seventh century,[13] that is, the period of Orlandini's Greek emporium.

The single-room dwelling had a sunken floor, typical of pre-Greek structures in this area from the Bronze Age onward and even of later colonial farmhouses. We presume that it had a thatch or daub pitched roof, since no tiles were found (figs. 11,

12). In overall appearance it would have been quite like the dwellings (reconstructed instead with flat roofs) that the earliest Greek settlers on the north coast of the Black Sea found and modified when they arrived there early in the sixth century.[14] The argument used by Orlandini and others that a rectangular house plan betrays the Greek origin of its occupants is hardly more convincing than one based on pottery types. The Greeks did not own patents on either. In any case, these two criteria, even taken together, would not be sufficient to prove that the seventh-century settlement at Incoronata was exclusively a Greek one. It is necessary to look at the broader context.

In 1984 a dramatic discovery was made in the area of the colonial city, under the sixth-century grid of the residential quarter. On this site, known as Andrisani, Antonio De Siena found an area of pits similar to those of Incoronata.[15] In fact the undisturbed lower levels contained comparable ceramics—the locally made "colonial" wares mixed with indigenous pottery. The pits, which were joined in

8. University of Texas excavations, Incoronata: foreground, two interconnecting, fully excavated "mixed" pits; background, rectangular structure

9. Excavation of rectangular structure, Incoronata, 1978, University of Texas excavations

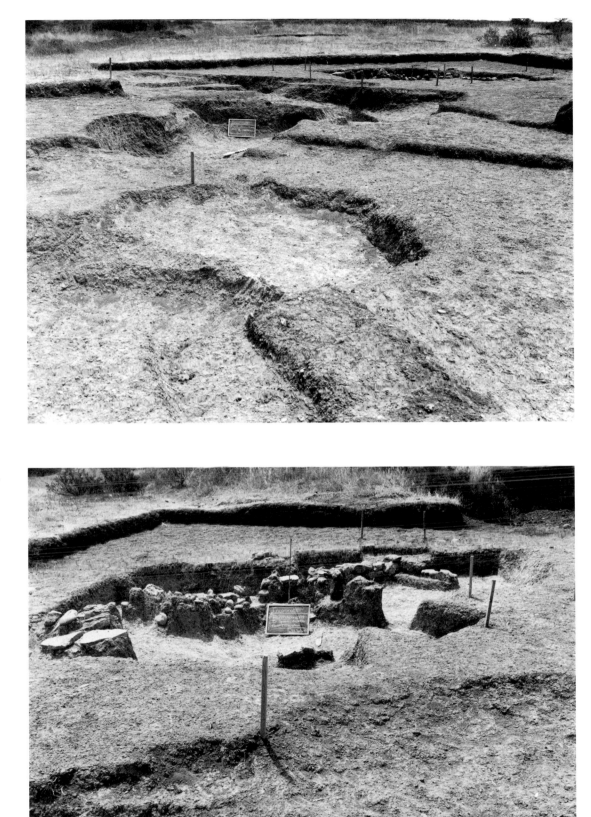

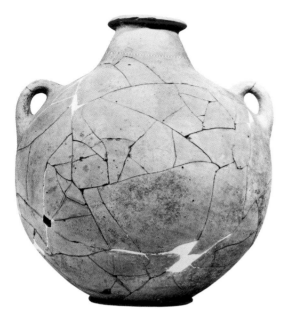

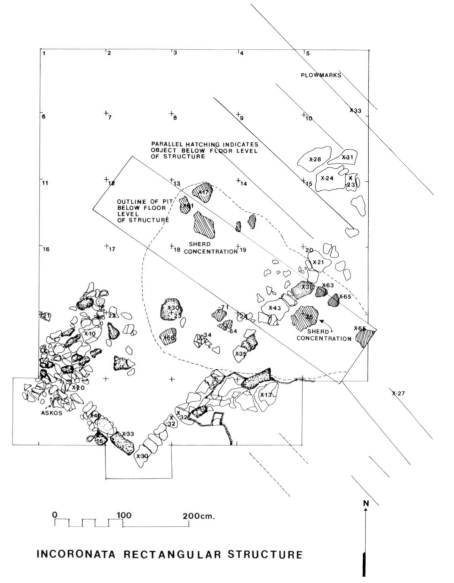

PLOWMARKS

PARALLEL HATCHING INDICATES
OBJECT BELOW FLOOR LEVEL
OF STRUCTURE

OUTLINE OF PIT
BELOW FLOOR
LEVEL
OF STRUCTURE

SHERD
CONCENTRATION

SHERD
CONCENTRATION

ASKOS

0 100 200cm.

INCORONATA RECTANGULAR STRUCTURE

N

clusters corresponding to the different activity areas of dwellings—a kitchen and storage areas have been identified—were much better preserved in the waterlogged sand dunes of the coastal site than they had been at Incoronata. De Siena theorizes that the plans of the pits are analogous not to those of the Greek pits at Incoronata but to the basements of huts of the ninth- to eighth-century indigenous village he was simultaneously excavating at the site known as "Incoronata indigena," near to but distinct from the later "Incoronata greca" under discussion. De Siena assumes that the structures on the coast were in the native tradition, and asks, What was the sense of a Greek emporium on the inland hilltop site, with an apparently contemporary, presumably native village on the coast?[16]

But was that settlement on the coast a native village? In the larger picture, native settlements are normally set back from the coast, on naturally defensible heights, often hidden from view. Greek colonists, however, chose the coast, and they found sites between rivers particularly attractive (fig. 13). The sites of Sybaris and Siris, or of Selinus in Sicily, exemplify this. Proximity to river valleys penetrating the interior was advantageous to traders. If any site was ideal as an emporium, it was not Incoronata but Andrisani.

General observations of this sort have been employed by Pier Giovanni Guzzo in constructing a now widely accepted model for early Greek contact and colonization.[17] He postulates that Greek settlements were made in a previously unoccupied area, near a native settlement (Taras-Satyrion, Metaponto-Incoronata, Sybaris-Torre Mordillo), but always on the sea to maintain links. The indigenous presence and their contact with the Greeks before colonization were motivated and sustained by the exploitation of the soil. Native settlements move closer to the coast—Guzzo points to those ringing the future site of Sybaris—to profit

10. Undecorated conical-necked indigenous jar, Incoronata, seventh century B.C.

11. Rectangular structure, Incoronata, plan

12. Rectangular structure, Incoronata, artist's rendering
Drawing by Ann Patterson

from these trade contacts. There is a continuous increase in indigenous sites down to the time of founding of a colony, or *ktesis* (literally, "the taking possession"), at which point the native sites are abandoned, not to be reoccupied for some time. In Guzzo's model, Incoronata behaves like a typical indigenous site.

Too little of the Andrisani site has been excavated to support a major theory, but this new element in the puzzle offers a basis for an alternative model, one quite different from those proposed by Orlandini or Guzzo, whose views in any case antedate its discovery. It is important to know that just above the undisturbed levels of pits, or basements, if you will, at Andrisani was the detritus of destruction, including pottery of a type associated with the earliest public urban structures on the site.[18] These are cups with striped rims, *coppe a filetti*, in the Proto-Corinthian tradition, but dating generally to the late seventh/early sixth century. This same material (whose chronology is not well established yet) was found in the earliest votive deposit in the area of the later sixth-century temples (the one near Sacellum C)

and in the destruction level of the wooden predecessor of the great mid-sixth-century stone *ekklesiasterion*, or meeting place of the citizens, in the agora. Excavation of this building, one of the truly sensational discoveries of recent years in the monumental public areas of the Achaean colony, is the result of a collaboration between the Archaeological Superintendency and Dieter Mertens of the Deutsches Archäologisches Institut, Rome, whose excellent models and plans document it.[19]

A second basis for this model is Leach's fundamental reassessment of the Incoronata pottery. Orlandini and others have stressed the striking similarities between the large bowls with incurving rims known as *deinoi* found at the site of Siris and those at Incoronata. Incoronata is thus, for them, an offshoot of Siris, destroyed because of a rivalry between the Ionians and Achaean settlers.[20] In attempting to respond to the question, Who were the Greeks at Incoronata or Andrisani? Leach has studied the whole range of shapes and decorations and concluded that Sybaris provides the closest parallels.[21]

With the discovery of Andrisani, evidence is growing for the widespread destruction of a settlement on the site of the colony, to be dated around 600 B.C. This, together with the now well-documented Sybarite affiliation of the earliest Greeks in the area, brings us much closer to Antiochus' account of the founding of Metaponto, according to which Achaeans sponsored by Sybaris resettled a previously destroyed and abandoned site. The "resettlement," I would suggest, was made almost immediately after the destruction of around 600. It would have replaced an earlier mixed Achaean-indigenous settlement on the coast, consisting of the Andrisani habitation site as well as the beginnings of an urban center—the sanctuary and perhaps also the wooden structure in a nascent agora. It has been assumed here—the evidence is incomplete—that there is no chronological gap among the three principal areas of this late seventh-century settlement at Metaponto.[22] In this view the mixed Achaean settlement at Incoronata would have been abruptly but—*pace* Orlandini—peacefully aban-

doned about 640/630 for the more convenient coastal location.

Thus, in contrast to the position taken by Orlandini, I have preferred to see an organic development up to about 600, consisting of mixed settlements of natives and a growing Greek element in the population. Just what sort of mix this might have been is an interesting and complex question, which may ultimately be unresolvable. The tradition of enmity between Greeks and natives reported by Antiochus, which would be a hindrance to this theory, could refer to a later period, as Leach has suggested.[23] It might, in fact, have been behind the destruction of c. 600 if it is true, as Antiochus states, that settlement on the site was wiped out by natives. This could be seen as the indigenous response to the threat of a rapidly expanding Achaean presence on the coast. Thus the events would have been the exact opposite of what the Guzzo model predicts: the natives eliminate the Greeks—but only briefly.

A proper colonial foundation, if there ever was one, would have taken place about 600 with the encouragement of Sybaris, as Antiochus says. It should be noted further, as Guzzo has done,[24] that at just about this time Sybaris had formalized an earlier settlement at the other end of the trade route leading from Metaponto up the Basento valley and across to the Tyrrhenian Sea, with the establishment of Poseidonia (Paestum).

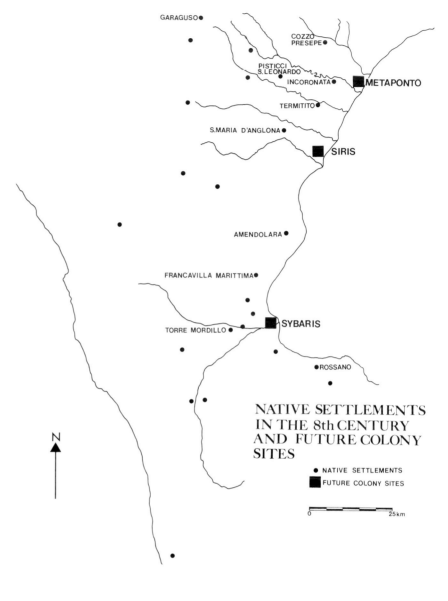

NATIVE SETTLEMENTS IN THE 8th CENTURY AND FUTURE COLONY SITES

● NATIVE SETTLEMENTS
■ FUTURE COLONY SITES

0 25 km

This reconstruction of events is bolstered by the fact that the earliest securely dated sites in the *chora* were established either slightly before or just after 600 B.C. (fig. 14). For the most part, they are sanctuaries. There is more to be said about the nature of the early settlement of the *chora*, but I will note briefly here the early evidence from one of a half-dozen known rural sanctuary sites.

The sanctuary around a spring at Pantanello was excavated by the University of Texas team in nine campaigns beginning in 1974 (fig. 15).[25] The archaic levels were below the actual water table, a difficulty that was eventually overcome by a "wellpoint" pumping system, and at last it was possible to trace the development of the

sanctuary from its earliest use, when it was simply a spring flanked by two massive walls of local stone. Middle Corinthian conical oenochoe fragments in the mouth of the spring give a date about 600 for this first phase (fig. 16). (A few fragments of cups with striped rims seem earlier.) The divinity worshiped here was female and concerned with fertility. The votives are identical to those from the urban sanctuary as well as to those from the other known rural sanctuaries: the temple of Hera called the "Tavole Palatine," San Biagio, and the small sanctuary excavated by the University of Texas at Incoronata (the one excep-

13. Southern coast of Italy from Sybaris to Metaponto, eighth century B.C., map: circles indicate native settlements, squares mark colonial foundations

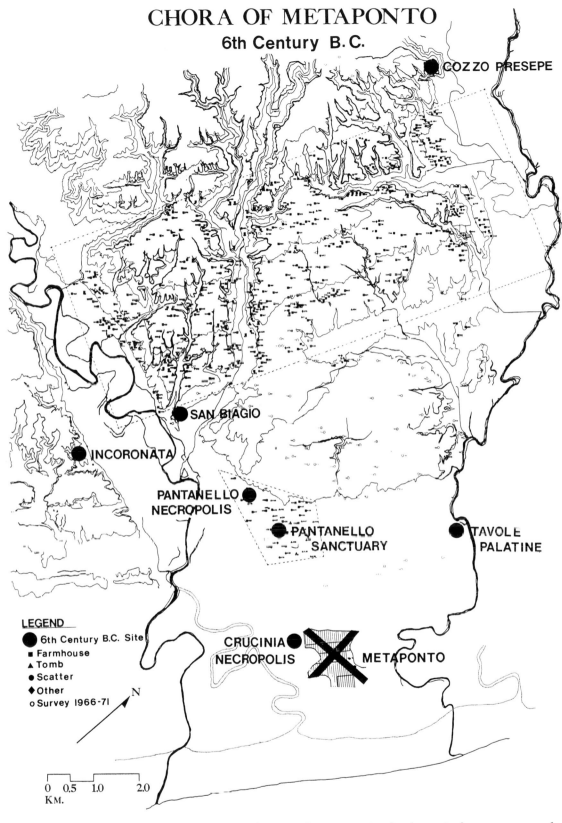

14. *Chora* of Metaponto, sixth century B.C., map: rectangle indicates survey transect

CHORA OF METAPONTO
6th Century B.C.

COZZO PRESEPE

SAN BIAGIO

INCORONATA

PANTANELLO
NECROPOLIS

PANTANELLO
SANCTUARY

TAVOLE
PALATINE

CRUCINIA
NECROPOLIS

METAPONTO

LEGEND
- ● 6th Century B.C. Site
- ■ Farmhouse
- ▲ Tomb
- ● Scatter
- ◆ Other
- ○ Survey 1966-71

N

0 0.5 1.0 2.0
KM.

tion to the 640/630 cut-off date at that site),[26] which were first frequented about this time. A large structure was built beside the spring in the late sixth century, at the time, as we shall see, of the first great wave of population in the *chora*.

The fact that sanctuaries seem to anticipate the widespread settlement of the *chora* by colonists has been interpreted in various ways. Some scholars have pointed to the evidence for an early native presence at these sites and have argued that the Greeks found and adapted preexisting cults.[27] Others have observed that the indigenous material at sites like San Biagio or the Temple of Hera at the Foce del Sele is really very slight, and have interpreted these cult places as early and purely Greek foundations intended to stake out the borders of the territory claimed by them, by putting it under divine protection.[28] The Greeks' motives, in this view, were aggressive, and the native pottery at the Greek shrines is said to have been deposited after the Greek foundation and to attest to the subaltern status of the *indigeni*. Unfortunately, the evidence has not yet been fully published. Our experience at Pantanello is that the native pottery consists of a few sherds that could well date after 600, and we suggest that there is a variety of reasons why they might be found at a shrine where Greek material clearly predominates.

The major contribution of Pantanello to the understanding of the colonial *chora* was quite unexpected. The same conditions that impeded excavation at first preserved in a miraculous way the most complete evidence known for the actual plant populations of the Greek countryside.[29] Although most of this evidence concerns later periods, the early sixth century is documented by extensive pollen and some seed remains. Some seeds have also been recovered from the pits of Incoronata. This information, and the considerable faunal remains from both sites, make it possible to compare the agri-

15. Spring-sanctuary, Pantanello, c. 600 B.C., part of University of Texas excavations: twin channels yielded votive figurines, pottery, and seed remains; mouth of spring overlain by a Hellenistic-Roman well; at right (partially visible), monumental retaining wall that flanked the archaic sanctuary

16. Fragment of late Middle Corinthian conical oenochoe, from mouth of spring, Pantanello, c. 600 B.C.

culture of the *chora* when it was under the control of an indigenous or mixed Greek and indigenous population with that of the period after the turn of the sixth century, when the colonial exploitation began. To summarize a complex argument briefly, the indigenous population seems to have practiced a mixed agriculture based on cereals, legumes, and the grape. This was continued in the colonial period with the apparent addition of the olive.[30]

Pastoralism, interpreted as a sign of an undeveloped agricultural economy, is often assumed for the indigenous inhabitants.[31] Surprisingly, pastoralism appears to have been relatively more important in the early colonial phase—that is, in the sixth century—than it was in either the immediately preceding or the later period. The grazing indicators[32] and the ratios of sheep to cattle[33] are never this high again in the Greek *chora*. Rather than thinking of the early sixth century as being somehow backward in its agriculture and its preference for horse raising and the like—which we know about, too, from Bacchylides' Eleventh Ode[34]—we should conclude that this is a reflection of its more aristocratic society. This situation gave way in the course of the fifth century to a more homogeneous society of tillers of the soil.

What effect does the inevitable selection of evidence have on the interpretation of a whole period? A considerable one, I suggest, especially for periods like the one under consideration, where the documentary evidence is so slight. Clearly the choice of sites for excavation is crucial. It is sobering to reflect that most sites are chosen not *by* archaeologists but *for* them, by the farmer or the road-building crew. It is a luxury to be able to choose a site to excavate, but a necessity that archaeologists participate actively in systematically searching for evidence and for sites over wide expanses of the research area. Only in this way will it be possible to have an idea of the context—of actual site densities and of historical changes in the broad patterns of settlement. Such information is essential as we confront the question of "taking possession of the land." What was the distribution of sites in the territory before the arrival of the Greeks? What were the stages by which colonial settlement advanced?

The intensive field survey begun in 1981 by Cesare D'Annibale and his crew was intended to provide the evidence.[35] The survey area, a rectangular transect of 42 km², cut across the heart of the Metapontine *chora*. The goal was 100 percent recovery of ancient sites in this area and the surface collection of all pottery and other artifacts. By 1984 this had been achieved, and 536 sites had been put on the map. The results and the analysis of the pottery by D'Annibale and Maria Elliot permit unusually detailed and precise answers to the questions we have raised.

The discussion of the relations of Greeks and natives up to this point has focused on a very few sites, principally Incoronata and Andrisani, at both of which could be found a high concentration of population in a restricted area. The generally accepted model for indigenous pre-Greek settlement is that of villages located on easily defensible heights.[36] In Guzzo's model these were seen to be moved from the interior toward the coast, as trade contacts with the Greeks accelerated in the seventh century, but they were canceled out completely, as at Incoronata, with the arrival of permanent agricultural colonies such as that at Metaponto.

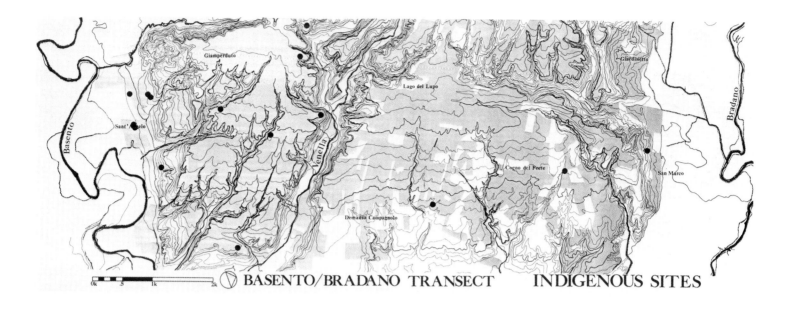

BASENTO/BRADANO TRANSECT INDIGENOUS SITES

Were village sites the only ones with indigenous pottery? And did they cease to exist with the arrival of the Greeks? These are questions to which we may turn with the results of the survey, not for final answers at the present stage of this ongoing research, but for tantalizing indications. A few sites in the survey, fifteen to be precise, have pottery in the surface collection that has been identified as "indigenous" (fig. 17). These are undecorated pieces, many simply body sherds, whose fabric is quite distinct from that of the coarse ware normally found on farm sites of the sixth century and later, and indeed resembles that of ware from Incoronata.[37] (Whether it belongs with the truly indigenous ware from that site or the so-called "colonial" ware is impossible to say.)

The sites with "indigenous" pottery do not form a completely separate group. This pottery is found on sites that in all but two cases also have the black-glazed pottery typical of the *chora* from the sixth century onward. It is interesting that in only three cases is the black-glazed pottery of the earliest type, from the first half of the sixth century, and that the sites with this early type are near a site (Site 7) that has no Greek pottery at all but sherds with distinctly indigenous profiles.

The question that begs an answer is the date of the indigenous pottery. If it is contemporaneous with the pottery from Incoronata, then a case could be made for a different model for indigenous—or mixed Greek and indigenous—settlement in the seventh century. This would be a dispersed pattern, which could then be seen to have anticipated and paved the way for the later Achaean settlers using black-glazed ware. It would be possible to argue that the territory was already being exploited agriculturally (as we should have suspected in any event) using a system of isolated farm units, which the Greek colonists eventually would have adopted and improved.

If, on the other hand, the "indigenous" pottery is contemporaneous with the black-glazed pottery, the idea that the Greeks simply eliminated any trace of the natives and their culture from the *chora* must be revised. It has been widely agreed—Guzzo's model is a case in point—that there had to be a native element in the population, that natives furnished wives and manual labor for the new settlers, but that they disappeared without a trace as a cultural entity. The existence of Site 7 with its distinctive native pottery, while it hardly constitutes a major presence, is nonetheless undeniable, and fortunately it is not alone. Comparable is Site 227, situated analogously on the opposite side of the territory. Similar material has been found also in the sanctuary at Pantanello (and San Biagio).

Until the pottery has been more fully

17. Survey transect between Bradano and Basento rivers, *chora* of Metaponto, plan, showing indigenous sites

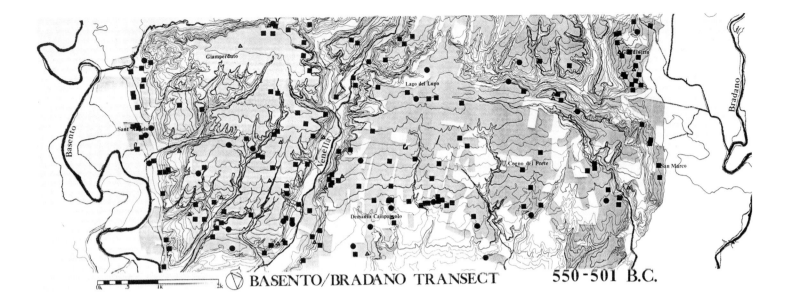

BASENTO/BRADANO TRANSECT 550-501 B.C.

18. Survey transect between Bradano and Basento rivers, *chora* of Metaponto, plan, showing farm sites datable to 550–500 B.C. on basis of black-glazed pottery

studied it will not be known whether or not Sites 7 and 227 and the thirteen other sites suspected of having an indigenous component predate the widespread settlement of the *chora*. If indeed they do, it is clear why the pattern of "indigenous" settlement and that of the early sixth century appear to have had little in common in terms of spatial distribution. (As noted, they overlap at only three sites.) If the indigenous sites did form part of the archaic sixth-century *chora*, then the sites with indigenous pottery may be sites inhabited by natives where black-glazed pottery came into use. A situation in which indigenous farms coexisted with Greek ones in the sixth-century *chora* would have serious implications for the question of the role of Greek and indigenous populations in the formation of the colony, as well as for the widely held belief that the *chora* was a culturally as well as politically homogeneous unit. The scanty inscriptional evidence from Metaponto (principally the Theages dedication in the urban Sanctuary of Apollo: "Theages, son of Burros," carved on the hind leg of a sphinx) testifies to the presence of Hellenized *indigeni* among the citizenry at least as early as 500 B.C.[38]

When did the large-scale settlement of the *chora* take place? For this, the survey can provide an unambiguous and compelling answer. Compare the sparse settle-

ment of the first half of the sixth century with that of the second half (fig. 18; the black squares indicate farmhouses). Although in the earlier period the sites are few, the prosperity of Metaponto is evident in the building of a monumental center, of the second phase of Temples A, B, and C, and of the stone *ekklesiasterion*, already in existence around 550.[39] As the territory grew, so did the need for centralized control symbolized by these structures. Citizenship acquired greater value, and the social and political relationship between colonizer and colonized would have been correspondingly altered.[40]

By the second half of the sixth century the number of farms in the survey area had increased from 6 to 180, and it is very easy to discern the course of roads that ran up the valleys of the Bradano and the Basento. The last half of the sixth century sees the monumental center at its most splendid. I am inclined to think that most of the demographic increase took place at the end of the sixth century, perhaps aided by influxes of outsiders, including Greeks like Metaponto's most famous immigrant, Pythagoras, and also natives from the interior. The momentum of the late sixth century carried over into the fifth. By then there is a clear relationship between the farm sites and the country lanes that divided the *chora* into parallel strips—the so-called "division lines" discovered by

aerial photography and from the ground—as in our excavation in the Pantanello necropolis.[41]

This brings me to the final major source of information about the early colonists: their burials.

A question that was often on the minds of all involved in the exploration of the city and the *chora* of Metaponto was, Where are the graves of the earliest settlers? Neither the necropolis associated with "Incoronata greca" nor that of Andrisani has yet been located. Around the colonial city, salvage excavations of groups of tombs, as for example at Crucinia,[42] have revealed a small number of burials with Middle and Late Corinthian pottery dating to the early sixth century, but nothing earlier. If, as I have maintained, the major colonial effort began about 600 rather than in 640/630, these would be the earliest burials of the site after it was resettled by the Achaeans sent by Sybaris.

Beginning in the fall of 1982 the University of Texas excavation team began to uncover an undisturbed area of burials at Pantanello (fig. 19).[43] By the time work was suspended in 1986, 320 burials and 43 ceramic deposits had come to light. They

19. Necropolis, Pantanello, plan, University of Texas excavations

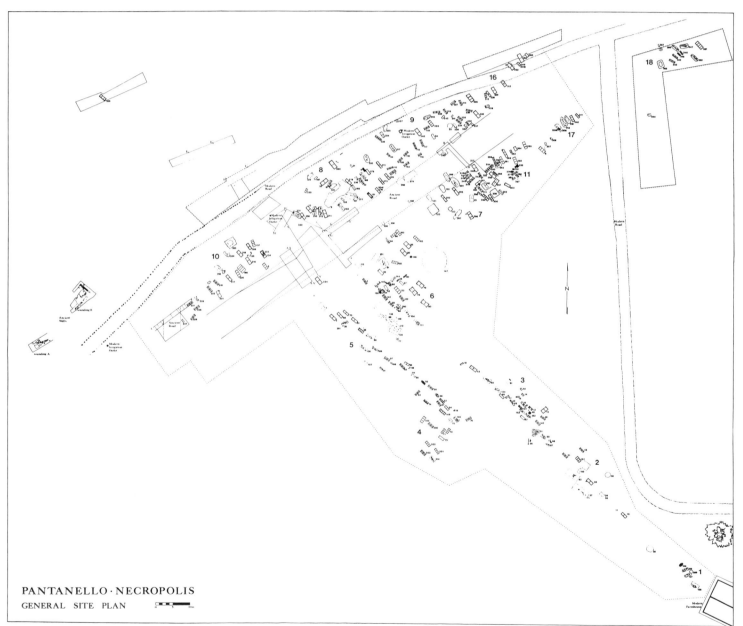

PANTANELLO · NECROPOLIS
GENERAL SITE PLAN

20. "Colonial" ware hydria, from Ceramic Deposit 289, necropolis, Pantanello, late seventh century B.C., University of Texas excavations

21. Late Corinthian aryballos, from Tomb 276, necropolis, Pantanello, c. 580 B.C.

document the changing burial customs of the *chora* of Metaponto from the early sixth century to the early third century, as no other site has done. The earliest evidence from Pantanello comes not from a burial but from a ceramic deposit (fig. 20). This banded "colonial" hydria is very early indeed, and for now unique outside seventh-century Incoronata or Andrisani. At this distance, 3.5 km from Andrisani and 5 km from Incoronata, it is truly isolated. I believe this is further tantalizing evidence for a dispersed, mixed settlement of the *chora* as early as the late seventh century.

The earliest securely dated burials are earthen graves with the body in supine position, arms at the side. A single vessel constitutes the grave goods. The Late Corinthian aryballos from Tomb 276 was made about 580/570 (fig. 21). This group of three burials (and traces of others in ceramic deposits) is contemporaneous with other small clusters, at Crucinia near the site of Metaponto and at San Biagio farther up the valley.[44] It would not be too fanciful, I think, to suggest that these burials reflect a population dispersed in hamlets, or *komai*—or in occasional isolated farmhouses, as the survey results indicate—and that a center, with sanctuary area, agora with public structures, and residential quarter, had begun to take shape. A true urban setting, however, with strict zoning, separated architecturally and culturally from the surrounding territory—in short the classic polis—still lay in the future.[45]

All the early sixth-century burials at Pantanello line up along the north side of what was to become a major road (fig. 22). Already at this date there is evidence of planning in the necropolis. New burials do not cut into earlier ones and seem on the whole carefully sited. Graves must have been marked, some with large vessels like the Attic crater of about 530 whose fragments were found in a ceramic deposit.

On the whole there is little activity in the necropolis in the middle years of the century, but this changes markedly about 500 with, again, a limited number of burials, this time in sarcophagi. The quantity and quality of the grave goods—for example, from Tomb 292 (fig. 23)—and above all the stone container illustrate the growing prosperity of the countryside. The burials are now located on both sides of the ancient road, in what took shape, in the succeeding century, as orderly family plots. In contrast to the situation later in the fifth century, burial here seems to have been restricted to the new, rural elite.

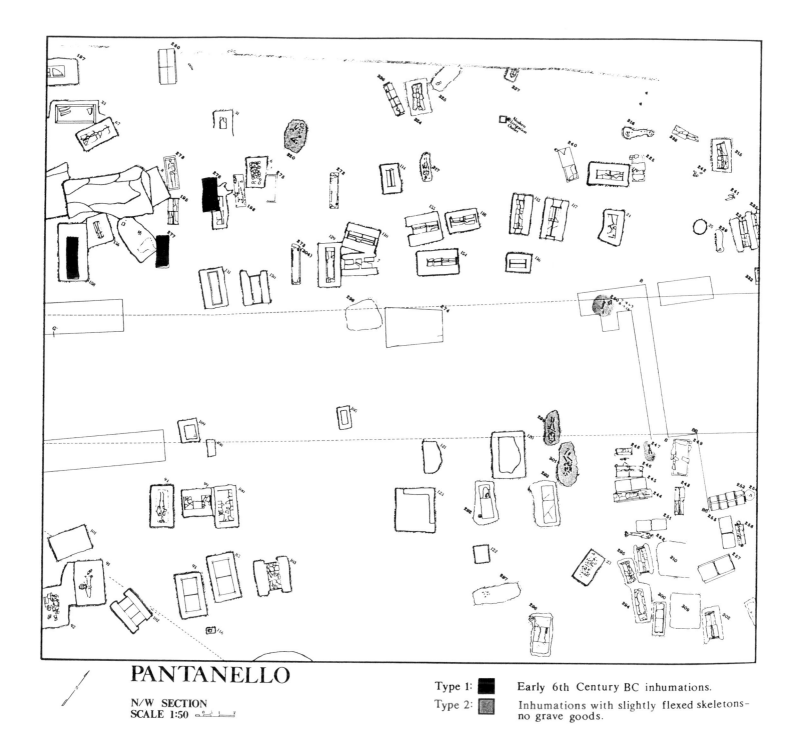

PANTANELLO

N/W SECTION
SCALE 1:50

Type 1: ■ Early 6th Century BC inhumations.

Type 2: ▨ Inhumations with slightly flexed skeletons—no grave goods.

Right beside the sarcophagi, however, within the confines of a family plot, are two very different burials, in earthen graves and without grave goods, and therefore undatable by conventional methods (fig. 21). The Radiocarbon Laboratory at the University of Texas has succeeded in dating the bones themselves, with considerable precision. There is a 50 percent probability that they are contemporaneous with Tombs 292 and 293, and a 30 percent chance that they antedate those burials. What is unusual about these inhumation burials is that the skeleton is not supine, but in a slightly contracted position—the standard burial position for the indigenous pre-Greek population of the area.[46] There is a good probability that we

22. Necropolis, Pantanello, detail of plan: burials of early and later sixth century B.C., and contracted burials

23. Grave goods from
sarcophagus of a young
man (?), Tomb 292,
necropolis, Pantanello,
shortly before 500 B.C.,
including Attic black-figure
hydria by Nikoxenos
Painter and lekythos by
Edinburgh Painter
Photograph: Chris Williams

have here a mixed burial plot. The lack of grave goods could point to a subaltern status for the contracted individuals. These *indigeni* might thus bear witness to the strife between Greeks and Oenotrians of the interior of which Antiochus speaks. After the founding of the second settlement, the territorial ambitions of the colonists made conflict inevitable, but indigenous slaves may also have come into the territory, not as spoils of war but as items of commerce between Metapontines and Oenotrians.

Such a mix of Greeks and their indigenous servants has been argued in the necropolis at Pithekousai[47] as well as at nearby Siris.[48] But there is also a probability, not quite so good, that the indigenous burials here preceded the Greek, and this would have even more interesting implications—namely, that the necropolis area was first used by an indigenous or a mixed population, as the hydria mentioned earlier indicates. Continuity of this sort would tell us something about the ethnic composition of the population of the Metapontine countryside. The growth of Metaponto, like that of Sybaris, would have depended at least in part on the ready assimilation into the citizen body of the native populations resident in the countryside.

During the first half of the fifth century large stone tombs continue to be placed along the east-west axis of the necropolis, but they are not the only ones. There are more modest tile tombs, and also infant burials begin to appear. The finest vessels are still of Attic manufacture. The tomb of a woman in her early thirties contains a mirror with an incised scene of the Death of Actaeon that is unique, as far as I know, in Greek art of this period (fig. 24). From a tomb of the second quarter of the fifth century comes a lekythos by the hand of the Berlin Painter. Fine or unusual grave goods are not restricted to the possessors of stone tombs. One man in his forties was accompanied by his drinking cup, probably the work of the Agathon Painter, and by his tortoiseshell lyre (fig. 25). His extraordinarily well-preserved skeleton lent itself to an attempt at facial reconstruction.

The physical anthropological study of the human remains from the Pantanello necropolis has furnished much information of a demographic nature and also information about the composition of family groups, the possible genetic links between individuals, and the physical traces of disease. Disease did not spare the occupants of the grander tombs, for example, the woman buried in a plaster-lined and frescoed tomb (fig. 26).[49] Accompanying her were a fine mirror and pyxis by the Pisticci Painter, the earliest of the Italiote

vase painters whose work begins to replace Attic imports about 440 (fig. 27). This tomb also contained a distinctive sort of fibula—one that is not typically Greek at all, but is found in indigenous tombs of the interior to the north and east of Metaponto (fig. 28). Could the occupant of this tomb, and several other women buried here, have preserved in the custom of their funeral dress an indication of their origin? Studies of other Western Greek necropolises, such as that at Pithekousai, have found a similar preference for appar-

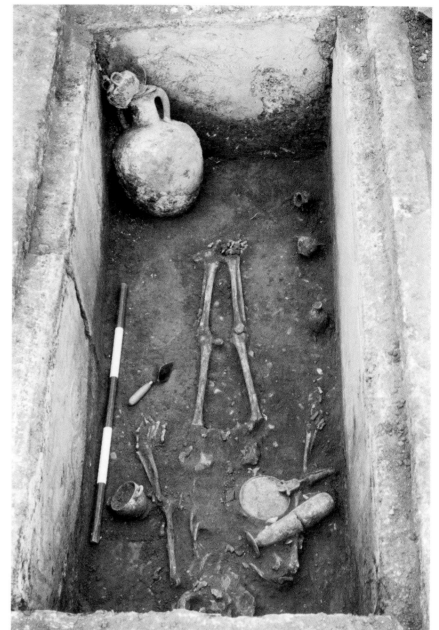

24. Bronze mirror from Tomb 350, necropolis, Pantanello, c. 450 B.C., detail: Actaeon attacked by his own hunting dogs

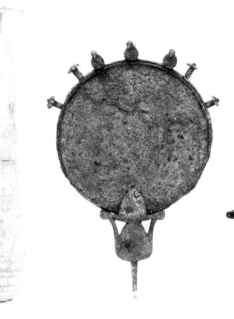

25. OPPOSITE BOTTOM: Portion of grave goods of forty-year-old man, necropolis, Pantanello, c. 450 B.C., including tortoiseshell sound box of a lyre, bronze strigil, and skyphos by Agathon Painter

26. OPPOSITE TOP: Opening of Tomb 354, necropolis, Pantanello, third quarter of fifth century B.C., the only chamber tomb in the necropolis to have frescoed walls
Photograph: Ben Vaughan

27. Grave goods from burial of a woman in her thirties, Tomb 354, necropolis, Pantanello, third quarter of fifth century B.C., including ceramic vessels, two alabastra, bone-handled bronze mirror, and red-figure *lebes gamikos* by Pisticci Painter

28. Fibulae from Tomb 354, necropolis, Pantanello, third quarter of fifth century B.C.

ently non-Greek fibulae and have come to just this conclusion.[50]

A clearer indication still of indigenous origins is the contents of a plaster-lined earthen grave a few years later in date. They consist of a fine Italiote red-figure hydria and a strigil—quintessentially Greek—but around the thighs of the skeleton is a belt of the sort found before now only in the native cemeteries of the interior of Lucania. Elsewhere I have argued that the sudden population explosion of the late fourth century B.C. was due to an incursion of Lucanians, who were peaceably added to the citizen body of Metaponto to restore its declining numbers, to cultivate the *kleroi*, and to bear arms in defense of the *chora*.[51]

What all this evidence shows is the stages of an evolving relationship between the colonizer and the colonized, which began in the *chora* of Metaponto before formal colonization, in a collaborative or mutually beneficial way; at Incoronata and Andrisani; and perhaps also in isolated farm sites. The agricultural practices of this phase were not materially inferior to those imported by the colonists. Current models are based too much on ancient texts, which emphasize Greek cultural superiority, and on modern theories of imperialist exploitation. As a result they have misunderstood this, as they have the later period. After the Achaean *ktesis*, or

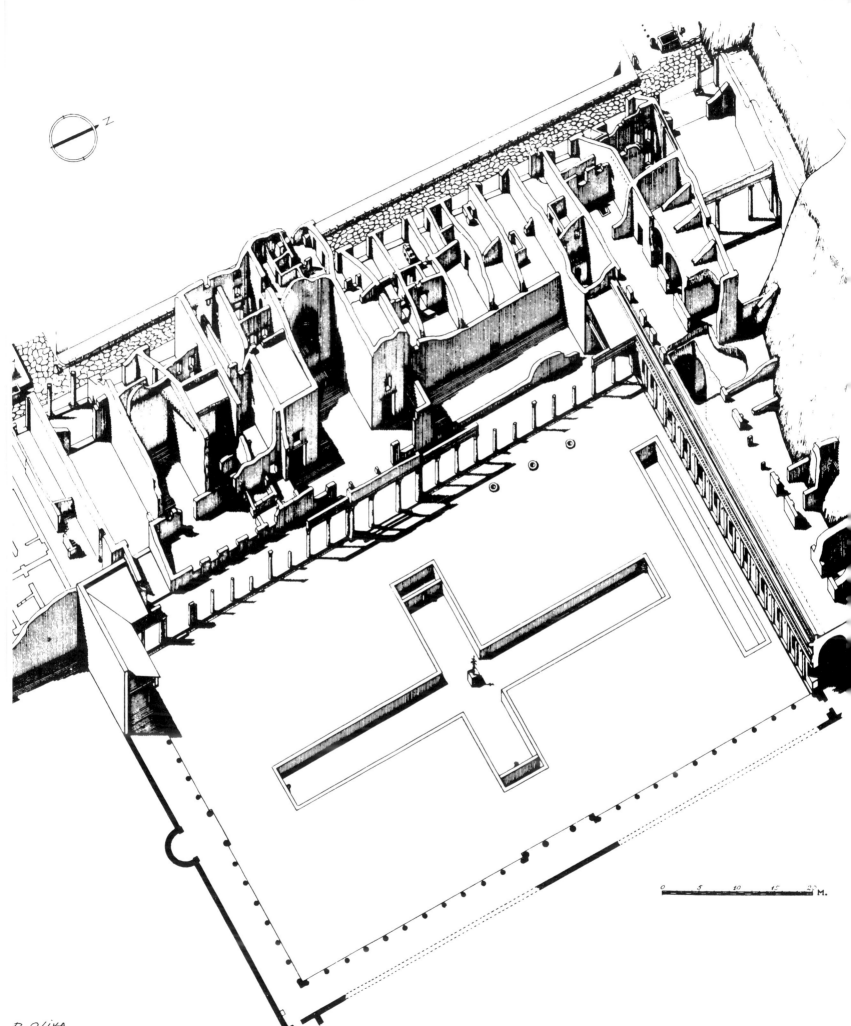

R. OLIVA

FIKRET K. YEGÜL
University of California, Santa Barbara

The Palaestra at Herculaneum as a New Architectural Type

*Of its very nature, [Roman architecture]
not only contained the specific action
it was framed for; it required it, prompted it,
enforced it.*

Frank Brown

In size, scope, and architectural character the palaestra at Herculaneum is an unusual building. Dating to the first half of the first century A.D., it is an attempt to reinterpret the traditional architecture and the educational functions of the Greek palaestra through forms more appropriate and meaningful for Roman society. It may even be viewed as a step toward the creation of a new architectural type, but a type that was destined for little growth and left no progeny.

Isolated between two east-west streets and a major north-south one, the palaestra at Herculaneum occupies a very large portion of the northeast quadrant of the city—a vast block roughly 118 x 80 m (fig. 1). The architectural character of this block, especially its western wing facing Cardo V (fig. 2), is significantly different from the rest of Herculaneum, Pompeii, or other Campanian towns of the first century A.D. Instead of the usual houses of the atrium type, or the luxurious urban villas with peristyles, the west wing of the palaestra block at Herculaneum was developed as a row of high-rise apartments and foreshadows the dense urban pattern of second- and third-century Rome and Ostia.

The palaestra proper consists of a large rectangular quadriporticus outlined on three sides (east, west, and south) by Corinthian colonnades and by a Tuscan portico of engaged columns defining the window wall of a cryptoporticus on the fourth side. The central area is divided into four quadrants by the intersecting arms of a gigantic, cross-shaped pool (55 x 31.5 m). It was planted with orderly rows of trees for shade. A monumental columnar propylon on the west side provides the formal entrance into the complex. Although the south and east sides and much of the central area of the palaestra still lie under a heavy burden of lava, the extensive tunneling of the Bourbons in the eighteenth century and the comprehensive archaeological investigations between 1938 and 1956 under the direction of Amedeo Maiuri have made it clear that only the west and north sides of the palaestra were developed architecturally (figs. 3, 4).[1]

The north end of the west wing is occupied by a public hall (the Aula Pubblica) of monumental dimensions positioned exactly on the axis of the *decumanus maximus*, at the end of the long prospect from the forum. This hall is connected directly to the upper and lower levels of the palaestra. It is entered from the street through a templelike porch with two columns *in antis* (fig. 5). The vast interior hall (11.25 x 26.60 m), paved with black marble, is divided unequally by a screen of two columns between brick piers. Since no traces of a masonry roof were found (and the walls are too thin to support a vaulted span of more than 11 m), it must

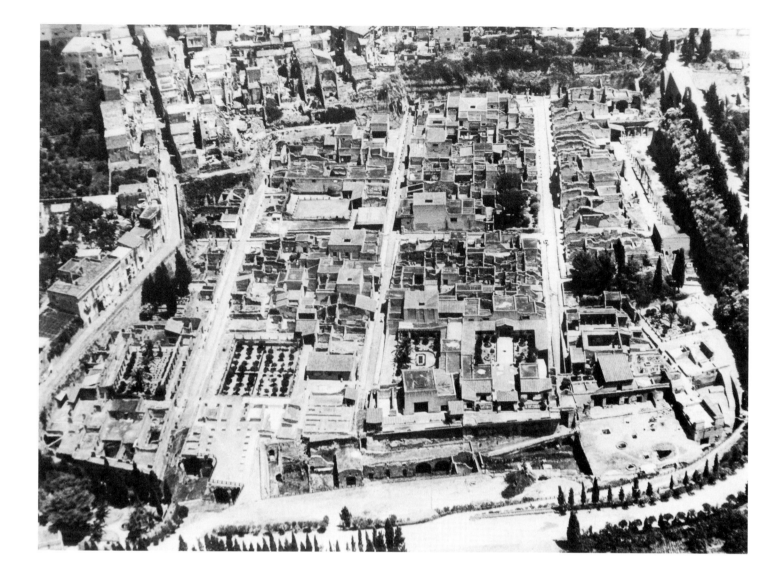

have been covered by a wooden roof. Walls preserved to a height of 6–7 m were revetted in marble at orthostat level (c. 1.20 m); above, Third Style architectural schemes in stucco were represented.

The units of the west wing were planned and built so homogeneously that it requires scrutiny to isolate the rooms intended to serve the palaestra from the rows of commercial and residential units facing the street, except for the larger size and conspicuous bearing of the halls on the palaestra side. The entire structure is built of concrete, the walls faced with largish, irregular reticulate work in tufa and sections of regular *opus reticulatum* or isodomic courses of small, squared tufa blocks. There is also some *opus mixtum*

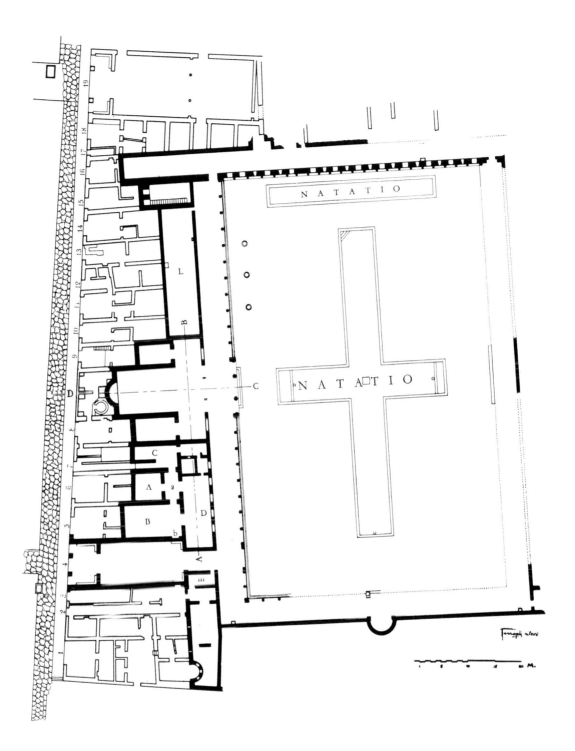

of tufa block construction alternating with brick courses. Arches are used sparingly; door and window openings have flat lintels in wood. The tight structural fabric of parallel walls is sewn together and developed in height by a series of concrete barrel vaults. The entire west wing, rising to three or four floors (c. 20 m) represents a unified structural whole, apparently the result of a single design conception. It can be dated to the early first century A.D., probably to the years immediately after

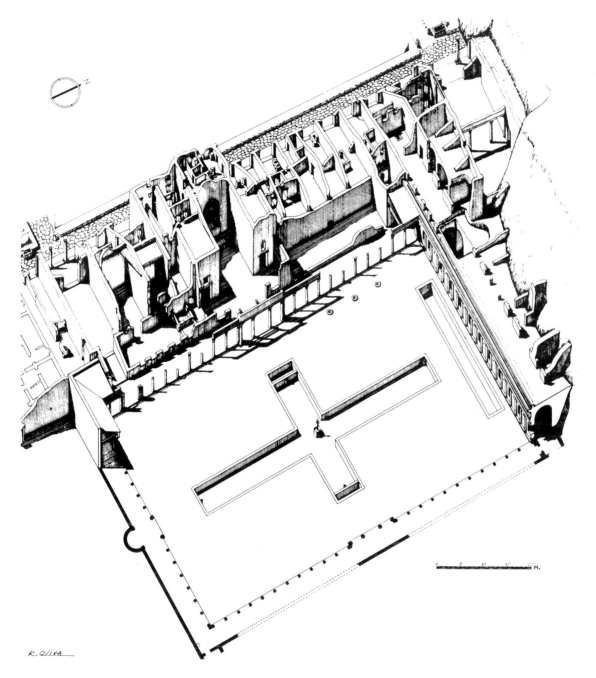

R. OLIVA

the Augustan era. The north, or cryptoporticus, wing, on the other hand, is believed to have been constructed somewhat earlier, but it shares the same alignment as the rest of the palaestra and the same character of planning. It appears that the whole structure suffered considerable damage during the earthquake of A.D. 62, and some of the walls, especially the *tabernae*, had been dismantled deliberately for renovation and restoration before the final catastrophe.[2]

The palaestra is entered through a lofty propylon with two Corinthian columns *in antis* (figs. 2, 3, 4), similar to the entrance porch of the Aula Pubblica, followed by a large rectangular vestibule (7.75 x 21.65 m). As with the Aula Pubblica, the urban significance of the entrance is emphasized by its templelike porch and its position at the end of the long visual axis created by a major east-west street. A secondary entrance at the north end of the west wing negotiated by stairs overcomes the 4 m

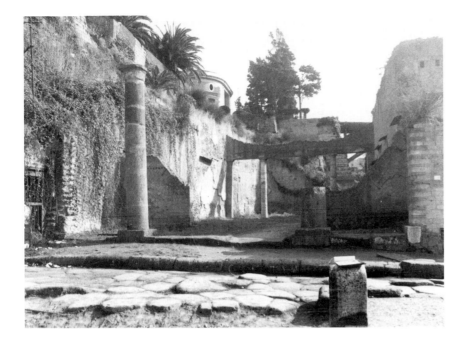

5. Aula Pubblica of palaestra, Herculaneum, first half of first century A.D., view from *decumanus maximus*
Author photograph

open onto an oblong vestibular area common to all, which is separated from the ambulatory of the western colonnade by a light screen wall. The tripartite design is mirrored by the generous openings of the screen wall, as well as by the tripartite pattern of the handsome opus sectile marble floor. The architectural prominence of the ensemble is enhanced by the tetrastyle porch projecting from the western colonnade in front of the apsidal hall (fig. 8). Featuring two very widely spaced columns between L-shaped, three-quarter-engaged piers, the porch is taller by a full meter than the regular colonnade and must have been crowned by a pediment.[5]

The apsidal hall was covered by a barrel vault spanning 7.7 m and reaching nearly 13 m at the intrados—an unprecedented height among the vaulted interiors of Herculaneum and Pompeii and quite uncommon anywhere during this period.[6] The vaults of the side halls, preserved intact, are much lower, keeping to the second-story level of the commercial units around them (figs. 6, 9). The vestibular area must have been roofed in wood; it kept a relatively low roof line below the towering central hall (fig. 10).[7] The floor and walls of the apsidal hall displayed a decoration of polychromatic splendor uncommon in an ordinary public building: marble pilasters and cornices over marble orthostats articulated the wall surface, and the upper zone of the walls was rendered in dazzling Fourth Style architectural schemes in paint and stucco. A spacious apse (W., 4.10 m; H., 6.20 m) provided a powerful architectural focus for the lofty hall. The apse must have been designed for a statue or statue group, but no trace of this has been found (an image of Hercules would be likely, considering the nature of the building and the special importance of the deity to Herculaneum). Perhaps the statue was not in place yet since the building was under restoration. A large but elegant marble altar table with eagle-claw legs (identified as *mensa agonistica* by Maiuri) was found intact in front of the apse, attesting the use of this hall for religious ceremonies connected with agonistic competitions and possibly with the imperial cult.[8]

difference between the street and the palaestra, but it was later blocked (15). A monumental doorway (3 m wide and 4.2 m high) connects the propylon to the barrel-vaulted entrance hall. The vault with its painted decoration was discovered intact but was later destroyed by the extensive and senseless tunneling activities of the eighteenth century. It was decorated in imitation of a starry sky with eight-rayed stars painted red, olive green, and dark yellow over a light blue background; Weber counted all of 966 stars![3] The walls, still substantially well preserved (south wall c. 4 m high, north wall c. 9 m high), carried stucco reliefs of elaborate architectural schemes. The columnar entrance, the monumental proportions, and the lavish decorations of the vestibule misled the early investigators into identifying it as a temple dedicated to the *mater deum* (the mother of the gods), an identification supported by the discovery of an inscription recording the restoration of this temple by Vespasian after the earthquake of A.D. 62.[4]

The most imposing architectural element of the west wing, and of the whole complex, is a lofty apsidal hall, or open exedra, flanked by a pair of rectangular halls positioned on the east-west axis of the building (figs. 6, 7). The triple halls

The decoration of the side halls was more modestly conceived. The floors are covered by plain white mosaic. Simple plastered wall surfaces are divided into rectangular panels that depict figurative scenes or decorative elements. The central panel in the larger, southern hall shows a scene of conviviality: a swarthy, athletic youth and a pale young woman share a *kline* (probably in a triclinium or banquet hall), while an attendant offers an open box filled with jewelry and personal items.[9]

Flanking the tripartite central group and occupying almost the entire length of the western ambulatory are two oblong halls (D and L; see figs. 3, 4). These halls were originally connected to the vestibular area through large doors, which were later blocked. They are curiously lacking in architectural features, apparently because they were in the process of major restoration and rebuilding at the time of the eruption; the northern hall (6.75 x 23.75 m) was found filled with debris to a height of 1 m. The south Hall D, which seems to have retained some of its original features, was lit by five windows that opened directly into the ambulatory. Immediately behind (west of) the long south hall and connected to it by a small hallway (a) is a suite of three rooms (A, B, and C; see fig. 3), which could be reached directly from the street by a long corridor (7). Hall B, the largest and covered by a barrel vault, displays a handsome tessellated black marble floor similar to that of the apsidal hall. Its walls are decorated with lively Third Style motifs on a black background: slender column shafts, plant stalks, candelabra, and festoons.

The full length of the western colonnade and two columns of the southwest corner, as well as short lengths of the south and east colonnade stylobates, have been investigated.[10] These define a central rectangular area of c. 77.8 x 47.6 m open to the sky. The floor of the central area is earth; the surrounding ambulatories are paved in *signinum*. The shafts, bases, and capitals are constructed in alternating rows of tufa and brick, finished in white stucco. The columns stood on a stylobate of Nocera tufa elevated some 0.50–0.60 m above the central area. A continuous open

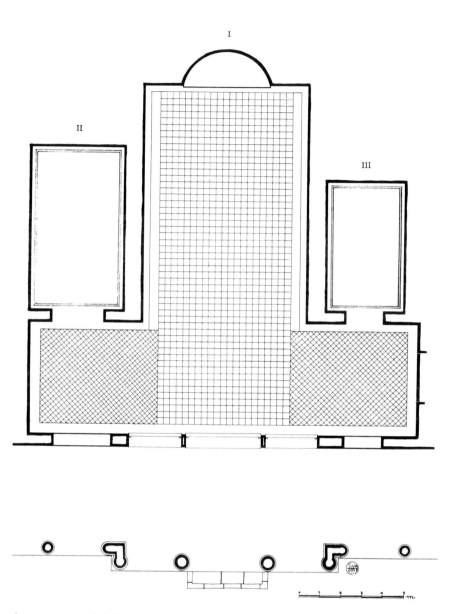

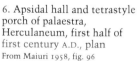

6. Apsidal hall and tetrastyle porch of palaestra, Herculaneum, first half of first century A.D., plan From Maiuri 1958, fig. 96

drainage canal follows the line of the stylobate, except along the north. The columns are 3.68 m high (with base and capital) and regularly 2.25 m apart at the centers (3.44 m between the middle columns of the tetrastyle projection of the west side). They carried wooden architraves supporting stucco-covered entablatures of tufa and brick. The soffit of the colonnade was decorated with painted panels of wood imitating coffers (fig. 8).[11]

The north wing of the palaestra displays unique features. The most remarkable of these is a barrel-vaulted cryptoporticus occupying the entire north side and sup-

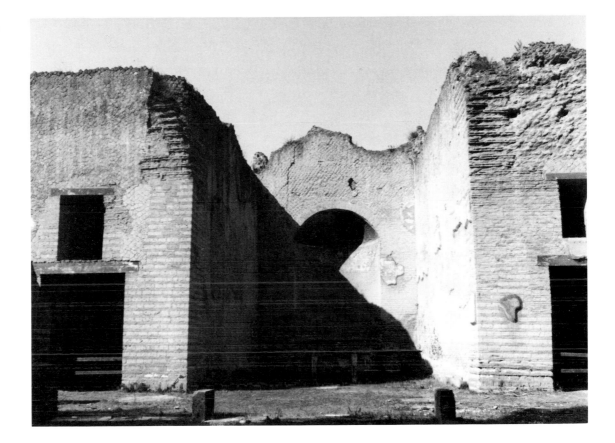

7. Apsidal hall of palaestra, Herculaneum, first half of first century A.D., view toward apse and altar
Author photograph

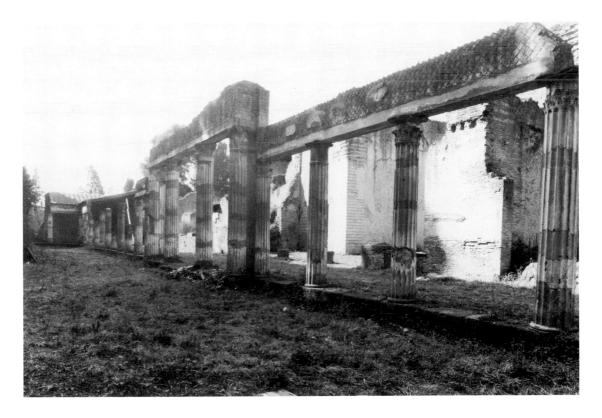

8. West colonnade with tetrastyle porch of palaestra, Herculaneum, first half of first century A.D., view toward southwest
Author photograph

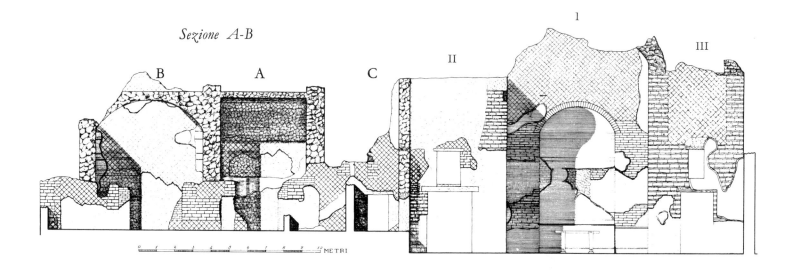

Sezione A-B

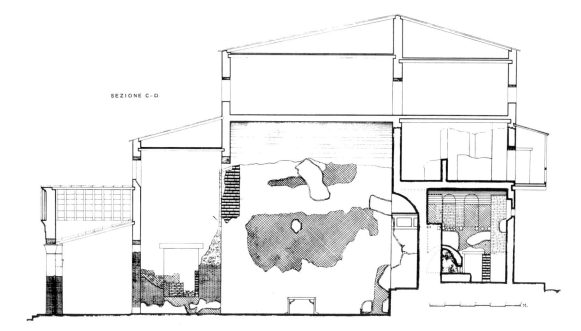

SEZIONE C-D

9. Apsidal hall of palaestra, Herculaneum, first half of first century A.D., north-south section (section A-B of fig. 3)
From Maiuri 1958, pl. 11

10. Apsidal hall and east colonnade of palaestra, Herculaneum, first half of first century A.D., east-west section (section C-D of fig. 3)
From Maiuri 1958, pl. 12

porting a spacious loggia built against the rising ground (figs. 11–13). The façade is designed as a *porticus fenestrata*, with large rectangular windows and small port-holes alternating between engaged columns. The latter are constructed in isodomic tufa blocks and brick and carry simple, square Tuscan capitals. They match almost exactly the height of the palaestra colonnade (3.60 m, compared to 3.68 m) and continue the regular cornice line profiled in stucco. The continuation of the cryptoporticus cornice behind the west colonnade indicates that the con-

struction of the north wing preceded the others (fig. 12). It appears that originally the row of engaged columns projected from short piers (or wall sections), leaving considerably more open space between them; at a later date (perhaps after the earthquake of A.D. 62), these spaces were partially blocked and the windows installed. Access into the cryptoporticus was restricted at its extremities by doors that opened into the west and east ambulatories. Stairs on the west end connected the cryptoporticus with the upper level of rooms and the Aula Pubblica (fig. 13).

11. North wing
(cryptoporticus) of palaestra,
Herculaneum, first half
first century A.D., showing
spectators' loggia and deep
rectangular pool
Author photograph

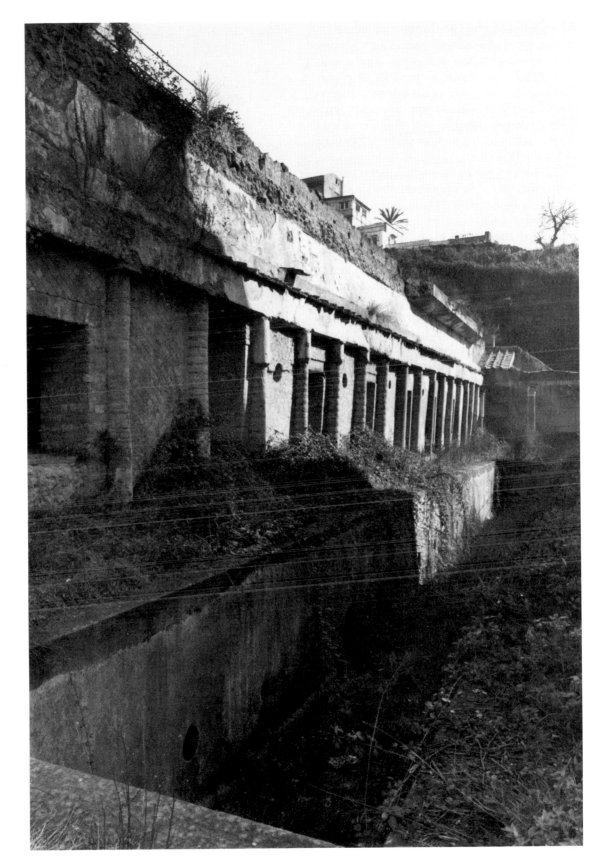

complex in Herculaneum were suffi-
ciently clear to be described *generically* as
palaestral. Maiuri could also see obvious
connections between the palaestra at
Herculaneum and the Great Palaestra at
Pompeii (fig. 16), a gigantic colonnaded
enclosure (c. 107 x 141 m) surrounded on
three sides by wide porticoes and located
immediately west of the amphitheater.[16]
The central area was planted with two
rows of large shade trees on three sides of a
very large swimming pool following the
colonnade (22.2 x 34.5 m; D., west end, 1.0
m, east end, 2.60 m). Besides the latrines
on the south side, the only indoor space
connected with the palaestra is a group of
three relatively small rooms located on the
center of the west side; the middle unit
was probably the cult exedra, displaying a
statue base placed against the back wall,
directly opposite the entrance. It opened
into the western ambulatory through two
columns *in antis*; the corresponding posi-
tion on the western colonnade was marked
by a pedimented porch carried by a pair of
engaged piers.[17]

Beyond general similarities, however,
the complex at Herculaneum is a very dif-
ferent building from the Great Palaestra at
Pompeii. Despite its lack of functionally
dependent spaces prescribed for the
"Greek gymnasium" by Vitruvius (5.11),
the Great Palaestra at Pompeii can be
broadly compared to dozens of other
palaestrae and gymnasia from Greece and
Asia Minor. Like them, it belongs to the
family of trabeated peristyle buildings in
the Hellenistic tradition. The palaestra at
Delphi, dated to 334 B.C., is perhaps the
earliest example of this family, with
colonnaded porticoes surrounding all four
sides of a courtyard. In Delphi only the
south and west sides of this courtyard
contain rooms; the large hall (E) on the
south must have been the *ephebeum*, the
clubroom of the young men, while the
small chamber featuring a porch with two
columns *in antis* appears to be a cult exe-
dra. The palaestra is connected to an
elaborate cold-water washing area next
door, identified by a row of marble basins
and a large circular pool; running tracks
(*dromoi*) are arranged separately on a
higher terrace. A good example of the

fully developed palaestra belongs to the
third century B.C. gymnasium at the pan-
Hellenic Sanctuary of Zeus at Olympia
(fig. 17). In this building all four sides of
the quadriporticus are surrounded by
rooms and halls. The *ephebeum* is
undoubtedly the large oblong hall in the
middle of the north side, and the *apody-
terium*, or changing room, the long colon-
naded hall occupying the south wing
between the double entrances. Washing
facilities are restricted mainly to a small
room (*loutron*) occupying the northeast
corner. Simpler arrangements met the

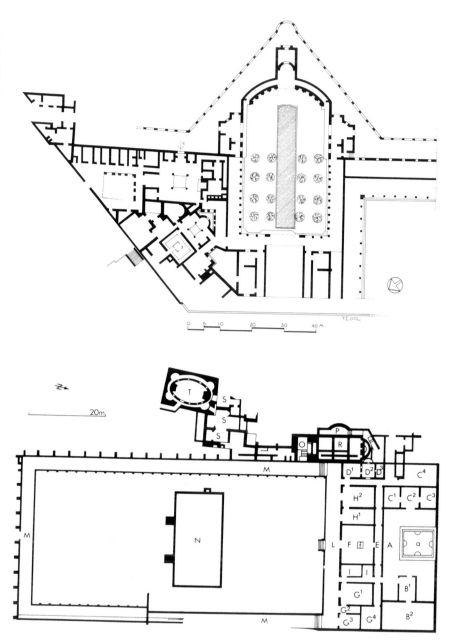

14. Villa San Marco, near
Stabiae, late first century
B.C., plan
From Michele Ruggiero, *Degli scavi
di Stabiae* (Naples, 1881), pls. 1, 2

15. Villa of Horace, Licenza,
second half of first century
B.C., plan
From Harald Mielsch, *Die römische
Villa* (Munich, 1987), fig. 35

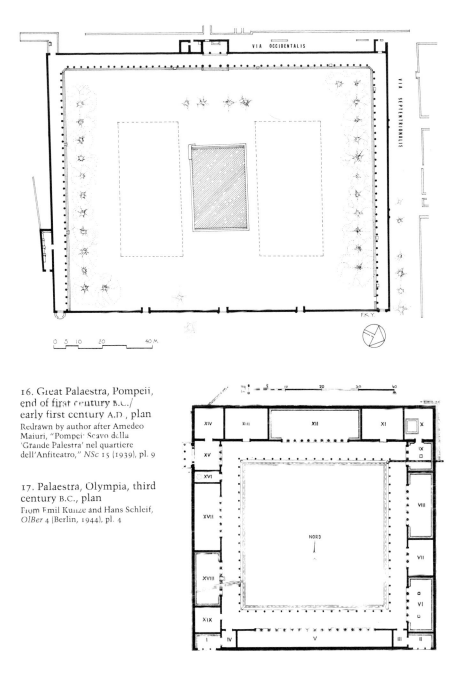

16. Great Palaestra, Pompeii, end of first century B.C./ early first century A.D., plan
Redrawn by author after Amedeo Maiuri, "Pompei: Scavo della 'Grande Palestra' nel quartiere dell'Anfiteatro," *NSc* 15 (1939), pl. 9

17. Palaestra, Olympia, third century B.C., plan
From Emil Kunze and Hans Schleif, *OlBer* 4 (Berlin, 1944), pl. 4

needs of Priene and Miletus, where only one side of the peristyle was architecturally developed. The same side is also emphasized by making the colonnade double, as at Priene, or by making it taller than the rest (a so-called Rhodian colonnade), as at Miletus.[18]

A palaestra or gymnasium conceived independently of a bath, intended primarily for athletic and educational aims— like the Hellenistic establishments just mentioned—was a very rare social and

architectural occurrence in Roman Italy. Vitruvius was right to begin the description of the Greek palaestra with the simple observation that "the building of palaestrae is not usual in Italy" (5.11.1). There may be many explanations for this, but one of the most cogent reasons appears to be the important difference between the two societies in the concept of education and the attitude toward athletics. Roman education from its inception did not develop along the same lines as the Greek gymnasium education: it lacked organization and national character, and it did not crystallize around an institution with a specific architectural form and individuality.

Early Roman education took place within the family and was shaped by custom. Teachers at all levels had to find teaching locations that varied from street corners (Quintilian refers disparagingly to *trivialis scientia*, that is, "knowledge gained at street corners") to simple spaces under colonnades and arcades, or lofts, mezzanines, and balconies above shops (*pergulae* and *maeniana*). The privilege of teaching in prestigious public spaces, such as atria, scholae, or exedrae, some related to imperial fora, was limited to a few select philosophers or rhetoricians who occupied the top end of the educational echelon.[19]

The use and enjoyment of the palaestra as a public institution dedicated to the pursuit of athletics and the spirit of competition was severely limited. Livy reports that Scipio Africanus, the hero of the Punic Wars, scandalized the Romans by visiting the gymnasium in Syracuse in 204 B.C.[20] The Greek love of sport appeared to be an aimless activity to the practical-minded Romans. Roman athletics were primarily aimed at military fitness. Hunting, riding, swimming, and military drill with arms were generally held in high esteem; organized activities, in the spirit of pure competition, as practiced in the gymnasium were not.[21] Martial advised a youth that it would be better to dig a vineyard than waste strength on the "silly dumbbells."[22] Even when, through the efforts of ambitious politicians or philhellenic emperors, Greek-style games were introduced to Italy, professional athletes were brought from

Third, the vertical emphasis at Herculaneum is expressed and enhanced not only by tall and monumental volumes, but also by the use of a multistoried scheme (figs. 9, 10, 13). This is partly in response to the topography, which inspired the creation of terraces and galleries, but partly also in response to the desire to maximize commercial use along the premium street frontage on Cardo V in order to generate revenue (much the same impulses were starting to determine the urban shape of Ostia and Rome). Although the Hellenistic builders, using more conservative techniques, could adapt their buildings to topography in creative and masterful ways—observe sites like Pergamum, Aigai, or Rhodes—there are few, if any, palaestrae exploiting a multistoried arrangement around an open quadriporticus (or triplex porticus). The only exception may be the gymnasium at Pergamum with its majestic terraces straddling the steep hillside (fig. 21).[30] Yet careful observation of the Pergamum gymnasium will reveal that the vertical, multistoried effect is the result of successive and superimposed terracing. The palaestrae built on these terraces are composed of traditional single-story elements with timber roofs and low, horizontal profiles, additive rather than integrated wholes. This is an architectural attitude fundamentally different from that responsible for creating the palaestra complex at Herculaneum, and even less the great sanctuary of Fortuna Primigenia at Palestrina.

Vertical emphasis, multistoried integration of volumes, monumental halls covered with vaults, full utilization of the sloped site: all these were made possible by the mastery of concrete construction. Concrete and the kind of dynamic manipulation of space it made possible underlie many of the architectural characteristics mentioned above that set the palaestra at Herculaneum apart from its Greek and Hellenistic forerunners. The structural exigencies presented by the steep site and the advantages of having abundant supplies of pozzolana furnish some of the important technical reasons why Herculaneum, along with Baiae, represents the forefront of development in the mature

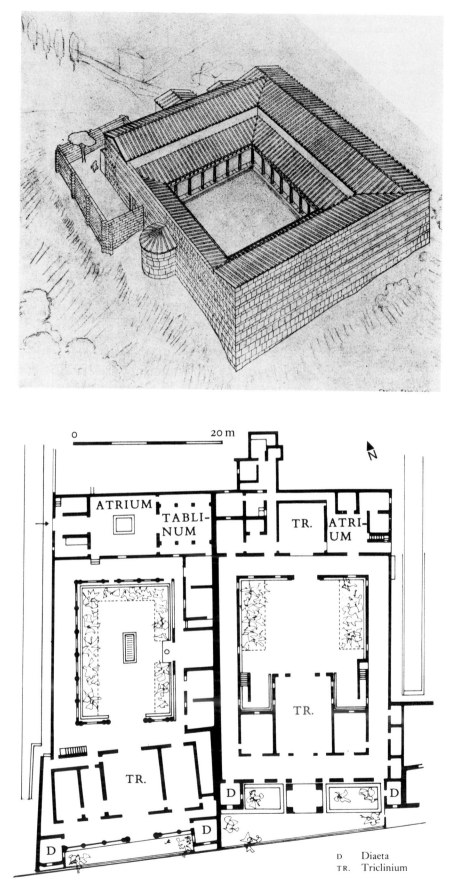

D Diaeta
TR. Triclinium

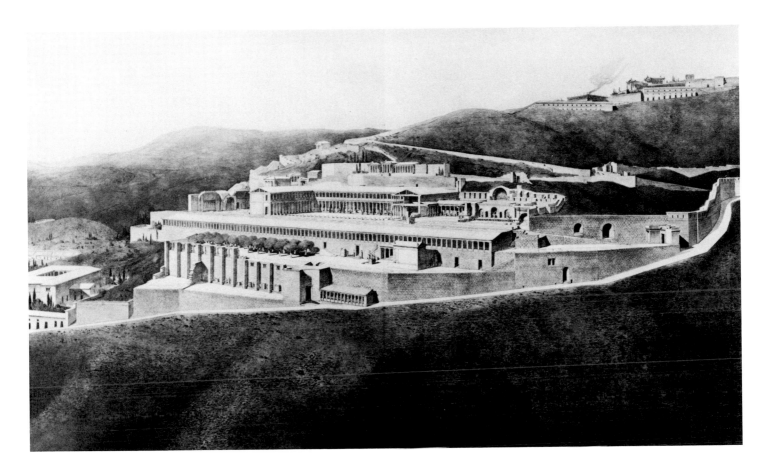

19. Heroon, Calydon,
c. 100 B.C., plan
From Ejnar Dyggve, Fredrik
Poulsen, and Konstantinos
Rhamaios, *Das Heroon von
Kalydon* (Copenhagen, 1934), pl. 5

20. House of the Mosaic
Atrium and House of Stags,
Herculaneum, A.D. 62–79,
plan
From John B. Ward-Perkins, *Roman
Imperial Architecture* (New York,
1981), fig. 112

21. Hellenistic gymnasium,
Pergamum, early second
century B.C., restored
perspective
From Paul Schazmann, *Altertümer
von Pergamon* 6.1–2, *Das
Gymnasion* (Berlin, 1923), pls. 1, 2

application of Roman concrete. Equally important, however, is the established position of Herculaneum among the Campanian cities as an opulent community whose leadership in the arts must have been paralleled by an equally progressive outlook in architecture and construction.

Finally, the design of the north wing of the palaestra at Herculaneum displays several architectural elements that may be described as patently Roman in form and content. The most important of these is the loggia created over the cryptoporticus, offering an excellent view of the exercise ground and the pools (figs. 4, 11, 13). Accessible from both the street (*decumanus maximus*) and the lower palaestra level, connected directly to the Aula Pubblica, the loggia highlights the Roman interest in gymnastics as spectacle. It also indicates that the palaestra at Herculaneum, besides being a training ground, was conceived as a center for athletic competitions and related agonistic ceremonies. An elaborately designed spectators' tribunal would have been an alien concept to the Greeks

and has no place in the design of the traditional palaestra.

The cryptoporticus itself is a Roman creation. So is its closely related alternative, a vaulted ambulatory supported along one side by series of piers or pier-and-engaged-column clusters—the form that appears to have been originally used for the cryptoporticus wing at Herculaneum (figs. 11, 13). Both the cryptoporticus and the semi-open vaulted portico are anchored in the late republican architectural tradition. The former is a familiar element in domestic architecture, especially the suburban villa, often occupying one side of the garden peristyle. The latter may plausibly be compared to the porticoed terraces of late republican complexes, such as the Sanctuary of Fortuna Primigenia at Palestrina (c. 130–100 B.C.),[31] the temple of Hercules Victor in Tivoli (c. 55 B.C.; fig. 22),[32] and the Tabularium in Rome (c. 78 B.C.),[33] the last the locus classicus of the motif. In these examples, however, rows of engaged columns alternate with arches, an aesthetically more

refined and structurally more advanced version with important applications in the architecture of the later empire, such as the "Stadium" (also called the Hippodrome) of the Domus Flavia on the Palatine in Rome (fig. 23),[34] or the peristyle of the Piazza d'Oro of Hadrian's Villa in Tivoli.[35] The *porticus fenestrata* motif of Herculaneum, characterized by a flat architrave over engaged columns with windows or doors between, finds a close parallel in the Central Baths in Pompeii (A.D. 63–79), dating to the last phase of building in Pompeii, perhaps later than the Herculaneum palaestra by several decades (fig. 24). The motif was unquestionably popular during the late republic, as amply attested by the buildings around the forum in Palestrina, dated in the last decades of the second century B.C. The back (north) wall of the basilica was decorated with engaged Corinthian columns with elegantly detailed slender windows between them (fig. 25); the interior walls of the boxy apsidal hall (curia?) immediately to the east displayed a superimposed order of engaged columns over a continuous podium, alternating with tall rectangular niches.[36] Immediate and cogent comparisons can be drawn from the domestic architecture of Herculaneum itself: three sides of the upper level of the atrium of the Samnite House (a house of the pre-Roman period) have a blank wall articulated by rows of engaged Ionic columns (fig. 26); the cryptoporticus walls that surround the garden court of the House of the Mosaic Atrium have been treated as an elegant *porticus fenestrata* with large, square windows (fig. 27); the lower level of the wall supporting the southern extension of the House of the Telephus Frieze displays the motif in a strictly utilitarian context (the engaged columns here were created by the later filling of a colonnade).[37]

A palaestra of such exceptional size and luxury in a small city simply to serve the traditional functions of education and gymnastics would have been "unusual," perhaps unnecessary, even in Hellenized Campania. It seems logical to maintain, as Maiuri suggested three decades ago, that this establishment was created instead to serve the rapidly expanding needs of

22. Temple of Hercules Victor, Tivoli, mid-first century B.C., showing terrace substructures
Photograph: Fototeca Unione, Rome

23. "Stadium" of Domus Flavia, Rome, end of first century A.D., restored perspective
From Christian Huelsen, *The Forum and the Palatine* (New York, 1928), pl. 57

24. Central Baths, Pompeii, A.D. 62–79, *porticus fenestrata*
Photograph: Fototeca Unione, Rome

25. Basilica, Palestrina, end of second century B.C., north (back) wall
Photograph: DAI

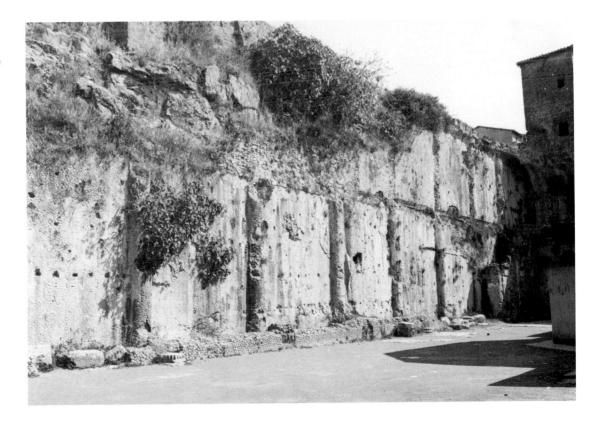

the Juventus, a prestigious paramilitary
youth organization unique to the Roman
world.[38] Instigated and encouraged by
Augustus, the Juventus was a very serious
attempt to incorporate Greek gymnastics
into Roman life and grew to be extremely
popular in Italy and the western prov-
inces.[39] It was, in a sense, the equivalent
of the *ephebeia* of the Greek east, with
greater political emphasis and perhaps less
universal appeal. The young men of the
upper social classes (like the *vereia
Pompeiana* of pre-Roman Pompeii) who
belonged to the *collegia iuvenum* spent
considerable time in the palaestrae, like
the Greek ephebes. In Rome, their train-
ing ground was the Campus Martius; in
Pompeii, it appears to have been the Great
Palaestra.[40] They also gave public perfor-
mances, competed in athletic games, and
took part in agonistic and religious cere-
monies. Processions, banquets, and social
events must have been an important part
of their activities. In Pompeii, a large hall
(III,3,6) on the Via dell'Abbondanza near
the Porta di Nocera has been identified
as their local club building, the Schola

Juventutis.[41] Besides serving as the training ground for the Juventus and offering a well-designed setup for the upper-class spectators to admire the performances of the privileged youth, the elaborate architecture and luxurious interiors of the palaestra at Herculaneum might have offered suitable accommodations for the club.[42] The importance of the activities of the *collegia iuvenum* in the civic and religious life of Herculaneum is attested by an inscription from a funerary altar located at the sacred precinct called Area Sacra. The inscription states that the leading citizen of Herculaneum, the proconsul Marcus Nonnius Balbus, was honored for his generous contributions toward the expenses of *ludi gymnici*.[43]

This remarkable building, featuring a strong and articulated axiality, large tree-shaded playgrounds, and tall vaulted halls, must have offered an ideal setting, functionally and symbolically, for the activities of the Herculanean Juventus. It is a building that mirrors the larger values of the Romans and one in which, as eloquently and succinctly expressed by the mentor to whom this essay is dedicated, "space was informed by ritual." The monumental propylon prompted entry and asserted the authority of the state behind the new institution; the grand public hall maintained a meaningful connection between the forum and the loggia where the town's notables watched the progress of *ludi juvenales*. Under the high vault of the apsidal hall, before the marble altar, watched by gods and the images of gods, the lofty aspirations of the fledgling principate were consummated as sacrifices were offered and young victors placed olive crowns on their heads.

As an architectural attempt toward the creation of a palaestra for a state balanced between a divided cultural world, the complex at Herculaneum remained an isolated experiment. As the empire matured, Augustus' youth organization assumed such diverse forms and meanings that no one type of architecture contained its needs and expressed its message. The future of Romanized palaestrae lay increasingly in the context of bathing institutions. Yet many of the design elements of this experimental but progressive building were absorbed into the creative forces that prepared, by the second half of the first century, the architectural revolution and emerged in the high-rise blocks of Rome and Ostia, in imperial villas and palaces, and in the "palaestrae" of the great imperial thermae.

1. The primary archaeological investigations of the Bourbon period were conducted between the years 1756 and 1760 under the supervision of Carlo Weber. For a full account of Weber's field notes and diagrams, and the early identifications of the complex as a palace and/or temple, see Michele Ruggiero, *Storia degli scavi di Ercolano* (Naples, 1885), 198; Julius Beloch, *Campanien: Geschichte und Topographie des antiken Neapel und seiner Umgebung* (Breslau, 1890), 214–238, pl. 8. The definitive source for much of what we know about the quadriporticus complex identified as a palaestra is the final publication of the post-1927 excavations by Amedeo Maiuri, *Ercolano: I nuovi scavi (1927–1958)*, 2 vols. (Rome, 1958), 1:113–143. For a recent and extensive bibliographical survey of Herculaneum and a history of the excavations, see Ia L. McIlwaine, *Herculaneum: A Guide to Printed Sources*, 2 vols. (Naples, 1988). For a popular, informative account of Herculaneum and the palaestra, see Joseph Jay Deiss, *Herculaneum: Italy's Buried Treasure* (New York, 1966), 123–128.

2. A few of the shops or shop groups along the western wing of the palaestra had assumed an industrial character, such as the "baking factory" behind Taberna 1 entered from the south cross street. Among the shops that can be identified are a second bakery (8), a wine shop (9), two grain dealers (6 and 13), dyers (5, 11, and 18), artisans and weavers (10 and 14), and several bar-restaurants. Several of the shops contained individual latrines connected to the main sewage line under Cardo V. Conceived as an integral part of the palaestra complex, the shops and the apartments above them must have been planned as a commercial enterprise to supply revenue for the palaestra. See Maiuri 1958, 117–118, 449–469.

3. Ruggiero 1885, 233–234, pl. 8, fig. 3.

4. *CIL* 10.1406; Ruggiero 1885, 232.

5. Comparable examples of a pedimented porch signifying a locus of religious or social importance can be seen in the Great Palaestra at Pompeii, in front of the cult exedra in the center of the west colonnade, and in the House of the Stags in Herculaneum, over the cryptoporticus, facing the garden. See Amedeo Maiuri, "Pompei: Scavo della 'Grande Palestra' nel quartiere dell'Anfiteatro," *NSc* (1939), 174–176, pl. 11, 2; Maiuri 1958, 312, fig. 245.

6. Only the major halls of the public baths in Pompeii and Herculaneum offer a close comparison to the apsidal hall of the palaestra at Herculaneum. None —with the exception of the caldarium of the Central Baths in Pompeii (9.80 x 19 m, H. unknown), an unfinished building of the postearthquake era—is larger. In Rome and the Italian provinces the late republic produced some ambitious vaulted spaces, such as the repeating units of the Porticus Aemilia in Rome, c. 193 B.C., and the market halls in Ferentino and Tivoli, that could match or surpass the apsidal hall at Herculaneum. Also important is the apsidal hall in the gardens of Maecenas on the Esquiline known as the Auditorium of Maecenas (perhaps a nymphaeum/garden pavilion). It is believed to date

from the early Augustan period (c. 40–30 B.C.), and was most probably roofed by a barrel vault with a span of 10.6 m reaching the height of c. 13 m and a semidome with a radius of 5.3 m over the spacious apse. This structure may be related to a number of barrel-vaulted halls of late republican garden pavilions or nymphaea, such as the nymphaeum on the grounds of the so-called Villa of Cicero at Formia and the more monumental "Doric Nymphaeum" on Lake Albano. See Filippo Coarelli, *Roma* (Guide archeologiche Laterza, 6; Rome, 1980), 217–219; Ernest Nash, *Pictorial Dictionary of Ancient Rome*, 2 vols. (London, 1961), 1:160–161; Luigi Crema, *L'architettura romana* (Turin, 1959), 122–125, 240–242. Particularly remarkable is the bath complex known as the Temple of Mercury in Baiae, a bold concrete structure probably of early Augustan date. It consists of a domed rotunda with a diameter of 21.46 m and two barrel-vaulted halls; the larger is c. 10 x 19 m (the height of the well-preserved but unexcavated vault is unknown). See William L. MacDonald, *The Architecture of the Roman Empire*, 2 vols. (New Haven, 1965), 1:3–12.

7. A masonry vault would have posed the problem of spanning the 7.80 m frontage of the apsidal hall without intermediary supports. Although the palaestra at Herculaneum was an advanced building in the application of the concrete technology of its day, its structural design was carefully limited to barrel vaults used singly or in series. Visual and structural problems created by joining vaults running in different directions and at different levels were not addressed much before the time of Nero.

8. "Altar tables" (*Opfertische*) of comparable nature are known from many Greek and Roman sites. One, supported by massive imperial eagles, has been associated with the observance of the imperial cult in the Marble Court of the bath-gymnasium complex in Sardis. See Fikret K. Yegül, "A Study in Architectural Iconography: *Kaisersaal* and the Imperial Cult," *ArtB* 64 (1982), 12, figs. 11, 12; Henner von Hesberg, "Tischgräber in Italien," *AA* 95 (1980), 422–439.

9. Maiuri 1958, 125–126, fig. 100. Paintings depicting similar scenes have been found in Herculaneum; see Wolfgang Helbig, *Wandgemälde der vom Vesuv verschütteten Städte Campaniens* (Leipzig, 1868), nos. 1435, 1460, 1462; for an illustration published in a source easier to find, see Deiss 1966, 126. See below, note 42, for the hypothetical identification of the room as a banquet hall.

10. Along the western colonnade, not far from the north hall (L), the Bourbon excavators found a votive inscription on a marble plaque reading, "Ivlia Hygia ex visv," and a marble statuette of the goddess Hygieia holding a serpent in her left hand. Both the inscription and the statuette were misattributed to Isis, leading to the misidentification of the palaestra peristyle as the temple peribolus of Isis. Maiuri suggested the possibility that Hall L could originally have functioned as a cult-space dedicated to Asclepius and Hygieia, deities commonly associated with

ancient palaestrae and baths. See *CIL* 10.929; Ruggiero 1885, xxxix, 248–250; Maiuri 1958, 127, fig. 101.

11. Structural details and heights of the western colonnade are based on exact measurements taken from the northwest corner bay joining with the cryptoporticus, preserved intact including column, entablature, and roof.

12. According to an inscription carved on a marble base, a comparable fountain of entwined bronze serpents originally decorated one of the streets of Sardis. The inscription, dated no earlier than the fourth century A.D., records that Basiliscus, one of the governors of Lydia, reinstalled the fountain in the imperial bath-gymnasium complex. See Fikret K. Yegül, *The Bath-Gymnasium Complex at Sardis* (Archaeological Exploration of Sardis, Report 3; Cambridge, Mass., 1986), 9, 146, 171, no. 7.

13. Both pools are connected to a large, vaulted subterranean drain that served the palaestra. This drain in turn emptied into the city sewage line, another large vaulted system under Cardo V, leading out to sea. The pool might have had at its ends simple washing facilities for the athletes. See Maiuri 1958, 467–469.

14. Maiuri 1958, figs. 7, 31; Beloch 1890, pl. 8.

15. Michele Ruggiero, *Degli scavi di Stabiae* (Naples, 1881), ix–xxi, especially pls. 1, 3, 4, 5, 7, 8, 11; Karl M. Swoboda, *Römische und romanische Paläste* (Vienna, 1919), 5–60; Harald Mielsch, *Die römische Villa* (Munich, 1987), 49–63; Arnold de Vos and Mariette de Vos, *Pompei, Ercolano, Stabia* (Guide archeologiche Laterza, 11; Rome, 1982), 315–331; John H. D'Arms, *Romans on the Bay of Naples* (Cambridge, Mass., 1970), 126–133.

16. Maiuri 1939, 165–238. Maiuri never really realized that the building whose identity as a palaestra he championed was of a type fundamentally different from the traditional Greek examples. Although he could clearly see that the palaestra in Herculaneum displayed far greater architectural articulation compared to the "linearity" of the Great Palaestra of Pompeii, he still thought they were closely comparable and assumed that the Herculaneum complex had been created under direct Greek influence emanating from centers such as Naples (Maiuri 1958, 116). He even attempted to interpret the architecture and functions of the palaestra at Herculaneum by using the vocabulary for the Greek gymnasium provided by Vitruvius (Maiuri 1958, 134).

17. In his study of Pompeian architecture, Lawrence Richardson, Jr., argues against the identification of the Great Palaestra in Pompeii as a palaestra proper because there are no dressing rooms, baths, and other spaces commonly found in palaestra design. He suggests that it might have been a "public park" comparable to the "palaestra" at Herculaneum. Admittedly, it is surprising that a palaestra with such a gigantic triplex porticus has so few functional dependencies. Yet one should remember that the traditional Greek/Hellenistic palaestra was also dominated by porticoes. The earlier examples from the classical

period, especially, are characterized by open spaces, simple colonnades, and planting. Hardly any of the palaestrae known from Greece and Asia Minor have all the elaborate parts and functions described by Vitruvius. A remarkably large number of traditional palaestrae, such as those in Assos, Alabanda, Nysa, Thera, Sicyon, even Miletus and Priene, display few and relatively insignificant spatial units attached to their peristyles; none has proper "bathing" facilities, except modest cold-water washrooms. Hot bathing, despite Vitruvius' prescriptions, was not a function commonly included in the design of traditional palaestrae before the end of the first century B.C. The type of palaestra that was eventually absorbed by the Roman baths is a different building, the process a different story. The great swimming pool at Pompeii has a shallow end no less than 1 m in depth. An effective swimming depth of c. 1 m is reached some 4–5 m away from the shallow end (a ledge 0.40 m below the rim on the opposite side has a runoff drain that might have reduced the maximum depth); it is quite admirably designed for swimming, contrary to Richardson's contention that it is "so very shallow at one end as to suggest that it was designed especially to let animals descend by this slope to be loaded with water." Given the architectural relationship of this establishment to the amphitheater, its overall design as well as its individual features, its relatively refined architectural decoration, and the implications of the inscriptions found inside, only very special pleading could make it anything but an enclosure for sports and exercise—in the broad sense, a palaestra. It was not a true Greek palaestra intended for ephebic education. Rather it appears to have been the "training ground" (*dromos*) of a gymnasium curiously lacking a palaestra, or a palaestra created for the specialized physical training of athletes (probably the large numbers of cadets belong to the Juventus Pompeiana). Its immense expanse, shaded by rows of trees, would have been ideally suited for military and quasi-military training, drill, and marching. It is easy and logical to interpret the exedra on the west side as a center for the imperial cult or some other divinity appropriate for Juventus (Maiuri 1939, 174–176). See Lawrence Richardson, Jr., *Pompeii: An Architectural History* (Baltimore, 1988), 211–215. For Greek gymnasia, see Jean Delorme, *Gymnasion* (Paris, 1960); for the relationship between gymnasium and baths, see Fikret K. Yegül, *Baths and Bathing in Classical Antiquity* (New York, 1992), 55–57, 172–175, 307–313. For a methodical study that presents diverse evidence—paintings, mosaics, and inscriptions—from Pompei (and some from Herculaneum) as testimony to the importance of athletics and athletic games in the lives of these cities, and to the use of the Great Palaestra at Pompeii as the official seat of *ludi gymnici*, see Bianca Maiuri, "Ludi ginnico-atletici a Pompei," in *Pompeiana: Raccolta di studi per il secondo centenario degli scavi di Pompei* (Naples, 1950), 167–205.

18. Delorme 1960, 76–80, 102–110, 126–133, 191–195. For Olympia, see Emil Kunze and Hans Schleif, *OlBer* 4 (Berlin, 1944), 8–31; Alfred Mallwitz, *Olympia und seine Bauten* (Munich, 1972), 278–284. For Delphi,

see Jean Jannoray, *FdD 2, Topographie et architecture: Le gymnase* (Paris, 1953). For Priene, see Fritz Krischen, "Das hellenistische Gymnasion von Priene," *JdI* 38–39 (1923–1924), 133–150; Martin Schede, *Die Ruinen von Priene* (Berlin, 1964), 81–90. For Miletus, see Armin von Gerkan and Fritz Krischen, *Thermen und Palästren* (Berlin, 1928), 1–21, pls. 3–6; Gerhard Kleiner, *Die Ruinen von Milet* (Berlin, 1968), 91–92.

19. Cicero, in a speech attributed to Scipio, summarized education in republican Rome thus: "Our people have never wished to have any system of education for the free-born youth which is either definitively fixed by law, or officially established, or uniform in all cases, though the Greeks have expended much vain labour on this problem, and it is the only point which our guest Polybius finds neglected in our institutions" (Cicero, *Republic*, trans. Clinton W. Keyes [Cambridge, Mass., and London, 1943], 4.3). For Roman education see Henri-I. Marrou, *A History of Education in Antiquity*, trans. George Lamb (London, 1956), 229–254; Stanley F. Bonner, *Education in Ancient Rome* (Berkeley, 1977), 115–125; William Barclay, *Educational Ideals in the Ancient World* (London, 1959), 143–191; Martin L. Clarke, *Higher Education in the Ancient World* (London, 1971), 59–63. For the use of the Forum of Trajan and the Forum of Augustus in education, see Henri-I. Marrou, "La vie intellectuelle au forum de Trajan et au forum d'Auguste," *MélRome* 49 (1932), 93–110.

20. "They kept censuring even the personal appearance of the general-in-chief, as not even soldierly, not to say un-Roman; that wearing a Greek mantle and sandals he strolled about in the gymnasium, giving his attention to books in Greek and physical exercise" (Livy, *Ab urbe condita*, trans. Frank G. Moore [London and Cambridge, Mass., 1949], 29.19.12–13). The republican general was, no doubt, trying to win the sympathy of the Greek population of the town.

21. Marrou 1956, 249; Harold A. Harris, *Sport in Greece and Rome* (Ithaca, N.Y., 1972), 50–54; Rachel S. Robinson, *Sources for the History of Greek Athletics* (Cincinnati, 1955), 164–166, 174–202.

22. Martial, *Epigrams* 14.49.

23. Pliny, *Letters* 10.40.

24. Yegül 1986, 147–151. See also Yegül 1992, 173–175.

25. Suetonius, *Augustus* 98.3 (trans. Robert Graves).

26. Strabo, *Geography* 5.4.7 (trans. Horace L. Jones); see also Delorme 1960, 221–222.

27. According to an inscription in Oscan placed on the east wall, the palaestra was built for the *vereia* of Pompeii with the money left by one Vibius Adiranus; the construction was supervised by the quaestor Vibius Vinicius. The widely accepted reading of *vereia* as an aristocratic youth organization with military and political overtones (like the later *iuventus*) has been recently questioned by Richardson who suggests that the building might have been a temple to Hercules; see Richardson 1988, 73–75. For the inscrip-

tion in Oscan, see Robert S. Conway, *The Italic Dialects*, 2 vols. (Cambridge, 1897), 1: no. 42. Also see Delorme 1960, 227–229; August Mau, *Pompeii: Its Life and Art*, trans. Francis W. Kelsey (New York, 1899), 165–167.

28. I am thankful to Miranda Marvin for this and other helpful suggestions.

29. Pliny the Elder, *Nat. Hist.* 34.10, mentions the growing popularity in his time of the nude athlete statues known as the Spearbearer (or Achilles figure) as a type that was commonly used in Greek gymnasia.

30. Paul Schazmann, *Altertümer von Pergamon 6, Das Gymnasion* (Berlin, 1923), 2: pls. 1, 2, 8, 11, 16, 17.

31. Furio Fasolo and Giorgio Gullini, *Il santuario della Fortuna Primigenia a Palestrina* (Rome, 1953), 155–165, 167–192, figs. 231, 232, 245, 247, 473, pls. 3, 12, 20; Axel Boethius, *Etruscan and Early Roman Architecture* (New York, 1978), 169–174, fig. 158; Crema 1959, 52–54, figs. 48, 54. Based on firm epigraphical evidence, Attilio Degrassi has shown that the sanctuary at Palestrina is not a Sullan structure, as commonly believed, but dates to the end of the second century B.C. Most of the inscriptions that belong to the original building mention the names of old Praenestine families (such as the Aulii, Etrilii, Saufeii, Feidenatii) that were decimated by Sulla. Other dedications by certain crafts and trade organizations also indicate a pre-Sullan date. See Attilio Degrassi, "Epigraphica 4," *MemLinc*, ser. 8, 14 (1969), 111–127; rpt. in *Studi su Praeneste*, ed. Filippo Coarelli (Perugia, 1978), 147–163.

32. Fasolo and Gullini 1953, 354–363, 424–434, figs. 519, 520, 521, pl. 28; Boethius 1978, 166–169, figs. 144, 157; MacDonald 1965, 7–9, pl. 5; Crema 1959, 57–58, fig. 53.

33. Richard Delbrück, *Hellenistische Bauten in Latium*, 2 vols. (Strasbourg, 1907–1912), 1:23–46, figs. 26, 31, pl. 7; Boethius 1978, 155–156, fig. 143; MacDonald 1965, 9, pl. 11; Crema 1959, 58, figs. 57, 58.

34. Christian Hülsen, *The Forum and the Palatine*, trans. Helen H. Tanzer (New York, 1928), 74, pls. 57, 58; MacDonald 1965, 68–69, pls. 72, 133.

35. Heinz Kähler, *Hadrian und seine Villa bei Tivoli* (Berlin, 1950), 64, pls. 15, 16; Erik Hansen, *La "Piazza d'Oro" e la sua cupola* (Copenhagen, 1960), 33.

36. Delbrück 1907–1912, 1:47–90, figs. 57, 58, 60, 81, pls. 12–15, 17, 18. In Delbrück's excellent study, the terrace on the north, overlooking the forum, is restored as an open paved courtyard defined on the north by a *porticus fenestrata* of engaged Corinthian columns separating tall and elegantly detailed blind windows. The second story is developed by a series of round arches carried on simple piers. Construction throughout is in *opus incertum* (Delbrück 1907–1912, 2: pl. 1). Subsequent studies have shown that a five-aisled basilica, instead of the open courtyard, existed on this terrace; the *porticus fenestrata* constituted the back wall of this basilica against the sheer cliffside. See Fasolo and Gullini 1953, 32–49,

figs. 43, 61, and for an axonometric reconstruction fig. 478; Boethius 1978, 170–173, figs. 161, 162; Crema 1959, 52–54, fig. 50. For a later use of walls articulated by engaged columns carrying a flat entablature (no arches), see the interior of the first story of the round hall of the so-called Accademia of Hadrian's Villa in Tivoli: Hansen 1960, 77 (a view by Giovanni Battista Piranesi, *Vedute di Roma* 3); also in Salvatore Aurigemma, *Villa Adriana* (Rome, 1961), fig. 140.

37. Maiuri 1958, 201–206, figs. 157, 158, 159, pl. 18 (Samnite House); 290–293, figs. 223, 230, 233, 234 (House of the Mosaic Atrium); 354–355, fig. 286, pl. 32 (House of the Telephus Frieze).

38. Maiuri 1958, 142–143.

39. Dio Cassius, 52.26; Marrou 1956, 299–301; Annamaria L. Silverio, "Le associazioni giovanili," in *Lo sport in mondo antico* [exh. cat., Museo della Civiltà Romana, Rome] (Rome, 1987), 27–34. For the seminal study of Juventus in Pompeii, see Matteo Della Corte, *Juventus: Un nuovo aspetto della vita pubblica di Pompei* (Arpino, 1924).

40. Even though many of the inscriptions and graffiti from the Great Palaestra in Pompeii are mixed in nature and content, study of them led Matteo Della Corte to maintain that there was an undeniable relationship between the users of the building and the Juventus organization of the city. This connection was underlined by Bianca Maiuri in her 1950 study searching for testimonials to gymnastic games in Pompeii through paintings, mosaics, and inscriptions. Della Corte's argument for the military use of the Great Palaestra as the castrum of the city is questionable. See Matteo Della Corte, "Pompei: Le iscrizioni della 'Grande Palestra' ad occidente dell'Anfiteatro," *NSc* (1939), 239–327, especially 318–322; Matteo Della Corte, "Il *Campus* di Pompei," *RendLinc*, ser. 7, 11 (1947), 555–568.

41. For the identification of this building, as opposed to the complex of Julia Felix (II,4), an elegantly appointed club incorporating baths, see Richardson 1988, 290–292.

42. I would suggest the vaulted hall south of the apsidal hall as a candidate for the clubroom/dining room of the *iuvenes* based on the discovery in 1757 of the painting representing a banquet scene and the overall architectural suitability of the room (ample size, good location, easy access from the suite of rooms A, B, C, before the blocking of the door from the vestibular area). Ceremonial and social banquets were also an important part of the Hellenistic gymnasium.

43. Amedeo Maiuri, "Un decreto onorario di M. Nonio Balbo scoperto recentemente ad Ercolano," *RendAccIt*, ser. 7, 3 (1942), 253–281.

WILLIAM L. MACDONALD
Washington, D.C.

Hadrian's Circles

In contrast with what is known of Roman architecture elsewhere, the Villa at Tivoli built by the emperor Hadrian in A.D. 118–133 is alive with innovation. Bath buildings aside, no other site has more than one or two buildings that deviate so distinctly from established practice, and few have any at all. This has sometimes had the effect of excluding the Villa from the mainstream of classical architectural studies and denying it the attention given to more traditional sites, although in recent years the situation has changed for the better. Hadrian and his gifted staff gave new life to the long and continuing evolution of the style they were heirs to—no small accomplishment in any period—by seeking within it new and meaningful expression. Like others to come, they saw that classicism was not exhausted, that its artistic potential had by no means been fully explored. Circles and their design possibilities fascinated them.

The Villa's famous Island Enclosure is circular, decidedly horizontal, and internalized (fig. 1).[1] It lies about 2.5 m below the adjacent Residence Quadrangle and almost as much below the Fountain Court to the northeast, and from the higher ground at the south and east it appears to be partly sunken in the earth; of its neighbors only the Apsidal Hall and the open ground to the north lie on the same level. As was so often the case at the Villa, changes were made in Hadrian's lifetime: the north stair system, for example, was rebuilt; several openings between rooms on the Island were altered; and at some point, probably also in the emperor's lifetime, an arched masonry bridge replaced the westernmost of two retractable wooden ones, and the ring wall was cut through for a northwest doorway. Like the Stadium Garden, the Island Enclosure has been carefully studied by scholars.[2]

The main axis is about 18° west of north (fig. 2). A five-foot planning module was used throughout— 30 units (150 Roman feet) for the overall diameter, 24 for the circle upon which the ring portico columns are centered, and so on. The actual diameter of the Enclosure is 44.20 m overall, almost exactly 150 Roman feet (the Hadrianic Pantheon's internal diameter is about 43.80 m, a difference of only one and a third Roman feet).[3] In addition to the north stair system, a staircase comes down on the west from the Residence Quadrangle, and another, external one, perhaps a maintenance facility, once rose next to the ring wall's northwest doorway. The Enclosure proper opened on the north through a spacious entrance hall (with external colonnades on the north and west) toward a fountain, on axis, set beside the northwest corner of the Fountain Court. On the west side of the ring two passages led to the Apsidal Hall; from the southern one of

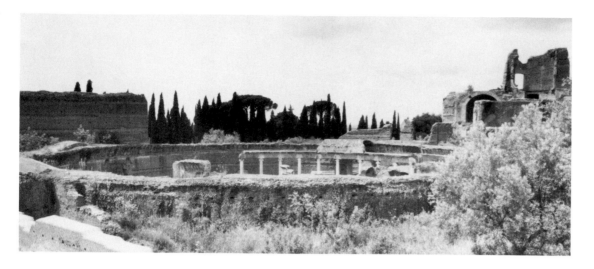

1. Hadrian's Villa, Tivoli, Island Enclosure, begun A.D. 118, view from southeast

2. Hadrian's Villa, Tivoli, Island Enclosure, begun A.D. 118, plan
After Mathias Ueblacker, *Das Teatro Marittimo in der Villa Hadriana* (Mainz, 1985), Beil. 17

these an underground passageway communicated with the Stadium Garden and the East-West Terrace axial chamber.

The ring portico is clarity itself: forty unfluted Ionic columns, evenly spaced except beside the main north-south axis, once carried an attic masking the portico vault (fig. 3). On the other hand the Island, with its fluted Ionic columns, has twenty-two well-defined spaces in little more than a third of the Enclosure's overall area (fig. 4). These spaces are arranged in three suites, plus an exedra-shaped court facing north, placed around a central peristyle whose incurving colonnades respond to the intrusive centered arcs of the four surrounding features. The eastern suite consists of a lounge or library with symmetrical side rooms; the southern suite has a centered salon or triclinium, also with matching, flanking dependencies; and the western one is a three-part bath. All rooms interconnect with their neighbors, except for the north bath chamber with its heated floor and plunge. Curving entrance walkways lead inward from the bridges past the exedra court to the central peristyle. The peripheral wedge-shaped spaces on the diagonals, reading clockwise from the northeast, contained a lavatory, a fountain or washbasin, another lavatory, and the sunken furnace room for the baths. Steps lead up out of the centered cold pool to an external flight leading down into the ring canal.

Both cardinal axes are transparent, run-

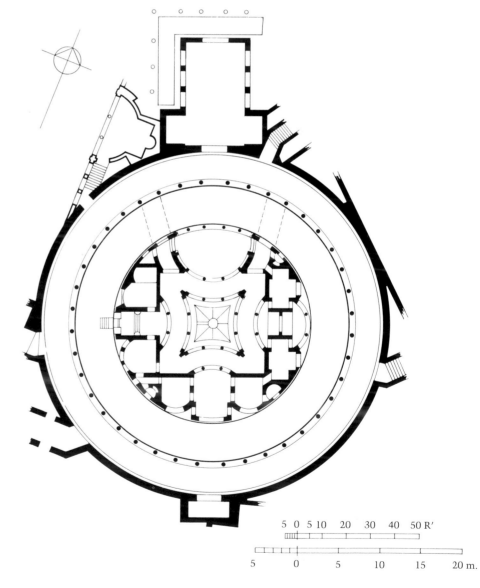

5 0 5 10 20 30 40 50 R'

5 0 5 10 15 20 m.

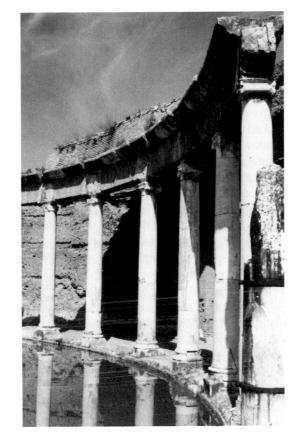

3. Hadrian's Villa, Tivoli, Island Enclosure, begun A.D. 118, ring colonnade (restored), view from east

ning between repeated openings and pairs of columns, but only the north-south one, extending from the Enclosure's southernmost chamber to the north fountain almost 100 m away, connects with open ground. Unless this particular view is deliberately sought out, there is little to remind one of the world outside the Enclosure. Of the six openings leading through the ring wall, four are doglegs, and of these two are visually blocked by their rising stairs. The northwest doorway, small and almost incidental, gave onto the windowed wall of the external staircase just outside, and the short western passage led not to open ground but to the interior of the Apsidal Hall. There was, however, a lot to be seen inside the Enclosure, in addition to water and architecture. The inner face of the ring wall was first painted red (brick banding) and yellow (tufa reticulate); the paint was replaced later with stucco, painted red and black, above a new marble baseboard.[4] At irregular intervals around this wall are six large recesses, about 2.9 m broad and 3.6 m high, which once contained large,

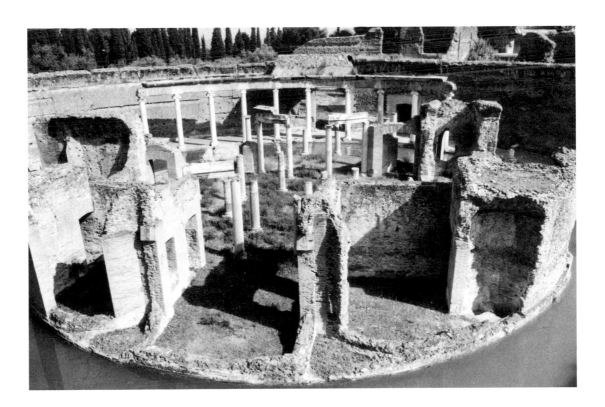

4. Hadrian's Villa, Tivoli, Island Enclosure, begun A.D. 118, island, view from southeast

of the "places most famous" in the much-debated passage about the Villa in the *Historia augusta*?[25]

The palace area, circular save for the intrusion of the great eastern tower, was framed by a walled-off walkway about 3.4 m wide (figs. 5, 6). The planning and architectural details of the palace, a major Romano-Hellenistic monument, are of great interest.[26] A large, oblong open court, with facing but nonaxial exedras on the shorter sides, nearly fills the circle's eastern half. The western half contains, from north to south, a Roman bath suite with a domed hot room, reception rooms, and private quarters.[27] The reception suite, centered on the main east-west palace axis, consists of a vestibule and a main T-shaped hall rather like the tablinum and alae of a Roman atrium house; the chief private room, flanked by the usual satellite spaces, connects directly with both the reception area and the open court. Irregularly shaped spaces formed by the collision of orthogonal planning with the curving inner walkway wall were put to use—for example, by the courtyard exedras and the baths' smaller rooms—much as such spaces are accommodated at the Villa. Security was paramount. The hillside stairs, some 6.5 m wide, were uncovered until 40 m from the fortress wall, where they went underground in a tunnel up through the fill. Only five small openings led into the palace area from the circular walkway. Those to the courtyard portico closest to the king's own chambers first opened into small squarish rooms that may have functioned as vantage courts; where the access stairs met the walkway there seems to have been a similar arrangement.[28]

Differences and similarities at Hadrian's Island Enclosure will be self-evident; the most significant connections are the plan concept and functions. Did Hadrian know Herodium? His interests and nature argue for it but taken alone prove nothing. He had, however, been in Judea as early as 113 or 115.[29] Later, as Trajan's chief officer in Syria, he would of necessity as well as by temperament have taken a keen interest in Judea, a province (in Hadrian's day Syria Palaestina) since 70. Between

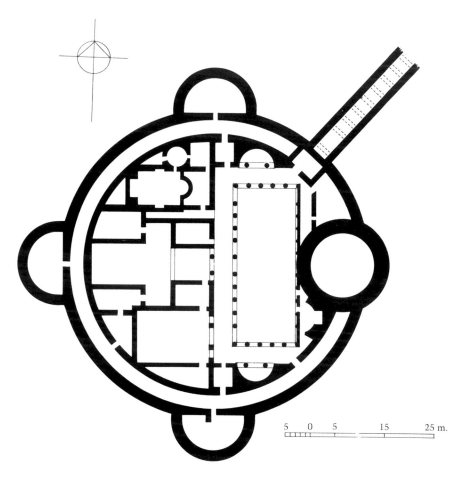

5 0 5 15 25 m.

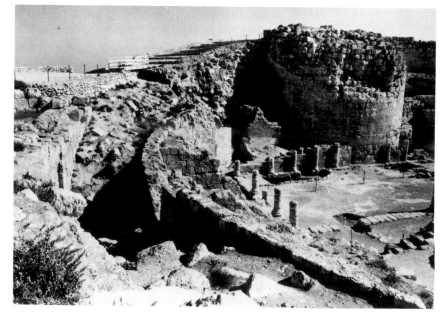

5. Herodium, probably 23–15 B.C., residence level, plan
After Ehud Netzer, *Greater Herodium* (Jerusalem, 1981), ill. 107.

his accession at Antioch on 11 August 117 and his permanent departure from his headquarters there early in the following October, he traveled south. Thus he had at least two opportunities to see Herodium before the Villa was begun.[30] Hadrian would have read Josephus and could not at the beginning of his reign have been ignorant either of Herodium or of Herod's close connection with Rome (he had been there twice, and in 37 Roman troops had stormed Jerusalem for him).[31] The king's subsequent dependence on his patron Augustus, Hadrian's own model in significant ways, would also have been known to Hadrian: as Octavian the future first emperor in 30 had confirmed Herod's authority and given him the city of Samaria (which the king then rebuilt and soon named Sebaste in honor of his patron's new title of 27), then as Augustus he added the territory of Caesarea (similarly named). Many signs, Hadrian's fascination with architecture and monuments not the least of them, point toward the probability that he had direct knowledge of Herodium as well as of its artistic and political connections with Rome. The Herodium palace is apparently the only known pre-Hadrianic structure the Island Enclosure closely resembles.[32]

The Island architecture is eclectic, with themes and shapes from the atrium house and its ancient parts, and above all from the ubiquitous Mediterranean peristyle houses and mansions and their palatine offspring. As previously mentioned, its plan is rational, based on five-foot squares and on circles with radiuses of five-foot multiples; for example, the Island's peristyle columns are set on arcs of fifty-foot circles, which if produced fall tangent to the circle of the ring columns' centers. But the essential character and force of the Enclosure arise less from these organizational features than from the unusual concept of which they are the servants: a moated, idealized retreat sequestered within a perfect and seamless figure.[33] So consideration of scale, function, and imagery is essential in an analysis of the Enclosure.

The Island is said to have been a miniature villa, suggesting that its architecture was disproportionately reductive.[34] Is this correct? To miniaturize architecture is to reduce its scale toward that of a doll's house, as for example at the charming half-scale town in the Children's Garden at Coimbra. But the Island covers some 510 m² (about 5,500 square Roman feet), an area equivalent to that of a fair-sized house or a spacious luxury flat. Its rooms are no smaller than many at the Villa—in the Southern Range, the pavilions beside the Scenic Triclinium, and elsewhere. Both levels of the Domus Augustana have such spaces, the upper one a dozen. The Island rooms are scaled to their purpose—Hadrian's pleasure, taken alone or with a few people close to him. Servants, presumably, would not remain there with him, for the plan contains no provisions for them and their activities. It was not a place to live in, but to go to, and its scale derives from that. It wasn't cramped, just comfortably sized, almost domestic. Thus the dimensions of the rooms: about 4.3 x 5.5 m for the central south room, a 6.1 m axis for the baths' cold plunge chamber, and so on. Behind this connection between function and size lies a fundamental feature of the Villa—the wide variety of different kinds of places to visit, in the manner of Pliny's villas but on an even greater scale, a variety suited to Hadrian's temperament and interests and ranging from fully public spaces to private enclosures. The Island was a station on the peripatetic circuit of intellectual and aesthetic enjoyment that a grand luxury villa provided. It has been thought to be a studio or workplace, but the multiplication of modest rooms may argue against the idea.[35]

The views, carefully calculated and framed, can still be traced; the ruins suggest the original sequences of light and shade, of open and closed spaces, so important to Roman architecture.[36] A lightweight structure could have risen above the peristyle colonnades. At this remove, relating the architecture to the marine and chariot-race friezes is difficult, but such scenes were staples of Roman art and may have been included for decorative and aesthetic reasons rather than symbolic ones. But it is hard to resist the notion that some overriding meaning is expressed by the Island's design; anything

6. Herodium, probably 23–15 B.C., circular residence-level enclosure, east tower, and courtyard, view from northwest
Photograph: Ehud Netzer

could easily be taken as architecture for architecture's sake.

Convincing historical antecedents for the plan seem not to exist, unless it reached back in some vague way to random room dispositions of the kind found, for example, in the Greek baths at Cyrene or the Piraeus.[42] The only traditional features are certain room-shapes, such as the paired cold plunges and their common hall (room N), and the installations for varied air and water temperatures and levels of humidity, perhaps even steam, in the different rooms.[43] Otherwise the building is original. Its rooms are fitted together in a kind of superb architectural joinery; nonfunctional spaces have been pared down or discarded, and internal walls often bear loads from three vaults, sometimes from four. Underlying these arrangements are the circles and circular segments of the plan, struck from points fixed by the plan's rectilinear underpinnings, which make the building unique. Pre-Hadrianic asymmetrical bath plans exist, because of the difficulty of rationally ordering the necessary room shapes, particularly in small and medium-sized buildings. (The larger the bath, the greater the likelihood of symmetry because of the space available; in huge imperial and other metropolitan baths, duplicate sets of rooms all but guarantee symmetrical plans.) But no other known building approaches the splendidly efficient and economical dovetailing of forms or the variety of spatial experience of the Smaller Baths.

The novel architectural thinking that produced the central plan of the Island Enclosure is also recorded at the Baths. Both structures are profoundly interiorized, without much regard for classical room sequences. Both are ingeniously compacted, which with their interiority generates a profusion of paths and possible goals. Established room-shapes, if used, are fitted into nontraditional overall plans, for functional needs are made to override artistic imperatives. The results are as nearly unique as premodern architecture can be. Of earlier buildings only Domitian's palace preserves evidence of this kind of planning, chiefly in the suite of rooms along the northwest side of the Domus Flavia peristyle.[44] There Rabirius

began with five circles of 40 Roman feet, in line. On the center one he fixed an octagonal room, on the end ones chambers half-circular and half-square; the two circles in between, each with its own half-circular feature, distanced the end chambers from the octagon. To the southeast, the rooms between the upper peristyle of the Domus Augustana and the palace stadium garden (hippodrome) are based on similar principles but with less differentiated results.[45] As at the Villa, these palatine designs evolved from imaginative uses of the circle and its radial potential.

Circular planning produced other novelties. The plan-shapes of the walls at the Baths and the Island help to define some new, nonclassical spaces and also, together with those of the Domus Flavia suite, are in themselves the record of new structural forms—usually a good index of serious architectural change. The structures connecting the southern Island suite with its neighbors, or the solids around the Baths' circular room are good examples; there are many others. In both buildings the inherent qualities of circles augment or replace traditional linear planning organization, so that any extended internal axial authority is much reduced if not eliminated. Intersecting circles, extended radial alignments, and tangential volumetric assemblies give these buildings special qualities. And where there are circles there are also

9. Hadrian's Villa, Tivoli, Smaller Baths, c. A.D. 120–130, part of roof system seen from southwest, from room S (lower left) and room N south plunge (lower right) to southwest window of superstructure of room J (seen beyond central vault windows of room N)

10. Hadrian's Villa, Tivoli, Hall of the Cubicles, c. A.D. 120–130, mosaic in room 9

squares, visible or not, with their own axial and 45° contributions; taken together, these two basic geometric shapes are very potent tools.

Because mosaic patterns use these same shapes, striking similarities exist between them and architectural plans. Ample evidence survives for pre-Hadrianic parallels—the central feature of the Domus Augustana's lower court, for example, is prefigured in Pompeian mosaics with concentric, repeating, and intersecting circles.[46] Starting work, the mosaicist and architect proceed along similar lines by preparing a plan, based on rational if sometimes quite elaborate geometric configurations, on a flat surface.[47] For the mosaicist the plan is the work, for the architect it is only the beginning, but both use circles and squares.

At the Villa's Hall of the Cubicles the artists (more than one was at work) have left a most useful record of possible affinities between mosaic pavement patterns and architectural planning.[48] The central panels in the cubicles are all based either on repeated shapes, circular or rectangular, deployed on a grid, or on centralized figures extended from center points also orthogonally determined. The peristyle

shape of the Island Enclosure is immediately recognizable in the mosaics of rooms 1 and 10, the Enclosure plan-scheme is intimated by the design in room 2, and the ubiquitous Roman octagon appears in room 8. The chrysanthemum pattern of room 3 suggests the protruding exterior curves of the Arcaded Triclinium and the Water Court vestibule. In room 9, the design is based on repeated orthogonal dispositions of larger and smaller circles, although the pattern is never fully achieved because of the delimiting frame (fig. 10). The circles there are reminiscent of those of the Smaller Baths and produce among them octagons with incurving sides much like the Baths' octagonal room. The frame's corners hold quarter-circles just as the Island's nichelike spaces hold fountains and lavatories, and along the borders are the half-circles found in palatine and Villa plans.

Other connections suggest themselves. The mosaicist must often deal with the juxtaposition of straight and curved lines. Sinuous reverse curves appear, as in the flowing garlands surrounding the central circles of room 9 of the Hall of the Cubicles.[49] The shapes that are, so to speak, left over after the major figures have been

Kings at Jericho at the End of the Second Temple Period," *BASOR* 228 (December 1977), 1–13.

28. The origins of Herodium lie outside the subject of this paper, but on earlier circular planning see, for example, Joseph Rykwert, *The Idea of a Town* (Princeton, 1976), 97–98.

29. Glanville Downey, *A History of Antioch in Syria* (Princeton, 1961), 219 n. 85; William D. Gray, "A Study of the Life of Hadrian Prior to His Accession," *Smith College Studies in History* 4 (1919), 185–187. Herodium had been taken by the Romans in 73; see Josephus, *Wars* 7.163.

30. For the postaccession southern journey, see Helmut Halfmann, *Itinera principum* (Stuttgart, 1986), 190, 191. Russell T. Scott suggests that by then Herodium may have been in the care of an imperial procurator, Herodian properties having presumably passed to imperial control after the Claudian annexation of 44.

31. For Herod's life and policies, see Abraham Schalit, *König Herodes: Der Mann und sein Werk* (Berlin, 1969).

32. This was noted by Jacobson 1986, 71: "certain features in common." Netzer 1981, 100, alludes to the Villa in general terms.

33. On architecture within architecture, see Robert Venturi, *Complexity and Contradiction in Architecture* (New York, 1966), 72–73.

34. Coarelli 1982, 61; Coarelli 1984, 145; Ueblacker 1985, 53.

35. Herbert Bloch, *I bolli laterizi e la storia edilizia romana* (Rome, 1947), 160 n. 123, records various opinions. See also Heinz Kähler, *Hadrian und seine Villa bei Tivoli* (Berlin, 1950), 164 n. 73.

36. Kähler 1950, 120, 121; Frank E. Brown, *Roman Architecture* (New York, 1961), 41, 42, pl. 90.

37. See for example William L. MacDonald, *The Pantheon* (London, 1976), chap. 4; and Edmund Buchner, *Die Sonnenuhr des Augustus* (Mainz, 1982). Henri Stierlin, *Hadrien et l'architecture romaine* (Fribourg, 1984), 127–152, discusses the Enclosure and on page 150 shows a dome over the Island's central peristyle, symbolizing "un dieu vivant" (151).

38. This analysis is largely the work of Bernard M. Boyle, who has generously allowed me to include it; see also William L. MacDonald and Bernard M. Boyle, "The Small Baths at Hadrian's Villa," *JSAH* 39 (1980), 5–27, 19 n. 30.

39. This paragraph and the two following are based on MacDonald and Boyle 1980.

40. MacDonald and Boyle 1980, fig. 7.

41. John B. Ward Perkins and Jocelyn Toynbee, "The Hunting Baths at Lepcis Magna," *Archaeologia* 93 (1949), 168, find that the Smaller Baths show a "studied waywardness" and, on page 192, "deliberate anarchy." Luigi Crema, *L'architettura romana* (Turin, 1959), 404, speaks of a "free association of spaces with varied configurations, one inserted in another." Ward-Perkins, *Roman Imperial Architecture* (Harmondsworth, 1981), 109, calls the Island Enclosure "bewildering."

42. For Cyrene, see George R. H. Wright, "Cyrene: A Survey of Certain Rock-Cut Features to the South of the Sanctuary of Apollo," *JHS* 77 (1957), 300–310; Sandro Stucchi, *Architettura cirenaica* (Rome, 1975), 478–479. For the Piraeus, see René Ginouvès, *Balaneutikè: Recherches sur le bain dans l'antiquité grecque* (Paris, 1962), pl. 57, and compare pl. 53.

43. For the paired cold plunges, see Pliny, *Letters* 2.17.11. See MacDonald and Boyle 1980, 16–18, for the hydraulic and heating installations, and pages 22–26 for the details of individual rooms.

44. Bernard M. Boyle, *Studies in Ostian Architecture*, 2 vols. (diss., Yale University, 1967; pub. Ann Arbor, 1988), 1:202–210, fig. 22, 2: pl. 6; MacDonald 1982, 54, pl. 40, nos. 7–9. Compare Kähler 1950, 103–104.

45. MacDonald 1982, pl. 40, no. 27.

46. Marion E. Blake, "The Pavements of the Roman Buildings of the Republic and Early Empire," *MAAR* 8 (1930), pls. 3.1, 3.3, 5.2, 22.4; Giovanni Beccati, *Scavi di Ostia* 4,2 (Rome, 1961), pls. 68, 224; John R. Clarke, *Roman Black-and-White Figural Mosaics* (New York, 1979), 22 and fig. 20.

47. For mosaic geometry and layout techniques, see R. Prudhomme, "Recherche des principes de construction des mosaïques géométriques romaines," *La mosaïque gréco-romaine* 2, Actes du IIᵉ Colloque international pour l'étude de la mosaïque antique (Paris, 1975), 339–347; Gisela Salies, "Untersuchungen zu den geometrischen Gliederungsschemata römischer Mosaiken," *BonnJbb* 174 (1974), 1–178. For architects' similar methods, see Boyle 1967/1988, 1:210–211.

48. Cubicles 1–5 lie north-south along the east side, 6–10 lie south-north along the west side. Seven of the pavements are illustrated in Salvatore Aurigemma, *Villa Adriana* (Rome, 1961; rpt. Rome, 1984), figs. 183 (Cubicle 3), 184 (10), 185 (8), 186 (9), 187 (2), 188 (6), 189 (5).

49. Compare Beccati 1961, pl. 202.

50. Blake 1930, pls. 22.1–2, 23.1, 23.3, 38; Beccati 1961, pls. 64, 70, 71.

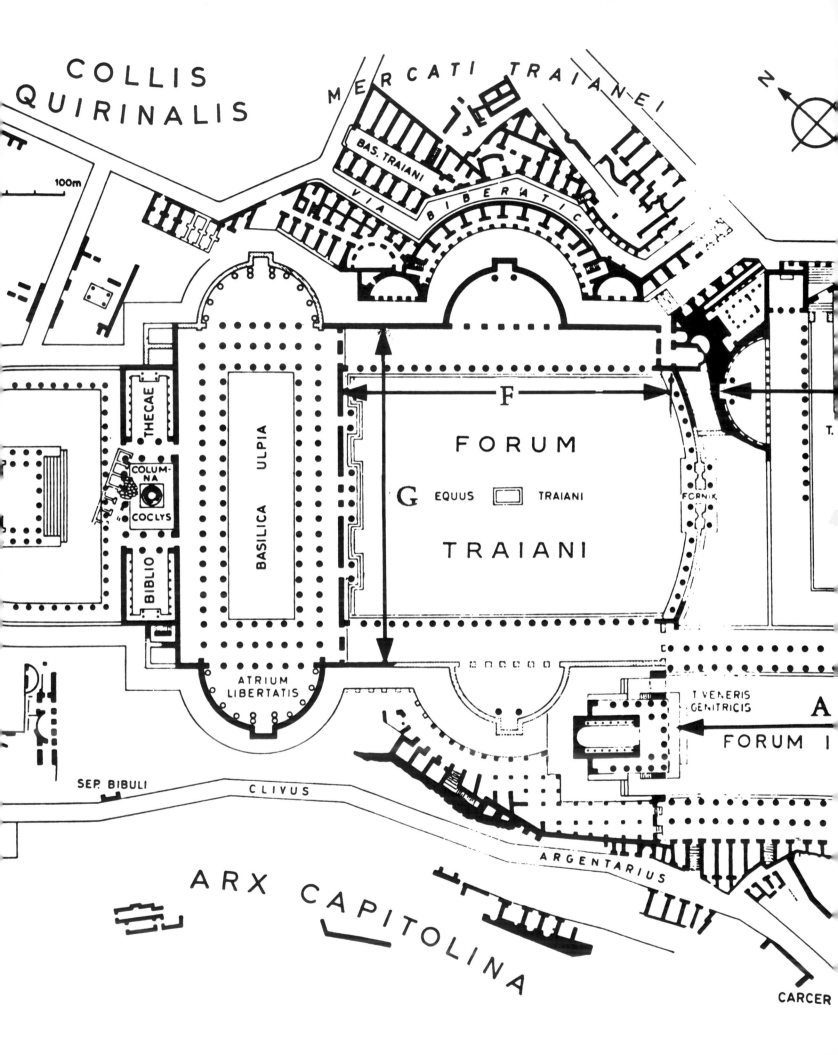

ALFRED FRAZER
Columbia University

The Imperial Fora:
Their Dimensional Link

The Imperial Fora, in their present incomplete state of excavation, still conceal beneath the Via dei Fori Imperiali many answers to questions concerning their form and details. The plans proposed in recent years for the complete or near complete excavation of this area in the heart of the ancient city have provoked heated controversy on ideological, urbanistic, and fiscal grounds.[1] The full excavation, which would include the elimination of the Via dei Fori Imperiali, may never take place for one, two, or all three reasons, but work has begun at the western end of the Forum Transitorium and in the Forum of Trajan on ground that does not threaten the modern thoroughfare. It is hoped that the results of these limited investigations will serve the cause of the complete disinterment of the Via dei Fori Imperiali and the revelation of the physical evidence lying beneath it.

In anticipation of that happy event, I present here a hypothesis that would link all of the Imperial Fora in a dimensional bond based on evidence that is available today. The testing of my hypothesis might be one of the benefits of the eventual laying bare of the fora in their full extent.

Frank Brown published in 1961 what is more an aphoristic sketch than a short book, under the title *Roman Architecture*. In it he had this to say of the Imperial Fora: "The master plan of the Imperial Fora, which identified the orders of the eternal and the transitory, was the basis of the new designs [by which he meant the new efforts in urban design throughout the empire], which sought to invest still more completely official life in a single spatial composition....The divine symbol of the Empire's dispensation and the place of its daily manifestation in human affairs were majestically balanced off, majestically united by the perfect responsion of their symmetries."[2]

Brown spoke of a master plan for the Imperial Fora. Characteristically, he did not expand on what he meant, in respect to an assemblage of monumental urban spaces whose construction extended over some 160 years, as to their obeying a "master plan."

Brown's friend and colleague of many years, Ferdinando Castagnoli, commenting on the Roman Soprintendenza's long-range plan for the complete excavation of the Imperial Fora, said that such a work "would be above all a demonstration of the unitary character of the Forum Romanum–Imperial Fora complex."[3] Perhaps both assertions were influenced by a brief article written by their common friend Peter von Blanckenhagen. In it, using Italo Gismondi's restored plan of the Imperial Fora, Blanckenhagen suggested that "there seem to be some striking regularities among the fora which hardly can be

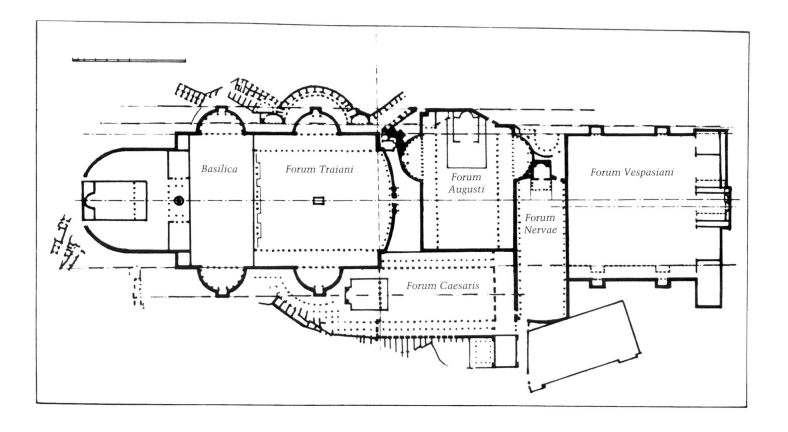

1. Imperial Fora, Rome, restored plan

After Peter von Blanckenhagen, "The Imperial Fora," *Journal of the Society of Architectural Historians* 13 (December 1954), fig. 2

explained by accident."[4] He illustrated the point of his assertion with a figure of Gismondi's plan, over which he had drawn in lines of correspondence that graphically linked the various fora in their two-dimensional plan relationships (fig. 1).

Such correspondences, in Blanckenhagen's words, "could never be recognized in any way save by actual measurement. And yet it is impossible to think that such an identity ... was not planned and planned as an important feature to the entire concept."[5] Concerning that concept, Blanckenhagen concluded that "it is merely the pattern of the blueprint, a love of regularity for its own sake, a dealing with architecture in an almost abstract way."[6] One may demur today at the term *abstract*, so central to the sensibilities of the 1950s when the article was written, but Blanckenhagen knew that a prolonged familiarity with the great plazas could allow one to "recognize a regularity which gave the old elements of axiality and symmetry a new significance and a deeper meaning."[7]

I wish to go beyond Blanckenhagen's recognition of the correspondences and pattern in the unfolding construction of the Imperial Fora and, taking up his assertion that some of the correspondences "could never be recognized in any way save by actual measurement," to consider actual measurements. In doing so I hope to validate Brown's intuitive recognition that from the time of Augustus' completion of Caesar's Forum and the construction of his own, one element existed upon which a master plan might evolve or which, in Castagnoli's words, might lend a unitary character to the growing ensemble.

Before turning to measurements, however, it may be useful to review the chronology of these majestic imperial spaces. They began when, as early as 54 B.C., Caesar commenced acquiring land to the northeast of the Forum Romanum for some sort of project, probably in response to the inauguration in the previous year of Pompey's impressive theater and porticus in the Campus Martius.[8] Point was given to the scheme by Caesar's victory over Pompey at Pharsalus in August of 48, before which battle Caesar was said to have vowed a temple to Venus Genetrix.[9] The temple and the

forum for which it served as the focal point were well along when Caesar was murdered in 44; both had been dedicated in an incomplete state two years previously.[10]

Unfinished as they were, the forum and temple formed part of the dictator's urbanistic legacy to Octavian. This portion of Caesar's far larger architectural testament was accepted by his heir and brought to completion by him, but by what date we cannot be sure. We can be certain, however, that Octavian vowed a temple to Mars the Avenger before the battle of Philippi in 42.[11] Whether at that time he thought of placing the temple in a forum, or indeed on the site it was eventually to occupy, we do not know.[12] This is perhaps likely, but the matter is complicated by the abnormally long time, by Roman standards, that it took to complete the project: the temple was dedicated only in 2 B.C., long after Augustus' other important architectural undertakings had been finished.[13]

The remaining Julio-Claudian emperors left the monumental core of the city unaugmented by splendid monuments of their own. Only with the accession of Vespasian and the establishment of a new dynasty some seventy-three years after the dedication of the Augustan Forum was the Templum Pacis vowed; it was dedicated four years later, in A.D. 75.[14] It stood on the site of the old *macellum* and was set at an axial right angle to the Augustan Forum; it was conceived in some sensible planimetric relation to the latter monument. But at the same time the two sites were still separated by the track of the Argiletum, the principal artery linking the Forum Romanum and the Esquiline quarter of the Subura, of largely proletarian habitation. We cannot know why Vespasian chose not to link the Templum Pacis more positively to the Augustan Forum. Was it to erect a related but discrete monument indicative of the autonomy of the new regime? Or was the decision made in deference to the convenience of the urban proletariat, whose access to the Forum Romanum would have been interrupted during building operations that involved the Argiletum? But there is no doubt that Domitian executed the project, in the form of the Forum Transitorium, to link the

Augustan Forum to his father's monument, and left it largely complete at the time of his death.[15]

A thorough restoration—indeed a virtual reconstruction—of Caesar's Forum and probably more than a mere projection of what was to become the Forum of Trajan formed parts of Domitian's gargantuan building program. The execution of the last and grandest of the Imperial Fora, however, was the work of the Optimus Princeps, and iconographically it was drenched with the message of his martial prowess.[16] Balanced about the axis of the Forum of Augustus, as a "forum belli" it appeared as a pendant to Vespasian's Templum Pacis, a monumental example of the Roman penchant for antitheses. With its construction the garland of Imperial Fora had come full circle, as demonstrated by the inauguration of Trajan's Column and the restored Temple of Venus Genetrix on the same day, 18 May 113.[17]

I now return to my dimensional hypothesis. I have taken Gismondi's often reproduced restored plan of the Imperial Fora and have correlated its data with those of supplementary drawings by the same author, as well as of others by Heinrich Bauer and Joachim Ganzert.[18] Almost all dimensions must be read from graphic scales, whose lack of precision, common to all such scales, is well known. Certain incremental dimensions in the Augustan Forum and certain dimensions in the Forum Transitorium, however, can be taken from detailed drawings at larger scale; some dimensions in both of these fora are given by Bauer in numerals that obviously record direct field measurements and notes. From a survey of these and several less important sources, seven different major distances encountered in all five imperial fora appear to be all but identical in dimension (fig. 2):

1. The length of the Forum of Caesar measured from the face of the podium of the Temple of Venus Genetrix to the opposing east wall of the forum (A).

2. The width of the Forum of Augustus measured between the apices of its two hemicycles (B).

3. The length of the Forum of Augustus from the chord of the apse of the Temple of Mars

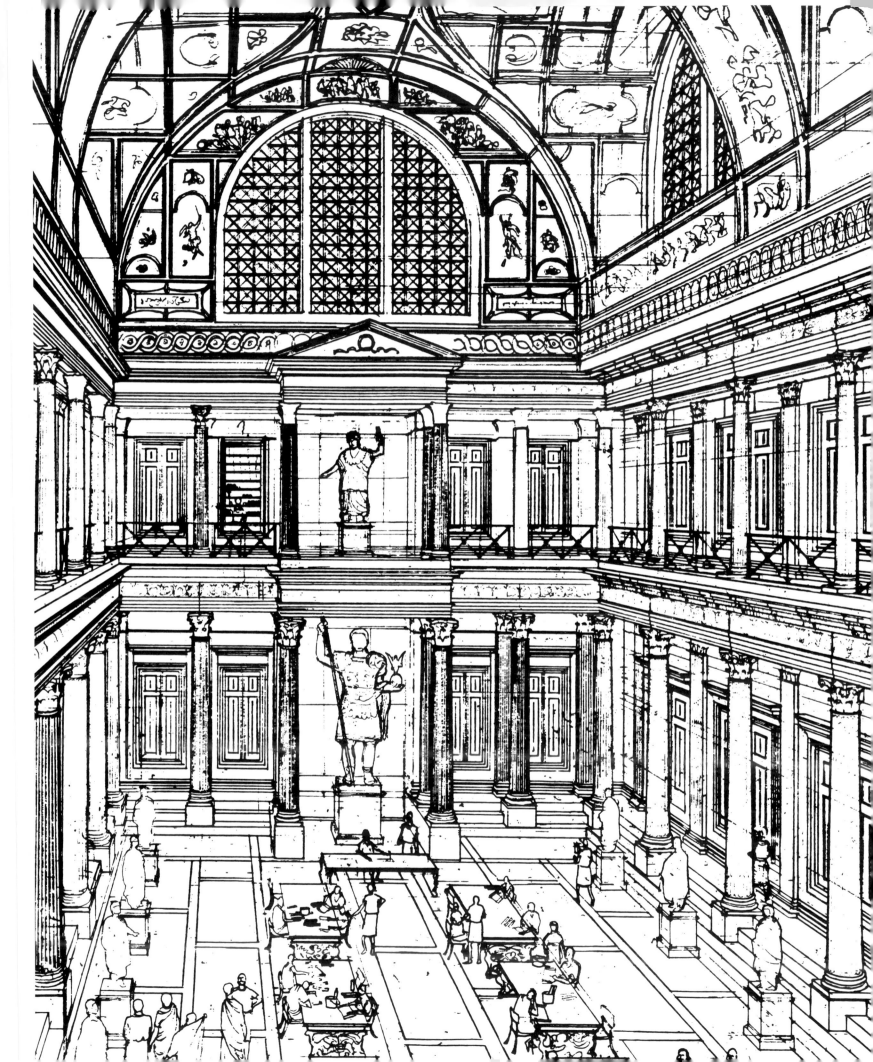

JAMES PACKER
Northwestern University

The West Library in the Forum of Trajan: The Architectural Problems and Some Solutions

Between 1928 and 1932 Mussolini's excavators in the Forum of Trajan cleared part of the Basilica Ulpia and completely uncovered the West Library,[1] in connection with construction of the boulevard now called the Via dei Fori Imperiali, which links Piazza Venezia with the Colosseum (fig. 1).[2] As shown on the ancient marble plan of Rome (the Forma Urbis),[3] the north and south walls abutted and were masked by the adjacent buildings; the west façade was half hidden behind one of the stairwells of the Basilica Ulpia; and the portico around the Column of Trajan largely concealed the east façade.[4] Thus this sizable rectangular hall (figs. 9, 10, 23, 24) was essentially an elaborate interior. Although the east, west, and south walls had disappeared, their foundations and the podium that framed the interior along the north, west, and south walls left little doubt as to their original positions (fig. 10). The intact lower section of the north wall and the surviving podia showed that the building had been constructed of concrete faced with *bessales* (tiles with sides of 20–22 cm). On the façades, these were concealed by stucco drafted to resemble ashlar masonry;[5] on the inside, they were hidden by marble veneers.[6] Part of the marble and granite floor remained intact (fig. 9 [K]), and fragments of two superimposed interior Corinthian orders littered the floor where they had fallen in the southwest corner of the room (figs. 9, 11). Except for chips or abrasions that had resulted from the collapse of the building, their carvings were fresh and crisp.

Under pressure to complete the excavations in the Forum in time for the opening of the Via dei Fori Imperiali,[7] the excavators left most of the architectural fragments in their original positions. To support the concrete canopy that carried the gardens adjacent to the Via dei Fori Imperiali above (fig. 7), the "esedra arborea,"[8] they erected a series of piers in the Library (fig. 9 [L], 11). In the next ten years, the political objectives of the Fascist regime did not include further excavation in the Forum of Trajan, and after World War II, during the first three postwar decades, study of the site, one of the great Fascist show projects, was politically inexpedient. Thus, when I initiated my studies of the Forum of Trajan in 1972,[9] scholars in Rome had neglected the site for forty years.

To begin my investigation of the Library, I first reviewed the reconstructions of the architect Ceschi, Italo Gismondi, and Carla Amici. In 1932 Ceschi had sketched a restored elevation of the interior north wall (fig. 1).[10] In 1939–1941 Gismondi, the architect for the Fascist excavations, produced a detailed restoration (part of a reconstruction of the entire Forum for a model commissioned by the Romanian government; figs. 2–4).[11] In 1982 Amici,

including their frames, were about as high as the shafts of the flanking columns.

While it is comparatively easy to restore conjecturally the heights of the two interior orders and the niches, the proportions of the columnar screen at the entrance to the building constitute a special problem. Gismondi and Amici assume that the screen columns (fig. 10) and those in the peristyle around the Column of Trajan were identical (figs. 2–6), but since the foundations of the screen order are three-quarters the size of the foundations of the columns in the peristyle (figs. 8 [A, B], 24), the screen order would also have been three-quarters the height of the peristyle order. Thus the screen columns would have been almost exactly the height of the interior lower order plus that of the podium on which it stands.[25]

To judge from these proportions, the entablature of the screen order ought to have been a little less than 0.75 Roman foot higher than the entablature of the lower interior order of the Library.[26] Since this difference is comparatively small, I assume that the entablature of the screen order and that of the lower interior order of the Library were identical and that by extending over the screen columns, the entablature of the interior order combined both orders into a unified and harmonious design (fig. 26). Rectangular sockets in the sides of the pavonazzetto marble shafts of the screen order (figs. 8, 9 [D], 10), and a round socket in the single preserved slab of the pavement between its columns (figs. 8 [C], 9), show that bronze screens restricted access to the West Library. The upper colonnade would have continued above the entrance as a row of pilasters separating panels of colored marbles. With shafts six lower diameters high and a low entablature, the screen order thus differed slightly from the other orders in the Forum. Yet, the entrances to the Libraries posed a special problem, solved, the surviving evidence suggests, by an order of unorthodox proportions.

Amici restores the roof of the West Library as a timber-truss (figs. 5, 6). Indeed, measuring the thickness of the north wall at 5.25 Roman feet and the width of the chamber at about 58.25 Roman feet, she

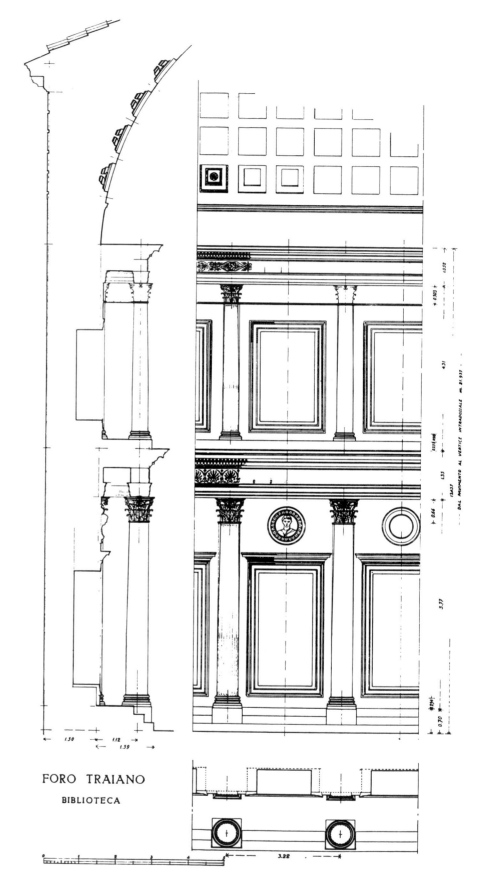

FORO TRAIANO

BIBLIOTECA

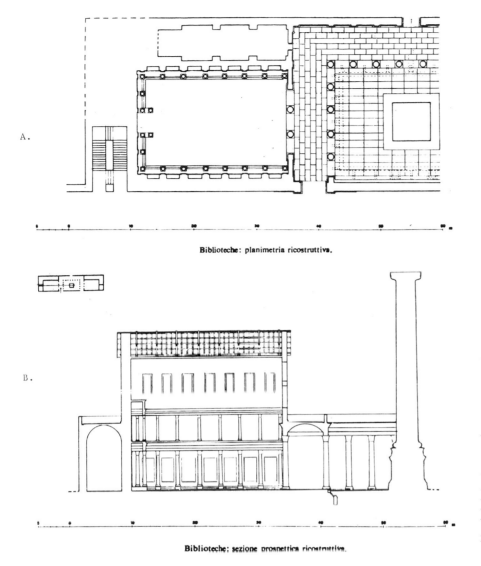

A.

Biblioteche: planimetria ricostruttiva.

B.

Biblioteche: sezione prospettica ricostruttiva.

4. West Library, Forum of
Trajan, Rome, c. 1941,
measured section and
elevation of north wall
Drawing by Italo Gismondi
Comune di Roma

5. West Library, Forum of
Trajan, Rome, 1982: A,
restored plan of Library and
part of peristyle around
Column of Trajan; B, east-
west section looking north
From Carla Amici, *Foro di Traiano*
(Rome, 1982), figs. 125, 126

insists that "nessuna altra soluzione è...
possibile."[27] The excavators of 1930–1932,
however, found numerous massive frag-
ments of concrete at the entrance and near
the south wall in the interior (figs. 8, 9 [J]).
In an article written soon after the excava-
tions, Gustavo Giovannoni, followed more
recently by Marion E. Blake and Doris T.
Bishop, assumes that these fragments came
from a vault that Giovannoni characterizes
as having "stratificazioni del materiale leg-
gero—pomice o lava bollosa."[28] According
to Gismondi (figs. 3, 4), Giovannoni's frag-
ments belonged to a barrel vault.

Nonetheless, the Great Hall in the Mar-
kets of Trajan (what William MacDonald
calls the "Aula Traiana")[29]—an analogous
neighboring space also probably designed
by Apollodorus of Damascus—suggests a
different solution. In the Aula Traiana, the
lateral vaults of a groin vault somewhat
smaller than the vault in the Library[30] rest
in part on travertine brackets. In the Li-
brary, the superimposed orders will have
replaced the brackets (figs. 26, 27); includ-
ing these orders, the walls would have been
10 Roman feet thick. Moreover, the traver-
tine masonry of the Basilica reinforced
the south wall; the north wall probably
received some support from the portico
around the precinct of the Temple of
Trajan; and the stairwell of the Basilica
Ulpia behind the Library strengthened at
least a part of the west wall.[31] We may thus
conclude with Gismondi (figs. 3, 4) that the
walls of the West Library could easily have
supported a vault.

This vault and the method of lighting
the interior were closely connected. With
Gismondi's barrel vault, light could have
been introduced only from semicircular
"thermal" windows at the east and west
ends of the room. Yet, with a groin vault,
each of the cross vaults could also have
housed a window (figs. 25, 29). Light
would have entered the building on all
four sides. While the cross vaults in later
bath buildings frequently sprang from
columns set close to the walls, the vaults in
the Baths of the Seven Wise Men and in the
House of Serapis at Ostia are reminders
that in the second century A.D. groin
vaults often sprang from walls without
additional supports.[32]

Finally, we asked how high the Library
vault would have been. While there is no
clear evidence on the site, the apparent
architectural geometry of the adjacent
Basilica Ulpia offers clues. There, the two
aisles have a combined width of 50 Roman
feet, and that was probably also their
height (from the interior pavement to the
terrace atop the vaults).[33] Fifty Roman feet
was also the width and height of the East
Colonnade,[34] and Sarring and I assumed
that the same module was also used in the
West Library (fig. 28). Consequently the
interior of the Library would have been

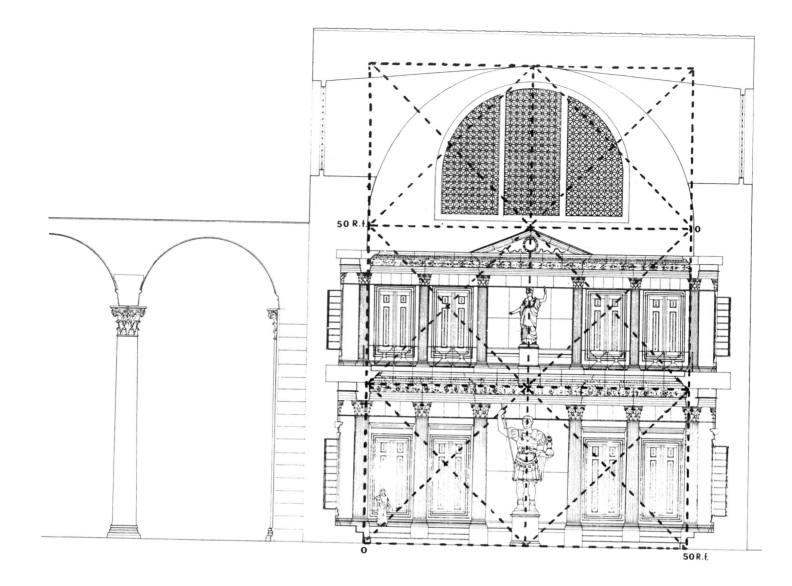

50 R.f. **0**

0 **50 R.f.**

28. West Library, Forum
of Trajan, Rome, restored
north-south section looking
west, showing architectural
geometry
Drawing by Studio Groma, Rome

29. West Library, Forum
of Trajan, Rome, restored
interior view
Drawing by Gilbert Gorski, AIA

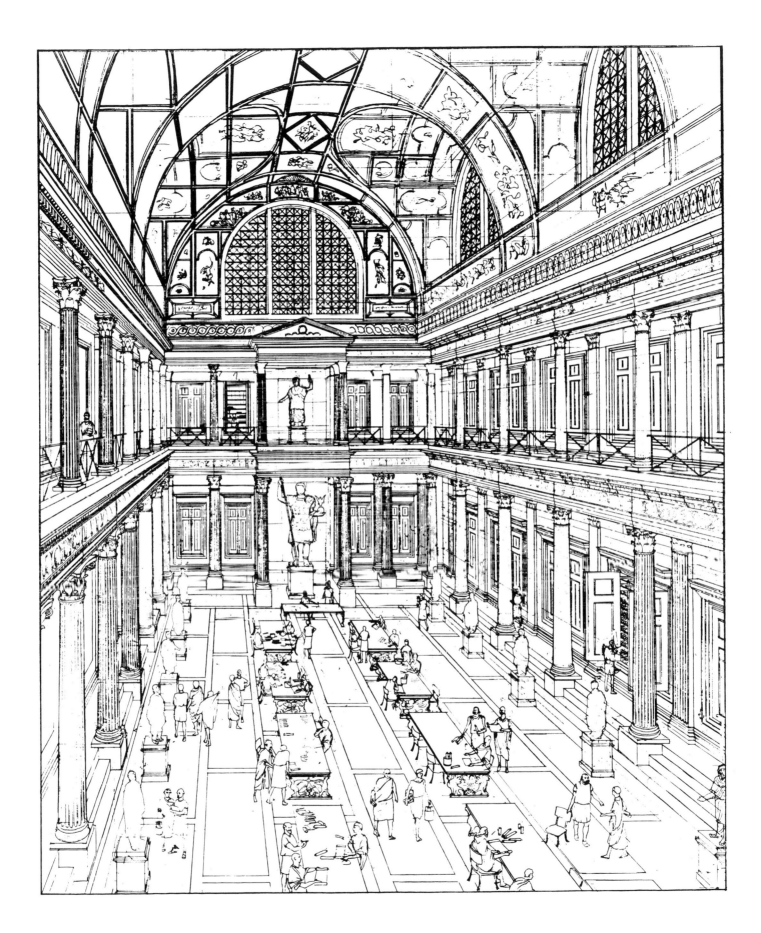

restored, one would understandably assume that they are complete. As I have explained, this is not at all the case, since the doors actually incorporate parts of three or rather four doors.[20] The question arises: how did that happen?

The disaster of 1944 had been preceded 600 years earlier by another catastrophe, the earthquake of 1349, which totally destroyed the magnificent abbey of Desiderius. As in 1944, the doors col-lapsed, but the majority of the panels was saved and could be reused in the recon-struction of the doors toward the end of the fourteenth century.[21] In view of what had happened to them, they were in remarkably good shape. In 1535, about 150 years after this restoration, the prior Benedetto Cano-filo had a copy of the inscription made, as it existed then. I published the document, which is important because it shows that the panels that decorated the doors were

5. Same doors, detail: Abraham, reverse of panel XIII

6. Same doors, detail: Isaac, reverse of panel XI

7. Same doors, detail: Saint Philip, reverse of panel VI

7. Same doors, detail: Saint Philip, reverse of panel VI

8. Same doors, detail: Saint Bartholomew, reverse of panel XII

identical with the present ones, although they were arranged differently.[22]

I decided to study the doors, and especially the inscription, because it had not been done before. But hardly had I embarked on the venture when I made another discovery even more startling to me than the one about the lack of a study of the inscription. There existed treatments of quite a few individual possessions of Monte Cassino, but no general attempt had ever been made to cover all the dependencies of Monte Cassino or of any other major monastery in the Western world.

As soon as I began my work, I encountered a strange obstacle. Every archaeologist who wishes to study a place, settlement, building, or the like obviously wants to know its site. But among those who had worked before me on the possessions of

Monte Cassino there seemed to be an inexplicable reluctance to give indications about their locations. This was true of Gattola, whose work I praised before and in whose time these dependencies were still in use, whereas nowadays most of them are in ruins, have been converted to other uses, or have disappeared altogether, sometimes leaving the name of a church as the name of a hill or a locality (*contrada*, in Italian). But it also applies to modern scholars, who have published the archives of monastic establishments that ended up in the archives of Monte Cassino without telling us where those establishments could be found.[23]

It was my familiarity with the topography of ancient Rome and its environs and my archaeological training in general that led me inexorably to the quest of the where-

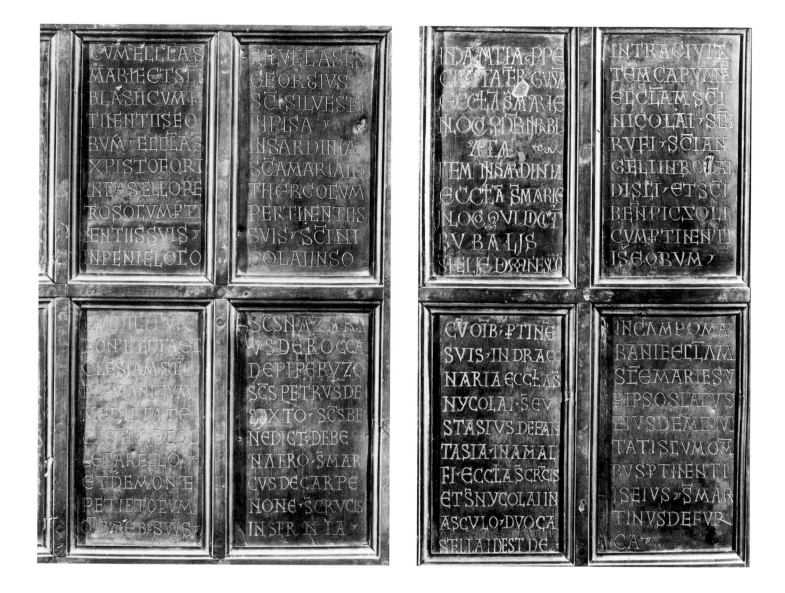

between panels comes sometimes in the middle of the description of a dependency: thus panel VI is followed by VII, VIII by IX, and XII by XIII. Other sequences can be established with certainty, such as the one containing the abbey's holdings from the Liri valley to Rome. It starts in panel XIX, continues in XIV, which in turn is followed by XV (for panels XIX and XIV, see fig. 14).[27] The most significant original sequence is preserved as what was surely always the beginning of the list: panels I–IV give the names of the villages in the *Terra Sancti Benedicti*, the area surrounding the monastery, which had been subject to Monte Cassino since the eighth century.

The existence of gaps in all three doors can easily be proved, precisely because

there are panels extant that start or end within the description of a possession, the beginning or continuation of which cannot be found among the preserved panels. That these gaps have escaped detection for 250 years is almost unbelievable.

Panel XXXI (fig. 12) begins with two important dependencies of Monte Cassino in Lucca and Pisa and moves from there logically—because of the ancient connection between Pisa and Sardinia—to this island, to which Abbot Desiderius had brought monasticism. We read: "Sca Maria in Thergo cum pertinentiis suis" (that is, with its dependencies), followed by "Sci Nicolai in So."[28] Here ends the panel. The church in question, now in ruins, is well known as S. Nicolaus in Solio. There must

12. Doors of Oderisius II, Monte Cassino, detail: panels XXV, XXVI, XXXI, XXXII

13. Same doors, detail: panels XXVII, XXVIII, XXXIII, XXXIV

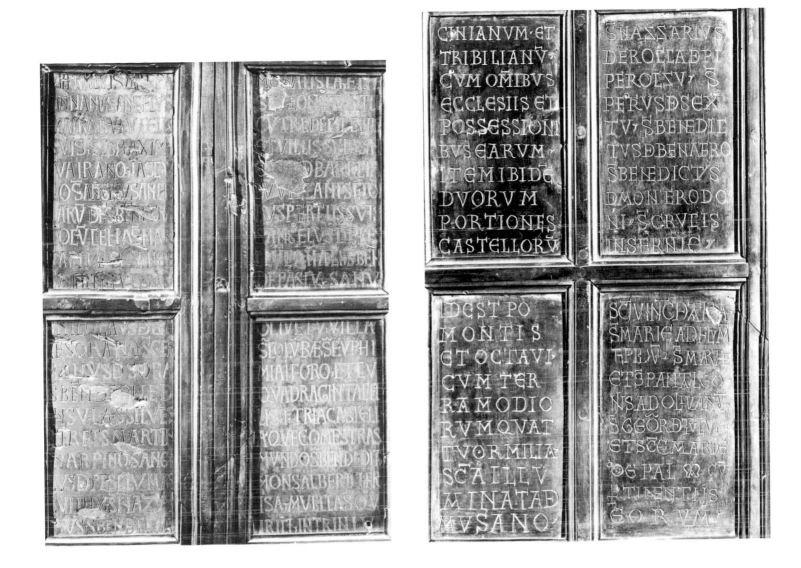

14. Same doors, detail: panels XIII, XIV, XIX, XX

15. Same doors, detail: panels XXIX, XXX, XXXV, XXXVI

have been a panel beginning with the letters *lio*. It does not exist anymore. It likely contained other Sardinian dependencies and was probably followed by another one, also lost, continuing the list of Sardinian possessions. Panel XXVIII (fig. 13) begins with the words "cum omnibus pertinentiis suis" (with all its dependencies). These words do not continue the text of any other panel, which means that the panel originally preceding panel XXVIII is not preserved.[29]

Other demonstrable gaps are as unassailable as the two just discussed, but they require a thorough knowledge of the possessions involved. I limit myself here to the case of the most important dependency of Monte Cassino in the Abruzzi,

San Liberatore, which in turn had many dependencies of its own. Its absence from the list should have aroused the suspicions of even the most superficial reader of the inscription. It didn't. But panel XX begins with the word *Olivetum*, followed by "Villa S. Columbae" and "S. Euphimia in Foro," all three dependencies of San Liberatore; these names are followed by the words "et cum quadraginta cellis" (and with forty [dependent] churches) and a cross uniquely marking the end of a section of the list (fig. 14). These words cannot possibly refer to Sancta Euphimia; they must belong to an item in the preceding missing panel, and this item can only be San Liberatore.[30] Although this statement needs no further confirmation,

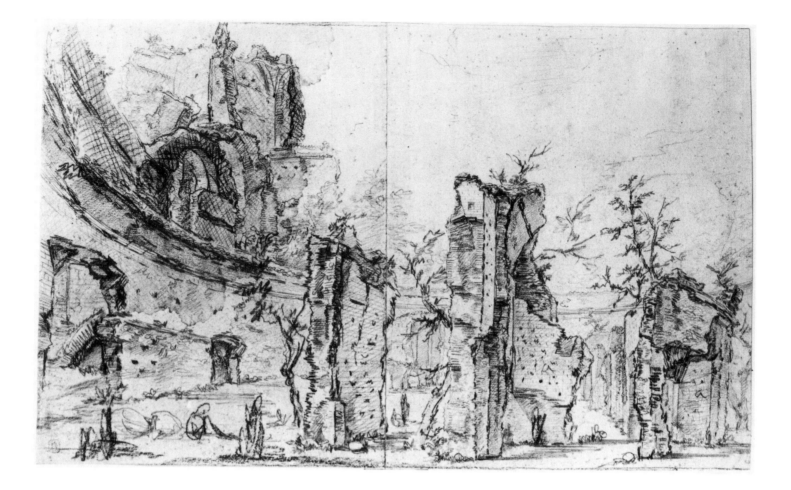

8. Giovanni Battista
Piranesi, *View of the Island
Enclosure at Hadrian's
Villa*, drawing
Ashmolean Museum, Oxford

interpret the evidence as for what they record. Once they are viewed together, rather than in isolation, Piranesi's representations of the Villa constitute a major theme within his oeuvre, a theme that grew in significance as his career matured. Moreover, these images constitute a fresh mode of seeing as well as documenting the past.

With far greater rigor and authority than in any of his earlier antiquarian studies, Piranesi applies the principles he first began to formulate in the mid-1750s. John Wilton-Ely's characterization of Piranesi's archaeological method developed in the course of compiling the *Antichità romane* applies equally well to his work at Hadrian's Villa.[39] No longer is Piranesi content with representing the exteriors of individual buildings, as in the *Vedute*; he now supplements these with analytical drawings, including plans and sections.

Furthermore, Piranesi fleshes out ruined or vanished structures by means of conjectural plans and whenever possible employs ancient literary sources, as in the key to the *Pianta*, where he uses the nomenclature found in the *Historia augusta* to interpret the function and meaning of the Villa's component parts. Most significantly, Piranesi binds all of these means together to accomplish his ultimate end: a complete reconstruction, as in the plan.

Werner Oechslin has observed how the act of translating ruined walls into archaeological plans, a task usually performed in the eighteenth century by artists and architects, led to a new kind of graphic abstraction.[40] This process, especially in the hands of a master draftsman like Piranesi, had the effect of blurring the line between archaeological fact and inventive fantasy. A comparison of Piranesi's archaeological plan of Hadrian's Villa and his fantastic

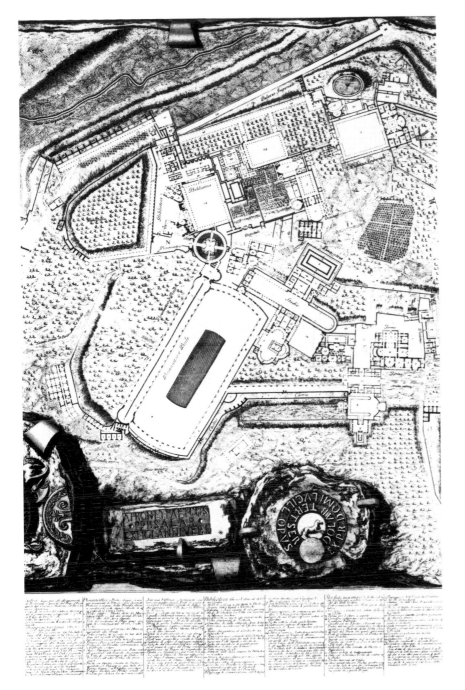

9. Giovanni Battista Piranesi and Francesco Piranesi, plan of Hadrian's Villa, detail of pl. 2, 1781, etching
From Francesco Piranesi, *Pianta delle fabbriche esistenti nella Villa Adriana* (Rome, 1781)
Author photograph

lapidary vision. Piranesi's plan of Hadrian's Villa, however, allows the ruins to speak more directly; in this archaeological mode they function as documents rather than metaphorical analogs. Piranesi himself remarked in the dedication to the *Campo Marzio*: "Before anyone accuses me of falsehood, he should, I beg, examine the ancient marble plan of the city...he should examine the Villa of Hadrian at Tivoli."[41]

More than any other ancient site known in the Renaissance, Hadrian's Villa embodied the richness and variety of Roman imperial architecture. Certain Renaissance architects, like Francesco di Giorgio, found this variety troubling and, looking at the Villa through Vitruvian glasses, felt the need to make corrections so as to bring it into conformity with prevailing theory.[42] Piranesi, on the other hand, emerged as the great champion of the virtues of complexity, which especially in later life he opposed to Johann Winckelmann's emphasis on the "noble simplicity and quiet grandeur" of ancient art, a revolutionary aesthetic interpretation central to the formation of the neoclassical style.[43] It is worth noting that ironically Winckelmann's view of antiquity was largely predicated on sculpture found at Hadrian's Villa, works like the celebrated Antinous relief in the Albani collection. Thus, at a crucial juncture in the history of Western art, Hadrian's Villa maintained its role as a touchstone, providing crucial evidence and justification for both sides in the boiling controversy over the primacy of Greek and Roman forms.

Winckelmann's austere vision of antiquity, championed by Marc-Antoine Laugier and Julien-David Le Roy as well, constituted nothing less than a sweeping repudiation of the characteristic baroque exaltation of creative license that constituted the core of Piranesi's conceptual genius.[44] The sophisticated pavilions of Hadrian's Villa are very far indeed from Laugier's Vitruvian hut. Piranesi viewed the diversity and inventive power of the ancients as an inspiration for creative design in his own day; paraphrasing Sallust, he dismissed his critics by observing, "They despise my novelty, I their timidity."[45] His plan of Hadrian's Villa and the intended

reconstruction of the Campus Martius (of 1762) reveals similar relationships of form, though one is substantially factual and the other largely visionary (figs. 9, 10). In the *Campo Marzio* Piranesi's vision of Roman grandeur takes its point of departure from the abstract geometrical conventions of the ancient *Forma Urbis Romae*. The fragmentary state of the real marble plan makes possible the fantastic configurations of his

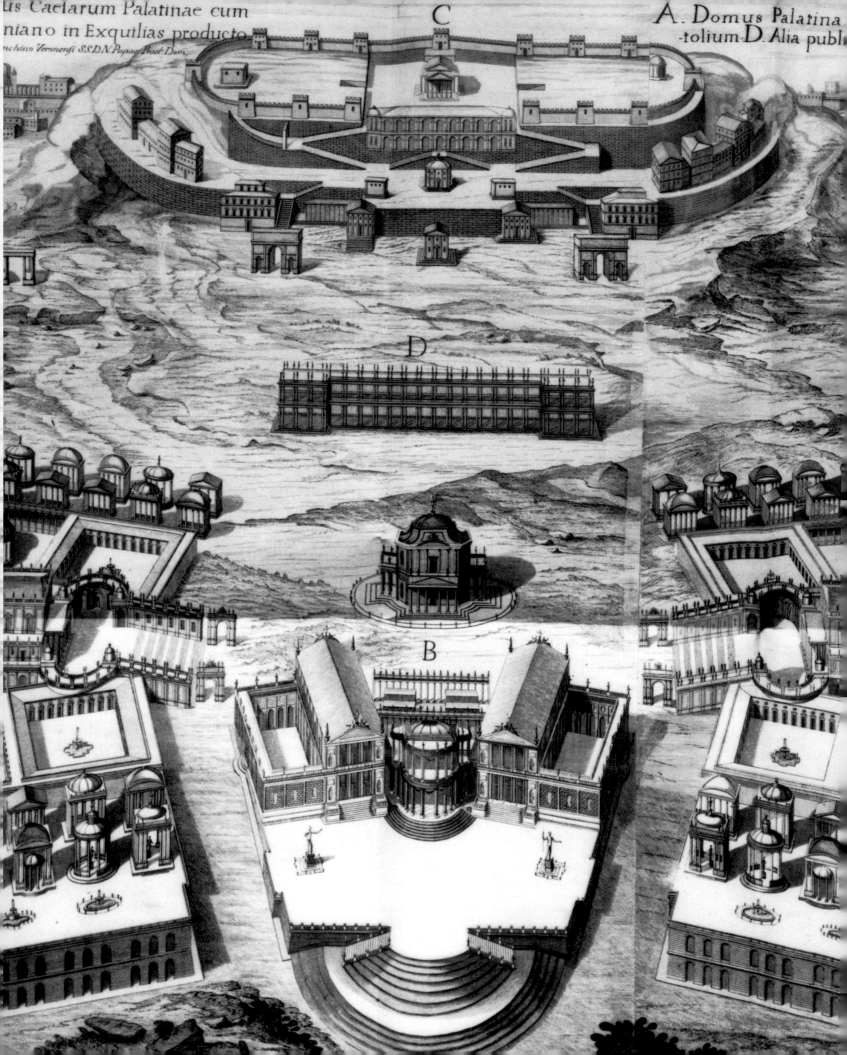

us Caelarum Palatinae cum
niano in Exquilias producto.
nchino Veronensi S.S.D.N.Papae Praed:Dom:

C

A. Domus Palatina
-tolium D. Alia publ.

D

B

HENRY A. MILLON

Center for Advanced Study in the Visual Arts
National Gallery of Art

Reconstructions of the Palatine in the Eighteenth Century

In the 1720s Francesco Bianchini (1662–1729) directed excavations on the Palatine Hill in Rome. The results of the excavations were recorded in a publication, *Del Palazzo de'Cesari*, that appeared in Verona in 1738. The volume included reconstructions of structures on the Palatine in both plan and elevation. The reconstructions were comprehensive, covering not only the full extent of the Palatine, but also structures built on the Velia and extending north toward the Viminal Hill. The Viminal, located to the west of the Esquiline, was at the time thought to be the site of the Golden House of Nero. An aerial perspective of the complex, looking west-northwest, includes, in the distance, the Capitoline Hill (fig. 1). The structures on the Palatine and north toward the Viminal Hill are symmetrically disposed about a central axis that runs north of the Temple of Venus and Rome, between the temple and its twin, at the lower center of the view. The axis continues through the site of the Forum to the Capitoline, which is depicted with symmetrical terraces and ramps and an axially placed central temple.

The architect Francesco Nicoletti was commissioned to prepare the large perspective drawing, dated 1729, which became the final plate in Bianchini's publication. Several other plates bear an earlier date, 1724, and at least one (Bianchini's pl. 3) was drawn by another draftsman, Balthasar Gabbuggiani. Giuseppe Bianchini, a nephew of Francesco who spent six years preparing the volume for publication,[1] notes in a postscript that even though the text was not finished, Bianchini already had in his possession all the plates that were to be appended to the volume. The exception was the large perspective, which was drawn in Rome and then engraved in Verona where the volume eventually was published.[2] The circumstances that led to this publication and to Francesco Bianchini's direction of the excavations on the Palatine merit examination.

Francesco Bianchini was educated by Jesuits in Bologna and developed there his initial interest in astronomy under Giuseppe Ferroni, a follower of Galileo.[3] In 1680, at age eighteen, he went to study theology at Padua. There he met the astronomer Geminiano Montanari, who had a decisive influence on his studies. Montanari's fame as an astronomer brought many scholars to Padua and led to Bianchini's meeting some of the leading figures in science. It is probable that in this company Bianchini learned of the continuing scholarly battle over the validity of literary evidence and became aware of the possibility of writing scientific history based on archaeological remains and numismatics rather than on literary sources.[4]

In 1684, at the suggestion of his parents, Bianchini went from Padua to Rome,

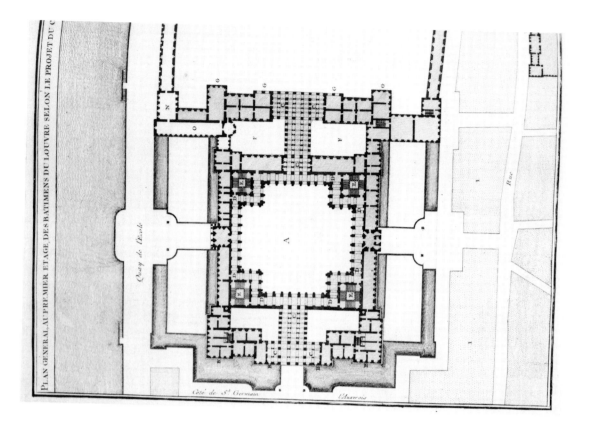

11. Gianlorenzo Bernini,
Final Project Plan for the
Louvre, 1665

From Jacques-François Blondel,
L'Architecture françoise (Paris,
1756), 4: bk. 6, no. 1, pl. 3 (National
Gallery of Art Library, Washington)

of Augustus and the Palace of Tiberius and Caligula, as well as that of Domitian, but repeated fires from the time of Nero until Domitian destroyed these palaces and eliminated distinctions between the first and second plans. He intended, therefore, to present only the plans of Domitian's Palace.[30]

At the beginning of *Del Palazzo de'Cesari*, Bianchini said that reconstructions should be limited by the evidence of remains and previous excavation reports. He somewhat stretched these limits when reconstructing the elevations of the palace. But by the time he wrote the eleventh chapter, the seduction of imaginative reconstructions had become irresistible. For the Golden House of Nero he found himself proposing the most fanciful reconstruction yet known. In introducing his description of the Golden House, Bianchini wrote,

I proposed in chapter 6 not to draw the plan of any of the states of the palace before Domitian, relying on the more secure vestiges of the large rooms (the basilica, main courtyard, and lararium) that allowed us to recognize other portions of walls not completely destroyed

and sufficiently manifest, and portions [of the palace] through the books of writers of that time. It will seem now that I have abandoned that resolution, since I propose in this chapter to discuss and perhaps provide a drawing of the prodigious additions made by Nero to the vast palace that already occupied all the area of the Palatine. It may appear yet further to be too daunting to attempt since the enlargement was so hated by his immediate successors that, not content to see it deformed by fire, and to extinguish forever the name [of Nero], Vespasian erected there the Temple of Peace and the amphitheater, completed by Titus who dedicated it and built nearby his baths, burying thereby in the foundations of his buildings every vestige of these structures. Even with all this I do not despair of the attempt to delineate some model, nor of the attempt to envisage the arrangement of the structures.[31]

As we have seen, his desire led to the fantastic reconstruction/repetition of the Palace of the Caesars as the Golden House of Nero on the slopes of the Esquiline and Viminal Hills.

Plate 15 (fig. 12) of Bianchini's volume is an elevation from the southwest of the Temple of Venus and Rome, the axially

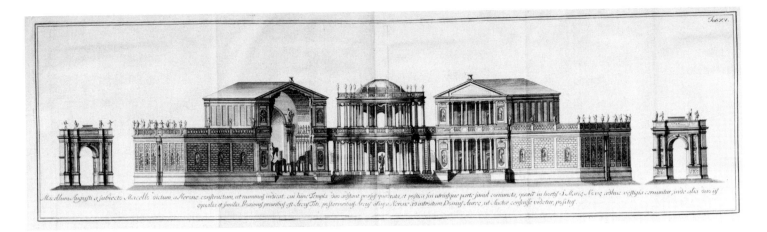

12. Façade of Temple of
Venus and Rome, Rome,
reconstruction elevation
From Francesco Bianchini 1738,
pl. 15

placed Macellum Augusti, and the match-
ing temple to the northeast. The converg-
ing angles of the two temple façades, their
extensions to left and right, and a cen-
trally placed domed structure recall aspects
of reconstructions of the Capitoline Hill
as proposed by Filippo Juvarra in 1709.[32]
This is not surprising, since the summary
reconstruction of the Capitoline Hill shown
in the large perspective (pl. 17; fig. 13) also
recalls the same group of designs by
Juvarra (fig. 14).[33]

There is much to learn about Bianchini's
thought and the development of history
in the early eighteenth century before
Giambattista Vico, and much to ascertain
concerning the architectural preparation of
those who assisted Bianchini with the
designs of the buildings. The only names
known are those of Balthasar Gabbuggiani,
who prepared plate 3, and Francesco
Nicoletti, the architect who prepared the
drawing for the large engraved aerial per-
spective. In the spring of 1728, Nicoletti
had shared the first prize of the first class of
architecture at the Accademia di San
Luca with two other contestants, Carlo
Marchioni (later to be architect of Saint
Peter's and designer of the Sacristy of the
Basilica), and Giovanni Maria Guagli,
whose contributions to eighteenth-century
architecture have yet to be recognized.[34]

The drawings that netted Nicoletti one-
third of the first prize have been preserved.
The program was for a large piazza facing
on a seaport of semicircular form to be sur-
rounded by a three-aisled Doric portico, at
the center of which a large building of
Ionic order with a *gran salone* would be

accompanied by other smaller structures
for the functioning of the port. The size of
the main building was to be proportioned
to the size of the piazza and port.[35]

Nicoletti's symmetrical design included
a three-level central structure with three
superimposed layers of orders and a
smaller central pavilion at a fourth level,
flanked by salient pavilions.[36] Concavely
curving porticoes with salient corner bays
enframed a piazza facing the sea. Nico-
letti's vocabulary includes many of the
elements that appear in the reconstructed
elevations of the Palace of the Caesars in
Bianchini's publication.

It seems likely that Bianchini realized
he would have need of an imaginative
young architect. An inquiry would have
produced the names of the outstanding
members of the first class at the Accademia
di San Luca, and Nicoletti may thus have
been brought to Bianchini's attention.

Bianchini died on 2 March 1729. It is not
known whether Nicoletti was engaged by
Francesco Bianchini before his death or by
Giuseppe Bianchini sometime during the
preparation of the publication. Nicoletti
and Francesco Bianchini would have had
much to discuss, and the descriptions in
the text suggest Bianchini had already
given thought to the appearance of the
reconstructions of the Golden House, as
well as those of the Palace of Domitian;
he may even have discussed the recon-
structions with other archaeologists, anti-
quarians, and architects.

Bianchini's architecture, in its layering
of the orders and its awareness of the
architecture of Bernini and Juvarra (who,

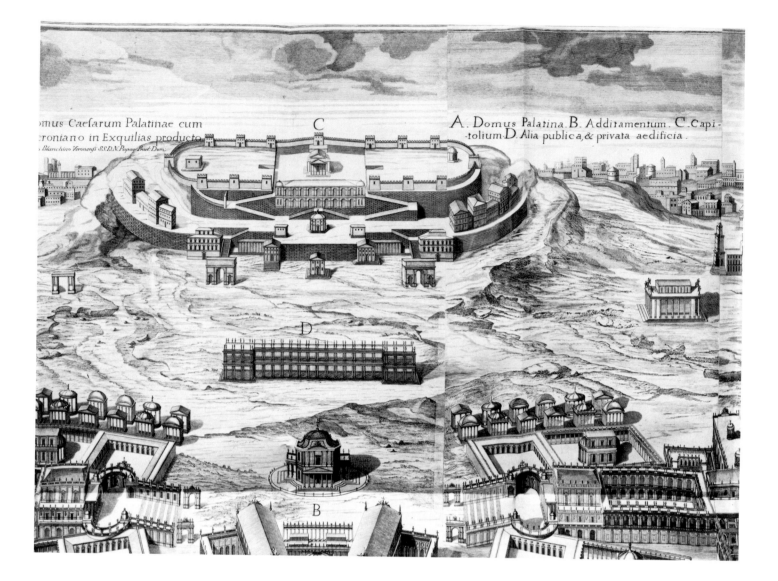

omus Caefarum Palatinae cum
roniano in Exquilias producto
Blanchino Veronenfi S.S.D.N.Papac Pract Dom.

C

A. Domus Palatina. B. Additamentum. C. Capi-
tolium D. Alia publica, & privata aedificia.

D

B

although first architect to the king of Savoy, was often in Rome and was an admired member of the Accademia di San Luca), demonstrates his knowledge and appreciation of the architectural traditions that shaped Roman architecture in the third decade of the eighteenth century.

Although the reconstructions of ancient architecture that Bianchini may have supervised seem to reflect prevailing ideas of contemporary architecture, it was nonetheless his plan of the Palatine that was followed for the excavations by the abbé Rancoureuil fifty years later and for the more exhaustive excavations under-taken by Pietro Rosa in 1865.

13. Palatine and Capitoline Hills, Rome, reconstruction aerial view (fig. 1), detail: Capitoline Hill
From Francesco Bianchini 1738, pl. 17

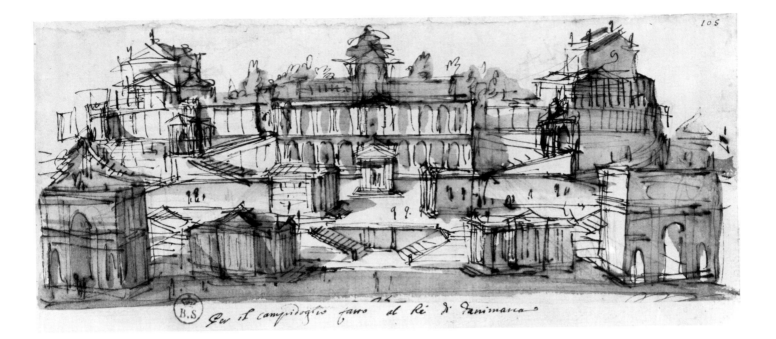

14. Filippo Juvarra,
Reconstruction of the
Capitoline Hill, Rome, 1709
Biblioteca Nazionale, Turin, Riserva
59.4, fol. 105 (drawing 1)

NOTES

An earlier version of this paper was presented in the session, "*Palatium Domini*: The Palatine Tradition in Fact and Fiction," of the meeting of the Society of Architectural Historians, Montreal, Quebec, Canada, 14 April 1989.

1. Giuseppe Bianchini, in Francesco Bianchini, *Del Palazzo de'Cesari* (Verona, 1738), on the third page of the dedication to King Louis XV: "hoc opere: quo in conficiendo sex annorum impendio."

2. Giuseppe Bianchini, in Francesco Bianchini 1738, 300: "Si daranno, ciò non ostante, al fin del volume le tavole appartenenti a questo capitolo ed al compimento dell'opera, giacchè preparolle l'Autore, anzi, come quasi tutte l'altre, le fece incidere in rame, toltante la più grande, che si è fatta intagliar quì in Verona sopra il disegno ritrovato di perito ed accurato Architetto, di cui mostra il nome."

3. For Bianchini, see the entry by Salvatore Rotta in *Dizionario biografico degli italiani* (Rome, 1968), 10:187–194. See also Benedetto Croce, *Conversazioni critiche*, 2d ed. (Bari, 1924), 101–109; Arnaldo Momigliano, "Ancient History and the Antiquarian," *JWarb* 13 (1950), 299–300, rpt. in *Prima contributo alla storia degli studi classici* (Rome, 1955), 85–86; and Christopher M. S. Johns, "The Art Patronage of Pope Clement XI Albani and the Paleochristian Revival in Early Eighteenth Century Rome" (Ph.D. diss., University of Delaware, 1985), 35–43.

Werner Oechslin notes that he has been at work on a detailed study of Francesco Bianchini and his excavations of the Palatine since 1970–1971 ("L'intérêt archéologique et l'expérience architecturale avant et après Piranèse," in *Piranèse et les français*, ed. Georges Brunel [Rome, 1978], 398, n. 16).

4. In discussing the debate in the eighteenth century over the nature of historical evidence, Momigliano 1950, 285–315 (1955, 67–106), has noted the degree to which nonliterary evidence became especially authoritative in the late seventeenth and early eighteenth centuries.

5. *La istoria universale provata con monumenti, e figurata con simboli degli antichi* (Rome, 1697); 2d ed., corr. and incl. Scipione Maffei, "Vita di Monsignor Francesco Bianchini Veronese" (Rome, 1747).

6. Jacob Spon, *Reponse à la critique publiée par M. Guillet, sur le Voyage de Grèce de Iacob Spon* (Lyon, 1679), 30–31: "Il nous fera voir dans ses premières dissertations, comment par un miracle inoui, les Auteurs anciens tout hommes qu'ils estoient avoient moins de passion que le marbre et que le bronze d'apresent, et comment au contraire le bronze et le marbre d'alors estoient plus susceptibles de passion que les hommes de ce siècle."

7. *De calendario, & cyclo Caesaris, ac de Paschali canone sancti Hippolyti: Accessit enarratio de nummo, & gnomone Clementino* (Rome, 1703).

8. Rotta 1968, 10:190.

9. The finances of Clement XI were not sufficient to sustain his intention to establish a museum of antiquities. The objects assembled by Bianchini were dispersed. See Christian Huelsen, "Il 'Museo ecclesiastico' di Clemente XI Albani," *BullCom* 18 (1890), 260–277.

10. See Giuseppe Lugli, *Roma antica: Il centro monumentale* (Rome, 1946), figs. 124, 125. See also Arturo Carlo Quintavalle, *La Regia Galleria di Parma* (Rome,

1939), 40; and Lucia Fornari Schianchi, *La Galleria Nazionale di Parma* (Parma, n.d. [1983]), figs. 8, 17, 21, 22.

11. On Giuseppe Bianchini, see Rotta 1968, 10:200–205.

12. Gabinetto Disegni e Stampe degli Uffizi, 163 Santarelli. See Anna Forlani Tempesti and others, *Disegni italiani della Collezione Santarelli: Sec. XV–XVIII* (Florence, 1967), 30–33; and Alfonso Bartoli, *I monumenti antichi di Roma nei disegni degli Uffizi di Firenze* (Rome, 1914), 1: pl. 11, fig. 24.

13. See, for example, Etienne Dupérac, *Urbis Romae sciographia* (Rome, 1574), reprod. in Amato P. Frutaz, *Le piante di Roma* (Rome, 1962), 2: plan 22, 7, pl. 44.

14. Filippo De Rossi, *Ritratto di Roma antica* (Rome, 1654), 86, pl. 27; and Alessandro Donati, *Roma vetus ac recens utriusque aedificiis illustrata* (Rome, 1662), pl. 225.

15. Francesco Bianchini 1738, chap. 4, 30, 32. See the detail of Bufalini's plan of 1551 showing the Palatine area in Frutaz 1962, 2: plan 109, 14, pl. 203; and Panvinio's reconstruction map, in Frutaz 1962, 2: plan 20, pl. 35.

16. Francesco Bianchini 1738, chap. 4, 30: "nella qual pianta essendo contrassegnate in più luoghi le antiche muraglie rimaste sopra terra delle fabbriche diroccate; anche nel sito del Monte Palatino si veggono indicate molte reliquie di antichità."

17. Francesco Bianchini 1738, chap. 4, 30, 32: "Ma quantunque la immagine di tutta la Città sia delle maggiori che siano state sinora impresse . . . il Monte Palatino occupa in quella carta, non è maggiore di un piede per ogni verso: così che poco apparenti sarebbe state le misure degli edificj, ancora quando fossero state stampate in rame con finissimi contorni. Ma quella stampa fu impressa in legno grossamente: e così negligente riuscì la cura del disegnatore; che in luogo di mostrarci la varia disposizione de'muri e la intersezione delle ruine, e rappresentare le fabbriche circolari e le rettilinee, si contentò di formare un craticcio di linee incrociate ad angoli retti, ovunque voleva indicare vestigio di antichità, tanto nel Palatino, quanto in molte altre regioni della Città: in modo che niun disegno sicuro può ricavarsi non solamente di tutto di Palazzo de'Cesari, ma neppure di quelle ruine di alcune sue parti, che restano a noi scoperte."

18. Francesco Bianchini 1738, chap. 4, 32, 34.

19. Francesco Bianchini 1738, chap. 4, 34.

20. Francesco Bianchini 1738, chap. 4, 34.

21. Lugli 1946, pl. 8.

22. The Baths of Titus were identified with known remains to the southeast of San Pietro in Vincoli.

23. See, for example, the Palazzo Bolognetti (Luisa Scalabroni, *Giuseppe Vasi, 1710–1782* [Rome, 1981], fig. 145), the Palazzo Corsini (fig. 152), and the Palazzo Altieri (fig. 159).

24. See the Palazzo Pio by Camillo Arcucci. Multistory palaces with orders at each level throughout the elevation or in salient sections were often seen in projects for the Concorsi Clementini at the Accademia di San Luca. See, for example, the design for a *palazzo pontificio* by Carlo Stefano Fontana, winner of the second prize, first class in 1703 (Paolo Marconi, Angela Cipriani, and Enrico Valeriani, *I disegni di architettura dell'Archivio storico dell'Accademia di San Luca* [Rome, 1974], 1: fig. 91); the design by Filippo Vasconi for a villa on a lake, first prize, first class, 1707 (1: fig. 176); and the design by Francesco Antonio Bettetini for a villa on a pentagonal plan, first prize, first class, 1710 (1: fig. 226).

25. On Bernini's Louvre projects, see Heinrich Brauer and Rudolf Wittkower, *Die Zeichnungen des Gianlorenzo Bernini* (Berlin, 1931), 1:129–133; Maurizio and Marcello Fagiolo dell'Arco, *Bernini: Una introduzione al gran teatro del Barocco* (Rome, 1967), 162; Franco Borsi, *Bernini architetto* (Milan, 1980), 132–138; Daniella Del Pesco, *Il Louvre di Bernini nella Francia di Luigi XIV* (Naples, 1984); Henry A. Millon, "Bernini-Guarini: Paris-Turin: Louvre-Carignano," in *"Il se rendit en Italie," Etudes offertes à André Chastel* (Rome and Paris, 1987), 479–500; and Irving Lavin, "Le Bernin et son Image du Roi-Soleil," in *Il se rendit en Italie*, 1987, 441–478.

26. Bernini's fourth project for the Louvre was published by Jacques-François Blondel, *L'architecture française* (Paris, 1756), 4: bk. 6, no. 1, pl. 3.

27. For Cronaca, Dupérac, and Panvinio, see above. Giacomo Lauro's reconstruction was published in *Antiquae urbis splendor* (Rome, 1612), bk. 2, pl. 98.

28. Francesco Bianchini 1738, chap. 8, 264: "Degli appartamenti poi voler dare il proffilo sarebbe fatica inutile, e rischio ed ardire soverchio: mentre, essendo stata abbattuta la maggior parte de'muri, e portati via gli ornamenti, che avrebbero potuto dar qualche lume per intendere la forma e lo stile di ciascheduno; nulla di quell'antico, che resta, potrebbe assicurare una elevazione fatta a capriccio sopra i vestigi soli, che non bastano a dimostrarla."

29. Francesco Bianchini 1738, chap. 4, 32, 34.

30. Francesco Bianchini 1738, chap. 6, 90, 92.

31. Francesco Bianchini 1738, chap. 11, 294, 296: "Feci proponimento nel capitolo 6 di non disegnare la pianta del Palazzo de'Cesari, quale fosse nell'età a Domiziano anteriore, rimanendoci del solo stato d'allora più sicuri i vestigj nella scoperta delle gran sale, che ci hanno introdotto a riconoscere l'altre parti non del tutto abbattute, e bastevolmente manifestate parte da'muri, che restano in piedi; parte dagli Scrittori di que'tempi, che ne'libri lor ce le additano. Sembrerà ora ch'io mi discosti da quella risoluzione, mentre propongo in questo capitolo di dare qualche notizia, e forse alcun disegno della prodigiosa Aggiunta fatta da Nerone al vasto Palazzo, che già occupava tutta l'ampiezza del colle Palatino, e tutta abbracciava la prima Città di Romolo Fondatore. Parrà in oltre troppo ardito l'azzardo: mentre di quella aggiunta fu così odiosa la memoria a'prossimi Successori; che non contenti di vederla deformata dall'incendio, per estinguerne del tutto il nome, Vespasiano vi alzò il

Tempio alla Pace e l'Anfiteatro, compiuto poscia da Tito, che dedicollo, e presso quello eresse le sue Terme, e seppelli ne'fondamenti delle sue fabbriche ogni vestigio di quelle moli. Contuttociò io non dispero che sia per non dispiacere il tentativo di figurarne qualche modello, nè sia per ascriversi a temerità l'investigarne la disposizione."

32. See, for example, the central structure and flanking temples(?) found in the Juvarra album in the Biblioteca Nazionale, Turin, Riserva 59.4, fols. 105(3), 64(2), as well as an elevation of one of the temples(?), fol. 78(3), reprod. in L. Rovere, V. Viale, and A. E. Brinckmann, *Filippo Juvarra* (Milan, 1937), pls. 13, 14, 18. For an account of Juvarra's drawings of the Capitoline Hill, see John Pinto, "Filippo Juvarra's Drawings Depicting the Capitoline Hill," *ArtB* 62 (1980), 598–616.

33. See, for example, the symmetrical disposition of triumphal arches, temples, pairs of scissor stairs flanking a two-level arcaded Tabularium, central temple, and perimeter wall at the upper level, as found in the album by Juvarra in the Biblioteca Nazionale, Turin, Riserva 59.4, fols. 105(1), 64(1), reprod. in Rovere, Viale, and Brinckmann 1937, pls. 16, 17.

34. For the 1728 Concorso Clementino, see Marconi and others 1974, 1:13–14, figs. 322–344; and Windsor F. Cousins, in *Architectural Fantasy and Reality: Drawings from the Accademia Nazionale di San Luca in Rome: Concorsi Clementini 1700–1750*, ed.

Hellmut Hager and Susan Munshower [exh. cat., Museum of Art, The Pennsylvania State University and Cooper-Hewitt Museum] (New York, 1982), 96–107; and Cousins, "The Ideal Port and the Concorsi Clementini of 1728, 1732, and 1738" (Ph.D. diss., Pennsylvania State University, 1982).

35. Marconi and others 1974, 1:13–14: "Una gran Piazza situata in elevazione a vista di un Porto di Mare di figura, parte in semicircolo, e parte retta di proporzione dupla alla sua larghezza, aperta, senza fabbrica dalla parte del Mare, con Portici intorno a tre Navate, ornata con colonne doppie, Pilastri, Contrapilastri, ed archi d'ordine Dorico, nel mezzo del quale semicircolo, s'innalzi una Fabbrica superiore d'altr'ordine Ionico di Colonne, e Pilastri, formando un gran Salone, con rincontro delle Arcate a corrispondenza de'Portini laterali per comodo del passeggio de'Mercanti, riserrata con cancellate di ferro, o balaustrate, da'lati del quale Fabbrica di stanze per vari Ministri del Porto. Scala nobile per ascendere al piano superiore, ed altre due scalette segrete, qual piano deve corrispondere al Salone di sotto, ornato con Pilastri, e riquadramenti elevandosi similmente le stanze con finestroni, e ringhiere a balaustrate alla vista del Mare, terminando alla cima con loggie scoperte, con parapetti a balaustrate, per osservare le Navi, e Bastimenti in Mare. La grandezza e misura della Piazza a considerazione."

36. Marconi and others 1974, 1: figs. 333, 335; Cousins in Hager and Munshower 1982, figs. 9-53, 9-54.

AntW	Antike Welt. Zeitschrift für Archäologie und Kulturgeschichte
AR	Archaeological Reports
ArchCl	Archeologia classica
ArchEph	Ἀεχαιολοζικὴ Ἐφημεείε
ArtB	The Art Bulletin
ASAtene	Annuario della Scuola Archeologica di Atene e delle Missioni Italiane in Oriente
AttiMGrecia	Atti e memorie della Società Magna Grecia
AttiPontAcc	Atti della Pontificia Accademia Romana di Archeologia
AttiVen	Atti. Istituto Veneto di Scienze, Lettere ed Arti
BABesch	Bulletin Antieke Beschaving. Annual Papers on Classical Archaeology
BAR	British Archaeological Reports
BASOR	Bulletin of the American Schools of Oriental Research
BCH	Bulletin de correspondance hellénique
BClevMus	The Bulletin of the Cleveland Museum of Art
BdA	Bollettino d'arte
BEFAR	Bibliothèque des Écoles françaises d'Athènes et de Rome
BMMA	Bulletin of the Metropolitan Museum of Art, New York
BonnJbb	Bonner Jahrbücher des Rheinischen Landesmuseums in Bonn und des Vereins von Altertumsfreunden im Rheinland
BSA	The Annual of the British School at Athens
BullCom	Bullettino della Commissione Archeologica Communale di Roma
Chiron	Chiron. Mitteilungen der Kommission für alte Geschichte und Epigraphik des Deutschen Archäologischen Instituts
CIL	Corpus Inscriptionum Latinarum
Corinth	Corinth. Results of Excavations Conducted by the American School of Classical Studies at Athens
CRAI	Comptes rendus des séances de l'Académie des Inscriptions et Belles-lettres
CVA	Corpus Vasorum Antiquorum
Dacia	Dacia. Revue d'archéologie et d'histoire ancienne
Délos	Exploration archéologique de Délos faite par l'École Française d'Athènes
DialArch	Dialoghi di archeologia

DOP	Dumbarton Oaks Papers
EAA	*Enciclopedia dell'arte antica, classica e orientale*
FdD	Fouilles de Delphes, École Française d'Athènes
GettyMusJ	The J. Paul Getty Museum Journal
Gnomon	Gnomon. Kritische Zeitschrift für die gesamte klassische Altertumswissenschaft
Gymnasium	Gymnasium. Zeitschrift für Kultur der Antike und humanistische Bildung
Hesperia	Hesperia. Journal of the American School of Classical Studies at Athens
Historia	Historia. Zeitschrift für alte Geschichte
HThR	Harvard Theological Review
IstMitt	Istanbuler Mitteilungen
JdI	Jahrbuch des Deutschen Archäologischen Instituts
JHS	Journal of Hellenic Studies
JRGZM	Jahrbuch des Romisch-Germanischen Zentralmuseums, Mainz
JRS	The Journal of Roman Studies
JSAH	Journal of the Society of Architectural Historians
JWarb	Journal of the Warburg and Courtauld Institutes
Kokalos	Studi pubblicati dall'Istituto di Storia Antica dell'Università di Palermo
LA	Libya Antiqua
LIMC	*Lexicon iconographicum mythologiae classicae* (Zurich and Munich, 1974–)
MAAR	Memoirs of the American Academy in Rome
MdI	Mitteilungen des Deutschen Archäologischen Instituts
Meded	Mededeelingen van het Nederlands Historisch Instituut te Rome
MEFRA	Mélanges de l'École Française de Rome, Antiquité
MélBeyrouth	Mélanges de l'Université Saint Joseph, Beyrouth
MélRome	Mélanges d'archéologie et d'histoire de l'École Française de Rome
MemLinc	Memorie. Atti della Accademia Nazionale dei Lincei, Classe di scienze morali, storiche e filologiche
MMAJ	Metropolitan Museum of Art Journal
MMS	Metropolitan Museum Studies
MonAnt	Monumenti antichi

MusHelv	Museum Helveticum
NC	Numismatic Chronicle
NSc	Notizie degli scavi di antichità
ÖJh	Jahreshefte des Österreichischen Archäologischen Instituts in Wien
OlBer	Bericht über die Ausgrabungen in Olympia
Palladio	Palladio. Rivista di storia dell'architettura
PCPS	Proceedings of the Cambridge Philological Society
Philologus	Philologus. Zeitschrift für klassische Philologie
Platner-Ashby	S. B. Platner and T. Ashby, *A Topographical Dictionary of Ancient Rome* (London, 1929)
PP	La parola del passato
QITA	Quaderni dell'Istituto di Topografia Antica della Università di Roma
RA	Revue archéologique
RE	Pauly-Wissowa, *Real-Enzyklopädie der klassischen Altertumswissenschaft*
REA	Revue des études anciennes
REL	Revue des études latines
RendAccIt	Atti della R. Accademia d'Italia, Rendiconti della classe di scienze morali
RendLinc	Atti del'Accademia Nazionale dei Lincei. Rendiconti
RendPontAcc	Atti della Pontificia Accademia Romana di Archeologia. Rendiconti
RhM	Rheinisches Museum für Philologie
RivIstArch	Rivista dell'Istituto Nazionale d'Archeologia e Storia dell'Arte
RM	Mitteilungen des Deutschen Archäologischen Instituts, Römische Abteilung
SBHeid	Sitzungsberichte der Heidelberger Akademie der Wissenschaften, Philosophisch-historische Klasse
StEtr	Studi etruschi
StRom	Studi romani
Syria	Syria. Revue d'art oriental et d'archéologie
TAPS	Transactions of the American Philosophical Society
ZDPV	Zeitschrift des Deutschen Palästina-Vereins

Contributors

Malcolm Bell III is a classical archaeologist who teaches at the University of Virginia. He has written on western Greek art and architecture. Since 1980 he has been field director of the United States excavation at Morgantina in Sicily. In 1991–1992 he served as Mellon Professor at the American Academy in Rome.

Herbert Bloch holds a doctorate from the University of Rome and wrote his first book, in Italian, on the Roman brick stamps (1936–1938). He is currently preparing a new edition of that work. He taught classics and medieval Latin literature at Harvard University from 1941 to 1982 and has published books and articles on Greek historiography, Latin epigraphy, the influence of the classics in the Middle Ages, and Monte Cassino.

Richard Brilliant is Anna S. Garbedian Professor in the Humanities at Columbia University and editor-in-chief of *The Art Bulletin*. His most recent book is *Portraiture* (1991).

Vincent J. Bruno is Ashbel Smith Professor of Art History and Archaeology at the University of Texas at Arlington. He is best known for his work on the painting techniques of classical antiquity and his projects in nautical archaeology along the west coast of Italy. His most recent book,

written with Russell T. Scott, is *Cosa IV: The Houses, Memoirs of the American Academy in Rome* XXXVIII (1993).

Joseph Coleman Carter is professor of classical archaeology at the University of Texas at Austin and director of the Institute of Classical Archaeology. He has been conducting interdisciplinary research in the territories of the Greek colonies of Metaponto and Croton since 1974. He has written two books on Greek sculpture: *The Sculpture of Taras* (1976) and *The Sculpture of the Sanctuary of Athena Polias at Priene* (1984). He is currently preparing a report on the university's excavations in the necropoleis of Metaponto, the first in a multivolume publication of the results from the *chorai* of Metaponto and Croton.

Jacquelyn Collins-Clinton is assistant professor of art history at Wells College. As a fellow of the American Academy in Rome, she has excavated at Cosa, written *A Late Antique Shrine of Liber Pater at Cosa*, and will soon publish the sculpture and furniture in stone from Cosa. She is currently collaborating on a catalogue of the antiquities in the collection of the American Academy in Rome.

Susan B. Downey is professor of art history at the University of California, Los

Angeles, and a fellow of the American Academy in Rome. Her research focuses on the Near East after the Greek conquest. She has published two volumes on the sculpture of Dura-Europos, as well as a study of Mesopotamian religious architecture after the Greek conquest. She has excavated at Dura-Europos under the auspices of the Mission Franco-Syrienne de Doura-Europos.

Alfred Frazer is professor of art history and archaeology at Columbia University. He has written on Hellenistic, late Roman, and early Christian architecture. Among his recent publications is *The Propylon of Ptolemy II: Samothrace*, vol. 10.

Anne Laidlaw is E. Marion Smith Professor of Classics at Hollins College. She has written on ancient wall painting and is the author of *The First Style in Pompeii: Painting and Architecture*. She received her doctorate in Latin and archaeology from Yale University in 1963 and is a fellow of the American Academy in Rome. Her excavation training was done under Frank Brown at Cosa in Etruria, and she has directed her own excavation in Pompeii.

Until 1986 **Eugenio La Rocca** was director of the Musei Capitolini e dei Fori Imperiali, Rome. He is now achaeological superintendent for the Commune di Roma, having served as chair in archaeology and the history of Greek and Roman art at the University of Pisa. His studies concentrate on placing Greek and Roman art in their social and cultural contexts. His publications include *L'età d'oro di Cleopatra: Indagine sulla Tazza Farnese* (1984); *La riva a mezzaluna: Culti, agoni, monumenti funerari presso il Tevere nel Campo Marzio Occidentale* (1984); and an exhibition catalogue, *Amazzonomachia: Le sculture frontonali del tempio di Apollo Sosiano* (1985).

William L. MacDonald is an architectural historian and critic educated at Harvard and in Rome. His books include *Early Christian and Byzantine Architecture, The Pantheon*, and the two-volume *Architecture of the Roman Empire*. A fellow of the

American Academy in Rome, he was formerly A. P. Brown Professor of the History of Art at Smith College. He has prepared, with John Pinto, a book on Hadrian's Villa and its artistic and architectural legacy.

Susan B. Matheson is curator of ancient art at the Yale University Art Gallery. She has written on Greek vases, ancient glass, and the ancient city of Dura-Europos, and has recently completed a book, *Polygnotos and Vase Painting in Classical Athens*. She is now working on fascicles of the *Corpus vasorum antiquorum* for the Yale collection and on an exhibition about Tyche in Greek and Roman art.

Lucy Shoe Meritt, editor of publications emerita for the American School of Classical Studies at Athens, is a visiting scholar in the classics department, University of Texas at Austin. She was a member of the Institute for Advanced Study, Princeton, for many years. Her field work as fellow of both the American School at Athens and the American Academy in Rome was mainly devoted to the study of Greek, Etruscan, and Roman architecture. Her publications include *Profiles of Greek Mouldings, Profiles of Western Greek Mouldings*, and *Etruscan and Republican Roman Mouldings*.

Henry A. Millon is dean of the Center for Advanced Study in the Visual Arts, National Gallery of Art, a position he has held since 1979. Educated at Tulane University and Harvard University, he was professor of the history of architecture and architectural design at the Massachusetts Institute of Technology from 1960 to 1980; since 1980 he has been a visiting professor at MIT. He is the author of *Michelangelo Architect* (with Craig Smyth, 1988), *Filippo Juvarra: Drawings from the Roman Period, 1704–1714* (1984), *Key Monuments of the History of Architecture* (1964), and *Baroque and Rococo Architecture* (1961).

Maria Teresa Marabini Moevs is professor emerita of classics and archaeology at Rutgers, the State University of New Jersey. Since 1952 she has been associated with the American Academy in Rome for the

publication of Roman ceramics found in the excavations of Cosa. She is the author of *The Roman Thin Walled Pottery from Cosa* and two monographs on Roman ceramics from Cosa. While continuing her work on the Cosa ceramics, she is also preparing a book on Greek art under the first Ptolemies.

James Packer is professor of classics at Northwestern University. Since 1967 he has written and lectured extensively on the ancient architecture of Ostia, Pompeii, and Rome. His book, *The Forum of Trajan: A Study of the Monuments*, will be published in 1993.

John Pinto teaches in the department of art and archaeology at Princeton University. Among his publications on Italian Renaissance and baroque architecture is *The Trevi Fountain* (1986). *Hadrian's Villa and Its Legacy*, written with William L. MacDonald, will be published in 1994.

Lorenzo Quilici is director of the Istituto di Archeologia and holds the chair of Topography of Ancient Italy at the University of Bologna. He taught at the Universities of Rome I and II from 1971 to 1990 and was a researcher for the Consiglio Nazionale delle Ricerche at the Centro di Studio per l'Archeologia etrusco-italica from 1969 to 1990. He has directed excavations at Civita di Artena, Fidenae; Aghia Irini on Cyprus; Civita di Bagnoregio; the Triopio di Erode Attico in Rome; and the Campus Martius at San Paolo alla Regola. His research concerns the historical-topographical, urban, and territorial nature of areas in central and southern Italy.

Stefania Quilici Gigli, a scholar of topography and urban planning of the ancient world, is a research director for the Consiglio Nazionale delle Ricerche. She has participated in excavations on Cyprus and in Latium and Etruria, and currently is directing the excavations of Norba. Her publications include works on topography and archaeology: *Tuscana* (Rome, 1970); *Blera. Topografia antica della città e del territorio* (1976); and in collaboration with Lorenzo Quilici, *Antemnae* (1978), *Crustu-*

merium (1980), *Fidenae* (1986), and *Ficulea* (1993). Since 1976 she has been responsible for the publication of the volumes *Archeologia Laziale* 1–9. In collaboration with Lorenzo Quilici she edits the journal *Atlante tematico di topografia antica*.

Emeline Richardson is professor emerita of classical archaeology at the University of North Carolina at Chapel Hill. She has been a fellow of the American Academy in Rome since 1952 and was one of the staff of the academy's excavations at Cosa in Tuscany. She has written particularly on Etruscan sculpture; her latest book is *Etruscan Votive Bronzes, Geometric, Orientalizing, Archaic.*

Emilio Rodríguez-Almeida received his doctorate in 1968 from the Pontificio Istituto di Archeologia Cristiana in Rome. Although his attention is devoted mainly to research, he has been visiting lecturer at universities in Italy (Rome, Naples, Perugia, Viterbo), Spain (Madrid, Barcelona, Seville), Switzerland (Lausanne, Bern, Basel), and the United States (Stanford, University of California). His most recent publications include: *Forma urbis marmorea: Aggiornamento generale 1980* (1981); *Monte Testaccio: Ambiente, storia, materiali* (1984); and *Los Tituli picti de las anforas olearias de la Betica, I* (1990).

Ann Reynolds Scott is a classicist with special interests in Roman archaeology, the history and transmission of classical texts, and Latin palaeography. An author and editor of the Cosa publications series, she currently teaches at the University of Delaware.

Russell T. Scott is professor of Latin at Bryn Mawr College and former Andrew W. Mellon professor-in-charge of the School of Classical Studies at the American Academy in Rome (1984–1988). He has written widely on Roman history and historiography and the archaeology of Roman Italy, particularly the excavations at Cosa and in the Roman Forum carried out by the academy under his direction.

Eva Margareta Steinby directed the excavations conducted by the Soprintendenza Archeologica di Roma in the area of the *lacus Iuturnae* from 1982 to 1985. She was director of the Institutum Romanum Finlandiae in Rome from 1979 to 1982 and is currently serving a second term as director from 1992 to 1995.

Mario Torelli is professor of classical archaeology at the University of Perugia. He received his degree in classical archaeology in 1960 from the University of Rome. He has written several books, including *Elogia Tarquiniensia* (1975); *Storia degli Etruschi* (1981); *Lavinio e Roma: Riti iniziatici e matrimonio fra archeologia e storia* (1984); *Arte degli Etruschi* (1985); and, with D. Musti, *Pausania, Guida della Grecia*, vols. 2–4 (1986, 1991).

Fikret K. Yegül is professor of architectural history and chair of the department of art history at the University of California, Santa Barbara. Also trained as an architect, he has excavated at Sardis, Cosa, and Isthmia. His primary area of research is Roman architecture and archaeology. He is the author of several books, including *The Bath-Gymnasium Complex at Sardis* (1986), *Gentlemen of Instinct and Breeding: Architecture at the American Academy in Rome, 1894–1940* (1991), and *Baths and Bathing in Classical Antiquity* (1992).

Fausto Zevi is professor of archaeology and the history of Greek and Roman art at the University of Rome, La Sapienza. He received his degree in Rome in 1961 and studied at the Scuola Nazionale di Archeologia in Rome and the Scuola Archeologica Italiana di Atene. Beginning in 1964 he served as inspector, then director, and finally superintendent in the Soprintendenze alle Antichità in Ostia, Sassari, Naples, and Rome (Museo Preistorico-Etnografico Pigorini).